INTERACTION OF CULTURES

INDIAN AND WESTERN PAINTING

1780–1910

THE EHRENFELD COLLECTION

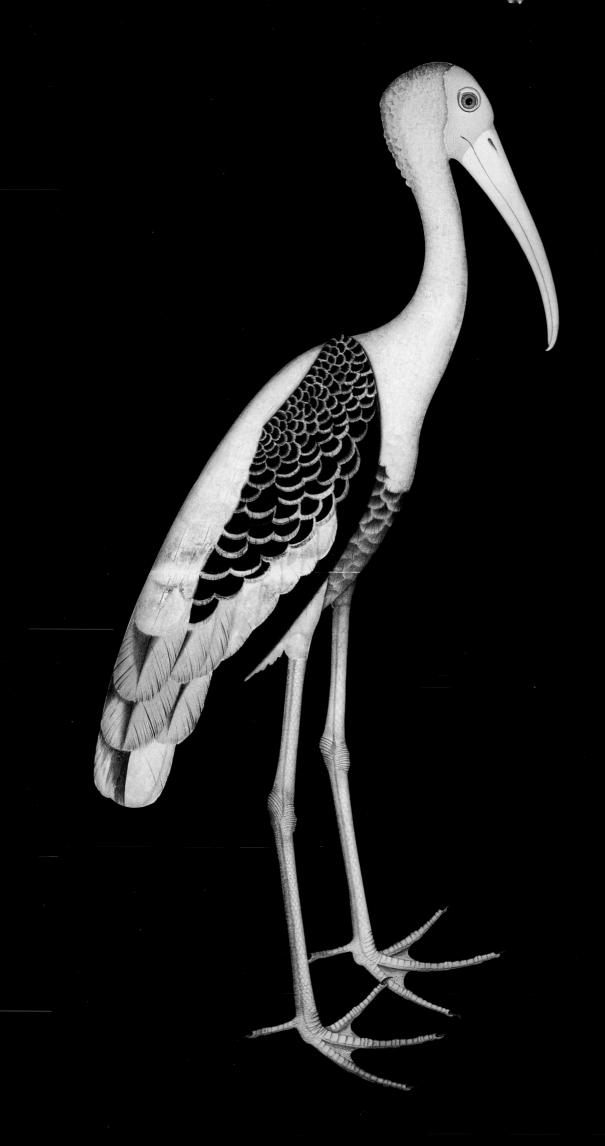

INTERACTION OF CULTURES

INDIAN AND WESTERN PAINTING
1780–1910

THE EHRENFELD COLLECTION

Joachim K. Bautze

Art Services International
Alexandria, Virginia
1998

Cover: Sita Ram, West View of a Mosque and a
Gateway in Upper Bengal, *ca. 1820–1821 (cat. 82)*.

*Inside Covers: Endpaper from an album of drawings
of the Taj Mahal by Sheikh Latif, ca. 1830, commissioned
by Robert Home (cat. 55)*.

Frontispiece: Zayn al-Din, A Painted Stork, *1782 (cat. 90)*.

This volume accompanies an exhibition organized
and circulated by Art Services International,
Alexandria, Virginia.
Copyright © 1998 Art Services International.
All rights reserved.

LIBRARY OF CONGRESS CATALOGING-IN-PUBLICATION DATA
Bautze, J. (Joachim)
 Interaction of cultures : Indian and western
 painting, 1780–1910 : The Ehrenfeld collection /
 Joachim K. Bautze.
 p. cm.
 "Accompanying an exhibition organized and
 circulated by Art Services International, Alexandria,
 Virginia."
 Includes bibliographical references and index.
 ISBN 0-88397-117-8 (hardcover : alk. paper). —
 ISBN 0-88397-124-0 (softcover : alk. paper)
 1. Painting. India—Exhibitions. 2. Painting.
 Modern—19th century—India—Exhibitions.
 3. Painting, India—British influences—Exhibitions.
 4. Ehrenfeld, William K., 1934- —Art collections—
 Exhibitions. 5. Painting—Private collections—
 California–San Francisco Bay Area—Exhibitions.
 I. Art Services International. II. Title.
 ND1003.B38 1998
 759.954 07473—dc21 97-36749
 CIP

EDITOR Dagmar Grimm, Ph.D.
DESIGNER The Watermark Design Office
PHOTOGRAPHER
OF CATALOGUE IMAGES Dennis Anderson
CONSERVATION Debra Evans and
 Colleagues at the Western
 Regional Paper Conservation
 Laboratory
 Fine Arts Museums
 of San Francisco
PRINTER Dai Nippon Printing

Printed and bound in Hong Kong.

Sites of Indian Painting Noted in the Catalogue Entries

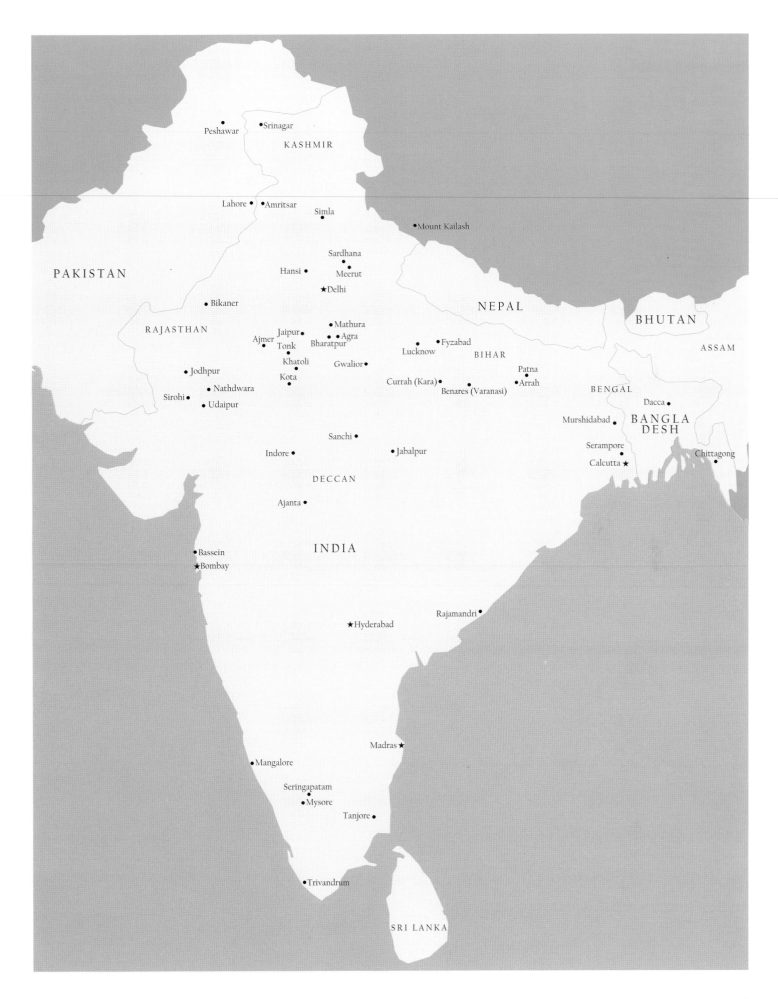

THE INDIAN
SUB-CONTINENT 1868

by Thomas Jefferys
for the East India Company

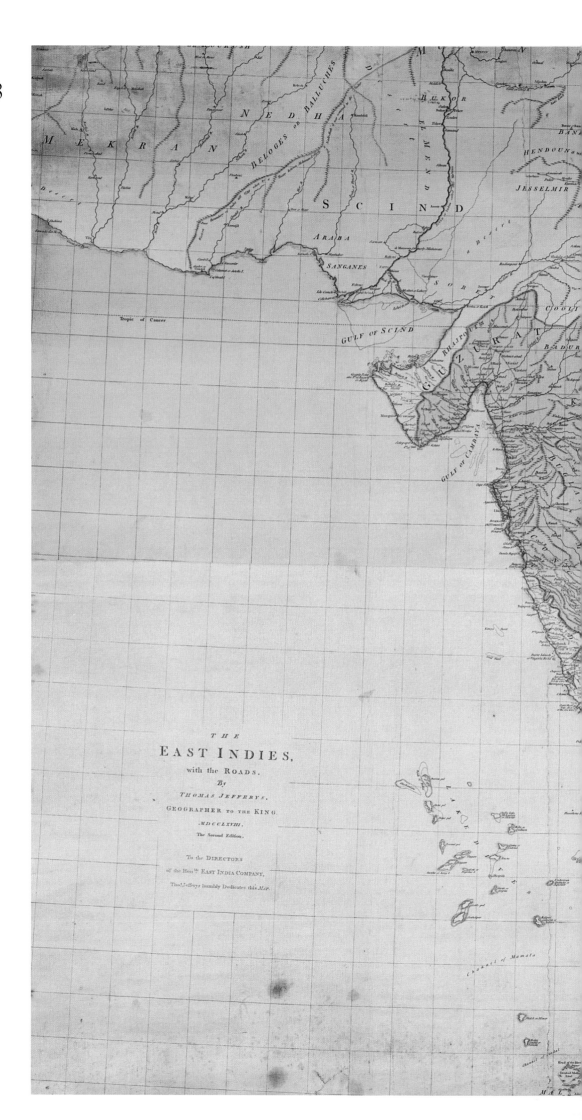

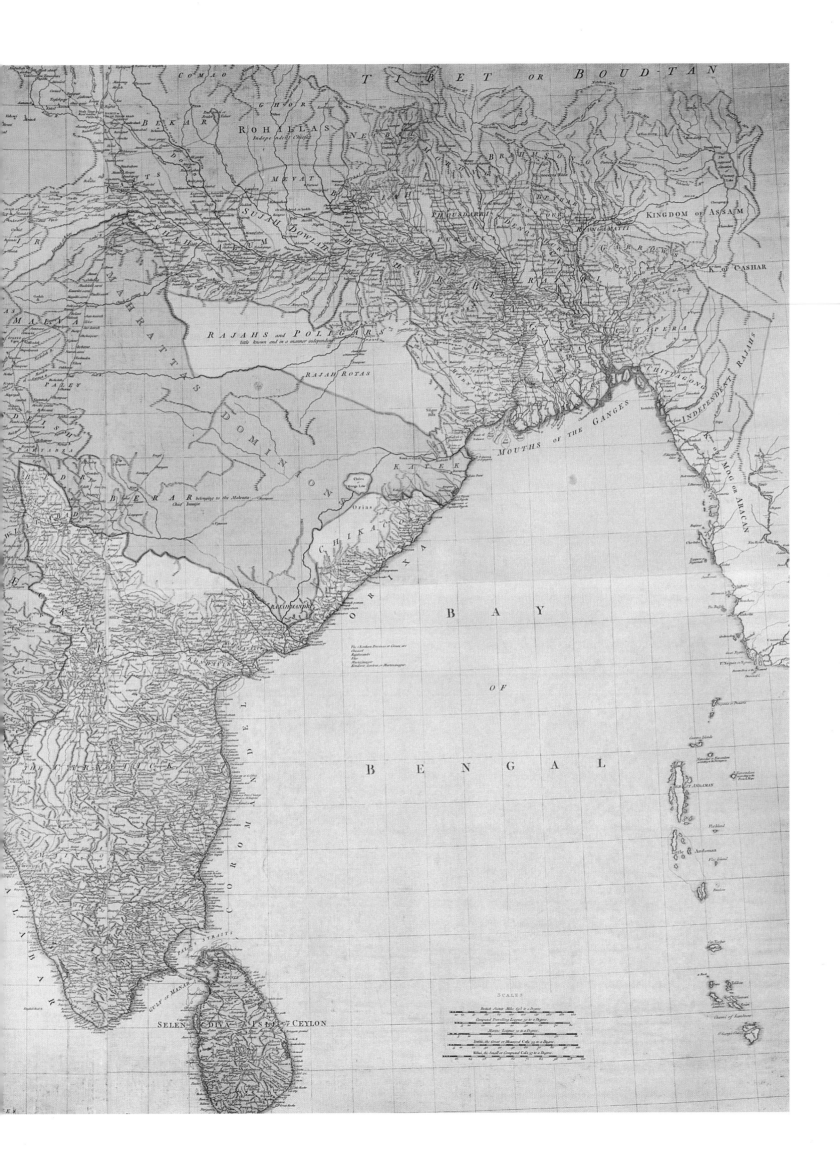

40

72

138

176

202

250

CONTENTS

328

Acknowledgments

The encounter of Eastern and Western aesthetic values on the Indian sub-continent during the eighteenth century had a significant effect on art forms. Artistic interchange followed the arrival of the Europeans, with the traditional hallmarks of both European and Indian art—each with its own set of divergent world views—being indelibly modified. A new insight and appreciation blossomed between these cultures, altering long-held perceptions and misconceptions and influencing the creativity of each. The inspired works assembled in this exhibition document the seminal confrontation of the European and Indian sub-continent cultures.

Interaction of Cultures: Indian and Western Painting (1780–1910), the Ehrenfeld Collection is the result of the combined effort of many talented individuals. Above all, we wish to express our gratitude to William K. Ehrenfeld, M.D., Professor Emeritus of Vascular Surgery, University of California, San Francisco, the visionary collector whose generosity in sharing his wonderful collection of Indian art is unsurpassed. He freely lent his expertise to every aspect of this exhibition, which has benefited by his intense admiration for Indian painting and culture. We are honored that he entrusted his exceptional collection to our care, and the collaboration has been most rewarding. The scholarship of this project was skillfully led by Dr. Joachim K. Bautze, Professor of Art History at the South Asia Institute of Heidelberg University, and curator and chief essayist of the exhibition and catalogue. Working closely with the collector, Dr. Bautze astutely selected paintings which clearly demonstrate the remarkable results that were achieved by both the Indian and Western painters. We applaud his painstaking research, which provides invaluable contemporary commentary that clarifies and enlightens. We further recognize and thank J. P. Losty, Curator of the India Office Library and Records of the British Library, for his discussion of Company painting; Dr. Partha Mitter, Department of Modern South Asia History at the University of Sussex, for his explication of the British Raj in India, and, posthumously, Toby Falk, former independent scholar and Consultant for the Indian and Persian Paintings Department of Sotheby's, London, for his essay which considers the assimilation of Western style by Indian artists. To each of these fine scholars, we send our appreciation for their collaboration and for so generously sharing their expertise.

It is fitting that this project should reach fruition during the celebration of the fiftieth anniversary of India's independence. Our gratitude is extended to the Honorary Patron of the exhibition, His Excellency Naresh Chandra, Ambassador of India, for his early support. We are also pleased to recognize the Minister of Press, Information and Cultural Affairs at the Embassy of India, Shiv Mukherjee, for his assistance.

We are indebted to the Fine Arts Museums of San Francisco, and particularly to Harry S. Parker, III, Director and Dr. Robert F. Johnson, Curator in Charge, Achenbach Foundation, for encouraging this collaboration from the outset and helping to shape its finished form. Also greatly valued is the enthusiasm for the project exhibited by our colleagues at the other museums on the tour: at Juniata College in Huntingdon, Pennsylvania, Robert W. Neff, President and Phillip Earenfight, Director, Shoemaker Galleries; Dr. Diane Lesko, Director and Christine Neal, Curator of Fine Arts and Exhibitions, Telfair Museum of Art, Savannah; George Ellis, Director and Jennifer Saville, Curator of Western Art, Honolulu Academy of Arts; and Dr. Kahren Arbitman, Director and Dr. Sally Metzler, Curator, Cummer Museum of Art, Jacksonville, Florida. In providing the opportunity to view this excellent collection, these knowledgeable professionals have performed an important service for their audiences.

With pleasure we commend the staff of Art Services International for the dedication and professionalism which they have exhibited in the preparation and management of this undertaking. In particular, we thank Douglas Shawn, Donna Elliott, Sheryl Kreischer, Linda Vitello, Mina Koochekzadeh, Kerri Spitler, Catherine Bade, Sally Thomas, and Betty Kahler. We also thank Dr. Dagmar Grimm, project editor, Lynne Komai of The Watermark Design Office, and Etsuko Minematsu of Dai Nippon Printing, New York, for so skillfully combining their talents in the preparation of this volume.

Lynn K. Rogerson, *Director* Joseph W. Saunders, *Chief Executive Officer*

ART SERVICES INTERNATIONAL

11

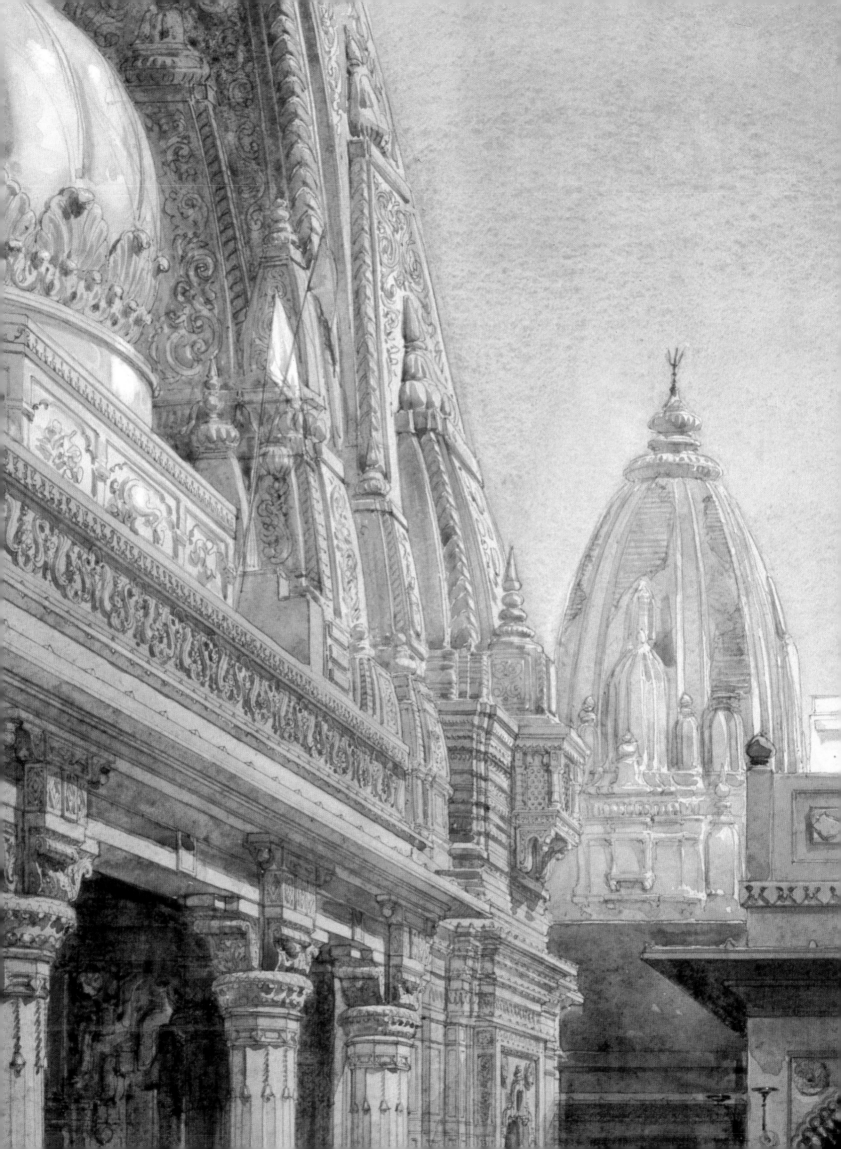

Preface

William K. Ehrenfeld, M.D.

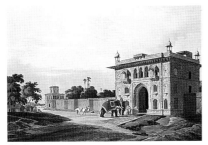

Fig. 1

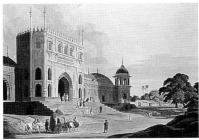

Fig. 2

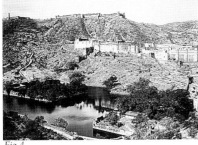

Fig. 3

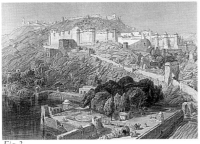

Fig. 4

Fig. 5

Left: Fig. 9 (detail)

All collectors who develop an interest in circa nineteenth century paintings on and from India inevitably also become exposed to a multitude of prints (i.e., aquatints, mezzotints, lithographs, engravings, etc.) as well as photographs. Indeed, exposure to such works has undoubtedly stimulated collectors to expand their collecting horizons. These pictures are more available, accessible, and affordable than original oil paintings, watercolors, or drawings, and aptly represent the "fabled lands" which were of great interest in England and elsewhere in Europe in the nineteenth century, and even earlier.

This exhibition includes some of my earliest acquisitions of paintings from India — some by the pioneers of painting at the end of this era who profoundly affected the renascence of tradition found in the wonderful contemporary Indian art that has been shown recently and widely — as well as three prints, and no photographs. The paintings and prints are ably and fully discussed in the catalogue text written by Joachim K. Bautze of the South Asia Institute at the University of Heidelberg. It is my intention in this preface to provide a few additional examples of prints and photographs pertaining to the exhibition and to offer some explicatory comments.

Several years ago I acquired two prints after works by Thomas and William Daniell. Apparently quite recently these prints had reached London from St. Petersburg, Russia, where they had been stored in cases unopened for nearly two centuries. They were the most pristine, the most vivid in color, that I had ever seen. The first print depicts the gate of the Loll-Baug at Fyzabad (fig. 1). It was drawn in July 1789 and hand-colored later in October 1801. Fyzabad had been the capital city of Oudh under the rule of Shuja ud-Daula from 1754–1775. His son subsequently transferred the capital to Lucknow. The second print shows the gate of a mosque built by Hafiz Ramut of Pillibeat (fig. 2). At his death in 1774 at the battle of Miranka Katra, Pillibeat came under the rule of the Nawabs of Oudh, who held it until 1801 when it passed to the British. In 1857 the population rose in revolt and expelled the British authorities. However, in that year of the mutinies, control passed back again to the British with the installation of the "Raj" during the rule of Queen Victoria of England.

Two works after William Simpson, a great English artist who spent much time in India and was very productive, depict scenes similar to photographs of sites where Simpson chose to paint. The first is a view of the city of Amber, notable for a fortress erected at great height above the city. The print was published by Day and Son in 1867 as part of *India Ancient and Modern*, volume 1, plate 10, where it is entitled "Ambair" (fig. 3). In a photograph from the turn of the century it is apparent that the photographer chose a similar viewpoint for his work (fig. 4). One is tempted to conjecture that he was familiar with Simpson's earlier, precise painting of the exact spot. It is interesting to note that the earliest photographic techniques were brought to India by the middle of the nineteenth century, and ultimately photography played a significant role in the demise of Indian painting traditions.

The second print from an original painting by Simpson is a well known image; the painting served as the cover illustration of a distinguished publication by Pratapaditya Pal and Vidya Dehejia, entitled *From Merchants to Emperors* (1986). Simpson entitled his painting *A Street Scene in Bombay, 1862;* the print (fig. 5) was also published by Day and Son in 1867. The scene depicts bustling commercial activity from rows of shops open to the street. Similar scenes, unchanged for centuries, may be encountered today, as very few shops, or even homes, are enclosed.

A photograph taken somewhat later in the nineteenth century, entitled *Street in Bombay,* apparently depicts the same shop, dominant at the far right in both painting and photograph (fig. 6). Evidently, in the intervening years, a wall was constructed adjacent to the large shop. The photograph also vividly displays different manners of transport on dirt

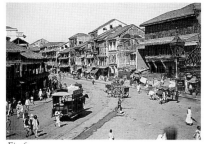

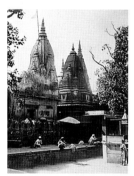

roads before the advent of the motorcar, later avidly acquired by prominent Indians (fig. 7). The inspiration of a photograph long in my possession recently prompted me to purchase an original painting by William Simpson. The photograph, probably taken in the latter part of the nineteenth century, shows a close-up view of the Hindu Golden Temple in Benares (fig. 8). Its great magnitude may be appreciated by comparing the relative size of the human subjects also included by the photographer. When an original painting of the temple by Simpson, signed and dated 1862, became available, its familiar golden spire and true beauty impelled me to pursue it (fig. 9).

Another print of interest is entitled *N.W. View of Nandy Droog*, which depicts a site located in the territory of Mysore, within thirty miles of Seringapatam (fig. 10). Taken by force by Hyder Ali, the father of Tippoo Sultan, Nandy Droog became a virtually inaccessible fortress, standing 4,856 feet above sea level and over 1,500 feet above flat ground. During the third of the so-called Four Mysore Wars, beginning in 1767 and ending in 1799, it was besieged in 1791 by a British force, and after fierce resistance was taken by "storm." The British forces at this siege were in the overall command of Lord General Cornwallis, who had earlier led British forces against General George Washington during the Revolutionary War of Independence in America. The print was largely drawn after Lieutenant Robert H.

Fig. 11

Fig. 12

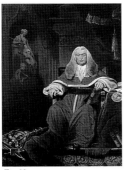

Fig. 13

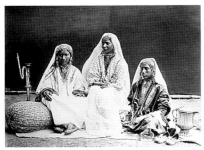

Fig. 14

Colebrooke and was published in London as part of Colebrooke's *Twelve Views of Places in the Kingdom of Mysore, the Country of Tippoo Sultan* (1793).

Two photographs taken some one-hundred years later illustrate well the size of the fortress and its fortifications as well as the much lower level of the adjacent flat land (figs. 11 and 12). The history of this fascinating period is comprehensively elaborated in the catalogue text.

A very beautiful colored print of a revered judge, and a sensitive photograph of three nautch girls from Cashmere (Kashmir) who display uncommon dignity, complete my selection. The hand-colored print (fig. 13) is from a portrait of Sir Henry Russell by George Chinnery. Russell was held in esteem by both the native Indian population as well as most of the British, and was appointed Chief Justice of the Supreme Court of Judicature of Bengal in 1807. Chinnery, who was thought to be the most accomplished artist of his time in India, recognized this as an extraordinary opportunity to paint a highly important commissioned portrait, which was to be hung in the splendid Town Hall. As demonstrated in this print, Chinnery's skill and sensitivity in portraying the subject as a man of strength and judgment more than justifies his choice by the commissioners.

Finally, the photograph of the nautch girls of Cashmere (Kashmir) (fig. 14) presents not only their beauty but also their decorous demeanor. It should be understood that nautch women were dancers and prostitutes but of a very special, elevated class.

In this preface I have just touched the surface of some material of this period that is often a significant part of any collection of merit. I have deliberately refrained from a discussion of specific aspects of prints and photographs better left to others with advanced knowledge and expertise. It is my hope that these additional examples of prints and the accompanying photographs provide further insights into the great tradition of Indian painting and, from the viewpoint of a collector, into the rewards of its study.

The development of this exhibition and catalogue has provided great satisfaction. Certain exceptional people have also made it a great pleasure, and I would like to take this opportunity to acknowledge their assistance. Firstly, the continued interest in my collecting by Robert Flynn Johnson, Curator in Charge, Achenbach Foundation for Graphic Arts, The Fine Arts Museums of San Francisco, has made this second exhibition possible. My thanks go to Lynn Rogerson, Joseph Saunders, and all of their wonderful staff at Art Services International, who have assisted me with their knowledge and help that has always been given with good cheer. The special expertise of Jerry Losty, Curator at the Oriental and India Office Collections of the British Library, available to me from the project's inception, has contributed significantly to this effort, and the personal interest in the progress of the undertaking demonstrated by Suzanne and William von Liebig, has been a continuing inspiration. Particularly gratifying on both a personal and professional level, as well as a great learning experience, has been the opportunity to work closely with Joachim Bautze, who is a remarkable scholar and sensitive individual.

With great sadness, I also acknowledge the contribution of Toby Falk to the essays in this volume. His untimely death last year has created a large void in the Indian art community, and I dedicate this catalogue to him.

A legion of others — I believe they know who they are — have helped in countless ways, and I thank them. This undertaking represents the culmination of my long-held interest in the traditional painting of India of the last century or more. It affirms that, no matter the degree of Western influence that came to bear, the import of the established values of Indian art and artists did not end.

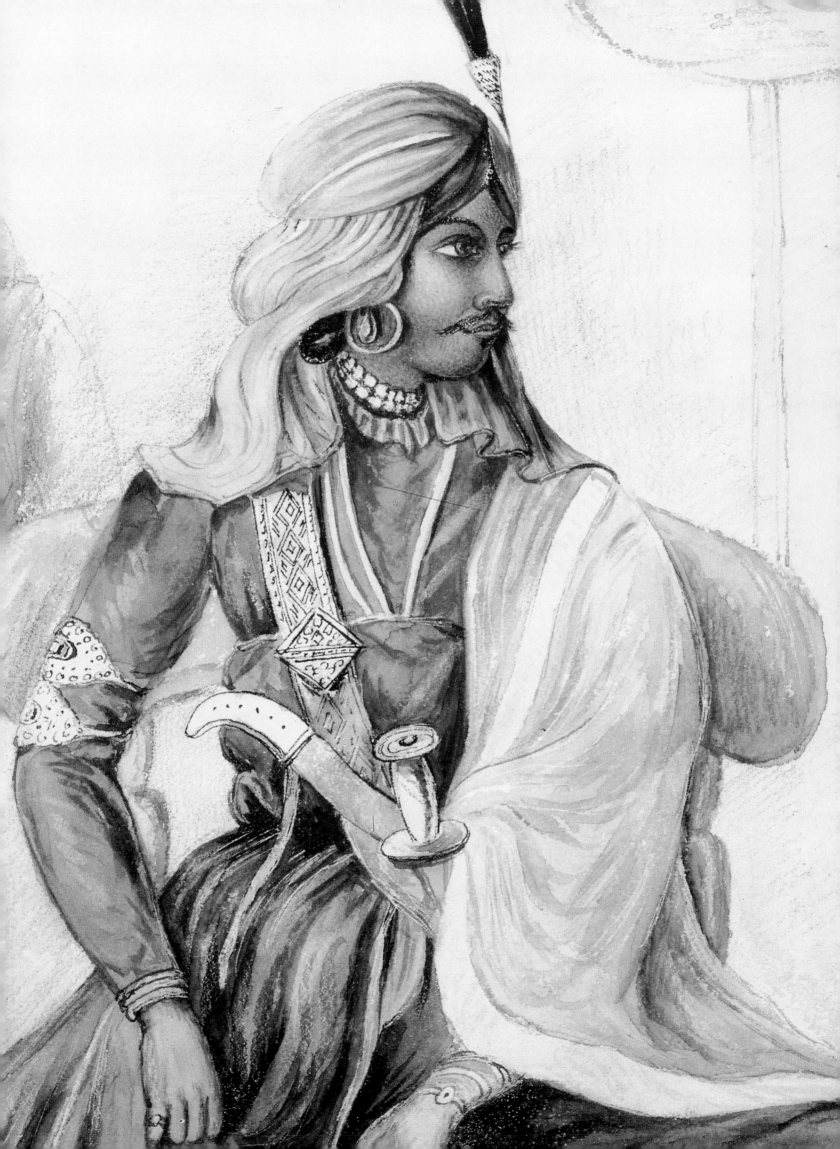

Introduction

India and the West: the Interaction of Artists

Joachim K. Bautze

C lose Western contacts with India date back to the time of the Greeks and Romans and continued to exist until the seventeenth century. European influence on Indian art was limited to the last two centuries B.C. and perhaps the first three centuries A.D. It was restricted to certain areas in the north-west (present-day Afghanistan and Pakistan) of the sub-continent, and seldom affected regions outside this area. Conversely, the effect that Indian art exercised on the art of Europe was almost negligible. This situation drastically changed towards the middle of the seventeenth century, when European powers of different national origin focused their attention on India, or, to be precise, on her assumed as well as existing treasures. The Portuguese, who had been in India already for some time, acquired a number of stations along the Indian coasts without ever really penetrating into the country. The Portuguese monopoly on East Indian trade lasted a long time, but was undermined, and finally broken: Portuguese ships gave way to Dutch, French, and increasingly, English vessels. A few naval expeditions sent to India by other European nations were of little importance.

The art-historical contact that the French and primarily the British had with India, and the Western reaction to Indian art as it was presented in Europe, forms the subject of a "modern classic," Partha Mitter's *Much Maligned Monsters.* By the end of the eighteenth century, those interested in Indian scenes were no longer satisfied with depictions that portrayed the fantasy of the European artist to a greater extent than, say, the intended portrait of a Mughal emperor. By then, too many people wanted to know more about the real India and no longer wished to rely on tales and engravings which showed that the engraver very often had no idea about his subject. J.M.W. Turner, R.A., for example, had never been to India. But seven of twenty-nine engravings in one of the then most successful picture books on the Indian Himalayas were conceived by him.[1] Today's Western image— or rather, concept— of India is based on information that first reached Europe and then America in the late eighteenth and throughout the nineteenth century. As today, the general public cared but little for the actual "truth" of this information. And, as today, the general opinion was based on images rather than texts or analyses, which, in those days, were even fewer than today. This exhibition reveals the sources of some of these more relevant "images," which have shaped the general public's opinion on India to the present day. A few pictures presented here are large-sized, actual engravings; the great majority of objects, however, are unique and often formed the basis for a published engraving, lithograph, or woodcut. Several other paintings and prints in this exhibition have never been published, or at least never printed before. All of the pictures, however, relate to India during a very crucial state of her development; they were created by the most eminent artists of their age and therefore are the most typical examples of their time.

Is there a difference between Western and Eastern—in this case Indian—aesthetic ideals? And who is to judge? India was conquered and occupied for some time by Western powers who wanted to benefit from her riches. Among those European powers, Britain finally managed to take the lead, and sought to rule and to exploit India. Britain was thus officially deemed superior, not only in warfare, but also morally and even aesthetically. Without this conviction of superiority—the normal attitude of the conqueror towards the conquered— no Scottish Highlander or common English soldier would have endured the Indian climate, culture, religion, and last but not least, Indian aesthetics. This attitude was not typically British; it was, and unfortunately at times, still is, typically European. The British alone are not to be blamed for it; any other European power in Britain's place probably would not have done better—or worse. All indications of a possible Indian "superiority" in regard to her people or art had to be seriously questioned by her conquerors or all those who wanted to profit from her. The beauty of the Taj Mahal, as an example, was universally accepted. But it was completely unacceptable that the Taj was built by an Indian. It had to have been created by a European, and it is hence not surprising to read a commentary by an American

missionary who used an engraving of the Taj as the frontispiece to his book in 1872: "An article on the Taj, without some account of its architect, would be indeed incomplete. But the record, assuming its correctness, enables us to supply this information also. The wonderful man whose creation the Taj is, was, it is believed, a Frenchman. . . ." [2] Following this line of thought, we do not even raise an eyebrow when we read that Mumtaz, the woman for whom the Taj was initially built, hated all Christians.[3] In the same vein, we are informed that the handsome Hira Singh (cat. no. 22) was, to put it mildly, of low character, and that the powerful Begam Sumroo (cat. no. 47) was cruel, and the then still very attractive Rani Jindan (cat. no. 48) was, by birth, a prostitute.

From the catalogue entries it will become clear that, particularly in the first half of the nineteenth century, official British government employees or missionaries almost had to condemn Indian art and its sponsors, either for the sake of the crown or for the sake of God, and sometimes for both. And, it must be added here, an American missionary was by no means more tolerant towards Indian religions and their associated art-forms than his colleague from Europe. "Unofficial" persons felt less compelled to criticize the Indian way of life and Indian art forms such as architecture, paintings, or dance. In criticizing Indian art forms, British women were less strict than their countrymen, and French spectators enjoyed Indian dance more than British officials. As a matter of fact, not all British officials in India were convinced that what was taught them about the "natives" was necessarily correct. In 1858, when passing a so-called *ghat* — steps leading to a river or tank on which the Hindus in some places cremate their dead — a special correspondent to *The Times* remarked:

In India, indeed, extremes meet. Heard dreadful stories of these ghauts, and of the deeds supposed to be done at them. How the last offices are sometimes complicated with parricide and murder, how the old are brought down to die, and are smothered with the filthy mud which is thrust into mouth and nostrils, the screams of the murdered being overwhelmed in the infernal din which is raised in mockery of grief, and such like tales that make one's own blood run cold. And we are the legislators, the law executors, and the teachers of this people! If the vices attributed to the Hindoo by the English exist to their full extent as described — if youth is made inexpressibly corrupt, and age is a maximized villainy — if infanticide and parricide are practices and customs of the people — how is it that the race itself maintains its vitality — that it increases ... that its numbers show no mark of diminution and no sign of physical deterioration?[4]

Ever since the last exhibition based solely on paintings from the collection of William K. Ehrenfeld[5] closed, the beauty, the charm, and the "mystery" of these exclusively Indian pictures has been admired and valued. Contrary to the declaration of a British official in January 1839,[6] these paintings were not "improper," they were not properly understood. To narrow the gap between the Indian "mystery" about — and the Western non-understanding of — Indian pictorial art, Dr. Ehrenfeld has assembled a collection that is also outstanding from the art-historical point of view. The Ehrenfeld Collection helps explicate pictures by Indian artists painted in the Indian style and paintings by European and American artists in the Western style. It illuminates attempts by Indian artists to paint in the European manner and elucidates a Rembrandt drawing after an Indian miniature.

All these pictures center around India and her history, culture, and art. Each catalogue entry that accompanies this exhibition is introduced by a contemporary or near-contemporary description of the object. In some instances the quoted text is by the artist himself, which, in a few cases, was to be printed with the painting in its engraved, published form. The contemporary description is meant not only to summarize the content of the picture or explain its details. It is hoped that it will convey the message of the *Zeitgeist*, the prevailing spirit of the age. The text also stresses important details which are generally omitted by people who work and deal with this kind of material every day.

Very few Indian sources can be quoted. Although they exist, they have not been translated and published in the West. Whenever an Indian opinion on a painting is quoted by a Westerner, however, it becomes clear that the Indian was accustomed to appreciate Indian art with his own eyes, irrespective of Western criticism often leveled at the work. It also becomes apparent that Western opinion always criticized certain "defects" in Indian painting, such as a lack of light and shade, and a lack of "Western" perspective, whereas Indian opinion practically never stressed the "defects" of Western pictorial representations. Western observers had more faith in a Western pictorial representation of an object. They had learned to "see" it and were brought up in a tradition which cared about the meaning, iconography, and interpretation of a picture. The same could be said about Indian observers, who were able to "see" and to "read" the products of Indian artists.

The most important subject in these works of art is the individual. The Western mind entertains the opinion that it is able to assess a person's character from his or her portrait. We forget in the West that the painter or photographer who depicted an Indian was generally informed about the character and the achievements as well as the shortcomings of his or her sitter. The artist's knowledge of the subject naturally influenced the rendering of the portrait. But even today, some Western writers claim a certain superiority for Western depictions when compared with Indian portraits done by Indian artists, which they criticize as lacking in "psychological depth." If it be true that we are able to determine a person's character from a portrait, why then was the great majority of the German — and not only the German — population fooled by portraits of a statesman which circulated on billions of postal stamps earlier in this century? The fact is that along with a portrait comes a story. When seeing another portrait of the same person, the same story comes to mind, and we imagine that we understand the character of the depicted. The stories accompanying Indian portraits were never heard; they never formed part of our education, our culture. This is why, in the Western mind, one Indian portrait resembles another. Quite unsurprisingly, to the "uninitiated" Western observer, Indian portraits always remain unrecognizable. The educated Indian observer, however, does recognize the subjects portrayed by Indian artists as does the educated Western observer recognize Western portraits. But contrary to Western opinion, the Indian observer would never criticize Western portraits, although perhaps having sufficient reason to do so.

The Harvard professor emeritus Stuart Cary Welch, probably the greatest living connoisseur of Indian pictorial art, has taught us to sample, to see, to enjoy, to evaluate, and to appreciate the great aesthetic merits of Indian pictures through exhibitions that he has curated. He understands the nature of a Mughal emperor, of the Sikh leader, Ranjit Singh, or a *maharao* from Kota. This exhibition intends to demonstrate that Indian artists and artists in India not only depicted aesthetically pleasing, rewarding, or challenging images but an element of Indian truth, or reality. It is this Indian reality, or rather the present understanding of it, which is purposed to be evoked by the present undertaking. The people introduced here existed, the events happened, and most of the monuments shown here still stand. The Western way of seeing and of depicting these people, events, and monuments is just one of the many possible ways. It is certainly not the only way. An alternative method of depiction is offered by the Indian way, free from the burden of exaggeration, fresh in appearance, and certainly devoid of prejudices — from which the Western world can learn the lessons Indian perception was constantly trying to impart. The fiftieth anniversary of Indian independence from British rule is a welcome opportunity to look at Indian paintings and paintings from India in the present exhibition in order to gain greater insight into the artistic interaction of India and the West.

AUTHOR'S NOTE

Even a small contribution to a project like this cannot materialize without the help of a number of people. I am most beholden to my colleagues at the South Asia Institute of the Heidelberg University, in particular to Dr. Georg Berkemer for his help in the identification of cat. no. 34, *The Battle of Rajamandri*; to Dr. Christina Oesterheld for reading and translating a great number of the *Nashtaliq*-inscriptions; and to Cand. Phil. Scarlett Walle for her patience and skillful diplomacy, enabling me to have more convenient access to rare and old library books which normally never leave the shelves. Dr. Martin Pfeiffer and Dr. Volkmar Enderlein from Berlin were also very helpful. Jeremiah P. Losty in London is to be thanked for a number of reasons. He is a reliable, modest, and inspiring friend and one of the *very* few great scholars of the "old school." Robert Skelton, who needs no introduction, generously allowed me to consult his library when staying with him in London while collecting material for this catalogue, and Andrew Topsfield from Oxford is to be thanked for kindly supplying information on the paintings by Raja Jivan Ram kept there. Dr. Dagmar Grimm, project editor, performed miracles in making my text readable. Dr. habil. Claudine Bautze-Picron of the C.N.R.S., Paris, not only exempted me from my household duties in order to allow me to work on this project, she also actively supported it by supplying essential information on various Western artists. Almost needless to say, without Dr. William K. Ehrenfeld's untiring enthusiasm, interest, and support, this exhibition and catalogue would never have seen the light of day.

NOTES

1. Cf. White 1838, frontispiece, pls. facing pp. 26, 31, 38, 43, 58, 78.
2. Butler 1872, p. 148. It should be mentioned here that the most informative book on the Taj Mahal ever published is in great part by an American art historian, cf. Begley/Desai 1989.
3. Butler 1872, p. 147. For a complete translation of the inscription on the cenotaph of Mumtaz Mahal as referred to by Butler, see Begley/Desai 1989, p. 237.
4. Russel 1860, vol. I, p. 126f.
5. Cf. Ehnbom 1985.
6. "Then G[eorge] Eden, Earl of Auckland, Governor-General of India 1835–1842 and brother of Emily Eden, the author quoted here would go up to his house [to the house of the Raja of Nabun, a Sikh state], and then up the steps, A. [John Russel Colvin, Private Secretary to the Governor-General] and C. [Sir George Clerk] objurgating him all the while; then the cunning old Nabun asked him to look at the paintings in the room. A. and C. grew desperate, and said the pictures were very improper. G. declared they were very pretty. . . ." (January 19, 1839) Eden 1937, p. 244.

The Place of Company Painting in Indian Art

J. P. Losty

Company painting has not had good press in this century. The prevailing view of this style, which owes its name to the patronage of Indian artists in the colonial period by the officials of the East India Company, has been that it is historically decadent as the product of colonial society, and aesthetically unexciting as a mixture of Eastern and Western artistic styles. Only a few voices have been raised in protest, such as that of Stuart Cary Welch in his pioneering exhibition in 1978.[1] Fortunately, the great London museums and libraries have long been richly stocked with such paintings for those interested,[2] while this attitude has neither hindered a select number of scholars and dealers from discovering new material nor prevented enlightened collectors, such as Dr. William K. Ehrenfeld, from acquiring it.

Let us first dispose of the calumny that Company painting, being heavily influenced by British painting, must necessarily be inferior to traditional Indian styles.[3] One of the most striking characteristics of Indian artists over the past millenium has been their openness to different styles. The Sultanate, Mughal, and Company styles differ greatly from each other, but are in fact alike in their having been initiated by foreign rulers.[4] What, it may legitimately be asked *is* Indian painting in this period, as opposed to painting that was done in India? What might to the casual observer seem to be the purest north Indian style is what we call Rajput painting: silhouetted figures boldly painted against non-representational backgrounds, painting that is almost abstract in its line and color compared to the formal concerns of naturalistic painting. In fact, such a style flourished for a bare two centuries — it emerged in the sixteenth century in the Rajput courts, and was gradually submerged in the spread of the Mughal style during the eighteenth century. The temple wall-paintings in the south are very different, and might have greater claim on being considered a representative Indian style were they not so clearly the fossilized remnants of an archaic style. The influence of Persian painting on that of India is obvious in the fifteenth and sixteenth centuries in contributing to the creation of first Sultanate and then Mughal and Deccani painting; and Mughal painting developed the way it did in the late sixteenth and seventeenth centuries, with its increasing concern for naturalism, because its patrons and artists were exposed to and impressed by the art of Europe.

It follows then that Company painting is traditionally Indian in adapting foreign influences, and that it cannot on that ground alone be inferior to earlier painting styles. If we actually look at the finest paintings of the period with unprejudiced eyes,[5] we can in fact see not only an aesthetically Indian approach to form and composition, but also a select number of artists working at the highest pitch of creativity. Company paintings can rise to the same heights as earlier styles. In order to appreciate them, however, one must overcome the prejudice that, because stylistically and in subject matter they often resemble European drawings, their obvious differences, as in their almost complete lack of attention to linear perspective, detracts from them as works of art.

Fig. 1. Scene from the Mahajanaka Jataka, *wall-painting in Cave 1 at Ajanta, 6th century A.D. (After G. Yazdani, Ajanta, London 1931, part 1, pl. XX.)*

Little has survived of the classic period of Indian painting of the first millennium A.D., apart from the paintings of the fifth, sixth, and seventh centuries decorating the walls of some of the Buddhist caves at Ajanta in western Maharashtra. In these heavily peopled and complex paintings, artists made use of deft figural stylizations combined with a naturalistic rendition of volumes, and a high viewpoint that allows placing of people and buildings in a landscape. Here is reproduced the natural world through the refined internal eye of the Indian aesthetic theorists, in a style that aims towards naturalism without itself being naturalistic (fig.1). In this example, the pavilions are rendered in different perspectives, which themselves differ from that of the landscape that continues up behind them, and which is clearly viewed from above. Indian painting of this period did not then aim at a fully representational art, or any kind of illusionism, as in Roman classical painting. Perspectival realism was innately foreign to the Indian mind, and remained so. These paintings represent, as does Indian sculpture of the first milennium, the classic flowering of a civilization secure in its beliefs and in itself.

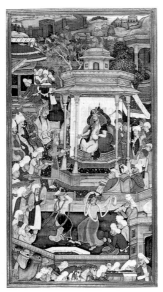

Fig. 2. Narsingh and Farrukh,
Humayun being entertained
at Herat in 1544. *Opaque watercolor*
and gold, from the Akbarnama, *ca.*
1604. 9⁷/₁₆ x 4¹⁵/₁₆ in. (24 x 12.5 cm.) British
Library (Oriental Collections),
Or.MS.12988, f.96v.

This civilization was brought to a precipitous end about A.D. 1200 by foreign invasions and conquests, and was followed by seven-hundred years of mostly foreign rule by miscellaneous Turks, Persians, and Britons. At the beginning of this period, Indian painters had to begin again. Complete changes of medium (palm-leaf to paper), painterly technique (simple color washes to the layered and burnished technique of Persian painting), and subject matter (from Hindu culture and literature to Islam and Persian poetry) were demanded of Indian artists by their patrons. In the illustration of Jain manuscripts, artists forged a broken-down, non-naturalistic style for book paintings for bourgeois patrons; those aspiring to court patronage had to learn to paint in foreign styles if they were to survive. There was little native court patronage, and any political or cultural resistance was only temporary.

In such circumstances Indian painters sought as best they could to adapt the styles of their new masters to reflect traditional concerns inherited from their far distant artistic progenitors of the classic period. The Persian styles during the fifteenth and sixteenth centuries, and European techniques in the sixteenth century were adapted to produce paintings that are recognizably, innately Indian, but which have few other contemporary Indian paintings with which we can compare them; for these artists were working largely in a vacuum, their ideals apparently inspired not by existing art, but by their mind's vision of what Indian art should be.[6] How else can we explain why Sultanate painting is not the same as that of Shiraz, or Mughal as that of Tabriz? And so, in the eighteenth and nineteenth centuries, Indian painters, dissatisfied with the stagnation of late Mughal painting, again adapted new ideas from Europe.

For this extended period of seven hundred years Indian painters slowly, painfully, tried to find the way to realize again the formal concerns that had dominated classic paintings of the past. The period roughly coincides in European painting with the long march, from Giotto to the nineteenth-century realists, towards naturalism and the triumph of representational painting, when a constant preoccupation of artists was to make the figures and spaces on their flat canvases appear three-dimensional and realistic. Indian artists were no less concerned with their inherited feeling for volume and space in their paintings, although without any corresponding desire to imitate reality. Thus, when faced with the high horizon and flat ground of a fifteenth-century Persian painting from Shiraz, they made sure that their figures stood with their feet on something solid, in order for them to appear to be securely anchored into the composition. In the same way, early Mughal painters seized on the beginnings of naturalism in the Tabriz school, and responded enthusiastically to imported European prints and paintings (cat. nos. 1 and 2), which helped them impart volume to their figures and recession to their compositions and landscapes. This framework of naturalism derived from European models was carefully controlled, always anxious to distinguish between the lifelike and the alive, for Islamic aesthetics no more than Indian approved of absolute realism. What emerged in Mughal painting was a naturalism miraculously close to classical Indian painting, a concern with volume, form, and spatial depth in a carefully controlled, perspectival framework viewed from an imaginary position on high (fig. 2). In this example, as in many others, are found the formal conventions of the Ajanta style (compare fig. 1): rulers, or important personages, are positioned in pavilions in gardens, or in courts over whose walls and gateways we can see because of our high viewpoint. Numerous attendants minister to the wants of the powerful, while others wait around.

A century of continuous experiment and expansion in Mughal painting from the reign of Akbar to that of Shah Jahan had resulted in paintings that answered to the Indian need for a painterly plasticity matching that of the classical period. However, by the mid-eighteenth century Mughal painting had run its course. Another century of first withdrawal of enlightened patronage and subsequent political disasters had reduced this naturalism to a dry academicism, in which stock subjects were endlessly repeated with few fresh insights. Renewed European artistic influence in the later eighteenth century, following on British

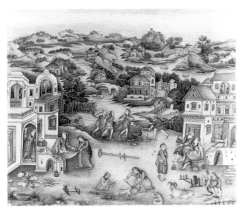

Fig. 3. *Mir Kalan Khan,* Village Life in Kashmir, *opaque watercolor and gold, ca. 1760. 11¹/₂ x 13¹/₁₆ in. (29 x 33.5 cm.) British Library (India Office Collections), Add.Or.3.*

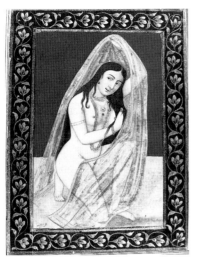

Fig. 4. *Mihr Chand, An Imaginary Courtesan, opaque watercolor, ca. 1765. 4¹/₄ x 3 in. (12 x 7.5 cm.) British Library (India Office Collections), Johnson Album 66,2.*

political gains in India, opened up for these artists new means of achieving their formal ends, and of reinvigorating the tradition of late Mughal painting.

We find the first stirrings in the territory of Oudh, in the center of northern India, whose capital cities of Faizabad and Lucknow had become refuges for artists and patrons alike fleeing the wreck of Delhi. Artists such as Mir Kalan Khan and Mihr Chand (cat. nos. 44 and 63) would seem to have had access to Flemish and French prints, and with their aid explored new ground, developing extended landscapes peopled with figures (fig. 3), and new techniques in lighting *chiaroscuro* subjects and in portrait studies (fig. 4). Both artists had before 1771, the year of Tilly Kettle's celebrated visit to Faizabad, largely abandoned the traditional Indian profile portraiture, and made use of the naturalistic and representational concerns of European art to impart volume to their figures and recession to their landscapes.[7] As in the later sixteenth century, artists of their own accord used formal concepts taken from European representational art in order to help them express what they felt was lacking in their own technical and stylistic equipment.

As British political influence expanded throughout India, artists practicing in many different styles similarly incorporated European ideas on the representation of volume and depth into their own works, relaxed the traditional stiffness of portraiture, and seized on such techniques as watercolor both to impart looseness and freshness into their work, and, of course, to speed up the whole process of painting. A few masters were happy with pure watercolor, but most thickened it to impart the body of the traditional techniques to their paintings, but without the labor. A very few artists converted to the medium of oils and practiced as portrait painters. While most British patrons, at least in the nineteenth century, were happier with Indian drawings that conformed more to European notions of art (although they endlessly criticized the Indian artist's "want of perspective"), there is no evidence that Indian artists were reluctant to change to new techniques. On the contrary, the readiness with which Lucknow artists in the 1770s and 1780s adopted watercolor and wash drawings for appropriate subjects, such as atlas and memoir illustration for Colonel Jean-Baptiste Gentil, and surveys of *ragamala* iconography for Richard Johnson, both of whom also assembled distinguished collections of historic and contemporary miniatures,[8] suggests that Indian artists were prepared to be as flexible in this as they were in more formal concerns. For again it must be pointed out that what seem the "traditional" burnished pigments of Indian miniatures are borrowed from Persian painting, and had no recognizable Indian ancestry before the fifteenth century.

The various styles and subject preoccupations that developed by 1800 in different parts of India depended to a large extent on the style to which these new concerns had been grafted. Calcutta had a great need for accurate draftsmen both to record the unofficial and official collections of flora and fauna, beginning with Lady Impey's celebrated series (cat. no. 90), and also to work in the various public and private architectural and engineering establishments. In Bengal and Calcutta, with their concentration of wealthy and cultured Britons, artists made use of the readily available prints and paintings of English artists such as William Hodges, Thomas and William Daniell (cat. nos. 13, 53, 78 and 79), and George Chinnery (cat. no. 83).

Artists in the Murshidabad, or Mughal style of Bengal, had of all the late Mughal painters the greatest concern with the rendition of landscape. Their sucessors made topographical and landscape drawings something of a specialty, culminating in the great watercolors of Sita Ram (cat. no. 82), topographical painter to Lady Hastings, wife of Lord Hastings, Governor General of Bengal from 1813–1823. This extraordinary artist combined an exquisite draftsman's technique with a grasp of the English picturesque style as presented to Indian artists through the paintings and prints of Hodges, the Daniells, and Chinnery in particular. The Hastings took Sita Ram with them on a tour of Bengal and the North-West provinces

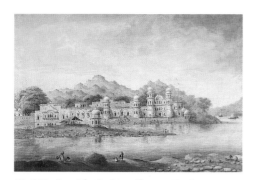

Fig. 5. Sita Ram, The Bathing Ghats at Hardwar, watercolor, 1814–1815, 14¾ x 21¼ in. (37.5 x 54 cm.) British Library (India Office Collections), Add. Or.4783.

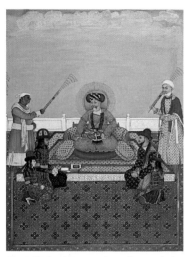

Fig. 6. Ghulam Murtaza Khan, The Mughal Emperor Akbar II with Four of his Sons, opaque watercolor and gold, ca. 1810. 14¹⁵/₁₆ x 11 in. (38 by 28 cm.) British Library (India Office Collections), Add.Or.342.

in 1814–1815. The resulting series of 230 large watercolors illustrating the mountains, rivers, cities, palaces, temples, and mosques seen on the journey is one of the great monuments of later Indian painting, in which for the first time an Indian artist can be seen to have the technical equipment and the artistic vision to respond fully to the landscape and topography of his own country (fig. 5). They are not, however, accurate renditions in the manner of the Daniells. Imbued by European naturalism and clearly inspired by fresh observation, they are still not realistic. Rather, the images are presented to us distilled through Sita Ram's Indian aesthetic framework: they are idealized visions of an India of the mind. In this sense they have more kinship with Poussin and Claude than with the Daniells (cat. no. 53).

In traditional Mughal strongholds such as Lucknow and Delhi, the still living tradition of portraiture developed most strongly when exposed to English influence. The British occupation of Agra and Delhi, expelling the Marathas from the area in 1803–1805, soon brought new artistic influences to bear on Delhi painters. One of the contributing factors was simply the presence of men like David Ochterlony, the first British Resident at the Mughal court, who lived in Indian style, but hung his ancestral Scottish portraits on his walls.[9] Late Mughal masters in Delhi, such as Ghulam Murtaza Khan and Ghulam 'Ali Khan, opened up the formal structure of Mughal portraiture by abandoning strict profile, thereby allowing themselves to suggest character, as in the former artist's portrait of the Emperor Akbar II with four of his sons (fig. 6). No Mughal emperor had been depicted almost full-face since the sixteenth century, nor had his cares of state played so clearly upon his features. His four sons are depicted more traditionally in profile, although the accurate rendering of the body as almost silhouetted in this position and the concern for volume under the rich textiles is new.

These artists were not slavish imitators of European styles, but rather adopted elements that best suited their particular concerns. Ghulam Murtaza Khan's portrait of Akbar II is beautifully balanced in an Indian way. It keeps to the traditional high viewpoint, leaving the position of artist and viewer unexplained, so that the eye of the viewer focuses straight onto the central portrait. The figures are placed in space, and we understand their relative positions in the three-dimensional space suggested, even though the figures do not accord perfectly with a fully representational perspective (the feet of the two courtiers, for example). Yet the carpet is depicted as traditionally from above, without any attempt at a view in perspective. Why? Perhaps to show that a fully naturalistic representational painting was not the artist's prime concern. Indeed, a carpet drawn in perspective would make the painting altogether too realistic, and would indeed have offended a Muslim artist or patron. Delhi artists reserved their most naturalistic portraiture for their foreign or half-foreign patrons: the Christian Begum Samru (cat. no. 47), or the half-Scottish, half-Rajput James Skinner, painted by Ghulam Murtaza Khan and again in oils by Ghulam Husayn Khan,[10] or the British patrons of Raja Jivan Ram, a painter in oils famous in his day, but whose work is only now slowly emerging (cat. no. 19).

Indian artists were perfectly capable of drawing in strict perspective if it suited them, as in the many architectural drawings of the great Mughal monuments of Agra and Delhi (cat. nos. 54–55, 66–68). The main British base in the North-West provinces was at Agra, and there Mughal artists migrated to serve the British need for the recording of India. Beginning about 1810, these drawings combine a still fairly high viewpoint with a devotion to linear perspective, in which the flagstones of courtyards and the lines of the monuments themselves recede in perfect order toward the twin vanishing points on the horizon. No Mughal artist, however, could ever bring himself to blur detail in an impressionistic *sfumato*: every stone, every piece of *pietra dura* work is present in these early drawings. Draftsman drawings in an alien style, they yet epitomize in their "supra-realism" a very Indian view of art: the distillation of the essence of the observed in the refining mind of the artist to produce an idealized vision. They show these buildings how they ought to have looked, not the dilapidated ones in the reality of the early nineteenth century.

Fig. 7. *Sita Ram*, Lady Hastings and her Party approaching the Kalan Masjid, Delhi, *watercolor, 1815.* 14¹⁵/₁₆ x 21¹/₁₆ (38 x 53.5 cm.) British Library (India Office Collections), Add.Or.4817.

Fig. 8. *Anon., perhaps Ghulam 'Ali Khan*, A Village Scene in Raniya, Haryana, *watercolor on paper, 1815–1819.* 12³/₈ x 16¹/₂ in. (31.5 x 42 cm.) British Library (India Office Collections), Add.Or.4057.

Ghulam 'Ali Khan succeeded Ghulam Murtaza Khan as imperial portrait painter, and was, perhaps, even more masterful in his command of styles. His earliest known work is in the exhibition (cat. no. 67), and shows him adapting the draftsman style of Agra to accord with the imperial pretensions of Delhi. His drawing of that Mughal *sanctum sanctorum*, the Hall of Private Audience in the Delhi palace, is less concerned with the niceties of perspective, more with showing that the palace was still inhabited by the Mughal emperor. As Mughal glories faded before the increasingly intrusive British takeover of India, this exquisite drawing is one of many designed to assert the continuation of Mughal splendors: the great processional panoramas of the 'Id festival of Akbar II and his son Bahadur Shah II; or the *darbar* scenes with the British Resident in attendance below the throne as the Persian ambassadors used to be in the *darbar* scenes of Jahangir,[11] or Ghulam 'Ali Khan's recreation of the imperial portraits of Shah Jahan in the accession portraits of Bahadur Shah II of 1837–1838.[12] Painting in the imperial court, however reduced, remained what it had always been, an assertion of power designed to impress not so much the subjects of the empire, for the art was strictly private, but rather the court's inner circle and the women's quarters: both the last emperors were governed by their favorite wives. But as these last imperial portraits, despite the pomp, always allow the concerns of state to show on the emperor's face, so Ghulam 'Ali Khan cannot resist the temptation to show the humdrum details of daily life, in the bath-heating arrangements on the right. Few Indian artists before him had been able to resist such temptation, but did not normally succumb to it when trying to assert the imperial claims of their patron.

One of the most important events in the development of Delhi painting in the nineteenth century was the visit to Delhi in 1815 of the Bengal artist Sita Ram in the Governor General's train. For political reasons, Lord Hastings himself did not go to Delhi, but sent his wife and his artist to observe and record the sights. We can imagine Sita Ram escaping his official party, as do traveling artists the world over, to talk shop with the local artists and to examine each other's work. Perhaps he would have shown them his current work, his views of the Mughal and earlier monuments of the city, such as the ancient Kalan Masjid (fig. 7) with Lady Hastings and her party approaching, in which Sita Ram imbues the monument with a grandeur akin to some of Hodges's work. Though we have no records of such meetings, it is nonetheless at this time that Delhi artists began to place their monuments in landscapes, and to investigate seriously watercolor techniques. Ghulam 'Ali Khan himself produced large landscapes in watercolor for James Skinner in the 1820s;[13] and it was in 1816 that those masterpieces of the Delhi Company style, the portraits produced for William and James Baillie Fraser,[14] and James Skinner, were first produced (cat. nos. 5, 17, and 38). It is easy to imagine one of the Frasers' artists being impressed enough by Sita Ram's quiet landscapes, with their rural mosques and temples, to produce his own version of a village scene (fig. 8). Sita Ram would have reminded these Delhi artists of the value of first-hand observation even in the depiction of the final idealized image. The great Mughal buildings now become placed within their landscapes, and we are even allowed by the 1820s to see the additions to the Delhi palace erected in the courtyards of Shah Jahan by the brothers and sons of Akbar II (cat. no. 66).

It is in this way that artistic developments in one part of India were passed on to others by artists as they sought new means to express themselves, and to release themselves from subservience to traditional subjects and techniques. British patrons might not have actually understood what their Indian artists were trying to achieve, but at this level of patronage and artistic vision they certainly allowed them to do it. Of course, masses of work were also produced at routine levels by artists slavishly copying their models, or producing for an undiscriminating audience a kind of picture-postcard art, routine images of India, or British life in India, as mementos to be taken home.

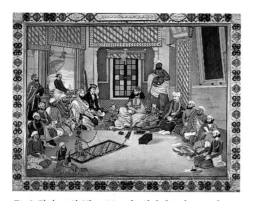

Fig. 9. Ghulam 'Ali Khan, Nawab 'Abd al-Rahman of Jhajjar Enjoying Music, *opaque watercolor and gold, 1852. 12¹³/₁₆ x 16¹⁵/₁₆ in. (32.5 x 43 cm.) British Library (India Office Collections), Add.Or.4681.*

Similar artistic developments occurred in other parts of India, and all former centers of painting that passed into British possession produced work at comparably high levels. Other such centers in Rajasthan, the Punjab Hills, and Hyderabad remained semi-independent politically, and royal patrons did not care to disturb the old certainties at the cost of ever-increasing stiffness in the traditional styles (cat. nos. 39 and 40). When European influence was finally admitted into these court styles in the late nineteenth century, it was perhaps an aesthetically mixed blessing (cat. nos. 7, 8, 29, 30, 31, and 43).

Company painting did not have time to develop at the higher levels into a genuine nineteenth-century, pan-Indian art. Indian artists might have had their own artistic agenda, but they were ultimately dependent on patronage; and changing British political and cultural perceptions of India, changes evident since the 1830s but which matured rapidly after 1857, cut off this source of patronage. One of Ghulam 'Ali Khan's last paintings serves as a kind of paradigm illustrating these changes (fig. 9). He had led Delhi artists into a new approach to naturalism, placing his minutely observed portrait studies in naturalistically observed settings. Both portraits and space are, of course, still largely idealized, paying just sufficient attention to naturalism for the figures to be occupying believable space. The style in essence is a recreation of the formal values of classical painting, but rendered with the palette and detail of the Mughal school.

Indian patrons, too, were learning to appreciate this style. The central figure of this painting and the artist's patron is Nawab 'Abd al-Rahman of Jhajjar, a nobleman with estates southwest of Delhi. Judged, however, not to have been sufficiently helpful to the British in the mutiny, he was tried and hanged in 1857.

The mutiny was a cultural as well as a political watershed in nineteenth-century India. Just as the British ceased to patronize contemporary Indian painting, but instead turned their attention seriously for the first time to the great monuments of India's Hindu past lying all around them, so Indian patrons themselves withdrew from this flirtation with what must have seemed to them too European a style, only to be overwhelmed a few decades later by Victorian academic realism (cat. no. 85). Those then seeking to forge a truly Indian style for the modern era, such as Abanindranath Tagore (cat. no. 88) rebelled, and sought direct inspiration in the art of the far distant past with copious mixtures of Japanoiserie — any influence so long as it was not European! Unaware of the largely private artistic developments in the first half of the nineteenth century on which they could have built a truly Indian modern art, this Bengal school was in turn overwhelmed by international modernism, so that Indian artists of this century have had a painful climb toward re-establishing a truly Indian artistic identity.

NOTES

1. In particular, S.C. Welch, *Room for Wonder: Indian Painting during the British Period 1760–1880*, New York 1978.
2. Principally the India Office Library (now part of the British Library) and the Victoria and Albert Museum. See Mildred Archer's *Company Drawings in the India Office Library*, London 1972, and *Company Paintings: Indian Paintings of the British Period*, London 1992 (the Victoria and Albert Collection).
3. Company painting here is taken to mean any Indian painting from the late nineteenth century to the dawn of modern Indian art which has been influenced by European painting: in fact, during this period only some Rajput and Pahari styles and religious paintings from the far south lack such influence.
4. See J. P. Losty, *The Art of the Book in India*, London 1982, for a discussion of the origin of these styles.
5. Like all art forms the style must be judged by its finest products, not by routine ones: Mildred and W. G. Archer's scholarly essay, *Indian Painting for the British 1770–1880*, Oxford 1955, obstinately refuses to discuss or illustrate the finest examples of the genre, and understandably comes to a fairly negative conclusion.
6. There must have been religious wall-paintings and possibly temple banner paintings in the medieval period, but none survives to inform this debate.
7. Mildred Archer in her *India and British Portraiture 1770–1825*, London 1979, pp. 80–84, argues that all Mihr Chand's and other Oudh artists' portraits of Shuja'al-Daula and his son Asaf al-Daula are copies of, or are based on, Kettle's portraits of 1771–1772. While not denying that some of these are obviously copies, it could also be argued in view of Mihr Chand's already existing interest in European portraiture, that the restricted iconography of the Kettle portraits (only two face positions for the former ruler and one for the latter) suggests that Kettle had in fact limited access to his royal patrons and instead relied on already existing portraits by Mihr Chand for his material. The lack of dates on Mihr Chand's portraits prevents the question's ever being satisfactorily settled.
8. Gentil and Johnson formed two of the earliest collections of Indian miniatures which are still intact, Gentil's in the Bibliothèque National, Paris, never properly published, and Johnson's in the British Library — see Toby Falk and Mildred Archer, *Indian Miniatures in the India Office Library*, London 1981.
9. As can be seen in the famous scene of Ochterlony enjoying a nautch in his Delhi house: see S. C. Welch, *Room for Wonder*, no. 46.
10. For Skinner's portrait probably by Ghulam Murtaza Khan, see J. P. Losty, *Indian Book Painting*, London 1986, p. 69. The portrait in oils of Skinner in the India Office collections long attributed to William Melville is in fact signed by Ghulam Husayn Khan (M. Archer, *The India Office Collection of Paintings and Sculpture*, London 1986, pp. 37–38, and pl. VIII).
11. Several examples are known of these huge panoramic processions, which cannot possibly correspond to the reality of the emperor's reduced circumstances. The one in the Delhi Album of Sir Thomas Theophilus Metcalfe is reproduced in M. M. Kaye's *The Golden Calm*, Exeter 1980, pp. 150–159). See M. Archer, *Company Drawings*, (pp. 202–203, and pl. 57), for a *darbar* scene with David Ochterlony, and S.C. Welch, *Room for Wonder*, pl. 45, for one with Archibald Seton.
12. One is reproduced in S.C. Welch's *Imperial Mughal Painting*, New York 1978, pl. 40.
13. In the National Army Museum, London. Reproduced in M. Archer "The Two Worlds of Colonel Skinner," *History Today*, London 1960, pp. 608–15.
14. For a comprehensive survey of the Frasers' artists' work, see Mildred Archer and Toby Falk, *India Revealed: The Art and Adventures of James and William Fraser 1801–35*, London 1989.

The Indian Artist As Assimilator of Western Styles

Toby Falk

Almost since the very first Europeans reached India, they have been intrigued and fascinated by Indian pictures. Europeans wanted pictures of the new subjects they encountered, and wished to record and understand them—plants and resources, animals and birds, local people. In later years they were additionally interested in having pictures and scenes incorporating their own achievements—property, possessions, buildings, horses. From the point of view of the Indian artist, foreigners were potential new patrons and clients, a source of good employment. For the European, Indian artists were worthy of attention for the part they played in the art and culture of the country; additionally, they could be employed as readily available painters and draughtsmen with considerable skills.

The first Europeans for whom pictures were provided were the Portuguese. Although these early pictures do not survive, or have not been recognized, artists were painting for Portuguese patrons in Goa within a century of Vasco da Gama's landing at Calicut in 1498. An artist who made colored drawings of plants to Portuguese specifications was noted at Goa before the end of the sixteenth century,[1] and there is no reason to believe that he was alone. During the seventeenth and eighteenth centuries Indian artists supplied the needs of Europeans who came to India in the service of their national trading companies—significantly the Portuguese, Dutch, French, and English. The majority of Europeans who visited India before the eighteenth century were not particularly artistic or academic. With certain exceptions, they were traders, soldiers, and adventurers, relatively rough diamonds whose behavior was driven by the need to advance themselves and survive. As far as Indian paintings were concerned, they bought what was offered or what was available as curiosities or souvenirs. In most instances Indian artists or agents sold them attractive and undemanding pictures: sets of portraits of Indian rulers, imaginary courtly ladies, and pictures illustrating musical modes or straightforward religious subjects. The specifically commissioned picture was the exception.

For example, in the Deccani kingdom of Golconda, a center of artistic activity in the seventeenth century, numerous sets of portraits were produced in a standardized style, painted in the traditional manner of miniature painting, though surely intended to appeal to Europeans. Many of these survive with contemporary English, French, or more frequently Dutch inscriptions, indicating Dutch traders as the main purchasers. Here the Indian artist was responding by producing subjects desirable to the European, rather than making any Western stylistic adaptation. Such pictures were brought home, sometimes to be engraved as reproductions in topical European books describing the Orient, but they are nevertheless not usually classified as Company paintings.

Pictures which Indian painters have westernized for the satisfaction of the European are generally known as "Company paintings," a term originally coined in reference to pictures made for British servants of the East India Company. While the term in its wider sense may include works made by Indian artists for any European and at any time between 1498 and Indian Independence, for the present purpose and the period 1780–1910, it need encompass no more than its original British contextual meaning. The second half of the eighteenth century saw changes which brought about the birth of the full-fledged Company school. A number of professional English artists came to India seeking commissions from the increasing numbers of wealthy Europeans living there. Also, the new class of British Company servant provided enthusiastic patronage to European and Indian artist alike. The British who reached India at this time created a fresh cultural milieu, particularly in Bengal and Calcutta, for among them were some of the most educated and culturally aware people of the day.

British India was at this time coming more and more under the eye of the London government, with a resultant tightening of parliamentary and legal control. Questions had

Fig. 1. Zayn al-Din, A Painted Stork, (detail), gouache on paper, 1782. 32¼ x 22 in. (81.9 x 55.9 cm). See cat. no. 90.

been asked about the fortunes made so rapidly by Clive and others—how could they have done this legitimately? India had a background and history to be valued and treasured as highly as the classical cultures of ancient Europe. In the view of the London authorities India should be respected, studied, understood, recorded, but not taken advantage of. Most of the finest Company paintings were produced in this period and during the following decades. In striving to understand how Indian artists reacted in these changed circumstances, we should here examine various significant examples.

One of the most impressive and colorful Company school series of natural history studies was made for Sir Elijah Impey (1732–1809) and Lady Impey (1749–1818) in Calcutta between 1777 and 1782 (cat. no. 90). Sir Elijah Impey's appointment was as first chief justice in Bengal, with the task of setting up and running a law court in Calcutta to administer English law according to the Regulating Act of 1774. Impey was exemplary of the new class of East India Company servant—educated, enthusiastic, and energetic. In common with other Englishmen in Bengal at the time, his interests knew few boundaries. It may have been primarily for his profession that he learned Persian and studied Indian law and its religious foundations, but for his own interest he collected Indian miniature paintings, which he arranged in great albums according to their subject matter. At the same time, Lady Impey collected and assembled species of birds and animals in the extensive garden of their Calcutta house, which must have become a veritable zoo. By 1777 a single artist, Shaikh Zayn al-Din, was employed to paint these creatures in an ambitious series. As an artist from Patna, a location of the Murshidabad court some distance up the river from Calcutta, Zayn al-Din would presumably have initially been trained in the Murshidabad manner of miniature painting (great numbers of which were in Impey's collection of miniatures). He probably had little experience of the European watercolor technique and none of oil painting. Yet the resulting pictures of the birds, animals, and flowers from Lady Impey's garden are astounding for their technique, accuracy, and finish. From the serial numbers inscribed on the pictures, we can calculate that Zayn al-Din painted about forty pictures in his first year (fig. 1). He may therefore have taken as long as a week on each picture. Having received instructions on what was required he would have worked at his task at a regular pace. But the question remains as to exactly how he was instructed and what he might have been shown as examples of the type of picture the Impeys expected.

Contemporary illustrations in European bird books were not as florid or exotic as Zayn al-Din's creations. Until that time European bird books invariably depicted birds in an unsophisticated manner (popularly known as "bird on a stump"). By contrast, Zayn al-Din's pictures illustrate birds in a lifelike manner expressive of their specific behavior, often with flowers and foliage, allowing for quite adventurous and highly decorative compositions. In the West such methods were not adopted until Audubon's innovative pictures of the birds of America, published a half century later. Each picture was carefully inscribed with the local name of the bird, noting that the specimen was in Lady Impey's Calcutta collection. One factor in the minds of the Impeys was probably the description of new species, a goal which occupied most eighteenth-century naturalists since the pioneering work of Linnaeus and his followers. Probably they also had the intention to publish the pictures in England and, though this was not achieved as such, valuable information from the pictures was incorporated in published works on new species of birds.[2]

The Impeys perhaps wanted their natural history pictures to have an oriental and exotic flavor, leading them to seek an artist who could paint in a Far Eastern, even Chinese manner. Apart from the fact that Zayn al-Din would doubtless have known of Chinese watercolors made for Europeans, Chinese painters were almost certainly working in Indian seaports by this date, and Zayn al-Din may well have experienced their work. Our knowledge of the artistic activities of the Chinese community in Calcutta at this period

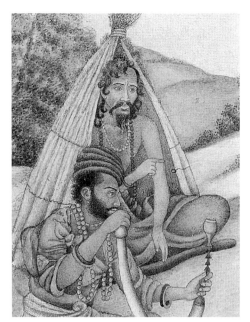

Fig. 2. Anon., perhaps Ghulam Ali Khan,
An Assembly of Ascetics and Yogins around a Fire,
(detail), gouache on paper, 1820–1830. 11 x 15¹/₈ in. (28 x 39 cm). See cat. no. 4.

is not well documented, but Chinese tea-trade pictures were current at the time, many of them illustrating birds in florid naturalistic settings. Furthermore, some subsequent Company school series are distinctly Chinese in their style and presentation, suggesting cross-influence between Chinese and Indian Company artists.[3]

A problem for the student today is the lack of first-hand information about Indian artists employed by the British. We know many of their names but usually there is little else to provide a broader picture of the circumstances. In the case of the great series of Fraser Company portraits, though some circumstantial information is documented in contemporary diaries, we are not told who the artist was. This may be the result of the special patron-artist dynamic which, special as it was, is worth examination.

James Baillie Fraser (1783–1856) visited India between 1814 and 1821 with the hope of succeeding in trade. Like most educated Britons, he had received instruction in drawing at school, but it was only when he became intoxicated with the beauty of the Indian landscape that he developed greater aspirations. As he himself related, "When the Devil of Drawing broke loose there was no holding him."[4] James developed a plan to refine his painting skills and prepare watercolors of India, later to have them published in England as aquatints, following the tradition of Hodges, the Daniells, and Salt. Ironically, it turned out to be his early dissatisfaction with his own drawing abilities that gave rise to the Company pictures.

In 1815 James Baillie Fraser had been with his brother William (cat. no. 18) in the Hills north of Delhi while the Nepal War was in progress. His new plan was to prepare pictures for publication, revealing the awesome mountainous landscape and including scenes of the war and local activities, but in August of 1815 he wrote:

This day as yesterday all day drawing and I have nearly finished my sketch of Gungotree with the figures— I am not satisfied with it but will not do more to it till I have the advantage of seeing some watercolour drawing which I may take a lesson from — I have got the native artist my brother has hired to take the likenesses of several of the servants and Ghorkas which will assist me much in several of my undertakings.[5]

We cannot be certain who this artist was, though his portraits rank high in the company of the portraiture of any culture. It is typical of the British-Indian patron-artist relationship at this time that neither James nor William mention the artist by name in their writings. He must have come from Delhi, where William Fraser was living at the time, and he is thought to have been related or associated with the family of Ghulam Ali Khan (fig. 2 and cat. nos. 4, 67 and 68). His importance for our present study is the way in which he responded to James Baillie Fraser's requirements. James had been attempting portraiture, exercises which he must have shown to the artist as indications of what he was trying to achieve. Yet the Indian artist was able to rise well beyond what might reasonably have been expected of him, assembling sophisticated groupings of figures and painting portraits with unusually acute psychological insight. A version of one of these portraits, of William Fraser's *diwan*, Mohan Lal, may have been painted by a member of the same atelier from which James first engaged an artist (cat. no. 17).

Among the professional English artists who went to India in the second half of the eighteenth century were several who specialized in miniature portraiture, fashionable with Europeans as mementos and keepsakes. Designed to be examined very closely, the making of these tiny portraits required a special and very refined skill. Here we find a parallel with the art of Mughal miniature portraiture, where pictures were painted on a small scale for inclusion in albums, again to be taken out at times and examined carefully. This tradition had stemmed partly from early seventeenth-century exposure to European miniature portraiture but had received minimal European input since that time. The English miniature

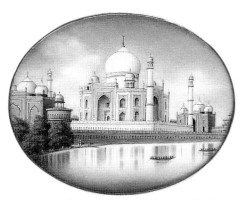

Fig. 3. Anon., Delhi artist, The Taj Mahal at Agra, (detail), oil on ivory, 2½ x 2 in. (6.4 x 5.1 cm.). See cat. no. 61b.

Fig. 4. Sheikh Latif, Side View of the Cenotaph of Shah Jahan, (detail), gouache on paper, ca. 1820–1834. 11¼ x 18¾ in. (29.8 x 47.6 cm.). See cat. no. 55.

painters of the eighteenth century found a ready market for their works in the society of Calcutta and Bengal, painting for wealthy local noblemen. Artists such as John Smart, Ozias Humphry, George Place, and Charles Shirreff are among the better known of these painters, and some of their most distinctive works were painted while they were in India. Other professional miniaturists, and numerous amateur practitioners, painted in this format to good advantage. It is not surprising, therefore, that almost immediately there were local artists who, jostling for patronage, adopted the same mode.

Whereas the Europeans painted more frequently on paper or card, Indian artists used ivory, which naturally lent itself to cutting into suitably thin oval sections (fig. 3). Unable to compete with the European professionals in obtaining access to the more wealthy English Company servants for sittings, Indian artists specialized in producing traditional subjects which would satisfy the European appetite for souvenirs. The earliest of these, painted in the eighteenth century by Mughal-trained artists of Oudh and Bengal, were sets of half-length portraits of Mughal emperors; similar sets remained popular well into the nineteenth century, by which time the British had occupied Delhi which, with Agra, became the main center for painting ivory miniatures. Here the most popular subjects were scenes of the palaces and monuments of Delhi and Agra (cat. no. 61). It is notable that Indian artists not only took up this European format for portraiture, but adapted it for the scenes and buildings popularly visited and wondered at by Europeans.

In addition to their depiction on ivory, monuments and views were also painted in watercolor. Their essential compositions are self-evidently derived from European scenes, particularly as found in the watercolor tradition. For his example the Indian artist did not, however, necessarily turn to the works of professional English artists in India — William Hodges, Robert Home, or Thomas and William Daniell — for their works, unless published, in any case may not have been easily accessible. Most English were trained to a good amateur standard in painting and drawing, while army officers were expected to draw views accurately for military purposes. This is more likely the type of European work to which pictures such as cat. no. 55 (fig. 4) are ultimately indebted. But Indian painters also played a valuable if laborious role in painstakingly depicting the details of the florid architecture of Muslim buildings. European time and patience did not generally run to recording a mass of detail, and most pictures involving such work were by Indian artists (for example cat. no. 55, by Sheikh Latif).

James Fraser gives a revealing insight into the part played by one of his Indian artists in depicting architecture. In his diary for the time he spent in Delhi he makes it clear that he felt bound to make drawings of all the monuments of importance, but by the time of his last visit in March of 1816, one gets the feeling that time was running out on him:

This morning I went to the Coutub with a view of making a sketch of Adams tomb as they call it, or the small beautiful building near the Coutub—but the painter I had sent for from Dehlee having arrived I was taken up with shewing him the views I wished to be made about the Coutub.[6]

On other occasions James Baillie Fraser would sketch the general outline of an architectural view he wanted before instructing the Indian artist to fill in the intricate and decorative details, thereby creating the picture with all the necessary architectural information while minimizing the time he spent on it. Such interaction must have given the Indian the opportunity not only to see and practice the European technique of watercolor, but also to take sketches for himself which he could subsequently repeat and adapt for his own use.

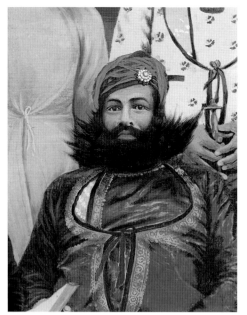

Fig. 5. Anon., Babu Sansar Chandra, Prime Minister of Jaipur State and Various Noblemen, (detail), photograph hand-painted with gouache, ca. 1900–1910. 17¹/₈ x 23 in. (43.5 x 58.4). See cat. no. 43.

With the advent of photography, the portrait style of Indian painters changed radically. Many European photographers travelled to India in the early years of photography, searching for new and exciting subject matter. In their wake came studio photography, the novel way in which an accurate likeness could quickly be taken. The principles were the same as for the painted portrait: a wealthy client wished to be seen at his best, wearing expensive clothes and in association with his Western-style possessions. So the formula for the studio portrait was set —a carpet, a chair, a table with a vase of flowers. Indian artists responded by adopting the same theme for their painted portraits. Once again, with an eye for survival in times of change, the Indian artist had adapted. He could paint an entire picture to look like a photograph, or, in association with a photographer, he could take a monochrome photograph and embellish it with color and added detail (fig. 5). Many city photographic studios provided what appeared to be painted portraits in the new mode, which were in fact hand-colored photographs. Some fine examples of these fashionable portraits from the photographic period can be seen in this exhibition, (cat. nos. 31 and 43).

NOTES
1. Mildred Archer, *Company Paintings. Indian Paintings of the British Period*, Victoria and Albert Museum Indian Art Series, 1992, pp. 11–13.
2. John Latham, in the 1787 volume of his *General Synopsis of Birds*, refers to Lady Impey's collection for his descriptions of over fifty birds, many of them newly described.
3. The series of Indian Company school pictures with the strongest Chinese characteristics was an album of the fishes of Bengal, acquired by Henry Plowden in May 1800. The illustrations were executed in a Chinese manner by an artist named "Shaik Abdulla" living near the Colinghy Bazaar, Calcutta. Bound in Chinese brocade, this album was sold at Sotheby's, London, March 29, 1982, lot 68, but has since been dismembered.
4. Undated letter from James Baillie Fraser to his sister Jane Anne Fraser. National Register of Archives, Scotland, Fraser Papers, B3 (M. Archer and T. Falk, *India Revealed. The Art and Adventures of James and William Fraser, 1801–35*, London, 1989, p. 23).
5. James Baillie Fraser's diary entry for August 8, 1815, at Saharanpur. National Register of Archives, Scotland, Fraser Papers, vol. 8 (Archer and Falk, p. 45).
6. James Baillie Fraser's diary entry for March 2, 1816. National Register of Archives, Scotland, Fraser Papers, vol. 19 (Archer and Falk, p. 39).

THE RAJ, INDIAN ARTISTS, AND WESTERN ART

Partha Mitter

Fig. 1. *Leonardo da Vinci.* Rule for the Proportions of the Human Figure, according to Vitruvius. *Pen drawing, 13¹/₂ x 9⁵/₈ in. (34.4 x 24.5 cm.) Accademia, Venice.*

Fig. 2. *Anon.,* Shiva Nataraja. *Chola Bronze, 27 ¹/₄ in. (70.5 cm.). South India, Tamil Nadu region, ca. 14th century. Sotheby's, New York, 1995.*

This exhibition, which celebrates the meeting point of two radically different cultures and sensibilities, marks a crucial period in world history—the ascendancy of Western colonial powers and the consequent transformation of traditional societies, and of progressive globalization. The British Raj was at the heart of this nineteenth-century historical process.[1] In the fateful encounter between India and Britain during the colonial period, few areas have had more profound implications for Indian culture than the relationship between Western art and Indian taste. One serious effect of colonial taste on Indian art has been that today Indian art is judged by the Western canon, which necessarily stands in the way of a proper appreciation of its unique qualities.[2] To put it baldly, the differences between Indian and Western taste are profound. Of course, in both ancient Indian and classical Western art, man was the measure of all things. We need not go further than to compare Leonardo da Vinci's diagram of the Vitruvian Man with the dancing Shiva Nataraja figure from the Chola period to sense the centrality of the human figure in these societies (figs. 1 and 2). Yet, while there is an affinity of interests in both cultures in the human form, no two cultures could be more dissimilar in their respective approaches to it.[3]

No less striking are the differences between Indian and Western pictorial conventions. From the Renaissance onwards, Western art harnessed scientific empiricism—single point perspective, consistent light, and scientific anatomy—to construct a world of illusion and make-believe. According to E. H. Gombrich, the European artist practiced a strictly representational method, centered on the initial rough sketch, followed by its progressive improvement based on observation of the particular. The principles of "schema" and "correction" underlay the successful likeness of a portrait.[4] The Indian artist on the other hand selected a basic design from a formulary of stencils which was first sketched on the paper and then filled in with color. Indian painting, which concentrates on the formal quality of a painting in an elegant blend of lines and colors, invites us to suspend our disbelief willingly. This is not to say that Indian artists did not observe the natural world with acuteness and sympathy. But in essence, Indian miniature painting was more concerned with conjuring up a magic world of exquisite images than in scientific accuracy. Even though some elements of European naturalism were absorbed by the Mughal masters, their outlook and approach remained essentially different from those of Western artists.

Set against this background, the East/West encounters from the days of colonial expansion assume an unusual interest. Two works in the exhibition are worth comparing for the meeting of cultures and the crossing of boundaries. The Mughal artist's interpretation of Raphael's *Death of Ananais* (cat. no. 2) manages to transform the Renaissance master's *chiaroscuro* into something utterly Mughal. On the other hand, Rembrandt's sketch of the Deccani ruler based on a miniature (cat. no. 10) confirms, if confirmation were needed, the great artist's ability to cross cultural frontiers with impunity. Living in Amsterdam in the seventeenth century, Rembrandt was right in the heart of the Dutch trade with the East Indies, which revealed to him the exquisite treasures emanating from the Mughal empire. With his unerring eye he was able to acquire one of the finest collections of Indian miniatures in Europe. His own rendering of an Indian subject here is within the Western tradition; yet, how rich is his understanding of an alien idiom.[5]

Profound changes in relationship between India and the West took place in 1757 with the founding of British rule in Bengal. European art institutions and practices were gradually introduced on the Indian subcontinent following this momentous event. Although the colonial regime did not embark on a systematic transformation of Indian taste through Western art schools until the 1850s, the "high noon" of empire, British taste had begun to infiltrate Indian aristocratic patronage from as early as the end of the eighteenth century. The *nawabs,* the *maharajas,* and the merchant princes of Calcutta, whose taste for Western art

Fig. 3. *Shaykh Muhammad Amir of Karaya.* Two Dogs in a Meadow Landscape. *Watercolor, 11 x 17¹/₃ in. (28 x 45 cm.). Calcutta, ca. 1840–1850. Victoria and Albert Museum, London, IS 61957.*

Fig. 4. *Kali Charan Ghosh.* Courtesan Smoking a Houkha. *Watercolor with pencil, average size: 18 x 11 in. (45.8 x 28 cm.). Kalighat, ca. 1900. Victoria and Albert Museum, London, IS 38–1952.*

Fig. 5. *Anon.,* Courtesan Playing a Violin. *Color-lithograph, average size: 16 x 12 in. (46 x 35 cm.). Calcutta, ca. 1930. Victoria and Albert Museum, London, IS 50–1968.*

was carefully nurtured by the new overlords of Hindustan, plied itinerant European artists with lavish patronage. One of the first tasks the East India Company officials set themselves was to "improve" the skills of the Indian artists by teaching them scientific drawing.[6] A quintessential British opinion of Indian painting was expressed by the Victorian painter, Valentine Prinsep, who lamented that the Delhi painters never worked from nature. They were remarkable solely for their mechanical capacity and "admirable patience."[7]

As the East India Company secured itself in Bengal in the last decades of the eighteenth century, it paved the way for British artists to make their fortunes on the subcontinent and for the establishment of Western artistic priorities in India. We can see the impact of European art not only in the celebrated Company painter, Shaikh Muhammad of Karaya (fig. 3), whose elegant works recall the aquatints of Thomas and William Daniell, but also in the Company artists shown in this exhibition.[8] However, it is equally true that from the outset, Indian artists did not simply copy the models set before them, but constantly modified the imposed Western taste in the light of their own experience and skill. One of the interesting examples in the exhibition is Zayn al-Din's clinical approach to a stork (cat. no. 90), whose ultimate source must be Jahangir's court painter, Mansur. When we compare the visiting European artists with indigenous painters, the difference in treatment and interests becomes recognizable at once. The two cultures expressed different sensibilities, Indians concentrating on endless detail and incisive lines (as in Udaipur painting here), as well as colors that denied tonal qualities, whereas Europeans romanticized their works after Claude and the Picturesque.

Let us now examine a little more closely how different artistic and cultural schemata produced different treatments of Indian scenes and subjects. *An Assembly of Ascetics and Yogins around a Fire* (cat no. 4), attributed to Ghulam Ali Khan, recalls Mughal works on similar subjects, while Sir Charles D'Oyly's Indian village scene (cat. no. 81) could be passed off as a Dutch landscape with some small changes. There are exceptions of course; notice the striking cross-over in Thomas van Buerle's painting of the Fortress of Bharatpur with its meticulously depicted tiny figures (cat. no. 70), comparable to the details in the Indian artist Ghasi's depiction of the *maharana's* court at Udaipur (cat. no. 39). Generally speaking, however, even in representations of the same subject, as for instance the celebrated Taj Mahal, it is instructive to see how different Thomas Daniell's watercolor treatment (cat. no. 53) is from the ivory painting by an unidentified Delhi artist (cat. no. 61b.). It is the difference in the Indian and European world-views that is so interesting in this exhibition of comparative cultures. It is beyond question that art history is essentially a modern Western discipline to which we are all indebted. Nevertheless, in order to "read" the Indian artist's works more accurately, we need to loosen the hold of the dominant canon, even as we benefit from the methods of art history. Only by being sensitive to cultural difference can the different visions of the two cultures be grasped with clarity.[9]

During the colonial period there were artists in India who had much less to do with the British than the Company painters. Many of them sought to resist the social changes being wrought by the foreign power. Traditional Bengali *pat* painters responded to the demand for popular pictures as Kalighat emerged as a major pilgrim center on the outskirts of Calcutta (figs. 4 and 5). These artists offered their own mordant social comment on the Westernization of Hindu society in this fast-growing colonial capital. The English-educated Bengali *bhadralok* (gentlemen), or *babus*, as the English preferred to call them, were the prime targets of the Kalighat painters. As print technology, the ideal medium for the wide diffusion of images and ideas, swept colonial Calcutta, enterprising printmakers became the purveyors of inexpensive pictures to the ordinary people. They also took over the Kalighat tradition of ridiculing the English-educated. The printmakers were secure in the knowledge that they had allies among the urban subculture that thrived on coarse satire and literary parodies of nouveau-riche pretensions.[10]

Fig. 6. Ravi Varma. Sakuntala. Oleograph. Ravi Varma Fine Arts Press, Lonavla, late 19th century. The Wellcome Institute, London.

Fig. 7. Abanindranath Tagore. Bharat Mata. (Mother India as a Bengali Lady). Watercolor. Calcutta, ca. 1905. Rabindra Bharati Society, Calcutta.

These subversions of colonial culture by the social underclass were unorganized and sporadic. Nor was there any systematic opposition to the importation of Western artistic norms. The most self-conscious resistance to European art came in the wake of Indian nationalist unrest at the turn of the century. During the first phase of Westernization in the early nineteenth century, the rationalism of James Mill and Jeremy Bentham had made a powerful impact on the Indian elite. But, as the century reached its halfway mark, disillusionment with ideas of progress was accompanied by a renewed pride in India's heritage. The reconstruction of India's past was due to European Orientalist and archaeological researches as well as to Indian scholars. The Bengali historian Rajendralala Mitra, an architect of nationalist revival, instilled a new pride in the *bhadralok*, in ancient Hindu and Buddhist artistic heritage. The first "art history" in any Indian language was written in 1874 by a Bengali graduate of the Calcutta art school, in order to inspire the youth of Bengal in the nation's art. Alongside this fresh perception of the historic past, there was a renewed interest in traditional Indian applied arts exhibited at the nationalist Hindu Mela in 1857.[11]

By the turn of the century an alliance was forged by Indian intellectuals, notably the great poet Rabindranath Tagore, the savant Swami Vivekananda, and the art critic Ananda Coomaraswamy, with European critics of progress such as Margaret Noble (Vivekananda's Irish disciple), the feminist Annie Besant, and the art teacher E. B. Havell. Their aim was to combat the dominance of Western art as part of the modern, industrial culture of colonialism. The questions that came to the fore were: What was the essence of Indian art? In what way did it differ from Western art?[12]

Indeed, what was this artistic nationalism in India all about? Nationalist art assumed different forms in different countries around the globe. If you take Mexican art, for instance, its resistance to the West took the form of murals glorifying the indigenous past. Yet, at the same time, the Mexican mural style belonged essentially within the Renaissance artistic tradition. On the other hand, to the Indian artist resistance meant less the production of "propaganda" art than the creation of an "indigenous" style that would reflect national aspirations. It was a growing consciousness of the difference between Indian and Western artistic methods that led to the rejection of the leading academic painter Raja Ravi Varma's art (1848–1906) as being inadequately nationalistic. Varma, whose oleographs of Hindu deities are still the best-known works by an artist in India, was the first painter to pioneer nationalist themes in his paintings based on Sanskrit literary classics. But he too had been impressed with the Victorian commonplace that Indian art was the highest form of decoration, because it lacked the moral concern of European art. Since his history paintings were based on academic naturalism, they were ultimately rejected by the next generation of nationalists, who inverted the above-mentioned Victorian commonplace by claiming that the very essence of Indian decorative art was a form of spirituality that eluded colonial art (fig. 6).[13]

The leader of the nationalist art movement, Abanindranath Tagore (1871–1951), dabbled in academic art in his youth (fig. 7). When he sought to create his first self-consciously non-illusionist style, he naturally turned to Indian miniatures. His first series illustrated the love of the divine pair, Radha and Krishna, as related in the medieval Vaisnava poem, *Gitagovinda*. Abanindranath's crucial meeting with the art teacher E. B. Havell in the 1890s led to the second landmark in the development of his art. Abanindranath showed *The Last Moments of Shah Jahan* at the Darbar exhibition of 1903, an oil painting done in a conscious Mughal manner, but highly charged with a melancholy mood that was quite Victorian. The Bengali painter was soon dissatisfied with *Shah Jahan* for he felt that it lacked feeling, or *bhava*, the quality he was seeking in art. It was during this quest that he discovered Japanese painting, gave up oils, and turned to watercolors. The beginning of this century witnessed a watershed in the Indo-Japanese relationship, when the Japanese intellectual Okakura Kakuzo Tenshin arrived in Calcutta to forge a Pan-Asian alliance as a powerful focus of

Fig. 8. *Rabindranath Tagore*. Person Riding a Crocodile. *Pen, ink, and watercolor, ca. 1929–1930. Visva Bharati University, Santiniketan, West Bengal, Acc. no. 1897.*

Asian aspirations. Asian societies were characterized by Swami Vivekananda, Rabindranath Tagore, and Okakura as spiritual, in contrast to the "rampant materialism" of the West.[14]

Abanindranath's atmospheric nationalist works, and works produced under this influence, reveal the combination of Japanese *morotai* wash technique with the Mughal arrangement of planes. *The Banished Yaksha,* based on Kalidasa's romantic poem, "Meghadutam," was reproduced in the English art magazine *The Studio* in 1905. *The Music Party* appeared in 1908 in the influential Japanese periodical *Kokka,* edited by Okakura. Abanindranath developed an understated watercolor style, which was imbued with a pervasive mood of stillness, built up with modulations of silvery grays and pale shades. Its lyricism was a visual embodiment of a deep sense of silence that had much to do with his contemplative temperament, the reason why he actively sought an "elective affinity" with Far Eastern art.[15]

The year 1905 was a historic year for India. The viceroy, Lord Curzon, partitioned Bengal, which precipitated the first major political unrest leading to widespread demonstrations and the boycott of British goods. The ensuing *swadeshi* (indigenous) movement inspired Abanindranath to make a rare political statement with his painting, *Bharat Mata* (Mother India). However, this was his only direct involvement with politics. Rather, the *swadeshi* movement gave him an opportunity to lead an anti-Western campaign in art through his Orientalist style that synthesized different Asian artistic traditions. Havell, then head of the Calcutta art school, invited Abanindranath to join him at the school in 1905, in order to found the first major art movement in India. This became known as the Bengal School, which soon engaged with utmost seriousness in exhuming the "lost language of Indian art." Many of Abanindranath's students, such as Nandalal Bose, Asit Haldar, and Kshitin Majumdar, were later to emerge as leading artists in India. The works of the Bengal School soon spread around the subcontinent, and were first exhibited in Europe in 1914. The Muslim minority in India, who anxiously observed the rise of militant Hinduism and its claim to represent all Indians at the turn of the century, sought to construct their own identity based on a wider Pan-Islamic basis. The finest product of this was Abdur Rahman Chughtai, whose paintings attempted to express nostalgia for the decline of Mughal grandeur in his sensuous, erotic pictures of decadence.[16]

By the 1920s, however, the fortunes of the Bengal School began to wane. With the launching of the non-cooperation movement by Mahatma Gandhi in 1921, artistic resistance to the Raj took second place to active politics. Moreover, the artistic situation in India became more complex with the arrival of modernism in the 1920s. Many Indian artists felt that the revolt of the European avant-garde artists, and their search for inspiration in primitive art and Eastern spirituality were similar to the Indian artists' own struggle against colonial rule.[17] One of the earliest exponents of modern art in India was the poet Rabindranath Tagore (1861–1941), whose "expressionist" works were much admired in Germany in the 1930s (fig. 8). The second leading figure was his nephew, Gaganendranath Tagore (1867–1938), who created a new genre of poetic fantasy based on Cubism.[18] The third leading personality was the woman artist, Amrita Sher Gil (1913–1941), who came to be hailed as the most accomplished exponent of modernism in India. Daughter of a Sikh nobleman and a cultivated Hungarian woman, she was the first Indian artist to be trained in Paris. This gifted painter offered her own vision of romantic India, before her untimely death in 1941, which deprived India of an artist of outstanding promise. Her early works show her training at the French academies. Some of her subjects of melancholy women and her portraits also link her directly to the Hungarian art of the 1920s. The beautifully somber landscape from her country house exhibited here reveals the dark colors of Hungary as much as her Parisian training. Her originality lay in gradually developing her own interpretation of village India, portraying women in particular with sympathy and understanding, as we know from her painting, *The Child Bride.*[19]

The pre-colonial responses of European and Indian artists to each other's art changed considerably during the colonial period when artistic expression was colored by colonial dominance and control, associated with the introduction of Western academic art in India. However, the actual reactions of the Indian colonial artists were more complex, as they sought to appropriate selectively the new idiom, as well as offering resistance to it. One of the legacies of the colonial/nationalist period has been the contemporary Indian artists' concerns with the question of national identity in response to the increasing globalization of art in the twentieth century—a concern that goes back to the first encounters between India and the West, and to constant oscillations of Indian artists between Western ideas and their own artistic integrity.

NOTES

1. E. Hobsbawm, *The Age of Revolution*, London 1962 and *The Age of Empire*, London 1987 on the impact of the industrial revolution on the West and the Third World. See also C. A. Bayly, *Indian Society and the Making of the British Empire*, Cambridge 1988.
2. P. Mitter, *Much Maligned Monsters: A History of European Reactions to Indian Art*, Chicago 1992.
3. K. Clark, *The Nude*, Harmondsworth 1956 on the importance of the nude in Western art and thought.
4. E. H. Gombrich, *Art and Illusion*, London 1962, p. 148.
5. On Rembrandt's collection of Mughal painting, see O. Benesch, *The Drawings of Rembrandt*, vol. 5, London 1957, p. 335.
6. M. and W. G. Archer, *Indian Painting for the British*, London 1955; M. Archer, *India and British Portraiture*, London and New York 1979; *Natural History Drawings in the India Office Library*, London 1962. See P. Mitter, *Art and Nationalism in Colonial India: Occidental Orientations*, Cambridge 1995, pp. 32–34, on the rise of Western art schools in India.
7. V. Prinsep, *Imperial India*, London 1879, pp. 47–48.
8. T. and W. Daniell, *A Picturesque Voyage to India*, London 1810; *Oriental Scenery*, 4 vols., London 1795–1808.
9. L. Venturi, *History of Art Criticism*, New York 1964, on the rise of the discipline of art history. The following writers were influential in the rise of Indian art history: J. Fergusson, *The History of Indian and Eastern Architecture*, London 1876; H. H. Cole, *Catalogue of Objects of Indian Art Exhibited in the South Kensington Museum*, London 1874; G. C. M. Birdwood, *The Industrial Arts of India*, London 1879.
10. On Kalighat, W. G. Archer, *Kalighat Paintings*, London 1971; H. Knizkova, *The Drawings of the Kalighat Style*, Prague 1975. On Chitpur prints, A. Paul, *Woodcut Prints of Nineteenth Century Calcutta*, Calcutta 1983, and chaps. 8, 21, 22, 23 in S. Chaudhuri, ed., *Calcutta, the Living City, I (The Past)*, Calcutta 1990.
11. S. Srimani, *Sukshma Shilper Utpatti o Arya Jatir Shilpa Chaturi*, Calcutta 1974. On the Hindu Mela, see J. C. Bagal, *Hindu Melar Itibritta*, Calcutta 1968; P. Mitter, *Art and Nationalism*, chap. 6.
12. ibid.
13. On Mexican art, D. Ades, ed., *Art in Latin America: the Modern Era*, London 1989. See Mitter, *Art and Nationalism*, chap. 5 on Ravi Varma.
14. Mitter, *Art and Nationalism*, chaps. 8 and 9. K. Okakura, *The Ideals of the East*, London 1903 was a seminal text.
15. Mitter, *Art and Nationalism*, chap. 8.
16. For an excellent and comprehensive account of Chughtai's life and work, see Marcella Nesom, "Abdur Rahman Chughtai: a Modern South Asian Artist," Ph.D. diss., Ann Arbor 1984. My own work, *Art and Nationalism*, pp. 336–339, discusses the construction of Muslim identity by Chughtai in response to Hindu nationalism.
17. Kandinsky's "On the Spiritual in Art" was published in 1912. On Rabindranath Tagore, Mitter "Rabindranath Tagore as Artist: A Legend in His Own Time?" in M. Lago and R. Warwich, *Rabindranath Tagore: Perspectives in Time*, London 1989, pp. 103–121. See also A. Robinson, *The Art of Rabindranath Tagore*, London 1989.
18. On Gaganendranath Tagore see J. Appasami, ed., *Gaganendranath Tagore*, Delhi 1964.
19. Sher Gil is one of the artists that I deal with in my forthcoming work on modernism, nationalism, and the Indian artist (ca. 1920–1947). But see J. Appasami, ed., *Sher Gil* (Lalit Kala Contemporary Art Series), Delhi 1965.

CATALOGUE

Page 40. Religious
Mendicant.
Photographed ca.
1870–1880.

Pages 72–73. Fateh
Maidan Sports—
H. H. the Nizam
Tent Pegging.
Nawab Sir Mahbub Ali
Khan of Hyderabad
(1884–1911)
photographed during
the visit of His Imperial
and Royal Highness
the Archduke Franz
Ferdinand of Austria
Este in January 1893.
Photograph by Lala
Deen Dayal, State.
Photographer
to the Nizam.

Pages 138–139.
Elephant
Procession—
Crossing Afzul
Gunj Bridge 6:15
p.m. *Nawab Sir*
Mahbub Ali Khan of
Hyderabad and His
Imperial and Royal
Highness the
Archduke Franz
Ferdinand of Austria
Este in January 1893.
Photograph by
Lala Deen Dayal,
State Photographer
to the Nizam.

NOTE TO THE READER
Dimensions of images are in inches, height
preceding width, followed by centimeters,
in parentheses. Corollary illustrations
in the catalogue entries are denoted as
"accompanying fig." and numbered
sequentially. Spelling of personal and place
names, titles, religious and other terms
varies throughout, due to differing
transliterations of Indian languages by
various authors.

Pages 176–177.
Bhootees dandy
bearers—
Darjeeling.
Photographed ca.
1880–1890.

Pages 202–203. The
"Golden Temple"
in Amritsar.
Photographed ca. 1870.

Pages 250–251.
Inscribed: "The breach
in the Fortress of
Seringapatam which
shews it now exactly
as it was on the day
4th May 1799 at 1 p.m.
when it was carried by
assault by the British
led by Sir David
Baird." Photographed
ca. 1895.

Pages 296–297.
The Darjeeling-
Himalayan
railway—the loop
below Tindharia.
Photographed ca. 1885.

Pages 328–329.
Fighting Elephants,
North-West India,
about 1900.

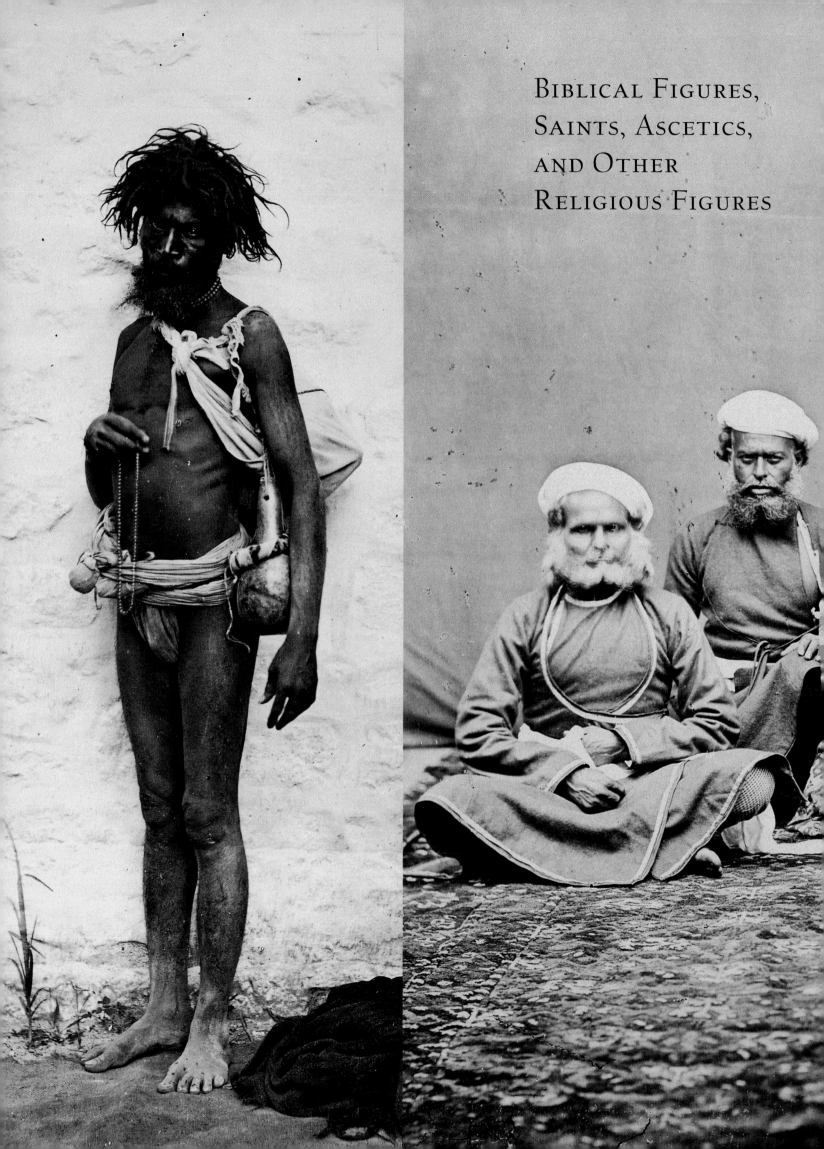

BIBLICAL FIGURES,
SAINTS, ASCETICS,
AND OTHER
RELIGIOUS FIGURES

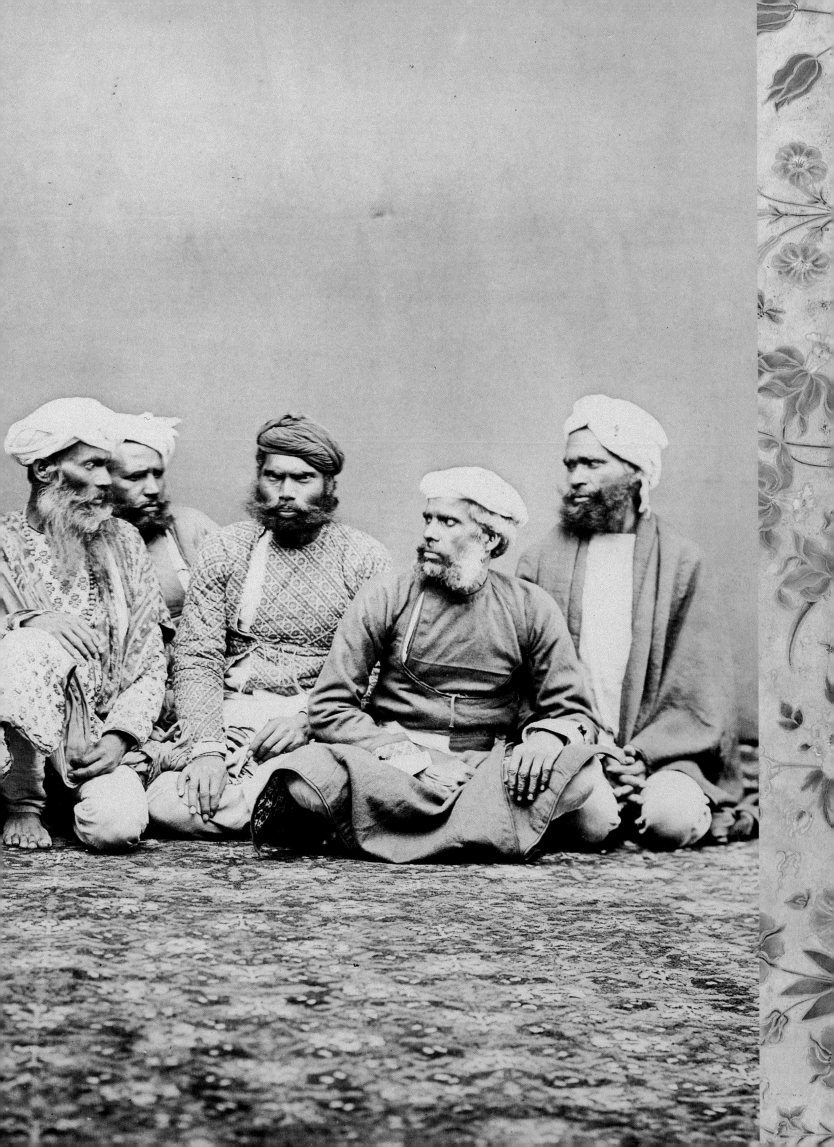

1 King David (1004–965 B.C.)
 Playing the Harp
 ∾
 by Manohar
 (ca. mid-1560s–1620, after
 the engraving by Jan Sadeler
 the elder (1550–1601), based
 on Peter Candid's (1548–1628)
 König David an der Harfe, Agra(?)
 ca. 1607–1620.
 Calligraphy by Mir 'Ali al-Katib
 (fl. 16th century).

Media: Gouache on paper

Size: page: 15⅛ x 10⅓ in.
(38.5 x 26.3 cm.);
painting: 8½ x 5³/₁₆ in.
(21.0 x 13.2 cm.);
calligraphy: 8½ x 5 in.
(21.6 x 12.6 cm.).

Published: Sotheby's, April 16,
1984, p. 32, full-page col. pl., lot
87; Sotheby's, April 23, 1996,
pp. 22–23, lot 8, with col. pls.

Provenance: British Rail Pension Fund

Inscribed: On recto, in *Nashtaliq:*
"The 'In the name of God, The compassionate, The Merciful'
Is the prayer at the table of the generous,
The divine bounty, prepared for the table [that inspires] eloquence.
He lifted a veil from the old fable
The cry of the scratching of the magician's reed pen arose:
'In the name of God' Help!
Nourishing words emerged,
Savour them!
The needy Mir 'Ali, the scribe."
On verso, on the base of the plinth of David: *amal-i-Manuhar* (work of Manohar).

Now the Spirit of the Lord departed from Saul and an evil spirit from the Lord tormented him. And Saul's servants said to him, "Behold now, an evil spirit from God is tormenting you. Let our Lord now command your servants, who are before you, to seek out a man who is skillful in playing the lyre; and when the evil spirit from God is upon you, he will play it, and you will be well." So Saul said to his servants, "Provide for me a man who can play well, and bring him to me." One of the young men answered, "Behold, I have seen a son of Jesse the Bethlehemite, who is skillful in playing, a man of valour, a man of war, prudent in speech, and a man of good presence; and the Lord is with him." Therefore Saul sent messengers to Jesse, and said, "Send me David your son, who is with the sheep." And Jesse took an ass laden with bread, and a skin of wine and a kid, and sent them by David his son to Saul. And David came to Saul, and entered his service. And Saul loved him greatly, and he became his armour-bearer. And Saul sent to Jesse, saying, "Let David remain in my service, for he has found favour in my sight." And whenever the evil spirit from God was upon Saul, David took the lyre and played it with his hand; so Saul was refreshed, and was well, and the evil spirit departed from him. (Holy Bible, Old Testament, Samuel 16, 14–23).

The Mughal emperor Jahangir (1605–1627), who commissioned this painting, apparently enjoyed discussions with missionaries about Christian pictures. With regard to King David, Father Fernao Guerreiro reported in about 1607:

The Fathers had long been anxious for an opportunity of disputing with the Moors before the King, that they might demonstrate the truth of our faith, and the falseness of the law of Mafamede. This opportunity they found soon after the King had settled down at Agra, and it extended over more than a month, during which many notable disputes took place.... The occasion arose out of the pleasure which the King took in looking at the coloured pictures of sacred subjects, which the Fathers, knowing his interest in these things, had presented to him. It happened one evening that he called for a number of these, and finding he did not understand them, sent for the Fathers that they might explain it to him. It happened that the first picture which he showed them was one of David on his knees before the prophet Nathan...[1]

The discussion which is provoked by the showing of the picture of David demonstrates the extent of Jahangir's interest in paintings illustrating Christian topics. It is hence highly probable that Jahangir had some of those "coloured pictures," which the Jesuit Fathers carried with them, copied by his court artists. Besides, David was not just one of many Christian characters; David also holds an eminent position in Islam, where he is known as Da'ud. The Koran mentions quite a few facts about him on which the Bible is silent, including his invention of a coat of mail; his discussions with the angels; and his division of the week into days of prayer, business, etc.

Like his father Akbar, Jahangir enjoyed discussions with Europeans, at least to a certain degree. He would, however, not accept them to the extent of having any of them mentioned in his memoirs, as Robert Skelton has pointed out on different occasions. Consequently, Jahangir's judgement with regard to paintings was not to be corrupted simply because they were done by European artists. Jahangir even rejected some European paintings as being inferior. One of them, "beeing in oyle, he liked not," as Sir Thomas Roe, then ambassador

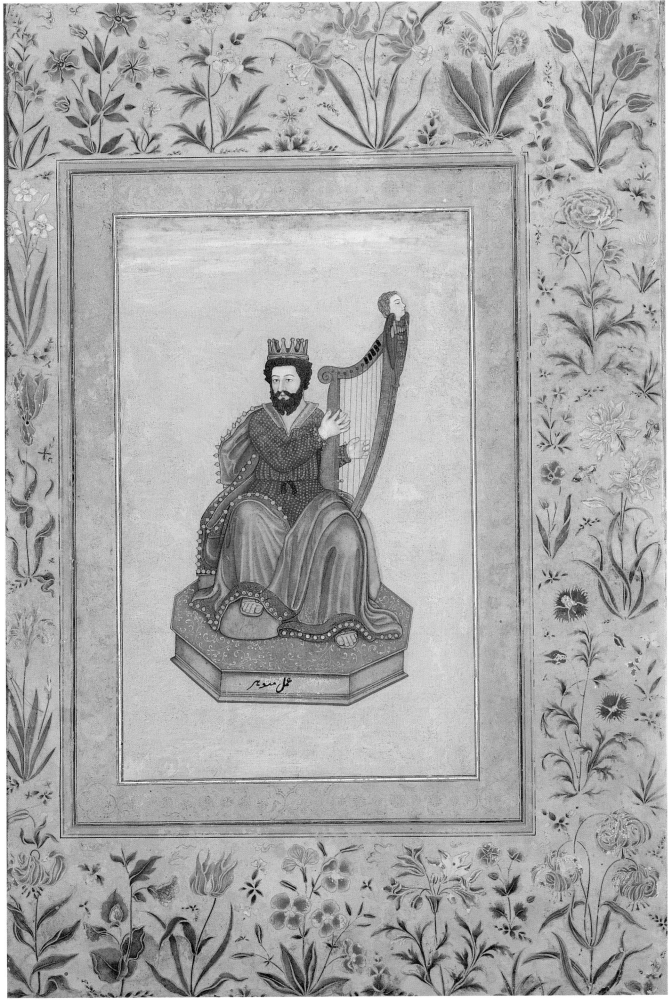

Cat. 1, verso.

BIBLICAL FIGURES, SAINTS, ASCETICS, AND OTHER RELIGIOUS FIGURES

at the court of Jahangir, recorded in September 1515.[2] Jahangir loved experiments, and he obviously loved to provoke reactions. He never became a Christian, but had his palace decorated with Christian paintings. These were noticed by a number of travellers; perhaps most noteworthy again is the description by Father Fernao Guerreiro:

Throughout the discussions of which we have spoken, the King always showed his deep regard for Christ Our Lord. He also spoke very strongly in favour of the use of pictures, which amongst the Moors, are regarded with abhorrence.[3] When he came from Lahore he found his palace very beautifully decorated and adorned with many paintings which had already been completed, and others which were yet to be completed both on the inside and on the outside of a verandah where he sits daily to be seen by the people. On the inner side where he goes at night and where he sits before he wishes to appear on the outer verandah, he has a large verandah, in the middle of the ceiling of which there is a good picture of Our Saviour in glory surrounded by Angels, and on the walls of the hall are some Portuguese figures of large size, beautiful painted, and some small pictures of Saints, including S. John the Baptist, S. Antonio, S. Bernhardino of Siena, and other Saints, male and female, also well painted. Of the janela or outer window what shall I say? On the sides of the palace where the King sits when he shows himself to the people there had been some excellent life-size portraits of some of his favourites, but some days later he had these obliterated and in place of these he had painted some very smart Portuguese soldiers, under arms, of life-size so that they could be seen from all parts of the maidan. There were three figures on each side of the window. Above them on the right was a painting of Christ Our Lord with the globe of the world in His left hand, and on the other side Our Lady very well painted: but when he had seen a picture of Our Lady by S. Luke which we have in our Church, he had it obliterated and a copy of our picture substituted in life-size. On either side of Our Lord and of Our Lady were various Saints in a posture of prayer. In the oriel of the verandah or janela where the king sits, at the sides, on the same wall, were full sized pictures of his two sons, very splendidly attired. Above one of these was a representation on a small scale of Christ Our Lord and next to Him a Father with a book in his hand; and above the other was Our Lady. In the same oriel recess were S. Paul, S. Gregory and S. Ambrose; they, being inside the oriel and on a small scale, are scarcely visible to the people standing below, but the rest can all be seen.

Often when attending on the King has one told one's beads before the picture of Our Lady and commended oneself to Christ Our Lord represented there. The Moors are astonished at this and God is to be thanked that the representations of Christ our Lord and of Our Lady Mary and of the Portuguese are so much in evidence. The verandah looks, in fact, as though it belonged, not to a Muslim King, but to a King of great devoutness. Then in the interior of the palace the King has had the walls and ceilings of various halls painted with pictures of the mysteries of Christ our Lord and scenes from the Acts of the Apostles taken from the book of their Lives which we gave him, and the stories of St. Anna, Susanna and others. All this the king did of his own accord without a suggestion from anyone. He had ordered his artists to consult the Fathers as to the colour to be given to the costumes and to adhere strictly to what we told them. The figures to be painted were selected by the King himself from his collection of prints and he decided where they were to be placed. He got his painters to make large-size sketches on paper of all the prints which he wished to have painted and the Fathers then stated how the painting should be done. . . . As the Moors deny all that pertains to the Passion of Our Lord, they especially resented a picture of Christ at the Pillar which the King had made at this time from a small print. It was a large picture well coloured and was to serve as the pattern for a picture with the same figure woven in silk like arras and he had the title in Persian woven in the same fashion in the silk picture. On the wall of one of his halls he had life-size pictures painted of the Pope, the Emperor, King Philip and the Duke of Savoy, all on their knees adoring the Holy Cross which was in their midst — a copy of a print which he had of this subject. (Father Xavier in a letter of September 24, 1608)[4]

This passage suggests that the present painting might also have been inspired by (uncolored) European prints of Christian figures. Life-size paintings, which the Father mentions, must have existed, as one of them, showing Jahangir himself, recently appeared on the art market.[5] Besides, there is a companion picture to the present painting, which belongs to the same *muraqqa* or album, showing "Christ Our Lord with the globe of the world in His right hand."[6]

Until the reign of Aurangzeb (1658–1707), pictures of Christian or European subjects were not uncommon at the Mughal court. This is not only shown by numerous contemporary descriptions of wall paintings of Christian subjects,[7] but also by still existing miniature paintings[8] in addition to a few published murals from both Agra and Lahore.[9] The presence of paintings with Christian subjects at the place where Jahangir used to present himself for *darbar* is well attested to by another painting of Manohar, once in the collection of Walther Ph. Schulz in Berlin and now in the collection of the Museum of Fine Arts, Boston. This painting is probably the best known Mughal painting, since no other Mughal painting was reproduced more often.[10] It not only includes a portrait of a Jesuit with his black cap, it also shows angels painted on the brackets above the emperor, Jahangir, in addition to a depiction of the Virgin Mary painted on the wall, visible just above the emperor's head. F. R. Martin, who first published this picture, remarked on the many portraits which are included in this painting—of the sixty-seven persons present, twenty-five were identified.[11] "The first," he wrote, "who appreciated the beauty of these portraits in Europe, was the famous English painter Sir Joshua Reynolds,"[12] who in fact, on the basis of his seal, is among the former owners of the following cat. no. 2.

Did Manohar really intend to illustrate the quoted passage of the Holy Bible which this painting depicts? Did Jahangir take the Jesuits at his court as seriously as they thought he did? Probably not. Jahangir's arrangement and selection of pictures for his *muraqqas* or albums, including those illustrating Christian subjects, followed a purely aesthetic intention, which cared but little for the "message" a European spectator would have received from looking at these. The aesthetic harmony achieved in these albums was a purely formal one.[13] That is not to say, however, that the new context in which the copies of these Christian paintings now appeared would render these paintings completely meaningless. It was even observed that in some cases "these details combine to create a composition of perhaps greater dramatic intensity than of the original."[14] Jahangir's highly aesthetic sense cannot be judged from a single painting, however. The album to which the present painting belonged was broken up by Jahangir's son and successor, Shah Jahan (1628–1658).

Another painting, which most probably formed part of the same album in Jahangir's time, depicts Jesus and was already mentioned here.[15] We are unable to assess properly the aesthetic position the present painting once held, when the album was still intact under Jahangir. It is certain, however, that Jahangir discussed the position of King David in a Jesuit-Christian context, and it does not seem unlikely that at that time he may have asked his artist, Manohar, to copy one of the "coloured pictures of sacred subjects" or European prints of the same subject, which in this case represented King David playing the lyre, in order to keep away the evil spirits from Saul. It should also not be forgotten that Jahangir could have inserted the original European prints, which the Jesuit priests would have disposed of with pleasure, into his albums, but he preferred to have them copied. For Jahangir, these copies were as good as the originals, and that Jahangir's artists were able to produce very close copies of European originals is attested to by the English ambassador, Sir Thomas Roe, whose story about the quality of Jahangir's copies is sufficiently well known to summarize it here in brief: On July 13, 1616, Jahangir was shown a portrait miniature by Roe. Jahangir sent for his "chief painter," who claimed he could do as well (in Roe's words: "The foole answered he could make as good"). On August 6 of the same year, Roe was called to the court. "The business was about a picture I had lately given to the King, and was confident that noe man in India could equall yt." Roe was shown his original together with five copies. Roe wrote that they were in fact "so like that I was by candle light troubled to discerne which was which; I confesse beyond all expectation; yet I showed myne owne and the differences, which were in arte apparant, but not to be judged by the common eye. But for that at first sight I knew it not, hee [Jahangir] was very merry... I replied I saw His Majestie needed noe picture from our country.[16]

Not only to Jahangir, but also to several of his successors (cf. cat. nos. 11 and 20) the (Indian) copies of and/or versions after European originals carried more aesthetic pleasure than the "originals" which were, very often, already Flemish copies after Dürer's originals. Jahangir, like all his successors, did not really prefer European paintings to the products of his own artists; he just liked to see certain qualities in them, which he could more easily enjoy through a kind of translation into Indian aesthetics. These Indian "copies," or rather, versions of European paintings, therefore are nothing more — and nothing less — than translations into Indian aesthetics which intensify certain traits of the European pictures.

In early 1663, the French traveller François Bernier remarked on Indian paintings that he saw in Delhi: "I have often admired the beauty, softness, and delicacy of their paintings and miniatures. . .," but he also said: "The Indian painters are chiefly deficient in just proportions, and in the expression of the face; but these defects would soon be corrected if they possessed good masters, and were instructed in the rules of art.[17] We do not know the quality of the paintings which Bernier saw. It is certain, however, that Bernier was not alone in his attitude towards Indian painting, which, with but few exceptions, has not changed to this day. It is as if the Indian artist was not conversant with what Bernier calls the "rules of art." Bernier, as most of his contemporaries, was unable to accept the "Indian" rules of art. What Bernier took into account were solely his, i.e. the Western understanding of art, or more precisely, painting. The paintings in this catalogue present both "rules," the Western as well as the "Indian," side by side. Jahangir would reject a European painting, probably for good reason, but he would never really declare that European paintings on the whole were inferior — or superior — to the products of his court artists. He would compare and assess both traditions, without making general statements on the genre of painting, as was done by Bernier. And this is, after all, what distinguishes the Mughal emperor from famous but jealous European travellers.

A later copy of the present painting was owned by William Fraser (for whom see cat. no. 18) in Delhi. Fraser also possessed a copy of the companion piece with Jesus on the throne, which shows that both paintings were considered to be of sufficient importance to be copied by artists trained in the Mughal style in the late eighteenth or early nineteenth century. [18]

Manohar was the son of Basawan, one of the most famous artists at the Mughal court under Akbar. His first dated painting bears the date of 1581. More than eighty-four paintings were either signed by Manohar or attributed to him by inscription. Some thirty additional paintings were attributed to him by modern writers. Two portraits, one by Manohar himself, show the artist at work, and three more works by him are known, in which he incorporated or copied European paintings or prints of Christian subjects.[19] Manohar's oeuvre has been described a number of times.[20]

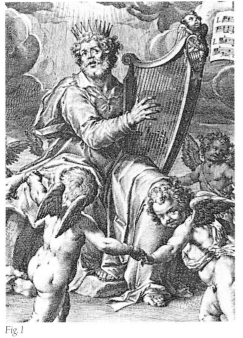
Fig. 1

The scribe Mir 'Ali or Mir 'Ali al-Katib, as he styles himself here, is one of the most famous Islamic calligraphers of the fifteenth century, whose works were used in many folios of the Imperial *muraqqas*. The painting of the present folio is, strictly speaking, the verso, and the calligraphy the recto of this page, whereas in the companion painting showing Jesus, the calligraphy is on verso and the picture on recto. Mir 'Ali was in fact not just a scribe. He was a "calligrapher, poet, and author of skillful chronograms and of some riddles, all on well balanced, medium-sized pages." He was born in the late fifteenth century in Herat and moved to Bukhara in about 1530; the date of his death is unknown. Most of the calligraphies in the well-known Kevorkian album, the older part of which was compiled under Shah Jahan, are by him, and many others of his signed calligraphies are known.[21]

The present painting, like its companion piece, belongs to *the* — or one of the — so-called late Shah Jahan albums, i.e. one or more albums compiled under the Mughal emperor, Shah Jahan.[22] The present subject is based on an engraving by Jan Sadeler (fig. 1). Quite a number

of Jan Sadeler's engravings were used by the artists working for the Mughal emperor Jahangir, as was discovered by a certain Mrs. Cabot, on whose research Milo Beach based his useful introduction to the subject.[23] A good number of Jan Sadeler's engravings are based on works by other artists, such as Peter Candid.[24] Peter Candid, also known by his original Flemish name, Pieter de Witte,[25] did his final version of *König David an der Harfe* (King David at the Harp) some time between 1588 and 1595. The engraving after Candid by Sadeler is mentioned in 1599.[26] A portion of the preliminary drawing of the composition, which as yet does not show the head at the upper end of the harp, is in the university library of Erlangen, Germany.[27] A more complete drawing of the composition which clearly does show the head which Manohar copied from Jan Sadeler's engraving, is kept in the Gabinetto Disegni e Stampe degli Uffizi, Florence, Italy.[28] This version comes closest to Peter Candid's original painting, which is now lost. *König David an der Harfe* is one of the most often copied works based on either the original by Peter Candid or on Jan Sadeler's engraving. To the eight copies, partly executed in relief, listed by Volk-Knüttel,[29] the present version may be added as the ninth, probably most exotic one.

NOTES

1. Guerreiro 1930, p. 49. For further discussions on David, see ibid., p. 68.
2. Or 1616, cf. Roe 1926, p. 224.
3. Guerreiro 1930, p. 63.
4. Quoted after Maclagan 1932, pp. 238–240; for the text cf. also Guerreiro 1930, pp. 63–65.
5. Sotheby's, October 18, 1995, pp. 74–83, lot 85, with several col. pls.
6. Sotheby's, April 16, 1984, pp. 34–35, lot 88; Sotheby's, April 23, 1996, pp. 20–21, lot 7, col. pls.
7. For the most comprehensive compilation and discussion on this subject, see Maclagan 1932, pp. 222–267 ("The Missions and Mogul Painting").
8. Cf. the well-illustrated survey by Löwenstein 1958, also Wellesz 1952. For a more recent, lavishly produced treatment of this subject, see Ahmed (ed.) 1995, with the following contributions by various authors: "History of Mughal Painting, Intercultural and Artistic Influences"; "European Painting and Mughal Miniatures"; "Mughal-Christian Miniatures"; Mirat-ul-Quds (The Mirror of Holiness) or Dastan-i-Masih"; "Mughal Influences on European Painting of the 17th Century."
9. Cf. Koch 1986 (Agra) and Koch 1983 (Lahore).
10. This picture was published well over twenty times. For probably the most recent publication, see Bressan 1995, p. 39, col. illus.; also McInerney 1991, p. 67, no. 16; Desai/Patry/Leidy 1989, col. illus. on front cover and p. 41, col. pl. IV, full page.
11. Stchoukine 1929–30, pp. 228–241, "Le Darbar du Museum of Fine Arts, Boston." The Jesuit priest was identified as Father Corsi, cf. Beach 1965, p. 62.
12. F. R. Martin in Sarre/Martin (eds.) 1912, vol. I, Tafel 38 and text to cat. no. 919.
13. Cf. Beach 1965, p. 67, p. 75.
14. Beach 1965, p. 78.
15. Cf. note 6 above.
16. Cf. Roe 1926, p. 189f. and p. 199f. The full story also reveals the high esteem in which Jahangir held the work of his artists.
17. Bernier 1916, pp. 254–255.
18. For the later version of the present painting see Sotheby's, October 13 and 14, 1980, p. 84, no. 207. For the later copy of the companion painting see Sotheby's, October 13 and 14, 1980, p. 84, no. 208, illus. on p. 82 (= *Maggs Bull.* 34, 1981, no. 11, illus. as frontispiece).
19. One of the European subjects was done in collaboration with the artist Nanha; see Losty 1982, col. pl. XXXI, no. 77, f5b (right) (= Pinder-Wilson/Smart/Barrett 1976, p. 63, no. 94a = Bressan 1995, p. 51, fig. 31, col.), the other two are by him alone, see Ivanova/Grek/Akimushkina 1962, pl. 21, top left (= Akimushkin 1994, col. pl. p. 60, folio 53a) and Okada 1992, p. 141, fig. 160.
20. Cf. Das 1978, pp. 188–192 ("Manohar"); Glenn D. Lowry in Beach 1978, pp. 130–137 ("Manohar"); Beach 1981, pp. 111–112 ("Manohar"); McInerney 1991 (no. 14, reproduced in col. on p. 66 of this article, is reproduced mirror reversed; for the unrestored condition of this painting see Sotheby's, December 14, 1987, p. 21, lot 26); Okada 1992, pp. 136–147 ("Manohar"); Verma 1994, pp. 248–259. Cf. also Poster et al. 1994, no. 36, pp. 81–83, col. pl. p. 82.
21. For Mir 'Ali's life, career, and work, see Schimmel 1987. For further calligraphies bearing his signature (as Mir 'Ali al-Katib as in the present case), see Palais Gallièra 1970, nos. 97–98; Sotheby & Co., July 10, 1973, lot 29, p. 34; Sotheby's, July 7 and 8, 1980, lot 164; Beach 1992, p. 319, no. 129i, to mention just a few.
22. For a compilation of published pages belonging to that album (or albums), see Beach 1978, pp. 76–77. For a recent discusssion, see Leach 1995, pp. 380–381, especially note 5, which lists the present painting.
23. For copies after Jan Sadeler's engravings, cf. Beach 1965, figs. 9a, 10b, 10c, 11a, 12a.
24. For an engraving by Sadeler based on Peter Candid's work, see Beach 1965, p. 85, 10d.
25. From 1586 onwards, Pieter de Witte worked for the rulers in Munich, Germany and as a result, had his name changed into what was then thought to be more "German": Peter Candid. He is also mentioned by the Latinized version of his name: Petrus Candido.
26. For details see Volk-Knüttel 1978, p. 33, note 5.
27. Reproduced: Volk-Knüttel 1978, cat. no. 4, Abb. 101.
28. Reproduced: Volk-Knüttel 1978, p. 32, fig. 10.
29. Volk-Knüttel 1978, p. 33, note 6.

2 The Death of Ananias or a Scene at Nandgaon, the Village of Krishna's Childhood

∾

after a cartoon by Raphael (Raffaello Senzio, 1483–1520), by an artist trained in the Mughal style, second half of the 17th century or slightly later.

Media: Ink on paper

Size: Overall: 7³/₄ x 12⁵/₈ in. (19.6 x 32.0 cm.)

Inscribed: On verso, in *Nagari* script, in ink: *pano namdgaon ka sev[?]ke hat ka juham sirai[?] likhai[?] kim[a]t rupiye 15 pamdrah* (Folio of the [divine] service[?] at Nandgaon . . . price: rupees 15, fifteen.)

Published and Provenance: Christie's, October 10, 1989, lot 83, full-page col. pl., p. 60; Spink, October 1991, no. 1.

But a man named Ananias with his wife Sapphira sold a piece of property, and with his wife's knowledge he kept back some of the proceeds, and brought only a part and laid it at the apostles' feet. But Peter said, "Ananias, why has Satan filled your heart to lie to the Holy Spirit and to keep back part of the proceeds of the land? While it remained unsold, did it not remain your own? And after it was sold, was it not at your disposal? How is it that you have contrived this deed in your heart? You have not lied to men but to God." When Ananias heard these words, he fell down and died. And great fear came upon all who heard of it. The young men rose and wrapped him up and carried him out and buried him. (Holy Bible, New Testament, Acts of the Apostles 5, 1–6).

Raphael's original cartoon of the *Death of Ananias* in the Victoria and Albert Museum, London, measures 151¹/₂ x 173¹/₄ in. (385 x 440 cm.) and was thus intended for a tapestry. A comparison of the drawing with Raphael's cartoon reveals that the artist of this cat. no. did not really copy Raphael's design. In comparison, Rembrandt's copies of Indian miniatures are much closer to the original than this drawing is to Raphael's painting.[1] The Indian artist here used only a certain number of figures from the original design and borrowed freely from other Mughal paintings with European subjects. Besides, he over-emphasized the pleats of the long garments of the apostles in introducing many more than there actually are in the cartoon. Raphael's scene takes place in a building, whereas the artist of the present drawing set the scene in a landscape studded with temple-like buildings known from several Mughal drawings.[2]

A detail of note in the present drawing is the presence of the two dogs in the lower left corner. As the temple-like structures, they do not appear in Raphael's composition and are also quotations from Mughal and possibly also Deccani paintings from the first half to the middle of the seventeenth century. Initially, these dogs as a subject in painting might have been adopted from a European picture brought to the Mughal court. A painting by Manohar, who painted cat. no. 1, shows the Mughal emperor Akbar (1556–1605) with a similar dog, probably a Tazi or Saluki, near him.[3] The bodies of the dogs of the present drawing, however, are shorter. They resemble more closely the type of dogs which one often meets in the company of ascetics of a certain sect, known as the *Kanphat yogins*.[4] The dog may also appear along with a

composite animal,[5] but more regularly is shown with various religious individuals.[6] In a drawing attributed to Manohar, a dog also appears as part of a copy of a European engraving.[7]

Were the apostles in this drawing understood to be religious people? The inscription on the back informs us that they probably were, with or without dogs. It is improbable, however, that the artist knew about the passage from the Bible quoted above. The apostles more closely resemble intoxicated *Kanphat yogins* than figures from the New Testament. The differently shaped bottles, one of which lies at the apostles' feet, do not appear in Raphael's cartoon. The hair in particular, arranged in strands, reminds more of the matted hair of the god, Shiva,[8] whereas the place name, Nandgaon, suggests a Vaishnava context. Nandgaon or Nandgram literally means "village of Nanda," which is situated near Mathura. Nanda was Krishna's foster father. Kota, the capital of the Rajput kingdom with the same name, was for some time renamed "Nandgaon."[9] Some ninety years earlier, Rao Ratan of Bundi, ruler of the capital of the senior line of the clan to which Kota belongs, bought "some tapestry" from a certain Mr. Willoughby, for the then large sum of 18,450 rupees.[10] Some European figures from these tapestries can still be seen as life-sized figures in wall-paintings within the old palace of Bundi. These wall-paintings are datable to about 1630, and it should not be surprising that the European figures are accompanied by dogs and cats. Stylistically, the present drawing stems from neither Bundi nor Kota and there is no proof that the tapestry sold by Mr. Willoughby was based on Raphael's cartoon.

The greatest Indian client for tapestries was the Mughal emperor Jahangir himself. Among the things that Captain Downtown, who sailed to India in 1614–1615, "desireth to bee furnished of by the nextt ships thatt come out of England," were "Cloth of Arras, wroughtt with pictures."[11] A contemporary Dutch chronicler reported from Agra, then the capital of Mughal India: "For the royal Camp or Court they [the English] bring tapestries, both silken and woollen, worked with stories from the Old Testament. . . in this way the English have secured much esteem at Court among the nobles, and sell their goods at the highest prices they can ask, under the pretence of doing a great favour. . . ."[12]

Jahangir might possibly have received a tapestry woven after Raphael's cartoon. The present drawing, however, gives the impression of having been adopted from one or more than one print. While copying, or rather quoting, parts of it, the artist transformed the apostles into religious figures that he knew from earlier Mughal drawings, without attempting to create a precise copy of the "original," and without any attempt at what the Western observer would call "proper shading." The Indian client thus read and for his or her requirements understood and appreciated the drawing, whereas the actual Raphael cartoon would probably not have been appreciated at all. Another drawing done by the same hand as the present recently appeared on the art-market.[13] It did not, however, give any clue as to its precise provenance or date.

NOTES

1. For a reproduction of Raphael's cartoon, see Oppé 1970, pl. 186.
2. Cf. very similar structures in Christie's, October 13, 1982, p. 22, lot 44 and p. 22, lot 45 (= Sotheby's, April 12, 1976, lot 142, illus. facing p. 61), to mention just a few.
3. For this often reproduced painting in the Cincinnati Art Museum see Smart/ Walker 1985, no. 6, col. pl.
4. For the *Kanphat yogins*, see Briggs 1973. The *Kanphat yogins* are recognizable by their large earrings, made of the horn of the Indian rhinoceros. Not all ascetics in company of such dogs as seen in cat. no. 2 are Kanphats, but quite a few of them are. For the respective drawings and paintings, see Kühnel/Goetz 1924, pl. 40, top right (fol. 6b) and bottom (fol. 13a); Sotheby & Co., December 6, 1967, lot 121, illus. opp. p. 43; Sotheby & Co., December 1, 1969, lot 130, illus. opp. p. 63; Sotheby's, December 9, 1975, lot 33, illus. opp. p. 9 (this painting is now in the Linden-Museum, Stuttgart); Kramrisch 1986, no. 20, p. 23, col. pl.; Leach 1995, vol. I, p. 304, no. 2.164, to mention just a few.
5. Cf. Hickmann 1979, no. 13, full-page col. pl.
6. Cf. Gahlin 1991, col. pl. 3, cat. no. 2 (two Mullahs); cat. no. 6, col. pl. 5, (copy after an engraving of St. Luke by Hans Sebald Beham, with two similar dogs instead of a bull); cat. no. 15, col. pl. 13 (a Hindu ascetic). Okada 1989, cat. no. 59, reproduced on p. 199 (a Jesuit missionary, probably a portrait from life, by Manohar). David/Soustiel 1986, no. 1, col. pl. p. 7 (Tobias [?] and angel), again to mention only a few.
7. Goswamy/Fischer 1987, no. 100, col. pl. p. 203 (= Christie's, October 16, 1980, lot 63, reproduced on p. 45).
8. That painters working in the Imperial Mughal atelier were able to represent the hair of such figures quite accurately is shown e.g. by Sotheby's N.Y., September 21 and 22, 1985, lot 372, col.
9. This happened after Maharao Bhim Singh of Kota (1707–1720) became an active member of the religious community known as Vallabhacharya Sampraday, in 1719.
10. Mundy 1914, p. 24. Rao Ratan, however, only paid 1,000 rupees, and it is basically for this reason that this incident was recorded by Peter Mundy.
11. Downtown 1938, p. 187. Arras is the name of the place at which these tapestries were made. See also Father Xavier's letter quoted in cat. no. 1.
12. Pelsaert 1972, p. 25.
13. Christie's, October 15 and 17, 1996, lot 12, p. 14.

3 An Urdhvabahu or Man with Raised Arm

∾

by François (Frans) Balthazar Solvyns (1760–1824), Bengal, ca. 1795–1798.

Media: Gouache on paper

Size: 14¹/₄ x 9⁵/₈ in. (36.2 x 24.8 cm.)

Inscribed: "AN OODDOOBAHOO," in pencil, below painted surface; "N 2" in pencil, top right corner, between black rules and painted surface; "4" in ink, top right corner of sheet.

Published: Engraved 1799, as in the adjacent text.

The artist himself described this painting after introducing it as follows:

What I have said of the text, may also in some degree be applied to the prints themselves, in which the objects such as they appeared to my view, and as such as they would appear at this hour to the reader, if he could be suddenly transported into the midst of them.[1]

The colored engraving which contains the present watercolor is then described:

In the foregoing number, we passed in review some classes of Faquirs; but they were reasonable people in comparison of those whose extravagances are to form the subject of this plate. In the foreground are two Faquirs called Ooddoobahoos: one of them holds up his arm continually extended in the air; the second keeps his two hands joined over his head....[2]

Some more detailed nineteenth century descriptions of this type of ascetic deserve a full quotation:

I saw repeated instances of that penance of which I had heard much in Europe, of men with their legs or arms voluntarily distorted by keeping them in one position, and their hands clenched till the nails grew out at the backs. (Reginald Heber, Banaras, September 6, 1824)[3]

I found there a fine specimen of those holy mendicants called fakirs; although, by the bye, I apply the epithet of mendicant undeservedly to him (as I also do most probably the term holy), as he would not take from me the money I offered. He was a pitiable object, although he had a handsome and — in spite of his downcast eyes — rather a roguish countenance. One arm was raised aloft, and, having been in that position for 12 years, the power of lowering it was lost: it was withered to one-fourth of the size of its fellow, and the nails were nearly two inches long. He was about to undertake a further penance of standing on one leg for 12 more years; after which he had some thoughts of measuring his length to Cape Comorin! Poor misguided enthusiast! (G. C. Mundy, Agra, January 1, 1828)[4]

En route were several parties of fakirs ... These rascals had some capital tattoos with them. Several of these men had one withered arm raised straight, with the long nails growing through the back of the hand. These people are said to be great thieves; and when any of them were encamped near us on the march, we directed the chaukidars [watchmen] to keep a good look out, on our horses as well as our chattels. The adage says of the fakir, "Externally he is a saint, but internally a devil." (Fanny Parks, December 2, 1826)[5]

In late 1858, in a chapter on "Self-torturing Fakirs," the American Reverend William Butler noted:

But even these are not the worst of the class. Quite a number of them give up wandering and locate, and engage in the most amazing manifestations of endurance and self-torture. A few must be mentioned. One will lash a pole to his body and fasten the arm to it, pointing upward, and endure the pain till that limb becomes rigid and cannot be taken down again. The pole is then removed. I saw one of them with both arms thus fixed, his hands some eighteen inches higher than his head, and utterly removable. Some of them have been known to close their hand, and hold it so until the nails penetrated the flesh, and came out on the other side.[6]

Nothing fired the Western imagination more than the Indian *fakir*. India was presented as being as degenerated as the upheld arm of the *urdhvabahu*.[7] Any evil was projected on him. Mrs. Parks, by the way, does not tell us how she imagines a horse to be stolen by a man who has lost command over his arms. In his description Butler mentions engravings by "Tavernier and others," and most probably alludes to a copper plate with ascetics around a shrine of Shiva, frequently published from 1729 onwards. This often reproduced copperplate in fact introduces a number of different Indian ascetics at a Shiva-shrine.[8] We quote here from Tavernier's own description, published in 1676:

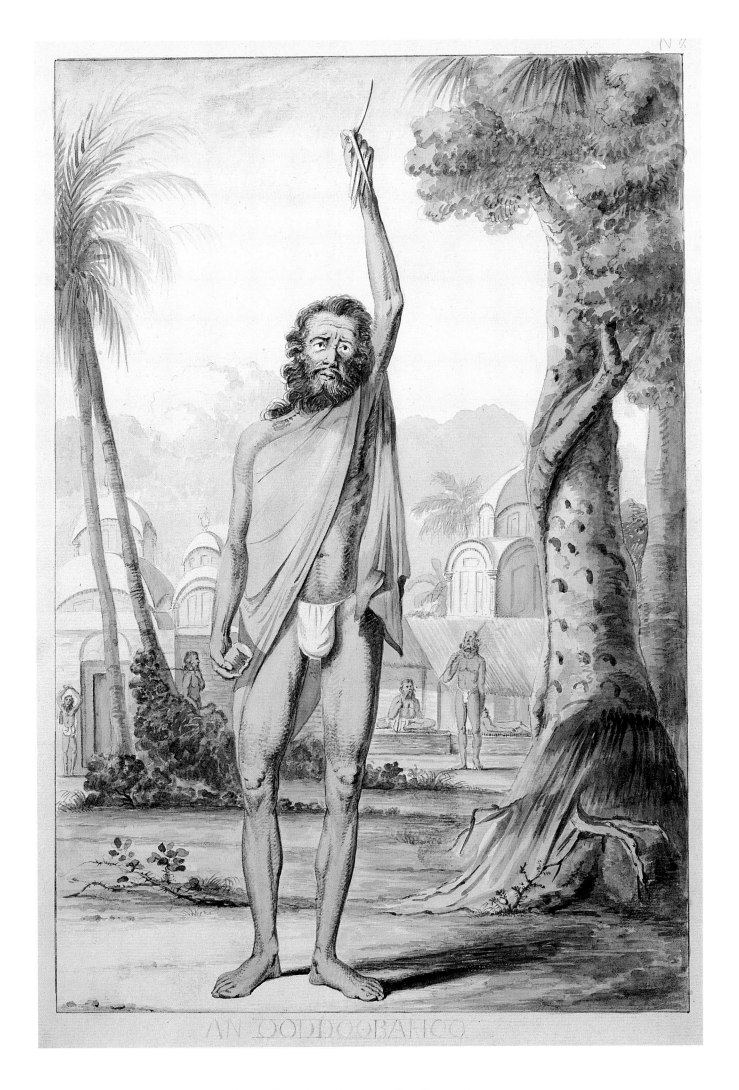

AN TOODDOOBANCO

These are the positions of two penitents who, till death, keep their arms elevated in the air, so that the joints become so stiff that they are never able to lower them again. Their hair grows below their waist, and their nails equal their fingers in length. Night and day, winter and summer, they remain stark naked in this position, exposed to the rain and heat, and to the stings of mosquitoes, without being able to use their hands to drive them away. With regard to the other necessities of life, as drinking and eating, they have Fakirs in their company who wait on them as required.[9]

Well-informed and interested Western observers knew from ancient Indian mythological texts that there were men who stood with raised arms on one leg for thousands of years, but they could not imagine that the bard only exaggerated with regard to the span of time. Faced with the reality in India, even the educated Westerner was shocked and preferred to flee into convenient Western prejudices rather than to confront this reality. Hindu ascetics such as *urdhvabahu* were part of Indian daily life for two millennia or even longer, and they therefore appear in Indian art. Perhaps more surprising is the fact that these "armraisers" have not ceased to exist. The accuracy of the seventeenth, eighteenth, and nineteenth century descriptions regarding the raised mortified arm and the duration of this kind of penance is corroborated by modern photographs recently published, and accompanying descriptions of this kind of penance, called *tapasya*:

The tapasya of keeping the right arm up—for twelve years or more—is even more mortifying and often leads to permanent physical damage. The arm withers away; it becomes a useless stick. Ascetics who practise this tapasya are called ek-bahu Babas (one-arm Babas). It has to be completed by bringing the arm down. If this is not done properly, it may result in insanity, or death. Formerly, there were ascetics who kept both arms raised. These Babas were totally helpless and had to be fed.[10]

It has been noticed that some of Solvyns's engravings are mirror-reversed when compared to the original drawings.[11] In the present case, whether the (Hindu) ascetic raises his left or right arm is significant.[12] The Paris edition of 1808–1812 shows the ascetic as introduced here, whereas the earlier Calcutta edition of 1799 shows him mirror-reversed,[13] keeping his "'dirty'" hand"[14] raised.

Already at the age of twelve, François Balthazar Solvyns[15] received a reward for his drawings issued by the academy of Antwerp.[16] It is known, however, that financially his engravings were not a success. Although they are very accurate and detailed, they did not suit either British or French taste.[17] It seems that some artists, including Charles d'Oyly, were inspired by Solvyns's picture of the *urdhvabahu*, as several later versions show considerable correspondences with Solvyns's original.[18] Although quite a few original watercolors from India by Solvyns were published in recent years, only very few pertain to Indian religious people in the same format.[19]

NOTES

1. Solvyns 1808–12, vol. I, p. 21; for the French text see ibid., p. 5.
2. Solvyns 1808–12, Tome II, 5e livraison (5th issue), planche I (pl. I), published 1810, labeled "Oudoubahous." The text introduces this engraving as "Oudoubahous et autres faquirs" and "Oodoobahoos and other faquirs." The man of the present watercolor is placed in the center of this engraving.
3. Heber 1828, vol. I, p. 281.
4. Mundy 1858, p. 28.
5. Parks 1975, vol. I, p. 64.
6. Butler 1872, p. 195
7. Solvyns's title derives from the Sanskrit term for this type of ascetic, *urdhvabahu*, which can be translated as "a person who holds the arm up" (urdhva = up, upwards; bahu = arm; this is a so-called Bahuvrihi compositum).
8. Cf. Mitter 1977, fig. 35; Hartsuiker 1993, illus. p. 19. For a Dutch variant, partly mirror-reversed but with Tavernier's descriptions and explanations, see the folded pl. facing p. 537 in Salmon 1731. The *urdhvabahu* is numbered "8" as in Tavernier's description, for which see the text. Curiously, but not surprisingly, the plate was omitted from the English editions, "being rudely drawn and of no great interest or importance." (Tavernier 1925, vol. II, p. 155). What in fact disturbed the editors was not that the illustration was "rudely drawn," which is not true in any case; the more disturbing factor is a scene "which shows a woman kissing the ascetic's penis." (Hartsuiker 1993, p. 18) This scene was excluded totally from the Dutch variant mentioned above, of which apparently the editors of the "Ball-" respectively "Crooke-edition" of Tavernier's text were not aware.
9. Tavernier 1925, vol. II, p. 157.
10. Hartsuiker 1993, p. 114 and the two col. photographs on p. 116.
11. Bruhn 1987, p. 60; Losty 1990, p. 33, text to col. pl. 4 and p. 70, text to fig. 36.
12. For a related incident, see Parks 1975, vol. I, p. 141f.
13. Cf. Okada/Isacco 1991, p. 74, left col. illus.
14. Hartsuiker 1993, p. 116.
15. It has been suggested that his Christian name should be "Frans" since he was born in Antwerp. "François" is the more generally used French rendering of this name.
16. For Solvyns's biography cf. *Bibliographie Nationale publiée par l'Académie Royale des Sciences, des Lettres et des Beaux-Arts de Belgique*, vol. 23, pp. 134–138: (Bruxelles: Etablissements Emile Bruylant).
17. For the history of Solvyns's publications, see Archer/Lightbown 1982, p. 68, pp. 83–84; Bruhn 1987, p. 60; Archer 1889, pp. 3–6; Bayly et al. 1990, no. 262, p. 211f.
18. Cf. Losty 1989, col. pl. p. 158, fig. 23, and ibid., p. 156, fig. 22; Archer 1992, p. 94, no. 67, col.
19. Cf. *Maggs Bros. Ltd, Catalogue 1092, Travel Books*, London 1989, cat. no. 89, illus. as col. frontispiece, *A Soonassey*, presumably a *sanyasi*, a kind of Hindu saint. For a related engraving of the 1799 edition, see Archer 1989, p. 4, fig. 3. For the same subject in the 1807 edition, published in London by W. Orme, see Bayly et al. 1990, p. 252, fig. 27. For a col. reproduction of an engraving of another religious person from the 1799 edition, see Okada/Isacco 1991, p. 74, right.

4 An Assembly of Ascetics and Yogins around a Fire

by Ghulam Ali Khan
or an artist of his circle,
Delhi region, ca. 1820–1825.

Media: Gouache and watercolor
on paper

Size: 11 x 15³/₈ in. (28 x 39 cm.)

Inscribed: In *Nashtaliq*, above
each figure, from left to right:
"Jagal Kishor Yogi" (the man
with the curved pipe), "Rasul
Shah Majzub" (the man in his
portable hut), "Awgahal Jogi
atop a mountain," "Shanbu
Nanha[?] Jogi" (smoking
the hookah), "Gokul Gosain"
(seated, with white beard),
"Badir Nath[?] Gosain Jogi"
(standing).

*Published: Archeologie, Arts
d'Orient,* 2 Juillet 1993, p. 61,
no. 185, col. pl.

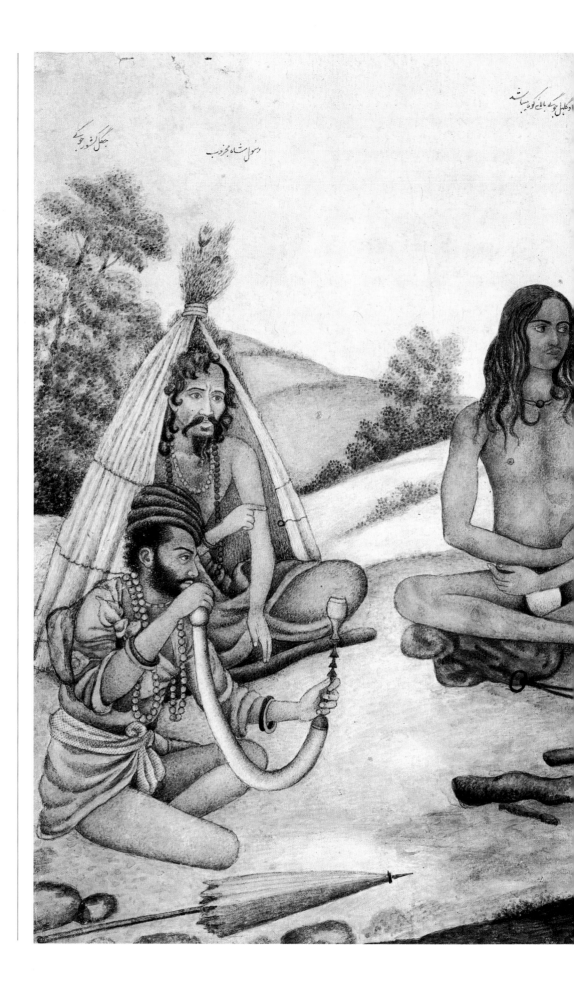

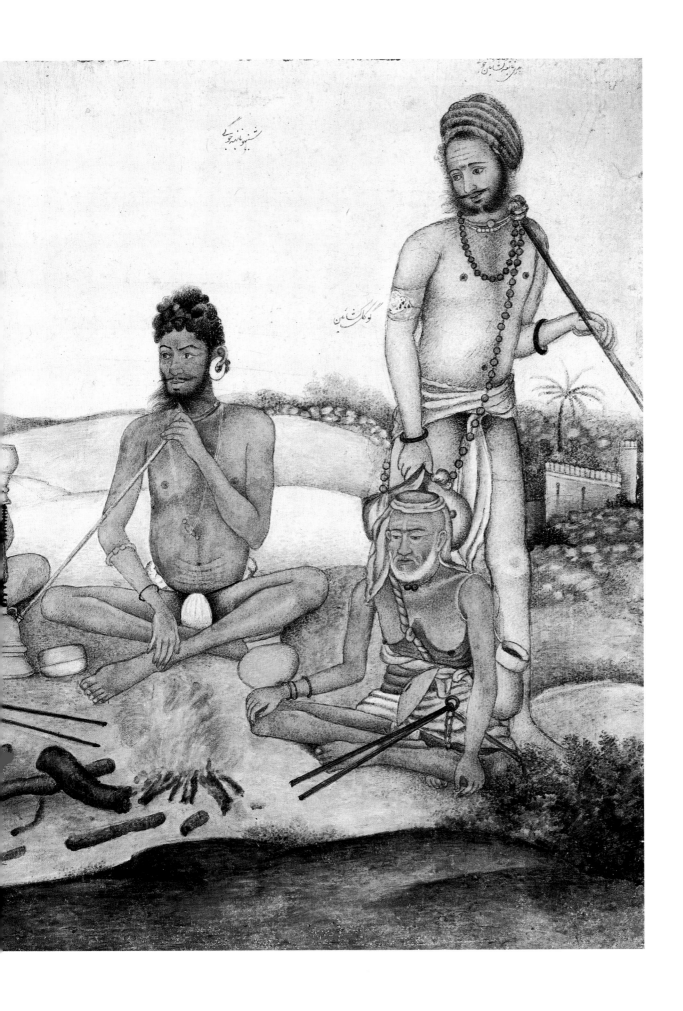

Amongst the crowd, the most remarkable objects were several Voiragee [bairagi, an ascetic] *mendicants; their bodies were covered with ashes, their hair clotted with mud and twisted round their heads; they were naked all but a shred of cloth.* (Fanny Parks, March 20, 1823)[1]

In a small hole in the earth lay a fakir, or religious mendicant; the fragment of a straw mat over him, and a bit of cloth covered his loins. He was very ill and quite helpless, the most worn emaciated being I ever beheld; he had lain in that hole day and night for five years, and refused to live in a village; his only comfort, a small fire of charcoal, was kindled near his head during the night. (Fanny Parks, January 15, 1824)[2]

This morning passed two faquirs or ascetics, who for forty years had denied themselves the gratification of lying down to sleep: their penance, which was a voluntary one, was to continue the whole night standing; of late years they admitted the luxury of a cross piece of wood tied to two upright ones, on which they leaned. One of the fanatics had been compelled to lie down an hour or two, owing to age and complete exhaustion. They possess both money and land; with the former they are building a handsome temple in the vicinity of their place of penance. (Major Archer near Delhi, November 17, 1828)[3]

They [the "fakeers"] *never wear any clothes, but powder themselves all over with white or yellow powder, and put red streaks over their faces. They look like the raw material of so many Grimaldis. . . ."* (Emily Eden, March 18, 1838)[4]

The Fakirs all go about almost naked, smear their bodies with cow-dung, not even excepting their face; and then strew ashes over themselves It is not easy to imagine anything more disgusting and repulsive than these priests. (Ida Pfeiffer, early January 1848)[5]

The artist who painted this picture has followed an age-old Indian tradition in depicting a group of *sanyasins, fakirs, bairagis, yogins,* or under whatever designation these six persons may be defined.[6] Three of the persons shown in this watercolor are also known from paintings in the "Fraser album." Rasul Shah Majzub is the second man from the left, and Gokul Gosain the second person from the right in one painting of that album.[7] The only standing person, the "Badir Nath[?] Gosain Jogi," appears as an individual study in the same album and is labeled there "Gulab Gosain[?] faqir. . .inhabitant of the top of the mountain of Nagarkot."[8] "Shanbu Nanha[?] Jogi" also exists as an individual study in the same position as shown here.[9] He is a *Kanphat yogi* recognizable by his earrings made of the horn of a rhinoceros. Very similar types of yogis are portrayed in an album done for Colonel James Skinner in 1825.[10] It is hence not possible to say with any amount of certainty, for whom the present picture was painted.

Ghulam Ali Khan had a brother named Faiz Ali Khan, who might have assisted him, and some think that he is one of the major "Fraser artists."[11] Ghulam Ali Khan and his colleagues worked not only for the Mughal emperor, William and James Fraser, or James Skinner. A "Delhi presentation album" is known, which was probably done for Charles Theophilus Metcalfe (1785–1846), Resident of Delhi.[12] The presence of this album thus increases the number of possible customers. In the absence of sufficient inscriptional evidence, it is not only difficult to decide for whom which painting was done, it is equally complicated to determine the identity of an artist, especially since it seems that the Indian artists could adjust their style according to the person for whom they worked. Ghulam Murtaza Khan is just another example of an artist from Delhi, who, like Ghulam Ali Khan, also worked for the Mughal court. His paintings, often showing members of the Mughal nobility, are rendered in — to Western eyes — a more decorative style with a predominant use of the full profile.[13] The same artist was also employed by Colonel James Skinner, who praised him as "the counterpart of Mani and Bihzad,"[14] and a painting in — apparently — Ghulam Murtaza Khan's "Indian style" is also part of the "Fraser album."[15]

Another Delhi artist who worked in Ghulam Murtaza Khan's "Indian style" was Khair Ullah, of whom also a number of portraits of the Mughal nobility survived.[16] Ghulam

Murtaza Khan as well as Khair Ullah both might have adapted their style to Western taste when working for one of the British Residents at Delhi. Besides, both artists were certainly known to Ghulam Ali Khan and it is therefore too early to decide on the exact authorship of the present painting, done in the more "Western" style by a Delhi artist. One of the characteristics of the "Western" style of the Delhi artists is the attempt to avoid the strict profile, with the effect that persons depicted never look at the artist. As in the present watercolor, they do not seem to communicate with each other: everybody looks in a different direction, and nobody looks at anybody present. This effect can doubtlessly be explained by the technique of such compositions. The artist probably never saw all these individuals assembled, as seen in this watercolor. He composed his painting from individual studies, as was done with most group-compositions during that time. The present picture is therefore a true Indian painting, and not only with regard to its subject, whoever commissioned it.

NOTES
1. Parks 1975, vol. I, p. 27.
2. Parks 1975, vol. I, pp. 38–39.
3. Archer 1833, vol. I, p. 379.
4. Eden 1937, p. 113.
5. Pfeiffer n.d., p. 172.
6. For similar assemblies of such individuals in earlier Mughal painting, cf. Binyon/Arnold 1921, Plate XXVIII, facing p. 58; Welch 1973, p. 105, col. pl., no. 63; Wilkinson 1948, pl. 10, col. Kühnel/Ettinghausen 1933, no. 46, to mention just a few.
7. Archer/Falk 1989, p. 102, no. 79.
8. Archer/Falk 1989, p. 101, no. 76 (= Sotheby's, October 22, 1993, p. 118, lot 224).
9. Bayly et al. 1990, p. 223, no. 283.
10. For this album, "Tashrih al-akvam," see Titley 1977, pp. 155–157, no. 372. For a reproduction of a comparable painting cf. Losty 1986, p. 71, no. 62, *Bhajan Das Vairagi*. The same person was painted for the Frasers, where, however, he is called "Lutchman Das" (Lakshman Das), cf. Archer/Falk 1989, p. 123, no. 118.
11. Archer 1982, under "The Plates" [p. 6].
12. Christie's, June 19, 1968, pp. 24–26, lot 57. Cf. also Christie's, July 7, 1976, pl. 18, lot 83.
13. For paintings ascribed to this artist by inscription, cf. Christie's, October 13, 1982, p. 35, lot 67; Christie's, November 25, 1985, p. 95, lot 164, col. pl. Falk/ Archer 1981, full-page illus. p. 431 (= Losty 1986, col. pl. p. 72, no. 63) and p. 430, top right (nos. 227i–ii); Leach 1995, full-page illus. p. 808, no. 8.55.
14. Archer/Archer 1955, p. 67.
15. Sotheby Parke Bernet N.Y., December 9, 1980, lot 139 (= Archer/Falk 1989, p. 117, no. 107 = Sotheby's, September 20 and 21, 1985, lot 368.)
16. Cf. Welch 1978, full-page illus. p. 103, no. 43; Christie's, July 7, 1977, pl. 19, lot 86 (= Christie's, November 22 and 23, 1984, p. 112, lot 197, to be compared with Sotheby's, May 2, 1977, lot 128, illus. facing p. 58); Leach 1995, vol. II, full-page illus. p. 786, no. 7.118; Archer 1992, col. pl. p. 163, no. 143.

5 Devotee with Large Turban

∾

possibly a follower of
Brahman Surdhaj Chaube
from Brindaban, by a "Fraser
Artist," Delhi, 1815–1820.

Media: Gouache on paper

Size: 3³/₄ x 3 in. (9.5 x 7.6 cm.)

In every part of Hindostan we meet with numbers of devotees, distinguished by various names, but not restricted to any cast. They become such from choice, and every Hindoo, except the Chandalah [outcaste], is at liberty to adopt this mode of life. Of all the numerous classes of devotees, none are so much respected as the Saniassies and Yogeys. They quit their relations, and every concern of life, and wander about in the country without any fixed abode. (Quentin Craufurd, as published in 1792)[1]

The tilak or forehead mark of this man with his enlightened expression consists of three white, horizontally applied, parallel lines with a white dot on the central line and a red dot below the lower line. These three lines, commonly known as tripundra, and the central dot are made of ashes, the red dot probably of vermilion, called sindura. This sectarial mark accounts for the devotee's belonging to a Shaivaite group of devotees.[2]

The same man appears mirror-reversed in a painting in the collection of the Victoria and Albert Museum, London,[3] where he belongs to a group of devotees, one of which is known from a number of paintings.[4] His portrait in the Fraser album identifies him as Surdhaj, a Brahman of the Chaube caste from Gokal [Gokul?] Brindaban," and the man holding the sunshade above him is "Ram Dani of the Bhopa caste, resident of Nandgaon Barsana."[5]

One of the artists working for William Fraser (cat. no. 18) employed the same type of small stones and plants to create a platform for the persons he portrayed against an otherwise uncolored background.[6] The name of this artist, however, remains obscure, and he together with his colleagues is hence referred to as a "Fraser artist," which, as the name suggests, is not just one person, but denotes at least three different artists who worked for James and William Fraser. The present, hitherto unpublished, watercolor is indeed a miniature in the sense of being small sized. The animated expression of the devotee's face marks a standard of portraiture which is rarely achieved by any of the "Fraser artists."

NOTES
1. Craufurd 1792, vol. I, p. 235.
2. Cf. Shah 1985, pl. I, fig. 12 and p. 2 for a similar *tilak.*
3. Archer 1992, col. pl. pp. 154–155, no. 134.
4. Welch 1973, p. 122, no. 72 (this being another version of the painting in the Victoria and Albert Museum, referred to above); Welch 1976, p. 55, no. 27; Kaye 1980, col. pl. p. 20.
5. Archer/Falk 1989, p. 110, no. 97 (= Sotheby's, July 7 and 8, 1980, p. 22, lot 45).
6. Cf. e.g. Archer/Falk 1989, p. 90, nos. 57, 62, 93.

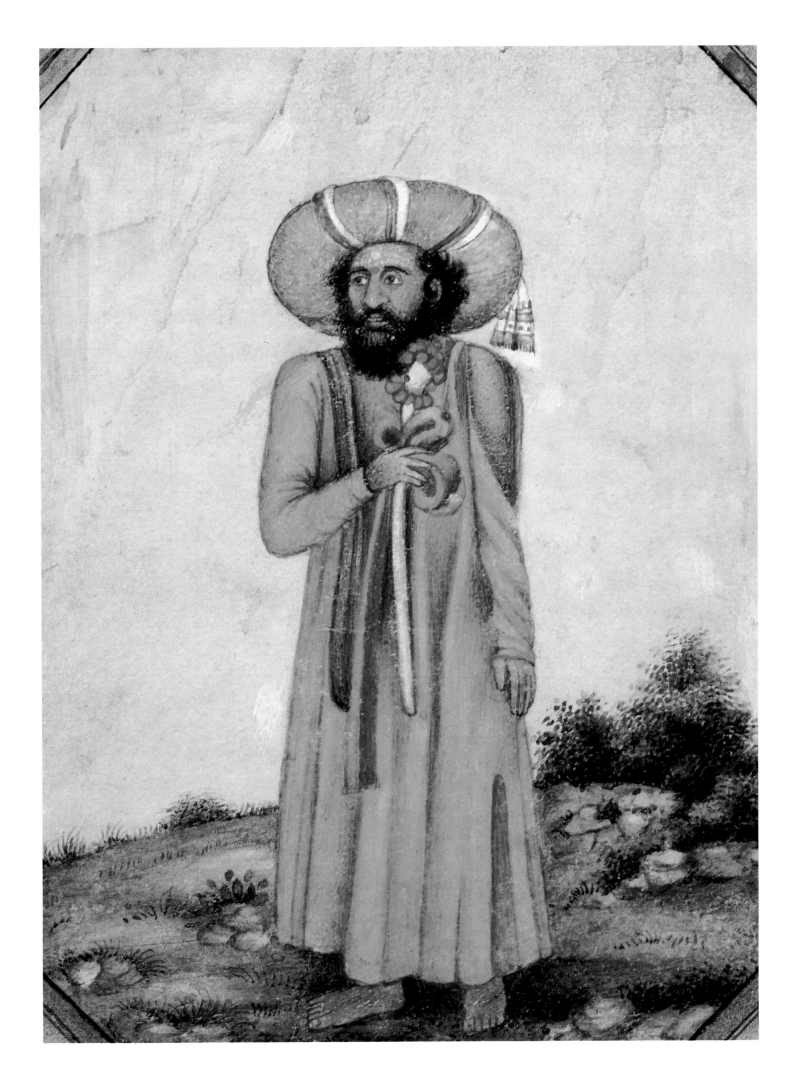

6 Bearded Man with Turban in Peshawar(?)

ᔆ

by Hugo Vilfred Pedersen (1870–1959), India, 1903–1910.

Media: Oil on canvas

Size: 28 ³/₁₆ x 20 ³/₄ in. (71.6 x 52.7 cm.)

Inscribed: Signed in lower right corner: "Hugo v.p."

The artist William Simpson conversed with an Indian "Jogi," around whose naked feet moved several rats. Simpson asked:

"Don't you see them?"
"Yes," was all he said.
"Why don't you kill them?"
"Why should I kill them?"
Here was the whole onus of the matter between us thrown on my own shoulders, and I felt how difficult it would be, with my limited knowledge of the language, to express to this man a European's ideas about rats. I thought to sum the whole case up in one sentence, "We people kill them." The sentence sounds much better in Hindostani, Hum log aisa karta hai. *To which he answered,* Hum log aisa nakin [sic, read: nahin] karta hai. *My sentence was literally, "We people do so"; his, "We people don't so." So far as there was any argument in either of these statements, I felt that the reply was quite as cogent as the words I had uttered, and that I was beaten by this ascetic, who sat there calm and cool … I always feel a twinkle of amusement when I look back to this conversation.* (William Simpson's autiobiography, as published in 1903)[1]

The person shown here is not the type of religious man who had "beaten" Simpson in the above quoted conversation, but he might have expressed the same opinion on the subject. Most Indians, especially religious-minded persons, always remained strangers to Western artists, and few Western artists were able to converse with them. This man is probably a Muslim, painted in or around the area of Peshawar, especially since a man in very similar dress with a striped kind of shawl wrapped around his shoulders is included in Simpson's view of a street in that city.[2]

Pedersen possibly painted this man in order to capture a certain picturesque "type" of Indian, just as he painted a *fakir* lying on nails which emerge from a board as large as a bed, as an example of one of these "types."[3] The man's behavior is unclear. Is he in a state of ecstasy? Does he laugh about something such as Simpson's conversation with an Indian saint, or is he a blind beggar asking for *bakshish*? This uncertainty is probably intended by the artist. Of all the known Indian subjects by Pedersen, this probably ranks among his most intense.

NOTES
1. Simpson 1903, p. 170.
2. Simpson 1867, vol. I, pl. 9, also reproduced in *The India Collection 1982*, p. 139. For photographs of rather similar characters, cf. Hürlimann 1928, pl. 274–280.
3. Cf. Gautier 1944, illus. p. 40 in addition to the illus. reproduced on pp. 51, 54, 56.

7 Tilakayat Govardhanlalji
(1862–1934), Head of Priests
in the Haveli of Shri Nathji
at Nathdwara, Rajasthan
∾

by Ghasiram Hardev Sharma
(1868–1930), Nathdhwara,
ca. 1915–1920.

Media: Gouache on paper

Size: 24³/₄ x 18³/₄ in.
(62.9 x 47.6 cm.)

Inscribed: "P. Ghasiram /
Nathdwara"

Tilakayat Govardhanlalji was a descendant of Vallabha, the godfather of a religious community known as "Vallabhacharyas," "Vallabhacharya Sampraday," or "Pushtimarg" ("the way of pleasure"). Vallabha was the son of a Tailangi Brahmana, Lakshman Bhatt, and his wife, Elemagara, from Kankarava in present-day Andhra Pradesh. He was born in 1479, and in 1492 he had a dream in which he saw Lord Krishna, who told him to go to the place where he (Krishna) spent his childhood. Vallabha went to that place (Vrindavan) and discovered a stone stele of about 4.5 ft. (1.37 m.) in height. This stele, called Shri Nathji, is still the major image of the Vallabhacharyas. Shri Nathji advised Vallabha to build a temple, which Vallabha did in 1520 at Mathura, after having married Maha Lakshmi, daughter of a *Brahmin* (priest).

One of Vallabha's successors, Tilakayat Damodarji, saved the image of Shri Nathji by transporting it on a bullock cart to Mewar via Kota and Kishangarh. The Mughal emperor Aurangzeb had threatened to destroy the more influential Hindu temples and on September 18, 1670, the cart with Shri Nathji left Mathura in a westerly direction. In the vicinity of a place called Sinhad, a wheel of the cart got stuck in the earth. This was interpreted as a signal of Lord Krishna himself, and on February 10, 1672 a new temple was erected at the place where a wheel of the cart was "swallowed by the earth." Ever since, that place has been called Nathdwara (Door to the Lord). [1]

As a direct descendant of Vallabha, whose wooden sandals are still worshipped in the sanctum of the Haveli of Shri Nathji, Govardhanlalji conducted numerous religious ceremonies (*pujas*) upon succeeding his father in 1877. He was certainly described by a number of writers; none of these descriptions, however, was published in any European language since no non-Hindu was allowed to enter the premises of Shri Nathji's *Haveli* until very recently. [2]

Several portraits of Govardhanlalji are known and published. Often he appears as head-and-shoulders set in an oval frame, at times with less than correct identification, such as "portrait of an Indian prince, Mughal, 18th century," [3] or "Portrait of a Rich Merchant." [4] He appears also in a full, standing portrait with his walking stick *(Portrait of a Prince of the Ruling House of Sindhia)*, [5] or simply seated on a European chair. [6] When not engaged in conducting religious ceremonies, Govardhanlal looks in fact like a prince, and it should be remembered that family-members of the Tilakayats were also called *maharajas*, as the entire movement was once called "Sect of Maharajas or Vallabhacharyas." [7] Quite often, Govardhanlalji is shown frontally, seated while engaged in prayer. [8] More often he appears in so-called *picchvais*, a kind of cloth painting which was to be hung behind a cult image of the Vallabhacharyas. [9]

Ghasiram Hardev Sharma was one of the most prolific artists of Nathdwara. His father, Hardev, was the chief painter or *mukhiya* of the temple of Shri Nathji. [10] After being engaged in painting murals for the Raja of Jhalawar, Ghasiram also advanced to the position of *mukhiya* of the painting department. Tilakayat Govardhanlalji was in fact Ghasiram's major patron. Ghasiram also turned to photography and, after a visit of Raja Ravi Varma (cf. cat. no. 9) to Udaipur, near Nathdwara (from March 16 to July 1, 1901) is said to have started to paint in oils. His portrait of the Rajput hero, Rana Pratap, 1925, in fact looks like a mirror-reversed version of Ravi Varma's painting of the same title. [11] Ghasiram's paintings are either in the more "romantic" style of Ravi Varma or they follow a photographic realism as shown in the present painting. By 1910 his pictures were printed in Germany. [12]

That the present painting was created during Ghasiram's later career might be indicated by the English signature, although it cannot be excluded that he might have simultaneously signed his paintings in either Hindi, viz. the *Nagari* script, or in English for quite some time. [13] No painting seems to be signed in both scripts. In the *Nagari*-inscriptions Ghasiram would style himself either *chitara* (painter) [14] or *musavir* (painter). [15] In pictures with English signatures he appears as "painter," [16] and we may presume that the "P." of the present inscription stands for the same word. In an almost identical picture in the P. Haubold

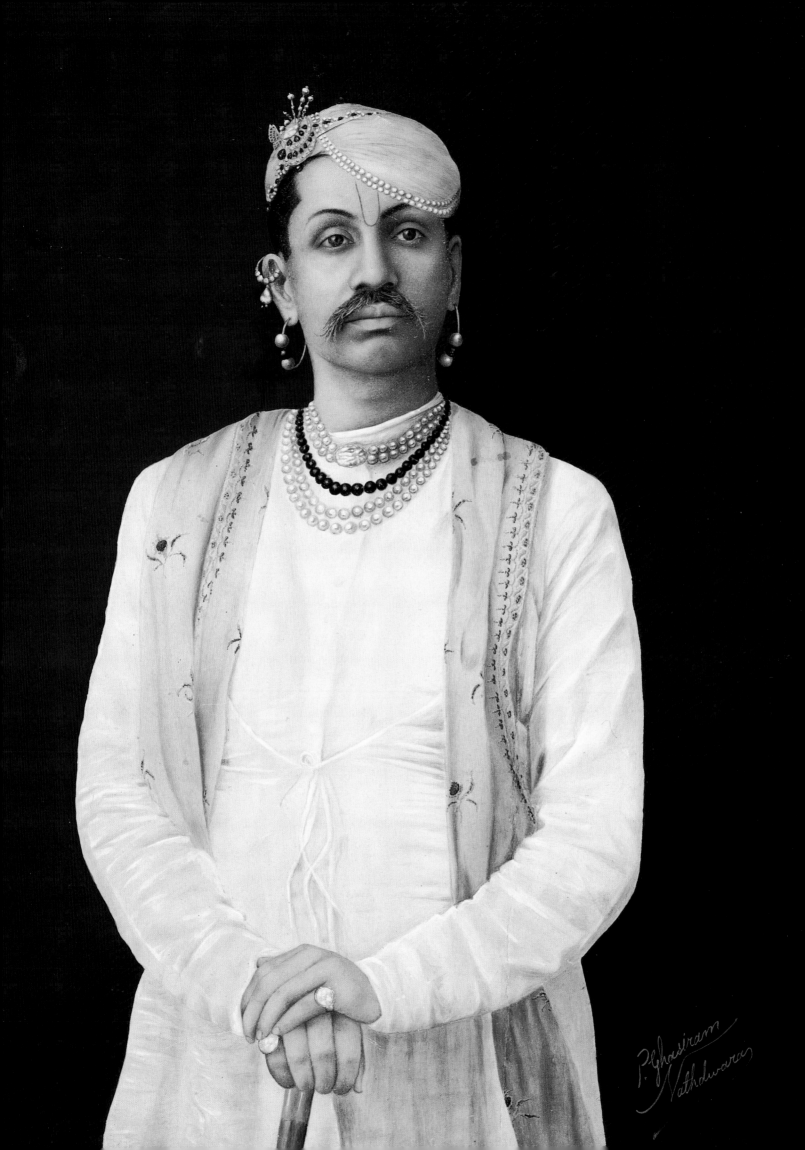

Collection, Germany, Ghasiram used the same abbreviation.[17] A few paintings are just signed "Ghasiram/Nathdwara."[18]

In some photo-realistic portraits of his patron, Ghasiram desisted from adding elements from photo-ateliers, such as the small table with the flower pot or the big round columns visible in the following cat. no. in addition to cat. nos. 31 and 32. In these portraits he may be said to have heralded the photo-realism which was to be current in the West only decades later.

NOTES

1. For a comprehensive and fully annotated survey of Vallabha's career, see Bautze 1995, pp. 170–180. For the religious sect see also Barz 1992.
2. For a description of the premises around the Haveli or temple of Shri Nathji and its festivals, see Jindel 1976.
3. *Art Islamique*, January 24, 1996, lot 6, col.
4. Christie's, October 10, 1989, p. 23, lot 22. For a similar, correctly identified head-and-shoulders of the said priest, see Ambalal 1987, full-page col. pl. p. 140.
5. Rousselet 1985, col. illus. on front cover (= Mason 1986, no. 51 as "Gwalior Artist, c. 1880").
6. *Art Islamique*, January 24, 1996, lot 114K, col., as "un personnage de la cour."
7. Karsandas Mulji 1865.
8. Ambalal 1987, p. 71, col. pl.; Bautze 1995, p. 180, col. pl. 163. For a related photograph, see Gutman 1982, illus. p. 54.
9. For illus. and an explanation of this term, see Krishna 1984, p. 134 and note 1, p. 140. For the use of these *pichhvais*, see particularly Skelton 1973, p. 25. For a *picchvai* showing Govardhanlalji as illuminating Shri Nathji with a lamp on the occasion of his (Govardhanlal's) birthday, see Ambalal 1987, full-page col. pl. p. 136.
10. Ambalal 1987, p. 85
11. Cf. Vashistha 1995, col. pl. 85 with Mitter 1994, p. 171, illus. 121.
12. Ambalal 1987, p. 88f.
13. Ambalal 1987, p. 89, suggesting that Ghasiram first signed in Hindi and later in English.
14. Cf. Bautze 1995, p. 180, col. illus. no. 163, signed *Chitara ghasiram hardev*, or Ambalal 1987, p. 90, top left illus., signed *Chitara ghasiram hardev shri nathdvara*.
15. Christie's N.Y., October 3, 1990, p. 53, lot 64: *musvavir* [sic, or *mukhavir?*] *ghasiram shri nathdvara*.
16. Gutman 1982, p. 46, below a head-and-shoulders showing Govardhanlalji in old age: "Painter Ghasiram Nathdwara," or Gutman 1982, p. 117, col. illus. top left showing his son Damodarlalji: "Painter Ghasiram Nathdwara."
17. Published: Bautze 1995, p. 180, col. illus. 164.
18. Ambalal 1987, p. 89, top.

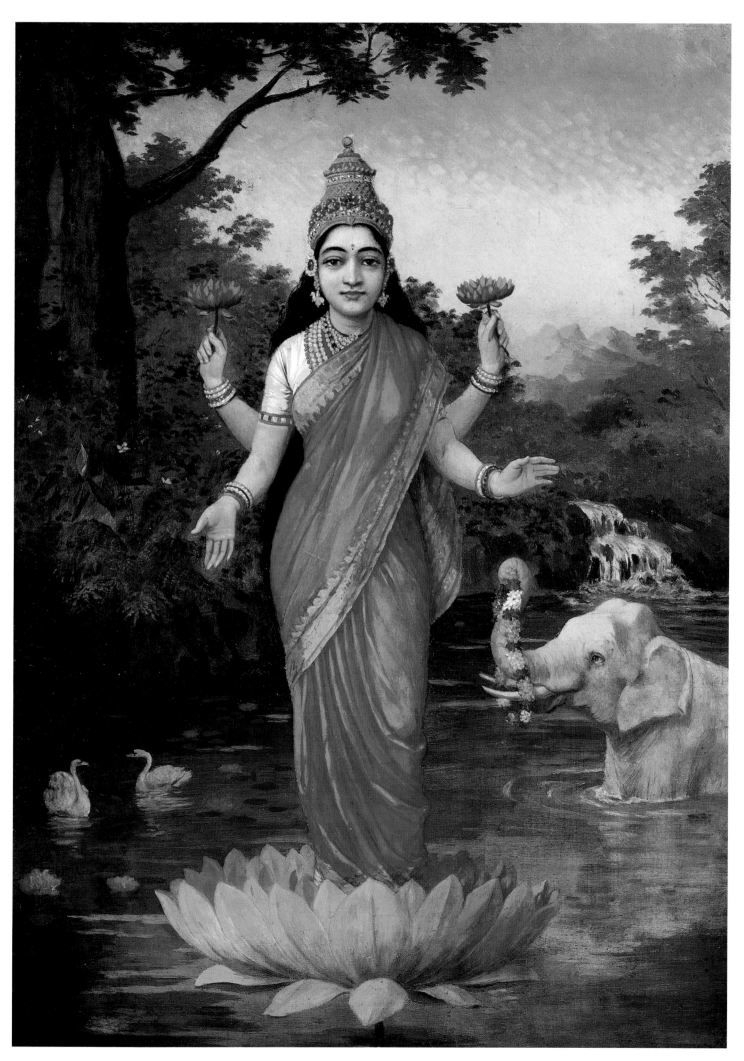

9 Goddess Lakshmi

~

by Raja Ravi Varma
(1848–1906), Trivandrum,
1880–1890.

Media: Oil on canvas

Size: 28 ³/₄ x 20 ¹/₂ in.
(73 x 52 cm.)

Provenance: Fritz Schleicher,
Lotti Singh, née Schleicher.

Published: Sotheby's, April 25,
1996, p. 113, lot 306.

Lakshmi is the oldest identifiable Indian goddess.[1] She is the goddess of wealth, fertility, good luck, prosperity, and beauty. The palm of her lower right hand is in the gesture of wish-bestowing (*varada mudra*). In pre-Christian times coins would shower from a small bag in that hand into the bowl of her worshipper.[2] Very soon, bag and coins were no longer represented,[3] as in this case. In the earlier periods of Indian art, when Lakshmi was still two-armed, she would hold at least one lotus, and at times one lotus in each hand, as shown here by her upper hands. The lower left hand displays the gesture of protection and blessing.

In the early period, Lakshmi may be depicted standing on a round jar or on a lotus. From the first century onwards, she exclusively appears on a lotus. The elephant waving a flower-garland with his trunk should actually pour water over Lakshmi from a bottle, or, since the first century B.C., from a globular earthen jar. Rajasthani paintings from the early nineteenth century show the goddess still thus anointed by a pair of elephants.[4] Here, the water which should be poured from the pot held by the elephant's trunk is represented by a cascade.

Ravi Varma's depiction of Lakshmi follows a tradition of some two millenia. It was to be recognized by everybody since it was to be sold as an oleograph. In 1893, Ravi Varma, a self-educated artist working in a Western academic style, established the Ravi Varma Oleographic and Chromolithographic Printing Workshop in Bombay. In this project he was helped by Fritz Schleicher from Berlin. The co-operation between Ravi Varma and Schleicher was so good that the former learned to speak German.[5] But when a plague broke out in Bombay in 1897, production came to a standstill. Two years later, the press started to print again at its new premises near Lonavla, a place situated near the famous *chaityagriha* of Karli. In 1901 the press came under the care of Schleicher himself and among the eighty-nine lithographic color prints were *Lakshmi* and another goddess, generally shown together with the latter, viz. *Sarasvati*.[6] The fact that many unauthorized prints were made during Ravi Varma's lifetime added to the belief that Ravi Varma was a producer of calendar prints rather than of artistic oleographs. Although Ravi Varma excelled as a portrait painter,[7] he became famous as an artist on mythological subjects through his oleographs.

Ravi Varma's oleographs are copied to this day, as a comparison of his oleograph of the Sarasvati with modern prints shows.[8] Oleographs as such were so much in vogue that at the beginning of the twentieth century a traveller observed such prints showing King Albert of Saxony next to an oriental beauty, while describing the dining-room of a hotel in Jaipur, Rajasthan.[9] A. K. Coomaraswamy, in his famous *Rajput Painting*, remarked that "in Hindu shops and houses you will find, not the portraits of the great Mughals, but mythological pictures that are either crude survivals of Rajput tradition, or German oleographs after genuine earlier drawings. I need not refer to the pseudo-Indian art of Ravi Varma."[10]

Although Ravi Varma was the first Indian artist to revive the tradition of Indian mythological paintings very successfully, the renowned Ceylonese art-historian A. K. Coomaraswamy was not appreciative of his style, as his foregoing remark shows.[11] One of Abanindranath Tagore's most famous paintings, the *Bharat Mata* (Mother India)[12] which was mounted on a flag and hoisted as a banner on August 7, 1905 by the *Swadeshi* (lit. own country, independence) leaders[13] would not have been possible without Ravi Varma's present oil painting. And although one of Ravi Varma's subjects from literature, Kalidasa's "Shakuntala Patralikhan" (Shakuntala writing a letter) circulated as a brown oblong postal stamp issued by the "India Postage" along with a quotation from Kalidasa's drama in *Nagari* script printed by the "India Security Press,"[14] Ravi Varma's paintings were almost forgotten outside India. This accounts for the neglected state in which some of his oil-paintings were found.[15] And although Ravi Varma's style is rather Western-academic, its glowing bright colors make it "Indian." Ravi Varma's mythological subjects owe as much to Rajput painting as the products of the new Bengali school of painting owe, according to A. K. Coomaraswamy, to Mughal paintings.[16]

middle age, Damodarlal fell in love with a singer, Hansa, whom he later renamed Ratnaprabha, radiance of jewels. Damodarlal left Nathdvara to join Hansa in Nainital. All efforts to separate the pair proved futile, although Govardhanlalji was able to persuade his son to return to Nathdvara for a while, in September 1932. There was great public resentment, however, when it became known that Hansa too was a member of the party which had returned from Nainital. The ensuing uproar caused Hansa's departure after three days. Damodarlal followed her later, leaving Nathdvara in December 1932 with his wife, son, and daughters. The family travelled to Simla, where Damodarlal rejoined Hansa. Govardhanlalji journeyed to Simla to remonstrate with him but his efforts to find a solution failed. Worn out by his exertions and deeply distressed by his son's behaviour, the aged Tilakayat breathed his last in Simla on September 21, 1934. Two years later, in 1936, in Shravana, a monsoon month, Damodarlal too died at Udaipur.[3]

The identification of the present painting is based on Damodarlalji's published head-and-shoulders by Ghasiram Hardev Sharma.[4] The artist, Nathulal Gordhan (probably an abbreviation of "Govardhan"), seems not to be recorded. His style pertains more to the then current mainstream of Nathdwara painting, as can be seen from the added flowerpots and the two pillars that frame the *tilakayat*'s son.

NOTES
1. Ambalal 1987, p. 72.
2. Cf. Bautze 1995, p. 179, col. illus. 162; Talwar/Krishna 1979, pl. 7B; Christie's, December 9, 1974, lot 117, pl. 20.
3. Ambalal 1987, p. 73.
4. Gutman 1982, p. 117, col. illus. top left. Gutman's understanding of the inscription is erroneous. The person shown is not Damodarlalji's son, whose name was Govindlal, but Damodarlalji himself. The *Nagari*-inscription identifies the portrait clearly as Damodarlalji, son of the first *goswami*, etc. of Nathdwara.

8 Damodarlalji of Nathdwara
(1897–1936)
∾

by Nathulal Gordhan,
Nathdwara, ca. 1925–1930.

Media: Gouache on paper

Size: 23³/₄ x 18¹/₄ in.
(60.3 x 46.3 cm.)

Inscribed: In *Nagari*, below the
black rule, bottom: *chitara nathu
lal gordhan* (painter: Nathulal
Gordhan).

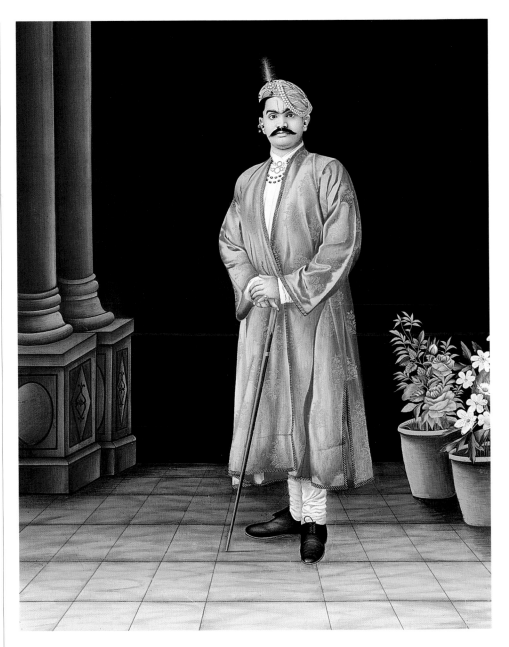

Damodarlal was the son of Govardhanlalji, the *tilakayat* or chief priest of the temple of Shri
Nathji in Nathdwara, as described in the preceding cat. no. 7. Govardhanlal had great regard
for his son in respect to the upkeep of the Shri Nathji temple and its old traditions.
Damodarlalji in fact introduced certain innovations in conducting the necessary religious
ceremonies and in the design of the *picchvais*. Besides, he

*was a spirited young man with a great interest in sports. His cricket team defeated the famous Jamnagar team
and his proficiency in wrestling, tennis, billiards and chess were well known. He was a good swimmer and
could swim the huge Raisagar Lake with ease. Equally adept in scholarly pursuits, his discourses on the
Subodhini, Vallabhacharya's commentary on part of the Shrimad Bhagavata, attracted large audiences.*[1]

He was so much respected that he was considered an incarnation of Vitthalnathji, who was
Vallabha's second son, born in 1516. It was Vitthalnathji who was asked to continue the
religious tradition founded by Vallabha, not the latter's elder son, Gopinath, who was born
in 1511. In many *picchvais*, some of which were possibly painted by Ghasiram, Govardhanlalji
and his son Damodarlalji are depicted together while conducting the holy service to Lord
Shri Nathji.[2] Their relationship seemed sound; in fact:

*Govardhanlalji had great hope of Damodarlal who, it was felt, would add luster to the sect. But fate decreed
otherwise and the last years of Govardhanlalji's life were deeply unhappy on account of him. In 1932, in early*

NOTES

1. For details on her origin and iconography, cf. e.g. Sahai 1975, pp. 157–179; Banerjea 1956, p. 193ff.; Mallmann 1963, pp. 183–189; Mani 1975, pp. 449–450.
2. Bautze 1995b, pl. XIII.
3. Bautze 1995b, pl. XII and XIV.
4. For examples from Bundi cf. *Maggs Bull.*, no. 18, 1971, no. 197; Lewis 1986, no. 7, to mention just a few.
5. Cf. Sharma (ed.) 1993, p. 132.
6. Cf. Sharma (ed.) 1993, p. 137.
7. Cf. Kapur 1995.
8. Compare Sharma (ed.) 1993, p. 78, *Saraswati* with Joshi 1994, col. pl. p. 239, print 1 or Vitsaxis 1977, p. 78, col. pl. 37.
9. Hesse-Wartegg 1906, p. 285.
10. Coomaraswamy 1976, p. 6. The first edition was published in 1916. In a footnote to that passage Coomaraswamy states: "It is pathetic to reflect that German tradesmen were the first 'discoverers' of Rajput painting." Were Coomaraswamy still alive he would probably be surprised to find that Ravi Varma's oil paintings at today's auctions fetch higher prices than many "Rajput paintings."
11. Cf. also A. K. Coomaraswamy's remarks in the following cat. no. 88 .
12. Reproduced: Guha-Thakurta 1992, frontispiece; Mitter 1994, frontispiece, and col. pl. XXI; Ray 1990, p. 161, col. illus. 1. See also fig. 7 in Partha Mitter's essay in this volume.
13. Chandra 1951, p. 23.
14. For the oleograph see Mitter 1994, p. 259; Sharma (ed.) 1993, p. 147, col.
15. Cf. the rather creased and flaked portrait of a woman when sold in 1978 (Christie's, July 6, 1978, pl. 7, lot 58) and its present state as part of the collection of the Victoria and Albert Museum, London (Guy/Swallow 1990, p. 226, col. illus. 201; Bayly et al. 1990, p. 363, fig. 58, col.).
16. "The new Bengali school of painting, insofar as it is a revival, is based more on Mughal than on Rajput inspiration." Coomaraswamy 1976, p. 5, footnote 5.

NAWABS,
CAPTAINS,
RAJAS,
VICEROYS,
AND OTHER
GENTLEMEN

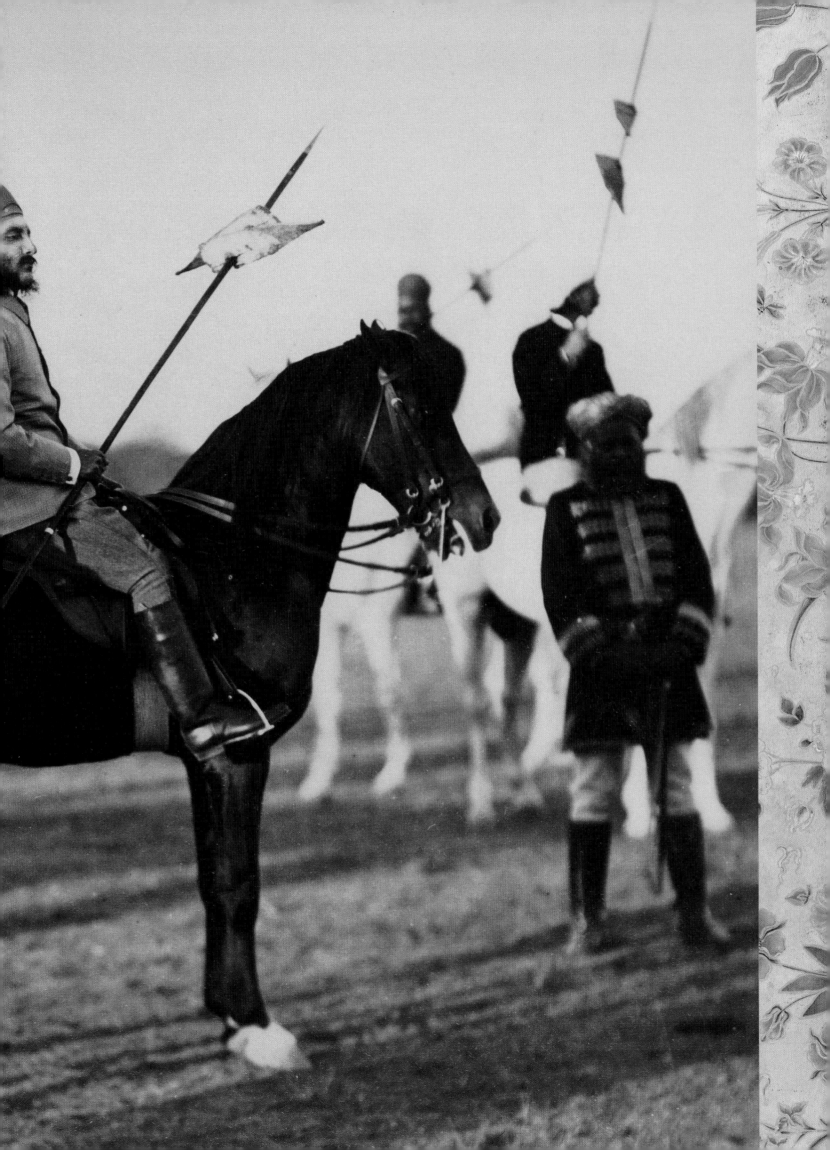

10 A Medallion Portrait
of Muhammad 'Adil Shah
of Bijapur (1627–1656)
ᔋ

copy of an Indian original by a
Deccani artist, by Rembrandt
Harmensz van Rijn (1606–1669),
Amsterdam, 1654–1656.

Media: Pen and brown ink, brown
wash, on Japan paper

Size: 3¹³/₁₆ x 3 in. (9.7 x 7.6 cm.)

Inscribed: On mount, in brown ink:
"Rembrandt." The sign and the seal-
impression on the actual drawing is
explained by a French inscription
in a nineteenth-century hand on
a piece of paper pasted on the back
of the frame:

Dessin original de Rembrandt
portant les marques de: 1er
Richardson, Peintre anglais mort
en 1745 2e Joshua Reynolds, Peintre
anglais né en 1723, mort en 1792.
 Ces marques sont authentiques.

La vente publique des dessins
de Richardson eut lieu en 1747
et produisit 2060 liv.st. Celle
de Reynolds eut lieu en mars 1798
et produisit 1908 liv.st.

L'album des reproductions de 200
dessins de Rembrandt [4 vols.
in-folio] donne les marques suivantes
aux numéros ci-après indiqués:

marque de Richardson	marque de Reynolds
116	23
166	90
174	104A
186	148B
	183

En outre, les dessins 116 et 159 se
rapportent à des personnages persans.

Provenance: Jonathan Richardson;
Sir Joshua Reynolds; Anonymous
French Collection; Private
Collection, New York.

Muhammad 'Adil Shah was the third son of his predecessor, Ibrahim 'Adil Shah II, who died on September 12, 1627. When Muhammad 'Adil Shah ascended to the throne in the same year, he was only fifteen years of age. He died in his forty-seventh year, on November 6, 1656, and was buried in the mausoleum which he had built for himself.[1] This tomb is known as the Gol Gumbaz and carries one of the largest cupolas in the world.[2]

Of Muhammad 'Adil Shah's numerous individual portraits,[3] only those showing him in an oval frame are considered here. The medallion shape was quite common in India by this time, and was not introduced by Rembrandt with this drawing. One of these head and shoulders in an oval frame shows Muhammad 'Adil Shah facing right. The painting is attributed to one of the most important court artists during Muhammad 'Adil Shah's reign, Muhammad Khan. Muhammad 'Adil Shah has almost a full beard and both his hands are visible.[4] A second, similarly framed head and shoulders shows him facing left, with only his left hand visible, but with more beard than in the painting which Rembrandt copied.[5] A third small painting for comparison comes closest to what Rembrandt must have seen. It is in the Institute of Oriental Studies, St. Petersburg and shows unmistakably the same man facing left, and without his hands, in an oval frame.[6]

The present work is not Rembrandt's only drawing of Muhammad 'Adil Shah of Bijapur. In the nineteenth century it was thought that Rembrandt copied Persian paintings, as the French collector noted on the back of the frame of this study. It was only in 1904 that

Friedrich Sarre published an article in which he proved that a certain number of Rembrandt's drawings were made after Indian, and not Persian miniatures. Rembrandt's study of the standing Muhammad 'Adil Shah of Bijapur was hence correctly identified as showing an "Inder" (Indian),[7] who compares well to several Deccani portraits of this ruler.[8] The majority of the other Rembrandt drawings after Indian paintings consists of studies of Mughal emperors, their sons, and officers, in addition to a few Mughal paintings of other subjects.[9]

Rembrandt's copies of Indian miniatures are, in a strict sense, not copies but transformations of Indian art into Western art, as is shown by the "intimation of the artist's chiaroscuro style which does not exist in the original."[10] Rembrandt "copied" Indian paintings for the same reasons Jahangir asked his artists to "copy" European pictures. Both Jahangir and Rembrandt understood the art of "the other" and appreciated it more easily by having it translated into their own "rules of art."

In 1642 Rembrandt painted Abraham Wilmerdonks, director of the Dutch V.O.C. (East India Company). It is possible that this contact brought Indian paintings to the attention of Rembrandt, who studied them for the seeming authenticity of their biblical scenes. Rembrandt's Indian drawings are mostly dated between 1654 and 1656; this was the period during which the influence of Indian paintings on his work was most apparent.[11] In the 1656 inventory of Rembrandt's possessions, the following description was found: "An album of curious miniature drawings as well as various wood and copper prints of all sorts of costumes." This album might have contained the miniatures which Rembrandt copied.[12]

Apparently twenty-one Rembrandt drawings after Indian paintings are known at the moment.[13] Since the Jonathan Richardson sale quoted on the back of the frame mentions "a book of Indian Drawings, 25 in number," it seems that Rembrandt owned at least four more such drawings which are as yet unrecorded.[14] Sarre closes his article on the "Indian" Rembrandt studies with the remark: "To those who struggle to secure for the little known and modestly valued art of the Islamic orient its rightful place in art history, it provides a certain satisfaction that one of the greatest masters did not abstain from the artistic expressions of the East, and that the Indian paintings copied by Rembrandt influenced his depiction of biblical stories to a high degree. . . ."[15]

NOTES
1. For the life of Sultan Muhammad 'Adil Shah cf. Nazim 1936, pp. 12–14; Cousens 1916, pp. 14–16.
2. For this world-famous structure, see Cousens 1916, pp. 98–106, pls. LXXXV–XCV; Nazim 1936, p. 42, inscription no. 495, pl. IV.
3. For a survey of painting under Sultan Muhammad 'Adil Shah, see Zebrowski 1983, pp. 122–138; Zebrowski 1986, p. 94.
4. Falk/Archer 1981, no. 406, reproduced on p. 502 (= Losty 1986, no. 44, full-page pl. p. 50).
5. Falk/Archer 1981, no. 407, reproduced on p. 502.
6. Grek 1971, no. 62.
7. Sarre 1904, p. 155. Also in Benesch 1973, p. 323, no. 1200 (fig. 1500), but without proper identification.
8. Cf. Sotheby's, April 7, 1975, lot 109, full-page illus. facing p. 62 (=Zebrowski 1983, p. 124, no. 92 = Zebrowski 1986, p. 102, no. 11, col.); Zebrowski 1983, p. 126, no. 94.
9. For a compilation see Benesch 1973, nos. 1187–1206.
10. Ettinghausen 1961, p. 6.
11. Cf. Benesch 1973, p. 319; Sarre 1904, p. 158; Schatborn 1985, p. 130.
12. Cf. Schatborn 1985, p. 130.
13. Cf. Goldner 1988, p. 270.
14. Goldner 1988, p. 270.
15. Sarre 1904, p. 158.

Pages 72–73. Fateh Maidan Sports—H. H. the Nizam Tent Pegging. *Nawab Sir Mahbub Ali Khan of Hyderabad (1884–1911) photographed during the visit of H. I. and R. H. the Archduke Franz Ferdinand of Austria Este in January 1893. Photograph by Lala Deen Dayal, State Photographer to the Nizam.*

**11 Asaf ud Daula,
Nawab-Wazir of Oudh**
(r. 1775–1798)

❧

by Gobindram Chatera,
Jaipur, ca. 1830, after an
original of 1784 by John
(Johann) Zoffany, R.A.
(1733–1810).

Media: Gouache on paper

Size: 22⁷/₈ x 15 in.
(58.1 x 38.1 cm.)

Inscribed: In *Nagari*, above the
lower border on the dress of
the ruler: *sabi banaii gobindram
catera* (portrait by Gobindram,
the painter). And on the back,
in Nagari: *jasalmar sharapha[?]
ki* (nobility from Jaisalmer).

No published document by the artist which describes the circumstances of the present portrait has survived. Asaf ud Daula's character might be guessed from the following description dated March 1, 1795:

Asuf-ud-Dowlah is mild in manners, generous to extravagance, and engaging in his conduct; but he has no great mental powers, though his heart is good, considering the education he has received, which instilled the most despotic ideas; he is fond of lavishing his treasures on gardens, palaces, horses, elephants, and above all, on fine European guns, lustres, mirrors, and all sorts of European manufactures, more especially English; from a two-penny deal board painting of ducks and drakes, to the elegant paintings of a Lorraine or a Zophani; … He has about 100 gardens, 20 palaces, 1200 elephants, 300 fine saddle horses, 1500 elegant double-barrel guns, 1700 superb lustres, and 30,000 shades of various kinds and colours! 'Asuf-ud-Dowlah is absurdly extravagant and ridiculously curious; he has no taste and less judgement. I have seen him more amused with a titotum than with electrical experiments; but he is nevertheless extremely solicitous to possess all that is elegant and rare; he has every instrument and every machine, of every art and science; but he knows none. His Haram is grand, and contains above 500 of the greatest beauties of Hindustan, who are immured in high walls, never to leave it except on their biers. He has large carriages drawn by one or two elephants, in which he may give a dinner to 10 or 12 persons at their ease; … Such is old Asuf-ud-Dowlah, as he is generally called, though he is now only 47; a curious compound of extravagance, avarice, candour, cunning, levity, cruelty, childishness, affability, brutish sensuality, good humour, vanity, and imbecility; in his public appearance and conduct he is admirably agreeable…. (Lewis Ferdinand Smith)[1]

Asaf ud Daula succeeded Shuja ud Daula (1731–1775), of whom a near contemporary description exists,[2] along with numerous individual portraits done by his artists mostly after paintings by the English painter Tilly Kettle.[3] In early 1772, Tilly Kettle arrived at Faizabad, then the capital of Oudh before it was shifted to Lucknow in 1775. Asaf ud Daula's first individual portrait by an Indian artist is based on a full-length, standing, life-size portrait of the then Nawab Shuja-ud-Daula with his son Asaf ud Daula done by Tilly Kettle and now in the Musée de Versailles.[4]

This painting was incorporated into several versions, as will be shown below. Jean Baptiste Gentil (1726–1799), then in the position of an aide-de-camp to Nawab Shuja ud Daula, had this painting copied by Indian court artists of the Nawab, in order to take a likeness of the ruler back to France. When, however, the copy was shown to the Nawab, he kept it and enjoyed it more than the original by Kettle, which Gentil managed to obtain.[5] This incident strongly reminds us of the Mughal emperor's reaction to a portrait of him presented by an Indian artist, Jivan Ram, who worked in a European technique (see cat. no. 19). Gentil initially ordered four of Kettle's paintings to be copied by the (Indian) court artists, but he only got two because immediately after Shuja ud Daula's death the British forced him to leave Oudh.[6] One of the two shows the Nawab Shuja ud Daula with seven sons, including Asaf ud Daula, and Gentil reported that it was presented to the French king in 1778.[7] The Musée du Louvre in fact owns such a painting, which entered the museum in the eighteenth century; it is inscribed on an attached leaf of paper in French. The beginning of the inscription can be translated as: "Portrait of Soudjaat Daula, grand Wazir of the Mughal emperor, surrounded by his family. When he died at the age of 45 at Faisabad on January 6, 1775, this prince left 52 children. Names of those portrayed here: Mirza Mani, who succeeded him…"[8] Mirza Mani is the name under which Asaf ud Daula was known before he succeeded his father. This Indian painting in the Louvre, however, shows the Nawab surrounded by ten sons.[9] The central group of this painting with Nawab Shuja ud Daula and his son Mirza Mani is based on the painting in the Musée de Versailles, mentioned above. The same central group re-appears in another version, showing the Nawab with ten sons in a painting of another Polier album, kept in the Museum für Islamische Kunst Berlin.[10] A third version with the same central group (the Nawab with ten sons) is known. It is an aquatint engraving by R. Renault after another Indian original based on Kettle's painting. It was published in London in May 1796.[11] Also a fourth version exists, with Shuja ud Daula and Asaf ud Daula in the center. It is a slightly later Indian copy which includes a self-portrait of the artist of the "arch version," Tilly Kettle.[12]

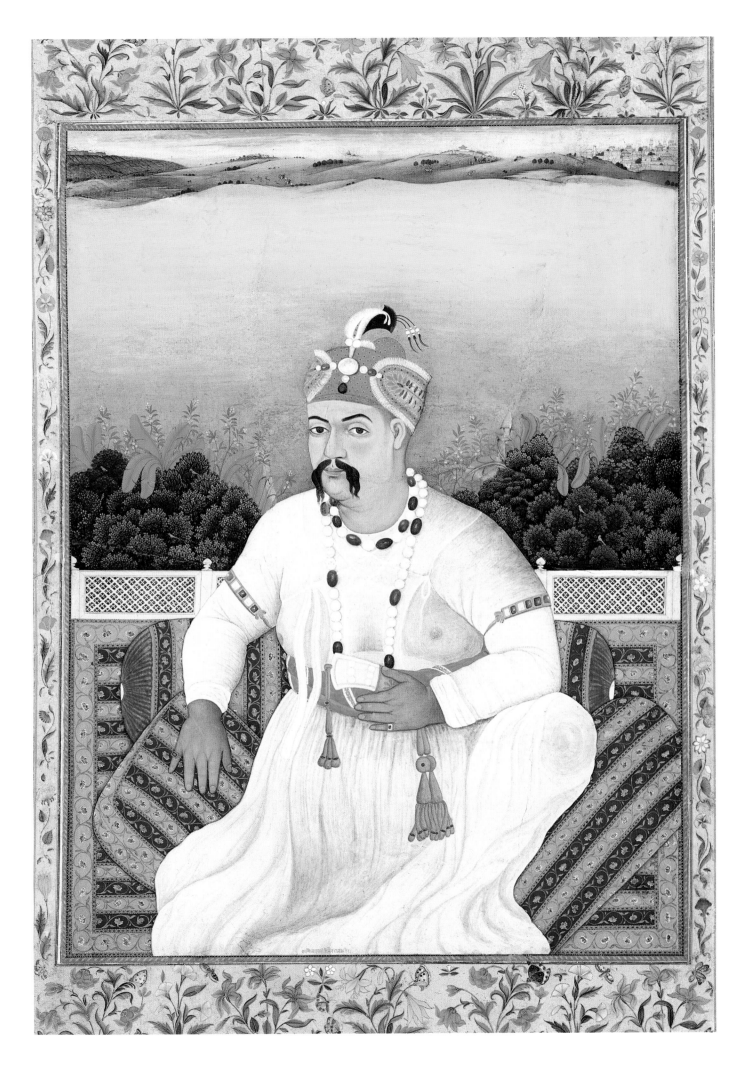

Asaf ud Daula's second known individual portrait by Indian artists is also related to a painting by Tilly Kettle. Kettle's painting from about 1784 illustrates an event of 1776. It shows the seated Nathaniel Middleton together with Nawab Asaf ud Daula, also seated, and the two ministers, Haidar Beg Khan and Hasan Reza Khan, both standing.[13] Although these portraits were finished by Kettle after his return to England in 1784, he must have worked on them while still in Lucknow, since all published versions are contemporary Lucknow paintings and closely relate to Asaf ud Daula's portrait as included therein.

So far, three different Indian versions are known.[14] What was published as another possible portrait of Asaf ud Daula, in this case after a painting by John Zoffany, appears to be doubtful with regard to its identification.[15] The present painting is the third individual portrait of Asaf ud Daula by an Indian artist and is in fact related to a portrait by John Zoffany. It is based on a portrait which Zoffany painted "at Lucknow, A.D. 1784, by order of His Highness the Nabob Vizier Asoph Ul Dowlah. . . ."[16] This oil-painting is known from several reproductions, only one of which, however, is colored.[17] From what has been explained here about the first two individual portraits, one would be inclined to think that the present painting is also the product of one of the many Faizabad-Lucknow artists of the period. But this is not the case and this is what makes this cat. no. so special. All Lucknow paintings, with regard to their authorship, bear inscriptions in the *Nashtaliq* script, which was used by the majority of the Urdu-speaking Muslims. The present painting is inscribed in *Nagari*, which betrays a Hindu origin. The way the inscription is written, neat and small, close to the lower edge of the actual painting, is strongly reminiscent of Jaipur portraits from the last third of the eighteenth and the first third of the nineteenth century.[18]

The present painting can be compared to another work by the same artist, Gobindram. It is dated 1834 A.D. and shows Maharaja Jai Singh III with his minister, probably Jhota Ram.[19] Jai Singh III was then about fifteen years of age.[20] It is not clear whether the painter Gobindram is the same as the painter Gobind, who worked for Sawai Jagat Singh, father and predecessor of Sawai Jai Singh III. Paintings with Gobind's name are similarly neatly inscribed.[21] Gobindram had, in any case, no access to Zoffany's original painting. That Gobindram cannot but have copied a Lucknow version of Zoffany's painting is shown by the flowers in the borders of the picture. They are partly an adoption of Mughal paintings from the reign of Shah Jahan (cf. cat. no. 1) and partly an adoption of a particular type of Lucknow border illustration (cf. cat. no. 63). The rulers of Amer/Jaipur had always been great collectors of Mughal paintings. It is hence not surprising that they also had a liking for paintings from Oudh. The artist had probably no idea whom he was copying, otherwise the inscription would have mentioned the name of the sitter, which is given in all other cases, even when the artist's name is not mentioned at all. The Nagari inscription on the back seems to identify the Nawab with somebody from Jaisalmer, a city in the Western desert of Rajasthan. When Gobindram copied that portrait of Nawab Asaf ud Daula, it was a period of strong anti-British feelings in Jaipur, which culminated in the attempted murder of the British Resident and the lynching of Blake, who rescued the Resident, on June 4, 1835.[22]

NOTES

1. Archer 1979, p. 144.
2. Dow 1792, vol. II, p. 419f.
3. I. Head and shoulders: 1) Ashmolean Museum, Oxford (Topsfield 1993, figs. 1–2 = Murphy 1987, p. 62, no. 30, col. = Sotheby & Co., November 27, 1974, lot 757, pl. 21); 2)present whereabouts unknown (Christie's, June 16, 1987, lot 137, p. 81); 3) Museum für Islamische Kunst Berlin, I 4594, folio 38 [Polier Album dated 1776]. Another one is said to be in the British Museum, cf. Archer 1979, p. 81. For an engraving related to these, see Gentil 1822, illus. facing p. 261.

 II. Full-length standing: 1) Bodleian Library, Oxford (Stchoukine 1929a, Planche LXVIIIb); 2) British Library India, Office Library and Records (Archer/Archer 1955, pl. 14, fig. 30 = Sharar 1975, pl. 1); 3) Binney Collection, San Diego Museum of Art (Binney 1973, cat. no. 101, p. 125); 4) Chester Beatty Library, Dublin (Leach 1995, vol. II, p. 699, no. 6.343).

 III. Full-length with retainers: Version A: Museum für Islamische Kunst Berlin, I 4594, folio 18 [Polier Album dated 1776]; B: Achenbach Foundation for Graphic Arts, San Francisco (Johnson/Breuer/Goldyne 1996, no. 227, col. pl. p. 175 = Welch 1978, p. 86, no. 35); C: Swallow 1990, col. illus. p. 181, no. 153 = Archer 1979, Victoria and Albert Museum, London (Archer 1992, col. pl. p. 116, no. 88 = Guy p. 81, fig. 32 = Archer/Archer 1955, pl. 14, fig. 29) D: present whereabouts unknown (Sotheby's, October 10, 1988, lot 31, col. pl. I); E: said to be in the British Museum, cf. Archer 1979, p. 81. For the actual painting by Tilly Kettle, which probably served as model for these versions, see Archer 1979, p. 78, no. 30 (= Bayly et al. 1990, p. 80, no. 77, col.).
4. Christie's, June 16, 1987, lot 136, p. 80. For Kettle's picture see Archer 1979, no. 29, full-page pl. p. 77.
5. This incident is related by Gentil himself, see Gentil 1822, pp. 310–312.
6. Gentil 1822, p. 312.
7. Gentil 1822, p. 310.
8. Stchoukine 1929b, cat. no. 116, p. 73f.
9. For a reproduction of this painting see Welch 1963, pl. 87 (= Archer 1979, p. 82, no. 34). Stchoukine 1929b, p. 73 wrote: "nine sons and a courtier."
10. Museum für Islamische Kunst Berlin, I 4596, folio 18. Reproduced: Hickmann 1975, fig. 85 (= Archer 1979, p. 81, fig. 33).
11. *Journal of Indian Art and Industry*, vol. XII, no. 107, July 1909, pl. 164 (= Archer 1979, p. 82, no. 35 = Head 1991, p. 208, no. 089.018).
12. Reproduced: Sotheby & Co., December 9, 1970, lot 131, bought by Robert Skelton for L 400 (= Woodford 1978, illustration p. 60f. = Archer 1979, p. 83, fig. 36 = Pal/Dehejia 1986, p. 157, no. 157 = Guy/Swallow 1990, col. illus. p. 181, no. 154 = Archer 1992, pp. 115–116, no. 87, col.).
13. Reproduced: Archer 1979, p. 95, no. 52.
14. Version A: Sotheby's, April 4, 1978, lot 234, full-page pl. p. 99 (= *Maggs Bull.* 30, 1979, no. 55, illus. on pl. XXV); B: Archer 1972, p. 158, no. 118, illus. as pl. 48; this version can be distinguished from version A by its longer moustache. C: Christie's, July 12, 1979, lot 58, illus. on pl. 3.
15. See David/Soustiel 1986, no. 16, col. p. p. 29 (= Christie's, July 7, 1976, lot 105, illus. pl. 22 = Christie's, November 17, 1976, lot 43, illus. on pl. 14).
16. Archer 1979, p. 147; for a discussion of this painting see also *Exhibition of Art 1947*, no. 1333, p. 123; Gray 1950, no. 914, p. 91 or Webster 1976, no. 102, p. 76.
17. *Journal of Indian Art and Industry*, vol. XII, no. 107, July 1909, pl. 165 (identical with Hendley 1909, pl. 165); Young 1959, illus. facing p. 48; Archer 1979, p. 147, fig. 89; Archer 1986, no. 65, pl. XI; Bayly et al. 1990, no. 78, p. 81f.; for the col. reproduction cf. Boyé (ed.) 1996, p. 45, right.
18. For a typical example, dated 1765 by the painter Ramjidas, see Bautze 1995a, col. pl. 122, p. 138.
19. For the apparently only reproduction of this historically important painting, see Sotheby's N.Y., March 23, 1995, lot 311. We were able to read the inscription, neatly written in tiny red *Nagari* characters on the lowermost step of the stairs leading to the terrace, before the painting was sold. It reads: *kalam gobamdram catera ki samat 1891 ka* (by the painter Gobindram, from V.S. 1891 [1834 A.D.]). An inscription on the border in *Nashtaliq*, below the minister, is apparently incomplete. It ends . . . *ta ram*. Another *Nashtaliq* inscription below the young ruler is even less legible. For the history of Jai Singh III and his minister Jhota Ram see Batra 1958, pp. 112–129.
20. Jai Singh III of Jaipur was born after his father and predecessor, Sawai Jagat Singh, expired. Jagat Singh died on the ninth of the dark fortnight of the month Posh, V.S. 1875 (November or December 21, 1818). His son was born on the first of the bright fortnight of the month Baisakh, V.S. 1876 (April 23, 1819) and died on the eighth of the bright fortnight of the month Magh (February 6, 1836). For the dates see Harnath Singh 1965, sheet 2, nos. 35–36. Brooke 1868, p. 20; Shyamaldas 1886, vol. II, pp. 1319–1320; Sarkar 1984, p. 333, and note 3 on p. 336. For another portrait of Jai Singh III of Jaipur, see Hendley 1897, pl. 15, no. 19.
21. For a relevant portrait of Sawai Jagat Singh of Jaipur, see Bautze 1995a, p. 143, col. illus. no. 127.
22. These events are narrated in Batra 1958, p. 132f.

12 A Portrait of Captain James Urmston (1750–?)

⌒

by Arthur William Devis
(1762–1822), England, 1797.

Media: Oil on canvas

Size: 29⅝ x 24½ in.
(75.2 x 62.2 cm.)

Inscribed: See adjacent text.

Two pieces of old paper, pasted jointly on the back of the canvas and obviously cut out from a catalogue, give the following information on the subject, artist, and date:

63 Captain James Urmston, R.N. Devis, 1797. Born 1750. Entered H.M. Navy in 1762 on board H.M.S. Weazel; removed to H.M.S. Bedford, 60 guns, served on her when on the American coast chasing the French fleet; also served in the Triumph in 1771–72, when Horatio Nelson was one of his messmates; joined the H.E.I.C. after this; held several commands. When in command of the Sir Edward Hughes, H.E.I.C.S., 1794, he was ordered to hoist the Broad Pendant at St. Helena as Commodore, and conduct a large fleet of Indiamen to England. In 1795 sailed in the Sir E. Hughes, in command of the East India Company's fleet of fifteen vessels which accompanied the British fleet under Vice Admiral Christian with the army under General Sir Ralph Abercomby, to capture the French West India Islands. Owing to heavy gales had to put back to Portsmouth, set sail again, and reached West Indies when Sir E. Hughes was engaged in the attack of St. Lucia and other islands. Offered knighthood for services, but declined. Lent by Captain E.B. Urmston.

Although "Devis rarely signed or dated his pictures,"[1]—we may add: equally rarely identified his pictures—there can be no doubt that the information given in cat. no. 63 is correct. A wash drawing of Captain James Urmston done in 1785 by Ozias Humphry confirms the identity of the portrayed person.[2] The masterly execution of the portrait together with stylistic correspondences with paintings known to be by Devis confirm the attribution to this artist. Arthur William Devis's father was an artist, which may partly explain Devis's great art and skill. He "evinced a genius for Painting from early Childhood and received his first instruction from his Father, who was esteemed a good Artist and a most excellent man."[3]

Devis reached India in late 1784, completed a number of paintings there, and started to work on a few others: "His style of painting, as it suddenly broke on Calcutta, had for many of the British a humane charm and relaxed elegance that made some of them prefer him even to Zoffany."[4] He returned to England on July 23, 1795.[5] "Home again in England at last, Devis set about his professional work in real earnest and produced a great number of historical pieces and portraits which gained him a great reputation."[6] Many of the portraits which Devis did in London after his return from India are lost. These include a portrait of Captain Gooch, exhibited in 1805.[7] Similarly, the present portrait of Captain Urmston seems not to be on record, with the exception of the quoted entry, the complete catalogue of which could not be traced. Nonetheless, Devis may rightly be called "one of the most brilliant portrait painters to go to India."[8] It may be added here that of all the top ranking professional artists having worked in India, Devis is the most undocumented and unknown personality.[9]

NOTES
1. Archer 1979, p. 239.
2. Archer 1979, p. 189, illus. 116.
3. Pavière 1937, p. 139.
4. For his works produced there, cf. Archer 1979, pp. 234–269; the quotation is from p. 238. For a short biography cf. Archer 1986, p. 22.
5. Pavière 1937, p. 142.
6. Carey 1907, vol. II, p. 211.
7. Pavière 1937, p. 165, Royal Academy, 21 Old Bond Street.
8. Archer 1979, p. 269.
9. For the Indian Section of the "Festival of Empire and Imperial Exhibition, 1911," it was only reported that A. W. Devis "Painted 30 pictures of Indian subjects," cf. *The Journal of Indian Art and Industry,* vol. XV, no. 117, January, 1912, p. 11.

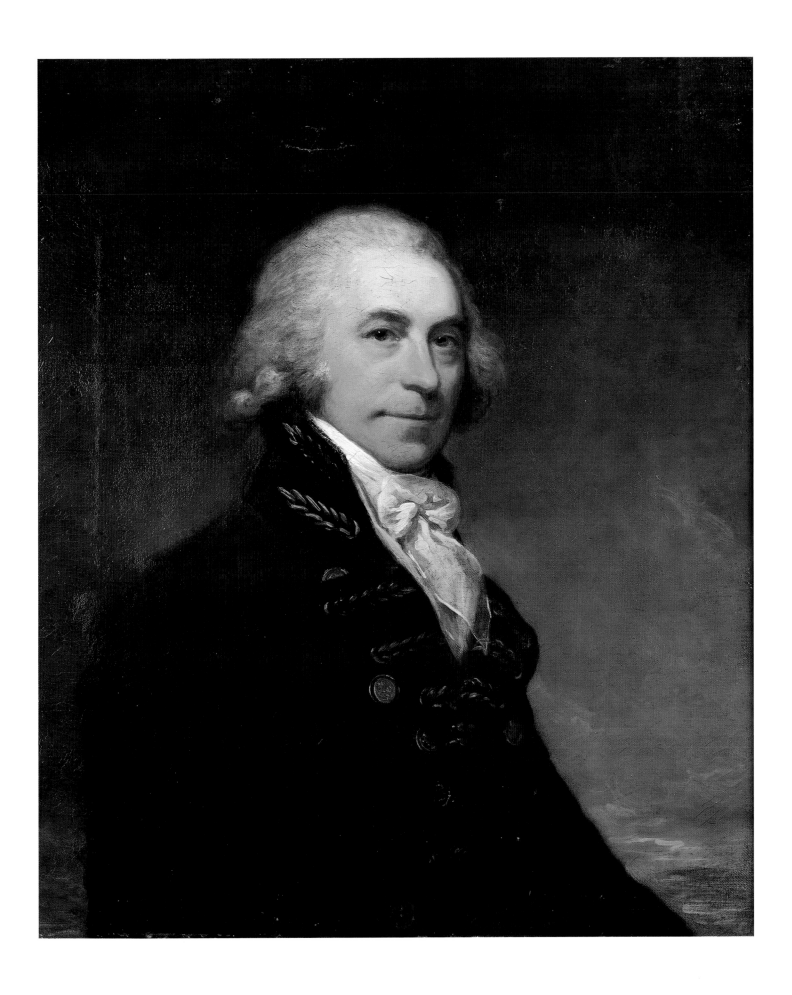

13 A Rich Mohammedan

∾

by William Daniell, R.A.
(1769–1837), England, ca.
1825–1833.

Media: Watercolor over pencil
on paper

Size: 3⁷⁄₈ x 5⁷⁄₈ in. (9.8 x 15.1 cm.)

Inscribed: On verso: "A Rich
Mohammedan"

Published: Annual Exhibition,
Spink 1995, no. 80, col. pl.
p. 111, bottom.

We proceeded down the coast, nearly retracing our former route as far as Tanjore. Here we fell in with a wealthy Mahomedan, who showed us particular attention, treating us with great hospitality during our stay, which made our time pass very agreeably. The first visit we paid him was in the afternoon, just after he had taken the siesta, and was enjoying his hookha in the veranda of his dwelling. He was seated on a rich carpet under a magnificent awning, attended by two domestics, one of whom was protecting him from the inconvenience of the sun's rays with a chatta composed of the palmyra-leaf, and the other was waving over him a yak's tail, in order to prevent the impertinent intrusion of flies and mosquitoes. The mussulman courteously invited us to his dwelling, which was in the neighbourhood of the city, upon the river Cavery; and we visited him almost every evening during our stay. He had a splendid mansion, with a numerous establishment. One evening, before we quitted Tanjore, he gave a sumptuous entertainment, to which we were expressly invited. Our host was about five-and-thirty years of age; he had a tall commanding person, was remarkably courteous in his manners, and of easy, unembarrassed address. Like most persons of his race, he was extremely fond of show, living in a state of almost princely magnificence. (William Daniell through Hobart Caunter in *The Oriental Annual 1836*)[1]

This text accompanies and describes an engraving done by J. Stephenson for *The Oriental Annual 1836,* based on the present watercolor by William Daniell.[2] *The Oriental Annual* may almost be considered as William Daniell's popular miniature edition of the *Oriental Scenery* which, at the close of the eighteenth century, made Indian views as well as the Daniells famous. In fact, a number of views already published in the much larger sized and colored aquatints of *Oriental Scenery* reappear in the much reduced size of *The Oriental Annual,* but for the most part, the engravings are based on drawings which until then were unpublished. It seems that the present painting was exclusively produced for *The Oriental Annual,* as were several others.[3]

The present watercolor has a closely related counterpart published in *The Oriental Annual 1835.* Instead of "A Rich Mohamedan," it shows a wealthy European in Calcutta.[4] The description of this engraving corrects a misnomer that occurs in the text to the present watercolor. The second servant standing behind the Mohamedan gentleman reappears with the same large object held by his left hand in the depiction of the European gentleman, where the man is more correctly described as *punka* bearer (lit. fan holder) and the object as a fan "made of the broad leaf of the palmyra."[5] That type of fan is incorrectly called *chatta* in the present watercolor, an object which is also more correctly described for the European gentleman at Calcutta: "When he (i.e. the rich European) chooses to go on foot — covered by a chatta …." The *chatta* in a footnote is then correctly translated as "an umbrella."[6] As with the aquatints of *Oriental Scenery,* the engravings of *The Oriental Annual* were also copied and re-published. The engraving of the wealthy European, to cite an example, reappears in an altered composition in Dubois de Jancigny's and Xavier Raymond's *Inde* of 1845 as "gravure 81," titled like the engraving after William Daniell, *Le Salaam.*[7]

NOTES
1. *The Oriental Annual 1836,* pp. 16–17.
2. *The Oriental Annual 1836,* engraving facing p. 16.
3. Cf. e.g. Christie's, June 5, 1996, p. 91, lot 119 (= Losty et al. 1996, p. 19, no. 15, col.) was probably intended for *The Oriental Annual 1837,* subtitled *Lives of the Moghul Emperors,* but does not appear in there, whereas Christie's, June 5, 1996, p. 92, lot 121 (= Losty et al. 1996, p. 19, no. 16, col.) does appear as an engraving in the same *Oriental Annual,* facing p. 29. Christie's, June 5, 1996, p. 94, lot 125, col. is the frontispiece of *The Oriental Annual 1834* and Christie's, June 5, 1996, p. 94, lot 126, col., appears as an engraving in *The Oriental Annual 1838,* facing p. 183.
4. *The Oriental Annual 1835,* engraving facing p. 52, titled *The Salaam.*
5. *The Oriental Annual 1835,* p. 51.
6. *The Oriental Annual 1835,* p. 52.
7. Jancigny/Raymond 1845, engraving facing p. 459: "Lemaitre direxit," William Daniell, is not mentioned.

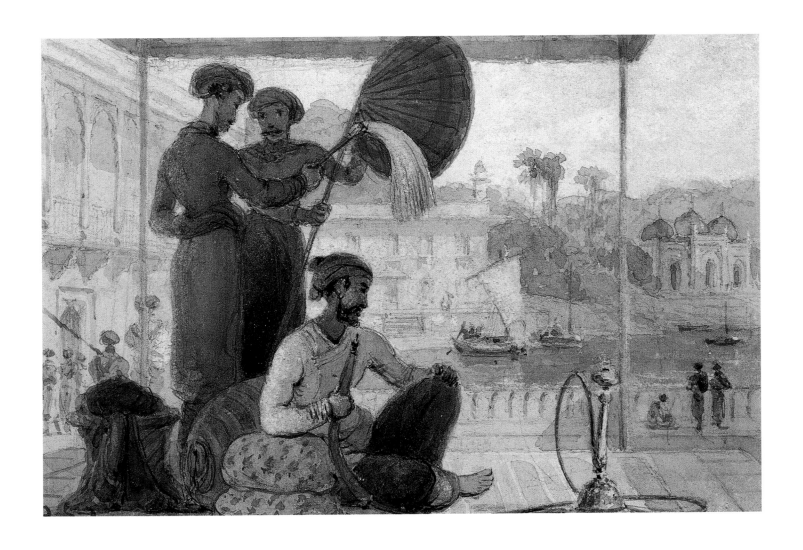

14 A Portrait of Amir Khan
Pindari (1768–1834)
∿

by an unknown Indian artist,
Delhi(?), late 18th century.

Media: Ink and watercolor
on paper

Size: 5¹⁄₈ x 4¹⁄₈ in.
(12.8 x 10.3 cm.)

Inscribed: Below painted
margin, in *Nashtaliq*,
"Amir Khan Pindari."

Published: Sanderson/Zafar 1911,
pl. LXI(c), no. C.240, text
p. 138.

Provenance: Khwajah Mahmud
Husain, Mr. and Mrs. K. S.
Hosain.

[Colonel James] *Skinner, who thought him* [i.e. Amir Khan] *mean looking, with dark, thin, evil face, and poorly dressed in a dirty white upper garment and a blue turban. What he said was trifling, badly expressed, and generally not in very good taste. He boasted he was king of Hindostan, but had resigned his claim to the title because of his friendship for General Ochterlony!*[1]

Ameer Khan was sole commander of his own army, entertained and dismissed whom he chose, and this made him in a degree independent; but this condition was little to be envied. His followers, who were always much more numerous than he had any means of paying, were in a state of constant mutiny, and for more than half of every year their chief was under restraint; the consequence was, that his conduct was always more regulated by the clamours of this turbulent rabble, and the necessity of providing for their support, than by any regular system of policy. The excesses of Amir Khan's Patans at Saugor have been noticed; but these were far surpassed at Poona, where he was seized by a party of them, and not only beat and bruised, but almost strangled with his own turban, which they fastened round his neck. (John Malcolm as published in 1824, reporting here on an incident which occurred in 1803)[2]

As early as 1824, Amir Khan's life and career were already described.[3] His contemporary biography, the *Amir Nama*, was written by his deputy secretary, Busawan Lal, a Persian scholar of Lucknow and translated into English by Henry T. Prinsep during Amir Khan's lifetime.[4] Amir Khan was always much sought after by rival factions because he commanded an army of Pendharis," corruptly Pindhari, or Pindari. A member of an organized association of mounted marauders and plunderers, who from time to time issued from their villages, and made distant excursions to commit depredations and bring home plunder,"[5] and with this army served the party, which offered the highest amount of payment. A contemporary author described his source of income:

[In 1806] *his army consisted of 35,000 men, with 115 pieces of field artillery, to support which his Jagheer* [fief] *was unequal, and it was necessary to subsist them upon other countries. His bands ranged over every part of Rajpootana, Malwa and Boondelcund, the disputes between the petty chieftains of which provinces presented a fine harvest for the predatory chief. Though he sometimes found it convenient to prosecute his own views under the sanction of the Holkur name, it was perfectly understood, that as that state had no power of control over his actions, it was not responsible for them. In 1806–7, he entered the service of the Raja of Jeypoor, who was then contending with the Raja of Joudpoor for the hand of the Princess of Odipoor. When the rival chief could no longer keep the field, and was compelled to take refuge in Jeypoor, Ameer Khan who was the partisan of that faction which paid him best, changed sides, and reversed the probable issue of the contest, while he plundered indiscriminately the country of both princes. The horrible deeds perpetrated during the Rajpoot war, by the cool-blooded policy of this chief, are unsuited to this sketch.* (John Clunes, as published in 1833)[6]

Although Amir Khan Pindari must have been a sort of "public enemy no. 1,"[7] he was only very rarely portrayed. The present colored drawing was in all probability done by an Indian artist who had some Western training. It is the earliest, and, in the Western sense, most reliable portrait of this freebooter, showing him at the height of his power. Another portrait exists, which was done for Maharao Umed Singh (r. 1771–1819) of Kota, and which is still with his descendant, Maharao Brijraj Singhji. This painting shows "one of the most eminent disturbers of public peace,"[8] as the Kota historian styled him, on horseback, fully bearded.[9]

In course of time, Amir Khan became so powerful — or so disturbing — that

the offer was made to Ameer Khan, in common with all the other petty states of Hindoostan, to accept the protection of the British Government, under the conditions that he should reduce his army to a certain specified number, and surrender his artillery at a valuation. In return, the assignments for the payment of troops, which he held under grants from the Holkur state, to which he was only nominally subject, were to be guaranteed to him in sovereignty; he relinquishing all the conquests made during his predatory career. The terms were hard, but as he could not be considered in any other light than as a principal supporter of the

امیرخان نیزه‌داره

predatory system, which the British Government were now putting forth their whole strength to annihilate, this chief may be considered as too liberally dealt with.[10]

"In accordance with the agreement, the districts of Sironj, Pirawa and Gogala Nimbhahera were confirmed in the possession of Amir Khan and his descendants. The fortress of Tonk Rampura, with the territories subordinate to it, was added to his possessions as a special favour."[11] This contract, which pacified Amir Khan and fulfilled Malcolm's hopes,[12] was ratified on November 15, 1817, and changed the freebooter into an accepted ruler of a state, now called Nawab Amir-ul-Daula Mohamad Amir Khan, who made Tonk in the former Jaipur state his capital. A contemporary author stated, as published in 1833:

He has grown devout in his old age, being now in his sixty-fifth year, dresses in sackcloth, reads the Koran, is surrounded by religieuse, is extremely rich, and has twelve thriving children, whom he is at particular pains to educate. In January, 1832, when he went to pay his respects to the Governor General at Ajmer six of his sons accompanied him. Five of them were in chain armour, which is sufficently indicative of their inheriting a portion of their father's esprit militaire. This interview was marked by a spirit of frankness and cordiality, and the Nuwab, who is particularly distinguished for his acuteness and powers of conversation, left a very favourable impression upon his entertainers.[13]

Nawab Amir Khan's last known portrait is in the style of a Jaipur miniature and represents him as any Rajput prince, standing and in full profile, but without the customary halo of a ruling chief.[14] Portraits of his successors are also in the then prevailing Jaipur style, but are unpublished.

NOTES

1. Holman 1961, p. 177. As throughout his book, Holman does not reveal the source of his information. Here it seems that he quotes from J. Baillie Fraser's *Military Memoir of Colonel James Skinner, C.B.*, London 1851.
2. Malcolm 1824, vol. I, pp. 327–328.
3. Malcolm 1824, vol. I, pp. 325–348.
4. *Memoirs of the Puthan Soldier of Fortune, the Nawab Ameer-ood-Doulah, Mohummed Ameer Khan, Chief of Serong, Tonk, Rampoorah, Numahera, and other places in Hindoostan.* Compiled in Persian by Busawan Lal; translated by Henry T. Prinsep, Calcutta 1832. This is now a very rare book, which is summarized in Maya Ram 1970, pp. 23–25 and partly in Shastri 1971, pp. 197–200.
5. Wilson 1968 (first published 1855), p. 414. Wilson continues: "They were extinguished as a body by the measures of the Marquis of Hastings when Governor General. As the word is properly Marathi, Pendhari is no doubt a more correct reading than the more usual one of Pindhari: the term also admits of a more plausible etymology than any conjectured for the latter, as it most probably is derived from *pendha*, a bundle of grass, and *hara* or *hari*, who takes; for the Pendharis were originally nothing more than a body of irregular horse allowed to attach themselves to the Mohammedan armies, employed especially in collecting forage, and permitted, in lieu of pay, to plunder.
6. Clunes 1833, p. 165.
7. For a contemporary account of British actions against Amir Khan, especially under Lord Lake, cf. Thorn 1818, pp. 335–337, 344, 357, 421, 424, 427, 429, 447–467, 496–497, 499.
8. Shastri 1971, p. 198.
9. For a reproduction and discussion of this painting, see Bautze 1995c, p. 43, Fig. 8 and pp. 44–45.
10. Clunes 1833, p. 166.
11. Maya Ram 1971, p. 25.
12. Malcolm ends the contemporary biography of Amir Khan with the following sentence: "Let us hope that he will understand his present condition, and seek, by the good management and improvement of his territories, the continued favour and protection of the British government." (Malcolm 1824, vol. I, p. 348).
13. Clunes 1833, p. 167.
14. Hendley 1897, pl. 25, 1, col. pl.

15 Portrait of General Gerard Lake

∿

known as Viscount Lord Lake of Delhi and Laswari (1744–1808), after an engraving by R. Cooper based on a painting by George Place (fl. 1775–1805), by an unknown Indian artist, Calcutta or Lucknow, ca. 1807–1810.

Media: Gouache on paper

Size: 7¹/₂ x 5³/₄ in. (10.9 x 14.6 cm.)

Inscribed: On verso: "Lord Lake / on loan from Khwaja Mahmud Husain."[1]

Provenance: Khwaja Mahmud Husain; Yasmin and Shahid Hosain.

This painting is a mirror-reversed detail, presumably after an engraving by R. Cooper[2] based on a painting by George Place.[3] The painting by Place illustrates an incident which occurred during the "Battle of Laswaree, November the first, 1803." A witness to the scene reported:

An awful pause of breathless expectation now ensued; the numerous artillery of the enemy seeming to watch an opportune moment to frustrate the meditated attack, by pouring destruction upon their assailants. The affecting interest of the scene was heightened by the narrow escape of the commander-in-chief [i.e. Lord Lake], whose charger having been shot under him, his gallant son, Major George Lake, while in the act of tendering his own horse to the general was wounded by his side. This touching incident had a sympathetic effect upon the minds of all that witnessed it, and diffused an enthusiastic fervour among the troops, who appeared to be inspired by it with more than an ordinary portion of heroic ardour. The cavalry trumpet now sounded to the charge; and though it was instantly followed by the thundering roar of a hundred pieces of cannon, which drowned every other call but the instinctive sense of duty, the whole, animated with one spirit, rushed into the thickest of battle.…But among the trials which exercised the fortitude of this excellent man on that day, the most distressing was the accident that befell his gallant son, Major Lake, of the ninety-fourth regiment, who attended his father in the capacity of aid-de-camp [sic] and military secretary throughout the whole campaign. In that part of the battle, of which an account has already been detailed, while the commander-in-chief was leading on his troops against the enemy, his horse fell under him, after being pierced by several shot; upon which his son instantly dismounted, and urged his father to accept the horse which he rode. This was at first refused, but after some entreaty, the general was prevailed upon to comply; when, just as the major had mounted another horse belonging to one of the troopers, he received a severe wound from a cannon shot in the presence of his father, whose agonized feelings at such a moment may be more easily imagined than described. It was, indeed, an awful moment; but parental affection was suspended for a while by the sense of public duty, and the general proceeded with unrelaxed vigour in the prosecution of the

great object that was paramount to all others; after accomplishing which, and remaining master of the field, he had the consolation to find that his brave and affectionate son, though severely wounded, was likely to do well, and prove an ornament to his country.[4]

A similar incident to the one described here already occurred during the earlier siege of Delhi (September 11, 1803): "In this interval, the commander-in-chief had a horse shot under him; on which his gallant son, Major Lake, dismounted, to accommodate the general with his horse, while he took one belonging to a trooper, whose rider was killed; and upon this he continued till one of his own could be brought up, which afterwards was shot under him."[5]

Lord Lake was perhaps the most illustrious commander-in-chief in the early nineteenth century, and probably also the most victorious. Besides, he was extremely courageous and quick-witted, not only in battle: "On one of these hunting excursions a tiger of large size was shot with a pistol by General Lake, just as the ferocious animal was in the act of springing upon Major Nairne, by whom it had been previously spared."[6] Lord Lake fought against Amir Khan (cat. no. 14) and under him served Colonel James Skinner (cat. no. 16). He successfully stormed Dig, but failed in four assaults on Bharatpur (for which cf. cat. no. 70). The Mughal emperor Shah Alam called him "The Sword of the State, the Hero of the Land, the Lord of the Age, and the Victorious in War."[7] His life and character were summarized by a contemporary writer:

Thus, after displaying the qualities essential to the character of a master in the art of war, during the great American contest, next in the early campaigns against revolutionary France, particularly at Lincelles and the wood of Alkmaar, and on the still more trying occasion of the rebellion in Ireland, did this noble veteran compleat his wreath of military glory, by rounding the British empire in the east within a circumference, the magnitude of which is only commensurate to the security of the interjacent country from foreign enemies and domestic depredators. . . . In private life, his pleasing manners, and condescending deportment, the cheerfulness of his conversation, and his willingness to oblige, endeared him to the more intimate circle of his acquaintance, and secured the respect of all who had any opportunity of observing his amiable character, and the influence of his virtues upon the society in which he moved. Thus distinguished by the personal esteem of his sovereign, and every branch of his august family, honoured by the nation, and adored by the army, did the general retire into the bosom of his family, followed by the sincerest wishes for the continuance of many years in the enjoyment of health and happiness.[8]

Another portrait shows Lord Lake and his son on horseback at Fatehgarh. This large-dimensioned painting is by Robert Home and dates from about 1805–1806. Unsurprisingly, Lord Lake looks similar to his portrait by George Place, an artist, of whom very little is known.[9] Even less can be said about the artist of the present watercolor, who can be recognized as being Indian by his painting technique, which is primarily based on the technique of the traditional miniature. Lord Lake is also shown in an Indian drawing, representing him with his characteristic cocked hat, on horseback.[10]

NOTES

1. This inscription informs that, as several others in the catalogue, this painting was intended for the "Loan Exhibition of Antiquities, Coronation Durbar, 1911," where, however, another portrait of Lord Lake was included in the illustrated catalogue, cf. Sanderson/Zafar Hasan 1911, pl. LXXIV, no. C.260, facing p. 164.
2. Reproduced: Archer 1979, p. 327, no. 230.
3. Reproduced: Holman 1961, illus. facing p. 23.
4. Thornton 1818, p. 220 and p. 226.
5. Thornton 1818, pp. 111–112.
6. Thornton 1818, p. 81.
7. Thornton 1818, p. 126.
8. Thornton 1818, p. 511. For a more detailed biography, cf. Hugh Pearse, *Memoir of the Life and Military Service of Viscount Lake*, London 1908.
9. For reproductions of this painting in the collection of the Victoria Memorial Hall, Calcutta, cf. Cotton 1928, pl. between p. 16 and p. 17; Archer 1979, p. 318, no. 223.
10. Sanderson/Zafar Hasan 1911, pl. LXXIV, no. C.260, facing p. 164.

16 Colonel James Skinner (1778–1841) on a Prancing Horse

∾

by an unknown Indian artist, ca. 1810.

Media: Watercolor on paper

Size: 7⅝ x 9¼ in. (19.2 x 23.5 cm.)

Inscribed: On verso: "On loan from Khwaja Mahmud Husain," and below, in a different hand: "C71 Some English General."

Exhibited: Both inscriptions inform that it was on display or at least intended for display in the "Loan Exhibition of Antiquities" during the "Coronation Durbar" in Delhi, 1911. It was, however, not included in the illustrated version of the catalogue.

Provenance: Khwaja Mahmud Husain; Yasmin and Shahid Hosain.

This is the earliest known portrait of the most famous Anglo-Indian military commander ever. His story has often been narrated and his character described. One particular contemporary account of this truly extraordinary man deserves our notice:

I will always keep the memory of Colonel Skinner, one of the best known names in northern India. He is the son of an English officer and an Indian mother. When he was 15, his father gave him a horse, a sabre, a shield, a matchlock, some Rupies, and, having him thus equipped, dismissed him in wishing him good luck. The young man had made up his mind. With eagerness he strived for his luck and found it. He entered the service of Sindhia, of whom General Perron commanded the armies. Here he distinguished himself through his valour, skill, activity and raised a cavalry unit which he trained to obey as the European soldiers obey to their military leaders, but he equipped and armed them in the Indian way and taught them to use their weapons, the sabre and the matchlock. Although he was still young at that time, his name was already known as leader of partisans, when Perron left the service of the Marathas. Skinner or Sikander, as the natives call him, also left the Maratha service and entered that of the British under the condition, which he himself faithfully followed, never to fight against his former master. Although according to the rules of the East India Company he was to be excluded from service being the son of an Indian mother, Skinner for a long time held the rank of lieutenant-colonel, and, under the command of Lord Combermere, he was given the order of the Bath. He commanded a large unit of irregular cavalry, of which the regimental depot is at Han, where he normally resides on a jagir [piece of land] which he received from the government. There he breeds horses and cattle, produces indigo, deals also with other things; and when his speculations are fruitful, he spends the money like a native. He built a temple, a mosque and it is at his cost that since several years a church is being built at Delhi, which cost him already more than half lakh [i.e. 50.000 rupies]. He attends to the Anglican religious service on Sunday, prays otherwise in the mosque on Friday and thinks more of Islam than of Christianity. His habits are a unique mixture of European as well as Asian habits. But they are mild and well-intentioned and he acquired an almost universal benevolence. He has only enemies amongst those of his own colour (he is quite dark), and some who envie him for his fortune. He speaks Persian as he speaks English. His mother tongue is Hindusthani. Whatever turmoil may happen in India, Skinner always falls back on his feet. He is a man around fifty and already shows signs of an embonpoint. He has, however, not lost his military skills, in which he excelled during his youth. None of his cavalrymen takes aim with more precision than he with his matchlock, to the front, to the side and towards the back, on his horse in full gallop. His corps consists of selected men, high born Musulmans for the most part; for warfare he prefers them to all other castes of Hindus. This corps has a high reputation with regards to warfare. It is reportedly indefatigable and of a

proven valour and of a deadly skill to the enemy. In times of peace it is noticed for being of greatest discipline. Fraser, who is closely connected to Skinner, already imagines of becoming its major. And Lord Hastings, who was already Governor General and chief general, gave him this title. My acquaintance with him helped me to get introduced to the colonel so well that after a quarter of an hour that I spent with him, he appeared to me like an old friend. To know Colonel Skinner, who is half Indian by birth and morals, but nonetheless perfectly accustomed to our manners, is extremely interesting. From his own he never talks about but the affairs of this country, since these are the only he knows well. If I would be commander-in-chief in India, I would consult him very often. He has probably seen more military actions than anybody else. He complains freely about the English sabre, with which 10 regiments of regular native cavalry are equipped. He says that he has never seen a native learning to use it properly. He does not approve of the eternal reviews of troops, great maneuvers, which always take place on a well levelled ground, which as such rarely occurs on the day of battle. (Victor Jacquemont, February 1832)[1]

Another eye-witness recalled:

Colonel Skinner … has long been known by persons connected with India, as one of the bravest and most distinguished soldiers in the East-India Company's army. The Colonel's father was an Englishman in the service of a native prince, and his mother was a Mussulmani; his complexion is, however, darker than that of most Mussulmans, although in his youth he is said to have possessed a skin more indicative of his mixed origin. He has for many years commanded a regiment of Irregular Cavalry, known as Skinner's Horse, which is generally considered the best disciplined and finest corps of the kind in service. … He is fortunately as generous as he is rich, and besides living in magnificent style, indulging in unmeasured hospitality, his purse-strings are ever most cheerfully loosened in favour of public institutions, and for charity. Altogether, the old gentleman is looked upon as one of the oldest, and ablest, and bravest, and most fortunate, and most distinguished, and happiest, and best rewarded officers holding a commission in the name of the Honourable Company. He is a most pleasant companion, full of anecdote and good humour, with no mean smattering of natural wit; and for his many excellent qualities, he is met by his brother-officers of the regular army, with perfect good-will, notwithstanding his Eastern origin: not that this behaviour on their part is deserving any particular praise; but then an opposite course of conduct would be highly disgraceful to them: he is esteemed and admired by all who know him, either personally or by character.[2]

Skinner and the skill of his Irregular Horse were often described by contemporary authors,[3] a mid-nineteenth century publication was considered his "Military Memoir,"[4] and, more recently, an entertaining biography was published.[5] His corps still existed earlier this century as the "1st Duke of York's Own Lancers (Skinner's Horse)" and the "3rd Skinner's Horse," to be amalgamated in 1922 as the "1st Duke of York's Own Skinner's Horse," which was later redesignated "Skinner's Horse (1st Duke of York's Own Cavalry)," and as such formed part of the Indian army until at least 1961.[6]

Although no inscription gives the name of the horseman, a comparison with published portraits of him reveals his identity. Significant is the way in which the hair is rendered above the forehead, the shape of the head, the sideburns, and the line of his nose.[7] All authors agree that Skinner was of comparatively dark complexion, which does not show in the present painting. This may be due to two factors: His complexion was brighter when he was younger, as Bacon stated, and this portrait shows him at a younger age. But more important is an observation Miss Emily Eden made on December 23, 1838, while sketching at a darbar of Ranjit Singh and watching a native artist at work: "They paint their own people with European complexions, from coxcombry, so that ours are a great puzzle to them, because we are so white."[8]

Skinner not only commissioned Indian artists to paint his own portrait. Out of either political or historical interest, he commissioned them to do the portraits of many of the important people of his time and from the area of his influence. As a result of this interest he requested Ghulam Ali Khan to work for him as is demonstrated by three large paintings in the National Army Museum, London, of which one painting, dated 1827, shows him on horseback together with William Fraser (for whom see cat. no. 18), who was mentioned by Jacquemont.[9] Another one, by the same

Nawabs, Captains, Rajas, Viceroys, and Other Gentlemen

artist and dated the same year, shows Skinner in *darbar* at his capital, Hansi,[10] and the third one introduces James Skinner on one of his farms in a phaeton.[11] That Skinner was rather generous is shown by the fact that he gave some of his paintings and albums to visitors and friends. One of these paintings is inscribed by the owner: "A Nautch at Col. Skinner's given to me by himself."[12]

Besides, Skinner commissioned a number of albums, among which is one in the India Office Library, with 42 drawings,[13] and several illustrated books, one of which is "a rule-book of military exercises for Indian musket and cavalry" with some 47 illustrations.[14] Another illustrated work commissioned by him, the *Concise Account of the People*, contains 110 miniatures and is dated 1825. Like the above-mentioned painting, this album was given by Skinner, in this case to General Sir John Malcolm.[15] Another copy of the same work, with 103 miniatures, appeared in a sale-room.[16]

At least two illustrated copies exist of James Skinner's *Description of the Nobles*. One, with 33 miniatures, is in the Chester Beatty Library, Dublin. It is dated 1830 and was dedicated by Skinner to J. Watkins, who labeled it "Memoirs of the Kings and Chiefs of India of the present time. Compiled by Lt. Col. J. Skinner C.B. and presented by him to the possessor."[17] The other, slightly more profusely illustrated version with 38 paintings, is dated June 10, 1830 and also bears a dedication to General Sir John Malcolm. It is in the British Library, London.[18] A third copy of this compilation, now dispersed, might also have existed.[19]

As Jacquemont's contemporary account has shown, Skinner not only had painters working for him, but also architects. His church in Delhi, St. James's, still stands, and after completion was often painted by Indian artists.[20] It was near this church that William Fraser was buried and that James Skinner himself found his last repose.[21]

NOTES

1. Jacquemont 1934, pp. 19–21.
2. Bacon 1837, vol. II, pp. 277–279.
3. From the above-mentioned sources only certain passages were quoted. Cf. also Archer 1833, vol. I, pp. 99–101, p. 375; Mundy 1858, pp. 164–169; Heber 1828, vol. I, pp. 546–547, to mention just a few.
4. James Baillie Fraser, *Military Memoir of Lieut.-Col. James Skinner, C.B. For many years a Distinguished Officer Commanding a Corps of Irregular Cavalry in the service of the H.E.I.C. Interspersed with Notices of the Principal Personages who distinguished themselves in the Service of the Native Powers in India.*, 2 vols., London 1851.
5. Holman 1961.
6. Holman 1961, p. 251.
7. Compare Holman 1961, frontispiece and Christie's, June 5, 1996, lot 25. For further individual portraits, see e.g. the oil-painting in Moorhouse 1983, p. 183, col. pl. (=Archer 1986, pl. VIII, no. 47); Sanderson/Zafar 1911, pl. LXIX(c); Holman 1961, second pl. after p. 166, probably the basis for the engraving reproduced in Compton 1893, illus. facing p. 337 (= Edwin n.d., illus. p. 11); Losty 1986, p. 69, no. 60, col.; Archer 1982, illus. p. [4] (mirror-reversed version of the preceding).
8. Eden 1937, p. 228.
9. Archer/Falk 1989, p. 46, fig. 13. For the full painting, see Holman 1961, illus. facing p. 167.
10. Reproduced: Moorhouse 1983, col. pl. facing p. 139, top (= Bayly et al. 1990, p. 167, no. 180 = Archer 1982, p.[2]. Skinner's portrait reproduced in Losty 1986, p. 69, no. 60, seems to be a study for Skinner's portrait in this picture of the National Army Museum.
11. Reproduced: Holman 1961, pl. facing p. 246, bottom (= Archer 1982, p.[3].)
12. *Maggs Bull. 8*, 1965, p. 33, no. 84, the painting is reproduced on pl. XLIII of this bulletin.
13. Listed: Archer 1972, pp. 197–201, cat. no. 169i-xlii. Reproduced: Holman 1961, 3rd illus. following p. 166 (iv); Archer 1982, full-page col. pl. 1–10 (iii, xvii, xix, xx, xxix, xviii [= Bayly et al. 1990, p. 169, no. 183, col.], xxii, xxv, xxiii [= Bayly et al. 1990, p. 169, no. 184, col. pl. viii).
14. Sotheby & Co., April 23, 1974, p. 32, lot 200; Sotheby's, October 13 and 14, 1980, lot 165, from the collection of Malcolm Fraser.
15. Listed: Titley 1977, pp. 155–157, cat. no. 372; cf. Bayly et al. 1990, p. 169, no. 185. Discussed: Losty 1982, p. 152, cat. no. 135. Illustrated: Losty 1982, p. 148 (fol. 134b) and Losty 1986, p. 71, no. 62.
16. Christie's, April 23, 1981, pp. 78–80, lot 155.
17. Listed, discussed, and in great part illus. in Leach 1995, vol. II, pp. 726–741, cat. nos. 7.1–7.33.
18. Listed: Titley 1977, p. 157, cat. no. 373. Discussed and partly illustrated: Losty 1982, pp. 152–153, cat. no. 136. For illus. of this manuscript see Losty 1986, p. 69, no. 60 (fol. 4a) and Losty 1982, p. 149 (fol. 8b).
19. Cf. Leach 1995, vol. II, illus. p. 731, no. 7.4 with Christie's, July 6, 1978, lot 7, illus. on pl. 1. Another, similar painting on paper, showing the same man, is in the Heil collection, Berlin.
20. It is practically the first illus. in the Metcalfe album of 1844, cf. Kaye 1980, pp. 14–15 (Sir T. T. Metcalfe lies buried in this church); cf. also Archer 1982a, p.[7] (= Godrej/Rohatgi 1989, p. 67, fig. 30); Holman 1961, illus. facing p. 246, bottom (= Archer 1982, illus. p. 7 = Archer/Falk 1989, p. 56, fig. 19).
21. For a comprehensive account and illus., cf. Edwin n.d.

17 A Portrait of Mohan Lal, Diwan of William Fraser

~

by a "Fraser Artist," Delhi
or Haryana, ca. 1816.

Media: Gouache on paper

Size: 6 x 4 in. (15.3 x 10.2 cm.)

Inscribed: On verso, in pencil:
"Hindu astrloger [*sic*],"
and below, in ink: "Pundit
Najomie."[1] A stamp impression
further below: "Delhi Museum
of Archaeology."[2]

This same person appears in a contemporary group portrait showing eleven "head men or elders of villages" of Haryana in addition to William Fraser's *Moonshee Fuzl Uzeem of Kheirabad near Lucknow — a Moossulman.*[3] The end of the fourth line and the following two lines of English text on the cover-paper of that painting, written by William Fraser himself, identify the second man from the right, who is identical with the man shown here, as "The Deewan Mohun Lal, a Kayusth of Dehlee with his Spectacles on Nose."[4] A Deewan (*diwan*) here signifies a man who is the head officer of some financial department, a kind of accountant.[5] A Kayusth (*kayasth*) is a member of "the caste of writers and village accountants."[6] It is hence quite possible that Mohan Lal was a predecessor to one of the "Lals" of the famous banker families in Delhi.[7] The present painting seems like a cut-down version of another, very similar depiction of Mohan Lal.[8] The existence of two such closely related paintings should not surprise us, as there are many more such examples within the group of paintings done for William Fraser. Khan Bahadur Khan, for example, was part of the Fraser album as an individual portrait,[9] which was incorporated in an identical rendering in a group-portrait done by one of the "Fraser artists."[10] Both versions of Mohan Lal show that he actually used a pince-nez, which was tied to a twisted thread attached to the turban. This thread is barely visible in front of the forehead and nose. It seems the pince-nez was some sort of identification sign of this profession, since Diwan Ram Babu, accountant of James Skinner (for whom see cat. no. 16) has a pince-nez lying in front of him on the red carpet.[11] The pince-nez on the nose together with the cast-down eyes indicate that Mohan Lal is actually writing or calculating. It is a study from life.

As with many of the persons painted by the "Fraser artists," nothing is known about the "clerkish scribe,"[12] apart from his name, caste, provenance, and the three known paintings. The English inscriptions on verso were probably added on the basis of the charts in the opened book in front of the *diwan;* these look in fact like astrological charts as they are used by Indian astrologers to this day.

NOTES

1. *Pandit* generally means a literate person, a man of letters, a savant, also a Brahman. A *najomie* is an astrologer.
2. This stamp indicates that the painting formed part of the "Loan Exhibition of Antiquities, Coronation Darbar, 1911," in the Delhi Museum of Archaeology. It is, however, not included in the illustrated version of the catalogue, for which see Sanderson/Zafar Hasan 1911. The painting hence most probably belonged, like several others in this catalogue, to Khwajah Mahmud Husain, Munsif.
3. A Moonshee (*munshi*) is a writer, secretary, "applied by Europeans usually to teachers or interpreters of Persian and Hindustani." (Wilson 1968, p. 356)
4. For colored reproductions of this painting, see Sotheby's, July 7 and 8, 1980, p. 10, bottom, lot 4; Welch 1985, p. 95, cat. no. 49, with a reproduction of the cover-paper; Archer/Falk 1989, p. 15, no. 5.
5. Wilson 1968, pp. 144–145.
6. Russel/Hira Lal 1969, vol. III, p. 404. For the history and nature of this community see Russel/Hira Lal 1969, vol. III, pp. 404–422.
7. Cf. *Gazetteer of the Delhi District 1883–4,* pp. 78–79.
8. Sotheby Parke Bernet N.Y., December 9, 1980, lot 145; Archer/Falk 1989, p. 118, no. 108.
9. Sotheby Parke Bernet N.Y., December 9, 1980, lot 138; Falk 1988, p. 9, cat. no. 7; Archer/Falk 1989, p. 124, no. 119; Sotheby's, October 12, 1990, p. 14, lot 26.
10. Sotheby Parke Bernet N.Y., December 10, 1981, lot 13; Sotheby's, April 15 and 16, 1985, lot 430.
11. Archer 1982, full-page col. pl. 7.
12. Welch 1985, p. 96.

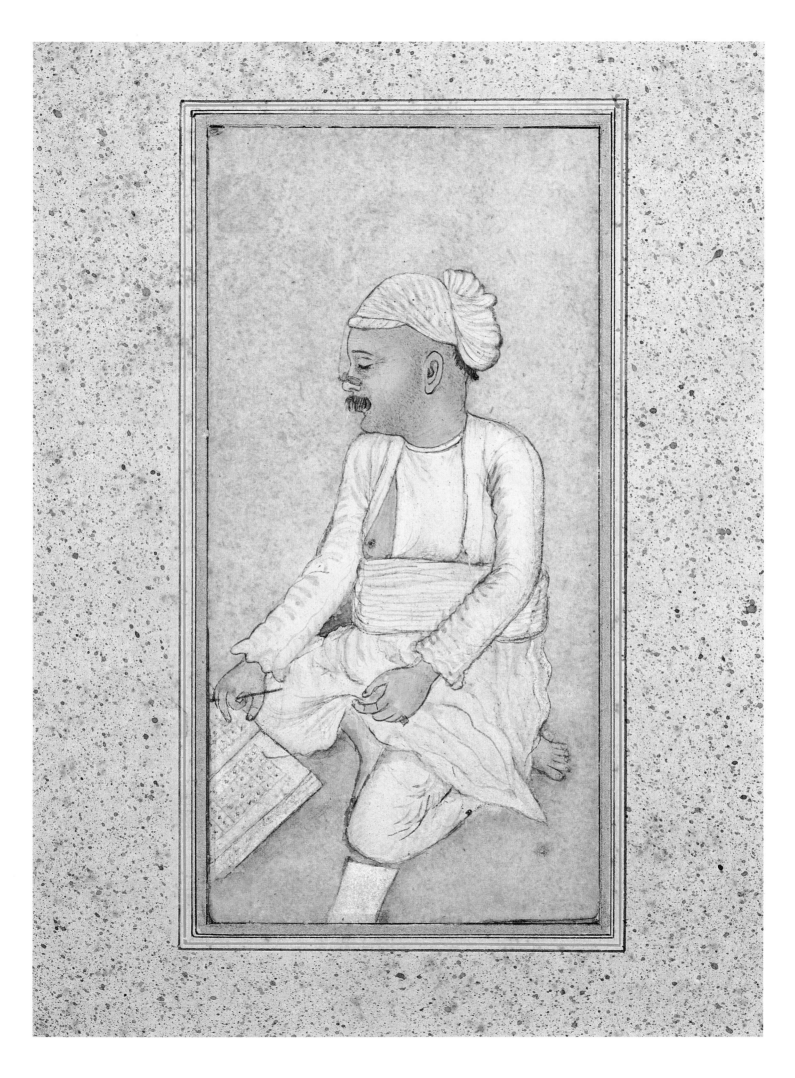

18 A Portrait of William Fraser
(1784–1835)

∾

possibly by Victor
Jacquemont, Delhi, ca.
1831–1832.

Media: Watercolor on paper

Size: 6¼ x 6 in. (15.9 x 15.2 cm.)

Inscribed: On verso, in pencil:
"27 Mr. William Fraser/assis-
tant Resident at Delhi/ on loan
from Khwaja Mahmud
Husai[n]."

Provenance: Kwajah Mahmud
Husain, Mr. and Mrs. K. S.
Hosain.

Published: Sanderson/Zafar
Hasan 1911, pl. LXII(b),
no. C.252; Archer/Falk 1989,
p. 52, fig. 15.

Passed a grazing farm belonging to a Mr. Frazer, of the civil service, but whose inclinations for a military life have induced him to seek the "bubble reputation even in the cannon's mouth." He is a major in the 1st Irregular Horse, and in the course of his career has seen some hot work. He has signalized himself as a brave, cool, and talented soldier; particularly at the capture of Bhurtpore, where he was entrusted with one wing of his corps. (Major Archer, November 13, 1828)[1]

Mr. or rather Major Fraser, who had marched with the camp from Delhi, took leave of us, and in him we have lost a most entertaining and instructive companion. His history and appearance equally declare him to be a character. He is a man of considerable talents and acquirements, and holds a high post under Government in the civil service of the Honourable Company. In this capacity his pen is said to have proved as trenchant as his sword is known to be in his second character of Major in a regiment of irregular cavalry. His countenance is remarkably handsome and intelligent, and much set off by his black beard and mustachios. At the siege of Bhurtpore — where the Major distinguished himself and was wounded — this ornament was of much luxuri- ant growth, flowing down upon his breast; but subsequent to that period, a depilatory mandate from the Supreme Government was fulminated against himself and other civilians, who, with less reason, indulged in this military decoration, and he was constrained (in the spirit of the half-batta times) to reduce the exuberant proportions of his beard; his fostering another crop looks very like bearding the Government.

Major Fraser is a great sportsman, and of the noblest order. He spurns the idea of securely butchering the tyrants of the desert from the turreted back of an elephant, and encounters the lion and tiger on horseback with spear and sword. He describes this species of sport, particularly with the king of brutes, as the only hunting worthy of a man. Indeed, there is a combination of courage, strength, and dexterity required which few sportsmen are able to bring into the field. The Major employs sometimes an hour or more in destroying his game, riding swiftly round in a circle, alternately approaching and retreating, and gradually narrowing the ring, until at length his furious antagonist becomes so confused and fatigued by his own exertions as to enable him to gallop past and deliver his spear. In these encounters he prefers the large country horse to the Arab, as being generally better on his haunches and more powerful. He is known to have, on one occasion, encountered on foot and slain a lion; but as he is not one of those who perform doughty deeds merely for the pleasure of recounting them, I could never cheat him out of a description of his combat with the king of the desert. Athough he is so fond of, and excellent in, these manly exercises, Mr. Fraser's diet is ultra-Hindoo, as he seldom eats meat, and never touches wine. (G. C. Mundy, November 28, 1828)[2]

Monsieur Fraser is a man of about fifty… He has travelled everywhere and always alone, because he never found, as he told me, a partner to his taste. For my part the only thing I find odd about him is a perfect monomania for fighting. Whenever there is a war anywhere, he throws up his judicial functions and goes off to it. He is always the leader in an attack, in which capacity he has earned two fine sabre cuts on his arms, a wound in the back from a pike, and an arrow in the neck which almost killed him. This is the price he has paid for always having succeeded in extricating himself from the frays into which he has rushed without being forced to kill a single man…. To him the most keenly pleasure emotion is that aroused by danger: such is the explanation of what people call his mad- ness. It goes without saying that, possessing this type of courage, Monsieur Fraser is the most pacific of men. In spite of his great black beard you would take him for a Quaker. (Victor Jacquemont, January 10, 1831)[3] *He is half Asiatic in his habits, but in other respects a Scotch Highlander, and an excellent man with great originality of thought, a metaphysician of boot, and enjoying the best possible reputation of being a country bear.* (Victor Jacquemont, January 11, 1832)[4]

Victor Jacquemont was in fact one of William Fraser's most intimate friends, and Jacquemont mentions him quite often.[5] When he met Fraser for the first time he thought that he was the "Viceroy of Delhi."[6] Another close friend of William Fraser was James Skinner (cat. no. 16), in whose regiment he served and with whom he is shown in a painting by Ghulam Ali Khan.[7] William Fraser became so fascinated with Indian life that he, in a way, became Indian himself. He commissioned paintings of Indian scenes by artists known today as "Fraser artists."[8] These "Fraser artists" were Indian painters, who worked for both Indians and British in and around Delhi. They combined both the Indian treatment of detail and observation of nature with an approach to Western painting techniques in addition to

unprecedented compositions of groups. One of their leading artists was undoubtedly Ghulam Ali Khan, whose earliest dated work is dealt with in cat. no. 67. Another artist was Lalji or Hulas Lal; more artists were not identified in the Fraser papers.[9] Lalji was reportedly a pupil of John Zoffany (cat. no. 35), which may explain the Western influence in these works.[10] Among the pictures of the "Fraser artists" is a painting of one of those lions slain by William Fraser as related by G. C. Mundy.[11] Another painting shows his Indian wife.[12] William Fraser not only commissioned paintings of extraordinary people which he saw during his travels on duty, he also collected Indian, particularly Mughal, paintings.[13]

William Fraser is best known for his totally unexpected assassination. On March 22, 1835, Fraser, who feared nothing and who never injured anybody, was shot dead. The circumstances which eventually led to his murder are too well known from contemporary as well as more recent publications to be repeated here.[14] A portrait of his assassin as well as the man behind the plot were published as early as 1844.[15] The circumstances of Nawab Shams-ud-Din's death, in other words, his execution, were described in great detail by an eyewitness.[16] William Fraser was buried at St. James's Church which Colonel Skinner caused to be built for himself. Colonel Skinner also wrote the epitaph.[17] A painting by an Indian artist, now in the India Office Library, London, shows the bearded William Fraser seated on a chair, smoking a *hookah* (Indian water-pipe).[18] A similar "houkha" was William Fraser's gift to Victor Jacquemont.[19] Another painting by an Indian artist presents William Fraser with a similar beard, which Fraser here sports like a Rajput chieftain.[20]

The present painting is technically very Western in its execution and might well be the work of Victor Jacquemont, who sketched a number of people he met in addition to monuments, views, and, above all, plants.

NOTES
1. Archer 1833, vol. I, p. 376.
2. Mundy 1858, pp. 182–183. Mundy does not mention Fraser by name in the passage quoted, but prior to this description, states (cf. Mundy 1858, p. 159): "Major Fraser of the same regiment [Skinner's horse] is, however, the lion-queller par excellence."
3. Jacquemont 1841, vol. I, pp. 307–308. That Fraser was in the midst of battle without doing harm to anybody was also repeated by Jacquemont in his letter to Victor de Tracy, dated January 11, 1832, cf. Jacquemont 1841, vol. II, p. 224.
4. Jacquemont 1841, vol. II, p. 224.
5. Cf. Jacquemont 1841, vol. I, pp. 296, 306–309, 311; vol. II, pp. 215–216, 226, 232, 237, 239–241, 283–285.
6. Jacquemont 1841, vol. I, p. 295.
7. For reproductions of this painting see Holman 1961, illus. facing p. 167; Archer/Falk 1989, p. 46, fig. 13 (detail).
8. For William Fraser's life and the paintings commissioned by him see Archer /Falk 1989.
9. Cf. Archer/Falk 1989, pp. 37–38, 45. Faiz Ali Khan, a brother of Ghulam Ali Khan, is also mentioned as being one of the "Fraser Artists," cf. Archer 1982, p.[6].
10. Archer/Falk 1989, p. 37.
11. Archer/Falk 1989, p. 16, fig. 6.
12. Archer 1986a, pl. 5 (= Archer/Falk 1989, p. 18, fig. 8).
13. Sotheby's, October 13 and 14, 1980, pp. 65–83, lots 161–211.
14. Cf. e.g. Sleeman 1844, vol. II, pp. 209–231; Parks 1975, vol. II, pp. 50–51; Lawrence 1878; Spear 1951, pp. 182–193; Archer/Falk 1989, pp. 54–56.
15. Sleeman 1844, vol. II, frontispiece, center, for "Kureem Khan" who shot Fraser, and the man who reportedly employed "Kureem Khan" to commit the murder, "Shumsoodeen," bottom right. For another portrait of Shams-ud-Din of Firozpur-Jhirka see Sanderson/Zafar Hasan 1911, pl. LXII(a).
16. For which see Bacon 1837, vol. II, pp. 266–276. For further references to William Fraser's death, see ibid., pp. 201–202, 221, 242, 246ff., 266, 319–320.
17. For which see Parks 1975, vol. II, pp. 193–194.
18. Christie's, October 10, 1989, p. 70, lot 97.
19. Cf. Jacquemont 1841, vol. II, p. 283.
20. Archer/Falk 1989, p. 55, fig. 17.

19 Half-length Portrait
 of an Unknown Officer
 ⁓
 attributed here to Raja Jivan
 Ram, Meerut or Delhi,
 1825–1835.

 Media: Oil on canvas

 Size: 11⅝ x 9⅝ in.
 (29.5 x 24.5 cm.)

A presumably British officer proudly displays three medals attached to his red uniform with gilded epaulets.[1] The painting is neither identified nor signed, but it can quite safely be attributed to Jivan Ram for a number of reasons. When comparing the position of the eyes of the officer, which is easily done by covering first one half and then the other half of the face, one notices that his eyes are not synchronous. It is as if the gentleman looks in two different directions. The same effect becomes apparent even more strongly in the portrait of the Begum Samru, cat. no. 47, which for the reasons there mentioned, is also attributable to Raja Jivan Ram.

Another argument in favor of Raja Jivan Ram is supplied by a contemporary account on his art. Colonel Sleeman narrates an episode that occurred in early 1836:

I have elsewhere mentioned, that the state of imbecility to which a man of naturally average powers of intellect may be reduced when brought up with his mother in the seraglio, is inconceivable to those who have not had opportunities of observing it. The poor old emperor of Delhi [i.e. Akbar II (1806–1837)], predecessor of Bahadur Shah of Delhi, to whom so many millions look up, is an instance. A more venerable looking man it is difficult to conceive;[2] and had he been educated and brought up with his fellow men, he would no doubt have had a mind worthy of his person. As it is, he has never been anything but a baby. Rajah Jewun Ram [i.e. Jivan Ram], an excellent portrait painter, and a very honest and agreeable person, was lately employed to take the Emperor's portrait. After the first few sittings, the picture was taken into the seraglio to the ladies. The next

time he came, the Emperor requested him to remove the great blotch from under the nose. "May it please your majesty, it is impossible to draw any person without a shadow; and I hope many millions will long continue to repose under that of your majesty." "True, Rajah," said his majesty, "men must have shadows; but there is surely no necessity for placing them immediately under their noses! The ladies will not allow mine to be put there; they say it looks as if I had been taking snuff all my life; and it certainly has a most filthy appearance; besides, it is all awry, as I told you when you began upon it!" The Rajah was obliged to remove from under the imperial and certainly very noble nose, the shadow which he had thought worth all the rest of the picture. Queen Elizabeth is said, by an edict, to have commanded all artists who should paint her likeness, "to place her in a garden with a full light upon her, and the painter to put any shadow in her face at his peril!" [3]

Sleeman is the only witness to call Jivan Ram a "Rajah," which in this case was most probably an honorific title and not the (functional) title of a ruler of some state (cf. cat. no. 47). At least two paintings by him, one showing General Cartwright, dated 1834, and the other representing Antonio "Regholini," dated 1835, are signed "Raja Jiwan Ram." [4]

The fact that the present British officer is "squint-eyed," in addition to the fact that the blotch under his nose, executed here in dark red, becomes most apparent if one looks closely, is alone sufficient to prove Jivan Ram's authorship. Perhaps the strongest proof, however, is the stylistic comparison with another oil, signed "Jewan Ram" and dated "1827." It is a more than half-length portrait of a Briton in a tight red uniform, partly set against a dark, cloudy background below which appears "the church and cantonment at Meerut." [5] Both paintings share a number of common features, such as the "blotch" under the nose,[6] and the fact that both gentlemen are "squint-eyed" and partly set against a dark background, as was the fashion for oils in those days. Jivan Ram was certainly a painter who operated from Meerut more than from any other place. All contemporary accounts on Jivan Ram quoted in the following cat. no. 47 mention that place as his center of activity. The recently published oil painting of Captain Robert McMullin (1786–1865) mentioned above was certainly painted there. Continuing his account on the "Rajah," i.e. Jivan Ram, Colonel Sleeman also remarked, "When the Rajah returned to Meerut. . ." [6]

Moreover, the Mughal emperor's comment regarding the blotch under the nose was appropriate, as the artists of all his predecessors as well as his own painted in an Indian style which greatly differed from what could be called a "European" style. That the Mughal painters did not employ European techniques and were therefore accustomed to the style which they had developed and cherished for centuries can certainly not be used as an argument against their aesthetic understanding, which was different, but certainly by no means inferior to non-Indian, European ideas about aesthetics. Sleeman, Bacon, and a number of others are in the line of François Bernier, who already in the seventeenth century remarked on Indian painting: "The Indian painters are chiefly deficient in just proportions, and in the expression of their face; but these defects would soon be corrected if they possessed good masters, and were instructed in the rules of art.[8] The "rules of art" were for Bernier, Sleeman, and others exclusively mastered, if not owned, by Western Europeans. Nonetheless, Bernier confessed: "I had often admired the beauty, softness, and delicacy of their paintings and miniatures." [9]

Another French source contemporary to the paintings by Jivan Ram judged Indian painting as follows: "One does not see any landscape, or just a tree or two, drawn without regard to perspective, without shadows nor light."[10] The Western "superiority" with regard to the aesthetically appealing depiction of a sitter or a scene was based on what the Westerner thought to be the "correct" depiction of shadow and light. Whereas the Indian artist—to the Western mind—was not concerned with it. The "baby" was in fact Sleeman himself, who was unable to transcend his own limits of aesthetic understanding and personal prejudices, nourished by Anglo-European despotism acted out under the aegis of parliament. Colonel Sleeman was the arbiter of "correctness." Sleeman, after all, did not

narrate the incident with Jivan Ram in order to illustrate the artist's skill; Sleeman wanted to demonstrate "imperial imbecility."[11]

Emily Eden, keeping with Sleeman's mode of expression, was doubtlessly more "adult," when she thought further while looking at "native" sketches during a *darbar*: "[I]f my drawing looked as odd to him [i.e. a native painter sketching at the *darbar*] as his did to me, he must have formed a mean idea of the arts in England."[12] That the native artist responded as Eden suggests is shown by the reaction of the Mughal emperor and his wives to European technique as employed by the versatile artist Jivan Ram. The native Jivan Ram's great achievement illustrated here by cat. nos. 19 and 47 must be seen in this context.

The only other published dated portrait by Jivan Ram is from 1831. It shows Maharaja Ranjit Singh (1780–1839, cf. cat. no. 22), painted "in 1831 at Rupar, on the Sutlej, in the present district of Ambala."[13] It was painted for the then Governor General, Lord William Bentinck.

NOTES

1. The same officer at an earlier stage of life may be depicted in Archer 1979, p. 405, fig. 323. This portrait, however, is also not identified.
2. Sleeman has published a col. lithograph of this emperor as frontispiece to the first vol. of his *Rambles*, but only in the first edition of 1844.
3. Sleeman 1844, vol. II, p. 285f. This passage, in a much more abridged form, is also quoted in Archer/Archer 1955, p. 68. The source mentioned should be Sleeman 1844, p. 525, according to footnote 1 on the same page. However, neither of the two volumes publishing Sleeman's account in the 1844 edition has that many pages. Losty in Losty 93, p. 18 of "silent pagination" [page 1 = title page] certainly quotes the 1844 edition, since he writes the title of the painter with an "h" at the end (Rajah) as it appears in the text, whereas in Archer's quotation the "h" is dropped. Losty, however, does not give any vol. or p. no.
4. Lafont 1992, p. 316, note 175. These paintings are now in the Ashmolean Museum, Oxford. For a fuller account on these paintings, see Cotton 1934, pp. 32–41. Another painting representing the Quartermaster Rogers is signed "J.R. 1833," which probably means that sometimes Jivan Ram did not use this title (Raja) when signing a painting.
5. Losty 1993, p. 16ff. of "silent pagination." In this case the officer, a captain, is properly identified.
6. Emphasized by Losty in Losty 1993, p. 18.
7. Sleeman 1844, vol. II, p. 287. This discussion is necessary since Jivan Ram was hitherto considered to have worked basically from Delhi. He was even called a "Delhi artist;" cf. Hendley 1909, p. 64; Archer/Archer 1955, p. 68, or more recently Archer 1992, p. 164 or Leach 1995, vol. II, p. 790.
8. Bernier 1916, p. 255.
9. Bernier 1916, p. 254.
10. Jancigny/Raymond 1845, p. 231: "On n'y voit pas de paysage, ou tout au plus un arbre ou deux, dessinés sans égard pour la perspective, sans ombres, ni lumière." Cf. also: "Ils [i.e. the Indian painters] font aussi des tableaux de petite dimension, qui ont la prétention d'être des portraits, et qui sont en effet quelquefois assez ressemblants; mais c'est tout ce qu'on en peut dire." (They [the Indian painters] also produce small-sized pictures, which claim to be portraits, and which, at times, resemble them a little; but this is all that can be said about them).
11. Sleeman 1844, vol. II, p. 285, headline.
12. For a fuller quotation of this passage see cat. no. 22.
13. Hendley 1909, p. 64. For the painting see ibid., col. pl. 49, fig. 324.

20 Nawab Nasir ud Din Haidar
(1827–1837), King of Oudh,
with his Minister Vazir
Motamad ud Daula Agha
Mir in the Kudsia Mahal,
Lucknow

∼

by a local artist, Lucknow, ca.
October–December, 1827.

Media: Gouache on paper

Size: 10³/₄ x 8¹/₈ in.
(27.3 x 20.6 cm.)

Inscribed: On painted surface,
below the table: "Kudsia
Mahal." Below the king, also
on the red carpet: "Nasiruddin
Haidar 2nd / King of Oudh."
And in the lower right corner:
"Nawab Wazir Motamud
daulah."

Contemporary descriptions of Nasir ud Din Haidar, seen here smoking an immense hookah or water-pipe, include the following:

The king, Nuseer-ood-Deen Hyder, is a plain, vulgar-looking man of about 26 years of age, his stature about 5 feet 9 inches, and his complexion rather unusually dark. His Majesty's mental endowments, pursuits, and amusements, are by no means of an elevated or dignified order; though his deficiencies are in some measure supplied by the abilities and shrewdness of his minister, who is, however, an unexampled rogue, displaying it in his countenance with such perspicuity of development as would satisfy the most sceptical unbeliever in Lavater. He is detested by all ranks, with the exception of his royal master, who reposes the most perfect confidence in him. (G. C. Mundy, December 11, 1827)[1]

On arriving at the palace we sat down to breakfast with his Majesty and his courtiers. The King was splendidly attired in a tunic of green velvet, and girded with a costly shawl. He wore a diademed turban, and his person was profusely ornamented with necklaces, earrings, and armlets of the most brilliant diamonds, emeralds and pearls. (G. C. Mundy, December 11, 1827)[2]

During breakfast I had an opportunity of observing the King's dress, which, being covered with jewels, was of great value. On his head he wore a turban, formed something like a coronet, having round it a circle of precious stones, radiating into points: two rows of large pearls went round the top, and the whole was crowned with a plume of heron's feathers. His clothes were of cloth of gold, called kimkaub, and he wore a collar in imitation of that of the Garter. This was formed of three rows of large pearls, with emeralds between, and separating the pearls into the form of links. Round his throat was a tight collar of pearls, and necklaces of the same valuable ornaments depended from his neck. His armlets were of diamonds, and appeared magnificent.
(Major Archer, December 11, 1827)[3]

The king was clad in a tunic of cashmere shawl, well suited to the coolness of the evening. He wore a red and gold turban, ornamented with a superb diamond aigrette, the whole surmounted by an elegant tuft of pendent feathers tipped with brilliants. Eight or ten necklaces of diamonds, emeralds, and pearls hung on his breast, and his arms and wrists were loaded with bracelets. (G. C. Mundy, December 14, 1827)[4]

Other descriptions of Nawab Nasir ud Din Haidar also exist. Their authenticity, however, cannot properly be ascertained.[5] Not less noteworthy are descriptions of the minister, Vazir Motamad ud Daula Agha Mir, standing behind the left shoulder of the king. He already appears in the first of Mundy's descriptions of the king, as quoted above. Earlier statements include the following:

I was told the prime-minister was come to call on me. . . . He is a dark, harsh, hawk-nosed man, with an expression of mouth which seems to imply habitual self-command struggling with a naturally rough temper. He is, I understand, exceedingly unpopular. He was originally khânsaman [butler] to the present king [Ghazi ud Din Haidar 1814–1827], when heir-apparent and in disgrace with his father, Saadut Ali. His house is the most splendid in Lucknow, and his suwarree [horse escort] exceeds that of the King, who is said to be so attached to him as to have given himself entirely into his hands. His manners, though not his appearance, are those of a gentleman; he is said to be a man of undoubted courage, and to be a pleasant person to do business with, except that too much confidence must not be placed in him. He was very civil to me, and very tolerant of my bad Hindoostanee, but saw that he was nursing some ill-humour towards Mr. Ricketts. . . . His dark countenance cleared up. . . . (Reginald Heber, October 21, 1824)[6]

Another visitor to Lucknow observed:

It was evident that something was going wrong with the Minister, as he was not admitted into the audience with the King and the Commander-in-Chief. At meals he invariably took his station opposite the King but scarcely had he sat down, when up he got, and hied round close to his Majesty's elbow, to find out what was passing between his master and the Commander-in-Chief, and Resident. This anxiety occurred every time the King appeared at table. Reports state his not being likely to continue as minister, as the person to whose place

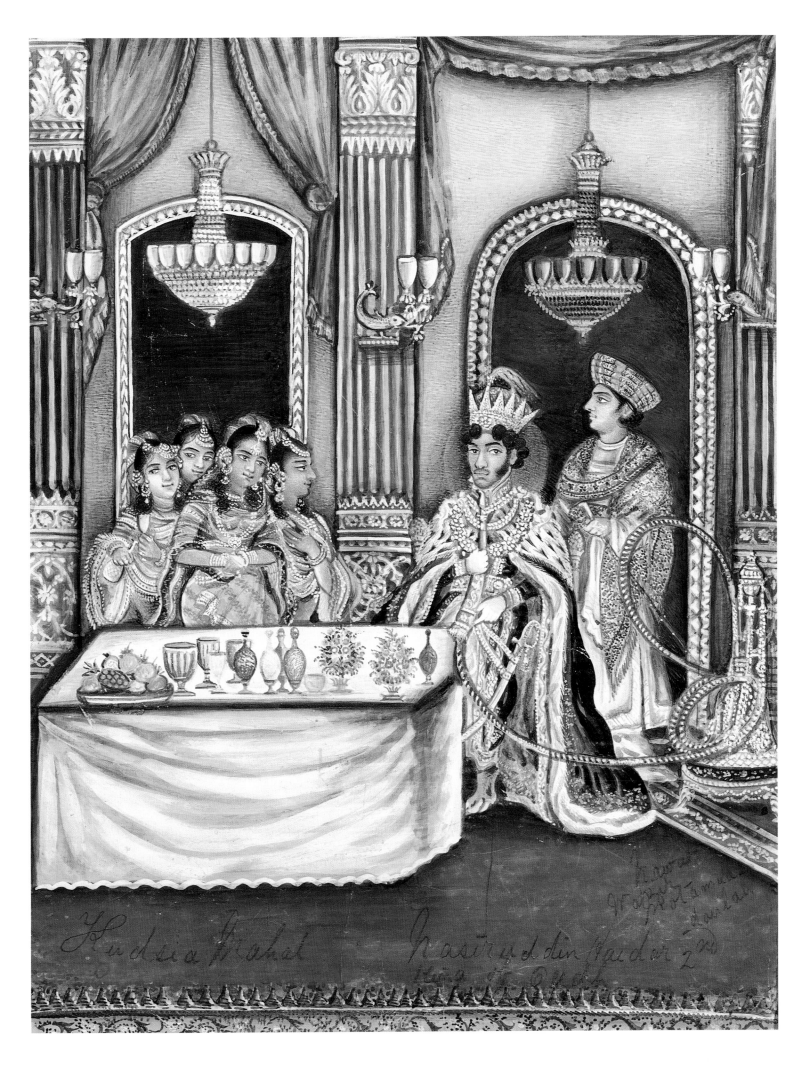

Kudsia Mahal

Nasir-ud-din Haider 2nd
King of Oudh

Nawab
Wajid Ali
Mirza
Damad

In the second half of December 1827, Vazir Motamad ud Daula Agha Mir was in fact dismissed from office,[8] which suggests that the present painting should be from about that period. That the man who is identified as being the "Nawab Wazir Motamud daulah" is in fact that minister is confirmed by a painting which shows Nasir ud Din Haidar's predecessor, Nawab Ghazi ud Din Haidar, entertaining Lord and Lady Moira. He is shown facing left behind the left shoulder of the king, standing below a lamp with three glass cylinders fixed to a wall.[9] That Agha Mir "had waited behind the prince's chair when the latter dined with Lord Moira at Cawnpore" is a historical fact.[10] The artist of the present painting also did another, in which the same minister is seen standing behind Nawab Nasir ud Din Haidar, who is seated on a bed.[11]

Writing in late January 1831, Fanny Parks stated that the King of Oudh had then "five queens, although by Mahummadan law he ought only to have four."[12] It is, however, not sure, whether the four women shown in this painting are four of the king's queens or just attendants, whose beauty by some was compared to that of Venus.[13] "Older residents of Lucknow assert that Nasir ud Din Haidar, in addition to his effeminate and puerile behaviour, was also extremely tyrannical and that because he spent the whole of his time with women, the objects of his tyranny were mostly women. He immured scores of women for the smallest faults or merely on suspicion."[14] The fish as seen as lampholder in this painting belonged to the insignia of the court of Lucknow.[15]

Only very few contemporary paintings of Nawab Nasir ud Din Haidar have survived. Another often reproduced example has on its back an inscription in pencil which reveals that the painting, together with other "drawings in the Book were found ... in the "Kaiser Bagh," a Royal Palace in Lucknow in the beginning of 1858–after the Capture."[16] Lucknow, the Dresden of India,[17] was stripped of its movable treasures by the British and its allied forces in 1858, after the capture of the "Kaisar Bagh," the royal palace, on March 14, 1858:

It was one of the strangest and most distressing sights that could be seen; but it was also most exciting. Discipline may hold soldiers together till the fight is won; but it assuredly does not exist for a moment after an assault has been delivered, or a storm has taken place. ... From the broken portals issue soldiers laden with loot or plunder. Shawls, rich tapestry, gold and silver brocade, caskets of jewels, arms, splendid dresses. The men are wild with fury and lust of gold — literally drunk with plunder. Some come out with china vases or mirrors, dash them to pieces on the ground, and return to seek more valuable booty. Others are busy gouging out the precious stones from the stems of pipers, from saddle-cloths, or the hilts of swords, or butts of pistols and fire-arms. Some swathe their bodies in stuffs crusted with precious metals and gems; others carry off useless lumber, brass pots, pictures, or vases of jade and china And now commenced the work of plunder under our very eyes. The first door resisted every sort of violence till the rifle-muzzle was placed to the lock, which was sent flying by the discharge of the piece. The men rushed in with a shout, and soon came out with caskets of jewels, iron boxes and safes, and wooden boxes full of arms crusted with gold and precious stones! One fellow, having burst open a leaden-looking lid, which was in reality of solid silver, drew out an armlet of emeralds, and diamonds, and pearls, so large, that I really believed they were not real stones, and that they formed part of a chandelier chain. ...

The scene of plunder was indescribable. The soldiers had broken up several of the store-rooms, and pitched the contents into the court, which was lumbered with cases, with embroidered clothes, gold and silver brocade, silver vessels, arms, banners, drums, shawls, scarfs, musical instruments, mirrors, pictures, books, accounts, medicine bottles, gorgeous standards, shields, spears, and a heap of things, the enumeration of which would

make this sheet of paper like a catalogue of a broker's sale. Through these moved the men, wild with excitement, "drunk with plunder." I had often heard the phrase, but never saw the thing itself before. They smashed to pieces the fowling-pieces and pistols to get at the gold mountings and the stones set in the stocks. They burned in a fire, which they made in the centre of the court, brocades and embroidered shawls for the sake of the gold and silver. China, glass, and jade they dashed to pieces in pure wantonness; pictures they ripped up, or tossed on the flames; furniture shared the same fate. . . .[18]

House after house was being plundered of its furniture and miscellaneous contents, and swords, in rich scabbards, embroidered cloths, shawls, ornaments, and a most extraordinary and varied assortment of European articles of every kind of description, guns, clocks, books, &c., were spread about in every direction. No order had been issued against plundering, and there was no doubt that an immense booty, in hard cash and jewels alone, was obtained that day.[19]

These quotations from eye-witness reports published shortly after the siege of Lucknow may explain why so few paintings from the atelier that created the present painting survived.[20] Nawab Nasir ud Din Haidar "presented the Commander-in-Chief with his portrait, set in diamonds, and suspended to a string of pearls and emeralds,"[21] as he must have probably done with other portraits of himself. It is not known what happened to them; the incident, however, proves that the Nawab of Oudh must have entertained an atelier of artists which produced the small portraits for that purpose. Nasir ud Din Haidar was, if we are to believe the descriptions of his appearance, of comparatively dark complexion. This is not reflected by his portraits done by Indian painters, such as Muhammad Azam[22] or the artist who did the present painting in addition to those in the same style. That the Indian artist used to depict his sovereign with a rather bright complexion was already observed by Emily Eden during a *darbar* of Ranjit Singh.[23] The present painting, along with the others executed in the same style, underlines that the rulers of Oudh, despite having a number of well-known European artists in their employ — among which were John Zoffany and Robert Home — always continued to support their own native artists.

NOTES

1. Mundy 1858, p. 11.
2. Mundy 1858, pp. 12–13.
3. Archer 1833, vol. I, p. 17.
4. Mundy 1858, p. 17.
5. A description of the Kingh of Oudh, reportedly by a British "member of the household" of the king, informs: "His majesty was dressed as an English gentleman, in a plain black suit, a London hat on his head. His face was pleasing in its expression, of a light, a very light sepia tint. His black hair, whiskers, and moustaches contrasted well with the colour of the cheeks, and set off a pair of piercing black eyes, small and keen. He was thin, and of the middle height." (Knighton, ed., 1921, p. 14).
6. Heber 1828, vol. I, pp. 375–376. Mr. Mordaunt Ricketts was Resident at Lucknow from 1823-1830.
7. Archer 1833, vol. I, pp. 37–38. For more historical information see the introduction by S. B. Smith in Knighton 1921, p. xxi and passim.
8. S. B. Smith in Knighton 1921, p. xxv. In the first half of that month, he was still seen in his office by Mundy and Archer. For a story illustrative of his character, see Sharar 1975, p. 159.
9. For this often reproduced painting in the India Office Library, London, see Archer 1972, pl. 54 = Sharar 1975, pl. 19, facing p. 176 = Welch 1978, p. 98, no. 41.
10. S. B. Smith in Knighton 1921, p. xxi.
11. Reproduced: Soustiel/David 1973, full-page illus. p. 123, no. 141 (= *Art Islamique*, 16 Décembre 1988, p. 54, no. 42).
12. Parks 1975, vol. I, p. 193.
13. Knighton 1921, pp. 21–22.
14. Sharar 1975, pp. 57–58.
15. For a contemporary description cf. Parks 1975, vol. I, pp. 187–188.
16. Archer 1972, p. 163. For a reproduction of this painting, see ibid., pl. 56 (= Sharar 1975, pl. 20, facing p. 176, bottom = Nevile 1996, p. 44, col. pl. 24).
17. Heber 1828, vol. I, p. 383.
18. Russel 1860, vol. I, pp. 329–333. The diamonds in the crown of the King of Oudh were even mistaken for pieces of glass, cf. Russel 1860, vol. II, p. 39.
19. Medley 1858, pp. 182–183.
20. For other paintings from the same atelier, cf. e.g. Pemble 1977, illus. opp. p. 148, top; Pal/Dehejia 1986, p. 159, fig. 160.
21. Mundy 1858, p. 13.
22. Sotheby's N.Y., September 19, 1996, lot 193, col.
23. For the quotation of the relevant passage, see cat. no. 16.

21 Portrait of Maharaja Chandulal, Chief Minister (1809–1843) of the Nizam of Hyderabad, Nawab Ali Khan, Asaf Jah IV (1829–1857)

∽

by a local artist after a painting presumably by John Goodwin Williams (fl. 1813–1837), Hyderabad, ca. 1836–1844.

Media: Gouache on paper laid down on board

Size: 10¼ x 8½ in. (26 x 21.6 cm.)

Inscribed: In *Nagari*, left part of the text-panel: *surapur davemkam[?] ua[?] / barad bhav* [or: *khav?*] *citra* (meaning not entirely clear). In English, left part of text-panel: "MahaRajah / ChundOOLal / BahadOOr / Dewan-Peshear / Hyderabad." In *Nashtaliq*, right half of the text-panel: *rajayan raja[h] Candu la'l, maharaja[h] bahadur, fadvi rustam-i dauran, aristo-i zaman; muzaffar-ul mamalik, Nizam u'd-daula[n], Nizam u'l-mulk, Asif Jah* (Maharaja Chandulal, servant to the present Rustam, the Aristoteles of the time, the conquerer of countries, the Nizam of the empire, the Nizam ul-Mulk, Asaf Jah).

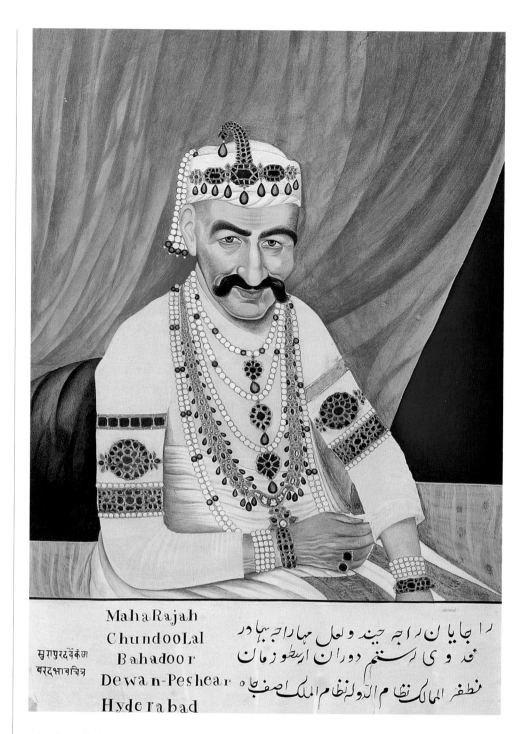

सुराणुरद्वेंक्ष
बरदभावचित्र

MahaRajah
ChundooLal
Bahadoor
Dewan-Peshear
Hyderabad

راجایان راجہ چند ولعل مہاراجہ بہادر
فدوی رستم دوران ارسطو زمان
مظفر الممالک نظام الدولہ نظام الملک اصف جاہ

Chundoo Lall, the Minister, is a remarkable man. Above seventy-seven years of age, attenuated to a mere shadow, and bent nearly double, he yet has all the active intelligence of earlier life, and the same keen and expressive eye, with that pleasing and benevolent smile that never abandons him. When he called upon me he was obliged, on alighting from his elephant, to be borne up the steps of the Residency in a tonjon [a kind of palanquin]. He conversed with me for an hour in the most animated way possible, speaking Hindustani and Persian with equal fluency. When I returned his visit, which was in the evening a few days afterwards, he gave me a magnificent entertainment in the grandest and most Oriental style. (General James Stuart Fraser in a letter to Lord Elphinstone, dated October 26, 1838)[1]

Chandulal was an experienced man, who could not easily be removed by the British in the usual way, by declaring him invalid, stupid, etc. The British hence had to look for another reason:

Chandoo Lall was manifestly the great obstacle to reform, the incubus that weighed heavily upon the Hyderabad State, sunk in uneasy slumbers, and yet the removal of that obstacle seemed a more and more delicate and troublesome operation. The Minister's position, both in Hyderabad and Calcutta, was a very strong one, if only from his extreme old age, and his thirty years of undivided power.[2]

James Stuart Fraser finally managed to have the minister "with that pleasing and benevolent smile that never abandons him," as Fraser had described him, removed. In a letter to the then Governor General of India, Lord Ellenborough, dated October 30, 1843, Chandulal himself described the way in which Fraser did it:

I beg to inform your Lordship, that there are two circumstances under which, on the general plea of bodily infirmity, I have considered it expedient to resign the office of Dewan... The ... reason is that General Fraser and Captain Malcolm have entered into a plot with Sooraj-ool-Moolk for the purpose of ruining me. These gentlemen applied for a private audience with the Nizam, and being admitted into the presence, accused and spoke disparagingly of me, and recommended that Sooraj-ool-Moolk should be appointed Dewan in my room. To this advice the Nizam was pleased to make answer, "Chandoo Lall has now for many years been conducting the duties of Dewan. On what grounds should he be dismissed from his post, or why should Sooraj-ool-Moolk, a man who shows by his being in debt some twenty-three lakhs [2,300,000] of rupees that he is incapable of managing his own private affairs, be considered able to discharge the duties of Dewan?" General Fraser and Captain Malcolm, on hearing these words, were silenced. They are, however, bent on my ruin, and I have therefore thought it better to tender my resignation. These gentlemen have, furthermore, recommended my expulsion from Hyderabad; and to this recommendation the Nizam has been pleased to reply that "now that Chundoo Lall has voluntarily resigned, he remains in his own house; and on what ground should he be turned out of the city? How can I adequately return thanks for His Highness for the kindness thus evinced on my behalf? Finally, General Fraser, acting under the instigation of Sooraj-ool-Moolk, will listen to no representations of mine, but endeavors to incense the Nizam against me.[3]

Chandulal died in April 1845[4] and "Sooraj-ool-Moolk" was invested with full powers as minister on November 2, 1846.[5]

The present painting is a copy, or rather a translation, of a British oil painting into an Indian portrait miniature either after a painting, which is now in the India Office Library, London, or after the mezzotint by C. Turner, published in 1844. The oil painting is signed "J. Williams," which in all probability stands for John Goodwin Williams, who is listed as "artist" among the inhabitants of Bombay.[6] Williams was not the only Western artist who happened to be in Hyderabad during Fraser's residency. F. C. Lewis probably sketched the very "magnificent entertainment in the grandest and most Oriental style" that Fraser mentioned.[7]

Williams's portrait shows the minister in plain white dress, without any ornaments or jewelry. The turban ornament, finger rings, necklaces, etc., were all added by the artist of the present painting. The golden ornaments are even applied in such a way as if they were real: they are executed in relief. It seems as if the painter has taken the designation "maharaja" literally, since all rulers thus designated are normally bedecked with the finest jewelry. What, however, is more astonishing than the jewelry, is that the artist very ably caught "that pleasing and benevolent smile that never abandons him."

NOTES

1. Fraser n.d., pp. 79–80. The author, James Stuart Fraser (1783–1869), was Resident at Hyderabad from September 1838 to December 1852. The copy of the book from which the letter is quoted, is lacking its title page. It contains Fraser's memoirs.
2. Fraser n.d., p. 114.
3. Fraser n.d., pp. 196–197.
4. Fraser n.d., p. 206.
5. Fraser n.d., p. 210.
6. Archer 1986, p. 47. For reproductions of this oil painting, see ibid., pl. XI, no. 63 or Bayly 1990, p. 193, no. 231.
7. Nevile 1996, p. 61, no. 39.

22 Portrait of Hira Singh
 (ca. 1815–1844), Favorite
 of the Sikh Leader Ranjit
 Singh (1780–1839)
 ∾
 by Emily Eden (1797–1869),
 Lahore-Amritsar,
 November–December 1838.

 Media: Pencil on paper

 Size: 12¼ x 9½ in.
 (31.1 x 24.1 cm.)

Miss Eden's remarks in her letters suggest why she was inspired to draw the likeness of this young gentleman:

Next to him [i.e. Ranjit Singh, the ruler of the Sikh empire] *sat Heera Singh, a very handsome boy, who is Runjeet's favourite, and was loaded with emeralds and pearls. Dhian Singh, his father, is the prime minister, and uncommonly good looking: he was dressed in yellow satin, with a chain armour and steel cuirass. All their costumes were very picturesque.* (Lahore, late November 1838)[1]

Luckily, beyond him was Heera Singh, who has learnt a little English, and has a good idea of making topics… (early December, Heera Singh, Runjeet's favourite, came to my tent to sit for his picture, but there was some difficulty about his coming, so he arrived late, and it was too dark to draw him well. Runjeet sent word that he considered him "his best beloved son," and hoped somebody of consideration would be sent to fetch him.) (Lahore, December 20, 1838)[3]

Ranjit Singh "made us over to… Heera Singh, who, in his capacity of favourite, enters the anderoon, and I should think must endanger the peace of mind of some of the thirty-two Mrs. Runjeets. He is very good-looking. (December 28, 1838)[4]

Frances (Fanny) Eden, who accompanied her sister Emily, left the following remarks on the sitter of the present drawing: "Heera Singh, a boy who has great power over Runjeet. . ." (Ferozepore, December 2, 1838)[5]

Heera Singh, his [i.e. Ranjit Singh's] *prime minister's son, whom he makes a favourite of, came to see us today with an enormous escort….* (Lahore, December 23, 1838)[6]

Major Wade went to see Runjeet today — he found him very low about himself as he is always when he is ill, sitting up in his little room, the faquir squatting at his feet, the Prime Minister, Dhian Singh, standing, and his son, Heera Singh, Runjeet's favourite, seated in a chair by him. Dhian Singh is never allowed a seat. Heera Singh lives in much more state than either of Runjeet's sons, and has a very large military command though he is not twenty. He talks a great deal of English, and is constantly writing notes to William, beginning "My dear Osborne" and "My dear Friend." His dress is always splendid. When George and Runjeet are in one howdah he sits behind and acts as Runjeet's interpreter. (Lahore, December 25, 1838)[7]

"Heera Singh, the favourite. . . (Lahore, December 28, 1838)[8]

Another passage on Heera Singh, by the artist's nephew, William Osborne, deserves a full quotation since it was written down only a few months before Lord Auckland and his two sisters (Emily and Fanny) arrived at the Sikh court:

Rajah Heera Sing, the son of the minister, a boy of eighteen years of age, is a greater favourite with Runjeet Sing than any other of his chiefs, not even excepting his father. His influence over Runjeet is extraordinary; and though acquired in a manner which in any other country would render him infamous for ever, here he is universally looked up to and respected. He is the only individual who ever ventures to address Runjeet Sing without being spoken to, and whilst his father stands behind his master's chair, and never presumes to answer him with unclasped hands, this boy does not hesitate to interrupt and contradict him in the rudest manner. One instance of the way in which he presumes upon the kindness of Runjeet Sing was the subject of public conversation at Adeenanuggur upon our arrival. The yearly tribute from Cachemire had arrived, and was, as usual, opened and spread upon the floor in the Durbar for the inspection of the Maharajah. It consisted of shawls, arms, jewels, &c, to the amount of upwards of thirty thousand pounds. Young Heera Sing, without the slightest hesitation, addressed Runjeet and said, "Your Highness cannot require all these things; let me have them." The answer was, "You may take them." Heera Sing is strikingly handsome, though rather effeminate in appearance. He was magnificently dressed, and almost entirely covered from the waist upwards with strings of pearls, diamonds, emeralds and rubies; he is intelligent and clever, and has taken a fancy to learn English, which he studies for some hours every day, and in which he has already made considerable progress, being perhaps the

Fig. 2

only individual who would venture to do such a thing openly. Good-tempered, gentleman-like, and amusing, he is certainly one of the most amiable and popular persons at the court of Lahore. (May 29, 1839)[9]

The attachment of Ranjit Singh to the son of his minister was already observed by Baron von Hügel as early as January 13, 1836: During the official reception (*darbar*), "Hiera Sing, ein Jüngling von 16 Jahren" (a youth aged 16) was allowed to sit on a chair, whereas all the other grandees of the empire had to sit on the floor.[10] From a remark by Vigne, another European visitor at Ranjit Singh's court, one is even inclined to believe that Hira Singh was Ranjit Singh's son.[11]

Hira Singh's life is summarized and his character "is thus sketched by the rude but vigorous hand of one who knew him well."[12]

Of Rajah Heera Sing, at one time the virtual ruler of the Punjaub a few words may be said. He was twenty-three years of age and was what might be called a spoiled child when he died. The pet of Runjeet, or Runjeet's own last darling chicken, perhaps his last and most loving victim; made up of many of the most curious and contradictory ingredients; still addicted to low cunning, pride, effeminacy and licentious debauchery — the shameless intruder and Paul Pry of the court harem. Crouching, mean and timid to superiors, or those to be dreaded; silent and suspicious to equals; proud, supercilious and arrogant to inferiors; subtle and deceitful to all: — too proud and high to take notice or even return the salute of men of higher rank and certainly of better character than himself; reared and brought up as the lap-dog of Runjeet and his dissolute associates; with a little smattering of English, Persian and Sanscrit, and pretending to a perfect knowledge of all! In person somewhat handsome, and approaching to his father's likeness; always rectifying his dress, whiskers, beard, mustachios, and invariably chewing or seeming to chew something. Clean, neat, and showy in appearance, the would-be copy of his father — but too effeminate and proud; unstable, or seemingly, dare not walk, stir, sit, rise, eat, drink, or sleep, or even speak, answer, think, suggest or decide, without what? A trifling sign — a careless nod — or some other sufficient token of consent from the magic finger of his mysterious jailor, his old and original guardian spirit, his grand secret, his sole adviser, his powerful magician, his sworn friend and protector, his preceptor, master, tutor, father and brother, — inferior and superior, Misser Jellah Pundit![13]

Emily Eden's portrait of Hira Singh is unsigned, but undoubtedly the portrait she did when he was sitting for her in 1838. It was lithographed for her *Portraits of the Princes and People of India during the Years, 1838, 39, 40, 41*,[14] published in 1844. The respective illustration is captioned "Raja Heera Singh," (see accompanying fig. 2) and is probably the best known of her lithographs.[15] Her publication as such was so famous that Fanny Parks added a note on it to her diary entry for May 14, 1836.[16] The present portrait was not only lithographed to become her most successful published picture: Hira Singh's portrait was among those which Emily Eden cut out of her sketchbook in order to have it copied on ivory by two painters from Delhi. On February 20, 1839 she reported from the Delhi residence:

I have had two Delhi miniature painters here, translating two of my sketches into ivory, and I never saw anything so perfect as their copy of Runjeet Singh. Azim, the best painter, is almost a genious; except that he knows no perspective, so he can only copy. He is quite mad about some of my sketches, and as all miniatures of well-known characters sell well, he has determined to get hold of my book. There is a fore-shortened elephant with the Putteealah Rajah in the howdah, that particularly takes his fancy. However, I do not want them to be common, so I cut out of the book those that I wish to have copied, and never saw a native so nearly in a passion as he was, because he was not allowed the whole book. Their miniatures are so soft and beautiful.[17]

On January 2, 1843, Leopold von Orlich was astonished to be shown among the precious presents for the queen of England "a bad portrait of Ranjit Singh, painted with body-colors on paper."[18] The reason for this portrait was almost certainly Emily Eden's portrait of the queen, which was given to Ranjit Singh when she saw Heera Singh for the first time. Emily Eden wrote on that picture on October 12, 1838:

G[eorge] wants to give Runjeet a picture of our queen in her coronation robes. The Sikhs are not likely to know if it is an exact likeness as far as face goes, and the dress I have made out quite correctly, from descriptions in the papers and from prints, and it really is a very pretty picture. It is to be sent to Delhi tomorrow, and it is to have a frame of gold set with turquoises, with the orders of the Garter and the Bath enamelled. In short, it will be "puffect, entirely puffect"; but I think they ought to give me Runjeet's return present, as it has cost me much trouble to invent a whole queen, robes and all.[19]

About six weeks later (November 24) she stated:

Then Mr. B. . . . undertook on the public account a frame for my picture of the Queen, which is to be given to Runjeet, and the frame came. . . . They had no time for the beautiful design of all the orders of the Garter and Bath, &c., which I wanted, and so only made the frame as massive as they could. It is solid gold, very well worked, with a sort of shell at each corner, encrusted with precious stones, and one very fine diamond in each shell.[20]

It was on the occasion of the presentation of this painting of the queen, when Emily Eden first noticed Hira Singh (see first quotation above):

[S]ome of our gentlemen marched up the room with my picture of the Queen on a green and gold cushion; all the English got up, and a salute of twenty-one guns was fired. Runjeet took it up in his hands, though it was a great weight, and examined it for at least five minutes with his one piercing eye, and asked B. for an explanation of the orb and sceptre, and whether the dress were correct, and if it were really like; and then said it was the most gratifying present he could have received, and that on his return to his camp, the picture would be hung in front of his tent, and a royal salute fired.[21]

The Sikhs also admired portraits of themselves and employed a certain number of artists which enabled them to have a visual record of the more important people as well as the more important events, mostly *darbars*. Hira Singh was almost about to marry a close relative of Raja Sansar Chand of Kangra, the famous patron of Pahari painting.[22] It is therefore not surprising that a certain number of portraits of Hira Singh done by Sikh artists have survived, some of them even stem from the collection of Emily Eden's "G.," Lord Auckland.[23] These Sikh portraits — showing Hira Singh at various stages of his life — demonstrate that Emily Eden's portrait is very reliable.

European art historians who are unaccustomed to judge portraits by Indian artists would probably be inclined to claim quite the opposite. Baron von Hügel admired the "skill and precision" of a Sikh artist, who painted Govind Singh on a standard or flag by January 25, 1836. The same artist carried a map of drawings by Vigne with him.[24] Vigne, when interviewed by Ranjit Singh, declared himself to be a painter.[25] Emily Eden, at the description of a royal reception at the Sikh court — Hira Singh was present — on December 22, 1838, wrote:

The review was quite picturesque, but rather tiresome; however, I did not much care, for I changed places with E., and got a quiet corner from which I could sketch Runjeet. I was on his blind side, but they said he found it out, and begged I might not be interrupted. One of his native painters was sketching G[eorge], and if my drawing looked as odd to him as his did to me, he must have formed a mean idea of the arts in England. They put full eyes into a profile, and give hardly any shade. They paint their own people with European complexions, from coxcombry, so that ours are a great puzzle to them, because we are so white.[26]

Hira Singh accompanied Leopold von Orlich to a *darbar* with Lord Ellenborough on January 2, 1843.[27] Von Orlich remarked during the *darbar*:

On occasions of this kind it is customary for the Indian nobles to bring the artist attached to the court, to take the portraits of those present: the painter of Shere Singh was, therefore, incessantly occupied in sketching with a black lead pencil those likenesses which were afterwards to be copied in water colours, in order that they might adorn the walls of the royal palace; and some of them were admirably executed. I was among the hon-

oured few and the artist was very particular in making a faithful representation of my uniform and my hat and feathers.[28]

A comparison of the present drawing with the published lithograph (see accompanying fig. 2) reveals to which extent Lowes Dickinson, the lithographer, has softened the provocative expression of the self-confident sitter. His face in the lithograph looks almost innocent when compared to the original drawing and one would probably not pay any attention to the description of Hira Singh's character, had the original drawing not survived the ravages of time. The following question, however, remains: Were all those who had drawn a rather negative picture of his character jealous of his beauty or was Hira Singh in real life the male counterpart of what the European mind considered to be a nautch girl?

Not many of Emily Eden's original drawings were published.[29] Owing to the artist's documented relationship with the sitter, it is probably the most intense of Emily Eden's drawings known to date.

NOTES

1. Eden 1937, p. 199.
2. Eden 1937, p. 208.
3. Eden 1937, p. 226.
4. Eden 1937, p. 232. An anderoon is a kind of palankin, cf. Yule/Burnell 1984, p. 29.
5. Eden 1988, p. 173.
6. Eden 1988, p. 190.
7. Eden 1988, p. 192. George is Fanny's and Emily's brother, George Eden, Lord Auckland, Governor General of India since 1835. William is William Osborne, George Eden's nephew. A *howdah* is a kind of seat carried on the back of an elephant.
8. Eden 1988, p. 196.
9. Osborne 1840, pp. 76–78. Osborne was an artist himself. For his portrait of Hira Singh, see Osborne 1840, lithograph facing p. 73. Hira Singh is seated on a chair next to Ranjit, while Hira Singh's father, Dhyan Singh, stands with clasped hands in attendance of his master. This lithograph was also reproduced in Eden 1937, illus. facing p. 198. It is quite a disappointment when comparing it to the present portrait, due not only to the small size in which it was originally reproduced. For an accomplished portrait of William Osborne by his aunt Emily, see Mahajan 1984, p. 51, fig. 28.
10. Von Hügel 1841, vol. III, p. 213f. ("Neben dem Maha Raja auf einem Stuhle sass Hiera Sing, ein Jüngling von 16 Jahren, der Sohn des Lieblings: Raja Dehan Singh, ersten Ministers des Königs; alle andern Grossen seines Reiches sassen auf dem Boden."). Cf. also ibid., p. 387: "Sein [i.e. Ranjit Singh's] jetziger Liebling ist Raja Hira Singh."
11. Vigne 1987, vol. I, p. 245: "Runjit, who, partly from fear, and partly on account of his affection for Hira Singh, his son. . . ."
12. Smyth 1961, p. 273.
13. Smyth 1961, pp. 278f. Jellah Pundit was Heera Singh's adviser. They were both killed together in December 1844. Heera Singh's head "was exposed at the Loharee gateway" of the city of Lahore. For an account of the career of Heera Singh, who succeeded his father in the office of minister, see Smyth 1961, pp. 106–141. Hira Singh's year of birth is given as ca. 1816 by Archer 1966, p. 131. The historian Kirpa Ram in his *Gulabnama of Diwan Kirpa Ram, A History of Maharaja Gulab Singh of Jammu and Kashmir,* New Delhi, 1977, quoted after Weber 1982, p. 325, states that he was born in 1815.
14. This title is taken from part IV of four parts. Part IV was published already in 1843 and, like the other parts, "drawn on stone by Lowes Dickinson."
15. It was apparently republished more often than any other of her lithographs, cf. Archer 1966, pl. 49; Bayly 1990, p. 213, no. 264. For a col. version, see Archer 1989, p. 12, fig. 10.
16. Parks 1975, vol. II, p. 51: "In the Hon. Miss Eden's beautiful work, 'The Princes and People of India . . .'"
17. Eden 1937, p. 263f. For the portrait of Ranjit Singh mentioned, see Eden 1844, pl. 13, re-published in Archer 1966, pl. 26 or Bruhn 1987, p. 50, fig. 65. For the ivory portrait of Hira Singh, see Sotheby & Co., July 14, 1971, lot 192, no. 13.
18. Orlich 1845, p. 120: ". . . aber ein besonders Gewicht legte der Prinz auf ein schlechtes Portrait Rundgit Sing's, welches mit Deckfarben auf Papier gemalt war" (. . . the prince considers especially important a bad portrait of Ranjit Singh, which was painted in opaque colors on paper).
19. Eden 1937, p. 175.
20. Eden 1937, p. 193. "Mr. B." is Sir William Hay MacNaghten (1793–1841).
21. Eden 1937, p. 199f. This picture had an astonishing effect on the Sikhs, for which see Eden 1937, p. 200f.
22. For the circumstances which finally prevented Aniruddh Singh, son of Raja Sansar Chand of Kangra, to agree to that marriage, see Vigne 1987, vol. I, p. 109f.; Hügel 1841, vol. III, p. 387f.; Hutchison/Vogel 1982, pp. 193–195, the latter version being more correct.
23. A good number of these is listed and reproduced in Archer 1966. For individual portraits of Hira Singh, see Archer 1966, p. 131f., no. 8, fig. 20 (= Poovaya-Smith 1991, cat. 9, col. pl. p. 49); p. 141f., fig. 29; Aijazuddin 1977, p. 102, no. 6, p. 81 for the text, but this identification appears to be doubtful. An unpublished portrait of Hira Singh on ivory is in the collection of the Museum für Völkerkunde in Munich. It was painted by "Ram Singh Pandit" and was brought to Germany by the Schlagintweit brothers in the nineteenth century. Another unpublished (posthumous) portrait of Hira Singh showing him in the company of his father is in the collection of the Royal Asiatic Society, London, cf. Head 1991, p. 152, no. 059.019. For Hira Singh in the company of Ranjit Singh, see Archer 1966, p. 129, no. 7, fig. 19 (= Poovaya-Smith 1991, cat. 3, col. pl. p. 46) and for Hira Singh's appearance in *darbars,* see again Archer 1966, figs. 35 and 62 and Weber 1982, pp. 320–327, col. pl. p. 321.
24. Hügel 1841, vol. III. p. 334f.
25. Hügel 1841, vol. III, p. 216. For further references to Vigne's activities as artist at the Sikh court see Hügel 1841, vol. III, p. 301, p. 303 and p. 333.
26. Eden 1937, p. 228.
27. Orlich 1845, p. 119.
28. Orlich 1845, p. 121f., the English translation is quoted after Archer 1966, p. 50.
29. For another drawing which was to be lithographed for her publication of 1844 (pl. 1) see Archer 1969, pl. 49, text p. 184 (= Bayly 1990, p. 184, no. 212, col.). The drawing for plate 24 of the same publication is published in Pal/ Dehejia 1986, col. pl. 7, opposite p. 104. For two original drawings in the collection of the Victoria Memorial Hall, Calcutta, see Mahajan 1984, p. 45, fig. 23 and p. 51, fig. 28.

23 Maharana Sarup Singh of Mewar (b. 1816, r. 1842–1882) Seated with Attendant

ᨎ

by William Carpenter (1818–1899), Udaipur, ca. 1851.

Media: Watercolor on paper

Size: 11³/₄ x 11⁷/₈ in. (29.8 x 30.4 cm.)

The Maharana possessed a mild and placid countenance with a firm lip and bright searching eyes expressive of an able unyielding disposition and though before his succession he held no office or rank in the state, his affable appearance and the most polished and courteous manners grace his kingly bearing and high position. His memory is very tenacious and his conversation highly intelligent. (J. C. Brookes, February 14, 1853)[1]

Sarup Singh was the younger brother of Sher Singh, who was the younger brother of Maharana Sardar Singh. Maharana Sardar Singh was the son of Maharana Jawan Singh (for whom see cat. no. 39). Sarup (actually Svarup) Singh was born on January 8, 1815,[2] and succeeded to the throne of Mewar on July 14, 1842.[3] He was then twenty-eight years, six weeks, and ten days old.[4] The coronation *darbar* took place on August 18, 1842.[5] Sarup Singh died, after an eventful life,[6] on November 16, 1862.[7]

Sarup Singh could succeed to the regentship of Mewar because his elder brother, Sardar Singh, had no male issue and hence adopted his youngest brother, with the consent of the younger brother, Sher Singh.[8] His rule is summarized in the following words: "His reign of nine years is chiefly noticeable for the continued contests in which he was engaged with his feudatory chiefs, most of whom, descendants of former R'an'as, possessed exclusive privileges, on which the R'an'a attempted to infringe. These disputes were finally settled in 1861."[9]

At least 139 paintings with Sarup Singh were part of the "jotdan"-inventory at the royal palace of Udaipur.[10] The present watercolor is ascribed to William Carpenter on the basis of another composition by the same artist, showing Maharana Sarup Singh with two standing attendants instead of one, as in this case. This more elaborate study is in the Victoria and Albert Museum, London, which houses at least some 272 sketches by this artist,[11] besides the comparative study already mentioned.[12] Carpenter also sketched one of Sarup Singh's major artists, the painter Tara,[13] and, presumably during a second visit in 1857, Bakhat Singh of Bedla, near Udaipur, who also figures in the *darbar* painting mentioned below.[14]

From 1857–1858, when India, as a result of its revolt against British rule, was the focus of attention in England, Carpenter, like Simpson and others, contributed drawings to the *Illustrated London News*, which published them as woodcut-engravings. As such, Carpenter's portrait of Tukoji Holkar, cat. no. 24, accompanying illustration, was published. One full-page engraving, published on p. 265 in the issue of September 12, 1857, deserves our attention (see the accompanying fig. 3). This full-page engraving shows "The eldest son of the king of Delhi, his treasurer, and physician. From a picture painted in the palace of Delhi by Mr. W. Carpenter." The original painting was considered of such great importance that it was photographed around the time of its publication in the *Illustrated London News*, or even earlier. Perhaps it was even photographed in India, since it is accompanied by five seals formerly in the possession of Mirza Muhammad Fakhr ad-Din, shown in the center of the painting/woodcut engraving.[15]

Almost contemporary with Carpenter's portrait of Maharana Sarup Singh is that of another European artist, Frederick Christian Lewis (1813–1875), who placed Sarup Singh in the center of a scene showing a *darbar* which took place in Udaipur in February 1855. Lewis's painting was often published and includes a portrait of J. C. Brooke, whose description of Sarup Singh was quoted above.[16] Most interesting is the fact that Tara Chand, one of Sarup Singh's court painters who was also portrayed by Carpenter, simultaneously painted the same event, and, what is more surprising, both paintings survived.[17] Tara's version is now in the National Gallery of Victoria, Melbourne.[18] Both versions place the same event at the same location and show the same persons, but in two different ways of artistic approach. Whatever Tara articulated in his version was almost neglected in the version of F. C. Lewis, and whatever element Lewis emphasized was of little importance for Tara. To get an idea of what actually happened, one has to see both paintings together. In the end, one starts losing confidence in European depictions of certain Indian events, without consulting the Indian view

Fig. 3

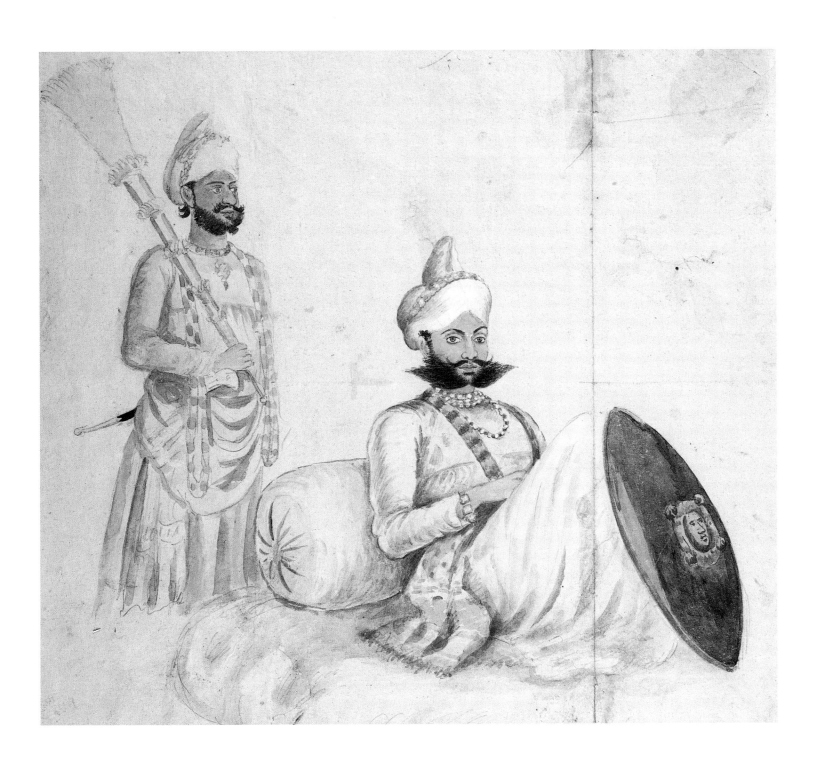

of the same. And, rather unfortunately, only European depictions as well as descriptions of many historic events are available.

Carpenter travelled through India between 1850 and 1857 and was frequently dressed in Indian style.

NOTES

1. Capt. J. C. Brooke's Report of February 14, 1853, Mewar Residency File No. 24F/6 (1862) Rajasthan State Archive/Basti No. 6, quoted after Somani 1985, pp. 240–241.
2. Shyamaldas 1886, vol. II, p. 2045.
3. On the eighth of the bright fortnight of [the month] Ashadha, V.S.1899, which Shyamaldas 1886, vol. II, p. 1909 calculates as July 15. July 14 follows Somani 1985, p. 203.
4. Shyamaldas 1886, vol. II, p. 1909.
5. On the sixteenth of the bright fortnight of [the month] Shravana, calculated as July 18 by both Somani and Shyamaldas.
6. For which see Shyamaldas 1886, vol. II, pp. 2909–2046; Somani 1985, pp. 203–240.
7. On the fifteenth of the bright fortnight of [the month] Kartik, calculated as November 17, by Shyamaldas 1886, vol. II, p. 2044. The date mentioned follows Somani 1985, p. 240. The date of death according to the Indian calendar, as given by Shyamaldas, is confirmed by Narayan 1913, p. 185.
8. Cf. Brookes 1859, p. 45; Somani 1985, pp. 200–201.
9. Malleson 1875, p. 26.
10. Topsfield 1995, p. 192. For some of these paintings see Topsfield 1980, nos. 265–269; Topsfield 1990, nos. 29–34; Christie's, April 24, 1990, p. 23, lot 24, col.; Sotheby's, October 10, 1988, lot 97, reproduced on pl. XVIII; Sotheby's N.Y., March 22, 1989, lots 142–143; Sotheby's, April 26, 1994, lot 51–56; Bautze 1995a, p. 173, Abb. 157, col.
11. Archer 1966, p. 148.
12. I.S. 128–1881, according to Molitor 1985. Reproduced: Molitor 1985, Abb. K.
13. For reproductions of this portrait, see Topsfield 1980, p. 15, full-page illus. fig. 1 (= Vashistha 1995, illus. 47).
14. Archer/Lightbown 1982, p. 138, no. 162.
15. For a reproduction and discussion of this photograph and the seals, see Christie's, June 11, 1986, p. 149, lot 267 (= Beach 1992, p. 361, col.) The actual painting is probably also in the Victoria and Albert Museum, London, I.S.193–1881. It is entitled *The Eldest Son of the King of Delhi*, cf. Archer/Lightbown 1982, p. 138, no. 156.
16. Woodruff 1953, frontispiece; Topsfield 1980, p. 165, fig. 2; Archer/ Lightbown 1982, p. 134, no. 133; Archer 1986, pl. XII, no. 73.
17. We know from written records that e.g. Emily Eden painted during *darbars* of Ranjit Singh and that Ranjit Singh's artists were doing the same. The respective sketches or paintings, however, have not survived to be compared with each other.
18. Reproduced and discussed: Topsfield 1980, pp. 164–165.

24 His Highness Maharaja Tukoji II of Indore

~

(b. 1833, succ. 1844, r. 1852–1886), by George Landseer (1834–1878), Indore(?), 1861.

Media: Oil on canvas

Size: 23³/₈ x 17 in. (59.4 x 43.2 cm.)

Inscribed: On verso, on canvas, in ink: "H.H. the MAHARAJAH of INDORE," signed below: "George Landseer / 1861." The inscription on a label of brittle paper, attached to the top part of the back of the wooden frame reads: "His Highness / Maharajah Holkar / of Indore." Another inscription in a different hand on the same label is incomplete due to missing parts of the paper. Still readable is "Arabic, Persian / Hindee Title/Engl[ish?] / Trans[lation?]." This label might date from Landseer's exhibition of Indian pictures at the Fine Art Society, London, 1876.

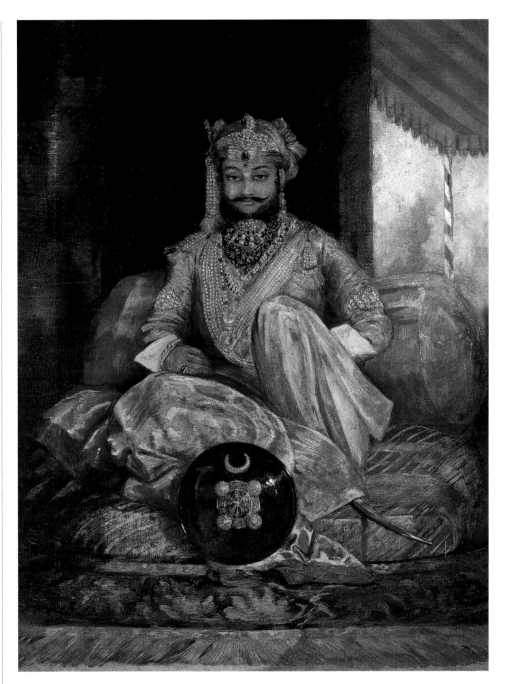

Landseer's description of this ruler, if it ever existed, is not available, but there are descriptions by another British artist, Valentine Prinsep, official artist for the 1877 *darbar* at Delhi, who painted Maharaja Tukoji Holkar on different occasions in 1876 and 1877 respectively:

On Wednesday I went for the first time to paint a rajah. I was to have begun with Sindia, but he begged to be excused, so Holkar was my first victim. Of course it was ridiculous to begin making studies before my design was made, but the committee were anxious for me to begin work, so off I went with Captain Barr, the political officer attached to Holkar. We were half an hour late, through no fault of mine, and when we arrived Maharajah Holkar was having his bath. We were received in his absence by the Prime Minister, a fat little tub of man, with a silly manner, but who talked English well. Holkar's elder brother came to join us.... Barr, while we were waiting, observed Sindia's carriage waiting also; so he asked whether the rival Maharajah was there. He was. "What is he doing?" "I cannot tell you," said the Prime Minister; but when Holkar frère left us he told us in confidence that Sindia had come over to cook Holkar's curry that morning! Some one had said Maharajah Sindia makes the best curry in India. So Sindia, in his delight at the compliment, had come to show Holkar what he could do. Holkar, after keeping me waiting an hour, at last made his appearance. Rather a fine-looking man, 6 feet high, with a dreamy, tired look. They say he suffers from bad health. After an introduction, I set to work. Barr said he behaved badly; but without breakfast, and a Maharajah, what could you expect? He made some jokes, at which, of course, all the world laughed, and lolled lazily in a chair, as if the world were not

worth looking at. People brought bracelets and necklaces, and placed them on him, he hardly moving his arms the while. Then a Bombay merchant brought more jewels to show him, strings of pearls were spread on the floor, for which the jeweller asked L20,000, for one diamond he asked L40,000, &c. The Maharajah looked on sleepily and yawned, whereupon all the Court standing around snapped their fingers to keep the devil from jumping down his Highness's throat. I never saw a man so bored, and should have felt more for the breakfast-less potentate, but that I was equally bored. Painting in a tent in this climate with a shining and blazing sun is next to impossible, even when you have a good sitter; and as I could not the least see what I was doing, I did not make a good beginning. After I had been painting half an hour, the Maharajah requested me to show him what I had done. "Ah!" said I, in excuse for saying no, "the great God himself took at least five and twenty years to make your Highness as beautiful as you are, how then can you expect me to reproduce you in half an hour?" Holkar smiled, and was, I flatter myself, "tickled." (December 22, 1876)[1]

I had Holkar sitting again; he was gorged this time, having had his breakfast, and could hardly keep awake. I had but a short sitting, and left him on the promise of going to Indore, to paint him and his son. (December 23, 1876)[2]

On Tuesday I go to Holkar. Tukaji Rao Holkar has been ill since Delhi; he has even now fever, the result of cold, and requested me to paint him as fat as he was at the Assemblage [the rendering of the Delhi *darbar* of 1877], *rather than he is now. He prides himself on his flesh, and can, they say, eat a whole wild boar unassisted at one meal! I must say I saw but little change in his vast bulk; he looks a little greyer, but that may be that he has forgotten the dye this morning. However, he is certainly seedy, and that does not render his society or conversation any more fascinating. I described Tukaji Rao at Delhi. I have since then seen many rajahs. His Highness is the twenty-fourth I have painted. Holkar is, however, the beau ideal of a rajah. He sits lolling about in his big chair while flies are brushed away by attendant slaves* [see the accompanying fig. 4], *and if his Rajahship leans back, a cushion is put under head or elbow; in fact, a rajah for the Surrey Theatre — "the Great Mogul called Bello" — the dream of one's youth; yet as sharp as a needle, and as cheeky and proud as the King of the Cannibal Isles with nothing on but a club and a few beads. The second day I went there the Rajah had to put on his jewels, and what a sight! It takes at least six men to dress him. There is the Hereditary Master of the Jewels, an old man with spectacles, who puts them on with the care of a real artist, while four men stand around with trays, on which are displayed jewels worth I do not know how many lacs* [1 lac = 100,000]. *"What shall I wear?" says the Rajah. "I think this handsome." And he holds up a kind of peacock made of diamonds and pearls. "Yes, that will do." And the peacock is "offered up" to his head while he lazily turns from side to side, gazing with self-satisfied look into a glass, which originally cost eight annas (one shilling), and which, held by a sixth man, contrasts strangely with the jewels it is called on to reflect. Squalor and magnificence are found side by side in all these rajahs' abodes. None of them have any sense of fitness — in fact, no native has. "We won't put on these pearls," cries the Maharajah, "for without them this looks more like a crown."* (October 26, 1877)[3]

A few slightly earlier, more official descriptions also exist. One of them describes Tukoji's visit to the Prince of Wales in Calcutta:

The guns announced the Maharaja Holkar of Indore, G.C.S.I. His Highness is a very tall man, with developments such as were attributed to Aldermen before they took to volunteering and athletic exercises. Conducted by Major Henderson and the Political Agent [Maitland], *he came into the Throne-room, rolling from side to side, and just touching his forehead slightly to the suite in a very regular manner. Holkar is very proud and punctual, and there have been difficulties about his precedence, so great, that the arrangements for a meeting with other Chiefs were attended with trouble. A certain interest is attached to Holkar, because, if report be true, he has five millions sterling stored up for a rainy, or let us say, as we are in India, for a dry day. . . . He received the gold medal and riband which is given by the Prince to the great Chiefs, introduced his sons and Sirdars, and left with a cheerful countenance.* (December 24, 1875)[4]

As the Prince [of Wales] *approached, Holkar came forth with his chiefs to welcome him. He wore a Mahratta turban, the riband and badge of the Star of India; a fine collar of diamonds was his only ornament save a brilliant-ring — a single stone of great size.* (March 9, 1876)[5]

Maharaja Tukoji Holkar of Indore was not an accidental favorite of the British. Most Maharajas who did not comply with the British mode of government were declared to be "imbeciles," to put it mildly (cf. cat. no. 39). Tukoji Holkar II, however, despite his "oriental" appearance and behavior, was praised, for good (British) reasons. One of the rulers of Indore was described by Thornton:

Hurre Rao Holcar appears to have manifested the full amount of incapacity for government which is ordinarily exhibited by Indian princes. Under his sway the country was so wretched that it was rapidly deserted by the inhabitants. . . . On the death of this imbecile specimen of oriental chieftainship, he was succeeded by a youth named Kumdee Rao Holcar, whom he had adopted with the sanction of the British government. The career of this adopted successor was, however, terminated by an early death, when it appears no person possessed any hereditary claim to the guddee [throne], neither had any one valid title to adopt, and the continuance of the Holcar possessions under a separate form of government became a question for consideration. It being determined that it should be so continued, the choice of a ruler was to be made; and, after weighing the competing claims of various candidates, the guddee was bestowed upon a youth named Mulkerjee, whose elevation it was avowed was not in virtue of either adoption or hereditary claim, but of the express nomination of the British government. . . . The young chief, educated under the auspices of the British government, displayed at an early age great capacity for public business, and drew forth, by his exemplary conduct, the approbation of the Governor General. In February 1852, upon the attainment of his majority, the young rajah assumed the reins of government.[6]

More details about his education can be obtained from the British press:

When the late Raja [of Indore] died without heirs, natural or adopted, Sir Robert Hamilton, the resident (before Lord Dalhousie came with his annexation mania), allowed his mother or widow to adopt an heir, and this youth and his brother were brought from the honourable occupation of tending cattle to choose an heir to the throne. The younger and better-looking was taken. . . . He was educated under Sir Robert Hamilton's superintendence. . . . He also learnt photography from an American, and wished to make an electric telegraph from Bombay to Indore at his own expense, but the Government would not allow it; but we believe that the first in use in India was that from the Palace to the Residency.[7]

When it came to distinguish friend from foe, during the "Mutiny" of 1857, the British hopes set in Tukoji Holkar were not disappointed. A contemporary newspaper reported:

Of the recent mutiny at Indore full details have appeared in our Journal. Holkar has behaved most nobly. Wherever he has heard of English fugitives he has threatened the local chiefs, and sent his satellites or household troopers to save them, and has expressed to Lieutenant Hutchinson (Bheel agent) his deep regret for what has occurred. No doubt can be entertained that on the termination of the mutiny some signal honour from the [British] Government awaits him.[8]

For that "signal honour" Tukoji had to wait four more years: He obtained the distinction of G.C.S.I. and also a sanad of adoption, in 1861. His Highness Maharaja Tukoji II of Indore became one of the more frequently portrayed Central Indian rulers by non-Indian artists.[9] His first reproduced portrait dates from the time prior to his accession. It was done by William Carpenter (for whom see cat. no. 23) and was published as a full-page woodcut-illustration in *The Illustrated London News* in 1857, accompanying fig. 4.[10] The present painting was done in 1861, when George Landseer, who spent eight years in India, returned from an up-country tour during which he accompanied Lord and Lady Canning. Charles John Canning became Governor General of India in 1856 and India's first Viceroy in 1858, as a result of the "mutiny." He stayed in India in that position until March 1862, when he returned to England to die there on June 17, 1862. Canning, whose portrait was drawn by George Richmond (for whom see cat. no. 48),[11] must have provided the necessary introductions and support for George Landseer. Another portrait in oils that has come to our notice was possibly done by an Indian artist.[12]

Fig. 4

Mahaiajah Holkai de Boidour. Inde Centrale.

Fig. 5

The probably best known published photographic portrait of a nineteenth century Indian ruler is reproduced here as accompanying fig. 5. It was first reproduced as Woodbury type in 1877 as part of the official publication on the Delhi *darbar* of 1877 and frequently thereafter.[13] It shows Maharaja Tukoji who, as Prinsep has put it "sits lolling about in his big chair while flies are brushed away by attendant slaves." It is interesting to note that the attendant of this photograph in his bearing somewhat reminds of the attendants in the earlier woodcut from 1851 as reproduced in the accompanying fig. 4. Tukoji's photograph of 1877 is also important for a different reason. It was reproduced, with some significant changes and without the attendant, in Prinsep's *Indian Journal*[14] and is a clear product after a photograph and not a painted portrait "from nature," which we have to emphasize, for Prinsep remarked about his Indian colleagues:

To-day I have received visits from the artists of Delhi: they are three in number, and each appears to have an atelier of pupils. The best is one Ismael Khan. Their manual dexterity is most surprising. Of course, what they do is entirely traditional. They work from photographs, and never by any chance from nature. Ismael Khan showed me what his father had done before photographing came into vogue, and really a portrait of Sir C. Napier[15] was wonderfully like, though without an atom of chic, or artistic rendering. I pointed out to the old man certain faults — and glaring ones — of perspective, and he has promised to do me a view of the Golden Temple [for which see cat. no. 61f.] without any faults. "These," said he, pointing to his miniatures, "are done for the sahibs who do not understand. I know they are wrong, but what does it matter? No one cares. But I will show you that I can do better." It is a pity such wonderful dexterity should be thrown away. Some means of really educating these fellows might be hit upon. If only they could see better work, they would quickly improve. At present the talent seems to be hereditary, and father, son and grandson are necessarily painters, and all with the same mechanical capacity and admirable patience. "Time is of no more value here than it is to a sitting hen," said my Yankee. (January 13, 1877)[16]

Prinsep later applied the last sentence to one of the maharajas that he painted: "Verily rajahs have no more idea of the value of time than sitting hens."[17]

The artist Prinsep was probably more confined to his limited (European) way of looking at art than he would have been ready to confess.

NOTES

1. Prinsep 1879, pp. 30–31.
2. Prinsep 1879, p. 33.
3. Prinsep 1879, pp. 282–283.
4. Russel 1877, pp. 355–356.
5. Russel 1877, p. 515.
6. Thornton 1854, vol. II, pp. 215–216.
7. *The Illustrated London News*, October 10, 1857, p. 359.
8. *The Illustrated London News*, October 10, 1857, p. 359.
9. Cf. Rohatgi 1983, p. 290. For a contemporary woodcut-illus. that demonstrates the impressive statue of the Maharaja, see Russel 1877, p. 355.
10. *The Illustrated London News*, October 10, 1857, p. 360. It is stated on p. 359 that this portrait was done in 1851.
11. Mersey 1949, illus. facing p. 71.
12. *Art d'Orient*, December 13, 1991, p. 52, lot 229.
13. The photograph is by Bourne and Shepherd, cf. Wheeler 1877, pl. 10 (= Worswick/Embree 1976, p. 79 = Allen/Dwivedi 1984, p. 80 = Fabb 1986, fig. 14 = Stapp 1994, p. 12, fig. 6, to mention just a few).
14. Prinsep 1879, woodcut-illus. facing p. 282.
15. Sir Charles James Napier (1782–1853).
16. Prinsep 1879, pp. 46–47.
17. Prinsep 1879, p. 126, when painting the Maharaja of Jodhpur, Jaswant Singh, February 26, 1877.

25 A Muslim(?) with Raised Hands

∾

by William Simpson
(1823–99), dated 1873.

Media: Watercolor on paper

Size: 7 x 5¾ in. (17.8 x 14.6 cm.)

Inscribed: Diagonally, near the
bottom, in the right half of the
painted surface: "Wm.
Simpson/1873."

This watercolor more closely resembles a rough, quick sketch than a finished painting and
seems to come from a sketchbook. It is possible that it was a work intended as an illustration
for *The Illustrated London News,* the weekly paper for which Simpson by that time worked as
illustrator and informant. The person illustrated here must not necessarily be from India,
especially since the pistol, sword, and dagger are Caucasian.[1] Published references are not yet
sufficient to determine with some degree of reliability the historical background for this
watercolor, if there is any. One possible explanation is that this is a preparatory study for
Simpson's self-portrait. The collector of oriental weapons, Henri Moser-Charlottenfels, was
painted in oriental dress, amidst his collection of weapons,[2] and the traveller Louis Rousselet
appears in Indian dress as the frontispiece to the (French) edition of his Indian travel-report.[3]
Besides, at least two photographs show William Simpson in oriental, probably Indian dress.
One is dated 1874,[4] and the other 1891.[5] Both photographs share a few features with the pre-
sent painting, but the facial differences prevail. Whatever the background of this watercolor
may be, it demonstrates that Simpson was, in the first place, a landscape artist.

NOTES
1. For the pistol cf. Purdon-Clarke 1910, pl. 27, nos. 602 and 610; Ricketts/Missillier 1988, p. 69, no. 108; Rohrer
 1946, pl. LXXXIII, nos. 399, 403, 404, pl. LXXXIV, nos. 406, 400, pl. LXXXV, nos. 406, 399, 400, pl. 404 and 402;
 Moser-Charlottenfels 1912, pl. XXXIX, nos. 766, 768, 769, 772; *Islamic Arms 1982,* pp. 88–89, no. 43. For the dag-
 gers cf. Purdon-Clarke 1910, pl. 27, no. 611; Ricketts/Missillier 1988, pp. 66–67, nos. 96–101; *Islamic Arms 1982,* pp.
 82–83, nos. 37–38; Moser-Charlottenfels 1912, pl. XX, nos. 186, 187, 191, 190; Rohrer 1945, pl. LXXVII, nos. 386,
 381, 380, pl. LXXVIII, nos. 388, 383, 385, pl. LXXIX, nos. 377, 387, pl. LXXX, no. 384, to mention a few examples.
2. Moser-Charlottenfels 1912, pl. I (= *Islamic Arms 1982,* full-page col. pl. p. 35).
3. Rousselet 1877, frontispiece. For the photographs which were turned into this wood-engraving see
 Vignau/Renié 1992, p. 129, pl. 71 and p. 130, pl. 72.
4. Archer/Theroux 1986, frontispiece (= Christie's, June 5, 1996, p. 48).
5. Glynn 1995, p. 137. See also Simpson 1903, photograph facing p. 288.

26 Maharaja Bhopal Singh of Khatoli

∾

by a local artist, ca. 1880.

Media: Gouache on paper

Size: 18³⁄₈ x 13³⁄₄ in.
(46.7 x 34.9 cm.)

Inscribed: In *Nagari*, top part of the picture: *maharajaji Śri bhopal sighji saru[p?] sighji ka bata* [for: *beta*] / *jan khatoli marajau ro* (The honorable Maharaja Bhopal Singh, son of Saru[p?] Singh, from Khatoli).

Published: Bautze 1990, fig. 13.

At about the time when this picture was painted, Khatoli was an estate of some thirty villages, fifty miles to the northeast of Kota in Rajasthan (for Maharao Umed Singh II of Kotah, see cat. no. 31). It was then a part of the kingdom of Kotah, but it formerly belonged to Bundi, the parent state of Kotah, which was separated from Bundi in 1631. Khatoli's ancestor was Maharaja Gaj Singh's second son, Amar Singh. Maharaja Gaj Singh was the eldest son of Indar Sal and his first wife, Harikumari, the daughter of a certain Kanaka Singh. Indar Sal was the eldest brother of Rao Shatru Shal (r. 1631–1658), the famous ruler of Bundi. Indar Sal founded Indargarh, and his second son, who could not succeed to his father's kingdom, was given Khatoli, which was wrested in 1673 from a certain Daulat Khan.[1]

One of Bhopal Singh's predecessors was Maharaja Bhuvani Singh, who was present at the Ajmer Darbar of 1832[2] of which one reception is shown elsewhere (cat. no. 40). In about 1894, Bhopal Singh's younger brother, Maharaja Partap Singh, was forty-four years of age. He succeeded his elder brother in 1890.[3] There is no pictorial representation of Bhopal Singh of Khatoli other than this one. Besides, there is no available description of this ruler. The most remarkable trait of this head-and-shoulders portrait is the blend of the tradition of the miniature painter who was used to working in an idiom of the Kotah school of painting and the influence of photography and European portrait painting. The green curtain covering a part of the framing arch is probably inspired by a similar curtain in a photographer's studio. The backdrop, a kind of curtain which fills the space behind the arch, reminds of Scottish textile patterns, although this type of fabric originated in India. It was known as "Madrasi," after the South Indian town, and as such is still available on Martinique, to which the "Madrasi" pattern was once brought by Indian workers, who were forced by the British to leave their homeland in order to work on sugar plantations, before Martinique was reconquered by the French. The "Madrasi" pattern on Martinique, however, is no longer produced in India, but printed in close imitation of the original pattern in Holland.

Typically "Rajput" is the strict symmetry, which creates an almost hypnotizing effect. This symmetry is enhanced by the equally proportioned beard in addition to the *Vaishnava tilak* or mark on the forehead.[4] Typically "Western" is the reflection of light in the eyes, indicated by white spots in the iris. The modelling of the face is achieved by stippling, a technique known in Rajasthan from the early eighteenth century onwards.[5] It seems that initially the Indian artist tried to imitate European prints, which must have flooded Rajasthan ever since the German Johan Josua Ketelaar and other members of the V.O.C. (Dutch East India Company) passed through Udaipur on their way to Lahore in 1711.[6] The *sarpech* or forehead ornament is a contemporary work of Jaipur enamelling, tied here to the turban in such a way that the thread is not visible. The modelling of the emeralds and pearls is represented here as in a contemporary publication by Jacob and Hendley, the latter of which probably once owned the Latif album (cat. no. 55).[7] The combination of the Indian tradition with certain traits of Western art- products such as photography and prints renders this portrait most unusual.

NOTES
1. For the early history of painting at Khatoli cf. Bautze 1987a, pp. 184–190 and, for the later phase, Bautze 1990b.
2. Bautze 1990a, fig. 16.
3. *Chiefs and Leading Families in Rajputana*, 1894, p. 56.
4. For this *tilak*, cf. Birdwood 1880, pl. M, no. 15.
5. For the "stippled style," cf. Topsfield 1980, p. 61, no. 56.
6. Cf. Topsfield 1984/85.
7. Jacob/Hendley 1886, pl. 19.

**27 Portrait of a Young Man
with Sunflower**

∽

by A.D.(?), Simla, 1888.

Media: Oil on canvas

Size: 23¹/₂ x 19¹/₂ in.
(59.7 x 49.5 cm.)

Inscribed: In lower right corner,
intertwined: "AD," and below:
"Simla / 1888."

The identity of this handsome young man is not known. He looks similar to members of the ruling family of Patiala, and in fact, the district known as Simla is composed of territory that the British partly acquired from the ruler of that state, and partly from the Raja of Keonthul.[1] A painted portrait of Raja Rajendra Singh of Patiala (b. 1872, r. 1890–1900) is signed in the lower right corner "AR / Co."[2] It somewhat resembles the present portrait, which could depict a young Indian man in his late teens or early twenties. Rajendra Singh married an English lady, Miss Florrie Bryan, "who previous to the ceremony had embraced the Sikh faith" on April 12, 1893.[3] Simla is "a British station in the lower or more southern part of the Himalayas, between the rivers Sutlej and Giree, celebrated as a retreat for those seeking renovation of health, or relief from the oppressive heat of Hindostan."[4] It is not difficult to understand as to why the English selected Simla as their summer retreat, when we read:

You cannot imagine how beautiful our weather is, since a storm on Wednesday, which cleared up the rains. Such nice clear air, and altogether it feels English and exhilarating. . . . (Emily Eden, Simla, September 8, 1838)[5] or: *The snowy range has appeared again after a fog of three months. The hills are all blue and green and covered with flowers, and there is a sharp, clear air that is perfectly exhilarating. I have felt nothing like it, I mean nothing so English, since I was on the terrace at Eastcombe, except perhaps the week we were at the Cape.* (Emily Eden, Simla, September 8, 1838)[6] or: *Yesterday the fair "came off," as they say, and today I am so tired I can't do anything. . . . There never was so successful a fête. More English than anything I have seen in this country.* (Emily Eden, Simla, September 27, 1838)[7]

Simla not only became the seat of government during the hot months in the Indian plains, it became the favorite place for all of the annual art exhibitions of India during the nineteenth century. "A really important event of a Simla season is the Fine Arts Exhibition. The Fine Arts Society, which sprang into existence in 1865, held their first show in September of that year in the present Bishop Cotton School, when nearly five hundred exhibits were displayed."[8] From then onwards, five to six hundred works were presented in September every year, and despite the fact that the Viceroy did not always grace the show with his presence, "Simla remained the favourite of the English amateur."[9] The exhibition of 1888 was held in the Townhall, which was used for that purpose from 1887 to 1912. Among the Indian prize winners at Simla is Raja Ravi Varma (cat. no. 9) and it was certainly not accidental that Amrita Sher-Gil (cat. no. 77) lived at Simla and exhibited there one of her first Indian paintings at the "Simla Fine Arts Society," in 1934. The present oil-painting must certainly be seen in the context of these annual Simla art shows.

NOTES
1. Thornton 1854, vol. IV, p. 486.
2. Griffith 1894, p. 18.
3. Griffith 1894, p. 28.
4. Thornton 1854, vol. IV, p. 483.
5. Eden 1937, p. 161.
6. Eden 1937, pp. 164–165.
7. Eden 1937, p. 167.
8. Buck 1925, p. 135.
9. Mitter 1994, p. 66.

28 "King of Delhi"

by Orlando Norie (1832–1901),
England, 1860–1890.

Media: Watercolor on paper

Size: 11³/₄ x 17⁷/₈ in.
(29.8 x 45.4 cm.)

Inscribed: Signed in lower right
of the painting: "Orlando
Norie"; inscribed on verso,
in lower right corner: "King
of Delhi."

Orlando Norie was a Victorian painter of military subjects. His earliest known Indian subject illustrates an incident of the Indian Mutiny, "HM 93rd Highlanders storming the Sikandarbagh, Lucknow, 16 Nov. 1857."[1] Another painting, dated 1864, shows the "Arrival of 3rd Dragoon Guards at Ahmednugger 1864 being reviewed by Sir Hugh Rose."[2]

The present watercolor apparently does not illustrate any historic event. By the time the painting was made, the "King of Delhi," the Mughal emperor Bahadur Shah II, was either exiled to Rangoon or already dead. Besides, he looked quite different from the present horseman, as a comparison with his portrait demonstrates (cf. cat. no. 61a.). The dress and beard of the horseman resemble those of the loyal Sikh cavalrymen which assisted Lieutenant Clifford Meecham of Hodon's Horse during the defence of the Lucknow residence in 1857,[3] or Afghan, Pathan, or even Wazir tribesmen.[4] But since Orlando Norie had never been to India, he had to work with second-hand material, probably sketches of amateur artists in the army, which Norie worked up in the then prevailing Victorian taste. The colors of the dress of the soldier shown here would have been much stronger had Norie painted him from life. The turban-ornament does not look very warrior-like, and probably only fulfills the requirements of an oriental subject.[5]

The horseman is too much the product of the artist's imagination to look for his description in contemporary travel reports or other sources on India. He gives the impression of being loyal to the British cause. Determined, but not daring, decorative, but not—due to the rather subdued palette—many-colored, he looks more like an oriental story-teller than a fierce Pathan warrior. One wonders whether the large royal umbrella visible some distance behind his horse is intended for him or has been introduced by the artist to fill the background with a typical Indian, royal insignia.

NOTES
1. Barthorp 1994, illus. p. 43.
2. Archer 1969, vol. II, p. 624, illus. pl. 76.
3. Wilkinson-Latham 1977, p. 12, illus. 9.
4. For comparable photographs cf. Knight 1990, pp. 8, 34, 37, 38, 43, and 45.
5. Cf. the study by John Frederick Lewis, reproduced in Sotheby's, April 14, 1976, p. 25, lot 52.

29 His Highness Ishwari Prasad
Narayan Singh, Maharaja of
Benares (b. 1825, r.
1835–1889) Seated, with
Prabhu Narayan Singh
(1855–1931) and Aditya
Narayan Singh (1875–1939)
Standing Behind As Well As
a Portrait of the Seated Late
Raja of Benares, Udit
Narayan Singh (r.
1795–1835) on the Wall
∾

by Madho Prasad, Ramnagar,
ca. 1885.

Media: Gouache on paper

Size: 14 x 11 in. (35.5 x 27.9 cm.)

Inscribed: On verso, in red ink:
"By Madho Prasad /
Ramnagar"

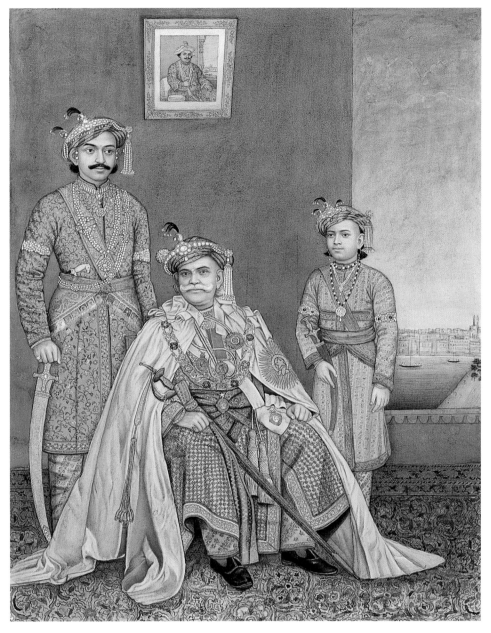

This painting incorporates four generations of rulers from Benares. Udit Narayan was the
son of Raja Mahip Narayan Singh (1781–1795), who died in 1795, and the nephew of Chait
Singh (1772–1781), who had been installed as Raja by the British. Ishwari Prasad Narayan
was Udit Narayan's nephew, who succeeded after the latter's death in 1835. Prabhu Narayan
Singh was Ishwari Prasad Narayan's nephew and adopted son, who succeeded in 1889.
Probably the best contemporary description of Udit Narayan Singh was published in 1828:

*I received a visit from the Rajah of Benares, a middle aged man, very corpulent, with more approach to colour in his
cheeks than is usually seen in Asiatics, and a countenance and appearance not unlike an English farmer. My few
complimentary phrases in Persian being soon at an end, Mr. Brooke interpreted for me, and I found my visitor very
ready to converse about the antiquities of his city, the origin of its name, which he said had anciently been Baranas,
from two rivers, Bara and Nasa, which here fall into the Ganges, (I suppose under ground, for no such are set down
on the map)[1] and other similar topics. I regretted to learn, after he was gone, that he resided at some distance from
the city on the other side of the river, and where I had no chance of returning his call; but I was told that he expected
no such compliment, though he would be pleased to learn that I had wished to pay it to him. The Maharaja's equipage
was not by any means a splendid one; he had silver sticks, however, behind his carriage, and the usual show of spears
preceding it, but no troopers that I saw. He is rich, notwithstanding, and the circumstances of his family have materi-
ally improved since the conquest of Benares by the English from the Mussulmans.* (Bishop Heber, September 7, 1824)[2]

Most subsequent visitors do not describe Udit Narayan Singh, but do write about the "Mr.

Brooke," mentioned by Heber as being his interpreter. "The most pleasing sight in Benares was the Chief Judge of the Civil and Criminal Court and Governor-General's Agent, Mr. Brooke, who, during our stay with him, completed sixty years of unbroken residence in India. . . . To pass Benares, and not pay one's respects to Mr. Brooke, would be an omission unpardonable." (Major Archer, February 18, 1829)[3]

"The conquest of Benares by the English," as Heber put it, was in fact one of the most important events in Anglo-Indian history:

[The Raja of Benares] *is descended from the nephew of Cheit Singh, the chief who made himself famous in the time of Warren Hastings. Had he displayed in that crisis a presence of mind and directness of aim corresponding to the circumstances in which he had been placed, the history of India might have been changed. . . . From the time of the expulsion of Cheit Singh, the administration has been entirely in the hands of the British, the Rāja* [i.e. Udit Narayan Singh and successors] *retaining his authority only over certain patrimonial lands of inconsiderable extent, a certain share of the surplus revenue or excess above the fixed tribute being assigned for his personal expenses.*[4]

The Indian "mutiny" might, in fact have happened already some seventy-six years earlier, as Hastings himself confessed: "Such a stroke as that which I have supposed would have been universally considered as decisive of the national fate; every state around it would have started into arms against it [i.e. the British], and every subject of its own dominion would according to their abilities have become its enemy."[5] "There is no doubt that the loss to the Government at that crisis of Hasting's administrative courage and genious would have been a blow from which the British power might never have recovered."[6]

RAJAH ODETNURAAN OF BENARES.

Fig. 6

Udit Narayan's portrait in the present painting deserves special attention. It is painted at the same window, with a view of the city of Benares on the other side of the Ganges, as in a similar portrait of his father, Mahip Narayan Singh.[7] The portrait of Udit Narayan as it is reproduced in this painting must have actually existed. It was published as a woodcut engraving in *The Illustrated London News*, November 28, 1857 on p. 549, for which see the accompanying fig. 6. It is published under "Sketches in India from Native Drawings" as *Rajah Odetnuraan of Benares.* The text, on the following page of *The Illustrated London News*, explained: "The present Rajah of Benares has no political power whatever, and lives at Ramnuggur."[8] The Raja's corpulence, as noted by Heber, is shown in the actual portrait more than in its woodcut engraving. It becomes most apparent in a head and shoulders portrait of the said Raja in the Victoria and Albert Museum, London.[9] That Udit Narayan was not always that well fed is shown by other published portraits of him.[10] Udit Narayan Singh commissioned a lavishly illustrated *Ramayana*-manuscript in 1813.[11]

Maharaja Ishwari Prasad Narayan Singh was visited by Emily Eden, who remarked: "The Rajah of Benares came with a very magnificent *surwarree* [cavalry, procession] of elephants and camels. He is immensely rich, and has succeeded an uncle who adopted him, to the great discomforture of his father, who goes about with him in the capacity of a discontented subject." (November 22, 1837)[12]

Emily Eden and her sister Frances were more interested to see the maharaja's wife ("Ranee") and concubines, whom they described in detail; one passage deserves to be quoted: "When we came back to the Ranee's room, she showed us her little chapel, close to her sofa, where there were quantities of horrid-looking idols—Vishnu, and so on.[13]

About ten years later, the maharaja was visited by the Austrian traveller, Ida Pfeiffer, who recalled:

The two princes were very richly dressed; they wore wide trousers, long under and short over garments,

all made of satin, embroidered with gold. The elder one, aged thirty five, wore short silk cuffs, embroidered with gold, the edge set with diamonds; he had several large brilliant rings on his finger, and his silk shoes were covered with beautiful gold embroidery. His brother, a youth of nineteen [i.e. Udit Narayan Singh], wore a white turban with a costly clasp of diamonds and pearls. He had large pearls hanging from his ears, and rich massive bracelets on his wrists. The elder prince was a handsome man, with exceedingly amiable and intellectual features; the younger one pleased me far less. (December 27, 1847)[14]

During the real "Mutiny" of 1857, which one of his forefathers almost triggered seventy-six years before, "the Rajah of Benares cast in his lot with the British who had established his family in the position he had inherited. He was constitutionally a timid man, but his heart was in the right place, and he never for a moment flinched from the loyal course he laid down for himself from the first moment."[15] The "Rajah has frequently attended the amateur theatrical performances at Secrole, which is the English station, two miles distant from Benares; for this reputed holy city is not, properly speaking, the British headquarters, Secrole being used for this purpose."[16]

During his visit to India in 1875–1876, the Prince of Wales received Ishwari Prasad Narayan Singh. The official report informs the reader:

The Prince received a visit from the Maharaja of Benares at 1 p.m. His Highness was escorted to and from Government House by cavalry, and there was a guard of honour and band to receive him, and artillery detachment to fire his salute of thirteen guns. His carriage was drawn by four horses, the leaders ridden by postillions, the wheelers driven by a coachman on the box — the effect unusual, but not at all distressing to native ideas. Indeed, the amount of pain we cause them by our love of uniformity is very great. They like disparity. I was told of a Raja who was very much displeased because a new carriage sent from London made no noise on the highway, and was only satisfied when the local authority, by a happy thought, ordered the screws and bolts of the springs to be loosened, and so gave room for the needful clatter and jingle. The Maharaja is a Brahmin, with a 900 years' pedigree. He has a revenue of 80,000l. a year, of which more than a quarter (30,000l.) is paid to the British government as revenue. He is learned, encourages education, and is gracious in manner. His position of Raja of the Sacred City, the holy monuments of which he has done a good deal to protect, gives him more consideration among the natives than he would be entitled from his possessions. (December 27, 1875)[17]

A few days later the Prince of Wales was received by the Maharaja of Benares in the most splendid manner possible:[18]

Shortly before sunset the Prince embarked in a handsome galley, with two sea-horses at the bow, which was towed by a steamer to the old fort of Ramnagar, four miles up the Ganges, where the Maharaja of Benares received the Prince on a canopied and garlanded landing-stage. It was the grandest and most characteristic reception possible.... The Maharaja led the Prince upstairs, where, after the usual presentations and a short conversation, a long file of servitors laid examples of gold brocade of the famed kinkob of Benares, Dacca muslin, and costly shawls at the Prince's feet, while the Maharaja sat, like a benevolent old magician in spectacles and white moustache, smiling, in his hall, with his hands joined in a deprecating way as each tray was laid on the ground, as though he would say, "Pardon that unworthy offering!" The Maharaja then conducted the Prince to a room where other beautiful presents were laid out on tables. In a third room a rich banquet was served, which was untouched. (January 5, 1876)[19]

At the Delhi Imperial Assemblage of 1877 Ishwari Prasad Narayan Singh obtained the distinction of a Knight Grand Commander of the Most Exalted Order of the Star of India, as can be seen from the present painting. The large gold medal with the profile of Queen Victoria, suspended from a red ribbon below his chest is the Delhi Imperial Assemblage Medal, 1877.[20] The radiating ornament to the right of the red ribbon is the "Star," as part of the Insignia of the Star of India.[21] The oval medal below the Delhi Imperial Assemblage Medal, 1877 is a "Badge," also as part of the Insignia of the Star of India.[22] A second version of the same badge is attached to the blue toga, held together by the "Collar" or Chain of the Order of the Star of India.[23] The remaining golden medal, to the left of the Delhi Imperial

Assemblage Medal, 1877, is most probably the gold medal which he received on the occasion of his visit to the Prince of Wales in Calcutta.

Maharaja Ishwari Prasad Narayan Singh is known from several other paintings.[24] He passed away on June 13, 1889 and was succeeded by his nephew and adopted son, Prabhu Narayan Singh, who was born on November 26, 1855.[25] He is present in the accompanying illustration to cat. no. 41, as "The Maharaja of Benares, though only a territorial magnate, receives a salute, and was given on this occasion the honours of a ruling Chief."[26] In one of his photographic portraits he looks as represented in the present painting, but there are also other published photographs showing him at a later stage of life.[27] One of Prabhu Narayan Singh Vibhuti Narayan Singh's descendants, Maharaja Vibhuti Narayan Singh of Benares, wore the same turban ornament as shown here, in the 1970s.[28] The then heir apparent, Maharajkumar Ananta, had a small portrait of one of his ancestors, apparently Maharaja Prabhu Narayan Singh, attached to his necklace in a photograph taken in 1972.[29]

The city-scape of Benares with the mosque of Aurangzeb and the river Ganges as seen in the present painting cannot be seen from Ramnagar. The mosque of Aurangzeb is too far away to be seen from Ramnagar. It seems Madho Prasad, of whom nothing is known but his name,[30] has incorporated a separate view of this part of the city in this truly detailed picture.[31]

NOTES

1. Heber does not say which map he consulted, but it was most probably the one surveyed by James Prinsep in 1822, cf. Cook 1989, p. 130, fig. 3. The Burna (Baran) as flowing into the Ganges "on the left side, at Benares" was common knowledge in 1854 (Thornton 1854, vol. I, p. 340) and the Assee Nala (Asi) flows into the Ganges at the southern end of the city, hence the name Asi Ghat. For a large map of Benares, surveyed in 1867–68, see the map "Published under the direction of Colonel J. E. Gastrell, Deputy Surveyor General in Charge of the Surveyor's General Office, Calcutta, January 1869." Its scale is six inches to one mile and it is entitled: "Cantonments of Sikrol and Pandypoor, also the Civil Station and City of Benares."
2. Heber 1828, vol. I, p. 300.
3. Archer 1833, vol. II, pp. 110–111.
4. Malleson 1875, p. 379. Raja Udit Narayan Singh was the nephew of Chait Singh (1772–1781). For the complete history of these events see the chapter "Benares under British Rule" in Havell 1905, pp. 210–224.
5. Havell 1905, p. 213.
6. Havell 1905, p. 214.
7. Ward/Joel 1984, full-page col. pl. p. 50. Cf. Losty 1989, p. 150, fig. 11, left.
8. A portrait of the ex-king of Oude (Lucknow) is published on the same page of *The London Illustrated News*, just above the portrait of Udit Narayan. It was considered to be of sufficent importance to be included as a full-page pl. in Butler 1872, p. 209.
9. Archer 1992, p. 219, no. 246, col. illus.
10. For another head and shoulders see Ward/Joel 1984, p. 55, col. illus.
11. For which see Ward/Joel 1984, pp. 63–77.
12. Eden 1937, p. 25. For Fanny's description see Eden 1988, pp. 80–82.
13. Eden 1937, p. 29. George Birdwood remarked on the "Puranic" deities, of which Vishnu is one: "The mythology of the Puranas is not an essential element in Hindu art, which, however, it has profoundly influenced. It lends itself happily enough to decorative art; but has had a fatal effect in blighting the growth of true pictorial and plastic art in India. The monstrous shapes of the Puranic deities are unsuitable for the higher forms of artistic representation; and this is possibly why sculpture and painting are unknown, as fine arts, in India." (Birdwood 1880, p. 125).
14. Pfeiffer n.d., p. 170. Ishwari Prasad was then actually twenty-two years of age.
15. Malleson 1889, p. 45.
16. *The Illustrated London News*, November 28, 1857, p. 550.
17. Russel 1877, pp. 365–366.
18. See Russel 1877, full-page illus. p. 388.
19. Russel 1877, pp. 389–390.
20. Cf. *The Journal of Indian Art and Industry*, vol. XII, no. 107, July 1909, col. pl. 149, illus. 1060.
21. Cf. *The Journal of Indian Art and Industry*, vol. XII, no. 107, July 1909, col. pl. 149, illus. 1059b.
22. Cf. *The Journal of Indian Art and Industry*, vol. XII, no. 107, July 1909, col. pl. 149, illus. 1059a, for both versions shown in the present painting.
23. Cf. *The Journal of Indian Art and Industry*, vol. XII, no. 107, July 1909, col. pl. 149, illus. 1059c; Gabriel/Luard 1914, p. 227, col. illus. on top.
24. Christie's, May 5, 1977, lot 109, illus. on pl. 26; Chakraverty 1996, p. 46, col. illus. at bottom, right.
25. Vadivelu 1915, p. 214.
26. Wheeler 1904, p. 84.
27. Golish 1963, illus. p. 151; Wiele/Klein 1903, thirty-third illus. after p. 114 (= Worswick/Embree 1976, p. 22).
28. Allen/Dwivedi 1984, illus. p. 312.
29. Allen/Dwivedi 1984, illus. on back cover.
30. Artists working for Ishwari Prasad Narayan Singh included Dallu Lal, Gopal, Lal Chand, Shiva Ram and his son Surat. Cf. M. Archer 1971, p. 74.
31. Cf. e.g. Christie's South Kensington, October 20, 1988, p. 11, lot 100, for *View of Benares from the S[outh] Side of the Ganges*, dated January 3, 1814.

30 Nawab Sir Mahbub Ali Khan
Bahadur Fateh Jung
of Hyderabad and Berar
(b. 1866, r. 1884–1911)
∿

by Moujdar Khan,
Hyderabad(?), 1906.

Media: Oil on canvas

Size: 57¹/₂ x 40⁵/₈ in.
(146 x 103.2 cm.)

Inscribed: Signed and dated in
the middle of the lower border:
"By Moujdar Khan / 22.1.1906."
An engraved metal plaque
attached to the center of the
frame, below the painting,
reads: "His Highness Nawab
Mir Mahbub Ali Khan
Bahadur 1866–1911."

*The Nizam is a gentleman of forty years of age, with a high-bred face adorned with a moustache and a pair of
whiskers which, when taken in conjunction with his black frock-coat and manner, make you forget his turban and
think of an Austrian banker. And yet this European-looking Prince has 300 wives and some 80 children; and the
revenues of a whole suburb — the Begum Bazaar — are devoted to his pin-money to his wife-in-chief. Moreover,
His Highness does not permit the printing of newspapers in his State, the journals from which the inhabitants of
Hyderabad learn what happens around them being published in Madras. Another point of similarity between the
Nizam and his august prototype is the extreme suspiciousness shown to strangers by his police. At every station
the newcomer is requested to enter in a book his name, nationality, occupation, and date of arrival and departure.
But perhaps this inquisitiveness is due to the provisions of the Plague Regulations. As to the ruler's inaccessibility,
the Old Resident has a very interesting story to tell. . . .* (G. F. Abbott, special correspondent of the *Calcutta Statesman* in
Hyderabad, accompanying Their Royal Highnesses the Prince and Princess of Wales on their tour in India, 1906)[1]

Nawab Mir Mahbub Ali Khan Bahadur was the son of His Highness Nawab Afzul-ud-Daula,
who died in 1869. Mir Mahbub Ali Khan Bahadur, who was then hardly thirty months
old, had Nawab Salar Jung, the famous chief-minister of Hyderabad, and Nawab Shams-ul-
Umara as co-regents. From 1875 onwards, he was educated by Captain John Clerk, Equerry
to H.R.H. the Duke of Edinburgh. In November 1876, John Clerk was succeeded by
his brother, Captain Claude Clerk. Sir Salar Jung died on February 8, 1873, and the

administration was carried on by His Highness as president and Raja Narinder Prashad, Nawab Bashir-ud-Daula, Nawab Shamsul-Umara as members, and Mir Laikh Ali Khan Bahadur as secretary. On February 5, 1884, His Excellency Lord Ripon invested the Nizam with full administrative powers. The Nizam of Hyderabad entertained such distinguished royal guests as the Duke and Duchess of Connaught, Prince Albert Victor, the Czar of Russia, Prince Ferdinand of Austria, the Crown Prince of Denmark, and the Crown Prince of Germany. Queen Victoria conferred on him the G[rand] C[ross of the] S[tar of] I[ndia] in 1885 and King Edward made him a G[rand] C[ommander of the] B[ath] in 1903. He died following a sudden stroke of paralysis on August 29, 1911.[2]

The obituaries written at the time of Mahbub Ali Khan's death do not mention the final postscript of his reign. It concerns a diamond. Near the turn of the century the Nizam agreed to buy a fabulous 162-carat diamond from its owner, Jacob, a gem merchant. Time and again, there had been financial confrontations between the Nizam and the British who feared his excesses would bankrupt the state. This time the British Resident intervened, forbidding the Nizam to purchase yet another bauble. The Nizam ignored him and bought the diamond anyway, paying half the purchase price to Jacob. An impasse developed; the Nizam had the diamond, but he was not allowed to remit the outstanding balance. Finally, the angry Jacob took the Nizam to court. The suit ruined the diamond merchant, and the Nizam suffered the public indignity of having to appear in a formal British court to explain the circumstances of his default. This permanently soured relations between the Nizam and the British. The notoriety of the diamond made the Nizam, who was once so eager to own it, now reluctant to display it. Years later, the seventh Nizam, Sir Osman Ali Khan, found the Jacob diamond wrapped in a piece of ink-stained cloth, stuffed into the toe of one of his father's slippers. A base of gold filigree was made for the magnificent jewel. Finally, it was used for the purpose originally intended — as a paperweight for state documents.[3]

The present painting is based on a photograph by the Nizam's court photographer, Raja Lala Din Dayal (1884–1910). Being official, it was reproduced in several publications, the first time in the official report on the Delhi Coronation Darbar of 1903, published in 1904.[4] The same photograph was used for the inclusion of the Nizam in cat. no. 41. Several of Raja Din Dayal's published photographs show the Nizam with a sporting gun and two slain tigers.[5] The Nizam wears the robe and insignia of the Grand Cross of the Star of India, which the artist rendered red, as if he had never seen it — it is actually blue, as in cat. no. 41. Moujdar Khan's oil of the Nizam is quite unique; other painted representations of the ruler of Hyderabad were done in the more traditional technique and size of Indian miniatures.[6] Moujdar Khan did not slavishly enlarge and copy Raja Lala Din Dayal's photograph. Thus, the Nizam's right hand no longer holds the rolled document as in the photograph, but rests empty on the back of the chair to the Nizam's proper right. The artist also added the small table to the Nizam's left, covered by a brocaded dark blue cloth, as well as a length of the dark red curtain, which covers much less space in the photograph. Moujdar Khan tried his best to adopt the Western technique of painting in oils, but in certain areas utterly fails in his attempt. The clumsy and flat rendering of certain details of the insignia contrasts with the modelling of the face and the use of light and shade, and adds to the charm of the painting. No further works by Moujdar Khan are known to date.

NOTES

1. Abbott 1906, pp. 264–265.
2. For an abstract of the Nizam's life, cf. Vadivelu 1915, pp. 5–9.
3. Worswick 1980, p. 15.
4. Wheeler 1904, photogravure facing p. 25, photographed by "Raja Deen Dayal & Sons, Bombay." The same photograph is published in Hesse-Wartegg 1906, illus. p. 71 and Vadivelu 1915, illus. facing p. 1, where the copyright is claimed by "Wiele & Klein, Madras."
5. Cf. Allen 1975, illus. p. 106. Worswick 1980, p. 52 and p. 53. Although in both these photographs reproduced by Worswick, the same pair of tigers is shown, the first is dated 1894 and the second 1892. Worswick 1980, p. 51, showing the Nizam during an outing, is dated, according to Worswick, "May 1892."
6. Cf. Hatanaka 1994, p. 109, no. 37, col.; Sotheby Parke Bernet N.Y., December 10, 1981, lot 73; Ward/Joel 1984, col. pl. p. 123, no. 5.

31 **Major His Highness
Maharao Umed Singh II
of Kota**, G.C.S.I., G.C.I.E.
(r. 1889–1940)

∽

after a photograph by Bourne
and Shepherd of about 1910;
hand-colored by an Indian
artist, ca. 1910–1911.

Media: Photograph hand-
painted with gouache

Size: 12³/₈ x 9¹⁵/₁₆ in.
(31.4 x 25.4 cm.)

Inscribed: On verso, "3693,"
and below, in pencil "Painted
Photo," and below: "ХМUХ,"
presumably the code of the
dealer Sultan Singh Backliwal
in Delhi.

Maharao Umed Singh of Kota displays in this official photographic portrait the badge be-
longing to the insignia of the Star of India[1] and the Star, in addition to the collar, as part of
the insignia of the Order of the Indian Empire.[2] The chief-minister or "Diwan Bahadur" to
the Kota state described this event in a report entitled "Investiture of the Indian Orders":

*The Investiture of the Indian Orders took place in the grounds of Government House at 9:30. P.M. on the 28th
January 1908. His Highness the Maharao was invested with the Insignia of the First Class of the Order of the
Indian Emprire, G.C.I.E. [= Grand Commander of the most eminent order of the Indian Empire][3]*

At about the time when the present photograph was taken, Umed Singh was visited by the
Queen-Empress, who accompanied her husband, The King-Emperor, to the Delhi Darbar of
1911. After this *darbar*, the King-Emperor went to Nepal and other places, while the Queen-
Empress visited several rulers in Rajasthan. She arrived at Kota in a "motor-car," coming
from Bundi, on December 24, 1911 and was entertained by His Highness Kota until
December 28. On that day the Queen-Empress left for Calcutta by train.[4] During her stay
she was offered a ceremonial present "consisting of elephants, horses, jewels, and rich
cloths,"[5] as shown during the Ajmer Darbar of 1832 (cat. no. 40).

Neither the impression which the personality of His Highness Kota made on the Queen-Empress nor a description of his appearance is mentioned in a single line of that report, which is accompanied by photographs of "Her Imperial Majesty at Kota" and "Her Imperial Majesty with the Maharao of Kota."[6] Another illustration that accompanied this report shows the uncolored and unchanged photograph of His Highness Kota, of which the present cat. no. is a hand-colored and slightly changed version. The appearance of His Highness Kota as such remained unaltered. There are drastic changes, however, in the rendering of the background. The two white pillars visible in the present version were introduced by the artist alone; they are not in the actual photograph. A bronze statue with a rider lifting his right arm in the actual photograph was painted over by the colorist.

Towards the turn of the last century, Indian rulers loved to be represented with decorations conferred on them by the British Empire, as can be seen in cat. nos. 29, 30, and 42. His Highness Kota was no exception. He appeared similarly at the 1903 darbar[7] as well as in a later stage of his life.[8]

Maharao Umed Singh II of Kota was born on December 15, 1873. He was the second son of Maharaja Chhagan Singh of Kotra, an estate within the state of Kota. His mother was Chaman Kunwar, daughter of the jagirdar Thakur Sahib Singh Chandrawat of Central India. Umed Singh was adopted by Maharao Shatru Shal II of Kota. Shatru Shal died issueless on June 11, 1889. Before that event, Umed Singh's name was Uday Singh. Umed Singh's reign began in the same year (1889) and lasted for over fifty-one years. He died on December 27, 1940, after having introduced numerous "reforms" based on European models. Part of Kota's independence was given up in 1901 when the Kota State Mint was closed due to the introduction of British silver currency. His Highness Kota's full titles were: "His Highness The Maharajadhiraj Maharaj Mahimahendra, Maharao Raja Colonel Sir Umed Singh Bahadur, G.C.S.I., G.C.I.E., G.B.I., LL.D." His life has often been described and his biography fills more than 356 pages.[9] His grandson Brijraj Singhji is the present Maharao of Kota.

NOTES

1. For a reproduction see *Journal of Indian Art and Industry*, vol. XII, no. 107, July 1909, pl. 149, no. 1059a.
2. For a reproduction see *Journal of Indian Art and Industry*, vol. XII, no. 107, July 1909. pl. 150, no. 1062b and no. 1062c; Gabriel/Luard 1914, p. 227.
3. Chaube Raghunath Das 1908, p. 3.
4. For the official (British) report on this visit, see Gabriel/Luard 1914, pp. 241–243.
5. Gabriel/Luard 1914, pp. 242.
6. Gabriel/Luard 1914, reproductions facing p. 238 (bottom) and p. 240 respectively. The former reproduction only shows a detail of a larger photograph, for which see Jagatnarayan 1983, sixth photograph following p. 48.
7. Wheeler 1904, photogravure facing p. 108 (= Golish 1963, illus. p. 146, top).
8. Sharma 1939, vol. I, frontispiece (= Sharma 1939, vol. II, illus. facing p. 700).
9. Jagatnarayan 1983. For further descriptions see Sharma 1939, vol. II, pp. 699–787; Gahlot 1960, pp. 99–105 in the Kota-chapter.

32 Kumar Mormukut Singh
of Isarda alias Man Singh
(b. 1911, r. 1931–1949, d. 1970)
at the Time of his Formal
Adoption as Maharajkumar
of Jaipur on March 24, 1921

~

painting after a photograph
probably taken by Madho Lal,
Jaipur, ca. 1921.

Media: Gouache on paper

Size: 14^{1}/$_{8}$ x 10^{1}/$_{2}$ in.
(35.8 x 26.7 cm.)

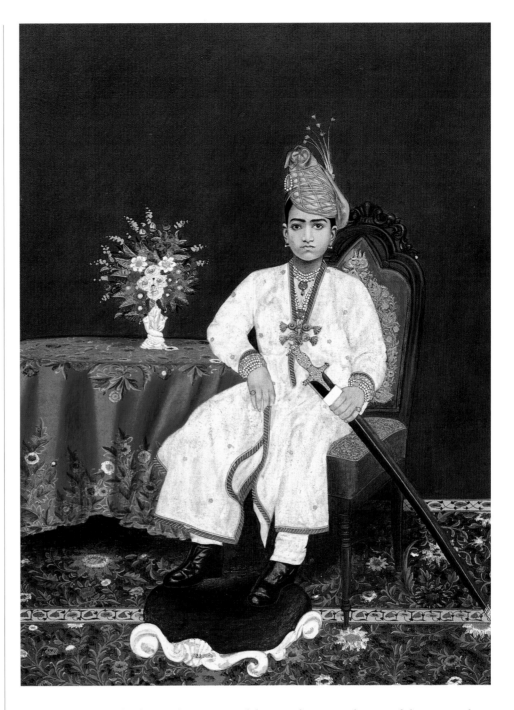

Maharaja Man Singh of Jaipur became one of the most famous Maharajas of the twentieth
century. His biographer even calls him "The Last Maharaja."[1] A contemporary episode about
his adoption as presented here is narrated in the memoirs of the third and most famous of
his wives, the Maharani Gayatri Devi of Jaipur, who first met him when she was only twelve
years and he about twenty years of age:

*It happened that the then Maharaja of Jaipur, Sawai Madho Singh II [for whom see cat. no. 41] had no
heir, and as he grew older he decided that it was time to choose his successor. Without explaining the reason,
he summoned Jai (as Man Singh was called by Gayatri Devi) and his elder brother, sons of his cousin, the
Thakur of Isarda, to come to Jaipur City to pay their respects to the ruler. They were given an audience in
the City Palace, and each boy held out in his cupped hand, in the ceremonial way, a gold coin to be accepted
by the ruler in acknowledgement of their allegiance. The Jaipur legend is that while Jai's brother stood there
properly waiting, Jai, who was only ten, grew impatient at the Maharaja's slowness in accepting the tribute,
dropped his hands to his side, and pocketed the gold coin. This so struck the Maharaja as a sign of indepen-
dence and character appropriate to a prince that he took the unusual step of adopting the younger boy. Four
months after his fateful visit to the capital, Jai was awakened in the middle of the night and told only that
he was being taken on a journey. It was all very mysterious, and the poor boy was quite bewildered and mis-*

erable. Only when he reached Jaipur did he discover that he was to be adopted by the Maharaja as his heir and would then become the Maharaj Kumar, or heir apparent, of Jaipur. All this meant very little to the small boy who had suddenly been taken away from his family, friends and companions and installed in the vast City Palace of Jaipur in the care of the first wife of the Maharaja. It was explained to him that he had to be guarded very carefully, as there was another family which claimed the right to succeed to the throne, but this did nothing to alleviate his homesickness. So great was the fear that some resentful person might try to harm him that he was rarely allowed out of the palace gates. . . . He told me, years later, that this was the most miserable period of his life, even though the zenana ladies spoiled him, fed him too many sweets, petted him, watched over him, and tried to be kind to him. . . . A month after his arrival in the zenana, his formal adoption took place and there was great jubilation throughout the state when Kumar Mormukut Singh of Isarda became Maharaj Kumar Man Singh of Jaipur. Gradually, in the months that followed, the security measures were relaxed. . . . [2]

Only ten years later, he was described by an English woman:

Because of his appearance and his charm, his possessions and his feats on horseback, this exceedingly good-looking young man, famous as a sportsman in three continents, occupies in the imagination of the Indian general public much the same position as the Prince of Wales did in the minds of workingmen [in England]. In no other way can I suggest the universal popularity, combined with a rather breathless wonder as to what he will do next, which surrounds this best-known of India's young Rulers. [3]

Kunwar Mormukut Singh was born on August 21, 1911. He was the second son of Thakur Sawai Singhji of Isarda. He was formally adopted by Lieutenant General His Highness Saramad-i-Rajaha-i-Hindustan Raj Rajendra Shri Maharaja Dhiraja Sawai Sir Madho Singhji Bahadur, G.C.S.I., G.C.I.E., G.C.V.O., G.B.E., L.L.D., of Jaipur on March 24, 1921. This adoption was sanctioned by the British Government ("Government of India") through Lord Reading on May 28, 1921:

I have . . . great pleasure in informing Your Highness that the Government of India recognise and confirm your adoption of Kunwar Mormukat Singh, now renamed Maharaja Kumar Mansingh, as your heir and successor to the Gaddi [throne] *of Jaipur. I fervently hope that Your Highness' action in adopting this boy will bring peace and happiness to yourself and I am confident that he will follow the example of Your Highness and your predecessors in loyalty and devotion the the British Crown.* [4]

His Highness Jaipur died on September 7, 1922 at about 9:00 p.m., after a protracted illness. On September 18, 1922, His Highness Maharaja Man Singh II succeeded to the throne of Jaipur. "What the British liked to see in a princely state was a pliant Maharaja, a soundly-run government and a placid, old-fashioned peasantry with no great knowledge of any other kind of existence. This they achieved in Jaipur." [5] Man Singh was sent to England, where he underwent training at the Royal Military Academy at Woolwich:

He was an extremely good-looking young man, not particularly tall, but now thin and well-proportioned. Despite his athletic strength, he had gentleness which certainly appealed to young English girls, who were more accustomed to young officers being rough and insensitive, red-faced and raucous. Furthermore, he was a Maharaja. Soon after his arrival in England, he got in touch with the remarkably beautiful and frolicsome widow of the Maharaja of Cooch Behar. She introduced him to the racier element of the British aristocracy. In no time, he was to be seen at the parties of those smart, international, sporting people whose names filled the gossip columns of the newspapers of London, Paris and New York. His taste of friends was always to be for the glossier rich. [6]

The investiture of Captain H. H. Saramad-i- Rajaha-i-Hindustan Raj Rajendra Shri Maharaja Dhiraja Sawai Man Singhji Bahadur, Maharaja of Jaipur, was celebrated at Jaipur on March 14, 1931 in the presence of His Excellency the Viceroy. A detail of the photograph which probably served as model to the present painting, was published in 1935. [7] It was most

probably taken by Madho Lal, by whom a signed photograph of Maharaja Madho Singh of Jaipur in old age existed in the collection of the late Kumar Sangram Singh of Jaipur. Apparently both an uncolored as well as a colored version of an actual photograph, taken at the same occasion and showing the prince standing, were published,[8] and the same subject as the present exhibit is also known as a painted photograph with additional columns, arches, and landscape, all painted.[9]

NOTES
1. Crewe 1985.
2. Gayatri Devi/Shanta Rama Rau 1976, pp. 94–96.
3. Rosita Forbes in Gayatri Devi/Shanta Rama Rau 1976, p. 91.
4. Jain/Jain 1935, chap. III, p. 3.
5. Crewe 1985, p. 66.
6. Crewe 1985, p. 69.
7. Jain/Jain 1935, chap. IV, illus. facing p. 1.
8. For the uncolored version, see Gayatri Devi/Shanta Rama Rau 1976, p. 97, reproduction on top. For the col. version see Galerie Pierre-Yves Gabus, December 10, 1990, p. 82, lot 265.
9. Galerie Pierre-Yves Gabus, December 10, 1990, p. 80, lot 258, dated "vers 1880."

33 Lonely Ranjha

by Muhammad Abdur Rahman Chughtai (1897–1975), Lahore, ca. 1930–1950.

Media: Ink and watercolor on paper

Size: 22³/₈ x 16³/₈ in. (56.8 x 41.6 cm.)

Ranjha is the hero of "Hir Ranjha," the love story of the beautiful Hir and Ranjha, who has to undergo hardships in order to woo Hir. Ranjha's home is Takhat Hazara, situated at the banks of the river Chenab in the Panjab, a state now shared by India and Pakistan. Ranjha, a Jat, was the most beloved son of his father Mauju Chaudhri, who had two daughters and eight sons. After Mauju Chaudhri's death, Ranjha suffered under his brothers, who saw to it that he only inherited a useless piece of land, whereas the seven brothers received that with the fertile soil. Ranjha finally left his home and lived through different adventures in the Panjab. According to the story, when Ranjha met Hir, rings decorated his ears and his beauty rivalled that of the full moon. He became a cowherd in the employ of Hir's father, who immediately realized that Ranjha's condition was too fragile to work with buffaloes. . . .

The story of Hir and Ranjha is impossible to summarize without spoiling the beauty of the tale. Its author was the Panjabi Waris Shah, who wrote it about 1766.[1] Ranjha is shown here as a cowherd with his long stick, and he looks dejected, as Hir's father noticed immediately upon his employment. This drawing is very typical of the partially colored drawing style of Muhammad Abdur Rahman Chughtai, to which a number of published works can be related.[2] His more current style is introduced by cat. no. 52 .

The present work consists of an ensemble of well composed lines which forms the garment of the cowherd Ranjha. The line is the essential element of Persian painting, which does, however, not allow any conclusions to be drawn as to Chughtai's art as a Muslim. As a contemporary art critic wrote:

The same good people or others have been heard to remark in front of one of Rahman Chughtai's pictures: "Ah, Persian influence." Persian surely, for the very reason that Chughtai is a Persian of the lineage of the Tartar-Mughals and of the family of the master-builders of the Pearl Mosque of Delhi and the Taj Mahal of Agra. It does not, of course, follow that, because Chughtai is in blood Persian, he should therefore paint Persian. Some of the masters of the Mughal art in the sixteenth and seventeenth centuries were pucca [i.e. pure, stout] Hindus, and some of the Indians to-day who ape a foreign art are not pucca anything, but in the case of Chughtai it just does follow. His cultural tradition takes fresh birth in him, with a difference due to passing time and personality. It is perhaps the "Oriental" character of Chughtai's pictures that will win admirers for them outside Asia. Their amazing technical skill is acceptable to all who are sensitive to excellence achieved. But the remoteness from so-called realism which Chughtai has deliberately cultivated will be specially acceptable to those who are now feeling the pull away from an alleged truthfulness to eyesight, towards the truth of the imagination. This has been the mission of Oriental art for ages, and a study of a set of Persian paintings (of which good reproductions can now be readily obtained) side by side with these of Chughtai, will show where they are at one in their mood of gentle repose, in their pictorial lyricism, and where Chughtai, with the impulse of the creative artist who has the sense of tradition, has made his wholly delightful and individual contribution. He retains the distinctive mood and posture of the Persian tradition but gives his pictures a special quality of his own in lovely colour combination, in delicious lines that seem to be less lines of painting than of some inaudible poetry made visible, in folds of drapery that are never mere coverings to or discoverings of the human body, but best men in the liturgy of beauty, in decorative backgrounds based on Saracenic architecture that call the imagination away from the tyranny of the actual into free citizenship of the realm of romance.[3]

It is not clear whether the author of these lines knew about the difference between Persian and Indian paintings from the Panjab hills, but his observations with regard to the use of line, especially in the drapery, are quite correct. Although Abdur Rahman Chughtai basically worked in his hometown, Lahore, he may be called a follower of the "Bengali" or "New school" of Indian painting, founded by Abanindranath Tagore. His paintings are hence classified as belonging to the "Bengal School of Art" within the catalogue of the collection in the Lahore Museum.[4] The present picture is somewhat related to an untitled pencil drawing, showing the head-and-shoulders of a herder in frontal view.[5]

NOTES
1. Waris Shah 1989.
2. Siraj-ud-Din n.d., col. pl. *Princess of Sahara;* col. pl. *The Tutor;* Tara Chand/ Kashmira Singh 1951, col. pl. *Nat-Raj;* col. pl. *With the Flute;* col. pl. *Tapasvi;* col. pl. *Amrit-Jal;* col. pl. *The Bather;* and col. pl. *The Divine Cowherd.*
3. James H. Cousins in Siraj-ud-Din n.d., pp. 9–11.
4. Cf. Nusrat Ali 1994, nos. 27–30 and no. 37.
5. Siraj-ud-Din n.d., *A Pencil Drawing.*

Battles,
Darbars,
Processions,
and Other
Assemblies

34 The Battle of the British and their Allies against the French and their Confederates at Condore, near Rajamandri

∾

December 9, 1758, by Nandkishor Soni, India, 1879(?).

Media: Gouache and oil on paper

Size: 29⁷/₈ x 52¹/₄ in. (75.9 x 132.7 cm.)

Inscribed: See adjacent text.

Inscribed: There are numerous inscriptions in *Nashtaliq* scattered over the painted surface. These inscriptions identify the major participants in the battle and its military units. Almost in the center on the right, dressed in a red coat, holding a plain sabre with his right hand and riding a white horse, appears "Karnal Ford," i.e. Colonel Francis Forde, who was sent by Robert Clive in October 1758, with 500 Europeans and 2,000 sepoys to Vizagaptam in order to create a diversion against the French there. The bearded horseman, also with drawn sabre, some distance behind Colonel Forde, is identified as Sayyid Muhammad. The fair-complexioned, richly dressed Indian gentleman on horseback, who is accompanied by several retainers on foot, including one man carrying a costly umbrella, is Raja Anand, the "Rajah" or "Anunderauze" of the description quoted below. The bearded horseman dressed in white, with a straight sword in his right hand, is Khwaja Ulla(?) Khan. The rider to his right is also identified, but the inscription is difficult to read. Zulfiqar Khan is the name of the Indian gentleman on horseback at the left edge of the picture, below an umbrella and surrounded by foot-soldiers dressed in dark blue. Wielding a straight sword with his right hand and turning towards Zulfiqar Khan is supposedly the Marquis de Bussy. The two Indian horsemen, dressed in white and standing together in the background at the left extremity of the painting, are labeled "Raja Gupti Raj" and "Chukrulla[?] Khan." Each artillery unit is labelled *top khana* (artillery) along with either "Bussy" or "Sultan" (for the

British cannons). Cavalry units are labelled *savari* (cavalry), and the elephant in the back is labeled *hathi* (elephant) together with an unreadable name. A partially obliterated inscription in the lower right corner gives a date as *isvi 1879* (A.D. 1879). A *Nagari* inscription in the lower left corner of the verso of the painting reads: "nandkishor soni" and below, with double underlining: *artish* (artist), followed by the numerals: "24.1.10."

When arrived at the village of Condore, the army was just as far as before from the French encampment at Gallapole, but with better ground between, and a village midway, which would afford a strong advanced post. Mr. Conflans imagined that the English troops had marched from their encampment to Condore, in order from hence to take possession of this village, and in this persuasion crossed the plain to prevent them, with his whole army, and succeeded in his wish without interruption; for Colonel Forde remained halting at Condore, to regulate his future motions by the enemy. Mr. Conflans imputed this inaction to a consciousness of inferiority, and now imagined that the English intended to march back to their encampment at Chambole, to prevent which, he formed his line, and advanced in much haste, and little order. The French battalion of Europeans was in the centre of the line, with 13 field-pieces, divided on their flanks, the horse 500 were on the left of the battalion; 3000 Sepoys formed the right wing, and the same number the left, and with each wing were five or six pieces of cumbrous cannon. The English army drew up with their Europeans in the centre, the six field-pieces divided on their flanks; the 1800 Sepoys were likewise equally divided on the wings.

Colonel Forde placed no reliance on the Rajah's infantry or horse, and ordered them to form aloof, and extend on each flank of the Sepoys: all this rabble kept behind, but the renegade Europeans under Bristol, who managed the four field-pieces belonging to the Rajah, advanced, and formed with the division of artillery on the left of the English battalion. The line having had time, were in exact order, and had advanced a mile in front of the village of Condore, during which, the enemy cannonaded hotly from all their guns. At length the impetuosity of the enemy's approach, who came on, out-marching their cannon, obliged the English line to halt for action; and it chanced that the whole of their battalion stopped near and opposite to a field of Indian corn, which was grown so tall that it entirely intercepted them from the enemy; but the Sepoys on the wings were free in the plain on each hand. For what reason is not known, Colonel Forde had ordered his Sepoys to furl their colours, which, besides the principal flag, are several small banners to a company, and to let them lay on the ground during the action. The Sepoys and horse of the enemy's wings greatly outstretched the wings of the English line, and came on each in a curve to gain their flanks; the French battalion in the centre, instead of advancing parallel to where by the wings they might judge the centre of the English line would be, inclined obliquely to the right, which brought them beyond the field of Indian corn, opposite to the English Sepoys on the left wing; whom from their red jackets, and the want of their usual banners, they from the first approach mistook for the English battalion; respecting them as such, they halted to dress their ranks before they engaged, and then began to fire in platoons advancing, but at the distance of 200 yards. Nevertheless, this was sufficient; for the Sepoys, seeing themselves attacked without cover by Europeans in front, and the horse and multitude of the enemy's Sepoys, gaining their rear, or coming down on their flank, scarcely preserved courage to give their fire, hurried, scattered, and without command; and then immediately broke, and ran away to shelter themselves in the village of Chambole, and were followed by the nearest of the enemy's horse.

This success was greater than even the confidence of the enemy expected; and several platoons of the French battalion were setting off to pursue them likewise, when they saw a line of men with shouldered arms marching fast and firm from behind the field of Indian corn across their way, to occupy the ground which the Sepoys had abandoned. Colonel Forde had been with the Sepoys before their flight, encouraging them to resolution; but saw, by the usual symptoms of trepidation, that they would not stand the shock, which prepared him to order the judicious movement, which the officers were now performing with so much steadiness and spirit. Captain Adnet, commanding on the left, led the line, and as soon as the last files were got clear of the corn, the word was given, when the whole halted, and faced at once, in full front of the enemy. This motion was quickly executed; for the foremost man had not more than 300 yards to march, and the field-pieces were left behind. During this short interval, the French battalion were endeavouring with much bustle to get into order again; for some of their platoons had advanced a considerable distance before others; and thus the fire of the English line commenced before the enemy's was ready; it was given in divisions, that is, the whole battalion divided into five, and began from Captain Adnet's on the left, which was within pistol shot, and brought down half the enemy's grenadiers; the fire ran on, and before

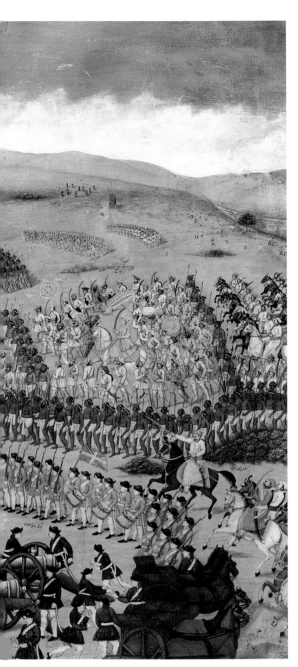

Pages 138–139. Elephant Procession-Crossing Afzul Gunj Bridge 6:15 p.m. *Nawab Sir Mahbub Ali Khan of Hyderabad and His Imperial and Royal Highness the Archduke Franz Ferdinand of Austria Este in January 1893. Photograph by Lala Deen Dayal, State Photographer to the Nizam.*

the time came for Adnet's division to repeat theirs, the whole of the enemy's line were in confusion, and went about running fast to regain their guns, which they had left half a mile behind them on the plain.

The ardour of the English battalion to pursue was so great, that Colonel Forde judged it best to indulge it in the instant, although not certain of the success of the Sepoys on the right, but concluding that the enemy's Sepoys who were to attack them, would not continue long, if they saw their Europeans compleatly routed. The order was given for the battalion to march on in following divisions, the left leading. Nothing could repress their eagerness. All marched too fast to keep their rank, excepting the fourth division commanded by Captain Yorke, who to have a reserve for the whole battalion, if broken, as the enemy had been, by their own impetuosity, obliged his men to advance in strict order.

The French battallion rallied at their guns, which were 13 in number, spread in different brigades, or sets, as they chanced to stand when left by the troops advancing to the action. This artillery began to fire as soon as the ground was clear of their own troops, and killed some men, which only quickened the approach of the divisions to close in with the guns, of which several fired, when the first division was within pistol shot, and Adnet fell mortally wounded; but his men rushing on drove the enemy from the guns of the attacked, and the other divisions following with the same spirit, obliged them to abandon all the others. The day, if not completely victorious, was at least secured from reverse by the possession of all the enemy's field artillery fit for quick firing; but their camp, to which they were retiring, still remained to be attacked; and Colonel Forde halted until joined by his Sepoys, and, if they would come, by the Rajah's troops. The Sepoys and horse of the enemy's right wing were in their turn panic-struck by the fire of the British battalion routing their own, and all turned to gain the rear of the guns, keeping aloof to the left of the English divisions; and then went off again with the French battalion to the camp. Their left wing of Sepoys behaved better, advancing to the use of musketry against the English Sepoys of the left, with whom the battalion, when filing off to oppose the French, left the three field-pieces of their right; and the Sepoys, encouraged by this assistance, the ardour of the Europeans marching off, and the spirit of their own commander Captain Knox, maintained their ground, facing and firing in various directions behind the banks of the rice fields, in which they had drawn up. The enemy's wing nevertheless continued the distant fire, until they saw their battalion of Europeans quitting their guns, and the Sepoys and horse of the right retreating with them to the camp; when they went off likewise; stretching round to the left of the English battalion halting at the guns, and keeping out of their reach. Captain Knox then advanced to join the battalion with his own Sepoys, and the six field-pieces, and had collected most of the fugitives of the other wing. Messages had been continually sent to the Rajah's horse to advance, but they could not be prevailed upon to quit the shelter of a large tank, at this time dry, in which they, his foot, and himself in the midst of them, had remained cowering from the beginning of the action.

As soon as the Sepoys joined, and all the necessary dispositions were made, which took an hour, Colonel Forde advanced to attack the enemy's camp; but, not to retard the march, left the field-pieces to follow. A deep hollow way passed along the skirt of the camp, behind which appeared a considerable number of Europeans regularly drawn up, as if to defend the passage of the hollow way, and several shot were fired from heavy cannon planted to defend the approach. Just as the English troops came near, and the first division of the Europeans stept out to give their fire, the field-pieces were arrived within shot; on which all the enemy went to the right-about, abandoned their camp, and retreated, seemingly every man as he listed, in the utmost confusion; but the English battalion crossing after them, many drew down their arms, and surrendered themselves prisoners. Mr. Conflans had previously sent away four of the smallest field-pieces; and the money of the military chest, laden for expedition on two camels. The spoil of the field and camp was 30 pieces of cannon, most of which were brass; 50 tumbrils, and other carriages laden with ammunition; seven mortars from thirteen to eight inches, with a large provision of shells; 1000 draught bullocks, and all the tents of the French battalion. Three of their officers were killed in the field, and three died of their wounds the same evening; 70 of their rank and file were likewise killed, or mortally wounded: six officers and 50 rank and file were taken prisoners, and the same number of wounded were supposed to have escaped. Of the English battalion, Captain Adnet and 15 rank and file were killed; Mr. Macguire, the pay-master, and Mr. Johnstone, the commissary, who joined the grenadiers, two officers, and 20 of the rank and file, were wounded; the Sepoys had 100 killed and more wounded. No victory could be more compleat. Mr. Conflans, the commander of the French army, changing horses, arrived on the full gallop at Rajahmundrum before

midnight, although the distance is 40 miles from the field on which the battle was lost; the troops took various routes, but most of them towards Rajahmundrum.

The cavalry of Anunderauze, although incapable of fighting, were very active as scouts to observe the flying enemy, and the concurrence of their reports determined Colonel Forde to send forward 500 Sepoys, which in the army were ranked the first battalion of these troops, under the command of Captain Knox. They were in march at five in the afternoon. (History of the Military Transactions of the British Nation in Indostan from the Year MDCCXLV, as published first in 1778)[1]

The British troops and their allies advance from the right and have occupied almost two-thirds of the terrain shown in the painting. The French and their allies offer resistance from the left part of the picture. Rajamandri (Rajahmundri or Rajahmundrum), situated to the south of Orissa, was one of the five so-called Northern Sarkars [Circars] seized by the French in 1753. These Sarkars provided valuable revenue to Hyderabad, where de Bussy, the Resident,[2] according to the English report on the battle, did not actively take part. The victorious English effected the transfer of revenue of the Northern Sarkars from Hyderabad to Calcutta. The English victory did not cause the immediate loss of French power in India, but undermined it. Two years later, the fate of direct French influence in that part of India was sealed.

Not surprisingly, in the present painting the Indian military units ("rabble") play a more important part than in the official English report. The picture of the army of Ananda Raja in particular is drawn more prominently in the painting than in the report. The depiction of this decisive battle stands out for its numerous details and the wealth of information supplied by its inscriptions. A most noteworthy detail is the temple-car at the tree near the lake, in the upper right of the painting. The date of the painting is controversial, as it seems to record two different dates, neither of which comply with its style, which in many aspects follows that of the traditional Indian painter. There is no other pictorial record of this battle and it cannot be compared to Indian depictions of similar eighteenth century military conflicts in India, since they do not seem to exist.

NOTES
1. *History of the Military Transactions 1985*, vol. II, pp. 378–382.
2. For a French portrait of de Bussy cf. Martineau 1932, p. 228.

35 Colonel Mordaunt's Cock Match at Lucknow, 1784–1786

∾

after an original oil by John (Johann) Zoffany, R.A. (1733–1810), engraved in mezzotint by Richard Earlom, London 1792; this copy published in 1794.

Media: Hand-colored mezzotint on paper

Size: 21 x 23³/₁₆ in. (53.3 x 58.8 cm.)

Inscribed: "Colonel Mordaunt's Cock Match. / At Lucknow, in the Province of Oude, in the Year 1786, at which were present several High and Distinguished Personages," and below, in smaller characters: "For the Names, see the Index Plate," and in small letters near the lower edge of the folio, center: "Published 12 May 1794 by Laurie & Whittle, 33 Fleet Street, London / (. . .)." The artist's name is given below the picture, lower left corner: "J. Zoffany pinxit"; the engraver's name appears below the picture, lower right corner: "R. Earlom sculp. London."

Published: Reproductions of further copies include Corfield 1910, p. 41, no. 40; Gupta 1979, p. 55, fig. 11; Archer 1979, p. 153, no. 94; Pal/Dehejia 1986, p. 73, no. 65; Bruhn 1987, p. 44, fig. 54, cat. no. 94; Bayly et al. 1990, p. 116, no. 136; Sotheby's N.Y., September 21, 1995, lot 134; Christie's, June 5, 1996, lot 206; Sotheby's N.Y., September 19, 1996, lot 432).

In the early twentieth century, a nineteenth-century connoisseur of the life at court reported on cock-fighting in Lucknow:

For fighting purposes in Lucknow, the cock's claws were tied so that they could not cause much damage, whilst their beaks were scraped with penknives and made sharp and pointed. When the two cocks were released in the cock-pit, their owners stood behind them, each trying to get his own cock to deal the first blow. When the cocks started to fight with beak and claw their owners incited and encouraged them shouting, "Well done my boy, bravo! Peck him, my beauty!" and "Go again!" On hearing the shouts of encouragement the cocks attacked each other with claw and beak and it seemed as if they understood what was being said to them. When they had been fighting for some time and were wounded and tired out, both parties, by mutual consent, would remove their birds. This removing was called pani [literally, water] in cock-fighting idiom. The owners would wipe clean the wounds on the cocks' heads and pour water on them. Sometimes they would suck the wounds with their lips and make other efforts, whereby the cocks were restored to their former vigour in the space of a few minutes. They were then once again released into the cock-pit. This method of pani was continued and the fights would last four to five days, sometimes even eight or nine days. When a cock was blinded or was so badly hurt that he could not stand and was unable to fight, it was understood that he had lost. It often happened that a cock's beak was broken. Even then, whenever possible, the owner would tie up the beak and set the cock to resume the fight.[1]

Cock-fights were organized in Jaipur — where John Zoffany's portrait of Nawab Asaf ud Daula was copied (cat. no. 11) — at least until December 1910, when they were witnessed by the German crown-prince and photographed by his attendants.[2]

Although the painting is called after Colonel Mordaunt, commander of the bodyguard of Asaf ud Daula, standing with outstretched arms to the left of the central group, it is the nawab himself who is centered in this composition. This is not surprising since John Zoffany worked for the nawab of Oudh after his arrival at Lucknow on June 3, 1784. Zoffany made two copies of this painting. One copy was for the nawab himself. It was last seen and described by Fanny Parks on January 24, 1831:

I … proceeded to Daulat Khana, a palace built by Ussuf-ood-Dowla, but now uninhabited, except by some of the ladies and attendants of the old king's zenana. We went there to see a picture painted in oil by Zoffani, an Italian [sic] artist, 3 of a match of cocks, between the Nawab Ussuf-ood-Dowla and the Resident, Colonel Mordaunt; the whole of the figures are portraits; the picture excellent, but fast falling into decay.[4]

The nawab's version was probably destroyed during the mutiny of 1857. It is possible that, before the mutiny, it was copied by another European court painter at Lucknow, Robert Home, as the so-called "Ashwick version."[5]

The history of the first version is very well documented. Zoffany painted it for Warren Hastings, Governor General of Bengal, who was present "At Mordaunt's Cock-fight" in April 1784, even before Zoffany arrived at Lucknow.[6] In a bill that Zoffany submitted to Hasting's accountant, Larkins, he charged rupees 15,000 "[f]or an historical picture of a Cock Pitt composed of a great number of small figures."[7] Hasting's version has survived, is quoted by some as the "Daylesford version," and was exhibited and reproduced.[8]

Along with the mezzotint engraving went a "key engraving," which was exhibited along with the original oil in probably the greatest exhibition of Indian art ever, in 1947–1948, where it was assigned a separate catalogue entry.[9] This "key engraving" was published in 1796, two years after the publication of the engraving by Richard Earlom, which was already released on May 1, 1792. Almost all reproductions of Earlom's engraving show the 1792 edition. The present engraving, however, was published in 1796, when the "key engraving" was already known, as is documented by the printed text of the present work, where it is actually called "Index Plate." This Index Plate lists nineteen different persons of which sixteen are identified by name. Most of these names (with the exception of the two present

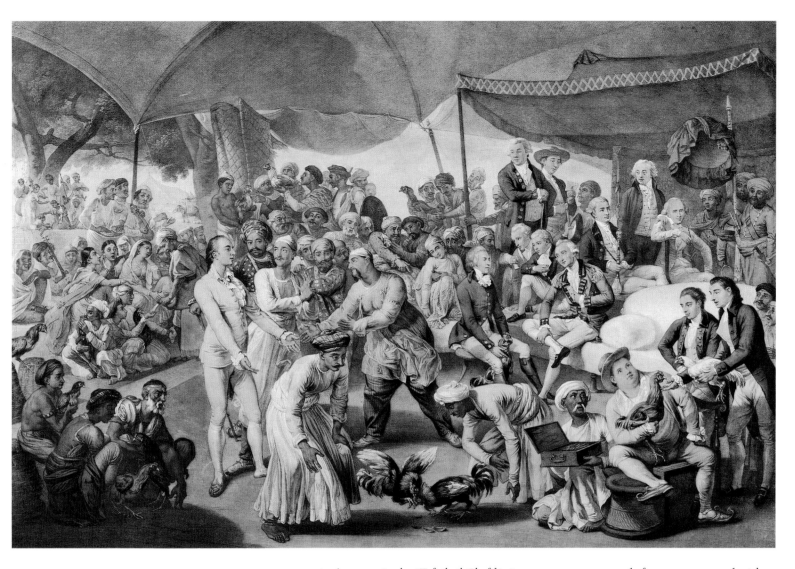

artists) appear in the "Tafzihu'l Ghafilin," a contemporary record of events connected with Asaf ud Daula's administration,[10] and, of some of them, individual portraits by Zoffany or other court artists exist.

The greatest European expert in cock-fighting was probably the French General Claude Martin who "had amassed a large fortune by trade and by winning bets on cock-fights. . . ."[11] He is numbered "4" in the Index Plate and is shown dressed in a red uniform, seated on a dais, with his right ankle placed on his left knee. Zoffany himself is also present. He is the gentleman seated in the background with his right elbow resting on some device and holding a pen in his right hand, numbered "16" in the Index Plate.

Another artist of note who arrived at Lucknow not before February 20, 1786 is Ozias Humphry. Numbered "15" in the Index Plate, he is the man who places his left hand on the right shoulder of John Zoffany.[12] This probably "most famous 'conversation piece' of the eighteenth century Anglo-Indian record," as Zoffany's painting was rightly called,[13] triggered a number of Indian copies and/or versions of either the lost version of the nawab or the engraving, which at some point must have arrived in India. The most closely related Indian copy was or still is in an American(?) private collection and dates from the early nineteenth century.[14] Still very closely related, but with the introduction of growing plants and flowers on the floor, is another nineteenth-century version, which is difficult to date more precisely.[15] A mid-nineteenth-century copy has reversed the whole composition but for the nawab and Colonel Mordaunt himself. This is the largest published version which was in the collection of Dr. William K. Ehrenfeld, who subsequently donated it to the Asian Art Museum in San Francisco.[16] A composition that is almost entirely new rather than a copy is offered by

another Indian painting of more modest dimensions. It shows the nawab seated with Haidar Beg Khan behind the nawab's right outstretched arm.[17] Haidar Beg Khan seems not to be present in the "Daylesford version."[18] Probably no other work of art shows more noted Europeans assembled and engaged at a native Indian court than this one.

NOTES

1. Sharar 1975, p. 123.
2. Heichen n. d., p. 146. For a photograph of this cock-fight see ibid., pl. opposite p. 152.
3. Zoffany was born on March 13, 1733, near Franfurt/Main, Germany. His name was then Johann Zauffely. He came to England in 1760.
4. Parks 1975, vol. I, p. 181.
5. Cf. Archer 1979, p. 149f.
6. Webster 1976, p. 77.
7. Archer 1979, p. 152.
8. See e. g. Webster 1976, p. 77f., no. 104; Archer 1979, pp. 150–151, nos. 92–93.
9. See *Exhibition of Art*, p. 122, cat. no. 1331 (for the oil) and cat. no. 1332 (for the key engraving). These entries were not changed for the later commemorative catalogue to that exhibition, cf. Gray 1950, p. 191, no. 918 (for the oil) and no. 919 (for the key engraving).
10. For the Index Plate see e.g. Archer 1979, p. 153, no. 95. For the contemporary history see Abu Talib 1971.
11. Sharar 1975, p. 245 and p. 123.
12. For Ozias Humphry and his miniature portraits of the Lucknow nobility etc., cf. Archer 1979, pp. 186–198.
13. Bayly et al. 1990, p. 116.
14. Welch 1978, pp. 94–95, no. 39.
15. Christie's, April 24, 1990, lot 102.
16. Ehnbom 1985, pp. 84–85, no. 34, col. pl. (= Christie's, October 13, 1982, pp. 36–37, lot 68, col.)
17. Tillotson 1985, no. 35, col.
18. For his portrait by Ozias Humphry, see Archer 1979, p. 195, no. 119.

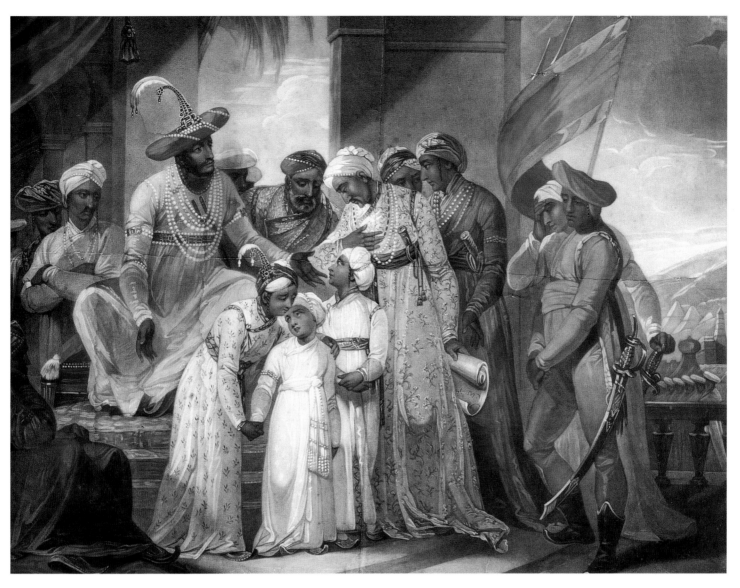

36 The Sons of Tipu Sultan (1749–1799) Leaving Their Father

∽

engraved by J. Grozer and published in August 1793; based on the oil-painting **Departure of the Hostages from Seringapatam** by Henry Singleton (1766–1839), England, 1793.

Media: Hand-colored mezzotint on paper

Size: 18¹/₂ x 23¹/₂ in. (47 x 59.7 cm.)

Published: For another copy cf. Bruhn 1987, p. 53, fig. 72.

Tipu Sultan, the son of Haidar Ali Khan of Mysore (1702–1782), succeeded his father, who was defeated by Sir Eyre Coote at Porto Novo in 1781, as ruler of Mysore in December 1782. Seringapatam, then Tipu Sultan's capital, was quite successfully attacked by the army of Lord Cornwallis and his allies, the nizam's force under Sikandar Jah and a party of Marathas, on February 6, 1792. On February 16, the siege army was substantially reinforced by Major General Robert Abercomby, who earlier served in North America until the peace of 1763 and again from 1776–1783. The siege was continued, together with negotiations. On February 22, an ultimatum was placed before Tipu by the allies. According to this ultimatum, Tipu had to cede half of his kingdom to the allies in addition to a payment of 1,300,000 rupees. He was also required to surrender all prisoners. In order to guarantee the execution of this ultimatum, Tipu was asked to send two of his three sons as hostages to the camp of Cornwallis. "These conditions, the last one in particular, were very painful to Tipu-Sahib. The grief and the dismay in the *zenana* [sérail] reached the extreme when the young princes were sent into hostage. When they left the fort, the Sultan himself ascended the bulwark to follow them with his own eyes." (J. Michaud, as published in 1801)[1] This terminated the so-called Third Mysore War.

Probably no Western observer witnessed the scene when Abdul Khaliq and Muiz-ud-Din, the two sons of Tipu Sultan, left their father on February 26 in order to become British prisoners. And when the news of the successful siege of Tipu's capital reached the contemporary British artists then in India (Arthur William Devis, George Carter, Robert Home), they started to paint the event illustrating the surrender of the hostage princes. History painters, such as Mather Brown (cf. the following cat. no. 37) or Henry Singleton,

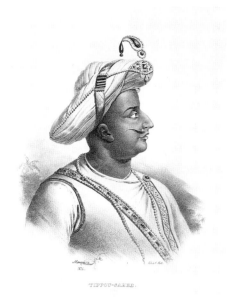

TIPPOU-SAHEB.

Fig. 7

also took up the subject, although they had never been to India. Singleton probably never left England and based his depiction of the scene on descriptions published in the newspapers reporting the event.

Most artists concentrated on the scene of the reception of the hostage princes; Singleton was one of the few who ventured to depict the most grievous scene,[2] for which he had to invent a portrait of Tipu Sultan, whose portraits are otherwise all alike.[3] Most noteworthy is Tipu's turban ornament, a kind of *sarpech*, which includes two white bird feathers. The unusual shape of the turban was probably adapted from a portrait of Tipu's father, entitled *Hyder Ally Cawn sitting in his Durbar*, then in circulation.[4] The actual oil painting after which the present mezzotint engraving was made was exhibited in the Royal Academy in 1794 under the title *Departure of the Hostages from Seringapatam*; it once belonged to Maharaja Sir Prodyot Coomar Tagore and was rightly described as "perhaps the most accomplished and vivid record of an early English response to the dramas of Empire."[5]

NOTES

1. Michaud 1801, vol. I, p. 149. Here we favor French sources, since they seem to be less partial than the British.
2. For Mather Brown's engraved version, see Pal/Dehejia 1986, p. 54, no. 40; for a reproduction of the actual painting, see Archer 1979, p. 422, illus. 334.
3. For what comes nearest to a contemporary Indian portrait from life, see Guy /Swallow (eds.) 1990, p. 185, col. illus. 161 (= Archer 1959, fig. 3, facing p. 4 = Archer/Rowell/Skelton 1987, p. 27, fig. 18 = Buddle 1990, col. pl. p. 17 = Archer 1992, p. 71, no. 31, col.), a painting in the Victoria and Albert Museum, London, of which another version also exists (cf. Pal 1983, p. 210, col. pl. D16). This possibly led to a portrait of Tipu in oils, done by G. F. Cherry, who was Persian Secretary to Lord Cornwallis, in 1792. The picture was then given by Lord Cornwallis to Tipu's mother, cf. Archer 1959, p. 27; for a reproduction of the same see ibid., fig. 1, facing p. 2. Based either on Cherry's oil or on a mezzotint engraving by Samuel W. Reynolds, published in A. Beatson's *A View of the Origin and Conduct of the War with Tippoo Sultaun*, London, 1800, (reproduced: Buddle 1989, p. 55, fig. 2) is a pencil drawing by T. Morris of 1802, now in the Freer Gallery of Art, Washington, cf. Beach 1983, p. 159, fig. 7. Either Cherry's or Morris's version formed the basis for the engraved frontispiece of James Hunter's *Picturesque Scenery in Mysore*, London, 1805 (reproduced: Archer 1959, fig. 2, facing p. 4 = Pal/Dehejia 1986, p. 53, fig. 39). Mirror-reversed versions, in which Tipu faces right, were published as early as 1801, as the frontispiece engraving in Michaud 1801, vol. I, shows. Others, like the lithograph by C. Motte after a painting by Mauraisse of 1826, entitled *Tippou-Saheb*, were to follow (see accompanying fig. 7). One of these versions was turned into oils, cf. Sotheby's, October 21, 1993, p. 157, lot 722. Copies of versions showing Tipu's head and shoulders facing left were produced until the twentieth century. There is an engraving by C. Moorish in G. Mohammed's *History of Hyder Ali and Tippoo Sultan* from 1855 (Buddle 1989, p. 64, fig. 12), and a large painting in oils from about 1920 (Sotheby's, October 10 and 11, 1991, p. 193, lot 713) in addition to an oleograph of about the same period (Bayly et al. 1990, p. 156, no. 160, col.). These head-and-shoulders were also incorporated into such paintings as *Tipu Sultan on his Throne* by Anna Tonnelli (Archer/Rowell/Skelton 1987, p. 119, no. 213, col. = Buddle 1990, p. 37, col. pl.) or *Tipu Sultan Undressing a Woman while Kneeling on Her Bed* (Sotheby's, April 26, 1991, p. 13, lot 21; Sotheby's, April 27, 1994, p. 91, lot 134). Christie's N.Y., May 25, 1978, said to represent Tipu Sultan, shows in fact Madhoji Sindhia.
4. For this engraving see Bayly et al. 1990, p. 153, no. 154.
5. For a reproduction of the actual painting, see Archer 1979, p. 423, illus. 336; for the text see ibid., p. 424; Eyre & Hobhouse 1981(?) col. frontispiece and p. 4, no. 15.

37 Lord Cornwallis (1738–1805) Receiving the Sons of Tipu Sultan as Hostages

∿

a hand-colored engraving by Daniel Orme after the painting by Mather Brown (1761–1831) of London, ca. 1793. Published: January 1799.

Media: Hand-colored engraving on paper

Size: 24½ x 35¾ in. (62.2 x 90.9 cm.)

Inscription: Immediately below the engraved surface, left side: "Mather Brown pinxt. Painter to Their Royal Highnesses The Dukes of York & Clarence." Below the engraved surface, right side: "Daniel Orme sculpt. Historical Engraver to His Majesty & His R.H. The prince of Wales." And in the center, in larger characters: "To the KING'S most Excellent MAJESTY / This Engraving of THE MARQUIS CORNWALLIS Receiving The HOSTAGE PRINCES, Sons Of Tippoo Sultaun/In View of Seringapatam—Is with His Majesty's gracious Permission Humbly Dedicated by His most dutiful Subject and Engraver/Daniel Orme."

As hostages for the fulfillment of the treaty Tippoo agreed to give his second and third sons. The elder, Abdul Kalik, was about ten years of age; dark complexioned, with thick lips, a small flattish nose, and a long pensive countenance, yet graceful in his manner, and, when the novelty of his situation wore off, animated in his appearance. The younger, Mooza ud Deen, was about eight; remarkably fair, with regular features, a small round face, large full eyes, and a lively countenance. His mother, a sister of Burham ud Deen, who was killed at Sattimungalam, a beautiful, delicate woman, died absolutely of fear, a few days after the attack of the lines.

On the 26th, [February 1792] about noon, the princes left the fort, mounted on elephants richly caparisoned, seated in silver hoeders [howdahs, usually covered seats on the backs of elephants], and attended by their father's vakeels at the tents sent from the fort for their accommodation, and pitched near the mosque redoubt, they were met by sir John Kennaway, and the vakeels of the nizam and the mahratta chief, also on elephants, who accompanied them to head-quarters. The procession was led by several camel hircarrahs, and seven standard bearers, carrying small green flags suspended from rockets, followed by a hundred pikemen, whose weapons were inlaid with silver. Their guard of two hundred sepoys, and a party of horse, brought up the rear. As they approached head-quarters, the battalion of Bengal sepoys, commanded by Captain Welch, appointed for their guard, formed a street to receive them. Lord Cornwallis, attended by his staff, and some of the principal officers of the army, met the princes at the door of his large tent, as they dismounted from their elephants; and, after embracing them, led them, one in each hand, into the tent. When they were seated on each side of his lordship, Gullam Ali, the principal vakeel, addressed him thus: These children were this morning the sons of the sultan my master; their situation is now changed, and they must look up to your lordship as their father. Lord Cornwallis, who had received the boys with the tenderness of a parent, anxiously assured the vakeel, and the princes themselves, that every possible attention should be shown to them, every possible care taken of their persons.

At this interesting scene the princes appeared in long white muslin gowns and red turbans. Each had several rows of large pearls round his neck, from which hung an ornament consisting of a ruby and an emerald of considerable size, surrounded by large brilliants, and in his turban a sprig of valuable pearls. The correctness and propriety of their conduct evinced, that they had been bred with infinite care, and taught in their youth to imitate the reserve and politeness of age. (Robert Home, as published in 1796).[1]

The princes were mounted on two richly caparisoned elephants. They sat in howdahs of silver [seats covered by canopies]; they were accompanied by servants of their father, also mounted on elephants. Lord Cornwallis greeted the sons of Tippoo Sahib in front of his tent; he embraced them and led them to the interior by taking their hand. The elder one, Abdal Kalik, was about ten years old, and Mooza-ud-Deen about eight. When they were seated next to Lord Cornwallis, one to his left, the other to his right, Gullam Aly, their royal tutor, said to Lord Cornwallis: "This morning, the children were the sons of the sultan, and they must now consider you as their father." The two princes trembled at the sight of the Europeans, because at the court of Tippoo, they always heard them represented as being the most cruel enemies to the inhabitants of Mysore; but through the asseverations of friendship and by the cordial reception rendered to them by Lord Cornwallis, they were soon calmed. They were dressed in white robes of muslin with red turbans on their head. Around their neck they had several large pearls as part of necklaces, from which an ornament of lavish size, composed of rubies and an emerald, suspended. To their turbans an aigrette of pearls was fastened. Elevated from early childhood, said Major Direton, with endless care and accustomed to imitate in their behaviour the politeness and restraint of mellowed age, they astonished all spectators with their wise and measured behaviour. (J. Michaud as published in 1801)[2]

Mather Brown, an American from Boston who moved to London in 1780, had never been to India. He "received every assistance by drawings made in India, and information from officers of high rank who were present on the occasion" as a contemporary announcement claims, but the coloring of the engraving after his painting, which is now in the Victoria Memorial, Calcutta,[3] does not exactly correspond to the descriptions quoted above. The portrait of Cornwallis, for example, who takes the children by the hand as described, could be more accurate.[4] The seated man who is carried in a quite uncomfortable way on some sort of square platform,[5] is probably the tutor, Ghulam Ali Khan, who resembles a man of the same name as drawn by Thomas Hickey.[6] The defeated Indians bow down to the British flag and to Cornwallis, who is about to burst of corpulence and pride, indicated by the only

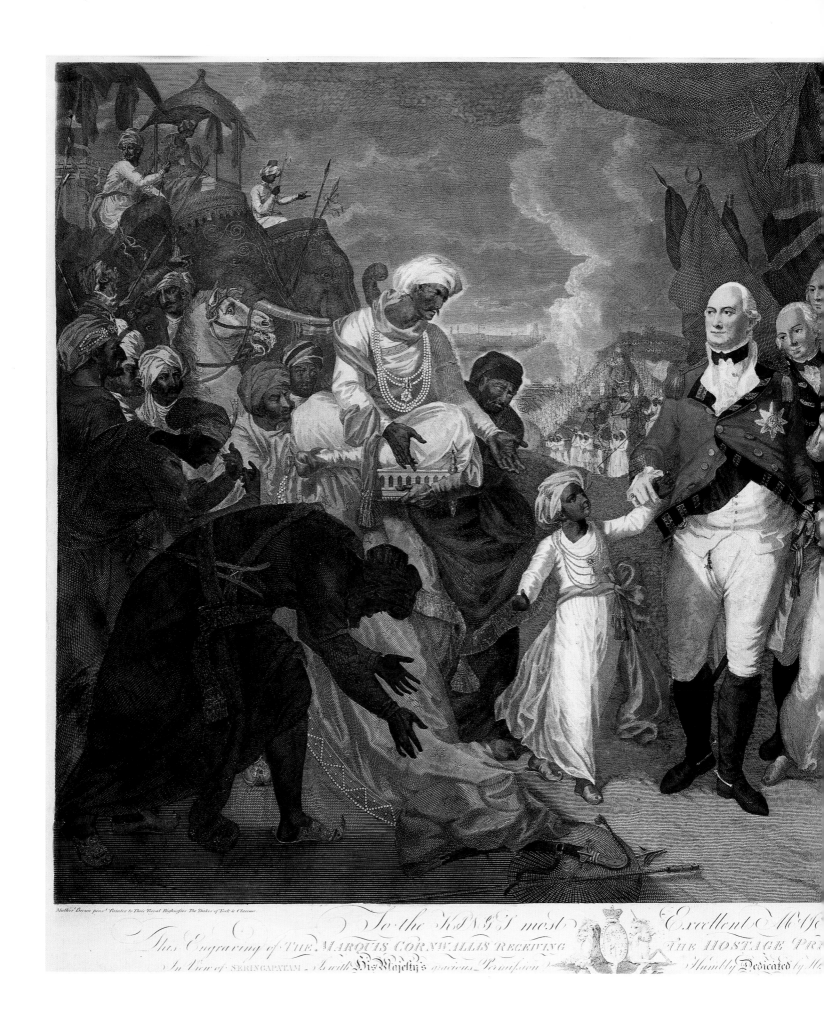

Mather Brown pinxt Painter to Their Royal Highnesses The Dukes of York & Clarence.

To the KING, most Excellent Ma.ffie

This Engraving of THE MARQUIS CORNWALLIS RECEIVING THE HOSTAGE PRI

In View of SERINGAPATAM, As with His Majesty's gracious Permission Humbly Dedicated by His

'Daniel Orme Sculp' Historical Engraver to His Majesty & His R.H. The Prince of Wales

...SS OF Tippoo Sultaun

Subject and Engraver Daniel Orme

button keeping together his tight coat. A much larger version of the same picture is now in the Oriental Club, London.[7] It might predate the smaller version, after which the present engraving was made.

In 1776 Cornwallis was sent to America, where he distinguished himself in several difficult actions under the command of Sir William Howe. In 1777 he won the battle of Brandywine and occupied Philadelphia. In the following year he returned to England because of his wife's bad health. She died soon after and Cornwallis returned to America, where he won the battle of Camden, and, some time later, took the town of Charleston. On October 14, 1781, however, he capitulated while facing a triple-strong force composed of French and Americans. In 1785 he was sent on a mission to Frederick the Great of Prussia, after which he became both Commander-in-Chief and Governor General of India. He defeated Tipu Sultan in 1792, and later reduced the French settlement of Pondicherry, for which service he was made a marquess.[8]

The "hostage subject" became one of the most frequent historical themes of the late eighteenth and early nineteenth centuries in England.[9] A brochure "issued by Orme with Mather Brown's print summarised the mood of all these paintings and engravings: 'the gallant Cornwallis' is shown as 'displaying to his captives a generosity which would have done honour to the brightest hero of the classical page of antiquity . . . the amiable princes looking up to that exalted character as their only protector, father and friend . . . the vakeel, their preceptor with all the splendour of Asian magnificence, and with a dignity, approaching the apostolical character.'" The pictures combine "the most splendid objects and scenery which could attract the human eye and the most pathetic incident which could ever warm the human heart."[10]

NOTES

1. Home 1796, pp. 3–4. Home's description is of importance, since he was present at the event.
2. Michaud 1801, vol. I, pp. 149–150. This description is either adopted from or confirmed by Robert Home, who was an eyewitness to the scene, cf. Buddle 1989, p. 57. The "Major Direton" is probably Major Alexander Dirom, author of *A Narrative of the Campaign in India which terminated the War with Tippoo Sultaun in 1793*, London, 1793.
3. Reproduced: Archer 1979, p. 408, illus. 325 and p. 421.
4. For a portrait of Marquess Cornwallis by T. Gainsborough, see Mersey 1949, illus. facing p. 21 (Bayly et al. 1990, p. 127, no. 152, col.). For a reproduction of an engraving see Corfield 1910, p. 14, fig. 21. For Arthur William Devis's masterly portrait see *Octagon*, vol. XX, Number 2, October 1983, p. 13, col. pl.; for another, also by A. W. Devis, see Archer 1986, pl. VI, no. 24 (= Moorhouse 1983, full-page illus. p. 68). In light of the other "hostage scenes" (cf. note 9 below), however, Mather Brown's portrait of Lord Cornwallis is still quite convincing.
5. This kind of transportable seat also figures in Robert Home's and John Zoffany's versions, for which see note 8 below. Ghulam Ali was reportedly lame and thus had to be carried.
6. Reproduced: Archer 1959, pl. 21.
7. Reproduced: Archer 1979, p. 422, illus. 334 and pp. 421–422.
8. For more details cf. Mersey 1949, pp. 21–26.
9. See e.g. the following reproductions of "hostage scenes": painting by Henry Singleton: Archer 1979, p. 422, illus. 335; engraving after H. Singleton: Bruhn 1987, fig. 73, no. 96 (cf. Buddle 1990, p. 54); mezzotint engraving by Laminet after Henry Singleton: Buddle 1989, p. 56, pl. 3, col. (= Archer 1959, pl. 15); col. mezzotint, published by R. Sayer: Christie's, May 25, 1995, p. 64, lot 95; oil-painting by Thomas Stothard: Archer 1979, p. 426, illus. 337 (= Christie's, June 5, 1996, p. 106, lot 133A, full-page col. pl.); reverse-painting on glass by an unknown artist: Sotheby's, June 15, 1987, p. 163, lot 392; painting by John Zoffany: *The Journal of Indian Art and Industry*, vol. XII, July 1909, no. 107, pl. 167; oil-painting by Robert Home: Buddle 1990, p. 53, col. pl. (= Bayly et al. 1990, p. 154, pl. 157, col. = Archer 1979, col. pl. XIV = Archer/Rowell/Skelton 1987, p. 25, fig. 16); oil-painting by Arthur William Devis: version 1: Archer 1979, p. 263, illus. 187, version 2: Bayly et al. 1990, p. 35, fig. 11 (= Archer 1979, p. 265, illus. 188; Devis in fact produced three versions of this subject, cf. Pavière 1937, pp. 157–158); painting by George Carter: Archer 1979, p. 278, illus. 194.
10. Archer 1979, p. 424.

38 Thakur Daulat Singh, his Minister (Divan), his Nephew and Others in a Council

∾

by a "Skinner Artist," Rajasthan(?) or Delhi, ca. 1820.

Media: Watercolor on paper

Size: 11⁷/₁₆ x 15¹/₂ in. (29.1 x 39.4 cm.)

Inscribed: See adjacent text.

Published: Christie's, April 23, 1981, p. 76, lot 152; Sotheby's, May 22 and 23, 1986, p. 9, lot 5; Desai 1988, p. 26, col.; Sotheby's N.Y., June 4, 1994, lot 138, col.

Inscribed: In *Nashtaliq,* with English equivalents, above the central figure: *Sher(?) Daulat Singh Ji qaum Radaur, Bashindah [-i] Jodpur* ([Lion(?)], the honorable Thakur Daulat Singh, from the Radaur [Rathaur?] clan, resident of Jodhpur) / "Thakoor Daulat Sing"; above the first standing figure from left: *Hari Singh Radaur...* (Hari Singh Radaur [Rathaur?]) / "Hurru Sing"; above the second standing figure from left: *Bha'i Jod Singh, Khavasi [-i] Takur Jodpur Radaur* (Brother Jodh Singh, personal servant of the Radaur [Rathaur?] Thakur [from] Jodhpur) / "Bhau Jod Sing"; near the head of the man behind Daulat Singh: *Divan Hirodas Ji, Bashindah [-i] Jodpur* (the honorable Minister Hirodas, resident of Jodhpur) / "Deewan Herow Dass"; on the shield and the forearm of the first seated figure from left: *"Ranabir(?) Radaur, Bashindah [-i] Jodpur* (Ranabir[?] Radaur [Rathaur?], resident of Jodhpur) / "Runu(?) Rathore"; on the breast of the second figure from left: *Padam Singh Ji Radaur, Bashindah [-i] Jodpur* (the honorable Padam Singh, resident of Jodhpur) / "Puddum Sing"; near the head of the standing figure on the right side *Charan Singh Ji, qaum Radaur, Bashindah [-i] Jodpur* (the honorable Charan Singh, from the Radaur [Rathaur?] clan, resident of Jodhpur) / "Churran Sing"; above the head of the man seated opposite Daulat Singh: *Badan Singh Ji Radaur, Biradarzadah [-i] Takur Daulat Singh Ji, Bashindah [-i] Jodpur* (the honorable Badan Singh Radaur [Rathaur?], nephew of the honorable Thakur Daulat Singh, resident of Jodhpur) / "Buddun Sing Rathor / a Nephew of the Thakoor"; below the seated figure behind Badam Singh: *Bail(?) Singh Ji, qaum Radaur, Bashindah [-i] Jodpur* (the honorable Bail[?] Singh, from the Radaur [Rathaur?] clan, resident of Jodhpur) / "Lal Sing"; on the spittoon and by the boy with the spittoon: *Rupiyah(?)...Daulat Singh, qaum...Radaur, Bashindah -i Jodpur* (Rupiya(?) . . . Daulat Singh, from the Radaur [Rathaur?] clan, resident of Jodhpur) "Roopa / . . . house / Boy of the Thakoor."

In October 1828, when travelling through the Panjab, Godfrey Charles Mundy observed: "The minister, as is usual with viziers, sat immediately behind the Rajah,"[1] who, in the present painting is a *thakur* (landlord) rather than a ruler of a state. In March of the same year, Major Archer remarked with regard to the *hookah* (water-pipe) smoked by a ruler: "[W]hat is of material consequence in the eyes of a native [is] the privilege of smoking his hookah, thereby establishing his equality [with the British]."[2] "Radaur" in the above-quoted inscription most probably stands for "Rathor" (also written "Rathaur" or "Rathore"), since almost every person is labeled as "a resident of Jodhpur," and Jodhpur in Rajasthan was then the capital of the Rathor clan.[3] Previously, the figures were published as coming from a place called "Radaur," although the inscriptions inform the reader that the people come from Jodhpur. We hence assume that Daulat Singh and his men are members of the Rathor clan from Jodhpur, especially since a number of paintings which show portraits of members of the Rajasthani nobility by the "Skinner artist," who painted in a similar style, survive.[4]

The subtle coloring renders this watercolor more agreeable than its later copy, painted in the strongly decorative style of Ghulam Ali Khan's later pictures,[5] the present whereabouts of which are unknown.[6] It is equally inscribed, though with less-detailed identifications which nonetheless confirm those of the present painting, and it was also described as showing people from a place called "Radaur."[7] As with Fraser's Divan Mohan Lal, the present Divan can also be identified by his pen-case *(qalamdan)* and inkpot *(dawat).*

NOTES
1. Mundy 1858, p. 156.
2. Archer 1833, vol. I, p. 157.
3. For a contemporary source on this clan or tribe, see Tod 1920, vol. I, pp. 105–106; vol. II, pp. 929–1121.
4. Cf. e.g. Leach 1995, vol. II, p. 730, no. 7.1 *(Javan Singh of Udaipur)*, p. 731, no. 7.4 *(Kalyan Singh of Kishangarh).*
5. Cf. Hazlitt, Gooden & Fox 1991, no. 16, dated 1849 and no. 17, dated 1852.
6. Sotheby's, April 29 and 30, 1992, p. 116, lot 264, col. The error as to the provenance of the persons is repeated here again.
7. The only exception is Desai 1988, where the provenance of the painting is given as "Sindh" and the date as "1850–60."

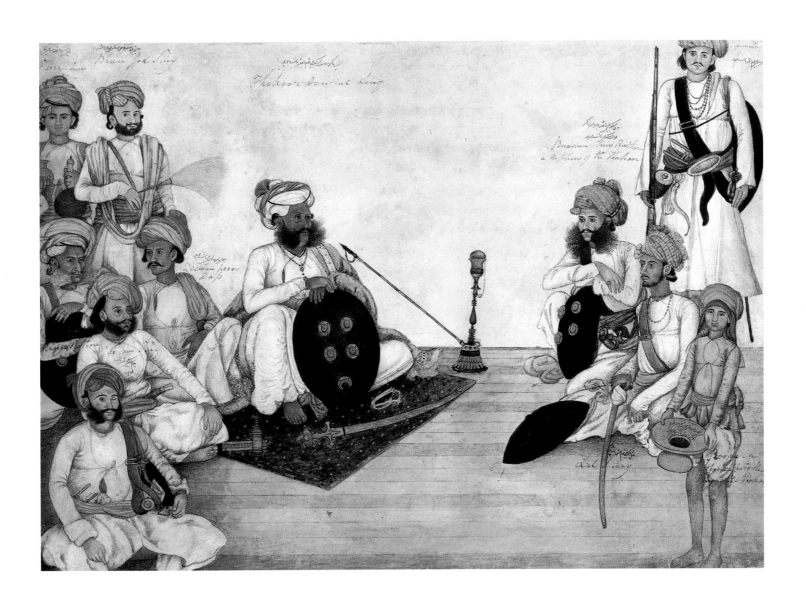

39 Maharana Jawan Singh of Mewar (b. 1800, r. 1828–1838) Receiving British Officers in the Bari Chitrashali (Large Picture-Gallery) within the Royal Palace of Udaipur

∾

attributed to Ghasi, Udaipur, ca. 1829.

Media: Gouache on paper

Size: 23 1/4 x 16 3/4 in. (59.1 x 42.5 cm.)

Inscribed: In *Nagari* script, on verso: *maharana shri javan sighji badi catrasali me birajya*[1] (The honorable Maharana Jawan Singh, having gone to the Bari Chitrashala) and, below: *nam⁰ ki⁰ 40* (Num[ber?], price: 40), a canceled "52" below which appear the *Nagari* numerals "6/16."

Provenance: The Maharanas of Mewar; British Rail Pension Fund

Published: Cimino 1985, p. 29, no. 28 with text by Andrew Topsfield; Sotheby's, April 26, 1994, p. 58, lot 48, col.

A contemporary publication introduces the rulers of Mewar in Rajasthan, the capital of which is Udaipur, as follows:

The Oodipur family boasts an antiquity of some thousand years, and a descent from the celestial Ramchunder [i.e. Ramachandra, an incarnation of Vishnu and hero of the Hindu epic *Ramayana*]. *But though the highest in rank, it is but the third in power or resources, of the states of Rajpootana. It is fruitless to seek for any accurate information respecting a people whose history is founded in a great measure upon the enthusiastic narratives of bards, who, by their marvellous traditions, draw largely on the credulity of wondering auditors.*[2]

The downfall of the Mughal empire caused inter alia by marauding Marathas, Jats, and Pindaris created a situation which became rather difficult to survey, and by the beginning of the nineteenth century nobody knew exactly who fought for whom in Rajasthan (Rajpootana), why, and when. The British hence decided to introduce "law and order" again, and involvement in the internal affairs of the Rajput states was considered necessary, especially since, according to the official British history, the Rajput rulers readily accepted British tutelage. Naturally, the British were ready to help:

In 1817 it was resolved by the British Government to extend British influence and protection over the States of Rajputana, and the Rana [i.e. the ruler of Udaipur] *eagerly embraced the opportunity and entered into a treaty. The British Government agreed to protect the territory of Oodeypore, and use its best exertions for the restauration of the territories it has lost, when this could be done with propriety: and the Maharana acknowledged the British supremacy, agreed to abstain from political correspondence, to submit disputes to the arbitration of the British Government, and to pay one-fourth of the revenues as tribute for five years and thereafter three-eights in perpetuity.*[3]

Nineteenth-century British historians perpetuated the story of the noble and unselfish conduct of their own government: "The British Government took the country of Udaipur under its protection. . . ."[4] or: "At length in 1817 the British Government resolved to extend its influence and protection over the states of Rajputana, and Bhim Singh [father of the present Jawan Singh] eagerly embraced the opportunity. . . ."[5] The British obviously preferred their own version to that of the Rajput bards, and relied on their own writers — officials who also doubled as historians. One in particular, Captain James Tod, published the still most important English history of Rajasthan in 1829 and 1832 respectively. Initially he was not a historian, but a British official who took his job very seriously:

Captain Tod was the first Agent appointed at Oodeypore. As the country was utterly disorganized and decided interference necessary to restore the State to prosperity, he was directed to take the control of affairs into his own hands. In 1826 the authority of the Maharana was finally restored; but before long, the extravagance and oppression became as great as before. Bhim Singh died in 1828, succeeded by his son Jowan Singh [i.e. the man with nimbate head facing right in the present painting], *who was a debauchee; and the consequence was that the government went from bad to worse: the tribute fell heavily into arrears, and the state was overwhelmed with debt.*[6]

Maharana Jawan Singh and his father, Maharana Bhim Singh, were similarly characterized by other British officials:

On the 31st March, 1828, died Maha Rana Bheem Singh, who, during his long reign of 50 years had experienced the greatest vicissitudes of fortune, and had witnessed the fall of his country from wealth and power, to be a field of robbers and the theatre of intestine internal feuds. . . . Raised from the dust, and his kingdom restored to him by foreigners, of a different colour and religion, by whose support alone he reigned, he had not learnt humility from affliction, nor had poverty taught him wisdom. He held fast by his faults and weaknesses to his death. He was accompanied to the funeral pyre by four wives and four concubines, and was succeeded by his son, Maha Rana Jowan Singh. This Prince, who had given promise of better things, immediately after his accession to the throne, became involved in a round of debauchery and was almost constantly intoxicated.[7]

DARBARS, PROCESSIONS, AND OTHER ASSEMBLIES

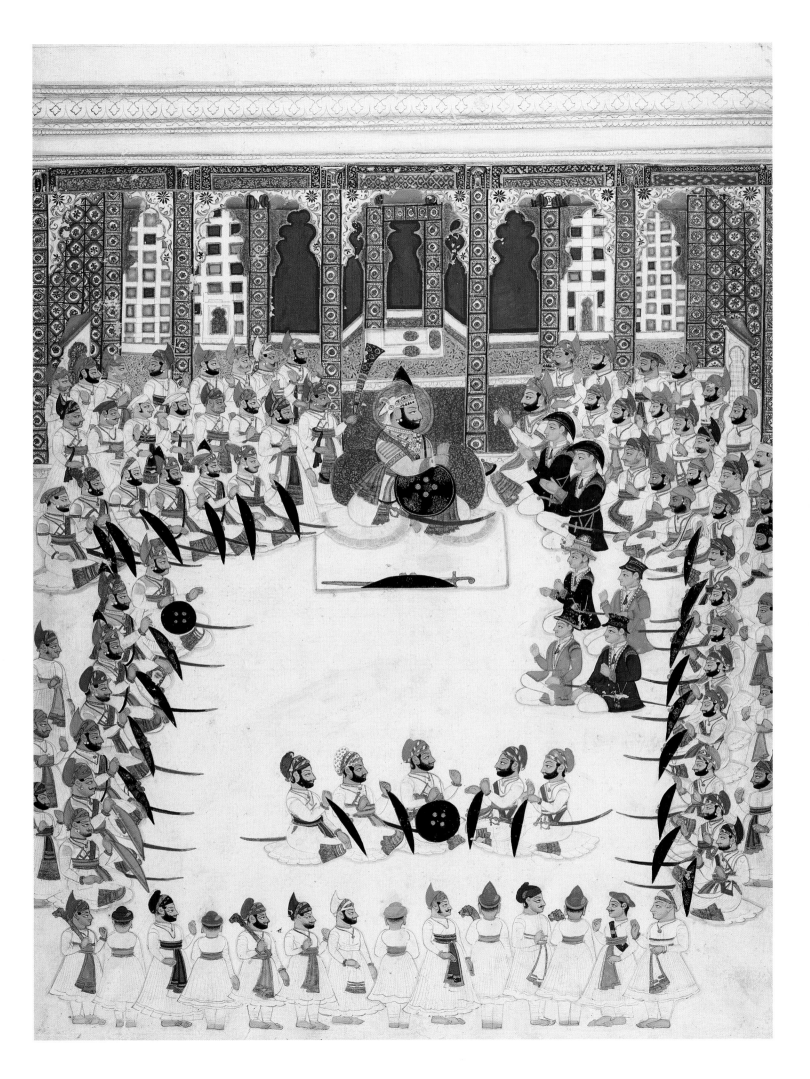

Or, as stated in another account: "Bhim Singh died in 1828, and was succeeded by his son Jowan Singh. The new ruler was, unfortunately, a man of no character, addicted to vicious habits and low pursuits. . . . To such an extent was maladministration carried that the Rānă had to be warned that unless he could keep his engagements with the British Government, a territorial or other sufficient security would be required." [8] And this was exactly what the British had in mind.

Maharana Bhim Singh died on 31st March 1828, having learnt neither humility from affliction nor wisdom from poverty. He held fast by his faults and weaknesses to his death, and he was accompanied to the funeral pyre by four wives and four concubines. He was succeeded by his son Jawan Singh, who gave himself up to debauchery and vice. Within a few years the tribute had again fallen heavily in arrears, the State was overwhelmed with debt. . . . [9]

By sending Captain Tod, Britain invested in Mewar and became alarmed when the tribute—payable, it should be remembered, to the British—did not yield the amount that was calculated. The present painting shows that "almost constantly intoxicated debauchee," that man of "no character," the Maharana Jawan Singh of Mewar, together with his nobles—amongst them probably Padam Singh of Salumbar, Nahar Singh of Deogarh, Keshav Singh of Begun, and others[10]—as he is being greeted by six kneeling Britons and other Rajputs at a *darbar*—(for this term see the following cat. nos. 40, 41, and 42) given in the *Bari Chitrashala.* It has been suggested that this painting illustrates "probably the official durbar held for Maharana Jawan Singh's investiture in March 1829." [11] Three very similar Europeans, apparently from this group, appear in a mural in the *Bara Mahal* of the Kota palace. The wall painting is dated the same year, 1829.[12] Ghasi, to whom this painting was first attributed by Andrew Topsfield, based his composition on an earlier work of about 1826. This painting shows Jawan Singh's predecessor and father, Maharana Bhim Singh, in an almost identical pose, in conversation with British officials, similarly arranged.[13] That painting showing Maharana Bhim Singh was copied in V.S. 1990 (1933 A.D.) by the painter Pannalal Parasram Gor, according to the *Nagari* inscription below the painted surface. Parasram's copy was published a number of times as showing Maharana Bhim Singh receiving "Colonel Tod." [14] Colonel Tod does appear in contemporary Mewar painting, but looks different,[15] and Topsfield has shown convincingly that the British officials in the earlier version of about 1826 cannot be identified with certitude, although some suggestions might be considered.[16] If the date of ca. 1829 is correct, then one of the British officials is most likely Captain Thomas Alexander Cobbe (1788–1836), who was the political agent for Mewar from 1822–1831.

The inscription calls the place of this *darbar Bari Chitrashali* or Large Picture-Gallery. A place with that name no longer exists in the Udaipur palace and it has been suggested that the premises are identical with the *Mor Chowk* (Peacock Court) of today,[16] which is not correct. It is the earlier version with Maharana Bhim Singh, mentioned above, which is placed in the *Mor Chowk.*[17] The *Bari Chitrashali* of Maharana Jawan Singh's time is called *Bari Chaturshala* today, perhaps a corruption of *Bari Chitrashala.* It is "distinguished by the blue ceramic tiles that ornament the columns and ceilings." [18] These tiles are easily recognizable in the present painting. From the balcony in the back, Maharana Jawan Singh could enjoy his view of what has today become the Lake Palace Hotel, one of the most luxurious in Rajasthan. The position of the *Mor Chowk* with regard to the *Bari Chitrashala,* alias *Bari Chaturshala,* is already shown in a published Mewar painting of 1765: The latter is in the top part and the former in the lower part of the painting.[19] It is probable that the *Mor Chowk* of today corresponds to the so-called *Choti Chitra Shali* (Small Picture-Gallery) of former times. It was in this part that Colonel Tod was first received in *darbar.*[20]

The blue tiles are the result of an earlier contact the maharanas of Mewar had with Europe. A German gentleman in the service of the V.O.C., the Dutch East India Company, passed through Udaipur in 1711, while on his way to Lahore. His name was Joan Josua Ketelaar and his journal of this voyage has in some parts survived.[21] Two large paintings on cloth have come down to us which show how Ketelaar and his colleagues were entertained by Maharana Sangram Singh of

Udaipur, and, also not to be forgotten, how Ketelaar and his crew entertained the maharana.[22] This intimate contact with the Dutch probably led to the so-called "Farangi-theme" in Mewar painting.[23] One may presume that the blue tiles shown in the present painting are of Dutch or perhaps of Chinese origin. The least that can be said is that without contact with the Dutch the maharanas of Mewar would not know about this type of tiles. Shyamaldas mentions a *Chini ki Chitrashala* which was ready for a festival on March 4, 1723.[24] The word "Chini" may stand here for china-ware in general, rather than indicating a Chinese origin. Shyamaldas mentions the Portuguese gentlemen, which still exist. They are in the *Bari Chatur Chowk* to the West of the *Bari Chatur Shali*, as it is called today.[25]

Maharana Jawan Singh, who reappears in the following cat. no. 40, commissioned at least 198 paintings including his portrait. The numerals on the back of the present painting indicate that out of these 198, this was no. 16.[26] Since he lived to rule 10 years, he must have commissioned about 20 portraits of himself in a year, not to mention pictures of mythological subject matter, or historical interest, or subjects from literature. We are not in a position to determine whether Maharana Jawan Singh really was of the character which the British officials repeatedly described. This picture, in addition to the 197 other ones, however, proves at least that the maharana was capable of commissioning such tastefully composed paintings.

NOTES
1. For a more scientific transliteration, see Topsfield in Cimino 1985, p. 111.
2. Clunes 1833, p. 139.
3. Yate 1880, p. 22.
4. Malleson 1875, p. 24. For the rest of the text, in almost verbal correspondence, cf. the text of Yate, note 3 above.
5. Erskine 1992 [first published: 1908], p. 26. For the rest of the text, in almost verbal correspondence, cf. the text of Yate, note 3 above.
6. Yate 1880, p. 22. For a more recent assessment of Tod's contribution, see Masters 1990, p. 76 ff. or Davenport 1975, pp. 77–84.
7. Brookes 1859, p. 35.
8. Malleson 1875, p. 25.
9. Erskine 1992, p. 26.
10. For the sixteen principal chiefs from the time of Jawan Singh, see Clunes 1833, p. 143.
11. Sotheby's, April 26, 1994, p. 59.
12. For this mural see Michell/Martinelli 1994, col. pl. 117, p. 141. For a detail cf. Bautze 1988/89, fig. 2.
13. Topsfield 1990, no. 25, pp. 71–73, col. pl. p. 71 and detail, pp. 72–73.
14. Beny/Matheson 1984, p. 41: "Colonel Tod presents his credentials to the Maharana Bhim Singh, fresco [*sic*] in Udaipur City Palace"; Vashishtha 1984, pl. paginated "72," top right (in Hindi): "Maharana Bhim Singh in darbar with Colonel Tod"; Das 1987, col. illus. p. 163: "This miniature shows Colonel Tod (1782–1835) presenting his credentials to Maharana Bhim Singh II (1778–1828)." James Tod, known throughout Rajasthan as "Colonel Tod," actually held the rank of Captain. He became "Lieutenant-Colonel" after his return to England. Topsfield 1990, p. 73, calculates the *samvat*-date of the Indian calendar ten years less, viz. "1923."
15. Topsfield 1990, no. 24, col. pl. pp. 68–69 and p. 70, footnote 8 for four paintings altogether, one of which is in a San Francisco private collection. A fifth painting in the Victoria and Albert Museum, London, is not mentioned in that footnote. It is another version of the more often published painting showing Colonel Tod on an elephant in the Victoria and Albert Museum, London. It introduces the "Colonel" as "Lord Sahib" and bears the date V.S. 1874 (1817 A.D.). It is published in color, but without the inscription on top, in Allen/Dwivedi 1984, p. 262, top.
16. Sotheby's, April 26, 1994, p. 59.
17. This is a recent name, not mentioned in the palace description in Dev Nath 1938. The modern name derives from the peacocks modelled in high relief and faced with colored glass mosaic. For reproduced col. photographs see Fatesinghrao Gaekwad/Fass 1985, p. 21, the two lower illus.; Michell/Martinelli 1994, p. 133, illus. 99–100. For a related Mewar painting see Beny/Matheson 1984, col. pl. p. 162 or Ward/Joel 1984, col. pl. pp. 142–143, the lower court. The Peacock Court is situated to the south and on a lower level with regard to the locality at which the *darbar* of the present painting took place. The *Mor Chowk* is numbered "16" in the groundplan of the Udaipur palace as published in Michell/Martinelli 1994, p. 159.
18. In Michell/Martinelli 1994, p. 159; it is numbered 15 in the plan and forms the easternmost part of it. The painter looked from west to east. For modern photographs of these premises cf. Beny/Matheson 1984, col. pl. p. 170 and p. 173; Fatesinghrao Gaekwad/Fass 1985, p. 18, the col. reproduction at the bottom; Tillotson 1987, p. 110, fig. 137.
19. Topsfield 1980, col. pl. no. 14, cat. no. 167. For a later picture painted from a comparable, though lower viewpoint see Beny/Matheson 1984, col. pl. p. 162 or Ward/Joel 1984, col. pl. pp. 142–143.'
20. Dev Nath 1938, p. 14 under *Choti Chitra Sali* and p. 15 under *Pritem Nivas*.
21. For this journal see Ketelaar 1937.
22. For the respective painting in the Victoria and Albert Museum see Topsfield 1984/85, p. 353, fig. 3: For the other painting in the Rijksmuseum, Amsterdam, see Bautze 1987, cat. no. 22, pp. 53–60, col. pl. pp. 54–55; Bautze 1988; Scheurleer 1989.
23. Topsfield 1984/85.
24. Shyamaldas 1886, vol. II, p. 965.
25. Rawson 1961, col. illus. p. 120; Tillotson 1987, p. 111, col. pl. X; Michell/Martinelli 1994, p. 133, col. illus. 101. Topsfield calls this locality *Shiv Vilas*, cf. Topsfield 1984/85, p. 355, fig. 5.
26. This becomes clear from Topsfield 1995, Table of Inventory Numbers, p. 192, under "6." "6" is also the first inventory number mentioned on the back of the present painting.

40 Maharana Jawan Singh of Mewar (b. 1800, r. 1828–1838) Receiving the Governor General of India, Lord William Cavendish Bentinck (1774–1839) at the Ajmer Darbar, February 8, 1832

∾

by a Mewari artist, ca. 1832.

Media: Gouache on cloth

Size: 74¼ x 51½ in. (188.5 x 130.8 cm.)

Inscribed: In *Nagari* script, upside down, at the bottom of the entrance to the first court: *rimat* [probably for *kimat* = price] 225

Provenance: The Maharanas of Mewar; Spink and Son Ltd., London

Several contemporary accounts of this *darbar* exist, none of which however, describes this unusually large painting of great historical importance. The Indian word *darbar*, often written "durbar" to suit English pronunciation, carries two meanings, viz. a royal court or its major representative (the ruler) and an official audience. In this catalogue it always has the latter meaning. At such a *darbar*, two chiefs or representatives of independent rulers meet. Occasionally, more chiefs also may gather at a *darbar*. This type of meeting is very ceremonial and follows a strict protocol, especially with regard to the gun-salute, exchange of *nazars* or presents, etc. In the course of time, its former political function was changed into a demonstration of rank and representation of power by the display of wealth and luxury. The *darbars* organized by the British culminated in the Agra Darbar of 1866 and the Delhi Darbars of 1877, 1903 (see cat. no. 42) and 1911.

The Ajmer *darbar* of 1832 may be considered as the first major Anglo-Indian *darbar* in this context. Ajmer is an ancient, formerly predominantly Muslim city in Rajasthan, and a good number of contemporary descriptions exist.[1] Lord William Bentinck, who arranged this *darbar*, was appointed Governor General of India in July 1827. For health reasons, Bentinck had to return to England in March 1835.[2] Bentinck is the gentleman dressed in orange, facing the maharana (with nimbate head) while sitting on the same sofa-like piece of furniture below an awning, in front of the large tent in the top part of the painting. To art historians of India, Bentinck will always be remembered as one of the most efficient Governors General. His efficiency in reducing costs and saving money resulted in the destruction of the Great Gun at Agra for the sake of selling its scrap-metal, the demolition of one of Shah Jahan's most splendid buildings in the Agra fort and subsequent transport of a part of these spoils to England, and his attempt to destroy the Taj Mahal in order to gain money from the sale of its marble. All this "showed the meanness and baseness of his mind, and made him odious in the eyes of all."[3] Shah Jahan's pillars, or the "Pillars from Agra," constituted one of the major attractions of the Colonial and Indian Exhibition, when British colonialism almost reached its zenith, and they were officially presented as "a gift from the Government of the United Provinces [of India] to the national collection at South Kensington [today the Indian section of the Victoria and Albert Museum]."[4] It is hence not surprising that the Ajmer *darbar* "was necessary in suppressing anti-British feelings and for better mutual understanding."[5]

The *darbar* started on January 17, 1832 and lasted until the following month. Bentinck initially invited seven of the major Rajput rulers, viz. Maharana Jawan Singh of Mewar, Maharaja Sawai Jai Singh of Jaipur (known as "Jai Singh III"), Maharao Raja Ram Singh of Bundi, Maharana Kalyan Singh of Kishangarh, Nawab Amir Khan of Tonk (for whom see cat. no. 14), Maharao Ram Singh of Kota and Maharaja Man Singh of Jodhpur, who, however, did not attend.[6] The descendants of the rulers of Jaipur, Bundi, Tonk, and Kota will be found present at the Delhi Darbar of 1903, as in the following cat. no. 42.

An overview of the painting, followed by a variety of details, provides insight into the ceremonial aspects of the *darbar*: The white rectangular area in the top half of the painting is the "arena," the "amphitheatre" of the later Delhi *darbars*. Here, the two parties meet. They consist of Lord William Bentinck with British officials, properly dressed but without boots, on the right-hand side and the Maharana of Mewar with his own officials on the left-hand side. Several camel-loads of chairs had to be provided for this meeting. The royal tent of the maharana, with two awnings in front of it, forms the backdrop below which he receives the Governor General and his entourage. The British gentleman on the maharana's side is an interpreter. To the left of the royal tent a second, smaller tent stands below another awning and within its own enclosure. The horses of royal relatives stand in line behind the back-enclosure of the royal tent. The horses, with two grooms in a smaller tent at the left end of the *paiga*, are also within an enclosure made of red *qanats* or tent walls. At the bottom of the painting, the foreground is filled with detachments of British cavalry to the left and elephants belonging to the Mewari *thakurs* or nobles on the right-hand side. The central lane

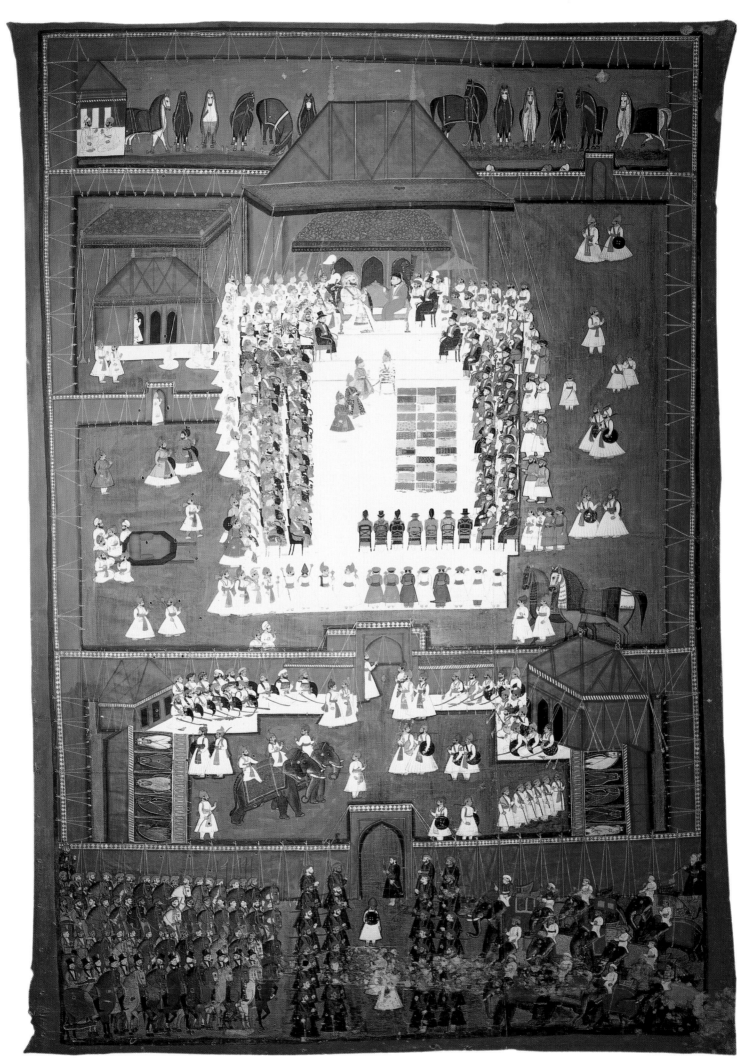

DARBARS, PROCESSIONS, AND OTHER ASSEMBLIES

leading to the arched gateway of the tent enclosure is guarded by armed Rajputs in blue uniforms. The rectangular tent enclosure has tent-roofed stables for the royal horses or *paiga* on the left- as well as on the right-hand side. The two elephants within that enclosure and the two horses within the next enclosure most probably form part of the customary gift of the Maharana of Mewar to the representative of the British government. The two tents within the first enclosure are probably meant for the royal servants.

Maharana Jawan Singh of Mewar was born in 1800 [7] and succeeded to the throne of Mewar on March 31, 1828.[8] He died without issue in 1838.[9] Several detailed accounts of his life exist.[10] His forefathers are known as the proudest members of the royal house of Mewar, the capital of which was then Udaipur. They did not yield to Mughal supremacy and had no intention of dancing to the tune of the British flute. The official British historian and witness of later events in Mewar recorded: "The Rana [i.e. Maharana Jawan Singh] intimated to Major Lockett, Officiating Governor General's Agent, that none of his ancestors had ever left their country to pay a visit of ceremony to the Kings of Delhi, and that some individuals of importance had not been inactive in dissuading him from the journey to Ajmere. Many old and experienced Officers in the Governor General's Camp predicted that the Rana never would be induced to visit Ajmere, and there was not a native who expected to see him.[11] The maharana finally did come to Ajmer on January 22 by "taking the route via Eklingji, Sanwar, Gilund, Pahuna, Bhilwara, Banera etc. On the border of Mewar, a political officer, and at Ajmer Major Lockett came forward to receive him."[12]

On February 5, the maharana visited the Governor General. He approached Bentinck's camp on the back of an elephant and a salute of nineteen guns was fired at the arrival as well as at the departure of the maharana.[13] The expert advice on "such extremely delicate questions as the scale of artillery salutes for the different chiefs, the gifts they were to receive, how they were to be met and where they were to be seated . . ." was most probably given by Colonel James Skinner, for whom see cat. no. 16.

On February 8, as shown in the present painting, Bentinck visited the camp of the maharana. Bentinck himself apparently did not leave any written document on this meeting, but there is a French eye-witness account by Victor Jacquemont, Bentinck's friend. Jacquemont rightly mentions that the Maharana of Mewar has an "uncontested pre-eminence" with regard to his rank within the Rajput system. It is for this reason that the maharana receives honors, which other Rajput rulers don't. One of the honors was "une sorte de trône fait pour l'occasion," a particular kind of throne specially manufactured for this occasion, on which both the maharana as well as the Governor General were to be seated.[14]

Jacquemont's description is more than confirmed by the present painting.[15] A series of misunderstandings ("certaines de fautes contre l'étiquette") almost brought this historic meeting to an end before it started. Jawan Singh was to receive Bentinck at a certain distance from the entrance to his tent. But the maharana, in order to meet and properly receive the Governor General, had to be officially informed about the arrival of the latter. This, however, did not happen, and when the Governor General, in his palanquin, reached the place where he was to be greeted by the maharana, the maharana was not there. Bentinck, who was not yet used to this kind of etiquette, wanted to be carried further. Prinsep, then chief secretary, protested because he feared that the British government would be discredited in the minds of the native chiefs if the Governor General did not insist on the honors due to him. Prinsep ordered the palanquin to be placed on the ground and Bentinck felt he had no choice but to do as he was told. After a while, one could see the maharana in the distance, seated in his palanquin and ready to move to the place where the Governor General was waiting for him. The maharana must have noticed the arrival of the Governor General, but since he was not officially informed about it, he refused to move towards him.

Finally he moved a few paces in Bentinck's direction. Bentinck also wanted to move towards the maharana, but Prinsep, furious, again protested. But when Bentinck saw a second movement of the maharana in his, Bentinck's, direction, Bentinck finally demanded to be carried in the direction of the maharana, much against the will of his own chief secretary.[16]

It is hardly surprising to read that the meeting was not very cordial. There were even more blunders in etiquette committed by some British officials. They entered the tent-enclosure with their parasols, the oldest symbol of rank and honor in India. This was the prerogative of the maharana alone — one which he never granted even to any of the Mughal emperors — and was considered by the king of Mewar as an *affront sanglant*, or serious insult. Jacquemont finished his report on Bentinck's visit in the camp of the maharana by saying that all the displeased Mewari chiefs asked the British government for a remission of one year's tribute to the crown in order to cover the expenses caused by their voyage to Ajmer.

Jacquemont, however, was not properly informed regarding the latter point. The conversation between the maharana and the Governor General was reported by Brookes, who wrote: "Several subjects of negociation were brought forward by the Maha Rana during the interview. A claim for the territory alienated previous to our treaty was given in, and subsequently another paper containing minor requests, viz. that the amount of tribute payable to the British Government should be diminished, and one year's tribute be remitted, on account of the expenses attendant on a proposed pilgrimage to Gyah [i.e. Gaya, in Bihar]."[17] The accuracy of Jacquemont's observation with regard to the palanquin of the maharana and the "parasol" is confirmed by the present painting. An umbrella which could be that of Jacquemont's description is carried by a bearer behind the man on an isolated chair, probably Prinsep. The palanquin of the maharana is visible between the left tent-enclosure and the white "*darbar* carpet."

Shyamaldas, the Indian historian of the maharanas of Mewar, enumerates the different kinds of gifts which were exchanged at this occasion. He mentions fifty-one trays of cloth, of which thirty-six are represented here, in addition to a pearl necklace, wrist ornaments, a shield, a sabre, a gun, three different types of knives or daggers, two horses with saddles, and one elephant.[18] The two horses and the elephant, often also two elephants, were customary gifts,[19] which Bentinck was not allowed to keep for himself. They were to be given to other Indian chiefs on similar occasions.[20] Shyamaldas also gives the names of those nobles who accompanied Jawan Singh at this reception. It is difficult, however, to identify them properly, especially since a number of faces were left unfinished.

On February 10, 1832, Maharana Jawan Singh met Maharaja Sawai Jai Singh at Ajmer. A painting that illustrates this event was included in an earlier exhibition based on Dr. William K. Ehrenfeld's collection of Indian paintings,[21] and another version of this painting was also published.[22] This painting and its variant show that the Rajputs never sat on chairs but on carpets. The chairs introduced here are hence a kind of novelty, a sign of British predominance. Bishop Heber, while describing a reception at Jaipur on January 29, 1825, remarked: "We sat cross-legged on the carpet, there being no chairs, and kept our hats on."[23]

Probably the most unforgettable description of a "pre-chair" *darbar* at a Maratha chief's camp is by G. C. Mundy. It dates from January 3, 1829:

The floor was carpeted with white cotton, so thickly quilted that we sank up to our ankles as we walked; and to this stuffing we were subsequently much beholden, as there was not such a quadruped as a chair in the Mahratta camp; and during the audience, which lasted a full hour, we were obliged to sit cross-legged, like Turks or tailors, on saddle-cloths spread on the floor, the characteristic seat of the warlike Mahratta, to whom the unsheltered and unfurnished bivouac is a natural home. In sitting, the great point to be observed was the keeping the soles of the feet out of sight, an article of etiquette which the native chiefs easily

accomplished by sitting on their heels, with their knees resting on the ground; but this posture, I found, after several fruitless (I was going to say bootless) experiments, totally incompatible with our armed heels. We therefore squatted, each after his own fashion: nor do I think any novelty of attitude was struck out which was likely to be adopted by the natives, who did not disguise their amusement at the unpliable rigidity of British limbs, the uneasy contortions of which they were in a good situation to witness, as we were all drawn up on one side of the narrow passage, whilst they were marshalled in a parallel line confronting us. At the end of the hour — one of the longest I ever passed — attar and paun were handed round, and we rose to depart with legs so cramped and benumbed, that we quitted the presence more like a troop of hobbling Chelsea pensioners than sound and active adolescents.[24]

Rose-oil and betelnut preparations, the "attar and paun" of Mundy, also terminated the reception of Lord William Cavendish Bentinck by the maharana of Mewar,[25] as was customary at the final ceremony of any such *darbar*.[26] Maharana Jawan Singh left Ajmer on February 16 and reached Udaipur via Shahpura and Sanwar in due course.[27] The chairs that had been introduced into the *darbar*-rooms by the British were abolished from most Rajput palaces following India's independence from British rule in 1947.

Some years ago, on the occasion of the engagement ceremony of the then Bhanwar of Kota (now Maharajkumar), a few selected European diplomats and other persons of rank, in addition to an American friend of the then Maharajkumar (now Maharao) of Kota, were invited to witness a special *darbar*, which was attended by numerous members of the Rajput nobility. There were no chairs, and I remembered Mundy's description more clearly than ever. The only non-Indian male spectator who did not suffer from the absence of chairs was the American collector and connoisseur Stuart Cary Welch. It may perhaps be said that India kept the maharajas and dropped the chairs.

The present painting might be attributed also to the artist Ghasi, who painted the preceding cat. no. 39.

NOTES

1. Broughton 1892, pp. 252–257, dated February 27, 1810; Heber 1828, vol. II, pp. 31–33, dated February 7, 1825; Jacquemont 1834, pp. 49–54, dated March 9 to 13, 1832. For a comprehensive compilation of early nineteenth-century accounts on Ajmer, see Ritter 1836, pp. 902–913.
2. For a short account of Bentinck's career, see Mersey 1949, pp. 51–54.
3. Thomas Seaton: *From Cadet to Colonel. The Record of a Life in Active Service*, London, 1866, vol. I, p. 88, quoted after Losty 1989a, p. 46.
4. Cundal 1886, woodcut-engraving facing p. 30 and text p. 31.
5. Somani 1985, p. 183f.
6. For Maharao Ram Singh's participation, see Bautze 1990a.
7. November 18, 1800 following Shyamaldas 1886, vol. II, p. 1808. Somani 1985, p. 179 mentions November 19 as his day of birth.
8. Shyamaldas 1886, vol. II, p. 1785; Somani 1985, p. 179.
9. On August 30, following Somani 1985, p. 192; on August 24, following Shyamaldas 1886, vol. II, p. 1807. These differences are basically due to the difficulty of putting dates of the Indian calendar into dates of the Gregorian calendar.
10. Shyamaldas 1886, vol. II, pp. 1785–1808; Somani 1985, pp. 179–192, to mention only the most often quoted sources.
11. Brookes 1859, p. 37. For an even more contemporary source see Clunes 1833, p. 142: "In January, 1832, the Governor-General invited the princes of Rajpootana to a general congress at Ajmeer, at which, among the rest, appeared the Rana of Oodipoor, whose ancestors never had attended upon the emperors, though forced to yield an unwilling submission. He did not consider his honour compromised by taking this opportunity of evincing his gratitude to a government which had raised him from a state of misery and destitution, to the enjoyment of a considerable revenue, and to nearly the whole of the territories possessed by his immediate ancestors."
12. Somani 1985, p. 184.
13. For the list of presents and more details of this reception, see Shyamaldas 1886, vol. II, p. 1798. The salute of nineteen guns was kept even in later periods, cf. Chakrabarti 1895, p. 248.
14. Jacquemont 1934, p. 53.
15. A comparable pictorial record, representing the reception of Bentinck by the Maharao of Kota on the same occasion, shows both the Kota ruler as well as the Governor General on two different chairs, cf. Bautze 1990a.
16. Jacquemont 1934, p. 53f.
17. Brookes 1859, p. 37. Maharana Jawan Singh in fact went to Gaya and a painting showing him in front of the Vishnupada temple of Gaya was once in the Ehrenfeld collection. For its publication see Cimino 1985, no. 32, p. 33 and unpaginated col. pl.
18. Shyamaldas 1886, vol. II, p. 1799.
19. For a description of this custom in quoting contemporary descriptions, see Bautze 1990a, p. 87, note 5.
20. This rule was introduced in order to prevent the "bribing" of British government officials, cf. Bautze 1990a, p. 87, note 9, for an example which was too peculiar to be thus "recycled."
21. Ehnbom 1985, no. 78, p. 169, col. pl.
22. Bautze 1990a, fig. 1, p. 72.
23. Heber 1828, vol. II, p. 6.
24. Mundy 1858, p. 216.
25. Shyamaldas 1886, vol. II, p. 1799.
26. Bautze 1990a, p. 89, note 34.
27. Somani 1985, p. 184.

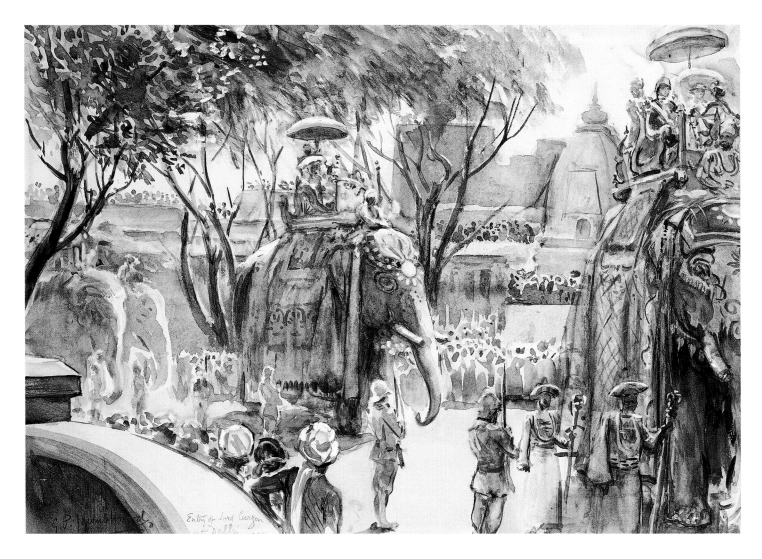

41 State Entry of Lord Curzon into Delhi

~

by George Percy Jacomb-Hood (1857–1929), Delhi, December 1902.

Media: Gray wash on paper

Size: 10 x 14 in. (25.4 x 35.6 cm.)

Inscribed: In lower left, signed: "G.P. Jacomb-Hood" and titled: "Entry of Lord Curzon into Delhi 1902." Inscribed on an old paper label, presumably in the artist's own hand: "3) Wash drawing / Delhi durbar 1902. Lord Curzons' / procession through the City / G. P. Jacomb-Hood. M.V.O. / 26. Tile Street / Chelsea. SW. Price £10.10."

Punctually at 11:30 A.M. on Monday, the 29th December [1902], *His Excellency the Viceroy accompanied by Lady Curzon arrived at the Railway Station* [of Delhi], *and a salute of 31 guns was fired. On the platform a brilliant group had assembled to welcome His Excellency. A quarter of an hour later, their Royal Highnesses the Duke and Duchess of Connaught arrived. His Excellency the Viceroy and Lady Curzon with Their Royal Highnesses the Duke and Duchess of Connaught mounted on two magnificent elephants left the railway station at twelve noon, immediately followed by His Highness the Gaekwar of Baroda and His Highness the Nizam of Hyderabad, the other Princes and Ruling Chiefs following in due order. The route of the Procession was extensive and throughout the entire distance the roads were lined with troops. Crowds of sight-seers occupying special stands erected and utilizing every point of vantage.*[1]

Another contemporary description, an account produced by an American company published with an actual photograph of certainly the greatest recorded elephant-procession of the twentieth century, informs the viewer of the stereograph:

Never since the western world has known the ceremonial pomp of Indian magnates has there been a more gorgeous street parade than this, in honor of the coronation of Edward VII of England as Emperor of India.… The crowd of dark-skinned, turbaned bystanders is itself picturesque enough to western eyes, but look at this long array of noble elephants almost buried under trappings worth uncounted millions of dollars. Scores of these superb creatures have already passed, scores more are coming and coming down the street, gleaming and glittering and shimmering and sparkling in the bright Indian sunshine. These are the private property of Indian princes, rulers over provinces and feudal states, once independent sovereigns, but now owing allegiance to the British crown … The jewels worn by a single one of these maharajahs themselves are in many cases worth $100,000 — sometimes even more.[2]

The official report on this procession is far too long to be quoted here in full. The following information, however, gives an overview of the proceedings:

The procession was headed by the Inspector-General of Police, Panjab, followed by the Deputy Assistant Quarter-Master-General, Viceroy's Escort, followed by One Squadron, 4th (Royal Irish) Dragoon Guards, followed by an H Battery, Royal Horse Artillery, followed by Three squadrons, 4th Dragoon Guards, followed by the Orderly Officer, Viceroy's Escort and the Deputy Assistant Adjutant General together with the commander of the Viceroy's Escort, followed by a Herald, who was followed by a Drummer and twelve Trumpeteers, followed by the Viceroy's Body-guard, followed by the Honorary Commandant and the Commandant of the Imperial Cadet Corps, followed by the Imperial Cadets, all on horseback. Then followed 6 elephants arranged in three pairs, carrying eight Aides-de-Camp to the Viceroy, the Private Secretary to the Viceroy, the Surgeon to the Viceroy, the President of the Durbar Central Committee and the Military Secretary to the Viceroy.[3]

What then followed is shown in the present picture, which the artist must have taken at the "Chandni Chauk," one of the main-roads of present day Old-Delhi.

Passing down Esplanade Row, the viceregal procession turned into the Chandni Chauk, at a point nearly opposite the Delhi Bank, once the residence of the celebrated Begum Sumru [cf. cat. no. 47]; … The march of the procession through the Chandni Chauk, the Silver Street of Delhi, which was thronged with Indian spectators, who also filled every window on either side, and crowded the flat roofs, was watched with intense and eager interest.[4]

The "lordly tusker" to the right carries the Viceroy and Lady Curzon. Two of the Viceroy's attendants are seen standing with their long clubs.[5] The name of the elephant is "Luchman Prasad" and was lent by the Maharaja of Benares (for whom see cat. no. 29).[6] We quote from the official report:

The howdah on its back was of burnished silver, with the royal arms, in gold resplendent on the side panels, and figures of Wisdom and Plenty in front, with a crown above them, while an umbrella, woven of silk and gold, overshadowed the crimson velvet seats. This stately howdah is the property of the Governor-General, and was made for the use of Lord Lytton in 1877. A scarlett velvet housing [jh'ul], heavy and stiff with gold embroidery, hung almost to the ground.[7]

Numerous photographs show His Excellency the Viceroy and Lady Curzon on this elephant as part of the procession.[8] The elephant in the center of the composition carries the Duke and Duchess of Connaught. It belongs to the Maharaja of Jaipur and is called "Maula Bakhsh." "The howdah for their Royal Highnesses, which was lent by the Maharaja of Bulrampur, was likewise of silver, with golden decorations in high relief; the arm at either side of the front seat being formed by a tiger springing upon a doomed antelope."[9] Likewise, this elephant was also photographed for the official records.[10] The two following elephants, in the left part of the picture, belong to Indian rulers. The one on the left-hand side carries His Highness the Maharaja of Mysore and the one on the right-hand side carries His Highness the Nizam of Hyderabad.[11] Following this group were 164 elephants with the rulers of various Indian states[12] in addition to a large number of carriages, horsemen, etc.[13]

Before that gigantic procession entered the Chandni Chauk, it passed around the Jama Masjid (for which see cat. no. 57) and there offered one of the most stupendous spectacles Delhi has witnessed since the processions of the great Mughal emperors. The accompanying fig. 8 shows a rehearsal (?) of that procession (the *howdahs* of the passing elephants are empty). Noteworthy is a photographer on a kind of scaffolding on the right-hand side of the photograph, who displays the American flag. The Stars and Stripes also appear in other photographs of the procession,[14] which may be due to the fact that Curzon's wife Mary, née Leiter, was the daughter of Levi Leiter, an American millionaire.[15] A contemporary American text to a very similar photograph explains:

This is the very heart of India's splendour. You are looking nearly northeast; within that long, high wall in the distance is the ancient palace of the Mogul emperors of India, once the most gorgeous court on earth. At your

Fig. 8

left those broad steps lead up to the Jumma Musjid, the largest mosque in the whole world, built by the same Shah Jahan who erected the celebrated Taj Mahal, one of the most beautiful structures ever created. And here to-day is the twentieth-century expression of the same Oriental passion for splendor. It is December 29, 1902, and this is a part of the state entry, marking the official arrival of the Indian Viceroy, Lord Curzon, and the Duke and Duchess of Connaught. (The formal proclamation of the Coronation of Edward VII, Emperor of India, takes place on January 1, 1903 in a great amphitheatre in the plain outside the town). Gold, silver and jewels you see now actually used as lavishly as in old fairy tales or the stories of the Arabian nights. Those elephant blankets are stiff and heavy with embroideries of gold; ... Notice how many of the great animals are resplendent with rings of gold and silver around their tusks. The howdahs on their backs are enormously heavy; the solid ones are of precious metals, and even those made comparatively light with canopies of embroidered silks have their pillars of elaborately chased silver set with jewels. These are state equipages of the maharajahs (native princes), whose wealth is almost beyond counting, descendants of families that were old and honored while England was the home of unskilled savages. More than one of these lordly riders wears to-day jewels worth $100,000. Many of them are highly educated, and some are beginning to share practical western views about the need of improved conditions for the common people in their various districts.[16]

The state entry procession passing by the Jama Masjid was captured by a number of photographers[17] and painters.[18] The whole procession lasted almost two hours. G. P. Jacomb-Hood was appointed as one of the official artists for the Coronation Darbar of 1903. One of his portraits of Marquess Curzon of Kedleston, dated February 1903, is still in Kedleston Hall;[19] another painting entitled *A Scene in the Street of the Native Camps, Delhi Durbar, 1903*, was exhibited in the Indian Section of the Festival of Empire and Imperial Exhibition, 1911.[20] He accompanied the Prince of Wales tour of India in 1905–06[21] and was correspondent for *The Graphic* and again official artist for the Delhi Darbar of 1911–1912.[22]

NOTES

1. Wiele/Klein 1903, p. 2.
2. Ricalton 1903, text to card (49).
3. Cf. Wheeler 1904, photograph by Bourne and Shepherd, facing p. 46.
4. Wheeler 1904, p. 45.
5. For a photograph of these see Wiele/Klein 1903, pl. 1.
6. Wheeler 1904, p. 30.
7. Ibid.
8. Cf. Wiele/Klein 1903, pl. 6; Golish 1963, full-page illus. p. 58 (= Allen/Dwivedi 1984, p. 18); Alexander 1987, illus. p. 154.
9. Wheeler 1904, p. 31.
10. For a photograph of the elephant without the Duke and Duchess of Connaught, see Ivory 1975, p. 24; for a photograph of the elephant with the Duke and Duchess of Connaught, see Bonetti et al. 1994, photograph 10A, p. 229.
11. For a photograph of the elephant of the Maharaja of Mysore see Fabb 1986, no. 72. For both the elephants of H. H. Mysore and H. H. Hyderabad together see Wiele/Klein 1903, pl. 15.
12. For a list of these see Wheeler 1904, p. 33 and p. 39.
13. For a list see Wheeler 1904, pp. 34–35.
14. Cf. Alexander 1987, illus. p. 154.
15. They married in April 1895, cf. Mersey 1949, p. 114.
16. Ricalton 1903, text to card (48).
17. Cf. Bonetti et al. 1994, photograph pp. 230–231, 11A (= Worswick/Embree 1976, only right half = Curzon 1984, full-page reproduction on p. 12, ditto); Ivory 1975, reproduction on pp. 22–23; Moorhouse 1983, reproduction on pp. 206–207; Wheeler 1904, illus. facing p. 30 (the elephant with Lord and Lady Curzon in the center); illus. facing p. 40 (the elephant with Lord and Lady Curzon in front); Wiele/Klein 1903, pls. 9–25.
18. For an oil painting by an unknown artist see Curzon 1984, double-paged col. pl. between pp. 112 and 113. Could this be the painting by Roderick D. Mackenzie, mentioned in *The Journal of Indian Art and Industry*, New Series, vol. XV, no. 117, January 1912, p. 16 under "The state entry into Delhi on the occasion of the Proclamation of the Coronation of King Edward VII, on the 29th December, 1902"?
19. Curzon 1984, col. pl. facing p. 113.
20. Cf. *The Journal of Indian Art and Industry*, New Series, vol. XV, no. 117, January 1912, p. 5.
21. Some seventeen paintings of this tour were exhibited during the Festival of Empire and Imperial Exhibition, 1911; for a list see *The Journal of Indian Art and Industry*, New Series, vol. XV, no. 117, January 1912, p. 5.
22. Cf. Kattenhorn 1994, pp. 176–177.

42 Lord Curzon and the Earl
of Connaught Surrounded
by Chiefs and Nobles of the
Anglo-Indian Empire on the
Occasion of the Coronation
Darbar, Delhi, 1903

∽

Delhi, 1903–1912.

Media: Gray wash on paper

Size: 10 x 14 in.
(25.4 x 35.6 cm.)

There are several official descriptions of all the events at the Coronation Darbar. None, however, mentions the event shown here. It is a collage which is based partly on photographs and partly on the artist's imagination. The Delhi Coronation Darbar was held on January 1, 1903 to celebrate the coronation of His Majesty King Edward VII, Emperor of India. The whole spectacle continued for quite a few more days and officially had started already in December of the preceding year. An entry in G. Nathaniel Curzon's notebook is closest to a contemporary description. Curzon was then Viceroy of India. He stands in the visual center of the picture and was officially the most important person present at the *darbar*:

By 11 o'clock [of January 1, 1903], *when a bugle sounded, the great arena was cleared. Every seat was occupied in the vast horseshoe amphitheatre, built in imitation of the Mughal style, with Saracenic arches, and light cupolas tipped with gold. Painted a creamy white, it shone like some fairy palace of marble in the fierce light of the Indian sun. There might be seen the princes of India, ablaze with jewels and in their most splendid raiment; behind them, a curtained box hid from the public gaze their wives and female relatives. There were the representatives of foreign states, of Japan, Siam, Afghanistan, Muscat, and Nepal, of the French and Portuguese possessions in India, and of the British Overseas Dominions of South Africa and Australia.[1] There were picturesque figures from the hill states that skirt the Chinese frontier, from the Persian borderland and the coasts of Arabia, and from the snowy passes of the Hindu Kush. There were the Members of the Governor-General's Council, the Governors of the Presidencies and Provinces, the Commander-in-Chief and his staff, and countless civil and military officers, all in brilliant uniforms. There were the High Court Judges in their state robes and full-bottomed wigs; and there also was a crowd of distinguished guests from all parts of India and from England. Seats were found for 13,500 persons; as many more stood.*

Out on the plain, through the two points of the horseshoe, could be seen in the near distance the serried ranks of the massed battalions in close formation, 40,000 strong; and behind them was a tall mound, packed from foot to summit with thousands of native spectators. In the centre of the amphitheatre the imperial flag floated at a height of 100 feet in the air. Round its base were massed the bands of twelve regiments that had won glory in the campaigns of the mutiny, nearly half a century before. The dais, in the inner hollow of the horseshoe, surmounted by a domed pavilion directly copied from a building of Akbar at Agra, awaited its Royal and Viceregal occupants. At the sound of the bugle a sudden hush fell upon the whole assembly...."[2]

The actual site of the "Durbar Amphitheatre" with the dais and the flag of Great Britain in its center,[3] was transformed here into a mere side-scene. The roof structure carried by slim pillars with fluted arches in between gives a certain impression of infinite space. The blue sky between these slender pillars is in fact the artist's fantasy. The roof with its kiosks actually covered the seats of the nobles and invited guests of this "Durbar Amphitheatre," as is shown in the accompanying fig. 9. This rare and important photograph with the boy holding a box-camera at the left, shows in the front row, block "R," from left to right: an unknown lady behind the boy, followed by two unidentified officers with cocked hats, and an unidentified lady dressed in white. Another unidentified gentleman sits to her left. The majority of the following guests is identifiable. His Highness the Raja of Tehri-Garhwal, Kirti Shah Bahadur, K.C.S.I., turns his head towards the Raja of Banaras, Prabhu Narain Singh, seated to his left. A pillar separates the Raja of Banaras from the Lieutenant-Governor of the United Provinces of Agra and Oudh, the Honorable Sir J. D. La Touche, K.C.S.I. and his wife holding a white parasol. Major His Highness Alijah Farzand-i-Dilpazir-i-Daulat-i-Inglisha, Mukhlis-ud-Daula Nasir-ul-Mulk, Amir-ul Umara, Nawab Sir Mohammad Hamid Ali Khan Bahadur, Mustaid Jung of Rampur is the last person in the front row of block "R" before an unidentified standing person with spiked helmet separates him from block "S," which was reserved for rulers of the Panjab. These include in the front row, from left to right: Raja Shri Surendra Bikram Parkas Bahadur, K.C.S.I., of Sirmur, and His Highness the Maharaja Shri Jagatsingh Bahadur, K.C.S.I., of Kapurthala. The latter almost completely hides His Highness the Maharaja Sardar Hira Singh of Nabha, of whom only his left hand holding some printed pages is visible. The British officer behind the pillar remains unidentified, but the woman to his left is Lady Rivaz next to her husband, the

Fig. 9

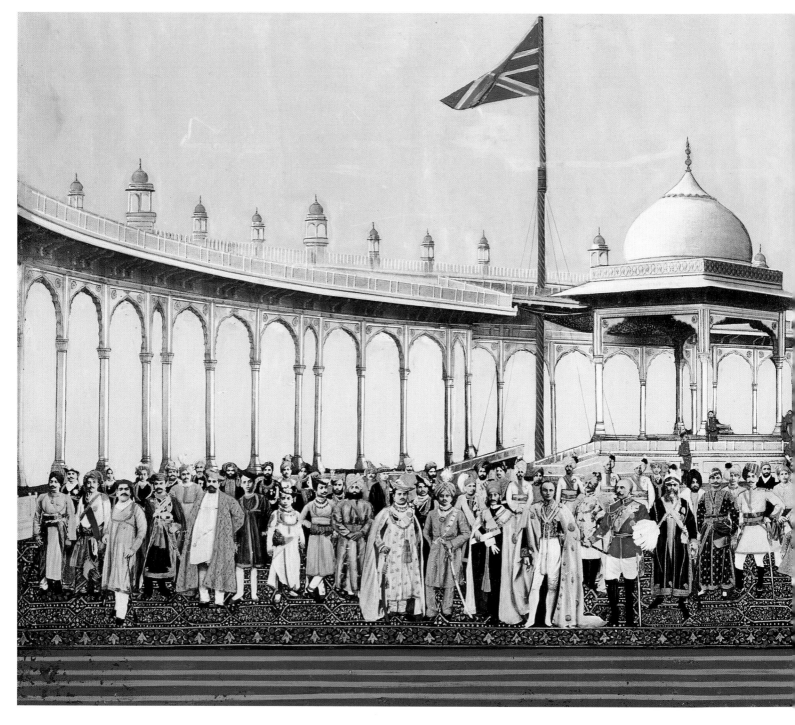

Honorable Sir C. M. Rivaz, K.C.S.I., Lieutenant-Governor of the Panjab. Block "S"
terminates with the following rulers: His Highness Maharaja Shri Ranbir Singh Bahadur
of Jind, Nawab Haji Sadiq Muhammad Khan of Bahawalpur, and the young Maharaja
Bhupindar Singh Bahadur of Patiala.

The following two standing officers, partly hiding two seated ladies and one gentleman, all
in the "T" block, are unidentified. The ruler to the left of the pillar is His Highness Maharaja
Sir Shri Rama Varma Bahadur, G.C.S.I. of Travancore with His Excellency The Right
Honorable Baron Ampthill, G.C.I.E., Governor of Madras, to his left. The latter is
accompanied by his wife. His Highness Shri Rama Varma, K.C.S.I., Raja of Cochin is
separated by a pillar from His Highness Raja Sri Brahadamba Das Sir Marthanda Bhairava
Tondiman Bahadur of Pudukottai. Block "U" starts to the left of the next standing
gentleman and contains mainly rulers of what was then called "Rajputana," more or less
identical with present-day Rajasthan. As can be seen from this short description,
photographs of this kind carry a wealth of information.

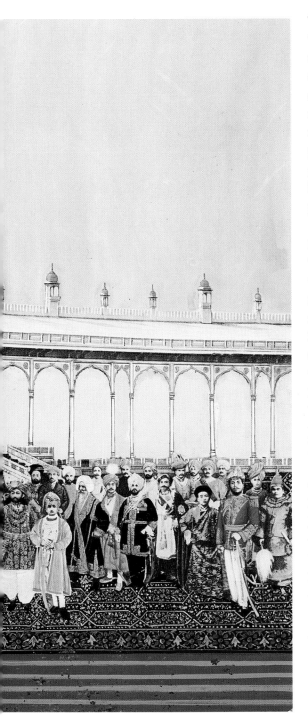

The airy atmosphere of the present amphitheatre was undoubtedly suggested by the "Amphitheatre for Chiefs and Nobles" of the earlier Delhi *darbar*, held in 1877. A photograph of this structure is shown here under fig. 10.[4] Another deviation from the original *darbar* scene is the large colorful carpet with geometrical design, on which the whole assembly stands. A very close published version shows the assembly more correctly as standing on the uncovered ground. Besides, the spaces between the pillars are dark due to the large roof and the stands of the spectators.[5] Each person was photographed separately. At the end, all photographs, which had to be developed to an appropriate size, were arranged in the way presented here. They were pasted on what the artist thought to be an appropriate background, the amphitheatre of the 1903 *darbar*. This montage technique using photographs was already common in India in about 1863.[6]

It would require a separate monograph to describe all the persons shown in this "collage." We therefore will describe only the more easily recognizable individuals, leaving aside those who might be identified as more than one or two persons. The reader will realize that a magnifying glass is of but little use, since an enlargement of any detail of this cat. no. only magnifies the printing screen. This lack of clarity explains why several identifications might be suggested for one depiction. The most important person of this assembly naturally appears in one of the most important areas of the picture: in its center. With the pole at which the British flag — the "Imperial Standard" — is hoisted as backdrop, proudly stands His Excellency Lord George Nathaniel Curzon of Kedleston, who, at that time had been Viceroy of India and Governor General for four years. More was said about him in the preceding cat. no. 41.[7] The gentleman to his left in high boots and dressed partly in red is Field Marshal His Royal Highness the Duke of Connaught.[8]

Curzon is flanked on his right by the the then probably most powerful Indian ruler, His Highness Nawab Mir Sir Mahbub Ali Khan Bahadur of Hyderabad, G.C.S.I. (1885). Born in 1866, he was invested with full powers in 1884, and enjoyed a salute of twenty-one guns.[9] He wears the blue robe, the star and the collar of the Grand Cross of the Star of India. To his right stands His Highness the Maharaja Sir Krishnaraja Wadiyar Bahadur, Maharaja of Mysore. Born in 1884, he succeeded his father in 1894. He was accorded a salute of twenty-one guns.[10] The gentleman to the right of His Highness Mysore is Major General His Highness Mukhtar-ul-Mulk Azim-ul-Iktidar-Rafi-ush-Shan Wala Shikoh Mohtasham-i-Dauran Umdat-ul-Umara Maharajadhiraja Alijah Hisam-us-Saltanat Maharaja Sir Madho Rao Sindhia Bahadur Srinath Mansur-i-Zaman Fidvi-i-Hazarat-i-Malika-i-Mauzzama-i-Rafi-ud-Darja-i-Inglishtan, Maharaja of Gwalior, G.C.S.I., G.C.V.O., aide-de-camp to His Imperial Majesty the King-Emperor. Born in 1877, he was invested with full powers in 1894. He enjoyed a salute of nineteen guns on British territory and a personal salute of twenty-one guns in his own territory.[11] Like the nizam, he wears the robe and insignia of the Grand Cross of the Star of India.

The ruler to the proper right of His Highness Gwalior is His Highness the Maharaja Sir Vyankatesh Raman Singh Bahadur, Maharaja of Rewa, G.C.S.I., dressed in green. Born in 1876, he started his rule in 1880 as a minor, and was accorded a seventeen-gun salute.[12] The man to his proper left, dressed in pink, is His Highness Sapta Sahasra Senapati Pratinidhi Sir Tukoji Rao III Pawar Bapu Sahib Maharaj of Dewas (senior line). Born in 1888, he succeeded in 1900, to be invested with full administrative powers only in 1908, and received a salute of fifteen guns.[13] The young prince dressed in blue, to the right of the Maharaja of Rewa, is His Highness the Raja Sir Udaji Rao Puar Sahib Bahadur, Raja of Dhar. Born in 1886, he succeeded in 1896 as a minor. He was invested with full powers in 1907, and received a fifteen-gun salute.[14] The Raja of Dhar is partly hidden by the eminent figure of His Highness the Maharaja Dhiraja Rai Rajeshwar Sivaji Rao Holkar Bahadur of Indore, G.C.S.I. He was born in 1859 and succeeded his father in 1886, and was allowed a salute of twenty-one guns in his own state and nineteen guns in British India.[15] The next most prominent figure to the right of His Highness Indore is His Highness Farzand-i-Khas-i-Daulat-i-Inglishia, Maharaja

Fig. 10

Sir Sayaji Rao Gaekwar, Seva Khaskhel Samsher Bahadur of Baroda, G.C.S.I. (1883) with his characteristic stick in his left hand. Born in 1875, he was invested with full powers in 1881 and enjoyed a twenty-one gun salute.[16]

Eminent rulers in the front row to the proper left of the Earl of Connaught include, from left to right, His Highness Saramad-i-Raja-i-Hindustan Raj Rajendra Sri Maharaj-Adhiraj Sawai Sir Madho Singh Bahadur, Maharaja of Jaipur, G.C.S.I. (1888), G.C.I.E. (1901). Born in 1862, he was invested with full powers in 1882 and accorded a salute of twenty-one guns.

Almost the same photograph which the artist used for the present picture was given by His Highness Jaipur to the German crown-prince as a Christmas present at Jaipur in December 1910, just one year before the Coronation Darbar at Delhi of 1911.[17] The ruler to his left is His Highness the Maharao Sir Umed Singh Bahadur II, of Kotah, K.C.S.I. (1900). Born in 1873, he succeeded to the *gaddi* after adoption in 1889. He was invested with full powers in 1896, and allowed a seventeen-gun salute (for the same ruler see also cat. no. 31).[18] To His Highness Kotah's left stands His Highness the Maharaja Sir Ganga Singh Bahadur of Bikaner, K.C.I.E. (1900). Born in 1880, he assumed ruling powers in 1898, and received a salute of seventeen guns.[19] Belonging to the same group as His Highness Bikaner and not far from him stands, in similar light-blue dress of the Jodhpur Lancers, His Highness the Maharaja Sri Sardar Singh Sahib Bahadur, Maharaja of Jodhpur. Born in 1880, he started his rule in 1895 as a minor, and was allowed a salute of seventeen guns. Jodhpur was then administered by his uncle, Sir Pratap Singh Bahadur, later Maharaja of Idar, who was also present at the *darbar*. Letters of the maharaja were sometimes accompanied by his autographed photograph.[20]

Next to His Highness Jodhpur appears His Highness Rukn-ud-Daula Nasarat-i-Jung, Hafiz-ul-Mulk Mukhlis-ud-Daula, Nawab Haji Sadiq Muhammad Khan V, Abbasi, Nawab of Bahawalpur. Born in 1884, he succeeded his father in 1899. He was invested with full powers on November 12, 1903, by His Excellency Lord Curzon, and received a salute of seventeen guns.[21] The boy to his left is His Highness Maharaja Sir Bhupinder Singh Bahadur of Patiala. Born in 1891 he succeeded his father in 1900, was invested with full administrative powers in 1910, and was entitled to a seventeen-gun salute.[22] His Highness Patiala is being observed by an elderly gentleman with a long beard. This is His Highness the Maharaja Sardar Hira Singh of Nabha. Born in 1844, he began his rule in 1871. He was created G.C.I.E. at the *darbar* and enjoyed a personal salute of fifteen guns.[23] Similarily dressed in black near the left shoulder of His Highness Nabha stands His Highness the Maharaja Sir Jagatjit Singh Bahadur of Kapurthala, K.C.S.I. (1897). Born in 1872, he succeeded his father in 1877, and received an eleven-gun salute.[24] The right-hand half of the front row includes (from left to right) the Maharaja Kumar Sidkyong Tulku, son and heir of His Highness the Maharajah Sir Thutob Namgyal Bahadur, Maharaja of Sikkim. He represented his father who could not attend this *darbar*.[25] To his left stands the Honorary Major General His Highness the Maharaja Sir Chandra Shumsher Jung Bahadur Rana, Thong-Lin-Pimma-Ko-Kang-Wang-Sian, Prime Minister and Marshal of Nepal. He was born in 1863 and can be recognized by his red uniform.[26] The last chief is Sao Maung, the Sawbwa of Yawnghwe (Burmese: Nyaungywe). He was born in 1851 and was entitled to a salute of nine guns.[27]

Quite a few rulers in the second and third row also deserve notice. The ruler between Lord Curzon and the Earl of Connaught is Major-General His Highness the Maharaja Dhiraj Sir Pratap Singh Bahadur of Idar, K.C.S.I. (1885), G.C.S.I. (1895), aide-de-camp to the King-Emperor (Edward VII), Knight Commander of the Bath (1902), honorary LL.D. of Cambridge University. Born in 1845 he became the prime minister of the Jodhpur state in 1878. He was entitled to a salute of seventeen guns.[28] He is surrounded by three members of the Imperial Cadet Corps.[29] The gentleman who appears behind Lord Curzon and the Nizam of Hyderabad is Major His Highness The Rajah Sir Sajjan Singh Bahadur, Raja of Ratlam. Born in 1880, he succeeded his father in 1893, was invested with full ruling powers in 1898, and

received a salute of thirteen guns. As a member of the Imperial Cadet Corps, he is dressed in a manner similar to that of the other three members of the corps shown in this assembly.[30]

Between the nizam and His Highness Mysore appears His Highness Sri Padmanabha Dasa Vancha Pala Sir Rama Varma Kulasekhara Kiritapathi Manney Sultan Maharaja Raja Ramarajah Bahadur Shamsher Jung, G.C.S.I. (1888), G.C.I.E. (1903), Member of the Royal Asiatic Society, London, Officier de L'Instruction Publique, Maharajah of Travancore. Born in 1857, he started to rule in 1885, and received a nineteen-gun salute.[31] The bearded man behind his left shoulder is probably His Highness Farzand-i-Dilband Rasikh-ul-Itikad Daulat-i-Inglishia Raja-i-Rajgan Maharaja Sir Ranbir Singh Bahadur, Maharaja of Jind, who, born in 1879, succeeded in 1887 as a minor, and was invested with full powers in 1899. He enjoyed an eleven-gun salute.[32]

Another South Indian ruler is visible between His Highness Rewah and His Highness Gwalior. Dressed in black is His Highness Sir Rama Varma, Rajah of Cochin, K.C.S.I. He was created G.C.S.I. at the 1903 *darbar*. Born in 1852, he started his rule in 1895.[33] Also dressed in black is the ruler Thakur Sahib Sur Singhji of Palitana, at the extreme right of the group.[34] Equally interesting individuals can be identified in the second row of the right-hand half of this composition. The bearded gentleman behind His Highness Jaipur and His Highness Kotah is Major-General His Highness the Maharaja Sir Pratap Singh Indar Mahindar Bahadur Sipar-i-Saltanat, Maharaja of Jammu and Kashmir, G.C.S.I. Born in 1850, he succeeded his father in 1885, and received a salute of twenty-one guns.[35] To his left, visible behind His Highness Kota and His Highness Bikaner, stands another Rajput ruler, His Highness the Maharajah Sawai Sir Jai Singh Bahadur, Maharaja of Alwar. Born in 1882, he succeeded his father in 1892, to be invested with full powers in 1903 by Curzon himself, and to receive a salute of fifteen-guns.[36] Near his left stands another ruler from Rajasthan, who is, however, not a Rajput: His Highness Amin-ud-daula Wazir-ul-mulk Sir Muhammad Ibrahim Ali Khan Bahadur, Saulat Jang, G.C.I.E. (1890), Nawab of Tonk. Born in 1848, he succeeded in 1867 but was entrusted with full powers only in 1870. The Nawab of Tonk received a salute of seventeen guns.[37]

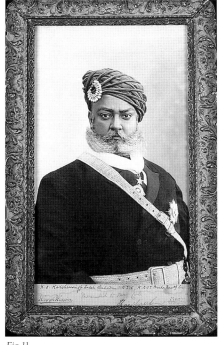

Fig. 11

The bearded gentleman behind the right shoulder of His Highness Jodhpur is His Highness the Maharaja Sir Kesri Singh Bahadur, Maharaja of Sirohi, K.C.S.I. (1895), G.C.I.E. (1901). Born in 1857, he succeeded in 1875, and had been maharao since 1889. A salute of fifteen guns was enjoyed by His Highness Sirohi.[38] The photograph, from the Herzog and Higgins Studio, Mhow, which in all probability was used by the artist, is reproduced here as fig. 11. It shows the ruler with the badge as well as the Star of India, clearly visible on his chest.[39] The photo is identified, probably by the ruler himself, as "His Highness Kaishreesinghji Saheb Bahadur, G.C.I.E., K.C.S.I. Maha Rao of Sirohi, and below, in pencil: "Presented to Mrs. Cole." Mrs. Cole was probably the wife of Henry Hardy Cole, who in 1874 published a *Catalogue of the Objects of Indian Art exhibited in the South Kensington Museum* and many other illustrated volumes on Indian architecture.[40]

Partly covered by the left shoulder of His Highness Jodhpur appears His Highness the Maharao Raja Sir Raghubir Singhji Bahadur, K.C.S.I. (1897), K.C.I.E. (1894), G.C.I.E. (1901), Maharao Raja of Bundi. Born in 1868, he was invested with full administrative powers in 1890, and accorded a salute of seventeen guns.[41] Almost sandwiched between His Highness Nabha and His Highness Kapurthala is probably His Highness Sri Nripendra Narain Bhup Bahadur of Cooch Bihar, Honorary Colonel in the British army, aide-de-camp to the King-Emperor, G.C.I.E. Born in 1862, he started his rule in 1863 as a minor, and enjoyed a salute of thirteen guns.[42] One of the individuals who can be properly identified, in this case by his peculiar headdress, is the ruler behind the right shoulder of the son and heir of His Highness Sikkim, the Honorable Maharaja Sir Rameshwara Singh Bahadur, K.C.I.E. (1902), of Darbhanga. Born in 1860, he succeeded in 1893 on the death of his elder brother.[43] There is probably no object other than this collage, depicting the Coronation Darbar of 1903, which demonstrates more strongly the magnitude and picturesqueness of the event.

NOTES

1. It should also be noted that The United States of America were represented by their consul-general at Calcutta, General R. E. Patterson. Germany was represented by Dr. E. A. Voretzsch, acting consul-general at Calcutta, then still the capital of British-India. For the representatives of other countries, see Wheeler 1904, p. 23.

2. Curzon 1984, p. 64.

3. For the plan showing the seats "assigned to ruling chiefs, January 1st, 1903," see Wheeler 1904, folded table opp. p. 300. For a general groundplan of the amphitheatre with measurements, see ibid., pl. opp. p. 102.

4. For another print from the same glass negative see Pal/Dehejia 1986, p. 86, no. 79.

5. Curzon 1984, p. 65. For another, col. collage see Allen/Dwivedi 1984, frontispiece.

6. Cf. *Shifting Focus* 1995, p. 47.

7. All dates given in the following merely provide information on the then position of the person shown. A more detailed survey can be obtained from the literature given in the notes. For the photograph of Curzon by Bourne and Shepherd that was incorporated in the present picture, see Curzon 1984, illus. on back cover or illus. on p. 64; also Wheeler 1904, photogravure facing p. 1.

8. For comparable photographs see Wheeler 1904, photogravure facing p. 8 or Wiele/Klein 1903, fourth illus. following p. 110.

9. For the photograph of the nizam, see Wheeler 1904, photogravure facing p. 25. For another reproduction of a print from the same negative, see Vadivelu 1915, pl. opposite p. 1 or Hesse-Wartegg 1906, illus. p. 71. It is this photograph which the artist incorporated in the collage. Two different photographic firms claim the copyright on this photograph: Raja Dee Dayal and Sons, Bombay (Wheeler 1904, photogravure facing p. 25) and Wiele and Klein, Madras (Vadivelu 1915, pl. opposite p. 1). For further discussion on this photograph and the Nizam of Hyderabad, see cat. no. 30 .

10. For published photographs see Wheeler 1904, photogravure facing p. 64; Wiele Klein 1903, twelfth illus. after p. 110; Golish 1963, p. 50; Gabriel/Luard 1914, illus. facing p. 120 (= Vadivelu 1915, illus. facing p. 27); Okada/Isacco 1991, p. 34, right. The latter photograph is dated by the authors to 1903. This date, however, is wrong since H. H. Mysore wears the dress and insignia of the Grand Cross of the Star of India, which was conferred on him only in 1907. For an abstract of his life and his state, see Vadivelu 1915, pp. 32–32j and Chakrabarti 1895, pp. 173–175; Wheeler 1904, pp. 63–65.

11. For published photographs cf. Wheeler 1904, photogravure facing p. 99; Wiele/Klein 1903, thirty-first illus. after p. 110; Golish 1963, p. 205; Gabriel/ Luard 1914, illus. facing p. 138; Hesse-Wartegg 1906, illus. p. 225, dated 1902. For an abstract of his life and his state, see Vadivelu 1915, pp. 45–49j and Chakrabarti 1895, pp. 92–94; Wheeler 1904, pp. 71–72.

12. For photographs see Wiele/Klein 1903, seventeenth illus. after p. 110; Gabriel/Luard 1914, illus. opposite p. 134; this photograph comes closest to the one used by the artist. For historical details, see Vadivelu 1915, pp. 135–137; Chakrabarti 1895, p. 126; Wheeler 1904, p. 73.

13. Photographs: Vadivelu 1915, illus. facing p. 191; Hesse-Wartegg 1906, illus. p. 245; Gabriel/Luard 1914, illus. opposite p. 171. For historical details see again Vadivelu 1915, pp. 194–196; Chakrabarti 1895, p. 69f.; Wheeler 1904, p. 74.

14. Photographs: Vadivelu 1915, opp. p. 174; Gabriel/Luard 1914, illus. opposite p. 151. For historical details see Vadivelu 1915, pp. 176–178; Chakrabarti 1895, pp. 71–73; Wheeler 1904, p. 75.

15. Published photographs include Griffith 1894, illus. facing p. 99 and Gutman 1982, p. 97. For historical details see Vadivelu 1915, p. 78; Chakrabarti 1895, pp. 99–100; Wheeler 1904, p. 72; Griffith 1894, pp. 99–109.

16. Wheeler 1904, photogravure facing p. 59; Griffith 1894, illus. facing p. 143; Hesse-Wartegg 1906, illus. p. 413; Koenigsmarck 1910, illus. facing p. 93; Vadivelu 1915, illus. facing p. 15. For more detailed historical information cf. Vadivelu 1915, pp. 15–26; Chakrabarti 1895, pp. 27–29; Wheeler 1904, pp. 62–63; Griffith 1894, pp. 99–109.

17. For a reproduction of this photograph, see Bongard 1911, p. 79; for the story, ibid. p. 91 and Heichen n.d., p. 148. The same photograph was used to illustrate the official publication on the Coronation Darbar of 1911; see Gabriel/Luard 1914, illus. facing p. 120. For a reproduction of the actual photograph which the artist used for his collage, see Wheeler 1904, photogravure facing p. 68. The same photograph was again used in 1906, when it was published in Noti 1906, p. 30 (= Golish 1963, p. 112 = Curzon 1984, illus. p. 16). For more detailed historical information see Sen 1902; Vadivelu 1915, pp. 58–63; Chakrabarti 1895, pp. 101–102; Griffith 1894, pp. 56–67. Wheeler 1904, pp. 67–68.

18. For published photographs cf. Wheeler 1904, photogravure facing p. 108; Noti 1906, illus. p. 34; Gabriel/Luard 1914, illus. facing p. 241; For short historical data cf. Wheeler 1904, p. 69; Vadivelu 1915, pp. 124–127; Chakrabarti 1895, p. 140.

19. The photograph which the artist utilized for the present work is published in Patnaik 1990, frontispiece. For further photographs cf. Kishore Singh n.d., p. 7, illus. on top, left; Ivory 1975, p. 21; Golish 1963, p. 248; Gabriel/Luard 1914, illus. facing p. 124; Comprehensive historical information can be obtained from Wheeler 1904, p. 69; Panikkar 1937; Vadivelu 1915, pp. 129–131; Chakrabarti 1895, p. 48.

20. For this photograph see Hesse-Wartegg 1906, illus. p. 376, for the story see ibid. p. 375. For further published photographs cf. Patnaik/Welch 1985, p. 173, fig. 6; Ivory 1975, p. 19. For historical information cf. Vadivelu 1915, pp. 118–122; Chakrabarti 1895, pp. 143–144; Wheeler 1904, p. 68.

21. For his published photographs cf. Golish 1963, p. 276 (= Ivory 1975, p. 28 = Fabb 1986, fig. 3); Pal/Dehejia 1986, p. 206, fig. 213. For historical information see again Vadivelu 1915, pp. 139–141; Chakrabarti 1895, p. 17 and Wheeler 1904, p. 80.

22. For his photograph see Wheeler 1904, photogravure facing p. 190. For historical information see Wheeler 1904, pp. 79–80; Vadivelu 1915, pp. 110–117; Chakrabarti 1895, pp. 197–198.

23. Photographs are published in Wheeler 1904, photogravure facing p. 195 (= Golish 1963, p. 275); Fabb 1986, fig. 9 and fig. 76; Prinsep 1879, illus. facing p. 252. Short historical information is provided by Wheeler 1904, p. 81; Vadivelu 1915, pp. 314–317 and Chakrabarti 1895, pp. 175–176.

24. For the photograph which the artist used for his collage, see Mayer 1922, pl. facing p. 33. For further photographs see ibid., illus. facing p. 32, p. 49, p. 97; Griffith 1894, p. 30 and p. 37; Wiele/Klein 1903, twenty-ninth illustration after p. 110; Curzon 1984, p. 28; Allen 1985, p. 201. Historical information is also provided by Wheeler 1904, p. 81; Vadivelu 1915, pp. 235–236; Chakrabarti 1895, pp. 123–124.

25. H. H. Sikkim was born in 1851 and began to rule in 1875. For his portrait photograph see Gabriel/Luard 1914, illus. facing p. 255. For historical information cf. Wheeler 1904, pp. 82–83, Vadivelu 1915, pp. 203–204; Chakrabarti 1895, pp. 231–232.
26. For his published photographs see Wheeler 1904, photogravure facing p. 18; Wiele/Klein 1903, forty-first illus. after p. 110; Vadivelu 1915, illus. facing p. 105. For more detailed information cf. Wheeler 1904, p. 85; Vadivelu 1915, pp. 105–109f; Chakrabarti 1895, pp. 183–184.
27. For the photograph which the artist used for this collage see Gabriel/ Luard 1914, illus. facing p. 120. For another photograph see Wheeler 1904, photogravure facing p. 132, front row, right-hand side. For *sawbwa*, a rank of chief in the Shan-states, see Scott 1911, p. 152. Yawnghwe is a southern Shan state. For more contemporary information cf. Scott 1911, p. 470.
28. For a photograph cf. e.g. Koenigsmarck 1910, illus. facing p. 263 (= Molitor 1985, Abb. 46). For historical data see also Vadivelu 1915, pp. 164–167; Wheeler 1904, p. 78; Chakrabarti 1895, pp. 82–83, where a salute of only fifteen guns is mentioned.
29. For a photograph of these see Wheeler 1904, photogravure facing p. 78 or Wiele/Klein 1903, pl. 73.
30. For his photograph see Vadivelu 1915, illus. facing p. 257. For historical and statistical information see ibid., pp. 257–259; Chakrabarti 1895, p. 215.
31. For the photograph which the artist incorporated see Hesse-Wartegg 1906, frontispiece. Cf. also Wiele/Klein 1903, eleventh illus. following p. 110; Griffith 1894, p. 260; Gabriel/Luard 1914, illus. facing p. 182; For further information cf. Wheeler 1904, pp. 75–76; Vadivelu 1915, pp. 50–57; Chakrabarti 1895, p. 246.
32. For the photograph cf. Vadivelu 1915, opp. p. 232a. More information: Vadivelu 1915, pp. 232a–232g; Chakrabarti 1895, pp. 113–114.
33. Reproduced photographs: Wiele/Klein 1903, forty-fifth illus. after p. 110; Gabriel/Luard 1914, illus. facing p. 183. For more information consult Vadivelu 1915, pp. 98–104; Chakrabarti 1895, p. 61f; Wheeler 1904, p. 76.
34. For the photograph which the artist used here see Hesse-Wartegg 1906, illus. p. 435. For statistical data, etc. see Chakrabarti 1895, pp. 192–193; Wheeler 1904, p. 79.
35. His photograph is published in Wheeler 1904, photogravure facing p. 66, cf. also Nou/Pouchepadass 1980, p. 26, fig. 7. Later in life he shaved his beard and differs in appearance, cf. Gabriel/Luard 1914, illus. facing p. 121; Vadivelu 1915, illus. facing p. 33; Golish 1963, illus. pp. 132–133; Further information is provided by Vadivelu 1915, pp. 37–42; Chakrabarti 1894, pp. 125–126; Wheeler 1904, pp. 65–66.
36. For his photograph see Hesse-Wartegg 1906, illus. p. 315. For more information see Vadivelu 1915, pp. 168–171; Chakrabarti 1895, pp. 8–9; Wheeler 1904, pp. 69–70.
37. His portrait is published in Gabriel/Luard 1914, illus. facing p. 137 and the artist most probably used this photograph. For more detailed information see Vadivelu 1915, p. 148–149; Chakrabarti 1895, pp. 244–245; Wheeler 1904, p. 70.
38. For his photograph see also Gabriel/Luard 1914, illus. facing p. 131. More information is provided by Vadivelu 1915, pp. 189–190; Chakrabarti 1895, p. 234; Wheeler 1904, p. 70.
39. For an illustration of these insignia see Hendley 1909, *The Journal of Indian Art and Industry,* vol. XII, no. 107, col. pl. 149, nos. 1059 (aa) and (b).
40. Cf. Thomas 1981, p. 69.
41. Photographs: Wheeler 1904, photogravure facing p. 89 (= Hesse-Wartegg 1906, p. 248); Noti 1906, illus. p. 35 (= Fabb 1986, fig. 2); Nou/Pouchepadass 1980, p. 6; Gabriel/Luard 1914, illus. facing p. 239 (= Worswick/Embree 1976, p. 114). For further information cf. Vadivelu 1915, pp. 151–153. Chakrabarti 1895, p. 51; Wheeler 1904, pp. 68–69.
42. Photograph, published: Wiele/Klein 1903, fourteenth illus. after p. 110; Okada/Isacco 1991, p. 35, left. For historical data cf. Wheeler 1904, p. 82; Vadivelu 1915, pp. 230–213; Chakrabarti 1895, pp. 143–144.
43. For a reproduction of the photograph which was probably used by the artist, see Wiele/Klein 1903, thirteenth illus. following p. 110. Cf. also Vadivelu 1915, illus. facing p. 502. For historical information cf. Vadivelu 1915, pp. 502–507; Wheeler 1904, p. 83.
44. Rulers and dignitaries who attended the *darbar* and who might still be identified in this collage, include: the Maharana of Mewar, present at *darbar,* but appeared at no function; the Majaraja of Alwar; the Maharaja of Kishangarh; the Maharaj Rana of Dholpur; the Maharaja of Karauli; the Maharawal of Jaisalmer; the Maharawal of Dungarpur; the Raj Rana of Jhalawar; the Maharaja of Bharatpur, infant; Her Highness the Begum of Bhopal; the Raja of Narsingarh, a boy of sixteen; the Raja of Rajgarh; the Maharaja of Orchha; the Maharaja of Datia; the Maharaja of Samthar; the Maharaja of Charkhari; the Raja of Dewas, junior line; the Rajput Rana of Barwani; the Rao of Alipura; the Thakur of Piploda; the Raja of Pudukota; Sir Muhamad Munawar Khan, titular Prince of Arcot; the Maharaja of Kolhapur; the Rao of Cutch; the Mir of Khairpur; the Nawab of Junagadh; the Thakur Sahib of Bhavnagar; the Rana of Probandar; the Thakur Sahib of Morvi; the Thakur Sahib of Limri; the Raja of Bariya; the Nawab of Janjira; the Chief of Miraj of the Patwardhan Brahmin family; the Thakur Sahib of Gondal; the Nawab of Cambay; the Pant Sachiv of Bhor; the Raja of Bansda; the Sultan of Lahej; the Amir of D'thali; the Sultan of Shehr and Mokalla; Nawab Fatheh Ali Khan Kizilbash; The Hon. Kunwar Sir Harman Singh Ahluwalia, uncle of the Raja of Kapurthala; the Baba Sir Khem Simgh, Bedi; Nawab Sir Imam Baksh Khan, Mazari; Makhdum Hassan Baksh; Mirza Suliman Shikoh, "the chief surviving representative of the old royal house of Delhi"; Khan Bahadur Dhanjibai Commodore, the Raja of Hill Tippera; the Nawab of Murshidabad, represented by his son, Asif Kadr Saiyid Wasif Ali Mirza, due to the bad health of the former; the Maharaja Dhiraj Bijay Chand Mahtab Bahadur of Burdwan; the Maharaja Sir Ravaneshwar Prasad Singh Bahadur of Gildhaur; the Maharaja Girja Nath Roy of Dinajpur; the Maharaja of Manipur; His Highness the Maharaja of Rampur; the Raja of Tehri (Garhwal); the Maharaja of Benares, who "was given honours of a ruling chief," the Maharaja of Bulrampur; the Maharaja of Ajudhya; Raja Jagmohan Singh of Atra; Raja Tasadduk Rasul Khan of Jehangirabad; Raja Bhup Indra Bikram Singh of Piyagpur; Raja Jai Krishen Das Bahadur; Raja Balwant Singh of Awa; Raja Ram Singh of Bansi; Nawab Faiyaz Ali Khan of Pahasu; Nawab Saiyid Ahmad Shah of Sardhana; six Shan chiefs, Burmese guests of the Government of India; the Raja of Sonpur; the Raja of Khairagarh; the Raja of Ehrakhol, the Raja of Raigarh; His Highness Beglar Begi Mir Sir Mahmud Khan, Khan of Kalat; Mir Kamal Khan, the Jam of Las Bela; Shuja-ul-Mulk, the Mehtar of Chitral; Nawab Muhammad Sharif Khan of Dir; Nawab Safdar Khan of Nawagai; Colonel Nawab Muhammad Aslam Khan, aide-de-camp to His Majesty, to mention just a few.

43 Thakur Sahib Zorawar Singh
of Kanota (1826–1908)
with Other Members
of the Council of the Jaipur
State, Jaipur, ca. 1900.
∾

Media: Hand-colored
photograph with painted areas

Size: 12³/₈ x 9¹⁵/₁₆ in.
(31.4 x 25.3 cm.)

Inscribed: On margin (now
severed from image), in *Nagari*
(from left to right, bottom):
*babu samsar candra sainji; nanaji
sahib / śri sardar simhji; thakur
sahib joravar simhji / phatah simhji
ka bhai* (Thakur [baron] Sahib
Zorawar Singh, brother of
Fateh Singh); *nanaji sahib / śri
kalyan simhji* and on top: *devi
simhji medtya / hukkavala* (Devi
Singh Merta, water-pipe
servant).

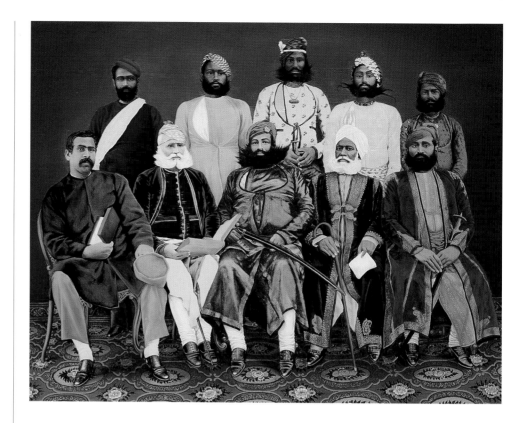

Thakur Sahib Zorawar Singh of Kanota (1826–1908) is the second seated figure from the right.[1] He was born on February 25, 1826 as the third son of Thakur Jivraj Singh Champavat of Pilva in Marwar.[2] His elder brothers were Abhay Singh and Shambhu Singh, and his younger brother was Fateh Singh, who is mentioned in the inscription quoted above. During the rule of Maharaja Sawai Ram Singh (r. 1835–1880) the three younger brothers went to Jaipur, where they were given high positions in the government of the state. In 1872, Zorawar Singh received the *jagir* (here: a piece of land granted in perpetuity) of Kanota, which is situated eight miles to the east of Jaipur.[3] It comprised seven villages and provided the ruler of Jaipur with cavalry. By the time this photograph was taken, he was a member of the state council under Maharaja Sawai Madho Singh (1880–1922). The Kanota House in Jaipur, partly a hotel since 1978, was built during his rule as was the fort of Kanota.[4] Fateh Singh, Zorawar Singh's younger brother, became prime minister of the Jaipur state. He was given the *jagir* of Naila and became the *thakur* of that place. Thakur Sahib Zorawar Singh died at Kanota. Babu Sansar Chander Sen, the second seated person from the left, was also a member of the State Council. He was born in April 1846 and entered the service of the Jaipur state in 1866. In 1874 he was made headmaster of the Rajput Noble School and in December 1880, he became private secretary to His Highness the Maharaja, which post he held until April 1, 1901. On that date he was appointed as a member of the Foreign Department of the council.[5] In 1902 he published a booklet on Maharaja Sawai Madho Singh.[6] The identity of the other persons is uncertain, but can be ascertained with the help of the unpublished painted photographs still available in the Kanota House in Jaipur.

This painted photograph combines two techniques: photography and painting. The composition as such is the result of the photographer's arrangement of his subjects; the colorful pattern of the carpet was introduced by the painter and/or colorist. Maharaja Sawai Ram Singh of Jaipur became the first Rajasthani "photographer prince." He bought his first camera in 1864.[7] Louis Rousselet, himself a photographer, talked to Sawai Ram Singh in his capital in 1866. He recorded: "The conversation then turned on photography (he [i.e. the Maharaja of Jaipur] is not only an admirer of this art, but is himself a skillful photographer), and afterwards on France. . . ."[8] William Howard Russel, who reported on the Prince of Wales's tour through India in 1875/76, remarked that: "Many of the Princes of India take to photography, but the Maharaja [i.e. Sawai Ram Singh] is a master in the art."[9] In fact, when

the Prince of Wales was about to leave Jaipur on February 7, 1876, he was given "some photographs on a large scale" by the Maharaja of Jaipur.[10] A year after the visit of the Prince of Wales, the official painter for the "Imperial Assemblage" — the Delhi Darbar of 1877—Val Prinsep, reached Jaipur in order to paint Sawai Ram Singh for said occasion. On February 10, Prinsep noted while stumbling through the premises of the palace at Jaipur: "I found myself in a comfortable room, where the Maharajah spends his leisure time photographing. . . . The windows of this photographic-room look over a charming garden . . ."[11] The school of art at Jaipur, opened by the maharaja in 1866,[12] caught Prinsep's attention:

Jeypore has a school of art, and being of course much interested therein, I stopped there, and was shown over by the principal. . . .It turned out to be a kind of general school for trades; and turning, watchmaking, carpentry, pottery, electrotyping, and many others are taught there. So far, no doubt, it does good, but there is also a school of drawing, and over this I should wish to cast a veil. Of all the feeble institutions here, it is the feeblest. The master is an Indian; the things turned out, so many nightmares: large copies of photographs of the Prince of Wales, Lord Northbrook,[13] and other Governors-General, with the ghastly stare such things have when done by beginners; drawings done from nature without an atom of art: in fact, a perfect artistic Bedlam. He showed us with considerable triumph some small heads copied in needlework from photographs. Poor Lord Northbrook! If he could only see himself, he would not, in his recent speech at a distribution of prizes in England, have been so laudatory of Indian schools of design.[14]

By 1888 a number of painters were working for the Jaipur court "for applying colours on photographs."[15] By 1870, the Jaipur painters worked in a photo-realistic style — probably by copying photographs — as a full standing-portrait of Sawai Ram Singh shows.[16] Other ateliers were also producing "watercolour paintings," which were less likely to be copied from photographs as "Pictures of Kings, Princes, Queens, mythological deities, native ladies in various costumes, avatars, buildings and other scenes of Mahabharat and Bhagwat Purans. Price varying from Re.o–6 to Rs.2–8 per each piece. All modern works."[17] Parallel to those painters who colored photographs were artists who continued to paint in the photographic style. One of them was Mohan Lal Musavir, whose painting is now in the Ashmolean Museum;[18] there were also several others.[19] Both the "photographic style" as well as the technique of coloring photographs continued under Maharaja Sawai Madho Singh (1880–1922) right into the twentieth century.[20] Although quite a number of colored photographs were commissioned during the late nineteenth and early twentieth century, only comparatively few are known to exist outside India.

NOTES

1. For a published identified photograph for comparison see Jain/Jain 1935, chapter "Jagirs and Jagirdars," illus. facing p. 34.
2. *Chiefs and Leading Families* 1903, p. 65; Jain/Jain 1935, chapter "Jagirs and Jagirdars," p. 35; Gahlot 1966, p. 208.
3. Sugich 1992, p. 32.
4. It is now called Narain Niwas Palace Hotel, Kanota Bagh, Narain Singh Road, Jaipur 302 004, cf. Sugich 1992, p. 108 and col. photograph between pp. 28–29.
5. *Chiefs and Leading Families* 1903, p. 66.
6. See Sen 1902.
7. This camera is still preserved; cf. Das/Sahai 1985, illus. 2; Das 1988, p. 24.
8. Rousselet 1878, p. 229. For the French text cf. Rousselet 1877, p. 270.
9. Russel 1877, p. 460.
10. Ibid.
11. Prinsep 1879, p. 91.
12. Russel 1877, pp. 460–461.
13. Thomas George Baring, afterwards Lord and Earl of Northbrook, was Viceroy of India from 1872–1876, cf. Mersey 1949, pp. 89–91.
14. Prinsep 1879, pp. 89–90. As is shown futher below (cat. no. 84), these "art schools" formed one of the reasons why a national movement for the revival of Indian art started in Calcutta.
15. As stated by T. N. Mukerjee in his "Art Manufacture in India," quoted after Das 1988, p. 29.
16. Cf. Christie's, July 4, 1985, p. 108, lot 159; Welch 1978, p. 145, no. 64.
17. Benn 1916, p. 97. *Avatars* means the different incarnations of Vishnu; *Mahabharat* is the great Indian epic; *Bhagwat Puran* no doubt signifies the tenth book of the *Bhagwat Puran*, which narrates the story of the deity Krishna.
18. Sotheby's N.Y., May 21, 1981, lot 85; Topsfield 1995a.
19. Cf. David/Soustiel 1983, col. illus. p. 111, no. 144 (« *Arts d'Orient*, 2 juillet 1993, col, illus. p. 60, no. 184).
20. Cf. e.g. the following portrait of Sawai Madho Singh in *Gabus*, 10 décembre 1990, p. 79, no. 254, gouache on photographic paper; p. 81, no. 262, done in oils. See also the preceding cat. no. 32.

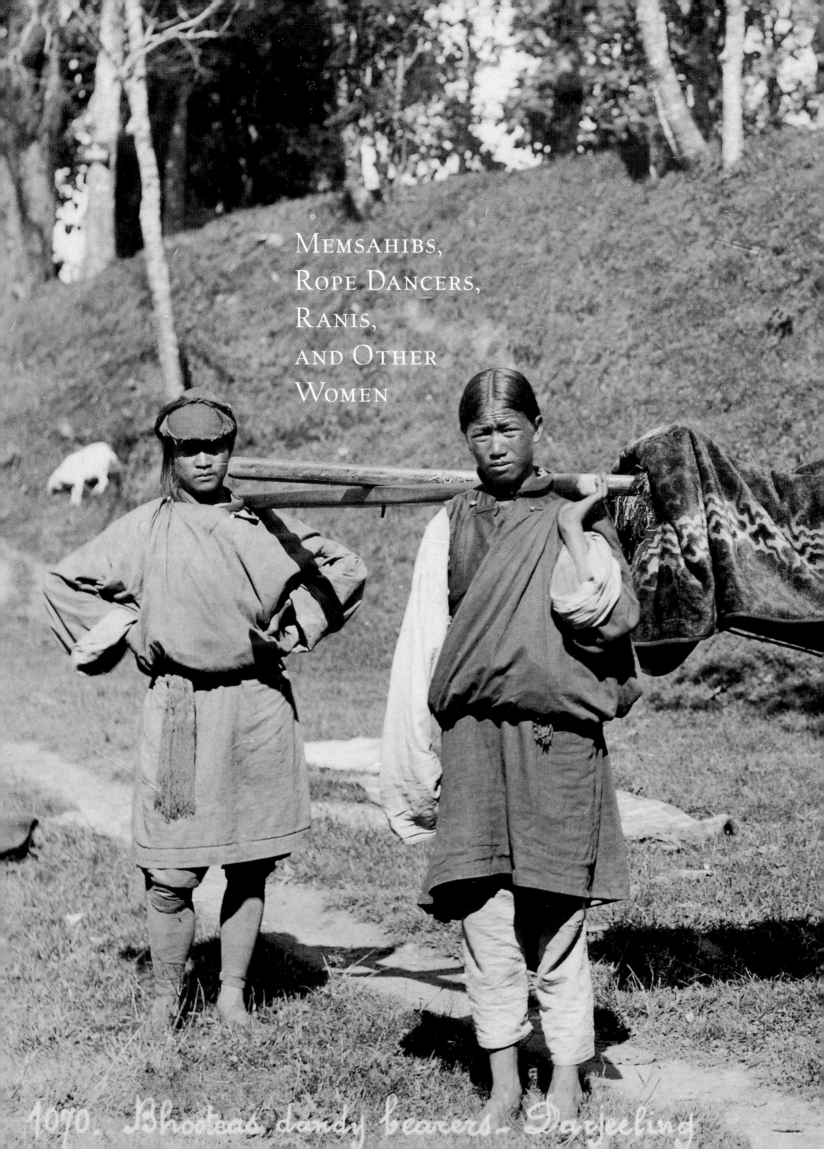

MEMSAHIBS,
ROPE DANCERS,
RANIS,
AND OTHER
WOMEN

1070. Bhooteas dandy bearers - Darjeeling

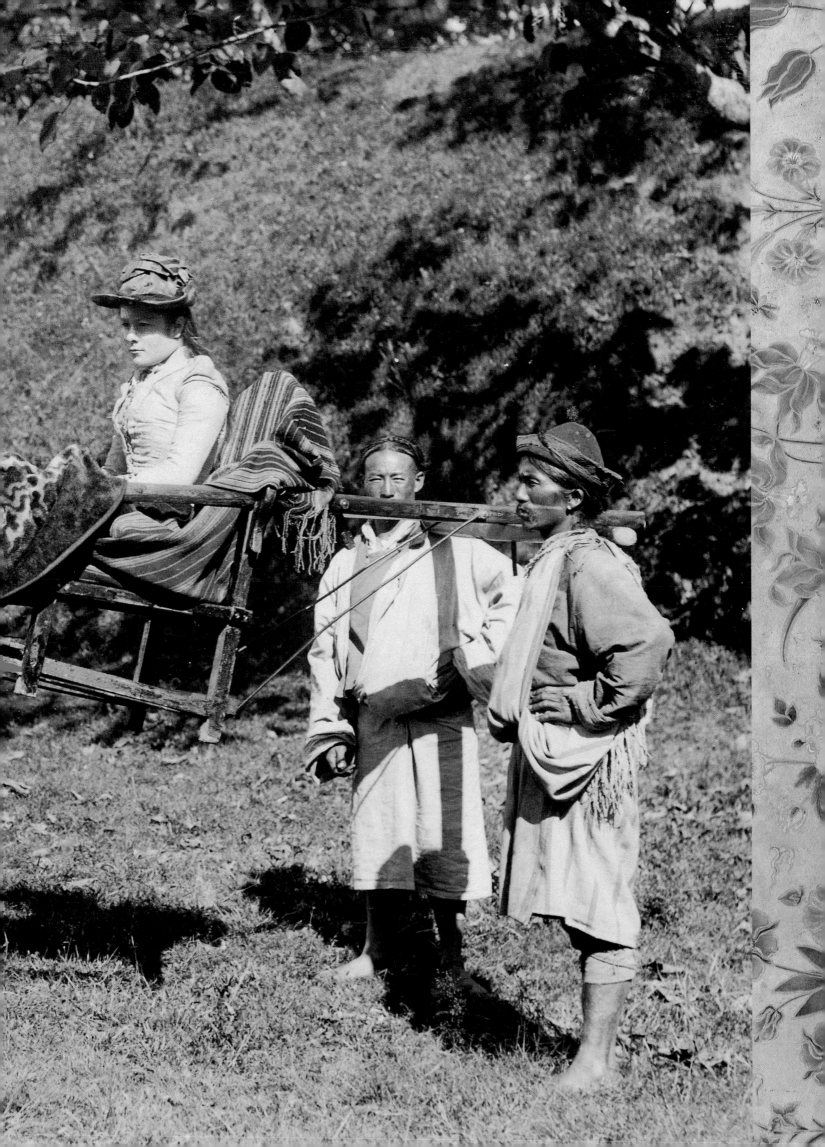

44 A Lady of Rank on a Terrace

Faizabad (1765–75)
or Lucknow (1775–80),
by an artist in the circle
of Mir Kalan Khan.

Media: Gouache on paper

Size: 10³/₈ x 7¹/₄ in.
(26.3 x 18.5 cm.)

Published: Octagon, vol. XXIV, no.
3, October 1987, p. 22, col. illus.
(as: Mughal, Lucknow or
Faizabad, ca. 1760–1770);
Ehnbom/Topsfield 1987, col.
pl. p. 36, no. 14 (as: ditto);
Sotheby's N.Y., June 4, 1994,
lot 137, full-page col. illus.
(as: ditto)[1]

Fig. 12. Staatliche Museen zu Berlin - Preußischer Kulturbesitz, Museum für Islamische Kunst, with permission.

Pages 176–177. Bhootees dandy bearers - Darjeeling. A "mem-sahib" carried in a "dandy," a kind of sedan chair. Photographed ca. 1880–1890.

This picture is an Indian fancy of how European women would or should look in India.

The painting was sufficiently well described by Daniel Ehnbom (see adjacent text under "Published"), but there are certain inconsistencies in that description. The title introduces this painting as showing "A European woman and her attendants on a terrace," whereas the actual description starts with "A lady in European dress. . ." which does not necessarily imply that the woman is actually of European origin. All four ladies are in European dress, or, at least, what the artist thought to look sufficiently European. The ornaments worn by the women are neither Indian nor European, nor half-Indian and half-European. What makes three of the ladies more European than Indian is the three-quarter view, which the Indian artist during that period mostly reserved either for the god Shiva or for the depiction of *farangis* or foreigners. But what makes the ladies most un-Indian is their blond, curly hair. At times women were depicted dressed as European page boys, in which case, however, they looked much more authentic than any of the women assembled on this terrace.[2]

Another European element in this picture is indicated by the tray with fruits offered to the woman on the chair by the lady dressed in a blue robe. The leonine armrests of the elaborate, gilded chair are not unusual. They also occur in earlier Rajasthani paintings and indicate a "lion throne" (Sanskrit: *simhasana*), an ancient Indian insignium of power and rulership.[3] Equally Indian is the pole with a kind of spade at the upper end, held by the woman immediately behind the back rest of the throne. This insignium is called *karani* or *karnya* in Rajasthan and *aftabgir* or *aftahadah* in the more Persian or Urdu speaking parts of India.[4] The object held by the remaining standing woman in green robe is a *morchal*, another Indian insignium of royalty, made of the bundled feathers of a peacock (Hindi: *mora*).

This composition was enormously successful, considering the fact that quite a number of versions/copies still exist. For example:

1. A slightly reduced version, from an album dated 1767/68, is in the Museum für Islamische Kunst Berlin, 14593, folio 25, accompanying fig. 12.[5] It is inscribed in Polier's own hand as "Princesse sur une terrasse." For Antoine Polier see the following cat. no. 63 .
2. Another version, evidently from another early Polier album, was auctioned in 1966. Since the painting was not reproduced, we quote here from the description: "A Lady in European Dress sits upon a gilt chair with a footstool on a terrace and is offered fruit by one of her servants; on the expanse of water beyond a crocodile is hunted from a boat, while on the far bank a horseman chases deer."[6]
3. A version in the Brooklyn Museum, New York, omits the woman with the *aftabgir* as well as two ships, but retains the rendering of the foreground. Stylistically the painting is very close to the work of Mihr Chand. This folio also might have been in the collection of Antoine Polier as is indicated by the numeral "36" in the lower margin. The painting shares the measurements of the above-mentioned folio.[7]
4. An inscribed version that also omits the woman with the *aftabgir* and one ship, is in the India Office Library, London. The inscription can be translated as: "Imperial princess, work of European . . ."[8]
5. The woman with the *aftabgir* was also omitted in a version with elaborate background which includes most minute depictions of scenes which are otherwise only visible in the present painting.[9]

The six known versions, all of which might be the creation of the same atelier, attest to the great popularity of the theme. The vessels reappear more or less in each version. In five versions the largest ship remains. It seems to be almost overloaded wilth musketeers aiming at a gigantic aquatic monster, the head of which looks like a spotted crocodile with fierce eyes and a long, flame-like tongue. The topic as such is not new in Indian painting; it already occurs in the emperor Akbar's greatest manuscript, the *Hamza Nama* from about 1567–1582.[10] New to these versions, however, is the fact that the ships are manned exclusively by European soldiers,

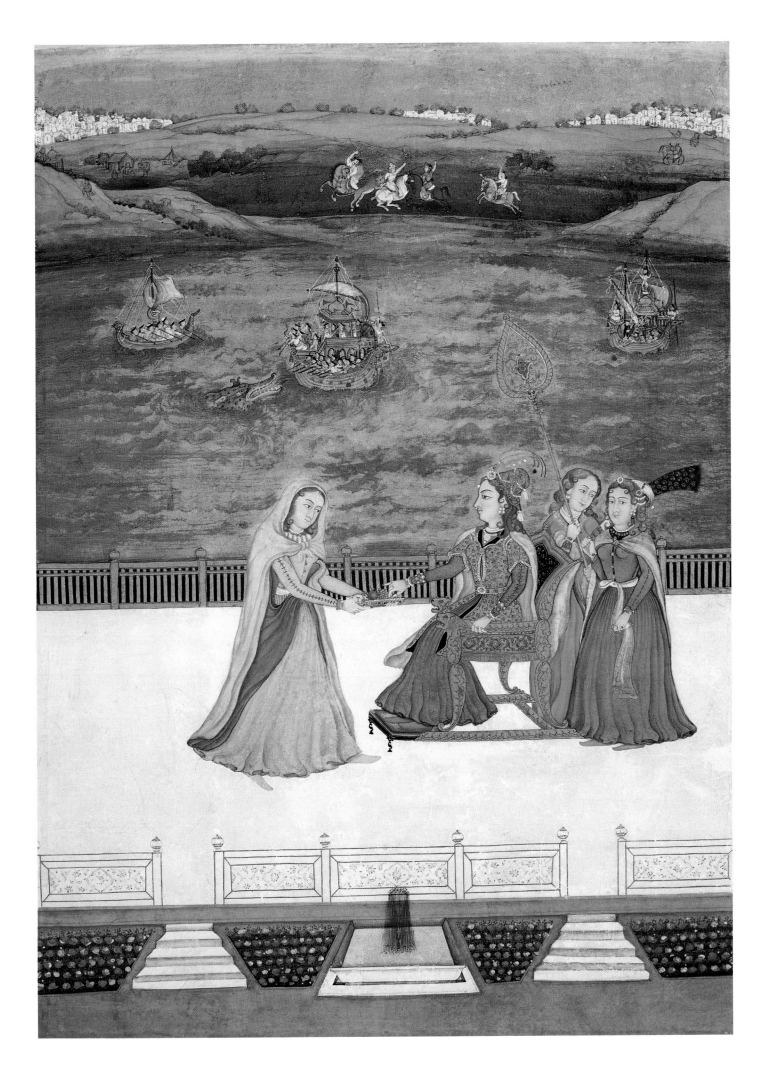

recognizable by their black hats.[11] Like three of the four ladies on the terrace, they are mostly represented in three-quarter views. Very similar scenes with Europeans shooting with muskets at a sea-monster are known from Lucknow as well as Rajasthan.[12] This often repeated seamonster-scene must have seemed exotic to the Indian viewer.

The four horsemen at the bank of the extensive lake are engaged in hunting down a lion with spears. The lion mauls the right arm of a rider dressed in white, while three galloping horsemen approach with long spears in order to rescue the attacked. All four riders are presumably meant to be European as well. A more typical Indian scene in this picture is presented by a seated saint and disciple in front of his hut, who accepts the offerings of a layman, who probably has come from the tent nearby. Two deers are grazing near this hermitage, suggesting its undisturbed peacefulness. Two minutely depicted persons seem to aim at birds with a sling behind a saddled, grazing horse in the top right part of the painting.

The picture represents a layered Indian allegory of contrasts. The quiet feminine scene on the terrace contrasts with the noisy, male musket shots of the two ships.[13] The silence of the hermitage is disturbed by the shouts of the horsemen and the roars of the attacking lion. Is the princely woman taking grapes to be identified with the huge crocodile that snaps at the large ship or the lion mauling the horseman? In absence of any text that explains this incident, it is rather unscientific to speculate. But it is evident that European women were imagined to be more peaceful than European men. With regard to the situation in India, the painter was not too far off the mark.

In all previous publications, Mir Kalan Khan is the artist said to have painted this miniature. Although this is certainly the most elaborated picture of the six known versions, it does not necessarily imply that it was created by Mir Kalan Khan.[14] Mir Kalan Khan was, along with Mihr Chand, one of the most versatile painters of the Faizabad-Lucknow ateliers, but he was not the only gifted artist. A more "Indian" rendering of the subject, with Indian women in Indian dress but without noisy Europeans on ships in the water behind, is signed by a certain Sital Das and has been published more than once.[15]

NOTES

1. If we really consider a date of 1760–1770 for this painting, it cannot stem from Lucknow to which the capital of Oudh (Avadh) was moved only in 1775.
2. Cf. the often published painting signed by Rahim Deccani, recently again reproduced in Leach 1995, vol. II, col. pl. p. 952, and p. 951 with five more references to further publications.
3. For an earlier example from Rajasthan, see Bautze 1995a, p. 141, col. illus. no. 125.
4. For a more recently published object of this type, see Krishna 1996, p. 113, no. 1. For an exhaustive discussion of this object, see Bautze 1988a, pp. 106–107.
5. For a reproduction of the dated dedicatory inscription see Hickmann 1979, p. 9 or Hickmann 1991, p. 21 (reproduced upside down, the accompanying text in each case is by Volkmar Enderlein).
6. The "earlier" Polier albums are inscribed in French, the "later" Polier albums are inscribed in Urdu, since over the years of his stay at Lucknow Polier learned to read and to write that language. The inscription "Seigneur Georgien" on folio 12 (folio 26 for Polier, who then did not count the pages in the Islamic fashion) of that album is clearly in Polier's hand, cf. Sotheby & Co., December 12, 1966, lots. 1–33. The quoted description is taken from lot 4.
7. Poster et al. 1994, p. 96, no. 51.
8. Falk/Archer 1981, p. 138, no. 242, reproduced p. 436.
9. Spink 1976, p. 27, no. 121.
10. Christie's N.Y., October 3, 1990, lot 28, full-page col. pl. p. 28. This painting is now in an European collection and was, earlier this century, in the collection of Egon Zerner, Berlin, Germany, cf. Glück 1925, p. 154.
11. Cf. the European soldiers in an Indian painting illustrative of the Battle of Lakheri in Boyé 1996, pl. p. 35.
12. Cf. Leach 1986, p. 144, cat. no. 49; Pal 1983, p. 226, R13, col. pl.
13. The third ship to the right is not included in several versions and seems only to balance the composition here.
14. For a more recent discussion of Mir Kalan Khan cf. Bautze 1993, pp. 280–281.
15. Sotheby & Co., July 10, 1968, lot 106 (= Maggs Bull. 14, 1968, p. 80, no. 70 = Sotheby's, April 24, 1979, lot 44).

45 Portrait of a Lady in Calcutta

∾

by Robert Home (1752–1834),
Calcutta, 1795–1814.

Media: Oil on canvas

Size: 28½ x 25 in.
(72.4 x 63.5 cm.)

Most memsahibs did not have strong views on India, they simply ignored it where they could. Unthinkingly they echoed the prejudices of their community so vociferously that they became the symbol both to Indian nationalists and to critics of the Empire at Home of all that was wrong with the Raj. Yet if they cannot always be excused they can at least be explained. The majority came to India when they were very young. As they grew older, they looked back, as people do, to the golden years of their youth, when the world seemed a better place. In their nostalgia they compared their idealized memories of home with the reality of India. Inevitably India came off second-best ….

The new arrivals were unformed; all they knew was that they were very far from home in a very strange country. What [could be] more natural than they should cling to the community that reminded them of what was familiar and that they should look to the older ladies to replace the mothers they had left behind? And the community took its responsibility to instruct its newest members seriously. They must learn the ropes partly for the sake of the Raj and partly for their own sakes. Learning the ropes was the way to safety, ignoring them was perilous. Most of us, in a similar position, would probably have chosen safety.[1]

Home left Madras on May 28, 1795 and reached Calcutta on June 4. There he opened a very successful studio, and his Sitters Book in the National Portrait Gallery, London, informs that between June and December 1795 alone, he had painted fifty-five portraits, earning 32,750 sicca rupees.[2] Home painted portraits of most of the principal residents of Calcutta. The present painting is unsigned, but a comparison with his Calcutta portaits reveals that it can be only by him. Mildred Archer described the general features of Home's Calcutta portraits:

All these portraits are of the same type…. The figure is dressed in splendid robes, one hand on the hilt of a sword or, if a civilian, on a table covered with papers. Some document symbolic of the occasion is frequently included. These properties are painted with care and … the portraits have a plain and simple dignity wholly typical of Home's honest directness.[3]

The "document symbolic of the occasion" is probably the envelope, the contents of which is not known. Most noteworthy is the carefully painted inkstand with an inkpot containing a pen, which reappears in a number of Home's published paintings.[4] The envelope might belong to the opened box on the table, which can be locked by a key. This box also seems to contain a piece of lace, or perhaps it is part of the woman's dress. The woman's mood is thoughtful, perhaps even dreamy, or musing. As the painting is not labeled, her identity remains obscure. It is known that in September 1795, Home married a "middle-aged woman, Ann Alicia Paterson";[5] it seems not to be known, however, what she looked like. While in Calcutta, Home was joined by his daughter from England, but her appearance also seems to be unknown.

In April 1814 Home left Calcutta for Lucknow, where he arrived in August of the same year to become the court painter of Nawab Ghazi-ud-Din Haider for the next thirteen years. In October 1824 he was visited by Bishop Reginald Heber, who left the following, often quoted account:

I sate for my portrait to Mr. Home four times. He has made several portraits of the King, redolent of youth, and radiant with diamonds, and a portrait of Sir E. Paget, which he could not help making a resemblance. He is a very good artist indeed, for a King of Oude to have got hold of. He is a quiet gentlemanly old man, brother of the celebrated surgeon in London, and came out to practise as a portrait painter at Madras, during Lord Cornwallis's first administration, was invited from thence to Lucknow by Saadut Ali a little before his death, and has since been retained by the King at a fixed salary, to which he adds a little by private practice. His son is a Captain in the Company's service, but is now attached to the King of Oude as equerry, and European aide-de-camp. Mr. Home would have been a distinguished painter had he remained in Europe, for he has a great deal of taste, and his drawing is very good and rapid; but it has been, of course, a great disadvantage to him to have only his own works to study, and he, probably, finds it necessary to paint in glowing colours to satisfy his royal master.[5]

Heber's last observation is very interesting as it shows that Home did, probably in the course of time, adapt his painting style to Indian taste, in using more intense ("glowing") colors.

NOTES
1. MacMillan 1996, p. 65.
2. Archer 1979, p. 312.
3. Archer 1979, p. 319.
4. Cf. Archer 1979, p. 313, illus. 217, p. 314, illus. 218–219, p. 220, illus. 220, p. 320, illus. 224, p. 322, illus. 226, to quote examples from a single publication.
5. Heber 1828, vol. I, pp. 394–395, also quoted in Carey 1907, vol. II, pp. 198–199; Cotton 1928, p. 19, where also the whereabouts of Home's portrait of Heber are given.

46 Portrait of a Lady

~

by Paul Frederick de Caselli
(1775–1817), Madras, 1811.

Media: Watercolor and pencil
on paper

Size: 16¼ x 11¾ in.
(40.7 x 30 cm.)

Inscribed: In lower left corner,
signed: "P. F. de Caseĺli de
Fresne Juin 1811 / Madras"; on a
label on the back: "Ci-devant
Capt. au Service de Sa Majestie
Imp. et Royale d'Autriche et
par sa fatale étoile aujourdhui
Peinthe aux Indes. Juin 1811.
(Formerly captain in the
service of His Imperial and
Royal Majesty of Austria and
through his fatal star today
a painter in India, June 1811).

Published: Losty 1993,
(pp. 12–13).

Provenance: Indar Pasricha
Fine Arts

About to land at Madras, Reginald Heber observed:

Two of the female passengers were also objects of considerable pity; the first being a young widow, whose hus-
band, a small indigo planter, had failed in business, and destroyed himself, and who was now going home, with
her child, to live on the charity of some poor relations. The other, a wretched crazy girl, also in an humble rank
of life, who had fallen in love with a man in a more elevated station, and who had since hardly spoken at all,
but continued crying all day long. (February 5, 1826).[1]

It is not known who the woman in this painting is, and hence nothing is known about her
fate. She might belong to a comparatively wealthy part of the European community in
Madras. She is very white-complexioned, as if she had never been exposed to the Indian
sun. Hence, she probably just arrived, after having been shocked by the nudity of the
Madras boatmen (cf. cat. no. 79). When landing at Madras in 1810, Maria Graham remarked
on the boatmen: "Naked, all but a turban and a half handkerchief fastened to the waist by a
pack-thread," and even this was often blown aside by the wind, "a very awkward exhibition
this for modest girls on their first arrival."[2] Her long white dress makes her look quite tall.
This was probably the latest fashion as Mrs. Fay already observed in Madras some thirty-
one years earlier: "The ladies here are very fashionable I assure you: I found several novelties

in dress since I quitted England, which a good deal surprised me, as I had no idea that fashions travelled so fast." (April 13, 1780)[3]

Another watercolor by de Caselli in the India Office Library, London, is dated 1810. It shows a "British infantry field officer of the Madras Army," with the city of Madras in the background.[4] We may hence assume that the present watercolor was done at or near Madras as well, especially since a contemporary source (August 10, 1811) informs us that de Caselli lived very near Madras.[5] The landscape with its waters and groves seems to indicate that the lady should be imagined as if having been portrayed in what was known as "Moubray's garden," which "takes its name from Mr. George Moubray, Government Accountant, who arrived in Madras in 1771. He acquired 105 acres of land in the neighbourhood, at a rental of pagodas [then an Indian currency] 80. Here he built a house in turn known as Moulbray's Cupola and Moulbray's Gardens."[6]

De Caselli was born in Basle and came to Madras on January 5, 1804, initially as ensign. By July he resigned his commission and became an artist. James Wathen, who saw him in Madras on August 10, 1811 reported:

I was introduced to Mr. Casellis, a miniature portrait painter who resided in the village of Persewachum a few miles from Madras. This gentleman was formerly a military officer in the Company's service but his passion for the arts induced him to lay down the sword for the pencil. I was happy to find that he had been successful beyond his expectations. His prices for miniatures was forty guineas and he had as much employment as he desired. His collections of pictures, drawings, and miniatures etc. was very considerable and two hours of my time were most agreeably taken up in their inspection and his conversation.[7]

The fact that de Caselli was primarily concerned with miniature portraits accounts for the large eyes of this lady, who shares her coiffure with Lady Eliza D'Oyly.[8] Although de Caselli probably benefitted from the interest in portrait painting in Madras, the market for which was then well prepared by George Chinnery and Charles d'Oyly, only very few paintings by him are known to date.

NOTES
1. Heber 1828, vol. II, p. 270.
2. Maria Graham, *Journal of a Residence in India*, Edinburgh, 1812, p. 124 and William Hickey, *Memoirs of William Hickey*, ed. by P. Quennel. New edition: London, 1975, p. 107, both quoted after MacMillan 1996, p. 35.
3. Fay 1986, p. 164.
4. Archer 1969, vol. II, p. 569.
5. James Wathen as quoted after Losty 1993, p. 12.
6. Newell 1919, photograph facing p. 107 and text, p. 107.
7. James Wathan, *Journal of a Voyage in 1811 and 1812 to Madras and China*, London, 1814, quoted after Losty 1993, p. 12.
8. Archer 1979, p. 397, no. 310, a miniature portrait by Martha Browne.

47 Portrait of the Begum
 Sumroo (ca. 1751–1836)

 ∼

 attributed here to Raja Jivan
 Ram, Meerut, ca. 1820–1830.

 Media: Ink on paper

 Size: 21 x 16¹/₂ in.
 (53.3 x 41.9 cm.)

 Published: Bayly et al. 1990, p.
 171, no. 189 (this reproduction
 does not show the painted
 surface in full).

 Provenance: Yasmin and Shahid
 Hosain.

A good number of published non-Indian eye-witness records of this most extraordinary woman exist:

Begum Somroo is about forty-five years of age, small in stature, but inclined to be plump. Her complexion is very fair, her eyes black, large and animated; her dress perfectly Hindoostany, and of the most costly materials. She speaks the Persian and Hindoostany languages with fluency, and in her conversation is engaging, sensible, and spirited. (W. Francklin, 1796)[1]

Her features are still handsome, although she is now advanced in years. She is a small woman, delicately formed, with beautiful hazel eyes; a nose somewhat inclined to the aquiline, a complexion very little darker than an Italian, with the finest turned hand and arm I ever beheld. Zophany, the painter, when he saw her, pronounced it a perfect model. She is universally attentive and polite. A graceful dignity accompanies her most trivial actions; she can be even fascinating, when she has any point to carry. (A. Deane, 1806)[2]

She is a very little, queer-looking old woman, with brilliant, but wicked eyes, and the remains of beauty in her features. She is possessed of considerable talent and readiness in conversation, but only speaks Hindoostanee. (R. Heber, December 20, 1824)[3]

It is, however, conjectured, from her exceeding fairness of complexion and peculiar features, that her family were of northern extraction. (Major Archer, February 20, 1828)[4]

In person she is very short, and rather embonpoint: her complexion is unusually fair, her features large and prominent, and their expression roguish and astute. Her costume consisted of a short full petticoat, displaying a good deal of her keemcab trousers, from under which peeped a very tiny pair of embroidered slippers. Of her hands, arms and feet the octogenarian beauty is still justly proud. She wore on her head a plain snug turban of Cashmere, over which a shawl was thrown, enveloping her cheeks, throat and shoulders; and from the midst of its folds her little grey eyes peered forth with a lynx-like acuteness. During the repast, which was served in the European style, the old lady smoked a very splendid hookah … (G. C. Mundy, November 25, 1828)[5]

Il parat que j'ai oublié l'an passé de vous parler de ma visite à la begum (princesse en persan) Sumro, à Serdhana, près de Meerut.… Je déjeunai et dînai avec cette vieille sorcière, et même lui baisai la main galamment.. …C'est une vieille coquine qui a une centaine d'années, cassée en deux, ratatinée comme un raisin sec, une sorte de momie ambulante, qui fait encore elle-même toutes ses affaires, écoute deux ou trois secrétaires à la fois, tandis qu'en même temps elle dicte à trois autres. (V. Jacquemont, December 26, 1831)[6]

Regarding the latter description, which appears to be somewhat exaggerated, we would like to quote from W. H. Russel's diary: "I read Jacquemont's Letters today. They are delicious — immensely conceited, shrewd, impudent, egotistical — all one grand "moi".… As far as I can judge, *his descriptions are very exact and true* [italics are mine, J.K.B.]." (June 23, 1858)[7]

Leopold von Orlich, who arrived in India only six years after the begum's death, summarizes descriptions of her given by various authorities in the following passage published in 1845: "Sie war von kleiner Statur, etwas wohlbeleibt, leicht und behende in ihren Bewegungen, im Ausdruck ihrer Züge lag Strenge und Härte, aber noch im spätesten Alter blickte aus den schwarzen großen Augen ein jugendliches Feuer."(May 8, 1843)[8]

It is interesting to note that the Begum Sumroo, like other Indian women of note (cf. the portrait of Rani Jindan, cat. no. 48), is said to have been a dancing girl (nautch girl) in her youth,[9] before she married the adventurer Walther Reinhardt alias Walterus Somer in 1776 in Delhi. Other contemporary sources claim quite the opposite: she was by birth a "*Squadance*, or lineal descendant from Mahomed, the founder of the Mussulman faith."[10]

Be that as it may, she took her name from her first husband, who was known by the name of Sumroo or Sombre. In regard to his origin, Sumroo is a rather shadowy figure. Opinions

about his original nationality differ: he came — according to sources — either from Germany, Austria, France, or from Switzerland.[11]

Almost all nineteenth century authors agree that "Sombre" is probably a corruption of "sombre," meaning "dark." Thanks to the research of K. Reinhardt, however, it has been determined to be a "nom de guerre" of "Somer" or "Sommer."[12] The Begum Sumroo's maiden name is not known. Her place of birth is given as Kutana, a place some 50 kms to the north-west of Meerut.[13] She was born around 1751,[14] the daughter of the second wife of a certain Lutf Ali Khan[15] or Asad Khan.[16] She died in her palace in Sardhana on January 27, 1836. By that time she had become a Catholic and was buried in the magnificent church, now a basilica, which she built.[17]

The Begum Sumroo was, next to James Skinner (see cat. no. 16), the most famous person in North India, and there are innumerable stories and anecdotes about her courage, her wit, her cruelty, her hospitality, her charity, and her presence of mind. Most of these incidents, but not all, are enumerated in two monographs about her.[18]

She was quite rich, but the British, taking revenge on her first husband's conduct in Patna,[19] managed to bypass the person who was to inherit her money and possessions.[20] Either Jacquemont's description quoted above or her immense wealth inspired Jules Verne to write his anti-German book, *Les Cinq Cents millions de la Bégum* (The Begum's Fortune, 1879). More recently, another book, in the form of an autobiography, was published on her.[21]

The employment of painters in her service is well documented by a number of published portraits and contemporary records, of which two shed light on the nature of the present painting. On November 25, 1828, General Mundy narrated the following incident:

The Begum Sumroo, at the epoch of the last siege of Bhurtpore (cf. cat. no. 70) *followed our army and pitched her tents in the neighbourhood of the Head-quarters camp.*[22] *The martial old Amazon was most eager to share our glory (and prize money), and harassed the Commander-in-Chief with daily importunity that she might be permitted to support the British army with her handful of vagabond retainers — a reinforcement which was politely declined. Her highness afterwards protested a great friendship for his Lordship* [i.e. General Lord Viscount Combermere], *sent him her portrait, and insisted upon a return of the compliment. The picture, a work of a native artist who resides at Meerut, and has made respectable progress in the art, was an exceeding good likeness; and my fingers always itched to transform her hookah snake into a broom, with which adjunct the old dame would have made no bad representative of Mother Shipton.*[23]

Mundy does not give the name of this artist from Meerut, who is mentioned, however, by another visitor who wrote from that place, situated not far from the Begum's capital, Sardhana, on February 11, 1838:

I treated myself to such a beautiful miniature of W[illiam] O[sborne]. There is a native here, Juan Kam [sic, i.e. Jivan Ram], *who draws beautifully sometimes and sometimes utterly fails, but his picture of William is quite perfect. Nobody can suggest an alteration, and as a work of art it is a very pretty possession. It was so admired that F[anny] got a sketch of G[eorge] on cardboard, which is also an excellent likeness; and it is a great pity there is no time for sitting for our pictures for you — but we never have time for any useful purpose.*[24]

Another visitor described the picture gallery in the palace of the Begum at Sardhana:

There are a great many paintings about the palace, but most of them are miserable daubs by natives. One or two portraits by Beechey, and a few specimens of Chinnery's landscapes, are valuable; and there are, among a cartload of trash, three or four good likenesses by a native painter, Juan Ram [i.e. Jivan Ram], *who has certainly more of the art in him than any other black man with whom I have met: his portraits, as far as features go, are very faithful, servile copies of the flesh; but he falls short, where all his brethren do, in the life*

and expression and in figure. He can paint an eye, a nose, a mouth, most accurately resembling the copy; but he cannot breathe life into the canvas and then he is sure to stick in a cow's leg in a sleeve instead of an arm; and as for composition, or light and shade, I believe he never heard of them.[25]

In his book on the Begum, Banerji draws a better picture of the Begum's collection at Sardhana:

The palace at Sardhana was chiefly remarkable for a collection of some 25 oil-paintings of the Begam, and her friends, relations and courtiers, drawn by artists of celebrity, such as Jiwan Ram, Beechey of Lucknow, and Melville of Delhi.[26]

The artist Jivan Ram, in all probability, also painted the preceding cat. no. 19, to which we hereby refer for further information and documentation of his career.

The Begum Sumroo also had another Indian painter working for her. Unlike Jivan Ram, a Hindu, he was a Muslim, Muhammad A'zam. His style differs greatly from that of Jivan Ram, who knew better how to employ European painting technique. Muhammad A'zam, however, painted more what Bacon would have called "miserable daubs by natives"; his style is more closely associated with the works of the Delhi/Haryana artists working for James and William Fraser or Colonel Skinner,[27] some examples of which are considered in the present catalogue.

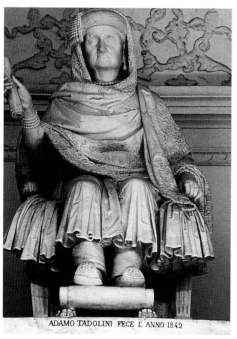

ADAMO TADOLINI FECE L' ANNO 1842.

Fig. 13

Several portraits of the Begum Sumroo were published, all showing her in an advanced age. The first published portrait of her appears as the colored frontispiece to the book of 1844 by Colonel Sleeman, who never actually saw her.[28] It appears to be painted on an oval shaped piece of ivory, unless the designer of the frontispiece took a detail from a larger painting.[29] Several paintings showing her portrait on ivory as well as on paper have indeed survived. It seems that Jivan Ram based his drawing either on a portrait by "Melville of Delhi,"[30] probably the best known picture of the Begum[31] or he was inspired by the "ambitious piece, a life-size portrait of the Begum in advanced life, seated on a sort of throne and smoking her hookah," which once adorned the central hall of the Begum's palace at Sardhana.[32] All other published single portraits of the Begum that have come to our notice are, more or less, strongly related to the present depiction, especially with regard to the rendering of the head, the dress, and the mouthpiece of the water-pipe.[33] The chair on which the Begum sits was certainly not inspired by Melville's picture of her. The chair and footrest of Jivan Ram's portrait of the Begum are identical to the chair on which she sits as top part of the monument, erected over her tomb in her Basilica of Our Lady of Grace, as the church is now called.[34] Noteworthy are the lions' heads at the top of the backrest and the legs of the chair, which terminate in the shape of lions' paws. The footrest is also supported by lions' paws, cf. accompanying fig. 13. This chair is intended to represent the Begum's throne. Thrones of sovereigns in ancient India were called *simhasana* (lion seats) and, as in ancient Egypt, parts of the throne indicated the presence of a lion. Those seated on such thrones include eminent Buddhists, Moslems, and Hindus, such as Gautama Buddha himself (cf. cat. no. 59), the Mughal emperor Jahangir (1605–1627),[35] or Maharaja Abhai Singh of Jodhpur.[36]

The Begum's monument consists of eleven life-size figures and three panels in bas-relief made of Carrara marble by the famous Italian sculptor Adamo Tadolini of Bologna. It was commissioned by her great-grandson, David Dyce Sumroo, when he was in Italy on the way to England. It measures eighteen feet in height, was completed in Italy in 1842, and erected at its present location in 1870. To capture the likeness of the Begum and her retinue, Tadolini probably made use of the Begum's paintings, copies of which her great-grandson must have given him for guidance. The three paintings which formed the basic inspiration for the three panels in bas-relief below the statue of the Begum are published.[37] All three paintings are by Indian artists, one of whom, Muhammad A'zam, is known by name. It is interesting to note

that for a project which cost 250,000 rupees—a fortune in those days—the Begum's great-grandson trusted the reliability of the Indian artist rather than the European. For the life-size statue of his great-grandmother he accordingly did not suggest the well-known portrait by Melville of Delhi, but a finished portrait which, in all probability, was the work of Jivan Ram from Meerut, most probably the court-painter of the Begum towards the last years of her life. The present picture of her is hence almost certainly Jivan Ram's preliminary study of the Begum, which culminated in the painting that Tadolini adopted for his life-size marble sculpture of the "Iohanna Nobilis," as the Begum was called as a Catholic.

Tadolini's sculpture of the Begum (see fig. 13) shows her holding the scroll of the Mughal emperor, Shah Alam II, conferring on her the *jagir* (fief) of Sardhana, whereas her left hand seems to clasp an object which is not visible. A comparison with all existing portraits of the Begum reveals that this missing object was nothing but the mouthpiece of the snake of her hookah, which Tadolini could not accommodate in his work. Jivan Ram's study is hence an important missing link between the famous disciple of Antonio Canova and the Indian tradition of portrait-painting under European influence.

NOTES

1. Francklin 1805, p. 92.
2. Deane 1823, p. 150, quoted after Banerji 1925, p. 177. For the artist "Zophany," see the present cat. nos. 11 and 35. Should Zoffany ever have painted her, the painting has as yet not been traced. Cf. also Noti 1906, p. 115.
3. Heber 1828, vol. I, p. 543.
4. Archer 1833, vol. 1, p. 138.
5. Mundy 1858, p. 178.
6. Jacquemont 1841, vol. 2, p. 220, in a letter to his father.
7. Russel 1860, vol. 2, p. 105.
8. Von Orlich 1845, p. 264.
9. Cf. e.g. Archer 1833, vol. I, p. 33.
10. Sleeman 1844, vol. II, p. 378.
11. For the most recent research on "Sumroo's" origin, taking into account hitherto neglected sources like passenger-lists of Dutch vessels sailing to India, French sources which were not published by the time of the first monograph, in addition to German church documents and the like, see Reinhardt 1993.
12. Reinhardt 1993, p. 9.
13. Noti 1906, p. 62; Banerji 1925, p. 14.
14. Noti 1906, p. 62ff.; Banerji 1925, p. 15.
15. Banerji 1925, p. 14f.
16. Noti 1906, p. 62.
17. Noti 1906, p. 129; Banerji 1925, p. 127f.
18. The most often quoted monograph on the Begum Sumroo is the booklet by Banerji. Almost unknown outside German-speaking countries is the earlier monograph on Walter Reinhardt, alias Sommer, and *The Begum Sumroo* written by a Jesuit, S. Noti, who also wrote a book on Sawai Jai Singh of Jaipur.
19. On this important issue see Reinhardt 1993, pp. 16–20.
20. Reinhardt 1995.
21. Larneuil 1981.
22. A picture of the camp of the Begum Sumroo was painted by the Indian artist Sita Ram and forms part of a collection of albums by this artist recently acquired by the British Library, India Office Library and Records.
23. Mundy 1858, p. 180f.
24. Eden 1937, p. 94. William Osborne was Emily Eden's nephew; he was the first to publish a portrait of Hira Singh (see cat. no. 22). Fanny was Emily's sister and George was the Governor General, Lord Auckland.
25. Bacon 1837, vol. II, p. 33f.
26. Banerji 1925, p. 204. In a footnote on the same page, Banerji mentions the following paintings with Begum Sumroo: (1) *The Begam in State Chair Smoking her Hookah;* (2) *The Begam Meets Lord Combermere after the Fall of Bharatpur;* (6) *H. H. the Begam and Dyce Sombre as a Boy;* (8) *The Begam Presenting a Chalice to the Clergy of Sardhana,* Keene 1907, p. 193, gives further information on this part of the Begum's palace: "In the principal reception-rooms used to hang a number of portraits of the Begum's friends by Beechey, Melville, and other local artists. . . . Amongst others was a small portrait-group, stiffly painted, representing the meeting of Lord Combermere and the Begum after the fall of Bhurtpur (1826). . . . In the central hall was an ambitious piece, a life-size portrait of the Begum in advanced life, seated on a sort of throne and smoking her hookah."
27. Leach 1995, vol. 2, pp. 788–795.
28. Sleeman 1844, vol. II, p. 339: "In the evening [of January 27, see ibid., p. 333], a trooper passed our tents on his way in great haste from Meerut to Delhi, to announce the death of the poor old Begum Sumroo, which had taken place the day before at her little capital of Sirdhannah [she died, in fact, on the morning of the same day]. For five and twenty years had I been looking forward to the opportunity of seeing this very extraordinary woman, whose history had interested me more than that of any other character in India during my time; and I was sadly disappointed to hear of her death when within two or three stages of her capital."
29. This painting was reprinted in Compton 1893, opp. p. 403.
30. Cf. annotation 25 above.

31. For reproductions of this painting cf. Keene 1907, frontispiece ("the portraits [*sic*] of the Begum by Melville being here reproduced by the courtesy of Sir James Digges La Touche," ibid., p. 193); Banerji 1925, frontispiece; Holman 1961, opp. p. 86. An engraved copy after this painting is marked "C. L. Becker [18]95 / Berlin," cf. Noti 1906, p. 116. Further reproductions are listed in Cotton 1934, p. 13. For another description of this painting cf. Cotton 1934, quoting Keene: "The central hall, opposite the entrance [of the Begum's palace at Sardhana] has in the centre a large portrait of the Begam, life size, seated on a sort of throne and smoking the hookah. This is an ambitious piece of colouring, not too well finished, by an artist of Delhi named Melville, who also painted. . ." (Cotton 1934, p. 9f.). For William Melville's life and career cf. Cotton 1934, pp. 13–15. Melville's style can be estimated from another, more recently published picture by him, see *Journey through India* 1996, col. pl. p. 44.

32. See note 25 above.

33. Cf. Sanderson/Zafar Hasan 1911, p. 138, pl. LXI(a); David/Soustiel 1983, p. 112, no. 149; Patrick 1987, illus. opp. p. 10; Sotheby's Colonnade, October 13 and 14, 1992, lot 522, col. pl. p. 39; Archer 1992, p. 164, no. 146, col., signed by (or attributed to?) Jivan Ram; Reinhardt 1993, p. 70b, Abb. 4; Leach 1995, vol. II, p. 790, no. 7.120, attributed to Jivan Ram. For another portrait of the Begum, which was given to Allard, the French general of Ranjit Singh, see Lafont 1992, p. 316f.

34. For this monument cf. Noti 1906, p. 145, Bild 41; Banerji 1925, illus. opp. p. 158; Patrick 1987, illus. facing p. 63; also Cimino/Scialpi 1974, illus. 70 and text, p. 114f.

35. See Skelton 1976, pl. 127, cat. no. V.70.

36. Bautze 1995, p. 141, col. pl. 125 and p. 288 and p. 298, note 90 for further references.

37. For the front panel depicting the Begum presenting a gold chalice to the Bishop, Monsignore Pezzoni of Agra, see Cotton 1934, illus. facing p. 30 (= Patrick 1987, illus. facing p. 11); this painting was already mentioned by Banerji as being part of the Begum's collection, cf. note 26, (8). For a description of the scene, see Patrick 1987, p. 59f. The panel on the Begum's right shows the Begum in grand *darbar*, see Reinhardt 1993, p. 122d, Abb. 40 and Abb. 42, detail, also in Leach 1995, vol. II, col. pl. pp. 788–799. The panel below her left shows her riding an elephant as part of a state procession, see Reinhardt 1993, p. 122d, Abb. 41 or Leach 1995, vol. II, col. pl. p. 792 and b/w- detail, pp. 796–797.

48 Maharani "Chund Kowr"
alias Rani Jindan (1817–1863)

∾

by George Richmond, R.A.
(1809–1896), London, 1863.

Media: Oil on panel

Size: 17³/₄ x 24¹/₈ in.
(45.1 x 61.3 cm.)

Inscribed: Signed and inscribed
on a label on the reverse
of the panel "Her Highness.../
(A Study from life)."

Provenance: Maharaja Dalip
Singh; Victor Albert Singh;
Frederick Singh; Pamela, Lady
Aylesford.

Published: Alexander/Anand
1980, fig. 17.

Probably the best description of Rani Jindan in England is by Lady Login, wife of Sir John Login, who arranged for the Rani's stay in London:

Jinda Kowr was truly an object of commiseration when one contrasted her present with her former state. To see her now, with health broken, eye-sight dimmed, and her once famed beauty vanished—it was hard to understand the power she had wielded through her charms. It was only when she grew interested and excited in conversation, that one caught glimpses, beneath the air of indifference and the torpor of advancing age, of that shrewd and plotting brain which had distinguished the famous "Messalina of the Punjab." She had only just received her jewels from the custom-house, and was naturally delighted to have them again in her possession; for since her flight from Chunar Fort to Nepal, the Indian Government had retained them, and only delivered them to her in Calcutta when she embarked for England. On this occasion she was decorated with a large assortment, the most remarkable being some beautiful pearls and emeralds...[1]

Richmond's diary for 1863 includes a description of the "Maharanee Chund Kowhr." He refers to her as "the real Governor of the Punjab" and accuses her of having been responsible for two Sikh wars. Richmond seems to have disliked her because "she sat for three whole days without once uttering a word." [2]

Rani Jindan and her son, Maharaja Dalip Singh, arrived in London in early summer, 1861. On September 30 of that year, Dalip Singh, staying with his mother at Mulgrave, wrote to Lady Login: "I want your advice about getting a good likeness of my mother (in oils)." [3] A preparatory sketch for the present painting, done in colored chalk and blue wash on light brown paper, is dated June 3, 1863.[4] A number of entries in the *Index Catalogue of the Works of George Richmond* in the possession of Miriam Hartley, Richmond's great-granddaughter, relate to the present painting: "95A Chund Kowr, Maharanee. Study from life for larger picture. R.A. 1865 (207). 1863." [5] This means that Richmond had done the painting in 1863 and exhibited it at the Royal Academy in 1865, as no. 207. The same subject is mentioned again under a different name for 1863: "59 Dhuleep Singh. The Maharanee." [6] Another entry for the same year reads: "13 Ranee. (The Maharanee Dhuleep Singh) "Study for a whole length picture." For this portrait, Richmond charged L105. [7] It was identified as being the present painting.[8] A fourth entry finally mentions "Ranee. The ['from 1864']" with two entries and the sum of L27.5.[9] It is possible that Richmond might have used a photograph of the "Ranee" as an aide mèmoire, for in 1862, after a visit to Bishopthorpe and New York, he wrote about the use of "photographers." [10]

Rani Jindan died on August 1, 1863. Richmond's daughter Laura was married to the Reverend Thomas Broughton Buchanan, Archdeacon of Wiltshire and Canon of Salisbury, on August 5 of the same year.[11]

Probably no other female character of Anglo-Indian history was more often accused of evil conduct than Rani Jindan. In the following we quote from three different accounts which supposedly shed light on Rani Jindan's early career:

Duleep Singh...was the last of the four "acknowledged" sons of Runjit Singh. He was born on 4 September 1838, at a time when the great man was unlikely to have been able to father a child for, apart from a preference for the company of beautiful boys, he had two strokes and was partially paralysed; in addition, an indulgence in laudanum, brandy fortified with powdered pearls, and fat quails stuffed with spices, had wrought havoc with his liver. Duleep Singh's mother was Jindan Kour, daughter of a palace doorkeeper, a woman of considerable character and influence in the royal household. Adopted by Runjit Singh at an early age, her ready wit and lack of sexual inhibitions had made her well qualified to organize the more outlandish entertainments of the court. It was said that the ageing Maharajah took perverse pleasure in her amours even to the extent of encouraging her lovemaking with his current favourite, formerly a bhishti or water-carrier in the palace courtyards. On the birth of a boy, Runjit Singh was amused to accept the flattering pretence that the child was his; by officially recognizing him as such he made more certain the continuance of his dynasty.[12]

A contemporary compiler of sources, Smyth, quotes an authority according to which Jindan's father was initially a dog-keeper in Ranjit Singh's service, who was raised to a door-keeper after

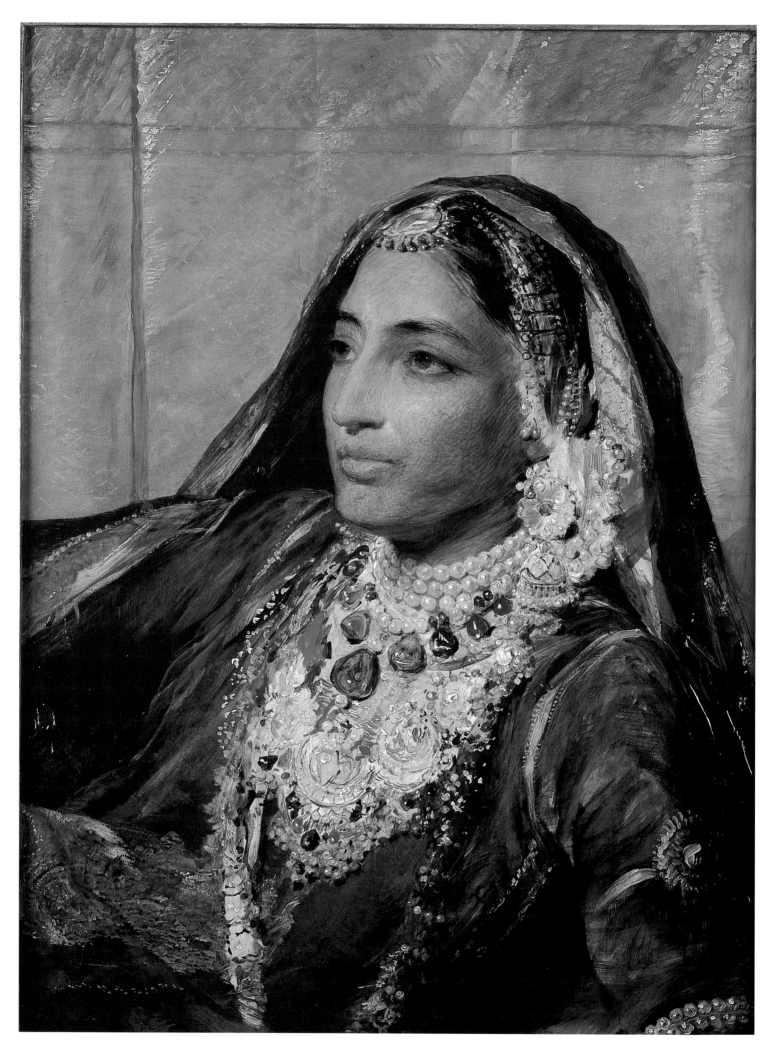

Memsahibs, Rope Dancers, Ranis, and Other Women

fifteen years of service. This doorkeeper, Munnoo Singh by name, praised his daughter Chanda as being the most beautiful girl and used to carry her on his shoulders in order to show her to Ranjit Singh. After a lapse of some time, Ranjit Singh sent the girl, Chanda, to Amritsar,

where she remained for four or five years in the house of Jewahir Mull. There she might have remained in quiet much longer, her guardian receiving for her maintenance forty-five rupees a month—but that she had even at so early an age won for herself a character for pertness, forwardness, and something even worse. So loose and immodest was her conduct that Jewahir Mull, fearing perhaps that the contagion of her vices might spread to the members of his own virtuous family, informed the Maharajah that he could not allow the young Chunda to remain in his house any longer. As a reason for praying to be released of his charge, he represented, that though the girl was then only thirteen or fourteen years of age, she was in criminal intercourse not only with one Jewahir Sing Bussthenee, whose house adjoined his own, but that she had more than one paramour in the very bazars of Umritsir. . . . Runjeet readily consented to relieve Jawahir Mull of his charge, and the young lady was brought to Lahore to enliven the night scenes of the palace. . . . Numerous were the amours in which she was now engaged, some with, others without the knowledge and consent of the Maharajah. To give a detail of these affairs and of scenes acted in the presence of the old Chief himself at his instigation, would be an outrage on common decency; suffice it then to say, that Runjeet actually encouraged and forwarded the amours of this woman, who passed as his wife, with a person known as Gullo Moskee—formerly a beestee [water carrier] *of the palace, but latterly an indulged favourite of the Maharajah—and that in nine or ten months afterwards the present Maharajh Dulleep Sing was born. . . . Such is the true history of Her Highness, Ranee Chunda* [sic].[13]

Another woman who rose to fame, or rather notoriety, after the death of the great Maharaja, was Jindan, the reputed mother of Maharaja Dhulip Singh. She was the daughter of Manna Singh, a trooper in the service of the palace, and as a clever mimic and dancer, she attracted the notice of the old Maharaja and was taken into the zenana, where her open intrigues caused astonishment even in the easy Lahore court. A menial servant, a water carrier, of the name of Gulu, was generally accepted as the father of Dhulip Singh. At any rate, the father was not Maharaja Ranjit Singh, who was paralysed several years before the birth of the child. Nor did he ever marry Jindan by formal or informal marriage. Many believed that Dhulip Singh was not born of Jindan at all; . . .[14]

Rani Jindan is the only female character who was painted and thus honoured by the Sikhs.[15] Does this mean that the Sikhs actually respected a woman of questionable reputation or was she simply just another victim of British imperialism? It seems historically almost certain that would Rani Jindan have either tolerated or sustained the British annexation of the Panjab, the British would have called her an angel and the Sikhs a whore. As it is, the most prominent Sikh historian, Khushwant Singh, claims that she "was married to Ranjit Singh in 1835" and quite rightly remarked: "The more restrictions and dishonour the British heaped on Jindan, the more she became a heroine in the eyes of the people."[16]

The history of Rani Jindan offers sufficient material for a major novel, in which another attractive person, Hira Singh (cat. no. 22), would have to appear. Hira Singh's downfall was caused, after all, by Rani Jindan. This is, however, a different story.[17]

NOTES
1. Login 1890, pp. 458–460. It was actually Henry Lawrence who called Rani Jindan the "Messalina of the Punjab," cf. Gough/Innes 1897, p. 54.
2. Christie's, May 25, 1995, p. 108.
3. Alexander/Anand 1980, p. 93; cf. Lister 1981, p. 91f.
4. Christie's, May 25, 1995, lot 164 (= Losty et al. 1996, p. 55, no. 56, col. illus.)
5. Lister 1981, p. 155.
6. Lister 1981, p. 156.
7. Lister 1981, p. 168.
8. Losty et al. 1996, p. 55 (". . . now in an American private collection.").
9. Lister 1981, p. 168.
10. Lister 1981, p. 92.
11. Alexander/Anand 1880, p. 97; Lister 1981, p. 92.
12. Alexander/Anand 1880, p. 2.
13. Smyth 1961, pp. 100–103.
14. L. Griffin, Ranjit Singh, pp. 109–110, quoted after Archer 1966, p. 176.
15. Cf. Archer 1966, pl. 97, 108 (woodcut), 109 (woodcut), 110 (woodcut); Alexander/Anand 1980, illus. 2, facing p. 150.
16. Singh 1966, vol. II, pp. 28–29, p. 64.
17. For which see Gough/Innes 1897, pp. 54–57.

49 A Courtesan of Maharaja
Sawai Ram Singh of Jaipur
(b. 1833, r. 1835–1880) Dressed
for the Spring Festival

∾

by a local artist, Jaipur,
1860–1870.

Media: Gouache on paper

Size: 6³/₄ x 8¹/₄ in. (7.2 x 21 cm.)

Courtesans like this were never really described by Western visitors because they were not to see them. And reliable Indian sources in this respect are not published, if they exist at all. Sawai Ram Singh's grandfather, Maharaja Jai Singh III (1803–1818), fell in love with such an irresistible courtesan, which again gave the English an opportunity to interfere with the internal affairs of an ancient Indian state in a well-known way:

He [i.e. Jai Singh III] has lately bestowed his affections, if his brutal passions may be ennobled by such a name, upon a common prostitute named Rus Kufoor — literally "essence of camphor!" — and has given such proofs of his passion as would, in any European state, entitle him to a private apartment in a mad-house. He began by bestowing on her a jagheer [piece of land] which had been appropriated to maintain the dignity of his legitimate wife and family. He has since presented her with a palace furnished in the most costly and magnificent manner, and assigned her a splendid establishment of servants of all descriptions, elephants, camels, &c. &c., to be paid regularly from the public treasury. He has not even blushed to escort her in person to this luxurious abode, through the streets of his capital, seated behind her on an elephant, and fanning her with a Chounree [a yak-tail, here: insignium of royalty] which he held in his hand, to the astonishment and indignation of the Rajpoots, who flocked from all quarters to witness the degradation of their Prince.
(Thomas Duer Broughton, September 26, 1809)[1]

The rosebuds attached to the courtesan's ears and held by her right hand indicate one of the spring festivals in which roses were central to the celebration.[2] The painting combines two entirely different styles: The large, almond-shaped eyes are typical of Jaipur painting of the first half of the nineteenth century, whereas the modelling of the face, which the artist achieved by employing a kind of stippling technique, is rather Western in its effect. It marks the transitional stage from painting to photography or from Indian to Western realism. During the earlier years of his reign, Sawai Ram Singh was portrayed in the then prevailing fashion: in strict profile.[3] The frontal view as shown here was introduced in Jaipur painting only in the 1860s, probably shortly before, or as a result of the introduction of photography by the ruler himself in 1864. Murals from this period show paintings like the present cat. no. side by side with portraits of Sawai Ram Singh and some of his ministers painted in the photographic style,[4] a coexistence of styles which is also apparent in a few miniatures from the same period.[5]

Being the maharaja of his own state, Sawai Ram Singh had the right to photograph what no other (male) artist had ever before portrayed with the same amount of reliability: the courtesans and concubines of his royal *zenana*. Sawai Ram Singh's photographs are hence the earliest and most authentic pictorial records of females which were generally never or rarely exposed to the public. Sawai Ram Singh's photographic portraits of these women[6] demonstrate the extent to which the artist of the present watercolor enhanced the beauty of his imaginary portrait, as he was never allowed to penetrate into the female apartments of the Jaipur palace: the mouth is almost as small as the eyes or the eyes are almost as large as the mouth.

The early introduction of photography in Rajasthan forced the traditional artists either to take to photography or to earn their bread as colorists of photographs. This is one of the last executed paintings in Jaipur, which is not based on a photograph; it is a rare testimony of a dying tradition.

NOTES
1. Broughton 1892, p. 202.
2. Cf. Bautze 1995a col. illus. pp. 145–146; Broughton 1892, p. 36.
3. For examples see Leach 1982, p. 135, no. 140. The dating "c. 1840" is, with regard to the beard of Sawai Ram Singh, quite unlikely: he was then only seven years of age. Sotheby's, October 11, 1982, lot 69, full-page illus. p. 22 (= Eyre & Hobhouse 1983, col. pl.).
4. Bautze 1989, figs. 2–4.
5. Cf. e.g. Christie's, November 25, 1985, p. 7, lot 2.
6. Cf. the *India Magazine*, vol. 10, December 1989, illus. p. 28 and p. 30, top (= Das 1988, full-page illus. p. 27); Das/Sahai 1985, fig. 6; Das 1988, full-page illus. p. 26.

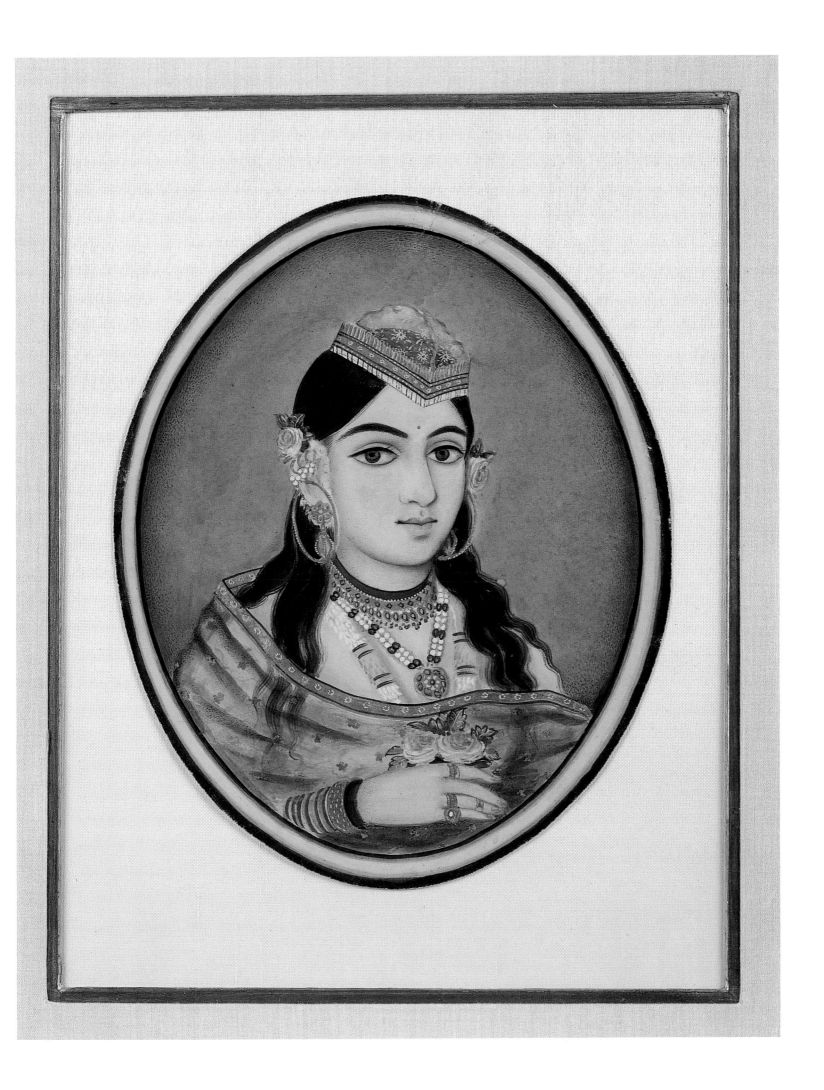

50 A Study of a Reclining Dancer (Nautch Girl) at Banaras

∾

by Edwin Lord Weeks
(1849–1903), Banaras or U.S.A.,
1893–1900.

Media: Oil on canvas

Size: 14⅝ x 19⅝ in.
(37.1 x 49.8 cm.)

Inscribed: On the canvas on
verso, as an ink-impression in
bold printed letters: "Edwin
Lord Weeks Sale / March 15.
16. and 17. 1905."

Provenance: Estate of Edwin
Lord Weeks, Sale, American
Art Galleries, New York,
March 1905.

It was our good-fortune to see a Nautch dance under the most favorable conditions, given by the Maharajah of Benares for the benefit of some friends, who stayed on, in spite of the heat, for this occasion.... The dancing began— dances by several bayaderes, and single dances accompanied with song or recitative, ending with a performance by the court actors. After a preliminary ballet, in which two or three took part, a dainty little personage came forward; graceful, gazelle-eyed, enveloped in a filmy cloud of black-and-gold gauze, which floated airily about her, she was the living incarnation of the Nautch as interpreted by the sculptors of Chitor; from the air of laughing assurance with which she surveyed her assembled subjects, it was evident that she was accustomed to homage and sure of conquest. She held her audience absorbed and expectant by the monotonous and plaintive cadence of her song, by long glances full of intense meaning from half-closed eyes, and by swift changes of expression and mood, as well as by the spell of "woven paces and of waving arms." This paragon of Nautch girls, like most of her sisterhood, wore nose jewels, but to our eyes they did not detract from her beauty, nor did they appear more unchristian than the bulky pendants which women in other countries suspend from the cartilages of their ears; the diminutive cluster of pearls or brilliants seemed rather to play the part of the black patch on the powdered face. As we were afterwards to learn, one may see many a Nautch without retaining such a vivid impression; much of its force was owing, no doubt, to the fitness of the place and the charm of strange accessories, the uncertain glare of the smoking torches, the mingling of musky odors with the overpowering scent of attar of roses, and of wilting jasmine flowers; these perfumes were intensified by the close air of the tent and by the heat of the night — the prelude to the fiercer heat which comes with the morning and the rising of the hot wind (Edwin Lord Weeks, 1893)[1]

That Weeks's study shows no other than the "graceful, gazelle-eyed" *nautch* girl from Banaras is shown by the "filmy cloud of black-and-gold gauze" depicted here. Weeks's account is illustrated by the frontal view of one of the *nautch* girls during the performance.[2] Ever since Tilly Kettle the *nautch* girl formed part of the inventory of Indian figures a European or American artist had to paint during his stay in India.[3] Other figures belonging to that inventory include an ascetic (or *yogi* or *fakir*, etc.), a ruler (*nawab* or *rao* or *thakur*, etc.) or the priest (or *brahmin*, *pujari*, etc.). The *nautch* girl was the only female figure that was "public." For an American or European male artist in nineteenth-century India, it would have been almost impossible, or at least rather difficult, to paint any other Indian woman of rank. It is hence not surprising that the *nautch* girl thus was probably the most often sketched, drawn, painted, engraved, and later also photographed Indian subject of European artists. Besides, probably no other social event was more often described by visitors to India than the *nautch* or dance which generally served to entertain visitors at a *darbar*.[4] Male British officials officially did not enjoy seeing it, female British officials unofficially did. Most of the non-British travellers were quite enthusiastic about it.[5]

Be that as it may, depictions of *nautch* girls exist in considerably large numbers. This representation, however, is unique, since it hides more than it shows. In almost all other paintings of *nautch* girls, the face is shown. Here, the attention is drawn to the left foot, while the rest of the figure is concealed in drapery. Her face is turned away and leaves us to speculate about the effect of her "long glances full of intense meaning from half-closed eyes." Weeks, who otherwise gives the impression of having painted half-dressed Indian women,[6] in this study very successfully chose a less often employed mode of attracting attention to the beautiful in woman. Since Weeks spent several years of his life in Paris — he died there — and read books on oriental art — he frequently refers to James Fergusson — he must have come across Gustave Le Bon's richly illustrated general book on India, published in 1887. This book includes a reproduction of a "Bayadère de Cachemire"[7] based on a photograph.[8] That *nautch* girl is shown in practically the same reclining position as is the dancing girl here, but she was photographed from the front in order to reveal her very attractive face.

NOTES
1. Weeks 1896, pp. 388–390. "Attar of roses" is condensed rose-oil.
2. Weeks 1896, p. 387, *Nautch Dancer*, full-page illus. The head of a *Young Nautch Girl* is reproduced in ibid. p. 378.
3. For Kettle's celebrated painting of the *nautch* girl, see Archer 1979, col. pl. 1 (= Bayly et al. 1990, p. 117, no. 137, col. = Nevile 1996, p. 99, no. 70, col.).
4. *Nautch* means dance, from the Sanskrit *nat*, to dance. For further reading and illus., consult particularly Okada/Isacco 1991, chap. "Sérails et Bayadères," pp. 95–112 or Nevile 1996, a well-illustrated picture book.
5. As we have tried to show elsewhere, cf. Bautze 1995a, pp. 141–144 and notes.
6. Cf. Weeks 1895, p. 263.
7. Le Bon 1887, p. 95, fig. 31.
8. For which see Okada/Isacco 1991, p. 119.

51 A Kashmiri Nautch Girl
with a Hookah

&

by Mortimer L. Menpes
(1860–1938), India, around
1903 or slightly later.

Media: Oil on panel

Size: 11 x 7¹/₄ in. (28 x 18.5 cm.)

Inscribed: Signed in lower right
corner: "Mortimer M...
[rest illegible]."

Reproduced: Losty et al. 1996,
col. pl. p. 57, no. 57 and col.
detail, on back cover.

Provenance: Spink and Son Ltd.,
London

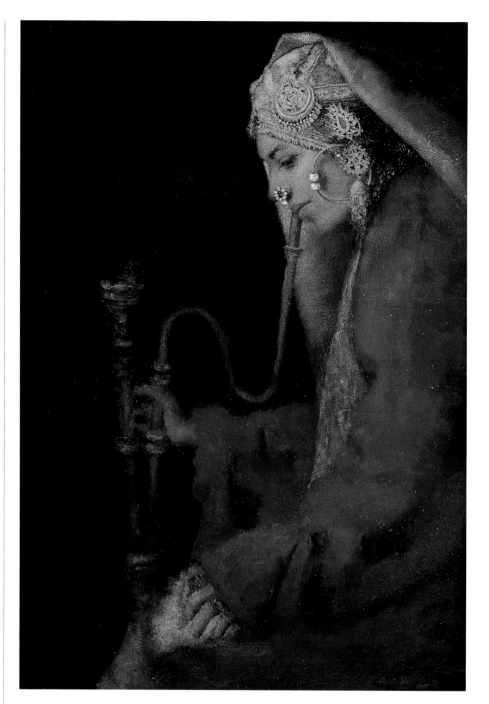

Whilst at Sreenugger [Shrinagar] I have painted two or three nautch girls, and it was through them that I got to this wedding, as they were amongst the singers. Now these girls, like most nautch girls in India, were all Moslemehs, yet had they all the caste feeling of the Hindoo. Of moral sentiment they were entirely innocent, but they would never permit any one to drink out of their cup or smoke from their hookah, and they always went about with these two utensils, for smoke and tea are the two things necessary to a Kashmiree. So in this song a Kashmiree Moslem is made to say "beautiful as Krishna." (Val Prinsep, May 30, 1877)[1]

The women are mostly tall and well-built; they are less graceful than the Hindu women in the plains, but their complexion is whiter and bestows them with a more European appearance. Their features are pleasing and often might be called pretty. During our excursions we often had the opportunity to see many girls and women, who looked at us full of curiosity, without even trying to hide their faces behind an ugly veil made of horsehair, as is done by their "sisters" in Central Asia. (Karl Eugen von Ujfalvy on the physiognomy of the Kashmiris, as published in 1884)[2]

In Kashmir the Hindu lady often wears a deep, rich red... (William Crooke, as published in 1906)[3]

In beauty, tradition always places the Kashmiri above her sisters. Mr. Drew describes them as decidedly good looking, with well shaped faces, good brows, and straight noses, black hair coming rather low on the forehead, their figures tall and well-developed, but this is obscured by the looseness of their dress. They have, however, little of the

MEMSAHIBS, ROPE DANCERS, RANIS, AND OTHER WOMEN

Fig. 14

delicacy of form that many other native women possess, and the well-turned arm and small hand are not common. The best Kashmiri women object to be photographed, and the pictures we have are usually B'atal dancing-girls, who are not the finest specimen of the race. (William Crooke, as published in 1906, based partly on information published in 1875)[4]

The beauty of the Kashmir woman was also reported by earlier sources, of which an eighteenth- and a seventeenth-century source are quoted here:

Mr. Forster, in his letter from Kashmire, dated in April 1783, speaking of the women says: "They have a bright, olive complexion, fine features, and are delicately shaped. There is a pleasing freedom in their manners, without any tendency to immodesty, which seems the result of that confidence which the Hindoo husbands in general repose in their wives." (Quentin Craufurd, 1792)[5]

The people of Kachemire are proverbial for their clear complexions and fine forms. They are as well made as Europeans, and their faces have neither the Tartar flat nose nor the small pig-eyes that distinguish the natives of Kacheguer [Kashgar], and which generally mark those of Great Tibet. The women especially are very handsome; and it is from this country that nearly every individual, when first admitted to the court of the Great Mogol, selects wives or concubines, that his children may be whiter than the Indians and pass for genuine Mogols. (François Bernier, travelling in Kashmir in 1665)[6]

This meticulously detailed painting compares well to a number of contemporary photographs, all of which show very similarly dressed and ornamented women.[7] A very similar subject appears in the accompanying fig. 14, a photograph of the 1870s, showing a reclining courtesan with a hookah, who compares well to the one in the present oil-painting. William Carpenter was one of those who could not resist painting the irresistible "Kashmiri Nautch Girls [at] Serinugger," when he traveled in the area in August 1854.[8]

Mortimer Menpes, born in Australia, studied in England under James McNeill Whistler and started exhibiting his pictures in the Royal Academy in 1880. He was commissioned to cover the Delhi Darbar of 1902–03 by *The Illustrated London News, Punch* and a well-known gazette. The coverage of this *darbar* resulted in Menpes's book *The Durbar*. Published already in 1903 with descriptions by D. Menpes, it contains 100 colored illustrations. Some of Menpes's paintings of that event are oils, such as the presentation of the veterans of the mutiny.[9] Two years later, a book entitled *India* appeared, which included his views of several Indian cities. He travelled widely in North-Western India, especially Rajasthan,[10] and painted the nautch girls of Delhi, probably also during the *darbar* of 1903.[11] Menpes held more one-man exhibitions in England than any other painter in the first third of the twentieth century. They included special exhibitions on "India," "Burmah," and "Cashmere." The present painting almost certainly formed part of the latter exhibition. The woman's golden jewelry is unusually finely painted and in execution and size, the work almost resembles a miniature.

NOTES

1. Prinsep 1879, p. 228. Prinsep's description is accompanied by the reproduction of one of the *nautch* girls he painted; see Prinsep 1879, full-page illus. facing p. 228, titled *Begoo, a Kashmiree Nautch Girl*. The same illus. is reproduced in Nevile 1996, p. 160, no. 109.
2. Ujfalvy 1884, p. 154.
3. Crooke 1906, p. 166.
4. Crooke 1906, pp. 526–527. "Mr. Drew" is Frederic Drew, who published *The Jummoo and Kashmir Territories. A Geographical Account* in London, 1875.
5. Craufurd 1792, vol. II, p. 50.
6. Bernier 1916, p. 404.
7. Cf. e.g. Okada/Isacco 1991, p. 94, reportedly a "Femme de Darjeeling," dated 1908, but dressed exactly like the woman in the present cat. no. and the *Ladies of the Kashmir Court* in Fabb 1986, no. 58; Okada/Isacco 1991, p. 111, *Danseuse de Cachemire*, dated 1908; p. 119, *Jeune fille du Cachemire*, of about 1870. Koenigsmarck 1910, photographic illus. facing p. 108. Although this photograph is labeled *The Belle of Udaipore*, it most clearly relates to the present painting. Besides, the *nautch* girls at Udaipur looked very different, cf. Okada/Isacco 1991, p. 110 (= Vignau / Renié 1992, p. 75, planche 90).
8. For a col. reproduction of this watercolor in the Victoria and Albert Museum, London, see Nevile 1996, p. 97, no. 68.
9. Sotheby's, May 8, 1997, p. 102, lot 237, col.
10. For more recent published oils showing Rajasthani subjects cf. Christie's, May 25, 1995, p. 46, lot 60, col. *(Jaipur)* (= Pal/Dehejia 1986, p. 151, no. 152); Christie's, May 25, 1995, p. 83, lot 132 *(Gateway at Ajmer)*; Christie's, June 5, 1996, p. 120, lot 155, col. *(A Rajput Retainer)*.
11. Nevile 1996, p. 166, no. 115, col.

52 The Bride

∾

by Muhammad Abdur Rahman
Chughtai (1897–1975),
Lahore, ca. 1930–1950.

Media: Watercolor on paper

Size: 16 x 13⁵/₁₆ in.
(40.7 x 33.8 cm.)

Inscribed: Signed in lower left
corner, in red *Nashtaliq:*
"'Abdu'r-Rahman Chughta'i."

Abdur Rahman Chughtai's paintings were greatly inspired by Indian miniatures, especially those from the Pahari area. The woman shown here is not an actual portrait and there is hence no description of her available. Samarendranath Gupta, the author of one of the first catalogues primarily on Pahari paintings,[1] became Abdur Rahman Chughtai's art teacher when the latter joined the Mayo School of Art in Lahore in 1911. Samarendranath Gupta was a pupil of Abanindranath Tagore (cf. cat. no. 88) and by that time painted almost in the same style as his teacher. After a visit to Delhi in 1916, Chughtai proceeded to Calcutta, where he met Samarendranath Gupta's tutor, Abanindranath Tagore. Chughtai became so fond of Abanindranath's works that his first paintings might be considered as versions of Abanindranath's pictures. *Jahanara and the Taj,* the frontispiece to the first book dealing with Chughtai's paintings[2] reminds of Abanindranath's related *The Passing of Shahjahan* of 1902.[3] Chughtai's *Jahanara,* however, differs in one aspect greatly from Abanindranath's *The Passing of Shahjahan:* the line. The line in Chughtai's paintings is generally thin, angular — often with acute angles — and underlines pleats or the braid or lace of a garment, as in the preceding cat. no. 33. In the present painting the angular line is almost totally subdued, with the exception of the remarkable angle in the eyebrows; all other lines appear to be soft and rounded, so that the few arrow-head patterns in the wrap are almost obscured by the all-embracing, dominant red-orange color as the sharply delineated nasal bone is softened by

the round tip of the nose. The hand, with its long, apparently limbless fingers, is almost certainly inspired by Indian "paintings from the hills," as the Pahari paintings were called. Rahman Chughtai possessed a good number of these and particularly valued paintings by the artist Gur Sahai, active in the early nineteenth century, on whose art he wrote.[4]

The present painting shares its sweetness with another painting titled *Gloomy Radha*, which looks like a profile view of the present with a pronounced green instead of red-orange.[5] On the whole, Chughtai preferred the profile view of the Indian miniature from the Punjab hills to the three-quarter view of seventeenth-century Persian painting, although his paintings are basically said to be under Persian stylistic influence.[6] The editor of the first monograph on Chughtai commented on a comparable view of a male face: "Rather an unusual sort of face for Chughtai to draw; it has none of the long lean characteristics of most of his faces. . . ."[7] The half closed, wide eyes of *The Bride* are characteristic of practically all of Chughtai's paintings. The stylistic proximity of the creations of the "Bengali" or "New Indian" school of painting and the eighteenth- and early nineteenth-century works of the often nameless artists working for the Rajput courts of northern India, was demonstrated by Chatterjee's Picture Albums, in which "old paintings" or paintings by the Pahari artist, Molaram, appear side by side with pictures by Dr. Abanindranath Tagore, Samarendranath Gupta, and Muhammad Abdur Rahman Chughtai.[8] It was only in recent years that Chughtai's paintings were considered as "Pakistani" or "Islamic." A great number of Chughtai's paintings illustrate Hindu subjects, and the founder of the "Bengali school," Abanindranath Tagore, in a letter written from Calcutta to Abdur Rahman Chughtai on October 18, 1929, remarks: "Your devoted labour for Indian art has awakened inexpressible pleasures in my mind + great hope for the future of our art. I wish you every success + happiness."[9] And even after the partition we read:

Though India has been divided, Chughtai is [sic] *still remains the artist of India. He was born in undivided India, and for centuries his ancestors lived and worked in this country. . . . When I first went to see Chughtai, I expected him to be painting the vision of a Moghal Princess or an interpretation of Omar Khayyam in his inimitable vein. But when through tortuous lanes, I finally reached his residence in Chabuk Sawaran, I found him painting the victorious Arjuna* [i.e. a hero of the Hindu epic, the *Mahabharata*] *Chughtai's art is undoubtedly the outcome of his wide out-look and universal sympathy. He transcends all political and territorial limitations. He paints the Hindu Gods with the same astonishing vitality as he interprets Omar Khayyam or Sadi or Hafiz . . . He has vigorously protested against the sectarianisation of his art and has silenced his narrowminded critics by paintings* [of] *about two hundred pictures on Hindu motifs and traditional themes.*[10]

NOTES
1. Gupta 1922.
2. Siraj-ud-Din n.d. Also reproduced: Mitter 1994, p. 337, fig. 174.
3. Chandra 1951, col. pl. (= Pal et al. 1989, p. 230, fig. 247 = Guha-Thakurta 1992, p. 244, fig. 56, where dated 1902).
4. Chughtai/Chughtai 1994. The paintings which the authors attribute to "Gaur Sahai" seem to originate from different hands.
5. Tara Chand/Kashmira Singh 1951, col. pl. titled *Gloomy Radha*. This painting somewhat relates to a Pahari painting, *Lady in Green*, reportedly signed by Gaur Sahai, cf. Chughtai/Chughtai 1994, col. pl. 4. The setting of this Pahari picture makes its appearance in *Usha*, cf. Tara Chand/Kashmira Singh 1951, col. pl. titled *Usha*. For a related painting in profile cf. also Sotheby's, October 8, 1996, lot 12.
6. Cousens in Siraj-ud-Din n.d., p. 9.
7. Siraj-ud-Din n.d., p. 20 on *The Earthen Bowl*.
8. Cf. e.g. *Chatterjee's Picture Albums* Number 5, col. pl. 1: *Kajri* by Abanindranath Tagore; col. pl. 5: In *Quest of the Beloved* by Samarendranath Gupta; col. pl. 6: *The Better Land* by M. Abdur Rahman Chughtai; col. pl. 11: *Watering the Tulasi Plant* by Abanindranath Tagore; col. pl. 12: *Radha Awakening from Her Swoon*, from an old [Pahari] painting; col. pl. 14: *Rabindranath Tagore (At the age of about 32)* by Abanindranath Tagore; col. pl. 15: *Krishna Holding up Mount Govardhan* by Molaram, to mention only some of the pictures reproduced in a single issue.
9. This letter was written from "TAGORE STUDIO," 5 Dwarkanath Tagore Lane, Calcutta. Abanindranath Tagore wrote: "Dear Mr. Chughtai / I am in receipt of your kind letter and the Copy of the Muraqqa-i-Chughtai. Accept My Sinceremost Congratulation + best Thanks for the rich gift which you have so kindly sent to me . . ." This letter is in the possession of Abdur Rahman Chughtai's son in Lahore. A Xerox of this letter was shown to me by Dr. William K. Ehrenfeld.'
10. S. Kashmira Singh in Tara Chand/Kashmira Singh 1951, pp. 12–13.

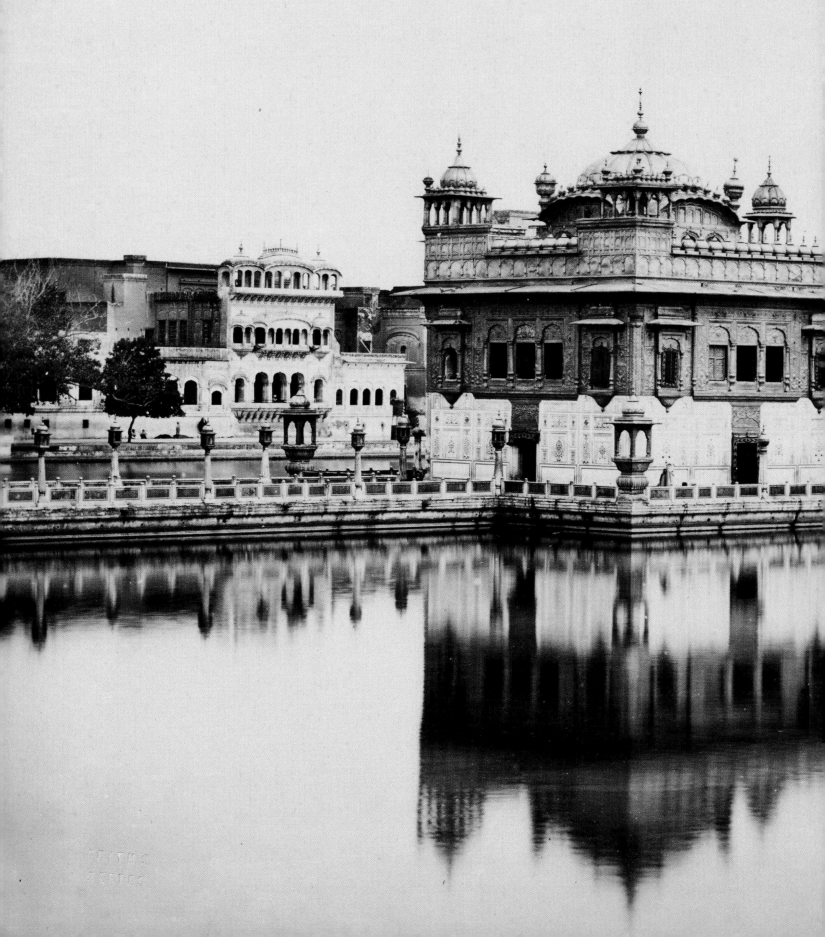

Tombs, Mosques, and Other Monuments

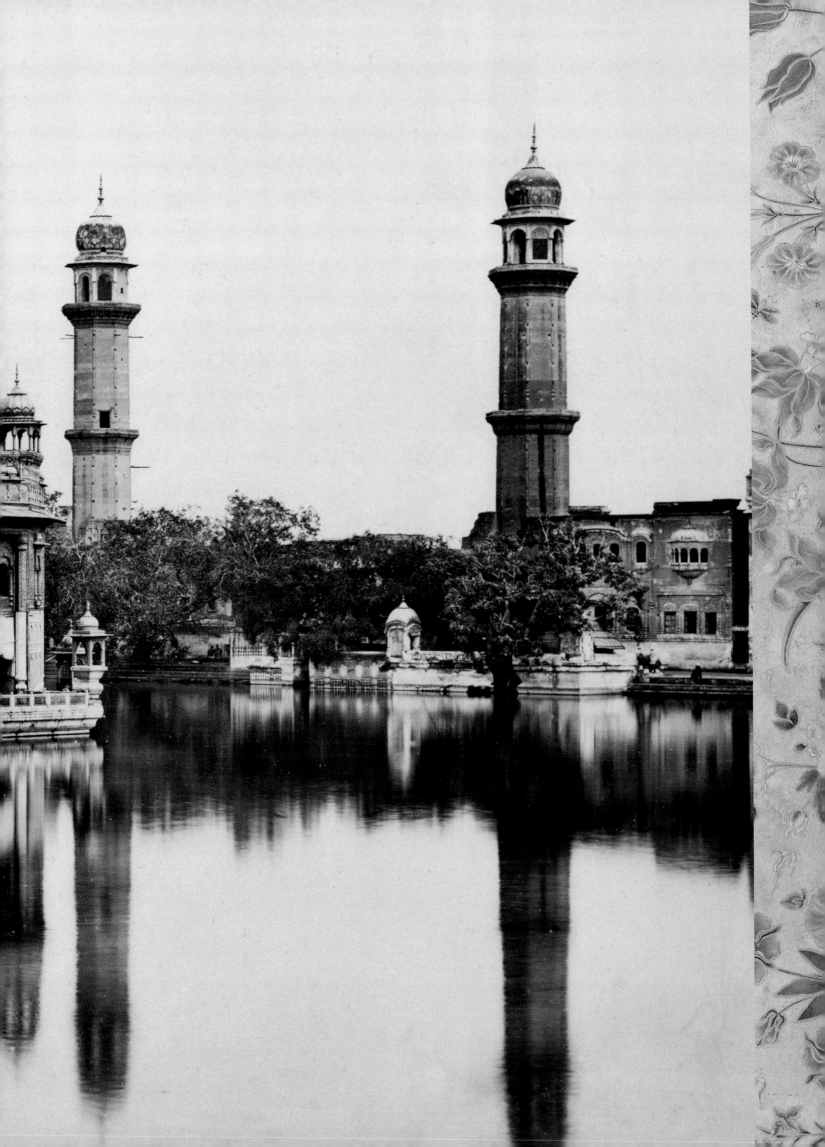

53 South View of the Taj Mahal at Agra

∾

by Thomas Daniell, R.A. (1749–1840) and William Daniell, R.A. (1769–1837), Agra-Lucknow, 1789.

Media: Watercolor on paper

Size: 17 ⅝ x 23 ¼ in. (44.8 x 59.1 cm.)

Inscribed: Below the painting, in pencil: "SOUTH VIEW OF THE TAJ MAHUL AT AGRA."

Pages 202–203. The "Golden Temple" in Amritsar. *Photographed ca. 1870.*

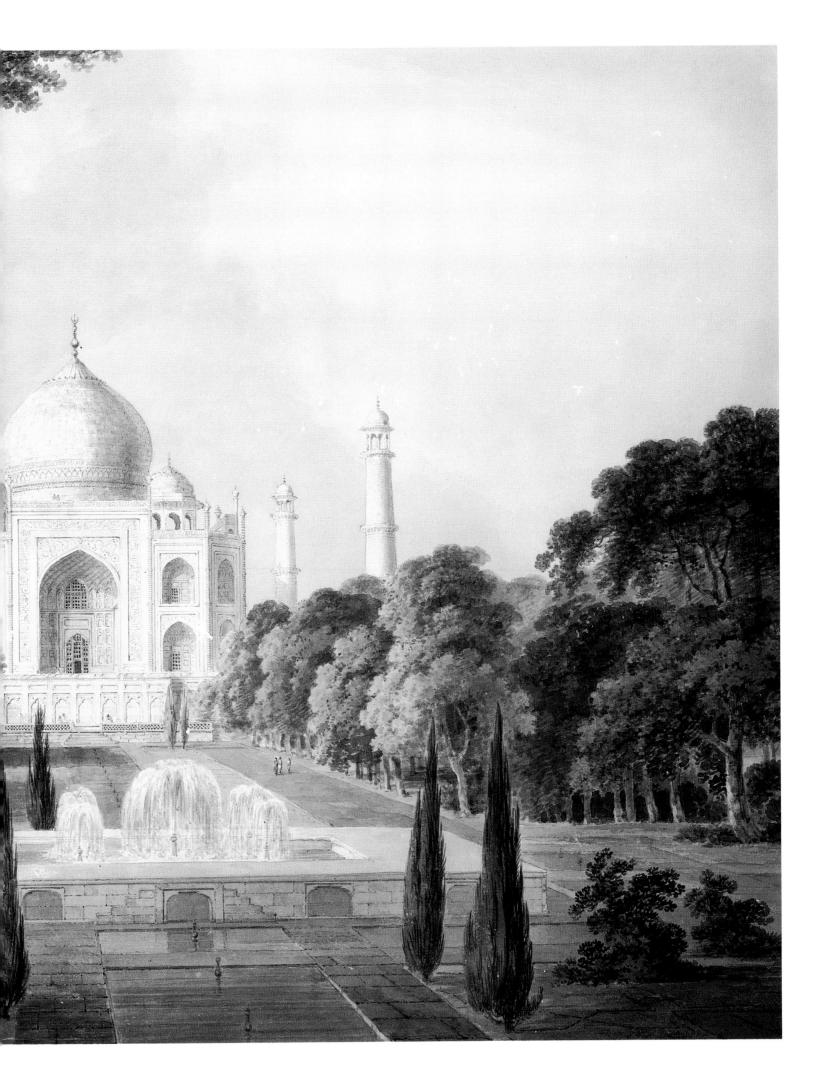

Crossed the Jumna ab[ou]t 7 o C[lock] & breakfasted with Major Palmer in one of the Mosques of the Tage. After breakfast we all visited the inside of the Tage & were much struck with its Magnificent Workmanship. We also went up to the top of one of the Minarets [from] where you command a very fine view of the country. (William Daniell, January 21, 1789)[1]

Spent the Whole Day at the Tage Mahl. Un[cle] [i.e. Thomas Daniell] drew the View from the Garden in the Camera [obscura]— myself employed on the inside. In the evening went upon the Dome. Both employed till 10 o'c washing our drawings. (William Daniell, January 22, 1789)[2]

Un[cle] finished the dead colouring of South View of the Tage Mahal... myself correcting the N.E. View of the Tage Mahal from my uncle's camera [obscura]. (William Daniell, August 27, 1789)[3]

Un[cle] dead coloured the View on a half length, Un[cle] and I sketched in yesterday, myself dead colouring the Tage Mahal. (William Daniell, August 29, 1789)[4]

The garden view of the Taje Mahel was taken immediately on entering it by the principal gate ... whence the Mausoleum, being seen down an avenue of trees, has on first entering a most impressive effect on the spectator. The large marble bason [sic] in the centre of the garden with fountains, and those rising out of the watery channel with paved walks on each side, add to the variety and richness of the scene, and give to it that coolness which is so luxurious an improvement to an Oriental garden. (Thomas and William Daniell, 1801)[5]

The first sight of the Taje is highly imposing; the edifice is constructed entirely of white marble, and, standing as it does upon a vast plain, under a vertical sun, the reflections are so vivid, that the shadows projected from the building are extremely faint, and therefore the less picturesque, if broad and massy effects, which I am disposed to doubt, are positively essential to the picturesque. I would remark here, that no one can form a just idea of an Oriental landscape, or of the peculiar effect of light and shade under a tropical sun, from a view in Europe. The forcible contrasts of light and shadow which are considered so attractive in the engravings made after the beautiful designs of our best living artists, will vainly be looked for in India. Nature there presents no such direct opposition; she throws one solemn tone of grandeur over the whole scene, except in the hilly country, where the aspect of her general features is entirely changed.

This splendid mausoleum, enclosing the remains of a sanguinary tyrant and his queen, is situated upon the banks of the Jumna, which flows majestically beneath its lofty minars; of these there are four: one at each corner of the quadrangle in which this incomparable structure stands. The quadrangle is one hundred and ninety yards square, and the dome which rises from the centre of the building is about seventy feet in diameter. The outer wall, within which this monumental pile is enclosed, is upwards of sixty feet high, and composed of plain red stone. In this wall there is a very unimposing gateway, through which the visitor passes to one composed of black and white marble, closed by a huge pair of brazen gates, and surmounted by several magnificent domes. Through this portal you enter the gardens, and here bursts at once upon the view, in all its unrivalled grandeur, an edifice perhaps altogether unparalleled among the works of human ingenuity. "Stretched upon an immense basement forty feet high and nine hundred in length, its prodigious mass of polished marble rises proudly over a river that not only adds to its majesty, but by reflection multiplies its splendour: in truth, exclusive of its magnitude, extent, and variety, whatever may be our architectural predilections, we are overwhelmed with its effect, and compelled to acknowledge it a most extraordinary assemblage of beauty and magnificence.

This incomparable structure has been often and variously described, but never yet has any adequate conception of it been conveyed. The principal dome was originally surmounted by a golden spire and crescent, which were stolen by the Mahrattas, and have been replaced by a substitute less attractive to those daring marauders, being now composed of baser metal gilt. This ornament rises thirty feet above the dome, forming an agreeable and striking contrast to the four stately pillars which, with a solemn but sublime grandeur, rear their polished shafts at the several corners of the quadrangle. They are composed entirely of white marble, and their spotless surfaces, reflecting the vivid rays of a tropical sun, but at the same time subduing their intensity, exhibit a sober stateliness of effect only to be felt and understood by those who have witnessed it. These minars

are about one hundred and fifty feet high, but considerably slighter than the Monument near London Bridge. The gardens which surround this marvellous work of art are beautifully laid out with plantations of vines and peach-trees, and from the centre of this terrestrial paradise rises in all its prodigious magnificence the mausoleum of Mumtâza Zemani, the once beautiful wife of the emperor, as that name implies. The ascent to it from the gardens is by a flight of solid marble steps, terminating in an extensive terrace. Crossing this terrace, you reach the door of the tomb, which is small and unimposing, presenting an humble contrast to the surrounding objects, as if to forewarn the visitor that he is about to enter the melancholy repository of the dead. ... A great many depredations have been committed on the Taje Mahal at different times by the predatory Mahrattas and the Jauts, who had possession of Agra for a considerable period. They removed the brazen gates of the city as well as the golden spire and other costly portions of the mausoleum. These have been in some measure, though very imperfectly, restored by the munificence of the East India Company, who, up to the year 1814, had expended above a lac of rupees, or twelve thousand pounds sterling, in effecting this object; but, as Mr. Hamilton truly says, "in India, owing to the nature and climate, the luxuriant vegetation, and other causes, undertakings of this sort may be described as never ending, still beginning. (The Oriental Annual 1834)[7]

The Tauje appears rising with imperial grandeur in the middle of gardens, ornamented with marble fountains, and laid out in extensive graperies, plantations of fruit trees, with flowers and shrubs, which exhale the most delightful odour, and were designed for the daily decoration of the tombs of Shah Jehan and his beloved spouse. On descending by marble steps into the gardens, at the distance of two hundred yards from the hall is a large square basin of marble, with jets d'eau at each corner. This was intended originally for a bathing-place, in which all visitors were to perform the purifying rite of ablution before they presumed to enter the sacred building. From thence there is a paved footway of broad stones, across which runs a canal for watering the garden, about one hundred feet long, and thirty wide, having a number of fountains down the middle. On either side of the walks is a row of limes, oranges and other scented fruit trees, between which and the walks are small octagonal parterres filled with balsams, framed with stone to prevent the water of the canal from running over. These walks afford a delightful noontide retreat to the inhabitants of Agra, and such occasional visitors as may be attracted by curiosity to view the wonders of this enchanting place. (William Thorn, 1803)[8]

After passing under its grand portal, a scene bursts at once upon the eye, which dazzles the senses, and wraps every other feeling in that of astonishment. The Taje appears embosomed in a mass of foliage of a deep green at the further extremity of a large and handsome garden, with its lofty and elegant minarets, and its dome of extreme beauty and airy lightness; the whole of the purest white marble, richly inlaid in patterns of the semiprecious stones, as cornelian, jasper, onyx, and a variety of others of all hues. A noble causeway of stone, raised considerably above the level of the garden, leads up to the main building, in the centre of which is a range of fountains, fifty in number; and midway a large basin, in which five other jets-d'eau of much greater height are thrown up. The garden is filled with trees of almost every kind common to India; some bearing fruits, others perfuming the air with the odoriferous scents of their blossoms. (C. R. Forrest as published in 1824)[9]

I went to see the celebrated Tage-mahal, of which it is enough to say that, after hearing its praises ever since I had been in India, its beauty rather exceeded than fell short of my expectations. There was much, indeed, which I was not prepared for. The surrounding garden, which as well as the Tage itself, is kept in excellent order by Government, with its marble fountains, beautiful cypresses and other trees, and profusion of flowering shrubs, contrasts very finely with the white marble of which the tomb itself is composed, and takes off, by partially concealing it, from that stiffness which belongs more or less to every highly finished building. ... (Reginald Heber, January 13, 1825)[10]

Visited the Taje, the cemetry of Shah Jehan and his favourite wife Noor Jehan (the light of the world)[11]. ... None but an imperfect account can be given of this building, for even those who have admired all that remains of Grecian or Roman art have not seen any thing by which a comparison could be instituted or a resemblance conveyed. It stands alone and unrivalled. Composed of white marble, and inlaid with various-coloured stones highly polished, it has the freshness of yesterday's erection. Seen at eight miles it looks large: on a nearer approach it loses this apparent magnitude, but its admirable symmetry and proportion are manifest. (Major Archer, January 8, 1828)[12]

In the evening we visited the far-famed Taj, a mausoleum erected by the great emperor Shah Jehan over the remains of his favourite and beautiful wife, Arjemund Banu, or, as she was surnamed, Muntâza Zemâni (the most exalted of the age). No description can convey an idea of the beauty and elegance of this monument of uxorious fondness. It is, I think, the only object in India that I had heard previously eulogised, in which I was not disappointed on actual inspection. Nothing can exceed the beauty and truth to nature of the borders of leaves and flowers inlaid in the white marble: the colours all have the delicacy of nuance, and more of brilliancy than could be given to the finest painting. . . . They [i.e. guides at the Taj] *show a small marble recess, in which the rhyming portion of the visitors of the Tâj record their extempore effusions in praise of the elegance of the building, the gallantry of the builder, and the beauty of its fair tenant; whilst others simply inform the world that they have visited this celebrated mausoleum by scrawling at full length an uncouth name and a date on its marble walls and pillars — a characteristic practice of English travellers . . .* (G. C. Mundy, January 8, 1828)[13]

I have hitherto refrained from making mention of the Tajh Mahal, the choicest of all the relics at Agra, from the feeling that the reader once made acquainted with it, even by the faint delineation of my pen, would have little admiration left for any of those places which I have already attempted to describe. On my reaching Agra, I was anxious first of all to visit this far-famed mausoleum, having heard its beauties and its wonders lauded to the skies, from the time of my first arrival in India; but, for the reason which has induced me to give it the last place in my sketch of Agra, let the traveller reserve it until he has visited all the other curiosities. So much had I heard, on all sides, of this extraordinary edifice, that I had fully prepared myself for a disappointment; but when I stood in presence of the noble pile, I could not help feeling that, had fifty times as much been said in its praise, and had it been but one-half as exquisite, I should have allowed that all these rhapsodies had fallen short of its real magnificence. It appears absurd to attempt a description of such a structure. I am fully sensible of my own utter inability to the task, but I fear this would be deemed an insufficient apology for passing over it.

This celebrated specimen of oriental architecture stands on the western bank of the Jumna, about half a mile below the fort, exalted above the water upon a high terrace of red sand-stone and granite. But I would recommend that a person visiting it for the first-time should not approach it by the water-side; let him rather take the old road leading from the fort, and, delaying only a few minutes at the beautiful gateway leading to the Tajh gardens (for day-light is too short for the enjoyment before him), let him advance onwards, without looking at the Tajh Mahal, until he arrives at the cruciform fountain-basin in the centre of the cypress grove, and there let him stand and gaze. I have had the curiosity to watch other visitors adopting this plan, and the invariable fact was, that the whole mind became absorbed in the object before them, and the silence of abstraction betokened their exceeding delight; while those who have wandered gazing in their approach upon all the other beautiful works with which the place abounds, may be heard uttering the usual exclamations of admiration, "How beautiful! How very exquisite! How grand! How solemn! How chaste!" Tush! they may talk till the millenium, they will never find words to indicate a tithe of the mingled emotions impressed upon the mind by the sight: this is not to be attributed to the circumstances of the building losing aught of its effect by a protracted inspection; on the contrary, every moment enhances the wonder and delight of the spectator, and whole days are inadequate to a full estimation of the work. It is not to be supposed that those who have not witnessed it can, with any degree of truth, picture to their minds an immense structure of pure white marble, richly carved and elaborately inlaid all over with gems and precious stones, in the most graceful devices, and most finely executed. The proportions of the building are perfectly enchanting, and it is the symmetry which charms, as much as it is the grandeur which astonishes, the spectator.

The edifice is built upon the plan of an octagon, having four of its opposite faces larger than the other four; in these, are arches of immense height, reaching nearly to the cordon of the building, and circularly faced, so as to form a niche, within which is a second arch opening to the interior. It is surmounted with a beautiful dome of vast proportions, in the centre, and four smaller ones overlooking the inferior faces. Around the body of the structure is a quadrangle arcaded terrace, forming the basement; this is also of white marble, and at each corner of it is a minaret of the same beautiful substance: these minarets are justly the admiration of all who have beheld them, so light, so chaste are they, and yet in such perfect accordance with the rest of the building, that they do not interfere with, but rather assist its effect. These delicate towers are built in three stories, the

Tombs, Mosques, and Other Monuments

uppermost of which is the highest; yet this singularity does not in any degree detract from their beauty, much as it is at variance with our established notions of proportion. The summits are crowned with open cupolas, particularly elegant, and here, as in all the rest of the building, the eye cannot rest on anything akin to a fault, or on that which gives merely cold content: the mind becomes altogether enwrapt in admiration and delight, intense as it is mysterious.

Below that already described, is a second terrace of red granite, as though the architect would have intimated that this exquisite piece of workmanship is too pure, too delicate, to stand upon the common earth. The summit of the centre dome is said to be two hundred and sixty feet in height, from the foundation of the lower terrace; and yet, from the perfect proportion of the fabric, it does not appear to be more than one-half that height. The whole is so finely finished, and in such complete repair, that it seems to have come but recently from the hands of the artist. Some French traveller (not Jacquemont, certainly) has remarked, that the Tajh Mahal is so very delicate, that it ought to have been preserved in a glass case. It was long since I had read this, but the idea recurred most forcibly to my mind on seeing the building. When we consider that the foundation was laid two hundred years since, it is indeed difficult to fancy how it can have been so perfectly preserved; it is to all appearance quite unfit for exposure, and yet it has scarcely a scratch or blemish upon the whole of it, except where a few of the gems were formerly broken out by the invading Maharhattas....

Until I was about to quit Agra, I had been so engrossed by the Tajh Mahal, that I devoted every spare moment to wandering about it; for it gains more strongly upon the admiration the more it is studied; and it is an universal remark with all persons who have seen it, that they have been more and more delighted on each successive visit. (Thomas Bacon, December 28, 1835)[14]

I asked my wife, when she had gone over it [i.e. the Taj Mahal], *what she thought of the building? "I cannot," said she, "tell you what I think, for I know not how to criticise such a building, but I can tell you what I feel. I would die to-morrow to have such another over me!" This is what many a lady has felt, no doubt.* (W. H. Sleeman, January 1, 1836)[15]

We came here yesterday and went off the same afternoon to see the Taj, which is quite beautiful, even more so, than we had expected after all we have heard, and as we have never heard of anything else, that just shows how entirely perfect it must be. You must have heard and read enough about it, so I spare you any more, but it really repays a great deal of the trouble of the journey. (Emily Eden, December 18, 1839)[16]

Came to the Taj Mahal; descriptions of this wonderfully lovely place are simply silly, as no words can describe it at all. What a garden! What flowers! ... Henceforth, let the inhabitants of the world be divided into two classes — them as has seen the Taj Mahal; and them as hasn't. (Edward Lear, February 16, 1874)[17]

The Taj forms but a small part of an earlier *View of the Fort of Agra, on the River Jumna*, taken by William Hodges in 1783 and published in 1786,[18] and there is a *West View of the Taj Mahal* by the amateur artist Thomas Longcroft, reportedly dated 1786,[19] but the Daniells' watercolor of the South View of the Taj Mahal is the oldest known individual depiction of this monument as seen from the garden by a professional Western artist. The Daniells made all the necessary drawings on the spot and did not entirely finish the coloring at Agra since we read that Thomas Daniell, when at Lucknow in August, "finished the dead colouring of South View of the Tage Mahal," undoubtedly the present watercolor. This watercolor is not only one of the earliest views of the monument by a Western professional artist, it is also the best known, although the present watercolor as such was probably never previously published. But the Daniells turned this watercolor into an aquatint engraving, which was published by Thomas Daniell in London in 1801 as plate 2 of their *Views of the Taje Mahel at the city of Agra in Hindoostan, taken in 1789*. It was then titled *The Taje Mahel, Agra*. Taken in the garden,[20] it has been reproduced a number of times since.[21] The first plate of that publication shows the Taj as seen across the river Yamuna.[22] It is based on another watercolor which recently appeared on the art market,[23] and of which two versions in oil[24] and one line-engraving[25] are known.

The monument left a lasting impression on William Hodges, who described its effect in 1786,[26] and in March 1775 it was minutely described by the Comte de Modave.[27] Neither author, however, left an individual, published illustration.[28] It was then Charles Ramus Forrest who, in 1824, not only published a description of the monument and its gardens — as quoted above — he also illustrated the "North View," although from a slightly different angle when compared to the similar view by the Daniells.[29] The "North View," which always had to include the river, was also favored by Emma Roberts, who described the monument in her *Views in India* of 1835,[30] by W. H. Sleeman, who reproduces three colored illustrations of the "North View" after native drawings,[31] and by Ida Pfeiffer.[32] Native drawings were also used for the "South Views" reproduced in full color and gold by Leopold von Orlich in 1845,[33] whereas some authors preferred the "West View," also after native drawings.[34] These examples may suffice to show, that the Daniells' depiction of the Taj is not only the earliest but also the largest published view of the structure.

The present "South View" was apparently so overwhelming that no other artist dared to publish a similar view for a long time. This may account for the fact that the present view is undoubtedly very picturesque, but is not flawless with regard to its architectural accuracy. The "large marble basin in the centre of the garden with fountains" has two flights of steps centrally situated at each centre, leading to the platform on which the two persons sit and five more persons stand, some of them with long spears. Each staircase consists of five steps, including the top one. The Daniells correctly depicted these two flights of five steps each in the center of the southern side of the "large marble basin in the centre"; they are even more clearly visible in the respective aquatint. These two flights of steps appear in the center of each side of the basin and are always marked by a central recess which is flanked by one flight of five steps on each side, i.e. in the north, east, south, and west. The spectator naturally only sees one side of the basin here, the southern. But instead of one central recess, the observer sees five evenly distributed niches. Four were hence added by the Daniells in the present watercolor and consequently also in the aquatint. Any modern photograph of the central marble basin reveals that there is only one central niche on each side. Were there, by the time the Daniells made their sketches, in fact five recesses at the southern side of the basin or were the additional four niches introduced by the Daniells to render the painting more "picturesque," as the Daniells did quite often? In order to render their "North View" more dramatic, the Daniells flooded the Taj Mahal with sunlight, although in January the sun's rays would not even touch the northern side of the Taj for a second, neither in the morning, nor in the evening.

The answer is quite simple. The watercolor shows that the Daniells have taken it from an elevated viewpoint, either from a kind of scaffolding or from the first floor of the main gate. Most probably the Daniells used the main gate, as did the photographer Samuel Bourne, some eighty years after the Daniells. Bourne's photograph, accompanying fig. 15,[35] demonstrates that the cypresses of the central avenue, running from north to south, cover the eastern and western parts of the central marble basin, leaving visible only the central part with the central recess and the two flights of steps. The Daniells must have had a similar view and when they started to "sketch in" the details in Lucknow, they remembered the strict symmetry of the lay-out and hence added four recesses at the basin in order to give it a convincing symmetrical effect, after they decided to depict the central marble basin in full. The complete view of the marble basin together with an almost undisturbed central view of the major monument in fact underlines the contrast of "wild" nature and "disciplined" architecture. The almost fully visible central basin with its fountains is the secret of the present painting. It inspired smaller sized Indian paintings, without, however, provoking the same effect.[36] Most "South Views" of the Taj done by Indian artists offer more symmetrical views and only show the central part of the marble basin, without playing fountains.[37]

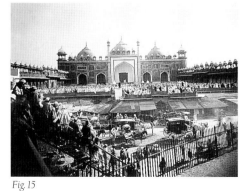

Fig. 15

TOMBS, MOSQUES, AND OTHER MONUMENTS

The Daniells' view hence remains unrivalled with regard to its composition and effect. Since the Taj stands at Agra and not at Edinburgh or Marseille, Western visitors found it difficult to accept its matchless beauty. In their view, the Taj could not have been designed by a native, and many of the writers quoted above vouch for a French architect: "This magnificent building and the palaces at Agra and Delhi [sic] were, I believe, designed by Austin de Bordeaux, a Frenchman of great talent and merit, in whose ability and integrity the Emperor placed much reliance."[38] This assumption was quoted verbatim by Fanny Parks in 1850,[39] and in 1872 we read: "The wonderful man whose creation the Taj is, was, it is believed, a Frenchman, by the name of Austin de Bordeaux, a man of great ability. The Emperor, who had unbounded confidence in his merit and integrity . . . He built the palace at Delhi and the palace at Agra, as well as the Taj."[40]

Leopold von Orlich thought that the architect was an Italian;[41] to Louis Deville, Austin de Bordeaux was either Italian or French, and his tomb was thought to be somewhere near the Taj.[42] Ida Pfeiffer was more careful: "Many ascribe it [i.e. the Taj Mahal] to Italian masters; but when it is seen that there are so many other admirable works of Mohamedan architecture, either the whole must be considered foreign or this must be admitted to be native." (January 1848)[43] William Russel noted: "It is said that the Taj must be of Italian construction because there are, it is stated, tombs in Agra of certain persons with Italian names, . . ."[44] and finally denied that the design of the Taj is Italian, after having looked in vain for the tomb of its Italian designer.

To some of the British, the Taj was not a tomb, but a kind of picnic-spot or "Disneyland." The Daniells had ascended one of the four minars, out of curiosity, and this became a kind of sport. Harriet Tytler, in recounting an incident of the late 1830s, remembered:

A sad tragedy took place when I was there a child. The Taj gardens used to be a great resort for picnics in those days. On one of these occasions, the whole station was there, when after lunch some of the officers and their wives proposed to run a race to the top of one of the beautiful white marble minarets. There was a poor young English woman, a Mrs. Monkton, a civilian's wife, who won the race and was so excited over it that she fell backwards over the very narrow parapet and was smashed into atoms. It was a terrible shock to all present.[45]

And Fanny Parks, in her more direct way, added:

[C]rowds of gaily-dressed and most picturesque natives were seen in all directions passing through the avenue of fine trees, and by the side of the fountains to the tomb: they added great beauty to the scene, whilst the eye of taste turned away pained and annoyed by the vile round hats and stiff attire of the European gentlemen, and the equally ugly bonnets and stiff and graceless dresses of the English ladies. Besides the mela at the end of Eed [Id], a small fair is held every Sunday evening beyond the gates; the fountains play, the band is sent down occasionally, and the people roam about the beautiful garden, in which some of the trees are very large and must be very ancient. (February 1, 1835)[46]

W. H. Sleeman openly protested:

I would, however, here enter my humble protests against the quadrille and tiffin parties, which are sometimes given to the European ladies and gentlemen of the station at this imperial tomb; drinking and dancing are, no doubt, very good things in their season, even in a hot climate, but they are sadly out of place in a sepulchre, and never fail to shock the good feelings of sober-minded people when given there. Good church music gives us great pleasure, without exciting us to dancing or drinking; the Taj does the same, at least to the sober-minded.[47]

To some of the British the Taj was to be kept in good repair: "Upon this famous building no less than three lacs of rupees (i.e. 300,000) have been expended since Agra came into our possession; and instead of despoiling the sacred repository of the dead of its remaining ornaments, the cracks produced in the tombs by the earthquake of 1803 have been filled

with silver," noted Major Thorn.[48] "The gardens are kept in fine order; the produce of fruit is very valuable. A great number of persons are in attendance upon, and in charge of, the tomb, the buildings, and the garden, on account of the Honourable Company, who also keep up the repairs of the Taj," wrote Fanny Parks,[49] and Leopold von Orlich reported that "Capitan Boileau spent 3000 rupies on the repair of some inlay work to the left of the main gate."[50] A street in Agra was named in his honor. Today, however, it is corrupted into "Balu Ganj" (Bear Street), the original name being forgotten.

To others of the British the Taj was just a kind of quarry for the production of paper-weights:

The Marquis of Hastings, when Governor-General of India, broke up one of the most beautiful of the marble baths of this palace [in the "Red Fort" of Agra] *to send home to George IV. of England, then Prince Regent; and the rest of the marble of the suite of apartments from which it had been taken, with all its exquisite fret-work and mosaic, was afterwards sold by auction, on account of our government, by order of the then Governor-General, Lord W. Bentinck. Had these things fetched the price expected, it is probable that the whole of the palace, and even the Taj itself, would have been pulled down, and sold in the same manner.[51] But long before the mutinies an enlightened Governor-General is said to have gravely proposed that we should pull down the Taj at Agra and sell the blocks of marble.* (William Howard Russel, June 8, 1858)[52]

The Western documentation of the most fascinating building in the world started with this watercolor. The Taj still stands, but, curiously enough, never formed the subject of a scientific and documentary monograph by the Archaeological Survey of India, or by any other institution or author.

NOTES

1. William Daniell's diary, quoted after Archer 1980, p. 66.
2. William Daniell's diary, quoted after Archer 1980, p. 66 and Rohatgi 1989, p. 50; "washing our drawing" means adding water-color washes.
3. William Daniell's diary, quoted after Shellim 1979, p. 13.
4. Ibid.
5. Thomas and William Daniell: *The Taje Mahal at Agra*, London: T. Bensley, Printer, 1801, quoted after Archer 1980, p. 67.
6. It is not said whether the eastern, western, or southern gateway leading to the "Jilau Khana" or courtyard, is meant.
7. William Caunter in *The Oriental Annual 1834*, pp. 193–198, describing a line engraving showing the Taj Mahal after a drawing by William Daniell. The text in great part relies on Thomas and William Daniell's descriptions. "Hamilton" is Walter Hamilton and the quotation is from the first *East India Gazetteer* of the same author.
8. Thorn 1818, p. 198.
9. Forrest 1824, pp. 187–188
10. Heber 1828, vol. I, p. 589.
11. For this frequently occurring error, see cat. no. 54, note 1.
12. Archer 1833, vol. I, pp. 69–70.
13. Mundy 1858, pp. 26–27.
14. Bacon 1837, vol. II, pp. 371–375, p. 382.
15. Sleeman 1844, vol. II, p. 32.
16. Eden 1937, p. 358.
17. Lear 1953, pp. 78–79.
18. William Hodges: *Select Views in India Drawn on the Spot*, London, 1785–88, pl. 15; reproduced: Godrej/Rohatgi 1989, col. pl. 13, facing p. 70; Mahajan 1988, p. 140 (col. version); Rohatgi 1989, p. 39, fig. 2; Christie's, May 25, 1995, p. 71, lot 118.
19. Boyé 1996, col. pl. p. 127.
20. Godrej/Rohatgi 1989, p. 150.
21. For more recent publications cf. Alexander 1987, col. cover-illus; Godrej/Rohatgi 1989, double-page illus. pp. 80–81, fig. 39; Archer 1980, col. pl. IV. (double page) and fig. 28; Rohatgi 1989, p. 49, fig. 10, col. pl.; Pal et al. 1989, p. 200, no. 210; Sotheby's N.Y., October 6, 1990, lot 76, to mention just a few.
22. Reproduced: Archer 1980, pp. 68–69, double-page pl., no. 29; Rohatgi 1989, col. pl., p. 46, no. 8.
23. Archer 1974, no. 5; Christie's, September 24, 1996, col. pl. p. 80, lot 49, now in the Lochner collection, Frankfurt.
24. For the version by Thomas Daniell, see Shellim 1979, p. 42, no. TD19. For the later version by William Daniell, see Shellim 1979, pp. 112–113, no. WD17 (= Mahajan 1988, pp. 140–141, col. pl.)
25. *The Oriental Annual 1834*, pl. 21, facing p. 195, based on a drawing by William Daniell.
26. William Hodges: *Select Views in India Drawn on the Spot*, London, 1785–88. For the quotation see Alexander 1987, p. 195. The same quotation, with a detailed description of the "South View" and other views of the Taj Mahal is also published in Hodges 1793, pp. 124–128.
27. Féderbe 1971, pp. 201–202.
28. Hodges's depictions of the Taj Mahal were only published more recently, cf. Bayly et al. 1990, p. 143, fig. 20 for a drawing and Mahajan 1988, col. pl. pp. 138–139, showing the north view in oils.
29. Forrest 1824, aquatint facing p. 187 (= Pal et al. 1989, p. 202, no. 213).
30. It is actually a "North-East View"; see Roberts/Elliot 1835, engraving facing p. 21 (= Mahajan 1988, p. 145). For the description cf. pp. 22–25. The view was originally sketched by Robert Elliot.
31. Cf. Sleeman 1844, vol. II, pls. 2–4. For his detailed description cf. vol. II, pp. 28–35.
32. Pfeiffer n.d., illus. facing p. 179: *The Taj-Mehal*.
33. Orlich 1845, pl. facing p. 178 with too high a terrace on which the Taj and the two flanking buildings stand, and the plate facing p. 182, omitting all the trees of the garden, as in the plate reproduced facing p. 178.
34. Sleeman 1844, vol. II, col. pl. 1, facing p. 28; Parks 1975, illus. facing p. 348, after Sheikh Latif; Jancigny/Raymond 1845, planche 51, drawn by "Gaucherel" but certainly based on a native work.
35. Samuel Bourne, Bourne and Shepherd cat. no. 1075. For an earlier Taj-photograph (paper negative) taken by John Murray from the same monument on January 30, 1854, see Welch 1985, p. 454, fig. 8 (= Christie's, June 5, 1996, p. 186, lot 288). This negative is now in the Lochner collection, Frankfurt.
36. Christie's, June 5, 1996, p. 37, lot 41, col.; Archer 1992, p. 145, no. 124 (19). The additional niches at the marble basin are there, but number only two in addition to the central niche.
37. Cf. *Maggs Bull.* no. 31, 1979, pl. V, bottom, no. 10 [not 11, as stated in the catalogue]; *Maggs Bull.* no. 37, pl. X, no. 29; Christie's, May 25, 1996, p. 17, bottom, lot 5 [this painting is now in the Lochner Collection, Frankfurt].
38. Sleeman 1844, vol. II, p. 34.
39. Parks 1975, vol. I, p. 358.
40. Butler 1872, p. 148. Butler visited India in 1858.
41. Orlich 1845, p. 182.
42. Deville 1860, p. 219. Deville travelled in India in 1853.
43. Pfeiffer n.d., p. 179.
44. Russel 1860, vol. II, p. 265.
45. Tytler 1986, pp. 12–13.
46. Parks 1975, vol. I, p. 353.
47. Sleeman 1844, vol. II, pp. 37–38.
48. Thorn 1818, p. 209.
49. Parks 1975, vol. I, p. 353
50. Orlich 1845, p. 183.
51. Sleeman 1844, vol. II, p. 37.
52. Russel 1860, vol. II, p. 73.

54 The Cenotaph Chamber and the Marble Screen Enclosing the Cenotaphs of Mumtaz Mahal (1593–1631) and Shah Jahan (1592–1666) in the Taj Mahal Facing North

∾

Agra(?), ca. 1830.

Media: Gouache on paper

Size: 23³/₁₆ x 17³/₄ in.
(58.9 x 45.1 cm.)

Published: Pal et al. 1989, p. 64, no. 52.

Provenance: Gary Crawford

Numerous contemporary European descriptions of this part of the Taj Mahal in Agra exist. Some of the more relevant include:

The Tage contains, as usual, a central hall about as large as the Ratcliffe library, in which, enclosed within a carved screen of elaborate tracery, are the tombs of the Begum Noor-jehan, Shahjehan's beloved wife,[1] to whom it was erected, and by her side, but a little raised above her, of the unfortunate Emperor himself. Round this hall are a number of smaller apartments, corridors, &c. and the windows are carved in lattices of the same white marble with the rest of the building, and the screen. The pavement is in alternate squares of white and, what is called in Europe, sienna marble, the walls, screens, and tombs are covered with flowers and inscriptions, executed in beautiful Mosaic of cornelians, lapis-lazuli, and jasper; and yet though every thing is finished like an ornament for a drawing-room chimney-piece, the general effect produced is rather solemn and impressive than gaudy. (January 13, 1825)[2]

Upon entering this costly receptacle of regal dust, which was thought too peerless to mix with vulgar clay, reflections on the vanity of all earthly grandeur almost instantly absorb the mind, in spite of the splendours that everywhere attract and dazzle the astonished beholder. In the centre of the mausoleum stand the tombs of the founder and his empress, the one celebrated for his tyranny, the other no less celebrated for her beauty. They are both enclosed by a screen of exquisite workmanship, formerly composed of jasper but now of marble, the more costly material having been pillaged by the Mahrattas.[3] On the right is the tomb of the empress [when seen from north to south, as in the present case], *for the especial reception of whose body this remarkable edifice was erected, and on the left that of the emperor. They are both covered with tracery and mosaic most elaborately wrought, and the shades and colours of the flowers, which are represented in almost endless profusion by different kinds of the inferior gems, are so true to nature that the eye is completely imposed upon by the resemblance. So minute and elaborate are some of the ornaments that the mosaic of a single flower is frequently composed of several dozen pieces of coloured stones. The astonishment which this wonderful production of art excites is acknowledgement by every visitor. I have never met with a person who had seen the Taje, that has not admitted how very far it transcended the expectations that had been formed of it, however highly these may have been previously raised.* (William Daniell in 1833 when remembering his visit to the Taj in January 1789)[4]

The first glance on entering [the cenotaph chamber] *is imposing in the extreme: the dim religious light, the solemn echoes,—at first I imagined that priests in the chambers above were offering up prayers for the soul of the departed, and the echo was the murmur of the requiem. When many persons spoke together it was like thunder,—such a volume of powerful sounds; the natives compare it to the roar of many elephants. "Whatever you say to a dome it says to you again." A prayer repeated over the tomb is echoed and re-echoed above like the peal of an organ, or the distant and solemn chant in a cathedral. On the death of Shahjahan, his grandson Alumgeer[5] placed his cenotaph in the Taj, on the right hand* [of Mumtaz Mahal, when seen from south to north], *and close to that of Arzumund Banoo* [i.e. Mumtaz Mahal]; *this is rather a disfigurement, as the building was intended alone for the Lady of the Taj, whose cenotaph rests in the centre. Formerly, a screen of silver and gold surrounded it. But when Alumgeer erected the tomb of Shahjahan by the side of that of the Sultana, he removed the screen of gold and silver, and replaced it by an octagonal marble screen, which occupies about half the diameter of the building, and encloses the tombs. The open fretwork and mosaic of this screen are most beautiful: each side is divided into three panels, pierced and carved with a delicacy equal to the finest carving in ivory; and bordered with wreaths of flowers inlaid, of agate, bloodstone, cornelian, and every variety of pebble. I had the curiosity to count the number contained in one of the flowers, and found there were seventy-two; there are fifty flowers of the same pattern. The cenotaphs themselves are inlaid in the same manner; I never saw anything so elegant; the tombs, to be properly appreciated, must be seen, as all the native drawings make them exceedingly gaudy, which they are not. The inscriptions on both are of black marble inlaid on white, ornamented with mosaic flowers of precious stones.* (Fanny Parks in January 1835)[6]

The sarcophagus just described is enclosed within a screen, which many people admire more than all the rest; for not only is it equally finely inlaid, but it is carved into the most delicate lattice work [The accompanying fig. 16a.[7] represents one side, the tomb itself being visible through the arched doorway.] *The second moulding above the arch is in bold relief, and is inlaid with a brilliant stone of gold*

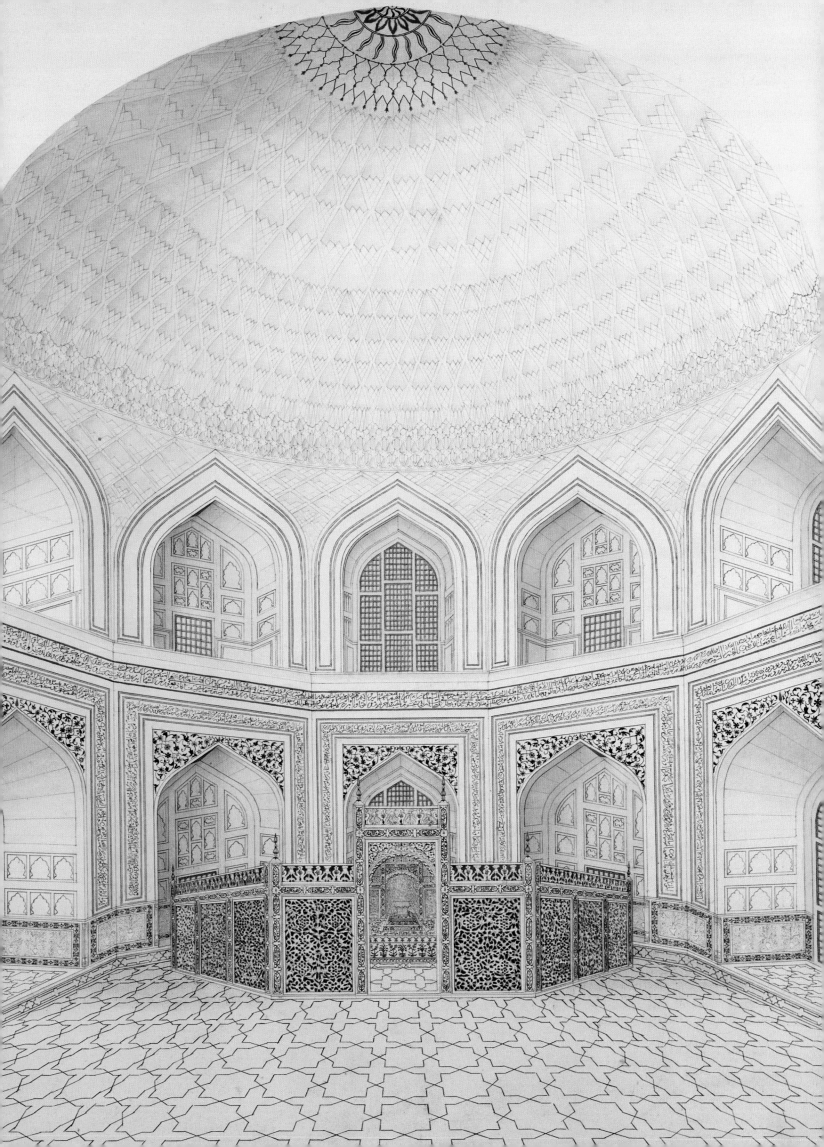

Fig. 16a.

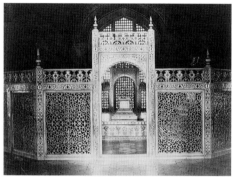

Fig. 16b.

colour, of great price, and very rare, being esteemed, therefore, the emblem of royalty. The space within this screen is somewhat encumbered with a second tomb-stone, that of the Emperor Shah Jahan himself, placed beside the former, a position it was evidently never intended to occupy in the original design of the building, it being placed over the rich mosaic borders of the pavement. Above, below, and around, wherever the eye can rest, is wrought in the same wonderful manner, and that which is really looked upon, strikes the imagination as far beyond the ingenuity or accomplishment of mere mortals: magic, or something superhuman, appears at once to claim the work; ... But, ... it is not the nicety of the handiwork, or the richness and beauty of the materials, which constitute its chief attraction; there is an air of grand and sublime majesty in the whole design, which irresistibly impresses the mind of the spectator with awe and veneration; and the effect of this becomes intensely heightened by the solemn of the place, and the supernatural reverberations which echo to the gentlest stir. So wonderfully do the vibrations multiply, that the slightest whisper, or the fall of the unshod foot, is carried in expanding eddies higher and higher, until the whole edifice is filled with a confused, but most imposing and supernatural music. There is another casual circumstance, which very greatly enhances the thrill of these sensations; while a tropical sun is smiting with its vertical rays upon the glaring white without, so as almost to inflict blindness, yet the moment the person is placed within this sacred mausoleum, a sudden chill is shed through the system; and, blinded at first by the sudden transition from scorching light to comparative though only partial darkness, it is only by a slow process, almost magical in its effect, that all the grandeur of the interior is gradually developed to the eye. All this must be seen and felt, again and again, before the mind is able to endure, without a painful sensation of its own inadequate powers, the train of combined emotions with which it is assailed.... (Thomas Bacon in late December 1835)[8].

Softly as you enter this upper part [i.e. the cenotaph chamber], *or your own voice will stun you; ... The effect of this echo is very beautiful when not excited too much; some soft notes of the voice, or a musical instrument are prolonged with reverberations, and indistinct sweet sounds for several minutes; a very pleasing effect is obtained by fastening a small musical box on a pole and elevating it up the dome; but a lady's voice is, perhaps, the most beautiful way of invoking the gentle murmurs of the angels supposed to inhabit the vault above; from this vault hangs, or used to hang, an ostrich egg on a golden cord, with a button of some precious stone; this is intended for the representation of the world floating about in the immensity of space ...* (from one of the earliest guide-books on the Taj, the first edition of which appeared in 1854)[9]

The artist of this watercolor—and all his colleagues—created a visual record of the central chamber of the Taj Mahal, which only an artist can paint. The painting gives a certain impression of space in using a strong foreshortening to the extreme (see accompanying fig. 16a.). This space, however, is actually not available. Already in 1862 we read in the preface to a second edition of a guide-book on the monument: "This little book may also be used as an accompaniment to those magnificent views of the Taj, which are now placed within reach of every one by the beautiful Art of Photography,"[10] and Fanny Parks also advised not to consider relevant "native drawings." Any photographic attempt to record this part of the centermost room of the monument, however, utterly failed and continued to fail, as is shown by the accompanying fig. 16b., a late nineteenth-century photograph of the same location.[11] Whenever the photographer tries to include more of the space above the screen in his photographs, the vertical lines start to diverge enormously as can even be demonstrated by published photographs from the early twentieth century.[12] It seems that even modern photography has not mastered this problem to satisfaction.[13] Another problem is the light. Fig. 16b. was taken in daylight. The entrance to the two cenotaphs—already used by Emily Eden for her *Portraits of the Princes and People of India*[14]—appears too bright, whereas the space behind is drowned in darkness. In order to achieve something near the result of the artist of the present watercolor, a photographer would greatly depend on artificial light.[15]

The artist has enlarged the floor tiles in order to escape the embarrassment of being inaccurate when it comes to the foreshortened depiction of the same. Furthermore, the size of the ornamentation of the center of the inner cupola, viz. the one visible in the watercolor, is slightly exaggerated and all the inlaid inscriptions are greatly simplified.[16] But on the whole, the artist of this painting has achieved what no photographer could: an appropriate

and early depiction of the central room of the probably most famous and most often depicted monument in the world. The artists concentrated mostly on the lower part of the cenotaph chamber with the marble screen and cared but little for the depiction of the dome above.[17] That the present painting should also be considered as the most detailed depiction of this space can be demonstrated by comparison with published drawings of the same premises.[18]

NOTES

1. Heber confused the wife of Shah Jahan with the wife of Shah Jahan's father and predecessor, Jahangir. Nur Jahan (1577–1645) (whose second marriage took place in 1611) was the wife of the latter, and Mumtaz Mahal the second wife of the former. Also, Bacon mistook Arjumand Banu Begam alias Mumtaz Mahal for "Neur Jehan," cf. Bacon 1837, vol. II, p. 376. This confusion occurred quite frequently and Fanny Parks already commented: "Noorjahan was the sister of the Vizier Asaf-jah, and aunt to the lady of the Taj. Many people, seeing the beauty of the building, confuse the two persons, and bestow in their imaginations the beauty of the aunt on the niece." (Parks 1975, vol. I, p. 351). For Nur Jahan see Findly 1993.

2. Heber 1828, vol. I, p. 589.

3. This is not correct. William Daniell possibly alludes to the golden railing which was replaced by the present marble screen during the time of Shah Jahan's reign in 1643 at the cost of 50,000 rupees. For details see Begley/Desai 1989, p. 73.

4. *Oriental Annual 1834*, pp. 196–197.

5. "Alumgeer" was in fact Shah Jahan's third son, who ruled from 1658–1707 under the name of Muhy-as-Din Abu'l-Muzaffar Muhammad Aurangzeb 'Alamgir. He was born in 1618. "If the European sources are generally unreliable in their descriptions of the Taj, their accounts and interpretations of people and events are even more suspect." Begley/Desai 1989, p.1.

6. Parks 1975, p. 350 and p. 349f.

7. Bacon's reproduction was taken from what would be called a "native drawing," of which Bacon made "fac-similes" (Bacon 1837, vol. II, p. 376). For Bacon's reproduction and similar ones, which on the whole capture the space shown in the accompanying fig. 16, see note 17. below.

8 Bacon 1837, vol. II, pp. 377–379.

9. N. 1862, pp. 10–11. The accoustic effect of the dome of the Taj Mahal can best be heard on a recording done with the flutist Paul Horn, made on April 25, 1968, available on CD. The egg mentioned strongly reminds of the "Brahma egg" of Hinduism.

10. N. 1862, unpaginated preface.

11. For similar published late nineteenth- early twentieth-century photographs, see e.g. Hesse-Wartegg 1906, illus. p. 217; Bongard 1911, illus. p. 95; Mirza n. d., pl. no. 4; Priya Lall 1911, p. 15, no. 15.

12. Cf. Priya Lall 1911, p. 14, no. 14.

13. Cf. Begley/Desai 1989, p. 100, pl. 38.

14. Eden 1844, title page with the Son of the Nawaub of Banda in the center.

15. For what could probably be called the best published color photographs of this part of the Taj Mahal see Nou/Okada 1993, pp. 39–98.

16. For depictions and translations of these inscriptions, see Begley/Desai 1989, pp. 186–187, p. 189, pp. 192–193, pp. 214–215.

17. Bacon 1837, vol. II, engraving facing p. 377, numbered "No. 3"; Sleeman 1844, vol. II, col. pl. 5, to face p. 28 (but sometimes actually facing p. 30); Latif 1896, woodcut facing p. 112. Bignold 1950, pl. IV; Archer 1968, pl. 26, pp. 40–41; *Maggs Bull.*, no. 23, March 1975, no. 175, reproduced on p. 136; Christie's, May 25, 1955, lot 7, p. 18 col. Cf. also *Side View of the Cenotaph* of the Latif album, cat. no. 55

18. Cf. Bignold 1950, pl. III; Archer 1968, pl. 25, p. 38; *Maggs Bull.*, no. 22, March 1974, no. 100, reproduced on p. 78; Patnaik/Welch 1985, p. 178, no. 84; Head 1991, p. 149, no. 058.004, contrary to the editor's note attached to this catalogue entry, we have to state that the caption ("An inside view ... at Akbarabad") is absolutely correct; Archer 1992, col. pl. p. 143, no. 122(6). Another version exists by Sita Ram, which is listed in Sotheby & Co., July 9, 1974, lot 263, no. 14 *(Interior of the Taj)* [= *Maggs Bull.*, no. 25, May 1975, no. 69, p. 61]; a reproduction of this painting has apparently never been published.

55 The Cenotaph of the Emperor Shahjehan Facing West

∾

by Sheikh Latif (fl. 1803–1835), Agra, ca. 1830.

Media: Gouache on paper

Size: 11³/₄ x 18³/₄ in. (29.7 x 47.6 cm.)

Inscribed: Numbered "21" in upper left corner of the painting, within inner black rule.

Provenance: Robert Home (1752–1834), Thomas Holbein[?] Hendley (1847–?)

The cenotaph of Shah Jahan (1592–1666, r. 1628–1658) is less often described and reproduced than that of his second wife Mumtaz Mahal (1593–1631) for whom initially the Taj was built. Shah Jahan's cenotaph is to the west of the centrally situated cenotaph of Mumtaz Mahal; (for the situation within the building see cat. no. 54). Some descriptions about the period of execution of the present watercolor are noteworthy:

Upon that [i.e. the cenotaph] *of the Queen* [i.e. Mumtaz Mahal], *amid wreaths of flowers, are worked in black letters passages from the Koran;... On the slab over her husband, there are no passages from the Koran; merely mosaic work of flowers, with his name, and the date of his death.¹ I asked some of the learned Mahomedan attendants, the cause of the difference; and was told, that Shah Jahan had himself designed the slab over his wife, and saw no harm in inscribing the words of God upon it; but that the slab over himself was designed by his more pious son, Ourungzebe, who did not think it right to place these holy words upon a stone which the foot of man might some day touch, though that stone covered the remains of his own father. Such was this "man of prayers" ... to the last.* (William Sleeman on January 1, 1836)²

But the richest work of all is on the cenotaph of the Empress within the screen. Upon her tomb — according to universal Mohammedan usage — is a slate or tablet of marble, while on the Emperor's is a small box representing a penholder. These always distinguish a man's or a woman's grave among these people; the idea being that a woman's heart is a tablet on which lordly man can write whatever pleases him best. And this mark of feminine inferiority was not spared even the beloved occupant of the Taj Mahal.... The Emperor's tomb is plainer than the other, has no passages from the Koran, but merely a similar mosaic work of flowers, and his name, with the date of his death, upon it. (Rev. William Butler ca. late 1857)³

The "penholder" quoted by Butler is the small device on top of Shah Jahan's cenotaph, clearly visible in the watercolor. It is called *qalamdan* and was actually a varnished, oblong case for holding pens and ink, worn in the girdle as the insignia of civil office. A view from the top of this *qalamdan*, as painted by Sheikh Latif and belonging to the same album, is reproduced here in accompanying fig. 17 and is numbered 28 in the list given below. The present painting belongs to an album of watercolors, of which the full contents as they appear on the title page of the album are listed below:

List of Drawings for Mr. Home executed by Sheikh Luteef at Agra

1	Ground plan of the Taje
2	Section of D°
3	North view of D°
4	South-west view of D°
5	Gateway leading to D°
6 & 7	Wainscoating of carved work round the interior
8	Screen round the cenotaph
9–13	Flowers on the framework of the screen—outside
14–15	D° D° D° inside
18	Carved ornament round the top of the screen with the flowers on the outside
19	Flower inside
20	Spire on the angles of the screen
21	Cenotaph of the Emperor Shahjehan
22 & 23	Flowers and borders around the *chubootra* / or pedestal / of D°
24	Surface of *chubootra*
25	Ornaments on the mouldings of the cenotaph
26	Flowers around D° between A & B
27	Top of the cenotaph/denotes the cenotaph
28	Kullumdan / or, inkstand on the top of D° of a male
29	Cenotaph of the empress, entitled Moomtaz Muhul
30	Borders around the sides of the *chubootra*
31	Flowers between the above two borders
32	Surface of the *chubootra*
33	Top of empress's cenotaph
34	Mausoleum of Yatmad-oo-Dowlah, father of Noor Jehan
35	D° of Emperor Akbur at Secundra
36	Gateway leading to D°
37	Interior view of the upper story of the mausoleum, including cenotaph
38	The Cenotaph
39	Eastern View of the Fort of Agra
40	Delhi Gate of D°
41	Motee Musjid in the Fort
42	Gateway of the Durgah/or Shrine/of Saint Suleem Cheestee
43	Tomb of Suleem Cheestee at Futtehpoor Sikree
44	Jumma Musjid at Delhi

Fig. 17

The numbers indicate the watercolors, not the page numbers. The present page, along with the covers and a few drawings from this album, is in the Ehrenfeld collection. A note in faded ink on a paper-label on the inside of one of the covers reads: "The Mr. Home for whom this book was painted was the author of 'Views in Mysore', published in 1794." This is the same "Mr. Home" who painted the following cat. nos. 56 and 64 a. & b. Another label calls the album "1 large book (engravings)," and mentions the name "Mr. Hendley." It has already been suggested that this was Thomas Holbein Hendley.[4] Hendley was residency surgeon in Jaipur until 1897 and published a good number of illustrated books on Indian art and industry, particularly painting. It might have been this very Latif-album which aroused Samuel Swinton Jacob's interest in architectural drawings of Indian monuments which resulted in his monumental publication *Jeypore Portfolio of Architectural Details*, published in six large portfolios in 1890. Many of these drawings published therein are in fact by native artists, led by "Lala Ram Baksh, head draftsman and teacher in the Jeypore School of Art."[5] Jacob was chief engineer of the Jaipur state when Hendley served there as surgeon, and both of them published the richly illustrated *Jeypore Enamels* in 1886. It is not clear how the album passed from Home to Jaipur, where it was picked up by Hendley. It might have passed in the same way as a (now lost?) Lucknow painting of Asaf-ud-Daula, of which the Jaipur copy is introduced here under cat. no. 11.

Robert Home, it should be remembered, spent quite a few years at the court of Lucknow. That Latif in fact worked at Agra is corroborated by Fanny Parks, who not only mentions him in her diary, but who also publishes at least two of his drawings, which were probably also present in this album by Latif.[6] With regard to Latif's drawing of the Taj facing west that she reproduces, Parks remarked in early January, 1835: "The outline of the Taj, that I have annexed, was executed by Luteef, a native artist of Agra. It merely gives a faint idea of the style of architecture; the beauty of the tomb, the handsome buildings that appertain to it, the marble courts, the fine garden, the fountains, the beautiful trees, the river Jumna,—all are omitted, the mere elevation is represented in the sketch."[7] Parks accuses Latif of not having taken into consideration the fountains, the Jumna , etc. It seems that Mrs. Parks never realized that Latif's drawing shows the Taj facing west, in which case none of those elements of the architecture that Parks mentions as "omitted" can be included. Furthermore, Parks's remark about the character of "native drawings" with regard to the cenotaphs in the Taj, quoted in full in the text to cat. no. 54 ("native drawings make them [the cenotaphs] exceedingly gaudy, which they are not") is not sustained by the present cat. no. 55. The second drawing by Latif which Parks reproducesd shows the tomb of Akbar in Sikandra. This she described as follows: "The sketch annexed was taken by Luteef, a native artist at Agra; it merely gives the outline of the building," and, "The tomb is seen as represented by Luteef, of Agra, in his sketch of the golden chamber, but not quite so distinctly." [8]

Latif's work was finally praised by Parks when she described the tomb of Colonel Hessing:[9]

This beautiful Mausoleum is in the Catholic burial ground at Agra, and well worthy a visit. It was built by a native architect, by name Luteef, in imitation of the ancient Muhammadan tombs. The material is the red stone from Fathipoor Sicri, which is highly carved, but not inlaid. The tomb is beautiful, very beautiful, and in excellent taste. Its cost is estimated at about one lakh of rupees. Luteef's drawings of the Taj and of all the ancient monuments around Agra are excellent; they cost from three to forty rupees each. I bought a large collection of them, as well as of marbles and other curiosities. Luteef inlays marble with precious stones, after the style of the Taj. (March 15, 1835)[10]

Since Latif not only painted the inlaid stones in the Taj but also knew how to inlay them, it can be surmised that his watercolors of the inlay work are more than accurate; and since Latif died in 1803, we may conclude that Hessing was active at least between that year and 1835, when Parks met him. A comparison of this watercolor with other paintings showing the same view of Shah Jahan's cenotaph demonstrates that Latif in fact was the most accurate painter.[11] Seventeen watercolors in the collection of the India Office Library and Records, London, are inscribed in Persian characters as "'amal i Latif"—work of Latif. The drawings show the Taj Mahal with details and further Islamic monuments of Agra, Fatehpur Sikri, Sikandra, and Delhi, of which, unfortunately, only one has been reproduced.[12] The album which contains these drawings formerly belonged to John Bax, who acquired it in India probably between 1821 and 1822. In 1824, Bax gave it to the East India Company.[13]

NOTES

1. The inscription on the lower moulding, south end or foot, reads: "This is the sacred grave of His Most Exalted Majesty, Firdaus Ashyani ('Dweller in Paradise'), the Second Sahib Qiran, Shah Jahan, Padshah Ghazi; may it ever flourish! The year 1076" [1666 A.D.]. Begley/Desai 1989, p. 193. Latif confounded the inscription on Shah Jahan's tomb in the crypt below the central room with the inscription on the cenotaph. We quote here his translation: "The sacred sepulchre of His most exalted Majesty, dweller of paradise, the second lord of constellation, the King Shah Jahan, may his mausoleum ever flourish, 1076 A. H." Latif 1896, p. 112. A third translation gives more information but is apparently less correct: "The illuminated sepulchre and sacred resting place of His Most Exalted Majesty, dignified as Razwan (The guardian of Paradise), having his abode in Paradise and his dwelling in the starry heaven —Dweller in the region of bliss— the second Lord of the Constellation, Shah Jahan The King Valiant - May his Mausoleum ever flourish and may his abode be in the heavens — He travelled from this transitory world to the world of Eternity on the night of the 28th of the month of Rajab 1076 A.H.," see Bignold 1950, text to pl. XII.

2. Sleeman 1844, vol. II, p. 30f.

3. Butler 1872, p. 138f.

4. Ehnbom 1985, p. 174.

5. Jacob 1890, Part I, preface.

6. Illus. facing p. 348 in Parks 1975, vol. I, titled: *The Taj Mehul*, and col. illus. facing p. 374 in Parks 1975, vol. I, titled: *The Tomb of Akbar Shah*. This probably corresponds to watercolor no. 35 of the present Latif album. Another drawing which we assume is originally also by Latif is the illus. entitled *Ground Plan of the Tomb of the Taj*, which closely resembles watercolor no. 1 of the Latif album, still in Dr. William K. Ehrenfeld's collection. Parks does not mention the authorship of this drawing, but remarks: "The ground plan annexed I copied from an original plan, shown to me at the tomb."(Parks 1975, vol. I, p. 357). The following watercolors of this Latif album were published (in the order of the sequence suggested by the numbers of the title/contents-page): 7.: Pal et al. 1989, p. 65, no. 55, col. 10., 11., 12., Ehnbom 1985, no. 82, p. 175, col.[= Pal et al. 1989, p. 65, no. 53, presently in a German collection]; 18.: Ehnbom 1985, p. 175, no. 83, col. 22: Dalrymple 1996, no. 14, col. 23: Dalrymple 1996, no. 15, col.; 25.: Sotheby's N.Y., October 6, 1990, lot 61; 41 : Pal et al. 1989, p. 83, no. 74; 44: *Octagon* vol. XXII, no. 2, June 1985, p. 20, col.

7. Parks 1975, vol. I, p. 349.

8. Both quotations from Parks 1975, vol. I, p. 375.

9. John Hessing, a Dutchman, born in 1740, came to India in 1764 and became commander of the Fort of Agra in 1800. He died there in 1803. For an earlier photograph and description, see Priya Lall 1911, chap. III, p. 19, no. 225.

10. Parks 1975, vol. I, p. 418.

11. Jancigny/Raymond 1845, planche 32; Bignold 1950, pl. XII; Archer 1968, pp. 42–43, pl. 27; Archer 1992, p. 138, no. 111(6), col.; Christie's, May 25, 1995, p. 19, lot 8, col.

12. Archer 1972, no. 142, i-xvii. Reproduced is no. vii, *Interior of the Private Hall of Audience at Agra*, pl. 65

13. Archer 1972, p. 182

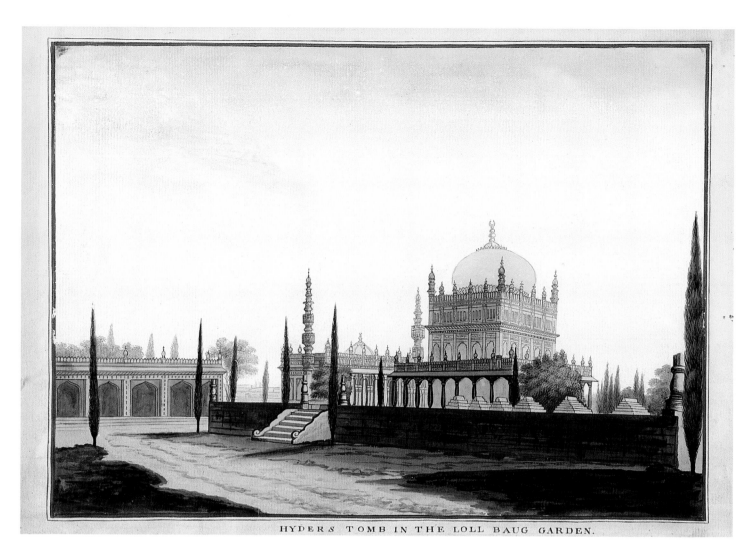

HYDER*S* TOMB IN THE LOLL BAUG GARDEN.

**56 Haidar Ali's Tomb
in the Lal Bagh Garden
at Seringapatam**
∿

by Robert Home (1752–1834),
Seringapatam, 1792.

Media: Watercolor on paper

Size: 9 x 12 in. (22.9 x 30.5 cm.)

Inscribed: Below painted
surface, in capital letters:
"Hyders Tomb in the Loll Baug
Garden."

Within the laul baug Tippoo had erected for himself a superb palace, and in the eastern corner of the garden a pleasant bungalo, or summerhouse, looking down the Cauvery, where a junction of those two arms that surround the island is formed. This bungulo and the upper part of the palace afforded excellent accommodations for our sick and wounded officers; as did the lower part of the palace, and the square of faquier's choultries round Hyder's tomb, for the private soldiers. . . .When Hyder died in 1782,[1] his remains were deposited in a tomb at the west end of the extensive garden at Seringapatam, and in honour of this founder of a new race of princes, over it his son and successor erected a superb and magnificent mausoleum. It is surrounded by a square of faquiers choultries which formed a convenient hospital for the sick and wounded of the British troops, during the siege of Seringapatam, in 1792. Opposite to the front of the mausoleum is a mosque; and in the centre of the front, facing the mosque, is a black marble slab, on which is a Persian inscription, in memory of the deceased, couched in terms of extreme hyperbole, whilst the pomp of its turgid diction is disgraced by a play on words, that to an European would appear highly ridiculous, though a native of Mysore seems to hold it not beneath the dignity of the most serious subjects. Near the tomb of Hyder Ali another has been more recently erected in memory of Burham ud Deen, the brother of one of Tippoo's wives, who fell at Sattimungalum, when that fortress was taken by Colonel Floyd, on the 26th of August, 1790.
(Robert Home, as published in 1796)[2]

The Mausoleum of Hyder Aly Khan at Laulbaug: Laulbaug is a favourite garden of Tippoo Sultan, situated at the south east end of the island of Seringapatam, in the center of which a palace has been erected, nearly upon the same plan as the one at Bangalore. The Mausoleum . . . was built over the body of his deceased father, at the western extremity of the garden. Contiguous to it is a mosque, or chapel for prayers. Near the southwest corner of the dome, is the tomb of Burhaun u'ddien, a cousin of Tippoo, who was killed at the battle of Sattimungalum, in September, 1790. It is reported, that soon after the burial of this chief, he caused four English prisoners to be sacrificed to his manes. They were tied to stakes, affixed to the four corners of the tomb, and in order that a flow of their blood might not pollute the hallowed ground, the inhuman Tyrant

TOMBS, MOSQUES, AND OTHER MONUMENTS

caused them to be beat to death with bludgeons. This account is corroborated by Mr. Cadman, who had it from a Jemmadar in the Tyrant's service, while in prison. On a black slab, fronting the mosque, is a pompous and hyperbolical inscription, in Persian, to the memory of Hyder Aly Khan. (Robert Hyde Colebrooke, as published in 1794)[3]

This watercolor is part of a series, of which two more are introduced and discussed here under cat. no. 64 a. & b. With regard to Home's description of the monument, another author remarked more than a hundred years after the campaign against Tipu Sultan:

The Sult'an was greatly enraged on seeing that the English army had deliberately cut down, for the purpose of making fascines, the cypresses and other trees in the L'al B'agh, where his father's tomb had been erected, and it must be admitted that this act of vandalism was, though perhaps unavoidable, one that might well rouse his wrath.[4]

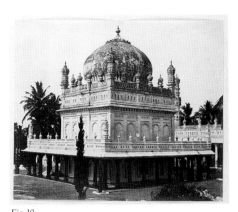

Fig. 18

The present watercolor corresponds to plate 29 in Home's *Select Views in Mysore, the Country of Tippoo Sultan, with Historical Descriptions, Maps and Plans* of 1794, where it is an uncolored engraving. For reasons given below (cat. no. 64 a. & b.) Home included this view also in his *Description of Seringapatam, The Capital of Tippoo Sultaun. Intended to Accompany The Six Following Views Drawn by Mr. Home, And Engraved By Mr. Stadler* of 1796, where it appears as a large colored aquatint, numbered 6. Colebrooke's *The Mausoleum of Hyder Ali Khan at Laulbaug*[5] is more detailed when compared to Home's watercolor, since it was intended for publication on a larger scale from the very beginning. Colebrooke's view of the monument thus includes the tents of the British officers in the Lal Bagh as mentioned by Home himself ("excellent accommodations for our sick and wounded officers"). Nevertheless, the accuracy of Home's view of Haidar's Tomb in the Lal Bagh Garden is validated by the accompanying fig. 18, a photograph from the second half of the nineteenth century.[6] Haidar's sepulchre, which after Tipu's death also contains the tomb of the latter, was to figure prominently in the center of one of the most frequently published Indian "capriccios," viz. Captain Robert Melville Grindlay's colored frontispiece entitled *Portico of a Hindu Temple with other Hindu and Mahometan Buildings,* published in 1830.[7] The same frontispiece was used in the same position for the first volume of Robert Elliot's and Emma Roberts's *Views in India, China and on the Shores of the Red Sea,* published only five years afterwards.[8] More recently, it was used as the front cover of the catalogue that accompanied the exhibition *India Observed, India as Viewed by British Artists* as part of the Festival of India in Great Britain, Victoria and Albert Museum, 1982[9]

NOTES

1. There are conflicting statements as to his year of birth. Beale 1894, p. 149, gives "about A.D. 1702"; Bowring 1893, p. 13, says: "There is some uncertainty as to the year of his birth, some authorities giving 1722, and others 1717." Haidar Ali was Tipu Sultan's father.
2. Home 1796, p. 1 and p. 4. The Persian inscription mentioned by Home is reproduced in ibid., p. 4, but without translation.
3. Colebrooke 1894, descriptive text to pl. 10.
4. Bowring 1893, p. 170.
5. Pl. 10 in Colebrooke 1794, re-published in Godrej/Rohatgi 1989, p. 109, fig. 57; *The India Collection 1982,* p. 88.
6. Published: Christie's, June 5, 1996, p. 235, lot 390. For a photograph published a century after Home's view of Hyder Ali's tomb, see Abbott 1906, frontispiece. For a more recent photograph, cf. Bayly et al. 1990, p. 24, fig. 5.
7. Grindlay 1830, with eight pages of description.
8. Roberts/Elliot 1835.
9. Archer/Lightbown 1982.

57 View across the Courtyard of the Jama Masjid in Delhi

~

Charles Ramus Forrest
(fl. 1802–1827), Delhi,
ca. 1808–1809.

Media: Watercolor on paper

Size: 14¹/₂ x 22⁵/₈ in.
(36.8 x 57.5 cm.)

Inscribed: On verso, in a
nineteenth-century English
hand: "Views in India / No. 55.
The Jumeh Musjid—the
Principal Mosque of Dehli."
And in the lower left corner:
"T. Ph. Forrest/ 1864 / No. 17";
and next to it, in a later hand:
"Given to his / Grandson."

The Jama Masjid is described in the artist's own words:

On the morning after our arrival [at Delhi] I waited on the British resident, who received me with the kindest attentions: after breakfast, he told me he had obtained the emperor's permission for seeing the palace, and introduced me to a native gentleman of rank, who was to be my guide. The first visit was to the Jumah Musjid, the cathedral of Delhi, that is, the principal mosque, situated on a high mound of rocks, and nearly in the centre of the city. It has three grand gates, the principal one to the eastward; by this, ascending a flight of forty steps, we entered: its doors are of solid brass. The area in which this magnificent mosque stands is about fourteen hundred yards square. The building itself is an oblong, two hundred and sixty-one feet in length, and surmounted with three white marble domes, banded with black; and at each of the two front extremities is a lofty and graceful minaret of three stories, of red and white stone striped, and one hundred and thirty feet high. I ascended the minaret on the right hand, and from thence had an extensive and grand view of the city of Dehli, the palace, and the country beyond to a great distance. The erection of this building, by Shah Jehan, cost 125,000l.[1]

A few years prior to Forrest's visit to Delhi, another description of the same mosque was published in 1798 in a volume by William Francklin, in a chapter entitled "Account of Modern Delhi." This account was considered of great importance for Fanny Parks, who, instead of writing down her own impressions and the ideas she had when visiting the monument on February 24, 1838, quoted verbatim from Francklin's description,[2] which we quote here in full after Francklin's own text:

First, The Jama Masjid or great cathedral. This mosque is situated about a quarter of a mile from the royal palace; the foundation of it was laid upon a rocky eminence called Jujula Pahar, and has been scarped on purpose. The ascent to it is by a flight of stone steps, thirty-five in number, through a handsome gateway of red stone. The doors of this gateway are covered throughout with plates of wrought brass, which Mr. Bernier imagined to be copper. The terrace on which the mosque is situated, is a square of about fourteen hundred yards of red stone: in the center is a fountain lined with marble, for the purpose of performing the necessary ablutions previous to prayer. An arched colonnade of red stone surrounds the whole of the terrace, which is

adorned with octagon pavilions for sitting in. The mosque is of an oblong form, two hundred and sixty-one feet in length, surrounded at top by three magnificent domes of white marble intersected with black stripes, and flanked by two Minarets of black marble and red stone alternately, rising to the height of an hundred and thirty feet. Each of these Minarets has three projecting galleries of white marble, having their summits crowned with light octagon pavilions of the same. The whole front of the building is faced with large slabs of beautiful white marble; and along the cornice are ten compartments, four feet long and two and a half broad, which are inlaid with inscriptions in black marble in the Nishki *character, and are said to contain the greater part, if not the whole, of the Koran.*

The inside of the mosque is paved throughout with large slabs of white marble, decorated with a black border, and is wonderfully beautiful and delicate; the slabs are about three feet in length by one and a half broad. The walls and roof are lined with plain white marble; and near the Kibla is a handsome taak *or niche, which is adorned with a profusion of frieze work. Close to this is a* mimber, *or pulpit, of marble, which has an ascent of four steps, ballustrated. The ascent to the Minarets is by a winding staircase of an hundred and thirty steps of red stone; and at the top the spectator is gratified by a noble view of the king's palace. . . .*[3]

The Jama Masjid of Delhi is, like the Taj Mahal, perhaps the most often described mosque of India. But ironically it is, also like the Taj Mahal, far from being the best documented Indian structure, as will be shown below. However, descriptions from the first part of the nineteenth century are quite abundant; only a very few are mentioned here. They may differ in the number of steps counted but in the end all agree that it is a most magnificent building. Bacon, who sketched it from "Begum Sumroo's Garden" climbed to the top of one of the minarets, as did Forrest.[4] William Sleeman, most impressed, thought that: "a similar building in England would cost at least four hundred thousand pounds,"[5] an incredibly large sum of money in those days. Sleeman goes on to write that "no worshippers of idols," i.e. Hindus, were allowed to enter the courtyard of the mosque, whereas Cooper noted a few decades later: "No native, whether Hindoo or Mahomedan, dare venture to enter the quadrangle without taking off his shoes, but Europeans are not required to shew this oriental mark of respect to the temple of the prophet of Islamism."[6] That Hindus now were allowed to enter this mosque and that Europeans were not to take off their shoes before entering the courtyard of the Jama Masjid was probably the result of the British reaction to certain Indian customs following the Indian mutiny of 1857–58, especially since: "It has been warmly suggested that we should destroy the Jumma Musjid. The advice was given under the excitement and blind rage produced by the mutinies," as another admirer of the structure wrote.[7]

The painting bears the date of 1864 and does not give the name of Charles Ramus Forrest. At first sight, this might argue against an ascription to this celebrated artist. Forrest, whose date of birth is not known, illustrated *Picturesque Tour along the Rivers Ganges and Jumna, in India*, one of the most beautifully illustrated travel books on the Indian picturesque, published by Ackermann in 1824. It contains "twenty-four highly finished and coloured views, a map and vignettes, from original drawings made on the spot." C. R. Forrest made his "drawings" between 1807 and 1809 but had to wait some fifteen years before he could see them published. The success of Forrest's book is linked more appropriately to a certain emerging fashion in Europe rather than the demand for pictorial information on India by the educated public. His book was "a picturesqe travel book or book of views as an armchair substitute for the toil of a real journey, offering the best or most characteristic view selected and engraved to the accompaniment of a descriptive text."[8] That there was also an Italian and a Spanish edition published three years later speaks for itself.[9] His rendering of the Taj Mahal was considered to be one of the best views of the structure; it was used as the central motif not for a small cup but for a large plate that forms part of the now famous set of earthenware from Staffordshire, produced by T. Hall and Sons.[10] Here, his view rivals those produced by the more famous Daniells.

C. R. Forrest's picture of the Jama Masjid does not appear in his book, but his published image of the Taj Mahal, which was never adequately republished in printed form[11] is one of

the key pictures that helps to determine the authorship of the present painting, especially since original views by C. R. Forrest are quite rare.[12] What makes Forrest's representation so unique in comparison to other depictions of the Taj Mahal is his emphasis on vertical lines in the structure, especially on the cupolas. The strong indication of the horizontal but more particularly, the vertical seams on the central cupola of the Taj or the large cupolas of the adjoining buildings makes them appear to be covered by a regular net or grid. These seams as such do exist, but the vertical ones are not regular at all. The outside of each cupola consists of a multitude of marble blocks which are, however, so skilfully joined that the joints become almost invisible, especially for a spectator on the other side of the river, such as C. R. Forrest.[13]

Forrest's emphasis on vertical lines of the cupolas becomes even more apparent in the present watercolor. The black intersections on the three main cupolas are emphasized to the extent that they resemble deep vertical furrows, which in reality are nothing more than vertically marked joints on the same level as the marble blocks. Forrest almost managed to represent the cupolas with their evenly rounded surface like onions with pumpkin-like chamfers. He obviously confused the (earlier) cupolas of these Mughal monuments with the (later) cupolas or roofs of Hindu temples, which appear on several plates in his book.[14] That the cupolas of the Jama Masjid had no vertical chamfers is shown again by comparison to a picture by Thomas and William Daniell, in this case an aquatint.[15]

Another feature of Forrest's depiction of Mughal monuments is the comparatively pale representation of the red sandstone. This is not the result of bleaching; parts of the painted surface were covered by the mount. The area covered by this mount does not show a more intense red than the red of the painted surface which was probably constantly exposed to light. The respective aquatints in Forrest's publication—we consulted a complete set of the plates which were practically never exposed to light for more than a few minutes at a time—show precisely the same dull rendering of the red sandstone as the present painting. The red sandstone in his representations of the "Red Fort" of Delhi (plate XXI)[16] or the Taj Mahal (plate XXIV) exactly match the subdued color-scheme of the present watercolor. This subdued color-scheme does not mean that Forrest did not employ intense colors at all. The pavilion on the barque in front of the Taj Mahal in plate XXIV of his book is a glowing red.

A few more indications reveal C. R. Forrest's authorship. The date on the back of the painting, 1864, cannot be linked to the date of the actual production of the watercolor. Ever since the reign of the last Mughal emperor, Bahadur Shah II (1837–1858), a kind of pavilion marks the top of the central flight of steps, in front of the large central opening of the mosque. This pavilion seems first to appear on wood-engravings published in 1857, illustrating events of the Indian mutiny of that year.[17] It appears in any photograph showing the "building itself," as Forrest called it,[18] and consequently in any engraving based on a sketch or photograph taken at about this time or later.[19] All earlier depictions are devoid of this structure,[20] which is, strangely enough, not really considered by any of the modern scholars concerned.[21] This is probably due to the fact that the Jama Masjid of Delhi was never declared a "protected monument" by the Archaeological Survey of India and hence does not figure in the annual reports issued by that institution since the end of the nineteenth century. The date on the verso of the watercolor most probably records the year in which C. R. Forrest's grandson, whose initials were "T. Ph.," inherited the painting from his father. C. R. Forrest died in 1827. Of the very few known watercolors by C. R. Forrest, one other is inscribed on verso with "Views in India," followed by a serial number.[22]

There is truth inherent in Prinsep's observation, made in December 1876: "The Jumma Masjid, or Mohammedan cathedral, has frequently been described; but no one in writing can convey the impressions it produces on the artistic mind. I say this advisedly, for the Anglo-Indian goes by general report, and never troubles himself with artistic impressions, nor does he see the beauty under his Anglo-Indian nose . . ."[23]

1. Forrest 1824, p. 177f.
2. Parks 1975, vol. II, p. 220f.
3. Francklin 1798, quoted after the Allahabad reprint of 1971. The chapter on modern Delhi is not icluded in the reprint published by Pustak Kendra in Lucknow, 1973. François Bernier (1620–1688), mentioned by Francklin, probably wrote the oldest account (1663) of this mosque published in any European language, in 1670. For Bernier's account of the Jama Masjid, "one of the best descriptions ever written," following its editor, see Bernier 1916, pp. 278–280. For the original French text recently reprinted, see Bernier 1981, pp. 209–211. Bernier's description was considered to be of such importance that its English translation was reprinted in one of the first more exhaustive guide-books on the city, cf. Cooper 1863, pp. 17–19. For the account given in what could be called the first guide-book on Delhi (*Beresford's Delhi*, published shortly after 1858), see Harcourt 1873, p. 79f. The inscriptions to which Francklin alludes are partly transliterated, translated and discussed in Husain 1936, p. 4, no. VII and Begley 1981.
4. For his lithographed sketch of the mosque, see Bacon 1837, vol. II, opp. p. 237. For the description see ibid., pp. 237–240.
5. Sleeman 1844, vol. II, p. 272f.
6. Cooper 1863, p. 38. For more relevant descriptions, see Archer 1833, vol. I, p. 106f, mentioning repairs to the dome carried out by the British government under Major Smith as early as 1828. Bishop Heber, when visiting the Jama Masjid on December 30, 1824, remarked: "It is in excellent repair, the British government having made a grant for this purpose, a measure which is very popular in Delhi."(Heber 1828, vol. I, p. 556). For a noteworthy Indian description, by Syed Ahmed Khan, published in 1846, see Nath 1979, p. 57f. An illustrated description by Sir Thomas Metcalfe from 1844 is published in Kaye 1980, p. 16f. For an illus. German description from Jan. 1843, see Orlich 1845, p. 161f., to mention just a few.
7. Russel 1860, vol. II, p. 73.
8. Archer/Lightbown 1982, p. 86.
9. Godrej/Rohatgi 1989, p. 153 in addition to p. 56f.
10. Pal et al. 1989, p. 202, no. 214.
11. Cf. Pal et al. 1989, p. 202, no. 213. In the original book, Forrest's view of the Taj Mahal is the last aquatint, facing p. 187.
12. The India Office Library acquired the only three drawings by him in that collection only quite recently, cf. Kattenhorn 1994, p. 144f. and two additional views were recently offered for sale, (see Christie's, May 25, 1995, p. 105, lot 159).
13. This "grid" is seen neither in the watercolor nor in the engraving or the aquatint of the Taj Mahal in a similar view across the river by the Daniells, cf. Christie's, September 24, 1996, lot 49 for the watercolor, *The Oriental Annual 1834*, engraving facing p. 195 for the engraving, and Archer 1980, pp. 68–69, fig. 29 for the aquatint.
14. For the vertically fluted cupolas cf. Forrest 1824, pls. XI, XII, XIV, XV and XVII.
15. Cf. *Oriental Scenery* I, pl. XXIII, Jan. 1797. Reproduced: Archer 1980, pl. 35; Pal/Dehejia 1986, p. 107, no. 100; Pal et al. 1989, p. 72, no. 63, col. Christie's, May 25, 1995, lot 85.
16. Forrest painted the "Red Fort" of Delhi (cf. cat. no. 66) from the minaret of the Jama Masjid which he ascended. His representation of the "Red Fort" is, in terms of correctness and appeal, unfortunately probably the weakest of all his published views.
17. Cf. *The Illustrated London News*, July 25, 1857, p. 92, *The Jumma Musjid, or Great Mosque of Delhi* or *L'Illustration, Journal Universel*, 31 Octobre 1857, illus. entitled *Parte septentrionale de la grande mosquée de Delhi*, republished in *Les Grands Dossiers de L'Illustration* 1987, p. 51.
18. For a photograph taken in about 1868 see Vignau/Reni 1992, p. 161, planche 134.
19. For the engraving based on the above-mentioned photograph see Rousselet 1878, illus. facing p. 480. See also a view by W. Simpson dated 1864 in Christie's, June 5, 1996, p. 51, lot 62, col. or Le Bon 1893, vol. II, p. 187, fig. 281. Christie's, June 5, 1996, p. 37, lot 40 shows this pavilion already and should hence be dated accordingly.
20. The first relevant depiction of this mosque is on a folio that belongs to one of the Lucknow albums collected by Antoine Polier (cf. cat. no. 63). It is reproduced in Gothein 1926, Tafel 30 (= Brentjes 1974, Abb. 118). Other depictions by Indian artists include no. 44 of the Latif album (Cf. cat. no. 55), reproduced in *Octagon* 1985, p. 20, col. Orlich 1845, col lithograph facing p. 160; The Metcalfe album in Kaye 1980, p. 17, col.; Jancigny/Raymond 1845, planche 58; Head 1991, p. 70, no. 017.002 (drawn 1811); *Maggs Bull.* no. 31, 1979, pl. VI, no. 13 and pl. VIII, no. 17; Christie's, June 5, 1996, p. 37, lot 40, col., to mention just a few.
21. Cf. e.g. Koch 1991, p. 119f.; Asher 1992, p. 202f. with pl. 124, again to mention just a few. The kiosk bears an inscription on its eastern side giving the dates of A.D. 1928 and A.H. 1347 respectively. Earlier this century, another kiosk was erected at the center of the eastern side of the central water reservoir. It resembles the one from the middle of the last century; see Sharma 1974, pl. XVIII, B.
22. Christie's, May 25, 1995, p. 105, lot 159. For more comprehensive information on C. R. Forrest's career in India, see Kattenhorn 1994, p. 144.
23. Prinsep 1879, p. 22. Valentine Prinsep was the official British painter at the Delhi Darbar of 1876–1877 as were Jacomb-Hood and Mortimer Menpes at the Coronation Darbar of 1902–1903.

58 The Great Kuttra at Dacca

 ⁓

by Sir Charles D'Oyly, 7th
Baronet (1781–1845), Dacca,
ca. 1812.

Media: Pencil on paper

Size: 13⅝ x 19½ in.
(34.6 x 49.5 cm.)

Inscribed: On verso, in pencil:
"Gateway near the Laul Baug /
Dacca."

The GREAT KUTTRA is a stupendous pile of grand and beautiful architecture, situated on the eastern bank of the river, and near the centre of the city. It has been asserted that it was originally built as a palace for the unfortunate Mahommed Sujâ; who, not being satisfied with it, even as a temporary residence for himself, bestowed it on Meer Aboo ul Kasim, the public officer who superintended its erection; and that it was afterwards appropriated to the accommodation of travelling merchants and strangers. This, however, does not entirely agree with the inscription on its walls . . . of which the translation is as follows: "SULTAN SHAH SUJA was employed in the performance of charitable acts. Therefore ABDOOL KASIM TUBBA HASSEINEE ULSUMANEE, in hopes of the mercy of God, erected this building of auspicious structure, together with twenty-two dookans, or shops, adjoining, to the end that the profits arising from them be solely appropriated by the agents and overseers to their repairs, and the necessities of the indigent, who on their arrival are to be accommodated with lodgings free of expense. And this condition is not to be violated, lest on the day of retribution the violator be punished. This inscription was written by Saadoodeen Mahommud Sherazee. Ann. Hegira 1055.

From the above description, which is in the Persian language, and Togra-Arabic character, it would appear that the Great Kuttra has been from the beginning,— to use the words of the dervise of the well known eastern tale,— "not a palace, but a caravansera": yet, since the erection of so spacious an edifice must have occupied some considerable portion of time, it may possibly have been begun as a palace, and finished as a caravansera. The superior style of its architecture seems to attest that it must have been originally designed for a princely residence; and there seems to be no other way of reconciling this idea with the direct evidence of the inscription.

The term Kuttra, or Kuttera, has been derived from the Persian (Chutter), a tent or pavilion; and again, from the Sanscrit (Ch'atra), or, as it is pronounced in Bengal, (Chhotro), an umbrella; a place where pilgrims are entertained: but it is most probably of Arabic origin, and referable to the word (Katar) or (Katarah), a cupola, or arched building. The Great Kuttra is divided into a vast number and variety of apartments, in which the poorest class of natives now take shelter. The turrets are lofty, and of an octagonal form. From the top of the building the prospect of the city and the surrounding country is very beautiful and extensive. During the rainy season the plains are deluged with water; in consequence of which the peasantry always place their habitations on the highest spots of ground; so that every village, or cluster of huts, looks like a small island; and hundreds of them appear interspersed over the face of the country as far as the eye can reach.

The great strength and durability of Indian masonry is exemplified by the situation and construction of a small room in this edifice, which must be crossed to arrive at the top of the building. The beams which formerly ran across the walls and supported the terrace, formed of tiles and plaster, have long since fallen, from decay, leaving the terrace standing, which shakes with the slightest weight, but is strong enough to bear the greatest. Many similar rooms are to be found in the more ancient buildings of India.

The foregoing description is quoted from the artist's *Antiquities of Dacca*, published in London between 1814 and 1827.[1] The text is accompanied by a full-page facsimile plate reproducing the inscription, the translation of which is quoted in the text[2]. The present drawing appears as a full-page engraving, probably on steel, in the same publication. Since it bears no pagination we quote here from its label, which reads in the lower left: "Drawn by Sir Chas. D'Oyly, Bart," and in the lower right: "Engraved by J. Landseer Engraver to the King & F.S.A." The plate is labeled: "THE GREAT KUTTRA. /Inscribed with Grateful Respect to Genl. the most Noble the Marquis of Hastings K.G.G.C.B. Govr. Genl. of India & Commander in Chief &c.," and below, in smaller characters: "Published 1st January 1823 by J. Landseer. Upper Conway St. Fitzroy Square. London."[3]

The description which was published along with the engraving is still one of the most detailed accounts of this monument. Due to its apparent dilapidated condition which is more prominent in the engraving than the present drawing, it was classified "IIb" by the government of Bengal in 1896. This classification was selected for "Monuments which it is now only possible or desirable to save from further decay by such minor measures as the eradication of vegetation, the exclusion of water from the walls, and the like, such being in

possession of private bodies or individuals."[4] D'Oyly's engraving was not referred to in the official account of 1896, which, being the most comprehensive work on the then known monuments of Bengal, provides the following information:

Name of monument: Great Katra (caravanserai). History or tradition regarding this monument: This was built by Mir Abdul K'asim Khan under the orders of the Prince Az'imushan during the latter's viceroyalty of Bengal in the year 1645 A.D. It is said that it was intended for travellers and was to serve the purpose of a caravanserai. It is a building of enormous massiveness and solidity, and will not rapidly fall into decay. The building from its dimensions looks imposing from the river; the main gateway facing the river is picturesque. On its completion the Prince inspected it, but did not like it, and gave it to Mir Abdul K'asim. Custody or present use: In private hands; pretty well looked after. Present state of preservation and suggestions for conservation: Nearly if not quite intact and not likely easily to fall into decay.[5]

Today, the monument is referred to as "Bara Katra." (Bara = great): The Bara Katra was originally approached from the river, so the frontage from this side is the dominating part of the construction. It was built in 1644 A.D., by Abdul Qasim, the Diwan of Shah Shuja. The prince bestowed it on the builder in 1646 A.D. The Bara Katra encloses a large quadrangle courtyard with living rooms on all the four sides. The Mughal grandiosity was apparent in the big gateways on the north and south. The rooms remained humble. The gateways were lofty rectangular structures with fronts towards the river. The mass is defined by tall alcoves, rising to the second story, and decorated with plaster network and other embellishments.[6]

Charles D'Oyly was appointed Collector of Dacca in 1808, a post he held until 1812, the year in which he went to Calcutta, first as deputy collector and then as Collector of Government

Customs and Town Duties, a post he held until 1821 when he was appointed Opium Agent in Patna. It was in Dacca, where George Chinnery developed his distinctive style of landscape (cf. cat. no. 83) and Chinnery went to stay with Charles D'Oyly there. Chinnery's artistic influence on D'Oyly's works of that period is so strong that the present drawing was originally marketed as: "Signed 'Geo Chinnery' in foreground."[handwritten; and printed:] "George Chinnery R.A. / East Turret-Dacca" [and below, handwritten:] "Gateway in the Laul Baug."[7] In fact, the title-vignette of D'Oyly's *Antiquities of Dacca*, labeled *Account of Dacca*,[8] another vignette titled *Approach to Tungy*,[9] and yet another of *Modern Habitations at Dacca*[10] are initially all by George Chinnery, in their engraved form by "Jn. Landseer."

The engraved plate after the present drawing is dedicated to Warren Hastings, to whom D'Oyly wrote earlier: "I shall some time hence please God offer you as companions a few of the ruins of the city of Dacca which I assure you are exquisite for their magnificence & elegance & are calculated to tempt the pencil of an artist." By that time, Chinnery himself had already collected some fifty views of the ruins of Dacca, and it seems that some of Chinnery's vignettes in D'Oyly's *Antiquities of Dacca* were originally intended for Chinnery's own publication which, as we know, never materialized as such.[11] The present drawing was not only turned into a line-engraving for the *Antiquities of Dacca;* it also formed the basis for a splendid painting in oils, which D'Oyly must have probably worked on when in Patna, between 1825–1830.[12]

D'Oyly's folio-volume *Antiquities of Dacca* is practically unknown today, but was not so when still in circulation. Bishop Heber mentions the work on July 19, 1824, when referring to the "'Pagla Pwll" or Mad Bridge, a ruin four miles below Dacca: "There is a very fine and accurate engraving of it in Sir Charles D'Oyly's 'ruins of Dacca.'"[13] D'Oyly basically painted architectural "antiquities" and not ruins, as Heber wrongly recalled the title of D'Oyly's publication. It was the picturesque style which probably presented the buildings in a more ruinous state than they actually were at the time of D'Oyly's stay at Dacca. To include climbers and all sorts of vegetation in these pictures was practically a "must."

NOTES

1. D'Oyly 1814–1827, pp. 9–10.
2. In the quotation we have omitted the reference to that pl., which bears no numbering in D'Oyly 1814–1827. It is labeled: "Fac Simile of an Inscription in the Great Kuttra./Published 26 Decr. 1825 by J. Landseer. Upper Conway Street. Fitzroy Square. London. / Engraved by Cosino Armstrong."
3. In the sequence of publication this would appear to be illus. no. 10, cf. Godrej/ Rohatgi 1989, p. 150, under "C. D'Oyly." The engraving is reproduced in Godrej/Rohatgi 1989, p. 59, fig. 25 and in Losty 1995, p. 97, fig. 19.
4 Quoted from the Government of India Resolution, Home Department (Archaeology), No. 3/168–83 of November 26, 1883.
5. *List of Ancient Monuments* 1896, pp. 198–199, where also the classification of this monument is given.
6. Ahsan 1974, p. 25. For a groundplan of the southern wing see ibid., p. 35, fig. 32. For a recent photograph of the monument see Ahmed 1984, pl. 72: *The Monumental Gateway of the Bara Katra, Dhaka.*
7. According to an old paper label pasted on the back of the wooden mount.
8. On p. 1 of D'Oyly 1814–1827, dated wrongly "Published 3 Sep. 1716. . ."
9. D'Oyly 1814–1827, p. 15.
10. Dated 1823, reproduced: Godrej/Rohatgi 1989, p. 63.
11. Losty 1995, p. 87.
12. For an assessment of that painting and a discussion of its date, see Losty 1995, pp. 101–102. The oil painting is reproduced in Shellim 1989, p. 12, no. 5 and Losty 1995, p. 96, col. illus. no. 17.
13. Heber 1828, vol. I, p. 153. The plate to which Heber refers was published in 1817 and is entitled: *Paugla Pool, with Part of Dacca in the Extreme Distance.*

59 Chaityagriha No. 19 at Ajanta

⁓

by William Simpson
(1823–99), Ajanta,
January 1862.

Media: Watercolor over pencil

Size: 19½ x 13¾ in.
(49.5 x 34.9 cm.)

Inscribed: In lower left corner:
"Chaitya Cave - Buddhist -
Ajunta" and in lower right
corner: "Wm. Simpson. 1862."

Published: Sotheby's N.Y.,
June 4, 1996, lot 353

The entry in Simpson's autobiography with regard to this watercolor reads: "From Ellora I went on to Ajunta, where the caves are all Buddhist. The sketching of these caves, as well as of temples, topes, &c., gave me a large amount of knowledge in detail of Indian architecture, and led me to study it still further afterwards."[1] William Simpson in fact studied the Buddhist architecture in detail and hence described a "Chaityagriha" or "Chaitya Cave" in the following passage:

The Buddhists had another kind of temple, the construction and arrangement of which we are familiar with from the rock-cut temples of them that still exist. These may be termed either Chaitya Halls, or Chaitya Temples, from the chaitya, or small stūpa, which formed the altar at one end [Simpson refers here to a groundplan of such a "chaitya-temple" which he reproduces along with his text]. *Although no connection is possible between them, these chaitya temples bear a strong resemblance, which has often been noticed, in plan to a Christian church. The chaitya occupies the end of the nave as altar; on each side are columns separating the aisles from the nave. The aisles pass round behind the chaitya, exactly as the aisles form a passage behind the high altar in most cathedrals, but the ritual of the two temples is far from being the same. From what I saw in the Tibetan Lamaseries, I take it that the monks sat in the nave in front of the chaitya, where they performed their elaborate service. The worshippers would enter the aisle on the left and walk along it, then round by the back of the chaitya, coming out again by the other aisle. In doing this they circumambulated the chaitya, and the performance was essentially the same as that already described which was done at the worship of the stūpa.*[2]

The outer facade of this "chaitya cave" was turned from the sketch into a finished watercolor by William Simpson in 1875, the year in which he was to accompany the Prince of Wales to India. This watercolor is published[3] as is the woodcut engraving after this watercolor, done for *The Illustrated London News,* accompanying fig. 19.[4] We quote from the descriptive text which is most probably again by Simpson himself, especially since the interior as shown here is also minutely described:

At Ajunta the caves are all Buddhist, which is a proof that these are a more ancient group. The excavations here are in a rocky cliff, forming the north side of of a dell or small valley, through which a stream of water runs, and from which a supply was led by a rock-cut conduit to the caves.[4] *The Buddhist caves are of two different kinds.... The other class of Buddhist caves are distinguished by the word Chaitya; these were the chapels, or churches, in which the monks went through the service devoted to Buddha. The place represented in our Illustration belongs to the latter class. In its interior, the chaitya or dagoba, both names being used to designate it, may be seen at the end, with a figure of Buddha sculptured on the front of it, and with three umbrellas, something like inverted saucers, surmounting the whole. This formed the altar of the temple. Colossal figures stood on each side; but now the feet and small portions of the legs only remain. The interior is about forty-six by twenty-three, and seventeen pillars form a passage, or aisles, up each side, and round behind the Chaitya. One striking feature of these Chaitya caves is the ribbed roof, cut out in most exact imitation of a wooden construction. This is very clear evidence of the style of architecture followed in such buildings, and of the material in use at that period. At present the houses of India have flat roofs, but these rock-cut caves tell us that such was not the case eighteen centuries ago; the roofs were at that time round, with a sort of horseshoe gable. The interior view of this Chaitya* [i.e. the present cat. no. 59] *gives us the minutest details as to how those wooden buildings were constructed in former times. The exterior view gives us, at least, the shape of the gable.... The horseshoe form of the gable will be noticed: it is open, and the ribs of the roof can be seen within. This, with the exception of the door, is the only opening for light. The perpendicular face of the rock in front has been elaborately enriched, and the horseshoe gable is everywhere repeated in miniature by way of ornament.... The Ajunta caves were covered nearly all over their interiors with paintings. Although very much dilapidated, a good deal could still be made out; and the Indian Government employed Major Gill, who was engaged for years making copies of them in oil....*[6] *Ajunta is fifty or sixty miles to the north east of Aurangabad....*[7]

After his return from his Indian tour of 1859–1862 Simpson met James Fergusson in London and both remained friends until the death of the latter in 1886. James Fergusson in collaboration with James Burgess published the then most important monograph on *The*

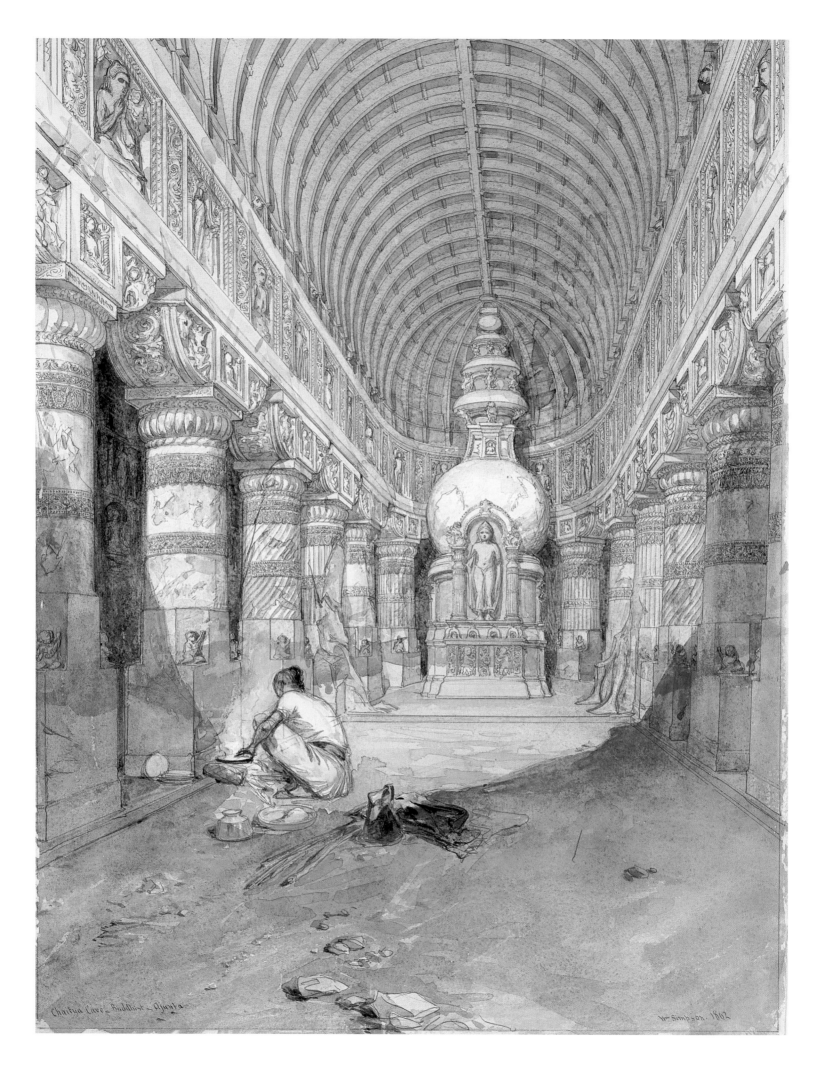

Chaitya Cave — Buddhist — Ajunta

W.ᵐ Simpson. 1862

TOMBS, MOSQUES, AND OTHER MONUMENTS

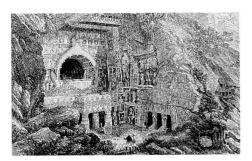

Fig. 19

Cave Temples of India in 1880. Earlier, James Fergusson had published two views of the same *chaitya*, of which Simpson was probably not aware at the time he made the present watercolor.[8] Fergusson and Burgess devote almost three pages of text and three illustrations on three plates to the description of this cave, numbered 19 ever since.[9]

Simpson's description as published in *The Illustrated London News* is one of the earliest and best observed descriptions by any non-archaeologist. His depiction of the interior is also one of the most reliable, especially when compared to an earlier depiction of a similar Buddhist cave, the so-called Vishwakarma cave of Ellura, mentioned by both Simpson and Fergusson/ Burgess[10] for comparison. The earlier depiction was published in 1824 and accompanies the first book ever published on the cave temples of Ellura by Seely.[11] Seely saw Gothic arches in the curved roof of the *chaitya* cave, whereas Simpson had drawn them correctly in a completely round shape. In creating this watercolor, Simpson has made use of the same device which was already used earlier by his Indian colleague who painted the cenotaph chamber of the Taj Mahal (cat. no. 54): The interior is shown as if seen through an extreme wide angle lens without distorted lines. To date, no single photographic shot of this view has been published without curved lines at the sides (fish-eye-lens-effect).[12] Cave 19 of Ajanta in Simpson's view, therefore, looks slightly larger than it actually is. Whether the woman was actually cooking her meal in the cave while Major Gill was occupied in copying the famous Ajanta frescoes next door remains doubtful. It seems Simpson only introduced her in order to give a kind of scale.

This painting almost certainly formed part of the 250 watercolors Simpson prepared for publication by Day & Son in London. Of these, however, only 50 were actually published in 1867.[13] The rest was "sold off as bankrupt stock." Simpson was not aware that Day & Son was heading for bankruptcy at the time he delivered his watercolors to that firm in 1866.[14] "I had not a penny," Simpson wrote. "Here was the reward of my seven years' work . . . This was the big disaster of my life."[15] Had Simpson succeeded in the proper publication of his watercolors he certainly would have become as famous as the Daniells, perhaps even more. . . .

NOTES

1. Simpson 1903, p. 170.
2. Simpson 1896, pp. 61–63.
3. Reproduced: *Maggs Bull.*, no. 17, 1970, p. 150, no. 174, inscribed at left corner: "Buddhist Rock-cut Temple, Ajunta," and signed and dated: "Wm. Simpson, 1875."
4. *The Illustrated London News*, April 1, 1876, full-page illus. p. 324. For Simpson's involvement with *The Illustrated London News* cf. Simpson 1903, p. 179 and Glynn 1995, pp. 44–146.
5. Precisely that scene was also painted by Simpson in 1862 and published as a chromolithograph by Day & Son in *India, Ancient and Modern*, London, 1867, pl. 29, with descriptive text by John Kaye.
6. For Simpson's painting showing Major Gill at work at the Ajanta caves, see Archer/Theroux 1986, p. 126, col. pl. 102.
7. *The Illustrated London News*, April 1, 1876, p. 323.
8. Fergusson 1845, pl. 6: Ajunta, exterior of Chaitya Cave No. 19; pl. 7: Ajunta, interior of Chaitya Cave No. 19.
9. Fergusson/Burgess 1880, pp. 315–317; pl. (woodcuts) XXXVI (longitudinal section), XXXVII (groundplan, top) and XXXVIII (illus. of a pillar in the center) and XXXIX (*Naga Raja*). These illustrations are by James Burgess. For another detailed description see also Gupte/Mahajan 1962, pp. 101–102.
10. Simpson in his description published in *The Illustrated London News*, April 1, 1876, p. 323; Fergusson/Burgess 1880, p. 317.
11. Engraving facing p. 185 in Seely 1824.
12. For published photographs of the interior and exterior of chaityagriha 19 at Ajanta cf. Dey 1925, illus. facing p. 149 (exterior) and illus. facing p. 153 (interior); Yazdani 1955, pl. LXXVa (exterior) and pl. LXXVb (interior); Gupte /Mahajan 1962, pl. XLIV left (exterior) and pl. XLIV right (interior); Ghosh 1967, pl. A (exterior) and pl. G (interior); Takata/Taeda 1971, full-page illus. p. 147 (exterior) and full-page illus. p. 148 (interior; this photograph comes closest to Simpson's interior view); Nou/Okada 1993a, full-page col. illus. p. 213 (exterior) and full-page col. illus. p. 25 (interior) just to give a cross-section of a few representative examples.
13. All listed in Godrej/Rohatgi 1989, p. 159.
14. Godrej/Rohatgi 1989, p. 99; Glynn 1995, p. 143.
15. Simpson's autobiography quoted after Archer/Theroux 1986, p. 135.

The Great Stûpa at Sanchi with its Eastern (left) and Northern Torana or Gate

∿

by S. E. E. Daly (fl. 1869–1881), Sanchi, February, 1871.

Media: Watercolor on paper

Size: 17¼ x 26¼ in. (43.8 x 66.7 cm.)

Inscribed: On verso: "'The Sanchi Tope' - near 'Bhilsa' - Central India / (Sketched in Febr. 1871– S. E. E. Daly)."

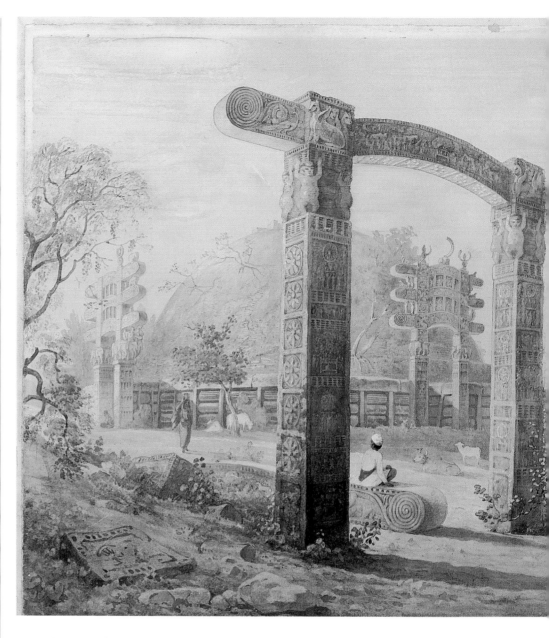

Since the artist who painted this watercolor is otherwise unknown, a description of this monument written by him probably does not exist. However, the "Sanchi Tope" was described by a number of other artists, including William Simpson, who offered the following definition of the term "tope" or "stûpa":

In Buddhist ritual the circular movement held a very prominent place. In order to understand this it will be necessary to give a slight description of one class of Buddhist structures. These are known as "Topes" or "Stûpas"— the last word being that now generally used. In Ceylon the same monuments are known under the term "Dagoba," while in the rock-cut temples of Western India they are called "Chaityas." The Burmese monuments are usually styled "Pagodas"; ... Wherever Buddhism flourished these structures were erected in great numbers. In reality they were temples, because they were places of religious devotion. Archaeologists are quite agreed as to the origin of these buildings. In primitive times the grave of an important person was heaped up till it became a mound or cairn. In process of time the heap or cairn was more carefully constructed, and at last it became a work of an architectural character. In India, when cremation became the custom, the stûpa may be said to have ceased being a tomb, and it became a "relic-holder," for it only required a small cell in which were deposited the ashes of the dead. When Buddha died and the body was burned, the ashes were divided into eight portions, these were carried off by his followers, and stûpas were erected to receive them. Stûpas were also erected for the ashes of the principal disciples, and men that acquired repute among the Buddhists for holiness or learning were honoured in this way. The stûpa, although of tomb origin, and practically a funeral erection, became the accepted type for a

monument; and many were erected on spots to mark where Buddha had done particular actions. . . . With the exception of the small cell, or at times cells, for the ashes or relics, these shrines were solid masses of bricks or stone. They were generally circular in plan. In the case of one that is well known from Cunningham's explorations and description of it,[1] the Sânchi Stûpa, also known as the Bhilsa Tope, "it was a solid dome of stone, 106 feet in diameter, and 42 feet in height."[2]

About nine years prior to Daly's visit to Sanchi, Simpson made a similar sketch of the Great Stûpa there and placed the eastern and northern *toranas* less closely together than in the present representation.[3] Simpson recorded the visit in his autobiography: "Bhilsa was my second stopping-place, and there I made my first essay in the study of Buddhist architecture. I stayed some days sketching at the old Sanchi stupa, which is about four or five miles from the town of Bhilsa.[4] The stupa was then covered with vegetation, and the whole place was in jungle condition. The south and west gates had fallen."[5]

In early May 1867, the French traveller Louis Rousselet visited Sanchi and photographed the central monument, of which he left the following account:

How can I describe the impression produced by this stately mass, rising proudly in the midst of temples and colonnades, with its gigantic enclosure and sculptured portals? All is grand here, all mysterious; the eye recognises no outline with which it is familiar; and the mind becomes confused in view of these mighty memorials of times which hardly reveal themselves to us from behind their veils of legends. A rapid description will enable the reader to appreciate the importance of the sight I had the good fortune to contemplate. The Great Tôpe is a hemispheric dome, about ninety feet in diameter, placed on a cylindrical basement fifteen feet in height, with a projection of nearly four feet round the base. This projection, which forms a circular terrace reached by a flight of steps with double balusters, was used for the perambulations of the faithful who came to strew flowers or lay offerings on the tôpe. The mass of the tôpe is composed of large-sized bricks arranged in regular layers; and the exterior casing is of slabs of white sandstone, two feet in thickness.

The sorry archaeologists of 1822[6] effected on the southern side a deep breach, which gives a perfect insight into its construction; and by means of this breach it is easy to reach the summit of the dome, which is level like a terrace. It was formerly surmounted by a beautiful altar, which was also destroyed by these mischievous antiquarians. Among the fragments which lie on the summit are to be found portions of the two superposed parasols which surmounted the altar. These parasols were stone discs, six feet in diameter; and the altar itself was surrounded by a massive Buddhist balustrade.[7]

Rousselet also describes the gigantic stone enclosure around the stupa, visible in the present painting, and finally describes the *toranas* or gates:

The design of these gates is of the extremest simplicity. The basement, formed by two vertical monoliths, supports a third monolith, placed horizontally; and above this architrave two small pilasters, placed on a line with the lower pillars, support a second horizontal monolith. The same arrangement is repeated with a third architrave, which forms the heading of the gate. The different pieces composing each gate are simply fitted in like carpenters' work, by means of tenons and mortises. This shows that the architect chose his model from a monument in wood. . . .

It now remains for us to speak of the bas-reliefs which decorate the gates. These bas-reliefs cover the four sides of the pillars and architraves. They represent the principal scenes in the life of the Buddha, religious ceremonies, processions or royal cortèges, sieges and battles; and a series of more unpretending but doubly precious pictures reproduce the interiors of palaces, apartments with their furniture, and kitchens with their accessories, and, finally, dances and gymnastic exercises. A detailed description of them, for which unfortunately I cannot find room, would of itself form a complete picture of the history and life of the Indian people during the centuries which precede the birth of Christ. These bas-reliefs unite a wonderful execution to great elegance of design; and they are all the more distinguished from everything else that Asiatic art has

produced, because the artist has limited himself to portraying what he had before his eyes simply and delicately, without being compelled to have recourse to mythology for those exaggerated forms or attributes which, after his time, were destined to become the basis of Hindoo sculpture.[8]

When the monuments of Sanchi were brought to public attention by General Henry Taylor (1784–1876) in 1818, its stupas were still intact and most of its *toranas* standing. The "Englishman" mentioned by Rousselet was Captain Johnson, Assistant Government Agent at Bhopal, who "opened up Stupa 1 from top to bottom on one side, thus leaving a great breach which resulted in the collapse of the West Gateway and a part of the enclosing balustrade."[9] It was only after 1881 that the monuments were cleared, the breach in the dome of Stûpa 1 filled, and the fallen West and South Gateways and part of the railing were set up again. By that time, also the gateway of Stûpa 3, through which we gaze in the present painting, was rebuilt.[10]

The spectator peers through the remaining part of the gateway of what is now called Stûpa 3. The stones in the foreground are the remains of that Stûpa and the two upper beams of the *torana* or gate are seen in the left half of the picture. The squatting man who is seen through what then remained standing of the gateway is sitting on the end of one of those architraves.[11] The portal seen through the gateway of Stûpa 3 is the northern gate of Stûpa 1.

The monuments of Sanchi were first discovered by British army officers during the Third Maratha War of 1817–1819,[12] and they were drawn as early as 1818, the year of their discovery.[13] In 1834 James Prinsep, who was the first person to re-read and translate into English the Ashokan inscriptions, expressed the wish that "some amateur would pay a visit to the spot [i.e. Sanchi] and bring away accurate drawings of the whole details."[14] This task was carried out by Frederick Charles Maisey (1825–1892) who, between about 1849–1852 made a number of drawings at Sanchi which were extensively used by James Fergusson in his *Tree and Serpent Worship* (published in London 1868, second edition 1873) and later, in 1892, in Maisey's own book, *Sanchi and Its Remains* (London, 1892).

Most useful, however, were photographs, in particular those taken by Louis Rousselet in May 1867. They were published as wood-engravings as early as 1873 and were also included in Rousselet's opus magnum *L'Inde des Rajahs* or *India and its Native Princes*. One of them can best be compared with the present watercolor;[15] the others, one of which was also used by Fergusson, show the then condition of the toranas or gates.[16] Whatever Daly's artistic career was, he followed the style of the picturesque in rather soft coloring. The mountains and hills visible in the right-hand background in reality do not exist and served to render this painting more "picturesque."

NOTES

1. Alexander Cunningham, *The Bhilsa Topes, or Buddhist Monuments in Central India.*, London 1854.
2. Simpson 1896, pp. 58–60. The last quotation is, following Simpson, from Alexander Cunningham, *Bhilsa Topes, or Buddhist Monuments in Central India*, London 1854, p. 184. For a comprehensive etymology of the words "tope," etc. and a short description of the monument, cf. Marshall 1936, p. 31ff; Mitra 1957, p. 12ff.
3. For a col. reproduction of ths painting, see Dehejia [ed.] 1996, p. 142, fig. (= Archer / Theroux 1986, p. 103, col. plate)."
4. For a comprehensive mid-nineteenth-century account on Bhilsa and its monuments, see Thornton 1854, vol. I, pp. 399–400.
5. Simpson 1903, p. 137.
6. Rousselet already referred to them earlier: "In 1822, some Englishmen, travelling over the country, discovered them [i.e. the Sanchi monuments], and shamefully pillaged them on the plea of archaeology." Rousselet 1878, p. 410
7. Rousselet 1878, pp. 410–411. For the French text see Rousselet 1877, p. 510.
8. Rousselet 1878, pp. 412–413. For the French text see again Rousselet 1877, p. 514. The last remark could also stem from George Birdwood, cf. Birdwood 1880, vol. I, p. 125 and Irwin 1973, p. 212.
9. Mitra 1957, p. 9. Wimalagnana 1972, p. 62. Marshall 1936, pp. 26–27. Head 1991, p. 25. For a groundplan showing the breach cf. Fergusson/Spiers 1910, p. 25.
10. Mitra 1957, pp. 9–10. It is believed that the gateways of the Great Stupa, also called "Stupa 1," were wrongly re-assembled, cf. Mitra 1957, p. 10, note 1.
11. For a plan of the monuments see Marshall 1936, pl. X; Mitra 1957, pl. XI. For a photograph of Stupa 3 in its reconstructed state with its reassembled gateway, see Marshall 1936, pl. VI, facing p. 92; also Le Bon 1887, p. 216, fig. 81 with the stupa behind still in ruins. The best and most comprehensive account of Stupa 3 is in Marshall/Foucher 1940, with reproductions of each of the bas-reliefs.
12. Archer 1990, p. 241.
13. For an account of the oldest British drawings of the Sanchi monuments see Head 1991, p. 25.
14. Fergusson/Spiers 1910, vol. I, p. 67; Archer 1969, vol. II, pp. 553–556.
15. Renié/Vignau 1992, p. 124, pl. 62, full-page engraving in Rousselet 1877, p. 507 = Rousselet 1878, p. 409.
16. The northern gateway: Renié/Vignau 1992, p. 124, pl. 63, full-page reproduction p. 70, full-page engraving in Rousselet 1877, p. 511 = Rousselet 1878, p. 411 = Fergusson/Spiers 1910, vol. I, p. 115. Northern gateway, right pillar: Renié/Vignau 1992, p. 124, pl. 64, full-page reproduction p. 71. Northern gateway, architrave: Renié/Vignau 1992, p. 124, pl. 65, reproduced p. 125, bottom. Eastern Gateway: Renié/Vignau 1992, p. 124, pl. 66, reproduced on p. 126, top, engraving in Rousselet 1877, p. 18 = Rousselet 1878, p. 414. Eastern gateway, architrave: Renié/Vignau 1992, p. 124, pl. 67, reproduction p. 126, bottom. Ruins of the southern gateway: Renié/Vignau 1992, p. 124, pl. 68, full-page reproduction p. 72, engraving in Rousselet 1877, p. 519 = Rousselet 1878, p. 415. Ruins of the western gateway: Renié/Vignau 1992, p. 124, pl. 69, full-page reproduction p. 73, engraving in Rousselet 1877, p. 520 = Rousselet 1878, p. 416.

61 Six Oval Paintings on Ivory

~

Delhi, between ca. 1850–1880

a. Portrait of Bahadur Shah II
(b. 1775, r. 1837–1858, d. 1862)
Size: 2¹⁄₂ x 2 in. (6.4 x 5.1 cm.)

**b. The Taj Mahal as Seen with
the River Yamuna in Front**
Size: 2¹⁄₂ x 2 in. (6.4 x 5.1 cm.)

c. The Qutb Minar, Delhi
Size: 2¹⁄₂ x 2 in. (6.4 x 5.1 cm.)

d. The Kashmiri Gate, Delhi
Size: 2¹⁄₂ x 2 in. (6.4 x 5.1 cm.)

**e. The South View of
the Jama Masjid, Delhi**
Size: 2¹⁄₂ x 2 in. (6.4 x 5.1 cm.)

f. The Golden Temple, Amritsar
Size: 2¹⁄₂ x 2 in. (6.4.x 5.1 cm.)

a. From the number of descriptions of the palace of Delhi visited by Europeans during the reign of Bahadur Shah II,[1] the following seems to be the most informative as to the description of Bahadur Shah in his position of being the last Mughal emperor:

We ... entered the room where the Emperor [i.e. Bahadur Shah II] *was sitting cross-legged, after the Oriental fashion, on a charpoy* [here: a kind of low stool], *with cushions on each side to lean upon, engaged in eating his dinner, using his fingers only, without knife or fork. As we entered, the Emperor looked up at us for a moment with a flash in his eye that was easily understood. We belonged to the white-faced race, and were of the religion that he detested; and the man must have keenly felt, as we stood in his presence and looked at him, how fallen he then was.... His dress was rich, his vest being cloth of gold, with a beautiful coat of Cashmere, and a turban of the same material. The figure of the old man was slight; his physiognomy very marked; his face small, with a hooked or aquiline nose; his eyes dark and deeply sunk, with something of the hawk aspect about them; his beard was grey and scanty, running down to a point. Notwithstanding his crimes, it was impossible to look upon this descendant of Tamerlane without emotion.*
(Reverend William Butler at Delhi, between December 5 and December 24, 1857)[2]

Abu'l-Muzaffar Siraj ad-Din Muhammad Bahadur Shah II was the last Mughal emperor. Between January 27 and March 9, 1858, he was put on trial by the British for taking part in the "mutiny" of 1857. Although he was basically a puppet in the hands of his son and other ambitious people — he was well over eighty-one years old when the "mutiny" broke out — he was found guilty on some charges.[3] As a result, he was exiled to Rangun, where he died on November 7, 1862. He was buried "behind the quarter guard of the English lines. But no Taj or Mausoleum will ever rise over the spot where he rests, solitary and alone, on a foreign shore and in a felon's grave, the last descendant of the Great Moguls!"[4] Indian paintings on ivory are only very rarely dated, and the dating of portraits of Bahadur Shah in particular can be quite controversial, even when the paintings in question bear dates, as shown elsewhere.[5] A few paintings on paper allow comparison. One of them, in the Metcalfe album, bears the date 1844 and represents "The Emperor Buhadoor Shah" with a white beard.[6] Another portrait set into an oval frame dates from about 1852. It was "painted on ivory by the Court portrait-painter" and is a beautiful specimen "of native art, and very correct likeness ..."[7] Undated head-and-shoulders set into an oval frame include another painting on paper[8] as well as a nineteenth-century reproduction in colors.[9] There are also paintings showing Bahadur Shah II in *darbar.* One of them bears the date of 1839 and represents the emperor with a black beard,[10] which is fully white in another, apparently much later painting.[11] As will be shown below, certain subjects like the portraits of the Mughal emperors or monuments, were copied throughout the nineteenth until the beginning of the twentieth century. It is very problematic to assign a safe date to a portrait like the present.

Portraits on ivory of Bahadur Shah II were indeed for sale to Western tourists, as the following quotation shows:

A number of dealers came to me to offer paintings on paper and on ivory. I noticed views of the different monuments of India, a portrait of the emperor of Delhi and those of several native women of delightful beauty. These paintings are generally of an extraordinary delicacy. (Louis Deville in Delhi, March 19, 1853)[12]

Painted portraits of Bahadur Shah II done by Western artists seem in no way more reliable than those by the Delhi painters.[13] A photograph, however, shows very clearly that the present portrait is in fact very reliable.[14]

b. *The Taj is situated on the banks of the Jumna, its golden crescent rising 270 feet above the level of the river.... The terrace of pink sandstone on which the Taj stands is 960 feet in length and 330 in width; and one end of it is bathed by the Jumna, while the other is only a few feet above the level of the garden....It is impossible not to be struck with the first view of the Taj, and here the traveller cannot, as is often the case, be deceived and*

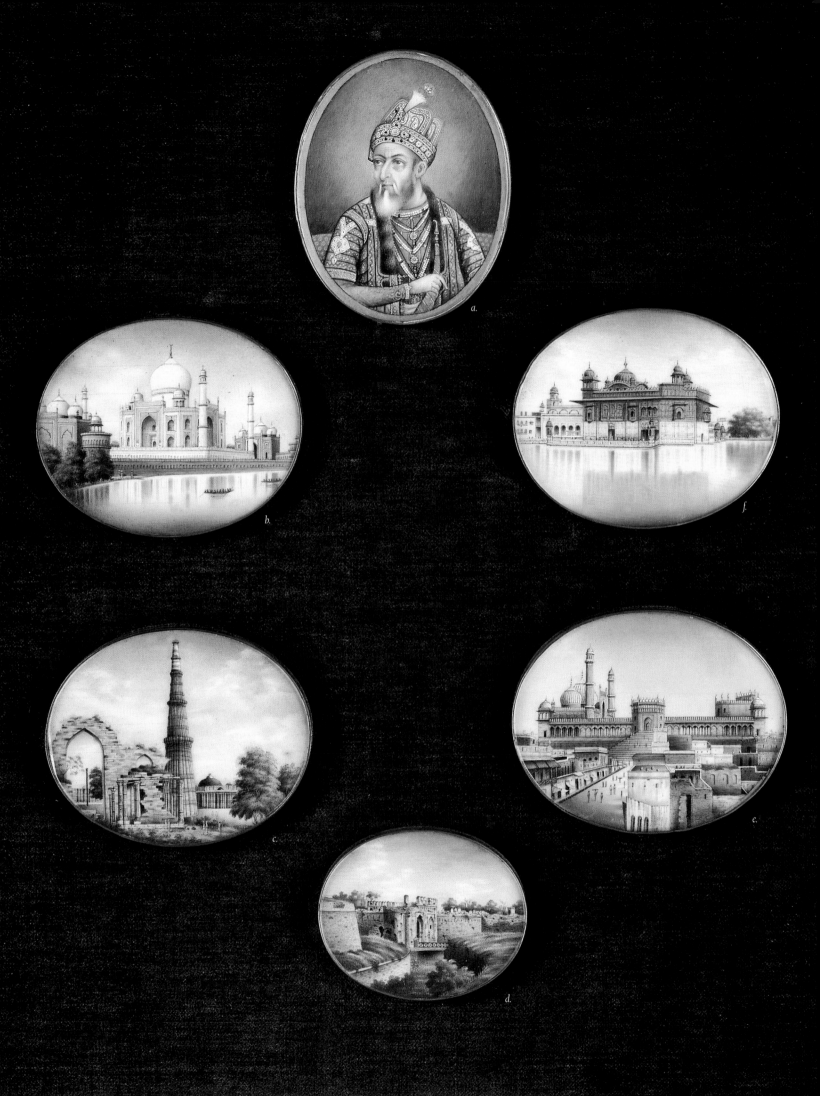

a.

b.

f.

c.

c.

d.

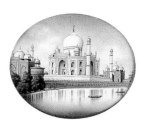

disappointed by an exaggerated description. Repeated visits only serve to bring some new beauty to light; and, as I myself found, you can live there a week without wearying of it, daily discovering new points of interest.... Complying with the Mussulman rule which requires a place of worship to be attached to every mausoleum, Isâ Mahomed built, at the western extremity of the platform, a beautiful mosque of red sandstone, surmounted by three domes, the colour and proportions of which contrast well with the Taj: but, when the mosque was completed, Isâ found that the terrace had a one-sided appearance; and to remedy this defect he erected a building similar to the mosque at the eastern extremity, which, however, could not be utilised on account of its position. This he named Jawab, or Response, as it answered to the mosque. (Louis Rousselet, November 1867)[15]

The "Response" can be seen in the left-hand part of the painting; the mosque appears in the right hand part behind the Taj. On the British use of the latter, Emily Eden remarked:

You cannot conceive what a pretty fête they gave us at the Taj, or how beautiful it looked by broad daylight. The whole society, with our camp, was just one hundred people, and we dined in what had once been a mosque, but it was desecrated many years ago. Still I thought it was rather shocking our eating ham and drinking wine in it, but its old red arches looked very handsome. (December 30, 1839)[16]

The great sight, every one knows, is the Taj Mahal. I had read of it, had seen models and photographs of it, but had not the faintest idea of its extraordinary beauty till I saw the reality. It is, I believe, the beautiful proportions of the huge building which so attract the eye; nevertheless, I cannot wholly account for the impression it leaves on the mind, of a peculiar solemn magnificence that can never be understood until experienced. (Francesca Wilson as published in 1876)[17]

But the wonder of Agra, if not of India, is the Taj, the famous monument of love, in which Shah Jahan lies at the side of the beautiful Mumtaz. I could repeat here its basic dimensions, the estimated amount of money spent for its erection, the number of its terraces, its minars and cupolas, the shape of its arches, the design of its wall-structure and the names of its ornaments; but I will not commit that same blasphemy. The Taj should be seen and felt, one can neither describe nor depict it. One has called it a poem, a dream in marble, a castle built in the air with dew and sunbeams. These epithets are not exaggerated if one wants to give an imagination of the parfume of courage and elegance which, in the light of this master-piece, for the first time made me understand the whole poetry of stone. (Eugene Goblet d'Alviella, 1876)[18]

A great number of paintings on ivory show the Taj from the South, at times set into a carved ebony or sandalwood frame[19]; fewer, it seems, represent the view with the river Yamuna in front, as in the present painting.[20] A number of oval ivory paintings were also placed symmetrically together on an ebony frame, quite often with the South View of the Taj in its center.[21] The present view might then become one of the often smaller ivory paintings that surround the central one, and at times, even forms part of a bracelet, in which each member is formed by an oval ivory painting.[22] When cataloguing an oval ivory miniature of the Jama Masjid of Delhi (cf. e. below), H. H. Cole remarked: "The artist's perspective is usually correct, owing probably to the use of a photograph to work from."[23] This assumption is corroborated by Valentine Prinsep, who remarked on January 13, 1877: "To-day I have received visits from the artists of Delhi: they are three in number, and each appears to have an atelier of pupils.... They work from photographs and never by any chance from nature."[24] The copying of photographs by the Delhi painters is also confirmed by the *Gazetteer of Delhi*, 1883–1884, which is quoted further below. Photographs which might have been used as models for the present ivory painting include two photographs by John Murray, taken in the early 1850s,[25] a photograph of slightly later date,[26] and a photograph taken in November 1867, now lost, of which a woodcut-engraving survives.[27] A comparison of these photographs with the ivory painting reveals the close similarity between both media, which, as in all the following cases, cannot be accidental.

c. *At the southern extremity of the plain of Delhi, marking the limit of its immense field of ruins, stands the stately triumphal column erected in the very centre of the last Hindoo capital by the Mussulman conqueror, Koutub-Oudin-Eibeg. Situated on a slight eminence, this column, commonly called the Koutub, is visible from all parts of the plain, over which it towers majestically. I was not a little eager to have a closer inspection of this colossus, round whose base are crowded some of the finest monuments of India, and towards which, for some days past, my companions had been constantly turning their glances, unable to comprehend why I lingered near ruins which had no interest in their eyes; but I should advise any traveller who may follow in my footsteps at Delhi to imitate my example, for, after once seeing the group of monuments of the Koutub, he can bestow only an indifferent glance on all the rest. . . . Not one of our European monuments can give an idea of the impression felt on standing for the first time before this colossus. The loftiest towers of our cathedrals, those of Strasbourg and Fribourg included, always rest upon such enormous basements, and terminate in such slender points, that their height impresses one more by the statement of the figures which represent it than by the effect itself. Here, on the contrary, the isolation of the building and the simplicity of its outlines lend it the appearance of even larger dimensions than it really possesses; and the architect himself has indulged his fancy for exaggerating the ordinary effect of perspective by giving the tower the form of a cylinder lessened towards the summit, or of a portion of a very elongated cone, and by dividing it into four stories, diminishing in height as they are farther removed from the ground. The diameter of its base is about forty-six feet, and of the platform at the summit ten. Its ornamentation is singularly effective, although very simple as a whole. Each story, alternately covered with perpendicular, round, or angular flutings, is surrounded by a broad girdle of flowers and arabesques, and supports a massive balcony, covered with sculptures of great beauty, standing out in strong relief from the tower. The entire building is of red sandstone, with the exception of the upper part, which is encased in white marble; and a fine winding staircase leads to the summit, which commands a very extensive view of the plain, stretching to the north as far as modern Delhi, and to the south reaching up to the environs of Bindraband.* (Louis Rousselet, February 2, 1868)[28]

The Kutub Minar is eleven miles from Delhi; it is an extremely lofty and ancient pillar, from the top of which there is a fine view of the interesting and picturesque country, surrounding the ruins of bygone Delhis, and of the present long-suffering survivor. (Francesca Wilson, as published in 1876)[29]

As to the [Qutb] Minar itself, I can only say that I have seen most of the splendours of Italy, yet nowhere — not even in Florence, where they can boast of Giotto's Tower — have I seen so perfect a work. Ring or belt after belt of delicate tracery, interwoven with texts of the Koran, rises to the height of 250 feet, while the whole is a beautiful reddish colour, slightly mottled, not by time but intentionally. I have not seen the Taj: I go there next week; but if it equals what I have already seen, it must be a wonder indeed! The Jumma Masjid, the Dewan-i-Khas, and the Kutub have sunk deep into my imagination; why, then, am I to paint Cremorne and the Crystal Palace and Brummagem ironwork? (Val. Prinsep, January, 1877)[30]

Several similar depictions on ivory of the Qutb Minar and adjacent buildings exist.[31]

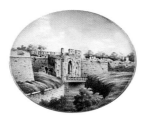

d. *No. 3 Column advanced to the turn in the road leading to the Cashmere Gate, and halted while the explosion party went on to blow in the gate. It was intended that this dangerous operation should be done just as the day broke, but, from the delay that had arisen, it was now broad daylight; and the operation was, therefore, one of fearful hazard.*

The explosion party consisted of Lieutenants Home and Salkeld, of the Engineers; Sergeants Carmichael, Burgess and Smith, of the Bengal Sappers, and eight Native Sappers to carry the bags of powder. A bugler of H.M.'s 52nd (Hawthorne) also accompanied the party, to sound the advance when the gate was blown in. There was an outer barrier gate which was found open, and Lieutenant Home then advanced over the broken drawbridge across the ditch with four men, each carrying a bag of twenty-five pounds of powder, which was deliberately laid at the foot of the great double gate. So utterly paralyzed were the enemy at the audacity of the proceeding, that they only fired a few straggling shots, and made haste to close the wicket with every

appearance of alarm, so that Lieutenant Home, after laying his bags, jumped into the ditch unhurt. It was now Salkeld's turn. He also advanced with four other bags of powder, and a lighted port-fire. But the enemy had now recovered their consternation, and had seen the smallness of the party, and the object of their approach.

A deadly fire was poured upon the little band from the top of the gateway from both flanks, and from the open wicket not ten feet distant. Salkeld laid his bags, but was shot through the arm and leg, and fell back on the bridge, handing the port-fire to Sergeant Burgess, bidding him light the fuse. Burgess was instantly shot dead in the attempt. Sergeant Carmichael then advanced, took up the port-fire, and succeeded in the attempt, but immediately fell, mortally wounded. Sergeant Smith, seeing him fall, advanced at a run, but finding that the fuse was already burning, threw himself down into the ditch, where the bugler had already conveyed poor Salkeld. In another moment a terrific explosion shattered the massive gate. The bugle sounded the advance, and with a loud cheer the 52nd charged through the broken gateway.

Thus was accomplished one of the most daring acts probably on record. Salkeld, Home, Sergeant Smith and Bugler Hawthorne received the Victoria Cross from General Wilson. But poor Salkeld, after lingering several days, died of his wounds; and the gallant Home, after his hair-breath escape, met death accidentally soon afterwards, while blowing up the Fort of Malagurh. (Julius George Medley, an eyewittness to the scene, who was himself wounded during the assault on Delhi, September 14, 1857)[32]

The Third column had, in the meantime, advanced toward the Cashmere gate, and waited the signal of the explosion. The party, to whom the blowing in of the gate had been committed, consisted of two officers of Engineers, three sergeants, and eight native sappers, with a bugler to sound the advance, if successful. This work was to have been done before dawn, but, through some mistake, it was broad daylight before they reached the spot. Lieutenant Home walked through the outer barrier gate, which he found open and crossed the broken drawbridge with four men each carrying a bag of powder. The enemy, in alarm, shut the wicket, and Home had time to arrange his bags and jump into the ditch. The firing party followed with four more bags of powder, and a lighted port-fire. The enemy now understood what we were about. The wicket was opened; through it, from above, and from every side, came the bullets of the sepoys. Lieutenant Salkeld was wounded in two places, but passed the light to Sergeant Carmichael, who fell dead while attempting to fire the train. Havildar Madhoo was also wounded. It was done by Sergeant Burgess, who immediately sunk with a mortal wound. Sergeant Smith ran forward to see if it was right, and had just time to throw himself in the ditch, while bugler Hawthorne bore away Salkeld upon his back, bound up his wounds, and carried him to a place of safety. The explosion took instant effect, and our column burst through the shattered gates.... (By an anonymous witness, whose report was published in 1858)[33]

The contemporary authors were so excited about this assault that they often forgot to mention that the "native sappers" were also not left unhurt. Havaldar Madhu, of the Bengal Sappers and Miners, was wounded, as stated by the source quoted above. A memorial tablet, placed at the gate in 1876, also mentions that Havaldar Tilak Singh of the Bengal Sappers and Miners was mortally wounded and Sipahi Ram Het of the Bengal Sappers and Miners was killed. Prior to September 14, 1857, the Kashmiri Gate was just one of the gates allowing entrance to the city of Shahjahanabad. It was then the only double gate of the city. After that event, it became one of the most often described and photographed landmarks of the city. A woodcut-illustration published in *The Illustrated London News*, November 28, 1857, is titled: *The Storming of Delhi - The Cashmere Gate*.[34] This illustration, however, hardly includes this by then famous gate. When describing and photographing places in India connected with the "mutiny," almost two decades after this event, Francesca Wilson noted, together with an actual photograph:

The strength of the walls [of Shahjahanabad] *must have been very great; they are wonderfully little injured considering all that they went through; but still, of course, there are numerous breaches, especially near the Cashmere Gate, rendered famous as long as the world shall last by some of the most glorious acts of bravery ever known. It was here, when Delhi was taken on the 14th of September, 1857, that Lieutenant Home with Sergeants John Smith and Carmichael, and Havildar Madhoo...*[35]

e. *I left the bungalow, and ... proceeded towards the mosque, the sacred Jummah Musjid, one of the monuments which the Mussulmans of Central Asia and of India most venerate and admire. This edifice, entirely composed of red sandstone, is raised upon an immense terrace, to the summit of which three magnificent pyramidal staircases lead, each terminating in a monumental doorway.* (Louis Rousselet, January 25, 1868)[36]

The Djemma Musjid [of Delhi] *is considered to be the most splendid mosque of India, if not of the Orient.* (Eugene Goblet d'Alviella, 1876)[37]

The Jumna Musjid [of Delhi] *is the largest mosque in the world, the next in size being that of Cairo* (Francesca Wilson, as published in 1876)[38]

The south view of the Jama Masjid of Delhi rarely appears on such ivory paintings, other views of the same monument — even the north view[39] — being more common. In any case, also the south view of this mosque is based on a photograph which was published as early as 1857, as a woodcut-engraving.[40]

f. *It is in the small city of Amritsar, two hours from Lahore by railway, where the major religious center of the Sikhs, the Golden Temple, is situated....* (Eugene Goblet d'Alviella, 1876)[41]

Umritsur is one of the spots most worth seeing in the Punjaub; it is — as doubtless every one knows — the capital of the Sikhs, and as such is doubly interesting, and in many ways different from other large cities. It is here that the great sight of the Punjaub is to be seen; I refer to the golden Temple of Umritsur. It is so unique, so unlike anything but itself, that nobody should be within 200 miles of it, and not visit it. The Temple rises out of the centre of a pretty tank, or lake as it is called, the blue rippling waves of which wash against the inlaid polished white marble court-yard which surrounds the lake. The Temple is connected with the same by a broad roadway of similar marble, protected by a golden balustrade, and golden lamps line the road on either side. The lower half of the outside walls of the building are elaborately carved white marble, the doors being solid silver, and the windows golden; while the upper half and the roof are a mass of gold, the ornamentation being numerous pretty minarets and a large bell, all made, like the rest, of brass covered with a thick plate of gold. The outside of the building is very striking, and the appearance is dazzling as it glistens in the brilliant sunlight, and is reflected in the sparkling waters of the lake. The inside — and indeed the entire edifice — is, as I said before, unique; the flooring mosaic marble, the roof consisting of thousands of looking-glasses inlaid in the most beautiful golden work, interspersed with the richest scarlet and blue lacquer-work, is nowhere imitated, except in a temple in Lahore, where, however, the resemblance is but small; the latter being very inferior. There are several chambers off the centre one under the dome, which alternate in gold and silver work; and it is hard to decide which is most striking. However, with me, the golden chambers gained the preference. In both the lower and first stories of these chambers there are priests continually employed; one to read out of the holy book belonging to the Temple, and the other to prevent even a fly from resting on the sacred pages. This he does by waving a long hair fly-flapper over the volume, sitting by the side of the priest, who reads in a droning, monotonous voice. The excessive greed displayed by the priests was both amusing and disgusting — every one expected to be fed, not excepting the men whose business it was to tie on the cloth shoes, which the police presented for our use on removal of our own shoes or boots. One must undergo this humiliating process, or one is not permitted to go down into the paved court surrounding the lake. (Francesca Wilson, as published in 1876)[42]

Golden Temple or Darbar Sahib as it is locally called is a Sikh Temple situated in the heart of the City of Amritsar which is a compound Sanskrit word. "Amrit" means immortality and "sar" is equivalent to the English word "water." (From an undated local guide, published in the late nineteenth/early twentieth century).[43]

A number of similar paintings on ivory exist; most of them belong to sets described further below.[44] That the Golden Temple was in fact painted by the Delhi painters is confirmed by

an interview by Val Prinsep.[45] The Golden Temple also attracted the attention of Western painters present in this catalogue, such as Edwin Lord Weeks[46] or William Carpenter.[47]

The first actual photograph of a Delhi landmark as part of the "Brief Historical Memoir of Delhi and Guide to Points of Interest together with the Official Programme in Detail of the Imperial Coronation Durbar of 1911, specially compiled for the Guests of the Government of India" is — not surprisingly — a photograph of the "Kashmir Gate."[48] The Kashmiri Gate still stands, sandwiched between an interstate bus-terminal and a large parking area in front, it is visited by foreign tourists but rarely. Rare also are published paintings on ivory, showing that monument, "famous as long as the world shall last."[49]

The Delhi painters, with their works executed on ivory, were famous throughout the nineteenth century. Their products were, if we believe the descriptions, offered for sale in the bazars. Describing such a Delhi bazar in February, 1843, Leopold von Orlich wrote: "Also paintings on ivory, of portraits, buildings as well as processions, are executed here to the greatest perfection and would do honour even to our own artists. It is not only the similarity, which one has to admire, but also the finesse and faithfulness in execution."[50] Some twenty-five years later, Louis Rousselet noted about the descendants of those artists mentioned by von Orlich:

Among the dealers who came to the bungalow at Delhi there was one class, however, that merits greater indulgence from the tourist, and which I certainly accorded to them; I mean the miniature-painters. These artists (for among them there are a few who deserve this title) execute very pretty copies on ivory of the principal monuments of Delhi and Agra; and their prices comparatively are very reasonable, since their works, although of remarkable finish, have never been much liked by English tourists. They are, for the most part, descendants of the painters formerly attached to the Court of the Moguls; and they have preserved by tradition the portraits of the principal personages of that dynasty, which they reproduce in the form of very pretty miniatures. A not less interesting fact is that some very curious and very correct copies of the principal monuments of Mecca are found amongst their works. (January 26, 1868)[51]

With regard to the last observation by Rousselet it should be noted that in one of the earlier scientific Western catalogues on Indian art an entry for Delhi painting on ivory showing a *View of Mecca* can be found. The author of the catalogue commented about its acquisition: "This view of Mecca is interesting as a record of a place of the greatest Muhammadan sanctity to which no European is permitted to go. The Delhi artist who painted it shewed me the original drawing, which he had made on the spot, and from which the miniature is copied."[52] Indian oval portraits or medallion portraits are known since the reign of the Mughal emperor Shah Jahan (1628–1656). They were executed on paper as a rule.[53] Oval portraits of the Mughal emperors illustrated Western books on Indian history since the eighteenth century,[54] but it is not stated whether they were painted on ivory or paper. Probably the best official and contemporary account on ivory painting in Delhi was published in the *Delhi Gazetteer* of 1883–1884:

There is no record of the introduction of the practice of painting on ivory. This was probably modern, and imitated from the miniatures with which our grandfathers took the place of the photograph of to-day. It is known that an English miniaturist, one of the earliest members of the Royal Academy, and a contemporary of Sir Joshua Reynolds — Mr. Ozias Humfrey — spent some years in India, and it is not unlikely that his work was copied. This is only a surmise, but it is certain that the material used in the older work was invariably fine grey paper, like that known as Cashmere paper. The "manner" of the modern Delhi miniature, excepting when it is copied from a photograph, is identical with that of the old portfolio picture or the book illumination. Water colour alone is used, and the head is drawn full front (do chasm) two eyed, or in profile (yek chasm) one eyed.

There is, it need scarcely be remarked, no indigenous oil-painting of any kind throughout the country. There are "Delhi painters" in Calcutta and Bombay, and a large amount of work is annually sold. Pictures of the

chief public buildings of Northern India are used to embellish carved ebony caskets. Others of small size are set in gold and sold as jewelry. Books and frames filled with a series of portraits of the Mughal dynasties are favourite subjects. Akbar II in durbar is frequently repeated, with a British officer who keeps his cocked hat on in the royal presence. The beauties of the court are also drawn, and it is noticeable that the Persian artist (those of Delhi claim Persian descent) paints the light-coloured Persian complexion and ignores the dusky hues of India. An exception is made in favour of Ranjit Singh, who is always represented as very dark. Sketches are extant which show that in former times the Delhi artists sketched from nature, but by dint of repeating the same heads over and over again, the features naturally became conventionalized and exaggerated, so that pecularities like Alamgir's long nose and Nur Mahal's round face are at once recognisable. In the same way in the early days of Punch, *before the multiplication of photographs put so many authentic studies from nature in the hands of the artist, familiar types were drawn and redrawn, until Lord Brongham, Derby, and Disraeli were indicated with a very few strokes. A characteristic of all Indian work is that the craftsman learns to do one thing, and then goes on doing it for the rest of his life. The Delhi draughtsmen many years ago learnt how to draw English gentlemen and ladies and English soldiers, and to-day when left to himself the* naqq'ash *shows English people in the costume of sixty years ago. The lady, even in pictures of a railway station, wears a huge poke bonnet, large gigot sleeves, her waist is just under her arm, her skirts are short and tied sandals are on her feet. The British officer invariably wears a cocked hat and a high cravat, while the private soldier is crowned by the tall infantry shako with a large round knob atop; a head dress, by the way, which copied from our troops, is still worn by the retinues of some native princes.*

The introduction of photography is gradually bringing about a change in Delhi miniatures. The artists are ready to reproduce in colour any portrait that may be given to them; and, although sometimes the hardness of definition and a certain inky quality of the shadows of some photographs are intensified, much of their work in this line is admirable. The stiffness which used to be their unfailing characteristic is disappearing; landscape, a branch of art treated in indigenous art with stern conventionality, is attempted in a freer spirit, and it seems not unlikely that a new and perhaps more fresh and vital way of looking at nature may be adopted. Supposing this change to be desirable, a point that is not absolutely certain, the Delhi work of to-day is strongly marked by the faults of its qualities — the excessive delicacy and minuteness of handling, well expressed by their customary phrase, ek b'al qalm, a brush of a single hair, the quality of the handling being far more esteemed than sound drawing, good colour, or truth of effect. The ivory used for miniatures is prepared in the city, and the mounts, said to be of Aleppo glass, are also cut, rounded and polished here.[55]

Painting on ivory flourished in Delhi until the early twentieth century, as is shown by guide-books and signed and/or attributed paintings on ivory in museum collections, as we have already remarked elsewhere.[56]

NOTES

1. On February 11, 1843, Leopold von Orlich witnessed how the Mughal emperor was lulled to sleep in the palace, cf. Orlich 1845, p. 171. When Ida Pfeiffer visited the palace of Delhi on January 20, 1848, she described it in great detail, but at the time of her visit Bahadur Shah II "was so unwell, that" she "had not the good fortune to see him," cf. Pfeiffer n.d., p. 186. For a detailed description of the emperor's physiognomy by A. Soltykoff as published in 1851, see Okada/Isacco 1991, pp. 31–32. Louis Deville describes a procession of the emperor in 1853, cf. Deville 1860, pp. 227–229.
2. Butler 1872, pp. 422–423.
3. For a comprehensive treatment of the role which the Mughal emperor played in the "mutiny," see Spear 1951, pp. 194–228.
4. Butler 1872, p. 426.
5. Cf. cat. no. 67, especially notes 11–13.
6. Kaye 1980, col. illus. facing p. 28.
7. Butler 1872, p. 113: "The pictures of the Emperor and Empress here presented were painted on ivory by the Court portrait-painter twenty years ago, and are beautiful specimens of native art, and very correct likenesses of them both." For the engraving showing "Mohammed Suraj-oo-deen Shah Gazee, Emperor of Delhi, the last of the Moguls," see ibid., p. 106.
8. Sotheby's, April 28 and 29, 1981, p. 27, lot 66.
9. Hendley 1897, pl. 9, no. 15.
10. Lentz 1986, p. 109, no. 14. For a half-finished variant cf. Leach 1995, vol. II, p. 813, no. 8.58.
11. Spear 1951, frontispiece.
12. Deville 1860, p. 227. For such a portrait on ivory see e.g. Chakraverty 1996, p. 94, col. illus., right.
13. For a woodcut-engraving after Schoefft as published on February 27, 1858, cf. *Les Grands Dossier de l'Illustration* 1987, p. 61 (= Okada/Isacco 1991, p. 28)

14. Worswick/Embree 1976, illus. p. 76; Okada/Isacco 1991, illus. p. 29.

15. Rousselet 1878, pp. 269–271. Rousselet thought that "Isâ Mahomed" was the major architect of the Taj Mahal.

16. Eden 1937, p. 362.

17. Wilson 1876, p. 25.

18. Goblet d'Alviella 1880, p. 211.

19. *Maggs Bull.*, no. 39, 1985, p. 26, no. 45; Christie's South Kensington, February 9, 1989, p. 11, lot 24; *The Journal of Indian Art*, no. 20, October 1887, pl. 2; Pal et al. 1989, p. 237, no. 255, col. Christie's South Kensington, February 2, 1995, p. 34, lot 258, lower right; Christie's South Kensington, April 27, 1995, p. 44, lots 286–288.

20. *Maggs Bull.*, no. 39, 1985, p. 46, no. 46; Pal et al. 1989, p. 234, no. 251; Christie's South Kensington, April 27, 1995, p. 43, lot 284.

21. Pal et al. 1989, p. 235, no. 253 (= Christie's, November 9, 1977, pl. 1, lot 3.) Christie's, November 24, 1987, p. 48, lot 97; Sotheby Parke Bernet N.Y., June 30, 1980, lot 10; Christie's South Kensington, April 27, 1995, p. 44, lot 285, with a view close to that under discussion in its center.

22. Christie's South Kensington, September 23, 1986, lot 40, third medallion from bottom; Sotheby Parke Bernet N.Y., June 30, 1980, lot 10, at 5 o' clock and at 10 o' clock.

23. Cole 1874, p. 75.

24. Prinsep 1879, p. 47. For a fuller quotation see cat. no. 24.

25. Christie's, June 5, 1996, p. 187, lot 290 and p. 188, lot 292.

26. Desmond 1982, illus on p. 7.

27. Rousselet 1878, full-page woodcut-engraving facing p. 266.

28. Rousselet 1878, pp. 496–497. Rousselet's description also includes several other monuments visible in this painting on ivory, as e.g. the iron pillar or parts of the Quwwat-al-Islam mosque. For a most detailed, illus. description see p. 1927.

29. Wilson 1876, p. 53.

30. Prinsep 1879, p. 43.

31. Archer/Archer 1955, pl. 11, fig. 24; Christie's South Kensington, July 23, 1985, pl. I, lot 43, central; Sotheby Parke Bernet N.Y., June 30, 1980, lot 10, at three o'clock; Christie's, November 24, 1987, p. 48, lot 97, at 12 o'clock; Christie's South Kensington, September 23, 1986, pl. I, lot 40, bottom; Christie's South Kensington, April 27, 1995 at 12 o'clock.

32. Medley 1858, pp. 108–110.

33. *History of the Siege of Delhi* 1861, pp. 247–248.

34. *The Illustrated London News*, Saturday, November 28, 1857, p. 552.

35. Wilson 1876, pp. 42–43.

36. Rousselet 1878, p. 480.

37. Goblet d'Alviella 1880, p. 228.

38. Wilson 1876, p. 42.

39. Cf. Christie's South Kensington, September 23, 1986, pl. I, lot 40, fifth ivory from top.

40. *The Illustrated London News*, July 18, 1857, p. 57, bottom: "The Jumma Musjid of Delhi.- From a photograph."

41. Goblet d'Alviella 1880, p. 249. Goblet d'Alviella goes on to describe the veneration of the "holy book," the Adi Granth of the Sikhs, which is in this temple.

42. Wilson 1876, pp. 16–19. This description is accompanied by an actual contemporary photograph.

43. *History of the Golden Temple*, n.d., p. 1.

44. Christie's South Kensington, September 23, 1986, lot 40, second medallion from bottom; Pal et al. 1989, p. 235, no. 253 (= Christie's, November 9, 1977, pl. 1, lot 3), at six o' clock; Sotheby Parke Bernet N.Y., June 30, 1980, lot 10, at one o' clock; Christie's, November 24, 1987, p. 48, lot 97, at six o'clock; Christie's South Kensington, April 27, 1995, p. 44, lot 285, at six o' clock.

45. Prinsep 1879, p. 15.

46. Eyre & Hobhouse ca. 1981, no. 45, pl. XII.

47. *The India Collection* 1982, illus. on pp. 160–161.

48. *Brief Historical Memoir of Delhi* 1911, photograph facing p. 11, by Johnston and Hoffmann.

49. Christie's South Kensington, July 23, 1985, pl. I, lot 43, right; Sotheby Parke Bernet N.Y., June 30, 1980, lot 10, at four o' clock.

50. Orlich 1845, pp. 166–167.

51. Rousselet 1878, p. 487.

52. Cole 1874, p. 74.

53. For their genesis and development see Weber 1982, pp. 50–52; pp. 249–266.

54. Cf. Dow 1792, vol. II, engravings facing p. 323 and engravings facing p. 406.

55. *Gazetteer of Delhi* 1988, pp. 137–138.

56. Bautze 1993, pp. 247–248.

62 The Taj Mahal along the River

∽

by Hugo Vilfred Pedersen (1870–1959), India, ca. 1903–1909.

Media: Oil on canvas

Size: 23⁵/₈ x 31¹/₂ in. (65.1 x 80 cm.)

Inscribed: Signed in lower left corner: "Hugo v.p."

However, Shah Jahan could easily afford to be genuinely, even tastefully, magnificent. He was a patron of the beautiful by right of birth. His Court had for generations been the comfortable resort of artists from Asia and Europe, and in him a whole age of artistic expenditure reached its colophon; a whole age of aesthetic aspiration found its highest expression in that mausoleum of marble which admires its own grace in the waters of the Jumna, when in flood, and which at this moment glares fiercely under the sun of Agra's heavens. It is the moment of Shah Jahan's grief for the loss of his favourite wife Arjumand Banu, "the Crown of the Palace." It still stands in all the pride of beauty: its smooth domes and chaste minarets without glancing white through the green tracery of the trees, its marble screens within surrounding the two empty tombs, the crypt below shielding the graves of the Emperor and the Empress, still wreathed with blossoms by pious hands, and the vaults above resounding with the voices of many visitors: the native gliding over the marble floors bare-footed, the foreigner gazing at the delicately flowered walls bare-headed — each, after his fashion, paying a tribute of respect to the memory of a lady once beloved and to the exquisite taste of a loyal prince. It is a work perfect of its kind, but it is of a kind which fails to arouse my enthusiasm. It makes me think of Euclid or of a toy-shop. The Taj seems to me to need a glass case. (G.F. Abbott, as published in 1906)[1]

Whose pen can conjure up the Taj-Mahal — this creation of the fairy world, this dream in marble that rises gleaming white in its proud purity, its lofty majesty: an overwhelming victory of Love over Death the conqueror? Who is there who does not know the Taj-Mahal in pen and pencil? Who is ignorant of its story, in its outward pomp and inward splendour? Words are powerless to depict it, colours to reproduce it — you have to see it to be able to feel its mysterious spell, to realise its incomparable beauty. An emperor's love has here raised an imperishable monument to his dead wife, has salvaged her name from oblivion and crowned her with the aureole of immortality.... In face of this snowy miracle, of this surrounding paradise, the sadness and gloom of the mutability of earthly things fade away; it is a paean as old as life and always new that falls on our ears in the whisper of the tree-tops, in the murmur of the waters. Limitless wealth and the treasures of every zone, creative power and creative instinct, the full resources of his Imperial power, did the Mogul ruler requisition to glorify his love. The Taj-Mahal is worthy of its builder, worthy of the beauty it was destined to immortalise ... Below the terrace flows the sacred Jumna.... (Count Hans von Koenigsmarck, as published in 1910)[2]

In 1892 the Danish artist Hugo Vilfred Pedersen left Copenhagen, travelled in Germany and Austria and in London, from where he proceeded to Sumatra and Java, then India, China, and even California. He is said to have spent twelve years altogether in Asia. His paintings are generally not dated, but due to the fact that in all probability he was present at the Delhi Darbar of 1903[3], and painted four portraits of the then Viceroy of India (1899–1905), Lord Nathaniel Curzon of Kedleston,[4] and one portrait each of the Earl of Minto as Viceroy (1905–1910) and Lady Minto, he must have worked in India at least between 1903 and 1910. A safe *terminus post quem* is offered by a painting illustrating an event of January 4, 1906 in Calcutta.[5] The Taj Mahal was one of Pedersen's favorite subjects. Of the present painting, a close, but much larger version as well as a smaller one exists. There are two additional views by him, showing the monument from the garden.[6] The hazy view seems to be characteristic of Pedersen's renderings of the Taj Mahal. It seems to reflect the somewhat romantic and dreamy descriptions of the monument which prevailed at that period.

NOTES
1. Abbott 1906, p. 156. Abbott had acccompanied Their Royal Highnesses the Prince and Princess of Wales on their Indian tour as a special correspondent of the *Calcutta Statesman*. The description is accompanied by a photograph which is taken from the same viewpoint as the present painting.
2. Koenigsmarck 1910, pp. 117–120.
3. We ascribe the painting of the procession in front of the Jama Masjid in Delhi to this artist, cf. Curzon 1984, double-paged col. pl. between pp. 112–113. Pedersen also painted the twenty-two members of the Imperial Cadet Corps present at this *darbar*, cf. Gautier 1944, p. 34.
4. For a photograph showing the artist at work on one of these portraits, see Gautier 1944, p. 10.
5. For this painting with the Prince of Wales, see Gautier 1944, p. 42.
6. Christie's, June 5, 1996, pp. 117–119, lots 150–153.

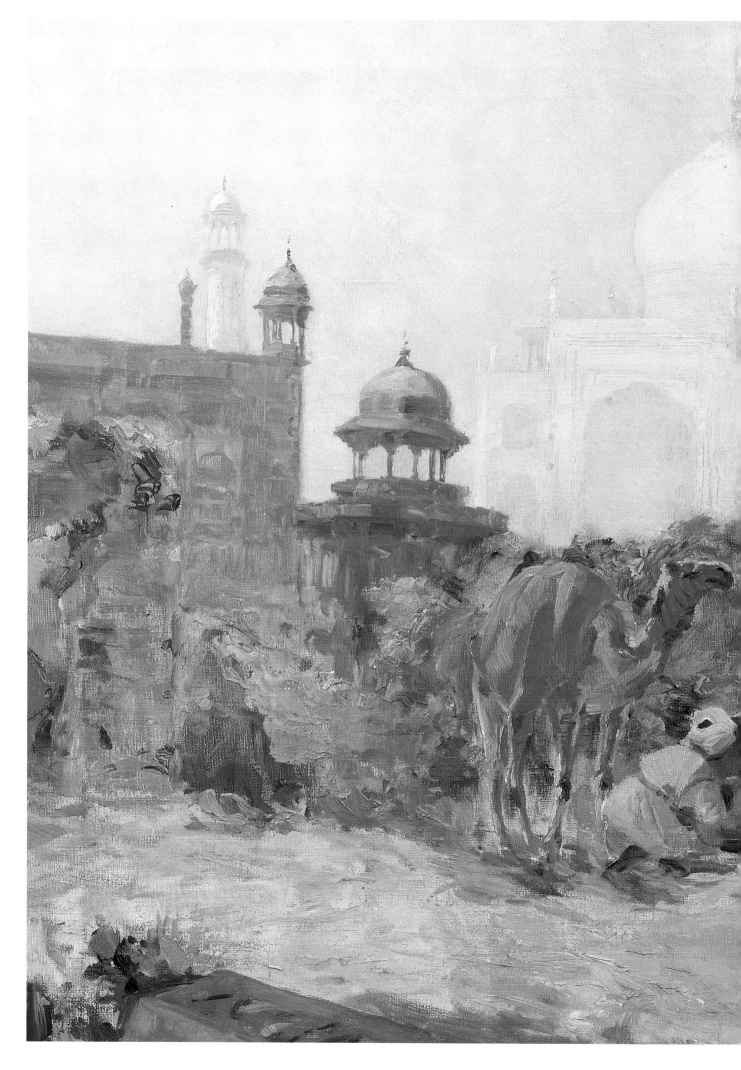

TOMBS, MOSQUES, AND OTHER MONUMENTS

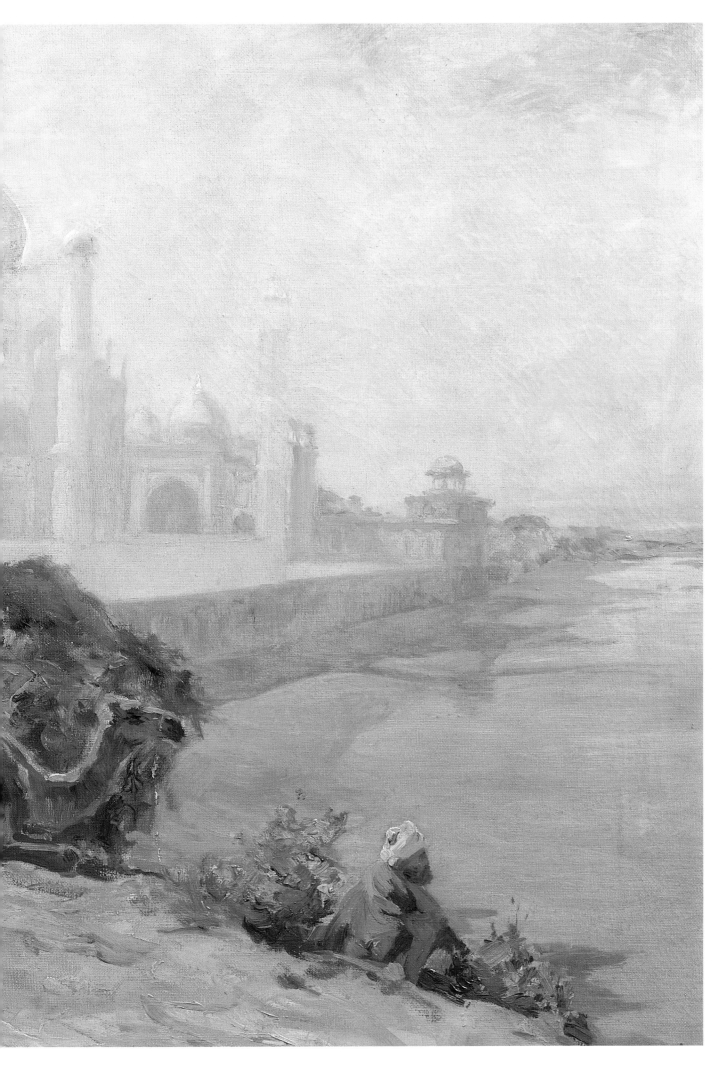

FORTRESSES,
CITIES,
AND THEIR ROADS
AND PALACES

63 Acrobats Performing on a Tightrope within the "Dilkusha"(Heart's Delight)-Palace

∽

ascribed here to the circle of Faiz-ullah, Lucknow, ca. 1775–1780.

Media: Gouache on paper

Size: 19 x 24¹/₂ in. (48.3 x 62.3 cm.)

Inscribed: In the text panel below the painting, in *Nashtaliq*, in ink: *majlis-i zanana[h] dar tamasha-i bazigaran-i rasanbaz 'imarat-dilkusha* (assembly of women during a performance of tightrope-acrobats in the beautiful buildings of the Dilkusha).

Provenance: Antoine Polier, Lady Coote, John MacDonald, William K. Ehrenfeld, M.D.

Published: Johnson / Breuer / Goldyne 1995, p. 173, no. 226, col. plate.

Collection: Achenbach Foundation for Graphic Arts, Fine Arts Museums of San Francisco, Gift of Dr. and Mrs. William K. Ehrenfeld, 1983.2.12.

On my assenting, in less time than I could have supposed possible, four long bamboos were fixed in the ground, and a slack-rope suspended between them, on which the boy, throwing off his bird's dress, and taking a large balancing-pole in his hand, began to exhibit a series of tricks which proved him to be a funambulist of considerable merit. He was a little and very thin animal, but broad-shouldered and well made, and evidently possessed of no common share of strength as well as of agility and steadiness. Meantime, while he was gambolling above, the musician below, who was an old man, and whose real or assumed name was Hajee Baba, went through all the usual jests and contortions of our English "Mr. Merryman," sometimes affecting great terror at his companion's feats and the consequence of his falling, — sometimes bidding him "Salam to the Sahib Log," or challenging him to still greater feats of agility and dexterity. (Reginald Heber, January 10, 1825)[1]

After the jugglers came the acrobats, the most remarkable of whose performances was the dance on a loose rope. The performer, with naked feet, walked upon this rope, carrying in his hand a balancing-pole, and upon his head a lot of earthenware jars. Having got to the middle of the rope, he caused it to swing rapidly to and fro, and balanced himself by accommodating the agitation of his body to that of the rope, his head meanwhile remaining motionless. Another acrobat walked along the rope with buffalo horns tied perpendicularly to his feet. Surprising indeed is the skill they exhibit. (Louis Rousselet, January 31, 1867)[2]

A structure called Dil Kusha in fact existed in Lucknow, but the present painting does not show it. The Dil Kusha of Lucknow, which became the residence of the British General of the Commanding Division in 1857, was only built during the reign of Nawab Sadat Ali Khan (1798–1814).[3] The structures shown in this painting are the depiction of an ideal world of the *zenana* or female apartments within the layout of a palace and hence only existed in the artist's imagination. The acrobatic feat, however, possibly happened, although it is unlikely that the rope-dancers performed at such a height as indicated here. Both performers have placed "earthenware jars" on their head, as observed by Rousselet. The woman to the right even walks on some "buffalo horns," as also mentioned by the French traveller.

Although individual Indian depictions of rope-dancers are very rare,[4] a second contemporary version of the same atelier, first provenance and dimensions exist. It is in the collection of the Museum of Indian Art, Berlin and was published a number of times.[5] The only major difference is the arched grill and the balustrade of the present version, which the painter introduced in order to give the impression of looking out of a window. This indication of a kind of window is not present in the Berlin version, which is also devoid of clouds and without any inscription in the text panel. The other differences are basically confined to the coloring of the terraces, the shape of the roof of the buildings in the background, the cypresses in the Berlin version and the central garden house of the San Francisco version. The Berlin version, like the present version, belongs to a *muraqqa* (album with Indian miniatures and calligraphies) which was once in the collection of Antoine Polier. Antoine Polier came from Lausanne and went to England to join the East India Company in 1756, when he was only fifteen years of age. The following year he moved to Calcutta, and in 1766, he became a Major. In 1767/68 Polier received from the emperor Shah Alam II (1760–1806) his first dated *muraqqa*. With the support of Warren Hastings, he received permission to stay at Lucknow. The support of Hastings was necessary since non-British citizens were not supposed to attain higher ranks in the army. At Lucknow, Polier continued to collect Indian paintings, *muraqqas* in particular. In an often published conversation scene by John Zoffany, Polier is shown with one of his *muraqqas* near him on the table,[6] and he also figures in the the mezzotint after the same painter's *Colonel Mordaunt's Cock Match*, standing in the back below the awning, in cat. no. 35.

After having spent thirty-two years in India, Polier left Lucknow in 1788 and reached London the following year. He took with him a considerable number of *muraqqas* to Europe, where he published books on Indian mythology and history. Finally he moved to France, and settled near Avignon, only to be murdered there in 1795. Today, Polier's albums are distributed among different museums in Europe. Some of them were offered at public sales as late as 1966 and 1974.[7] A dedicatory inscription on the third fly-leaf of the album (in the Western sense) provides evidence that the present painting forms part of a Lucknow album that was once in the possession of Colonel Antoine Polier. The original binding of the album is preserved and has entered the collection of the Achenbach Foundation for Graphic Arts, Fine Arts Museums of San Francisco together with ten folios of paintings and seven folios of calligraphy, including the dedicatory page.[8] The inscription reads: "For / Lady Coote / from / Her most obedient H[onoura]ble Ser[van]t / A[ntoine] P[olier]." Lady Coote was the wife of Eyre Coote (1726–1783), whom she married at St. Helena on July 8, 1763. Until then she was Miss Susanna Hutchinson, daughter of the governor of that island.[9] Mrs. Coote was "a very agreeable woman, with an uncommonly mild and sweet toned voice."[10] It is not known when and where she was given this album. Lady Coote returned to London from India in 1784 to arrange the last burial of her husband, who had been exhumed from St. Mary's Church, Madras, where he was buried with full honors on April 28, 1783. It is not reported whether she returned to India before 1788, the year Polier left Lucknow. She might therefore have received the album in London, in or some time after 1789, the year in which Antoine Polier returned to that city. Lady Coote died in London in 1812.[11]

The album in the Achenbach Foundation for Graphic Arts, Fine Arts Museums of San Francisco is the only known Polier album outside Europe. Polier might have given it away because he owned another closely related copy. The Berlin version of the present painting belongs to that other copy which Polier had; it is still complete and consists of sixteen folios. The album in Berlin was assembled in 1785 or later; the latest calligraphy is dated that year. Eight of the sixteen folios of the Berlin album reappear in very close versions in the album of the Achenbach Foundation for Graphic Arts.[12]

While in Lucknow, Polier might well have seen scenes very similar to those shown here. A pavilion which resembles the one in the present painting reappears in the background of a painting that shows him watching a *nautch* (dance performance), presumably at Fyzabad, the capital of Oudh. Since the painting is an Indian copy of a picture by a European artist, it seems to be quite reliable as to its subject.[13] Antoine Polier was probably one of the few Europeans in India who appreciated and probably also understood Indian paintings without questioning their aesthetics. He certainly valued and he definitely collected them. The inscriptions below the paintings of the album in the Achenbach Foundation for Graphic Arts might even stem from Polier himself. The paintings of the first albums that Polier acquired were labeled by him in French. In course of time he learned to use Indian languages with ease and identified the paintings in the local language.

It is difficult to decide which artist painted this picture, since the Nawabs of Oudh seemed to have supported an immense atelier. Of the possible artists, Faizullah, Mihr Chand, Sital Das, Faqir Ullah Khan, and Mir Kalan Khan, it seems that one of the first two mentioned painters is most likely to have done this painting. Faizullah is known for his garden scenes which he rendered utilizing Western perspective, and Mihr Chand often painted his figures with shadows.[14]

NOTES

1. Heber 1828, vol. I, p. 584. The "bird's dress" of the boy mentioned by Heber was part of the performance as shown in Indian miniatures. It appears e.g. in the lower left corner of a painting in the Museum of Indian Art, Berlin (reproduced: Goetz 1930, Tafel 41, fig. 112; Weber 1982, p. 554, Abb.114).
2. Rousselet 1878, p. 321. For the original French text see Rousselet 1877, pp. 392–395.
3. Sharar 1975, p. 52. For further information on the "Dilkoosha" cf. Ubbas Ali 1874, pp. 10–11. For an actual photograph see ibid., view 5.
4. This subject should not be confused with the depiction of acrobats balancing on the top of a pole or some sort of cross-beam; cf. the painting referred to in note 1 supra or Vatsyayan 1982, col. pl. XXXIV and fig. 134. An illus. of the *Nat Ragini* in the India Office Library, London, showing rope dancers, is in fact not an individual miniature since it forms part of a larger series of pictures, a *ragamala*. For the reproduction of this painting see Goetz 1930, Tafel 41, fig. 114 (= Falk /Archer 1981, p. 462, no.351xxxvii).
5. Gothein 1926, pl. 35, reproduced without inner border; Hickmann 1975, fig. 86, reproduced with inner border; Härtel/Lobo 1986, p. 203, cat. no. 110, reproduction of the full page; Härtel/Lobo 1986, p. 197, cat. no. 105, reproduced in full color, but without the outer floral border. The page measures 18^{1}/$_{16}$ x 24^{5}/$_{8}$ in. (45.7 x 62.5 cm.)
6. Archer 1979, dust cover and col. pl. VII. Polier is the seated man to the left, the album is at his left ellbow. The artist John Zoffany is seated behind him.
7. Two albums were sold in one auction in 1966, cf. Sotheby & Co., December 12, 1966, lots 1–33 and lot 85 (album with 44 leaves). The French inscriptions below the paintings are in Polier's hand. Another album was auctioned in 1974, cf. Sotheby & Co., November 27, 1974, lots 723–769. Antoine Polier is shown on one folio, lot 723, reproduced on p. 78 (= Goswamy/Fischer 1987, col. pl. p. 213, no. 106, with further references to reproductions of this painting).
8. One folio of calligraphy is in the Binney collection, San Diego, cf. Binney 1973, p. 133, cat. no. 113, with a dated calligraphy of 1780/81, cf. Weber 1982, p. 574, note 3. Two more sheets are in the Fogg Art Museum, Harvard University.
9. Sheppard 1956, p. 98.
10. James Boswell in Sheppard 1956, p. 103.
11. Sheppard 1956, p. 183.
12. For a complete concordance of this large Lucknow album in Berlin see Weber 1982, Appendix 2, pp. 574–575, where all pages are listed together with their earlier publications; some of the paintings are republished by Weber himself. See also Härtel/Lobo 1984, pp. 198–205 for folios 7, 12, 13 and 14 of the Berlin album as well as Härtel/Lobo 1986, pp. 194–201 for the same folios, but with folio 14 in col.
13. This painting was presumably done by Tilly Kettle and was probably also destroyed after the storming of Lucknow during the Mutiny of 1857. It survives, however, in two Indian copies. Cf. Welch 1978, p. 89, no. 36 (= Archer 1979, p. 85, fig. 39 = Skelton et al. 1982, p. 51, no. 90) for the first and Sotheby's July 2, 1984, lot 187 for the second version.
14. True monographic surveys have not been written about any of these artists. For Faizullah cf. Goetz 1955, fig. 5; Welch 1978, p. 82, no. 33; Sotheby's, December 14, 1987, col. pl. p. 49, lot 58. For the latest research on Mihr Chand, the son of Ganga Ram, see Leach 1995, vol. II, pp. 654–656.

64 Two Views of Seringapatam

☙

by Robert Home (1752–1834),
Seringapatam, 1792.

a. N.N.E. View of
Seringapatam from Captain
Sibbald's Redoubt

Media: Watercolor on paper

Size: 9 x 12 in. (22.9 x 30.5 cm.)

Inscribed: Below painted
surface, in capital letters:
"N.N.E. View of Seringapatam
from Capt. Sibbald's Redoubt."

**b. Distant View of
Seringapatam from
Meadow's Redoubt**

Media: Watercolor on paper

Size: 9 x 12 in. (22.9 x 30.5 cm.)

Inscribed: Below painted
surface, in capital letters:
"Distant View of Seringapam
(*sic*), from Meadows Redoubt."

Contemporary descriptions relating to a. and b:

Seringapatam, the capital of the kingdom of Mysore, and of Tippoo Sultaun's dominions, derives its name from the god Serung, or Seryrung [actually: Shri Ranga], *to whom one of its pagodas is dedicated. It is situated on an island, formed by the river Cauvery, in latitude 12° 25' 40" south, and longitude 26° 34' 30" east from Greenwich. This island extends about four miles in length, from east to west, and is about a mile and a half across, in its middle or broadest part. The ground in the central part is somewhat more elevated than the rest, and slopes with a gentle declivity towards each end. The fort and out-buildings occupy about a mile of the western end of the island; and the laul baug, or great garden, about an equal portion of the eastern. This garden was laid out in regular paths of shady cypress; and abounded with fruit trees, flowers, and vegetables of every kind. But the axe of the enemy soon despoiled it of its beauties; and those trees, which once administered to the pleasures of their master, were compelled to furnish materials for the reduction of his capital. At the same time the dowlat baug, or rajah's garden, which was situated on the north side of the island, nearer to the fort, was undergoing a similar devastation by order of Tippoo, lest that also should be applied to the same purpose. The whole space between the fort and the laul baug, except the small enclosure, called the dowlat baug, just mentioned, was filled with houses, forming an extensive suburb, of which the pettah of Shaher Ganjam alone remains; the rest having been destroyed by Tippoo to make room for batteries to defend the island, and to form an esplanade to the fort. This pettah or modern structure, built in the centre of the island, is about half a mile square. The streets regularly crossing each other, are all wide, shaded on each side by trees, and full of good houses; and a strong mud wall surrounds it. In all probability this town was preserved for the accommodation of the bazar people and merchants, and for the convenience of the troops stationed in that part of the island for its defence....*

The fort itself, constructed on the west end of the island, is of a triangular figure. The two branches of the river embrace it on its longest sides. The base of the triangle, towards the island, being the face most liable to attack, is covered by strong outworks, and defended by two broad and massy ramparts, the second a considerable distance within the first. Each of those ramparts has good flank defences, a deep ditch, with drawbridges, and every advantage of modern fortification. The white walls of the fort, its regular outworks, magnificent buildings, and ancient Hindu pagodas, contrasted with the more lofty and splendid mosques lately raised in honour of the Mohammedan faith, of which Tippoo was the zealous apostle, render it a conspicuous object.
(Robert Home, as published in 1796)[1]

In late 1790 or early 1791, Robert Home arrived at Madras, when Cornwallis and his army were about to leave for Bangalore. Home, with official approval, caught up with Cornwallis and became an official artist during the third Mysore war. A portrait of Cornwallis, painted in 1792 at either Madras or Seringapatam[2] must be mentioned next to a portrait of General William Medows (1738–1813)[3]. This must be the "Meadows" of cat. 64b. William Medows, who joined the 50th regiment in 1756, served in Germany, and America, at Brandywine, 1776; at St. Lucia; at the Cape of Good Hope, 1781, and went to India the following year. He captured Nandidrug on October 19, 1791[4] and led a column in the attack on Seringapatam in February, 1792.[5]

Capt. Sibbald's redoubt of a. is known to this day: "Across the river, below Karighatta Hill, is Sibbald's Redoubt, where Captain Sibbald, Major Skelly and a small contingent of 100 Europeans and fifty sepoys repulsed three fierce attacks in February 1792."[6] In March or April 1792, Home returned from the campaign to Madras, where he contacted a certain John Sharp, who worked up Home's sketches of the Mysore country for possible publication in England. Home added a descriptive text and Sharp dispatched the worked up drawings to England, where twenty-nine of them were engraved and published in London in February 1794 as *Select Views in Mysore, the Country of Tippoo Sultan*, with historical descriptions, maps, and plans. Apparently, another edition was edited in Madras the same year.[7] The present two watercolors appear in that publication as uncolored engravings.[8] In the same year, two more publications on historical sites of the third Mysore war appeared, viz. Alexander Allan's *Views in the Mysore Country* and Robert Hyde Colebrooke's *Twelve Views of Places in the Kingdom of Mysore, the Country of Tippoo Sultan*. Both these publications contained large-sized etchings,

a.

b.

FORTRESSES, CITIES, AND THEIR ROADS AND PALACES

those of Colebrooke were even aquatinted in colors, and hence somewhat overshadowed Home's smaller, uncolored engravings.

Home reacted promptly and selected six engravings of the 1794 edition to be published on a much larger scale and in sensitive coloring. They were published in 1796 under the title *Description of Seringapatam, The Capital of Tippoo Sultaun. Intended to Accompany The Six Following Views Drawn by Mr. Home, And Engraved By Mr. Stadler.* These colored aquatints are larger than the present watercolors and partly differ in the coloring of the sky and a few other minor details. Cat. no. 64 a. corresponds to plate 1, and b. to plate 5 of that publication. As with the present watercolors, the title of each aquatint appears below,[9] with the numbering of the plate immediately below the engraved surface of the plate, right-hand corner. In the lowermost left corner of each folio is printed "Home delt.," in very neat characters. The publisher is given in the same small letters in the center, at the lowermost edge of the folio: "Published as the Act directs by Robert Bowyer, Historic Gallery, Pall Mall. April, 1796."[10]

When comparing Colebrooke's aquatints showing Seringapatam to those of Home it becomes clear that Home originally did not intend to have his views published on a large scale. Colebrooke's *East View of Seringapatam*[11] and his *N.W. View of Seringapatam*[12] are much more detailed when compared to Home's views. But both Home's and Colebrooke's views of Seringapatam share a certain lack of information: neither author describes the site; each author prefers to report on the historical events connected with the site. Colebrooke, e.g., while "describing" his "East View of Seringapatam" only states: "The annexed view was drawn from an island a little above the town, and is intended likewise to convey some idea of the river Cauvery, whose bed is full of rocks and stones."[13]

The two towers rising from the center of cat. 64a. are certainly the two minars belonging to the Jama Masjid or Friday Mosque of Tipu Sultan, who had it constructed in 1787. The other tower-like structures in a. mark the temple gates or *gopurams*, probably belonging to the temple of Shri Ranganatha Swami, after whom the town is named. The foundation of this temple dates back to the year 894.[14]

NOTES

1. Home 1796, p. 1.
2. Reproduced: Archer 1979, p. 302, illus. 207.
3. For which cf. Cotton 1928, pp. 3–4.
4. For a description of the campaign and an aquatint of this fortress see Colebrooke 1794, pl. 5: *North West View of Nandy-Droog.*
5. For details cf. e.g. Malcolm 1826, vol. 1, pp. 73–77.
6. Davies 1989, p. 572.
7. Godrej/Rohatgi 1989, p. 113.
8. a. corresponds to pl. 24, b. to pl. 27.
9. The misspelling of the place name in b. is printed correctly below the respective plate in the 1796 edition.
10. Quoted from pl. 1.
11. Pl. 11 in Colebrooke 1794, republished in Archer 1959, pl. 11; Buddle 1990, p. 10, fig. 3; *The India Collection* 1982, p. 149.
12. Pl. 12 in Colebrooke 1794, republished in Archer 1959, pl. 12.
13. Colebrooke 1794, text on the back of pl. 11, where labeled *West View of Seringapatam.*
14. For more details cf. Davies 1989, pp. 569–573.

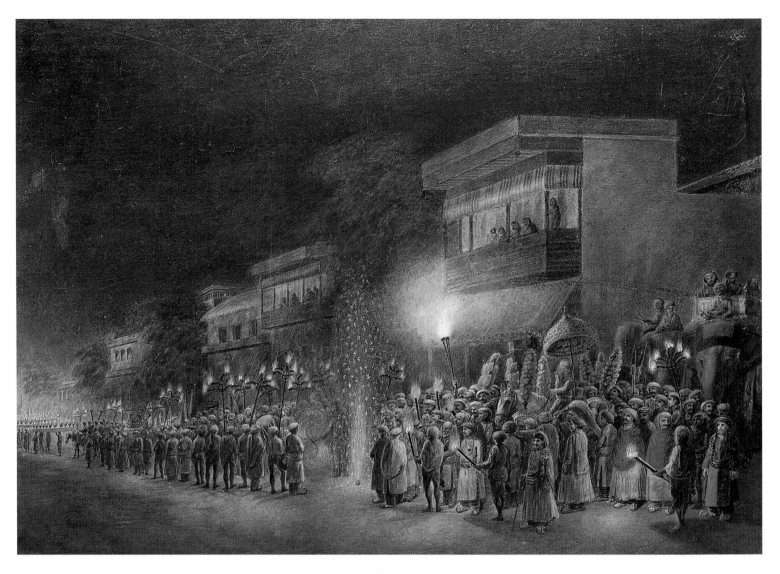

65 A Marriage Procession at Night

~

by Sevak Ram, Patna, ca. 1810–1815.

Media: Gouache on paper

Size: 15½ x 22 in. (39.4 x 55.9 cm.)

Inscribed: Below painted surface: "The Barát or Marriage Procession."

A marriage procession, here called *barát* moves from right to left in a Patna street. The *barát* is the procession of the bridegroom to the house of the bride. It generally takes place at night, as in this case. The procession is led by several men carrying large wooden tablets with lamps set in green or red glasses. This group is followed by mounted musicians in red uniforms, playing drums and long trumpets.[1] Two torch-bearers walk among them. A kind of stage, carried on men's shoulders like a huge palanquin, comes next. On this stage, two seated musicians accompany the performance of two singing women who seem to address the bridegroom. Sentries with long-barrelled guns on their shoulders seem to guard the movable stage. Additional torch-bearers[2] and men playing huge drums follow. Four red flags are visible in the back of this group of people. Fireworks in the shape of a large sparkling fountain emerging from a comparatively small container placed on the street separates this part of the procession from the bridegroom and his retinue.[3]

The young bridegroom rides a white pony.[4] His face is covered by strings of pearls. A bearer walking behind him carries a large, ornamented umbrella, the most ancient Indian symbol of sovereignty. Another such symbol is the *chauri*, a white yak-tail attached to a stick, waved by an attendant to the left of the bridegroom. Other retainers flank the small horse with beautifully arranged wands of red and pink flowers, resembling roses. Two mounted elephants, one of which carries a huge drum which is being beaten by a man behind the *mahawat* or elephant-driver, indicate that the procession changed direction here. The balconies on the upper floors of the mostly double-storied houses are populated by onlookers, partly hidden in the dark.

This painting comes from Eastern India, more precisely Patna in Bihar, which was known for its magnificent marriage processions.[5] Although the painting is not signed it can safely

be ascribed to Sevak Ram, a painter from Patna. A very similar painting once formed the fourth folio of an album which included altogether fourteen paintings by the same hand. This album was formerly in the possession of the Second Earl of Caledon; it was offered first at auction by the Trustees of the Caledon Family Settlements in 1982 during the Festival of India in Great Britain and was then acquired by Hobhouse Limited in London, from where it was dispersed in due course.[6] The paintings of this album were not done earlier than 1813, according to the "J. Whatman" watermark of that year as mentioned in the sale catalogue. The Caledon album includes another marriage procession which takes place in daylight, folio 1. This painting shows the transportable stage with the performing singers and musicians more clearly than the present painting, which with its effects of light and dark is certainly one of the most dramatic of Sevak Ram's works. The bridegroom of the first folio of the Caledon album is carried in a palanquin of which an individual study, clearly by the same artist, exists.[7]

Another marriage procession in daylight demonstrates the extent to which Sevak Ram used the houses of the Patna streets like scenes for a stage. At first sight, the houses of that painting appear to be identical with those of the present.[8] In another painting, Sevak Ram seems to have captured the same marriage procession, but here it moves from left to right.[9] The close similarity of both folio 4 of the Caledon album and the present painting is by no means an exception. Sevak Ram illustrated the same festivals in slightly varied compositions. Folio 8 of the Caledon album illustrates the Ramlila procession and so does his painting in the Chester Beatty Library, Dublin.[10] For another album or sequence of pictures, Sewak Ram selected a different kind of stage for his festivities. Everything seems to take place in a courtyard below a huge awning. His two versions of the marriage ceremony are almost identical.[11] Further similarities in composition can be detected when comparing his two depictions of the Muharram festival, each belonging to another sequence, one of which is signed and dated 1807,[12] but he also created scenes with compact masses of people which are reminiscent of Albrecht Altdorfer's *Battle of Darius and Alexander*.[13]

Sewak Ram was probably the most prolific and influential of all Patna painters, who also painted less spectacular scenes, such as his depictions of Indian professions which seem to illustrate Buchanan-Hamilton's survey of Patna and neighboring districts carried out between 1811 and 1812.[14] Buchanan, in fact, collected drawings of Indian professions which are, after all, stylistically not too different from Sevak Ram's works.[15] Francis Buchanan does not mention him by name but counts "12 Picture painters Musawir wallehs"[16] and states:

The painters (mosouwer) possess a good deal more merit than those in the districts hitherto surveyed, although they are far behind Europeans as the statuaries are. They have many sets of miniatures representing the princes of the House of Timur, and, especially in the minute attention to various parts of dress, these are well executed. They also sell various groups, representing Indian scenes and customs, in which some attention is even shewn to exhibit the effects of light and shade; but I suspect that they are copied from the drawing of some persons who have been acting under European guidance, and that they could not make any new drawing in which attention was paid to these circumstances. They are all Hindus, and are very superior workmen to the painters that were employed in the palaces of Tippoo Sultan. An inferior description of painters are at Patna, called Nukkash....[17]

Buchanan's remark, on the nature of the "Indian scenes and customs" in particular shows that he must have seen examples of Sevak Ram's works. Sevak Ram's tradition was maintained and carried on by the eleven other painters of Patna and their descendants,[18] and Patna paintings served as illustrations of things Indian in British publications of the first half of the nineteenth century. Leopold von Orlich, who travelled in India from 1842–1843, illustrates his book with numerous drawings done by artists of Agra and Patna, which were omitted from the subsequent and reduced English translation.[19] Patna paintings thus, like the aquatints of the Daniells, were influential in the shaping of the "Indian picture" in the Western mind.

1. For a contemporary description of all the different classes of musicians and dancers employed at marriage processions and ceremonies in Patna see Buchanan 1936, vol. II, pp. 612–615. The text of Buchanan's report from 1811–1812 was first published in an abridged form by Martin 1838, vol. I, pp. 327–328.

2. Bishop Heber passed a marriage procession in Calcutta on the evening of March 5, 1824. He thought that: "The number of torches carried before and on every side of the bridegroom was a practical illustration of the glorious simile of the rising sun in the Psalms," see Heber 1828, vol. I, p. 71. Buchanan reports: "The torch-makers [bari] are a numerous class. They make their torches, as usual, of cotton rags, that they chiefly procure from the dead bodies of Hindus, which, before they are placed on the pile, are stripped naked, and the cloth is thrown into the river, from whence it is collected by the Dom, and sold to the torch-makers." For this passage see also Martin 1838, vol. I, p. 330.

3. Fireworks are still customary today with both Hindu and Muslim communities. For the latter cf. Asad 1988, p. 66. The chapter on "State of the Arts and Commerce in Patna and Behar" in Martin 1838, vol. I, p. 335 informs that "The fireworks are chiefly employed in marriages." For the original text see again Buchanan 1936, vol. II, p. 625f.

4. Cf. Russel 1860, vol. II, p. 404 while describing a marriage procession on February 26, 1859: "The defilé lasted for half an hour, but at length the bride or bridegroom, no one could decide which, made an appearance, . . . mounted on a milky white pony which was covered with rich brocades and gem-studded saddle-cloths."

5. Cf. Jancigny/Raymond 1845, p. 250. Dubois de Jancigny was "Aide de Camp du Roi d'Oude." Writing on Patna, Buchanan remarked: "Marriages are here still more outrageously expensive than in Bhagalpur, and are the principal cause of ruin;" or: "In this district the marriages are a most intolerable burthen,. . . ." Buchanan 1936, vol. I, p. 276 and p. 354.

6. All paintings of this album, henceforth called the Caledon album, were reproduced in full col. The numbering of the folios follows Sotheby's, March 29 and 30, 1982, lot 67.

 Folio 1: Rousselet 1985, col. pl. p. 111. Labeled: *Shadee-Marriage.*
 " 2: Rousselet 1985, col. pl. p. 142–143. Labeled: *Kalee Myhe Pooja-Festival*-Losty 1989, p. 148, fig. 8.
 " 3: Rousselet 1985, col. pl. p. 134–135. Labeled: *Doorga Pooja- Festival.*
 " 4: Rousselet 1985, col. pl. p. 124–125. Labeled: *Shadee - Marriage Procession by Night.*
 " 5: Rousselet 1985, col. pl. p. 119. Labeled: *Rhuth Sattree... drawing the ... carr.*
 " 6: Rousselet 1985, col. pl. p. 131. Labeled: *The Visit Moolaquata to the Commander in Chief.*
 " 7: Rousselet 1985, col. pl. p. 106–107. Labeled: *Nashta - Break- fast.*
 " 8: Rousselet 1985, col. pl. p. 114–115. Labeled: *Mailah - Jhan.*
 " 9: Rousselet 1985, col. pl. p. 160–161. Labeled: *Nautch - dance.*
 " 10: Rousselet 1985, col. pl. p. 99. Labeled: *Durbar - audience.*
 " 11: Rousselet 1985, col. pl. p. 154–155. Labeled: *Hulwaji - confec -tioner.*
 " 12: Rousselet 1985, col. pl. p. 148–149. Labeled: *Charak Pooja - Penance* = Hobhouse Limited 1986, no. 25 = Sotheby's, December 14, 1987, lot 41, illus. p. 35.
 " 13: Rousselet 1985, col. pl. p. 94–95. Labeled: *Jolojogue - Break -fast* = Sotheby's, March 29 and 30, 1982, lot 67, illus. p. 35.
 " 14: Rousselet 1985, col. pl. p. 103. Labeled: *Howlee-Throwing the ... red stuff.*

7. Archer 1947, pl. 4.

8. Sotheby's, April 26, 1990, lot 92, col.(= Galerie Pierre-Yves Gabus, 10 décembre 1990, lot 130, col.).

9. Archer 1972, pl. 38.

10. Leach 1995, vol. II, p. 765.

11. Cf. Leach 1995, vol. II, illus. on p. 764 (= Archer/Archer 1955, pl. 8, fig. 17) with Christie's, November 17, 1976, lot 45, illus. on pl. 15 (= *Maggs Bull.*, no. 27, 1977, p. 52, no. 67).

12. For the dated painting see Archer 1972, no. 68i, p. 105, reproduced as color pl. C, opp. p. 59. For the other version see Pal/Dehejia 1986, p. 164, fig. 168. Other paintings of the "awning" sequence include Woerkens 1995, double-page col. pl. 7 and Sotheby & Co., December 13, 1972, lot 43. More of Sevak Ram's scenes are said to be in the Patna Museum, cf. Diwakar 1959, p. 784.

13. Cf. Archer 1972, pl. 37 (= Bayly et al. 1990, p. 225, no. 286, col.)

14. Buchanan classified altogether 158 different "artists," see Buchanan 1936, vol. II, pp. 765–773, Table no. 41 = Martin 1838, vol. I, Appendix, pp.(35)–(38). For reproductions of Sevak Ram's drawings of some of these "artists," as Buchanan called the different professions, see: Archer 1947, pls. 1–4; Archer 1955, fig. 15 (= Archer 1947, pl. 1); *Maggs Bull.*, no. 13, 1968, nos. 47 and 49, illus. p. 52; Harle/Topsfield 1987, p. 84f., no. 95.

15. For the drawings collected by Buchanan, partly lithographed and published in 1838, see Archer 1972, pp. 107–109, cat. no. 71i-xliii.

16. See note 14 above, p. 765 and p.(35) respectively.

17. Buchanan 1936, vol. II, p. 612. Martin 1838, vol. I, p. 327.

18. Archer 1947.

19. See Orlich 1844, p. XVI: "Die Originalzeichnungen der Aufzüge, der meisten architektonischen Gegenstände, so wie die der Kaufleute und Handwerker sind von Eingeborenen in Agra und Patna entworfen worden," (The original drawings of the processions, the majority of architectural views and of the merchants and artisans were designed by natives of Agra and Patna). The reproduction of these drawings, many of which were printed in color, proved to be so costly that they were all omitted in the second German edition of the same book, published in the same year as the first edition by Gustav Mayer in Leipzig.

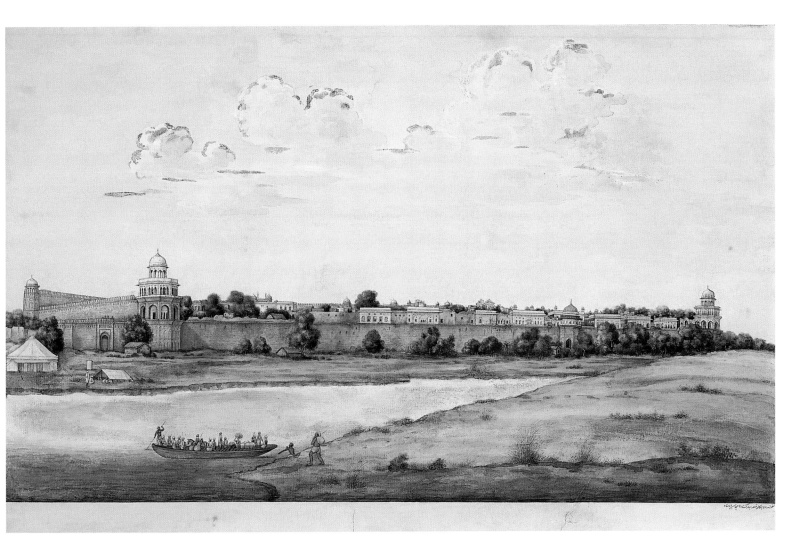

66 **East Side of the Royal Palaces in the Fort, Shahjahanabad (Delhi) as Seen across the Yamuna River**

∾

by a royal artist in the circle of Mazhar Ali Khan. Delhi, ca. 1830.

Media: Gouache on paper

Size: 11³/₈ x 18⁷/₁₆ in. (28.5 x 46.8 cm.)

Inscribed: In lower right corner, in *Nashtaliq: naqsha[h] rupkar qal'a[h] mubarak shahjahan badshah* (picture by the painter of the blessed fort of the emperor Shah Jahan).

The east side of this building [i.e. the palace of Delhi], *facing the Jumna, was formerly washed by that river; but of late years, as if to indicate the fluctuating instability of human greatness, the stream has receded from the mouldering walls, so as no longer to reflect on its pellucid bosom the faded glory of the house of Timur.* (William Thorn, early nineteenth century)[1]

Sir Thomas Metcalfe, commenting in the early 1840s on two corresponding, though smaller paintings, noted:

The following are two views of the Palace at Delhi from the River or east side. The first [which corresponds most to the present watercolor] *includes the whole length of line from the Shah Burj, or Royal Tower on the right to the Ussud Boorj on the left. Ussud literally signifies a Lion: But as tradition does not in any way connect this animal with the Building in question, the latter may be properly denominated as the Tower of Kingth.*[2]

Marched into Delhi: the first sight of the city from the sands of the Jumna is very imposing; the fort, the palace, the mosques and minarets, all crowded together on the bank of the river, is a beautiful sight. (Fanny Parks, February 18, 1838)[3]

At the end of the principal street [of Delhi] *stands the imperial palace, which is considered one of the finest buildings in Asia. It occupies, together with its adjoining buildings, an extent of more than two miles, and is surrounded by a wall of forty feet high.* (Ida Pfeiffer, January 20, 1848)[4]

The area was in fact so large that "The emperor issues a newspaper in his own palace. . . ."[5]

Of all published Indian paintings showing the east side of the so called "Red Fort" prior to

about 1850, this is the best finished and most accurate view.[6] It is also of great importance since several of the buildings still existing at the time this watercolor was made underwent significant changes or disappeared completely. The ferry on the river has arrived from a place called Raj Ghat (royal *ghat*; for the meaning of *ghat* see cat. no. 72.). The Raj Ghat was close to the Raj Ghat Darwaza (royal *ghat* gate), one of the gates of Delhi facing the riverside. It is still indicated in a Delhi map of 1850[7] and the first individual printed map of 1869.[8]

The description of the buildings starts from left to right. The gate to the south of the large tower, called invariably Asad Burj or Lion Tower,[9] is present or should be present in all groundplans showing the fort. It is simply called River Gate.[10] Today, the Asad Burj looks quite different. The white marble story and its cupola have disappeared altogether. A simple *chattri* (pavilion) of sandstone tops the remaining part instead.[11] The two red cupolas and tiny minars with a number of small cupolas in between indicate the upper structure of the Lahore Gate, one of the main entrances to the palace, situated on the western side.[12]

The first building of white marble on the river side is the so-called Khurd Jahan (Little World), which no longer exists. Why it was so called is unknown.[13] The second building is the Mumtaz Mahal (lit. Palace of Mumtaz), also mentioned as Chhota Rang Mahal ("Little Rang Mahal") or Khass Mahal. The Mumtaz Mahal, called Moti Mahal by some authors,[14] still stands and houses the Delhi Museum of Archaeology.[15] The building was initially constructed for the royal princesses, but during the British period it served as a military prison (carvings by the prisoners can still be seen on the marble dadoes).[16]

The third building is known as Chhoti Baitak or Darya Mahal (River Palace), "a comparatively modern apartment, with two openings towards the river,"[17] as shown in this painting. This structure also no longer exists. The following building is the Rang Mahal (Palace of Color), which is so called from the colored decoration with which it was formerly adorned.[18] At the time of Shah Jahan it was known as Imtiyaz Mahal (Palace of Distinction).[19] The building was the largest of the apartments of the royal seraglio and underwent many changes in the course of time. After the events of 1858, it served as a hospital to the British as well as an officer's mess room. The palace is particularly known for its well-shaped water basin.[20] The protruding tower is the Musamman Burj (Octagonal Tower) added in 1810. Due to its gilded roof of copper it was also called Sunehri Burj (Golden Tower).[21] The gate below is called Khizri Gate. The shape of the cupola is confirmed by photographs taken in or before 1857.[22] The gilded copper that can still be seen in the present painting was sold by the British after 1858 and replaced by a quite differently shaped cupola of plaster.[23] It was near this Musamman Burj that during the third Imperial Darbar at Delhi of 1911, their Imperial Majesties presented themselves to the public like the Mughal emperor.[24] The Musamman Burj is part of a structure called Khas Mahal, indicated on any map of the fort.[25] The Khas Mahal actually consists of three rooms, which are, from south to north (here: left to right): the Tosha Khana (wardrobe) or Baithak (sitting room), the Khwabgah (dormitory) and the Tasbih Khana (chamber for telling beads), which the emperor used for private worship.[26] The small *chattris* (pavilions) on the corners of the roof of that building were also removed by the British without having them replaced at a later date. They are missing to this day and are still visible in place in the present watercolor. To the north of the Khas Mahal stands the most famous of all the buildings within that part of the "Red Fort," the Diwan-i-Khas (Hall of Private Audience). For a description of this monument see cat. nos. 67–68.[27] What follows in sequence is the building containing the Hammam (bath). It consists of three apartments separated by corridors. The stone-inlay in the floor is spectacular. Like the following Moti Mahal, it is built of red sandstone which had originally been plastered white.[28] The two gilded cupolas behind the Hammam belong to the Moti Masjid (Pearl Mosque). That its cupolas were in fact once gilded is shown by paintings of the early to mid-nineteenth century.[29] The small Hira Mahal (Diamond Palace) of today is not shown in this painting. It was built under the emperor Bahadur Shah II in 1842 or 1844. The present painting thus has to be of earlier date.[30]

The last but one structure shown in this painting is the Moti Mahal (Pearl Palace). This palace was built of red sandstone which has also been plastered white and profusely painted in floral designs and gilded. It no longer exists. Its place was taken by the gun-battery as late as this century.[31] The sequence of palace buildings ends with the Shah Burj (Royal Tower). It was once three-storied and corresponded to the Asad Burj at the southern end of the east side of the fort of Shahjahanabad. The present representation is confirmed by an Indian pre-1857 description[32] in addition to other Indian paintings from that period.[33] The structure lost its upper two stories during the mutiny of 1857 and was severely damaged by the earthquake of 1905. The top part was never rebuilt.[34] As with all other comparable paintings, the interior of the Shah Burj, which actually faces south, is represented as if facing east.[35]

Comparable views by contemporary artists are quite unreliable in comparison.[36] Mazhar Ali Khan, who contributed paintings to the Metcalfe album of about 1840–1844, painted an impressive long scroll showing the panorama of the Delhi fort, which is now in the India Office Library, London. The scroll is dated 1846 and can be compared stylistically to the present watercolor.[37]

NOTES

1. Thorn 1818, p. 155.
2. Kaye 1980, p. 79.
3. Parks 1975, vol. II, pp. 192–193.
4. Pfeiffer n.d., p. 185.
5. Pfeiffer n.d., p. 186.
6. For other, similar views cf. 1) the Metcalfe album of about 1840–1844 (Kaye 1980, p. 79); 2) a similar painting in an album in the Victoria and Albert Museum, London (Nicholson 1989, col. illus. pp. 8–9 = Archer 1992, p. 146, no. 124(21), col.); 3) a painting in the India Office Library, London, with apparently Shah Jahan in the foreground (Crowe et al. 1972, p. 156, top, acc. no. not specified); 4) another painting in the India Office Library, London, apparently unpublished (Archer 1972, p. 178, no. 133(xxvi), not stated whether seen across the river, watermark dated 1808); 5) another painting in the India Office Library, London, apparently unpublished (Archer 1972, p. 180, no. 136(ii), watermark dated 1816), 6) yet another watercolor in the India Office Library, London, also apparently unpublished (Archer 1972, p. 185, no. 143(iv), partly with an identical inscription as on the present painting) and 7) a panoramic view, the present whereabouts of which are unknown (Tillotson 1985, no. 40, col. pl. detail - Christie's, May 25, 1995, pp. 88–89, lot 138, col. pl.)
7. For a reproduction of the "Red Fort" as part of the original map in the India Office Library and Records see Crowe et al. 1972, p. 156, bottom. For a high quality reprint of this map with transcribed names of the buildings, places etc. see Ehlers/Krafft/ Malik 1992.
8. *Survey of India* 1869, sheet no. 1.
9. For the latter cf. Hearn 1906, folded groundplan facing p. 160.
10. Cf. Fanshawe 1902, groundplan facing p. 23; Hearn 1906, folded groundplan facing p. 160.
11. For a short description see Sanderson 1945, p. 19. For a modern photograph showing the east or river side of the "Red Fort," see e.g. Brunel n.d., col. pl. 64, with the cupola of the Asad Burj in the background behind the tree. Cf. also Nicholson 1989, p. 12, full-page col. illus.
12. For a photograph of this gate cf. Fanshawe 1902, illus. facing p. 22. For a description cf. Sanderson 1945, p. 3.
13. Cf. Hearn 1906, pp. 160–161 and the folded groundplan facing p. 160; Sanderson 1945, p. 9.
14. Cf. Koch 1991, p. 110, groundplan of the fort of Shahjahanabad. For the position of this palace cf. however, Sanderson 1915, p. 10; Sanderson 1945, groundplan facing p. 8 or Nicholson 1989, groundplan on p. 123, Hearn 1906, folded groundplan facing p. 160, etc.
15. For photographs of interior views of this museum, taken in the early twentieth century, cf. *Annual Progress Report* 1912, pls. 3–4 and *Annual Progress Report* 1914, pl. 2. For a groundplan of the building when in use as a museum, see *Annual Progress Report* 1912, pl. V. For a view of the building before and after its restoration by the Archaeological Survey of India, see *Annual Progress Report* 1912, pls. 6 and 7–8.
16. Sanderson 1945, p. 9. For further descriptions cf. Hearn 1906, p. 160; Sharma 1974, pp. 151–152; Sanderson 1915, pp. 22–23; Newell n.d., p. 64; Nath 1979 (based on Syed Ahmad Khan's Atharu-s-Sanadid of 1846), pp. 13–14.
17. Hearn 1906, p. 160. The position of this building is also indicated in the groundplan by Sanderson 1945, pl. facing p. 8 (no. 9, as Choti Baitak) and in Nicholson 1989, p. 123, groundplan, no. 9 (Darya Mahal).
18. No. 10 in Sanderson 1945, groundplan facing p. 8; No. 11 in Nicholson 1989, groundplan p. 123; No. 5 in Koch 1991, groundplan p. 110 etc.
19. As such it appears in the groundplan published by Asher, cf. Asher 1992, p. 192, no. 11.
20. For the best illus. description see Tucker 1911. Also Sanderson 1915, pp. 21–22; Sanderson 1945, pp. 9–11; Hearn 1906, pp. 158–159; Sharma 1974, p. 152; Newell n.d., pp. 63–64; Nath 1979 (based on Syed Ahmad Khan's Atharu-s-Sanadid of 1846), p. 15; *Annual Progress Report* 1908, pl. 2, bottom. Reuther 1925, pl. 66. For photographs of the water basin see e.g. Nicholson 1989, full-page col. illus. p. 81. For early photographs of this building as taken from the riverside cf. Nicholls 1909, pl. X; Sanderson 1915, pl. III, fig. 1.
21. For a description cf. Newell n.d., p. 63; Sharma 1974, p. 153; Nath 1979 (based on Syed Ahmad Khan's Atharu-s-Sanadid of 1846), p. 15.
22. Cf. Nicholls 1909, pl. X, top and pl. XI, top; Sanderson 1915, pl. III, top.

23. Cf. Nicholls 1909, pl. X, bottom and pl. XI, bottom; Sanderson 1915, pl. III, fig. 1; Fanshawe 1902, photograph facing p. 33 (= Sharp 1928, photograph facing p. 90); LaRoche 1921–1922, vol. V, p. 204 top; Nicholson 1989, p. 50, top; Brunel n.d., col. pl. 64, to mention just a few.

24. For a photograph of this scene see Gabriel/Luard 1914, illus. facing p. 189.

25. Cf. Hearn 1906, pp. 156–158.

26. For a description of these rooms cf. Sanderson 1945, pp. 11–13; Sharma 1974, pp. 152–153; Fanshawe 1902, pp. 35–36; Newell n.d., pp. 62–63. Nath 1979 (based on Syed Ahmad Khan's Atharu-s-Sanadid of 1846), p. 15. For the best photographs see Reuther 1925, pl. 67–70, also Nicholson 1989, p. 41. For the most detailed published groundplans see LaRoche 1921–1922, vol. V, p. 206, fig. 318 and Reuther 1926, pl. 60.

27. For photographs showing this structure from the riverside see Nicholls 1909, pl. X and pl. XI; Sanderson 1915, pl. III, fig. 1; Fanshawe 1902, photograph facing p. 33 (= Sharp 1928, photograph facing p. 90); LaRoche 1921–1922, vol. V, p. 204 top; Brunel n.d., col. pl. 64, Gascoigne 1971, illus. on p. 183, Nicholson 1989, col. photograph p. 84, to mention just a few.

28. For a description cf. Fanshawe 1902, pp. 38–39; Hearn 1906, p. 152; Sanderson 1915, p. 12; Sanderson 1945, pp. 17–18; Sharma 1974, pp. 154–155. Nath 1979 (based on Syed Ahmad Khan's Atharu-s-Sanadid of 1846), p. 16. For a detailed groundplan see LaRoche 1921–1922, vol. V, p. 206, fig. 318 and Reuther 1926, pl. 60 in addition to Reuther's remarks on p. 55. For the most instructive interior as well as exterior views cf. LaRoche 1921–1922, vol. V, p. 204, fig. 317, p. 205, fig. 322, p. 209, fig. 320; Reuther 1925, pls. 71–72(top); Nicholson 1989, the following col. pls. on p. 14 (top), p. 24, pp. 67–68, p. 90 (top), p. 95, p. 104 and p. 120 (top right).

29. Cf. a painting in the Metcalfe album, reproduced in Kaye 1980, p. 103 or a similar one in Nicholson 1989, col. pl. p. 108, bottom. For a modern photograph see Nicholson 1989, p. 14 (top) and pp. 36–37. For a description cf. Fanshawe 1902, p. 39; Sanderson 1915, p. 13; Sanderson 1945, p. 18; Sharma 1974, p. 155.

30. Cf. Hearn 1906, pp. 153–154; its position is indicated on the plan published by Hearn, cf. Hearn 1906, folded plan facing p. 160. Sanderson 1915, p. 10 and pl. II, col. groundplan, no. 12; Sanderson 1945, p. 18. In the map of 1850 it is indicated together with the Moti Mahal, cf. Ehlers/Krafft/Malik 1992. For a modern photograph see Nicholson 1989, col. pl. p. 113, top; for an earlier photograph see the *Annual Progress Report* 1912, pl. 30.

31. Sanderson 1915, p. 10. For a description cf. Hearn 1906, pp. 153–154; Nath 1979 (based on Syed Ahmad Khan's Atharu-s-Sanadid of 1846), p. 17. This palace is indicated in most groundplans of the fort based on maps made prior to 1857, cf. Sanderson 1945, groundplan facing p. 8, no. 16; Sanderson 1915, pl. II, no. 13; Hearn 1906, folded groundplan facing p. 160; Nicholson 1989, plan p. 123, no. 17, etc. For the position of the gun battery see Sanderson 1915, pl. I or Sanderson's plan in the *Annual Progress Report* 1912, pl. XXI. For a photograph of this gun-battery see *Annual Progress Report* 1914, pl. 40.

32. Nath 1979 (based on Syed Ahmad Khan's Atharu-s-Sanadid of 1846), pp. 18–19.

33. Cf. the Metcalfe Album, Kaye 1980, p. 101; Sanderson 1915, pl. VI; Nath 1979 (based on Syed Ahmad Khan's Atharu-s-Sanadid of 1846), illus. no. 16, part of the gun-battery is visible in the right-hand corner of this engraving.

34. For an article on its partial restoration see Sanderson 1914. For photographs documenting its changing condition during the early twentieth century see the *Annual Progress Report* 1909, pl. 5; *Annual Progress Report* 1912, pl. 32.

35. The interior, source of the "Nahar-i-Bahisht" (heavenly canal) that used to flow from north to south along the entire chain of palaces at the riverside, was shown as in a modern photograph, for which see Nicholson 1989, p. 41 top, instead of Asher 1992, p. 197, pl. 120.

36. Cf. e.g. Godrej/Rohatgi 1989, p. 54, col. pl. 12.

37. For this scroll see Pal et al. 1989, pp. 234–235.

67 The Divan-i-Khas (Hall
of Private Audience)
within the "Red Fort" of
Shahjahanabad (Delhi)
≈

by Ghulam Ali Khan of Delhi
(fl. 1815–1852), Delhi, dated 1817.

Media: Watercolor with gold
on paper

Size: Folio: 21³⁄₈ x 29⁷⁄₈ in.
(55 x 76 cm.) . Painting:
19⁵⁄₈ x 29¹⁄₈ in. (50 x 74 cm.)

Provenance: H. J. Allcroft

Publication: Sotheby's,
September 29, 1994, vol. III,
p. 22, lot 681.

Collection: British Library, Oriental
and India Office Collections,
London (India Office Library),
acquired with funds given by
William K. Ehrenfeld, M.D.

Inscribed: The title of this picture appears in the center of the text-panel below the actual painting, in ink, in *Nashtaliq: Naqsha[h]-i anjuman-i- Divan-i khas dar dar-ul-khilafa[h] Shahjahanabad* (picture of a party in the Divan-i Khas within the capital of Shahjahanabad [Delhi]). The name of the artist and the date are mentioned in the second inscription from left: *Amal Gulam 'Ali Khan Musavvir Fadvi Muhammad Akbar Shah Badshah Sani, sana 11 panjam-i mah-i Shavval* (Work of the painter Ghulam Ali Khan, devoted servant to the emperor Akbar Shah II, in [his] year 11, on the fifth of the month Shaval).[1] The remaining inscriptions give the names of the other buildings in the palace as shown in the painting. The first inscription from the left states: *Aqab-i hammam* (back of the bath); the fourth: *Tasbih khana[h]* (prayer-room); the fifth: *Hammam-i andarun-i mahal-i mubarak* (bath in the interior/inner bath of the blessed palace) and the sixth: *Jilau khana[h]* (courtyard in the interior of the portal/anteroom, vestibule, entrance-hall).[2]

After entering the palace, we were carried to the Dewaun Khana, or hall of audience for the nobility, in the middle of which was a throne, raised about a foot and a half from the ground. In the center of this elevation was placed a chair of crimson velvet, bound with gold clasps, and over the whole was thrown an embroidered covering of gold and silver thread.... The king was at this time in the Tusbeah Khana, or oratory, an apartment in which he generally sits. On passing a screen of Indian Connaughts [i.e. qanats], we proceeded to the front of the Tusbeah Khana, and being arrived in the presence of the king, each of us made three obeisances in turn ... This building [the Divan-i Khas] likewise is situated at the upper end of a spacious square, elevated upon a terrace of marble about four feet in height. The Dewaun Khass, in former times, was adorned with excessive magnificence; and though repeatedly stript and plundered by successive invaders, still retains sufficient beauty to render it admired. I judge the building to be an hundred and fifty feet in length by forty in breadth. The roof is flat, supported by numerous columns of fine white marble, which have been richly ornamented with inlaid flower work of different coloured stones: the cornices and borders have been decorated with freize [sic] and sculptured work. The cieling [sic] was formerly incrusted with a rich foliage of silver

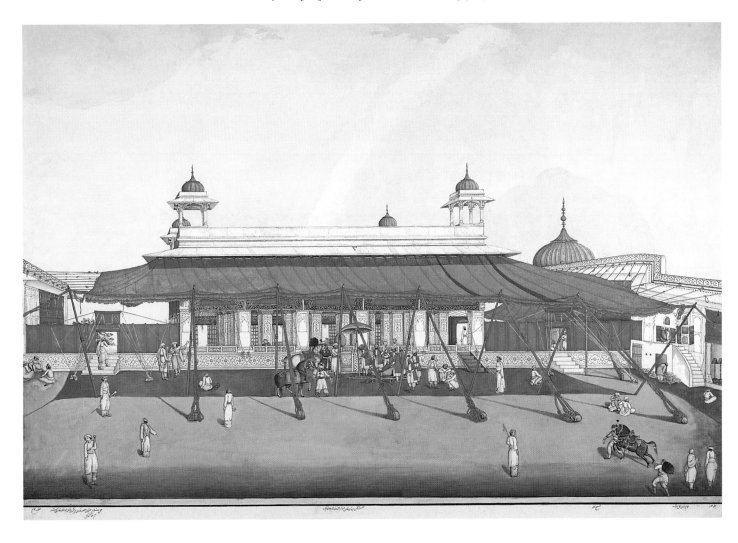

throughout its whole extent, which has been long since taken away. The delicacy of the inlaying in the compartments in the walls is much to be admired; and it is matter of bitter regret to see the barbarous ravages that have been made by picking out the different cornelians and breaking the marble by violence. Around the exterior of the Dewaun Khass, in the cornice, are the following lines, written in letters of gold upon a ground of white marble: "If there be a paradise upon earth, this is it — 'tis this — 'tis this."³ The terrace of this building is composed of large slabs of white marble, and the building is crowned on top with four pavilions or cupolas of the same materials. The royal baths built by the emperor Shah Jahan are situated a little to the northward of the Dewaun Khass, and consist of three very large rooms surmounted by domes of white marble, having beautiful borders of flowers, worked with cornelians and other stones executed with much taste. —The floors are paved throughout with marble in large slabs; there are fountains in the center, which have passes to carry the water into the different apartments: large reservoirs of marble, four feet in depth, are placed in the walls. The light is admitted from the roof by windows of stained glass; and capacious stoves with iron gratings are placed underneath each separate apartment. (W. Francklin, March 11, 1794)[4]

The description of the royal bath was also included here, since the building appears in the left-hand part of this painting and is properly identified in the caption below. What "bath in the interior" means is not fully known. Perhaps there was another bath, indicated by the *bhishti* or water carrier in the entrance at the top of the stairs near the right-hand edge of the picture.

Another gateway leads to a similar square, at the farther end of which is the Dewan Khoss, or the place of audience peculiarly set apart for the nobility. This building, which is of white marble, and elevated on a terrace of the same material about four feet in height, is one hundred and fifty feet in length, by forty in breadth. The roof, which is flat, and surmounted with four pavilions, or cupolas, is supported by a number of columns, all like the latter, of white marble, and inlaid with flowers, constructed of the most beautiful and costly precious stones. Round the cornice, in the interior of the Dewan Khoss, the following proud inscription is engraved in letters of gold: "if there be a paradise upon earth, this is it - 'tis this! 'tis this!"... In this hall of audience was the famous Tukt Taus, or peacock throne, which, on all accounts, was one of the most superb works ever formed for the gratification of human pride. (William Thorn as published in 1818)[5]

"Lo, the ornament of the world! Lo, the asylum of the nations! King of Kings! The Emperor Akbar Shah! Just, fortunate, victorious!" We saw, in fact, a very handsome and striking court, about as big as that at All Souls, with low, but richly ornamented buildings. Opposite to us was a beautiful open pavilion of white marble, richly carved, flanked by rose-bushes and fountains, and some tapestry and striped curtains hanging in festoons about it, within which was a crowd of people, and the poor old descendant of Tamerlane seated in the midst of them....We then went to the Hall of Audience, which I had previously seen but imperfectly, from the crowd of people and the necessity of attending to the forms which I had to go through. It is a very beautiful pavilion of white marble, open on one side to the court of the palace, and on the other to a large garden. Its pillars and arches are exquisitely carved and ornamented with gilt and inlaid flowers, and inscriptions in the most elaborate Persian character. Round the frieze is the motto, recorded, I believe, in Lalla Rookh, "If there be an Elysium on earth, It is this, it is this!" The marble floor, where not covered by carpets, is all inlaid in the same beautiful manner with the little dressing room, which I had quitted. (Reginald Heber, December 31, 1824)[6]

The eight persons dressed in white with some sort of red coat right in front of the building are the porters of the *takht revan* (moving throne) or "royal Litter, with a Canopy and an Umbrella, one led horse and a drum," as described for one of Akbar Shah's predecessors, Muhammad Shah (1719–1748).[7] The porters of Muhammad Shah's "travelling throne" were indeed dressed in the same costume when carrying the emperor as is demonstrated by an earlier painting showing the emperor in front of the same building.[8] During an audience given at the Divan-i-Khas, le Comte de Modave describes Shah Alam II (1760–1806) as "seated in a palanquin without bamboo, or more in a kind of throne carried by 8 persons on their shoulders."[9]

This is the earliest dated painting by the celebrated Ghulam Ali Khan; another portrait by him showing the same emperor is dated into "the 22nd year of His Majesty's reign," when he also painted a portrait of Akbar Shah's second son, prince Abu'l-Nasir Siraj ad-Din

Muhammad Bahadur Shah. Both these portraits are on ivory and Ghulam Ali Khan styles himself "His Majesty's devoted faithful servant."[10] He continued to work for Akbar Shah's second son and successor, Muhammad Bahadur Shah II (1837–1858), the last Mughal emperor. A painting dated 1837–1838 shows him together with two of his sons in front of the "Tasbih Khana."[11] Of this painting attributed to Ghulam Ali Khan by inscription, two very close versions exist, and although both of them are dated into the same year as the version by Ghulam Ali Khan, one of them shows the emperor with a black[12] and the other with a completely white beard.[13] Ghulam Ali Khan worked not only for the Mughal emperors. Among his clients were Colonel James Skinner, for whom he painted three individual paintings, two of which are dated 1827.[14] There are also undated paintings attributed to Ghulam Ali Khan by inscription. One of them shows a "Harem scene,"[15] and another one introduces a tiger hunt at Jhajjar in the Rohtak district, near Delhi.[16] Ghulam Ali Khan's last two dated paintings were done for Nawab 'Abd Al-Rahman Khan of Jhajjar. They are dated May-June 1849[17] and January-February 1852[18] respectively. For further comments on the Divan-i Khas see the following cat. no. 68.

NOTES

1. Abu'l-Nasir Mu'in-Din Muhammad Akbar II was born on May 4, 1759. He died on September 28, 1837 and ruled from November 11, 1806 to the day of his death. His successor Abu'l-Muzaffar Siraj ad-Din Muhammad Bahadur Shah II (b.: October 24, 1775, r.: September 29, 1837– March 29, 1858, d.: November 7, 1862, in exile [Rangoon, Burma]) was the last Mughal emperor.
2. The Jalau Khana or Abode of Splendor is described by Fanshawe 1902, p. 33; Newell n.d., p. 57.
3. For this famous inscription see Husain 1936, p. 4, no. V. It is from Francklin's description quoted here that Moore incorporated the refrain "And, oh! if there be an Elysium on earth, it is this, it is this" in his *Lalla Rookh* (Cf. Moore 1868, pp. 313–314 and note 372, p. 379).
4. Francklin 1971, pp. 204–207.
5. Thorn 1818, pp. 155–156.
6. Heber 1828, vol. I, p. 557 and p. 561. For the motto cf. note 3, supra. It is not certain whether Heber described in his concluding sentence the floor of the Divan-i Khas, as there are actually no mosaics in the floor.
7. Fraser 1742, p. 162; cf. also p. 178 and p. 205.
8. Welch 1963, p. 150, no. 78, col. (= Welch 1978a, p. 116, no. 39, col.).
9. "Assis dans un palanquin sans bambou, ou plutôt dans une espèce de trône que 8 hommes soutenoient sur leurs épaules," cf. Féderbe 1971, p. 217.
10. The regnal years are probably lunar years. For a description of these portraits see Archer 1972, pp. 205–206, cat. no. 175.
11. Published: Sotheby's, July 7 and 8, 1980, col. pl. p. 69, lot 150; Beach 1992, col. illus. p. 358, no. 142.
12. Christie's, June 11, 1986, col. pl. p. 112, lot 161; Goswamy/Fischer 1987, col. pl. p. 210, cat. no. 105.
13. It is dated May-June, 1838. Cf. Christie's, July 7, 1976, pl. 19, lot 85; Welch 1978, full-page illus. p. 119, cat. no. 52; Welch 1978a, full-page col. pl. p. 118, no. 40; Skelton et al. 1982, p. 55, no. 109; Welch 1985, col. illus. p. 428, no. 284.
14. For these paintings cf. cat. no. 16, notes 9–10.
15. Pal/Dehejia 1986, p. 165, no. 170. The text does not state whether the painting is actually inscribed with the artist's name or whether the attribution was made by the authors on stylistic grounds.
16. Archer 1992, col. illus. p. 158, no. 136.
17. Hazlitt, Gooden & Fox 1991, no. 16. The descriptive text is by Toby Falk.
18. Hazlitt, Gooden & Fox 1991, no. 17. The descriptive text is by Toby Falk.

68 The Divan-i Khas (Hall of Private Audience) within the "Red Fort" of Shahjahanabad (Delhi)
∾

by a local artist, Delhi, ca. 1825–1830.

Media: Watercolor and gold on paper

Size: 12¼ x 18½ in. (31.1 x 47 cm.); or: 11½ x 18½ in. (28.9 x 46.6cm.)

Inscribed: Below the painted surface, in ink, in *Nashtaliq*: A picture of the Divan-i Khass of the Qila'ah-i-Mubarak (blessed fort) of Shahjahanabad (Delhi) Paper watermarked "[Jo]hn Dickinson & Co / 1810."

Provenance: Eyre & Hobhouse, London; Jacqueline Kennedy Onassis, New York

Publication: Sotheby's N.Y., April 23–April 26, 1996, lot 601.

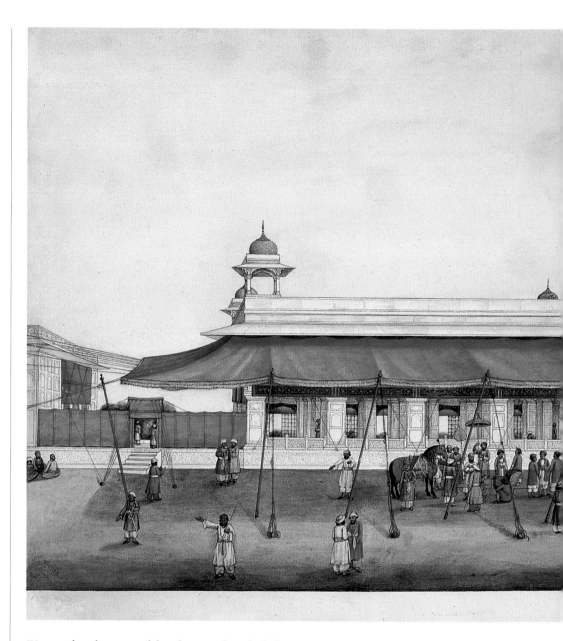

We arrived at what is termed the red curtain, through which every one, save the king, must proceed, using his legs and nothing else. Here we dismounted, and entered into a large square. In front about forty yards was the Dewan-khass, or throne room, in which the king was already seated....The King sat on a raised throne, supported by cushions; the throne had a canopy, propped by slender pillars; all round were sentences in Persian, expressive of the majesty of royalty, and one, declaring that "if there was a heaven upon earth," this place was it. This latter is a celebrated quotation, and is applied to all beautiful places and delicious climates. It had nearly been forgotten to mention, that the peacock throne carried off by Nadir Shah, was in the recollection of the court, as the present one is ornamented with small figures of that bird in enamel and gilding. The Dewan-khas, or Private Palace, is a mansion of one story, flat roofed, composed wholly of marble, and richly embellished with carving and paintings of flowers. (Major Archer, February 3, 1828)[1]

We shortly arrived at the archway leading into the quadrangle, in which the Dewânee Khâs, or hall of audience, is situated, where the Commander-in-Chief was required to dismiss his palankeen. On passing the Lal Purdah, or great red curtain which veils the entrance, the whole of our party, English and native, made a low salaam, in honour of the august majesty of which we were as yet not in sight....The Dewânee Khâs is a beautiful open edifice, supported on white marble columns, the whole elegantly inlaid and gilt. The roof is said to have been vaulted with silver in the more prosperous days of the Delhi empire, but it was spoiled by those common devastators of India, the Mahrattas. Around the cornice still remains the (now, at least) inapplicable inscription, "If there be a Paradise upon earth, it is this, it is this." The throne, occupying the centre of the building, is raised about 3 feet from the floor, and shaded by a canopy of gold tissue and seed-pearl. There are no steps to the front of the throne, the entrance being in the rear." (G. C. Mundy, February 3, 1828)[2]

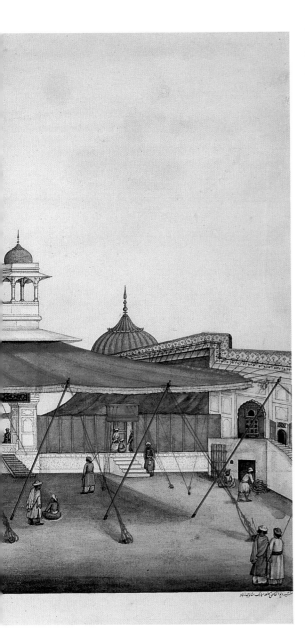

The hall of audience, built by Shah Jahan, is a kind of square room, the terraced roof rests on four rows of pillars. Only a simple balustrade of little height surrounds these arcades. Its floor is some feet higher than the courtyard; one reaches it through some side stairs. This small building is entirely built of white marble, surmounted by elegant cupolas, flowers and arabesques; the mouldings and the reliefs are gilded. (V. Jacquemont, March 4–13, 1830)[3]

The moment the gate was opened, we complied, and found ourselves in presence of the Dewani Khass, the imperial hall of judgment. This is a very elegant building of pure white marble, sculptured into delicate screen-work, and inlaid with precious stones in the pattern of wreaths, flowers, birds, insects, &c: the design is very chaste and simple; it consists of a light dome supported by double rows of marble pillars, highly ornamented, and beautifully proportioned. Upon this we were not suffered to set foot, until after having a second time made a humble obeisance to the vacant throne. Within the ceiling is wrought in enamel of every brilliant colour, inlaid with small pieces of looking-glass, and elaborately gilded in patterns and devices purely Eastern. In the centre of this apartment, or, more correctly, pillared terrace, is the Emperor's judgment-seat, hewn out of a solid block of natural cristal, about twenty inches in breadth, and the same in depth; it stands below an archway of larger dimensions than the others, and in front of it three jets of clear water are kept continually playing, whose waters are carried through the hall on either side of the duct formed of the same beautiful material as the rest of the building. This exquisite place is now rarely made use of by the Emperor; never, indeed, unless for the reception of some personage of exalted rank. It is abandoned to the crows and kites, and is left in a filthy state of impurity, while the paltry expenditure of three rupees monthly would allow of its being kept in order, or at least cleanly. . . . Nothing but desolation and decay is to be found among these once proud emblems of regal magnificence, and this is to be attributed to the miserable poverty of the present Emperor, who receives from our Government a wretched pittance, barely sufficient to feed his family and to support his paltry train (Thomas Bacon, October 1835)[4]

The Dewani Khas, or hall of private audience, is a much more splendid building than the other [i.e. the Divan-i Am or hall of public audience], from its richer materials, being all built of white marble beautifully ornamented. The roof is supported upon colonnades of marble pillars. The throne stands in the centre of this hall, and is ascended by steps, and covered by a canopy, with four artificial peacocks on the four corners. . . . Within this apartment and over the side arches at one end, is inscribed in black letters the celebrated couplet, "If there be a paradise on the face of the earth, it is this - it is this - it is this." Anything more unlike paradise than this place now is, can hardly be conceived. Here are crowded together twelve hundred kings and queens, (for all the descendants of the Emperors assume the title of Sulateens, the plural of Sultans) literally eating each other up. (W. H. Sleeman, January, 1836)[5]

We all . . . went to see the palace. It is a melancholy sight—so magnificent originally, and so poverty-stricken now. The marble hall where the king sits is still very beautiful, all inlaid with garlands and birds of precious stones, and the inscription on the cornice is what Moore would like to see in the original: "If there be an Elysium on earth, it is this, it is this!" (Emily Eden, Delhi, February 20, 1838)[6]

It was too hot for me to venture round the walls of the palace [of Delhi], and I only paid a flying visit to the Diwan-i-am, or Hall of Public Audience, and the Diwan-i-khass, or Hall of Private Audience. The latter is built of white marble, beautifully ornamented, and the roof is supported on colonnades of marble pillars. In this hall the peacock throne stands in the centre; it is ascended by steps, and covered with a canopy, with four artificial peacocks at the four corners. Around the exterior of the Diwan-i-khass, in the cornice, is the well-known inscription, in letters of gold, upon a ground of white marble: "If there be a paradise on earth, it is this, it is this." The terrace of this building is composed of large slabs of white marble, and the building is crowned at the top with four pavilions or cupolas of the same material." (Fanny Parks, February 23, 1838)[7]

The emperor Shah Jahan, having founded the modern city of Delhi,—still called Shahjehanabad by the Mussulmans,—was desirous of erecting an edifice which should be, at once, a fit habitation for the glorious descendants of the immortal Taimour, and an imperishable memorial of the power and magnificence of the builder. The Badshahi Mahal, the fruit of his design, is still standing—is still the residence of the imperial family; and the boastful inscription surmounting the state presence-chamber, "If there be a paradise on earth, it is this, it is this, it is this," remains as legible as on the day when first engraved. . . . All the costly beauties of this regal abode are now abandoned to neglect and desolation. Their pride is overrun by grinning poverty; and

amid these still solid monuments of former grandeur, a skeleton of departed might and magnificence haunt every avenue.... The late emperor, Akbar Shah the Second, was a state prisoner to the British power within the walls of this his own palace, whence he could not move, even for change of air, without permission from the British authorities. (Thomas Bacon in *The Oriental Annual*, 1840)[8].

The handsomest part of the imperial palace [of Delhi] *are the universally admired and magnificent audience saloon and the mosque. The former stands in the centre of an open court; it is a long, square building; the roof is supported by thirty columns, and is open on all sides; several steps lead up to it, and a prettily decorated marble gallery, two feet high, surrounds it. The present Great Mogul has so little taste, that he has had this divan divided into two parts by a very paltry partition wall. A similar wall adjoins both sides of the saloon, for what purpose I could not learn. In this divan is a great treasure: the largest crystal in the world. It is a block of about four feet in length, two and a half broad, and one foot thick; it is very transparent. It was used by the emperors as a throne or seat in the divan. Now it is hidden behind the blank wall; and if I had not known of its existence from books, and been very curious to see it, it would not have been shown to me at all.* (Ida Pfeiffer, January 20, 1848)[9]

Probably no other building of Shahjahanabad was described more often than the Divan-i Khas.[10] Therefore one would expect that during the first half of the nineteenth century, it was illustrated as frequently in Western publications. Strangely enough, this is not the case. Sleeman, whose description was quoted above, reproduces a colored lithograph entitled *Dewan Khan's Palace at Delhi*, but the lithograph shows in fact the Divan-i Khas of the Fort at Agra.[11] A woodcut-illustration in *The Illustrated London News* of July 18, 1857, is supposed to show the Hall of Justice at Delhi, based on a photograph, but shows a building with Gothic arches and conical massive towers on the four corners of the roof.[12] The American William Butler reproduces an engraving which he fully describes and labels *The Dewan Khass; or Hall of Audience, Palace of Delhi.* This building is again the Divan-i Khas of the Fort at Agra .[13] A more reliable line-engraving, probably based on an Indian view, was published only shortly after the mutiny.[14] Whatever the Persian invader Nadir Shah or the marauding Marathas did not remove from the Divan-i Khas of Delhi was taken by the British in and after 1857. A publication contemporary to the mutiny of 1857 states "Head-quarters were at first established in Skinner's House, afterwards in the Dewan Khass in the palace."[15] Butler wrote that "the Dewan Khass [was] the most gorgeous audience hall in the East,"[16] and added: "When I again visited the once magnificent Dewan Khass, I found it despoiled of its glory, its marble halls and columns whitewashed, and the whole turned into a hospital for sick soldiers! Has the world ever witnessed a ruin more prompt, more complete, more amazing than this?"[17] "The gilded copper of these [the four kiosks on the roof] was taken and sold after the occupation of the Fort by the British in 1857."[18]

Besides the stripping of the structure of its metal and the disfiguring of the mosaics with whitewash, there were also other changes. A ball was given in the Divan-i Khas on January 12, 1876, to honor the presence of the Prince of Wales:

The manner in which this famous palace was arranged reflected credit upon the committee for the ball; but there were transformations not in the best taste, and adaptions which could scarcely have been grateful to those who had sympathy with ancient recollections. Selimghur [here meaning the entire old palace of Delhi] *has certainly not been improved by British occupancy. In the noble square stand red-brick barracks of amazing ugliness; ... All the world has heard of the Dewan Khass, wherein stood the "Peacock Throne." "If there is a Paradise on earth, it is this! it is this! it is this!" But ideas of Paradise cannot be altogether realised in a pavilion filled with men in uniforms and evening dress, women in ball dresses, military bands playing Offenbach and Strauss, and, above all, a ceiling of distressing colour.*[19]

These "restorations" were also remarked upon by an artist, who saw the premises on December 20, 1876:

The Dewan-i-Khas is the most beautiful building I have yet seen. All the inside, ceiling and all, is covered with a beautiful raised pattern, seemingly lacquered over gold; the lower panels are inlaid with wonderful semi-

geometric renderings of flowers, mostly lilies and pinks. The bath at the left side looking towards the river is also inlaid, while on the right is a small suite of rooms quite covered with patterns painted. There are a few restorations in awful colours, made for the ball given here to the Prince of Wales, and, alas! many mutilations.[20]

Another state ball was given in the same premises on January 6, 1903, as part of Lord Curzon's or the "Delhi Coronation Darbar" (for which see cat. nos. 41 and 42). Strauss was again played, this time by the bandsmen from the 15th Hussars, the first Northamptonshire Regiment, the first battalion Royal Irish Rifles, etc. The dancers were Lord Curzon and the Duchess of Connaught, the Duke of Connaught and Lady Curzon, Lord Northcote and Lady Ampthill, the Grand Duke of Hesse and Lady Northcote, etc. During the ball, supper was served in the Divan-i Khas as well as in the adjoining Tasbih Khana (oratory). The event is fully described in official sources.[21]

Keeping in mind what happened to the Divan-i Khas after 1857, it is a rather fortunate coincidence that Ghulam Ali Khan's watercolor of 1817 and its present, later version, have survived, since both representations show, how these palaces looked when in proper use.[22] Ghulam Ali Khan's view of the Divan-i Khas of Delhi had triggered a number of similar pictures which were probably produced throughout the first half of the nineteenth century. Ghulam Ali Khan's view includes the royal palankin-bearers in addition to a groom with a horse in the right-hand foreground. These elements of composition reappear in two further versions of the Divan-i Khas of Delhi.[23] The present version without the horse and groom in the right hand corner but with the palankin-bearers is also known from other examples.[24] Besides, there are several versions in which the palankin-bearers and the horse with the groom in the right-hand corner of the painting are dropped altogether.[25] The present version belongs to the same series of views of Delhi as does cat. no. 66.

NOTES

1. Archer 1833, vol. I, pp. 110–111 and pp. 114–115.
2. Mundy 1858, pp. 38–39.
3. Jacquemont 1933, p. 198.
4. Bacon 1837, pp. 230–231, p. 233. The inlay work with flowers, birds, insects etc. that Bacon claims to have seen in the Divan-i Khas is actually to be seen in the Divan-i Am or Hall of Public Audience. "October 1834" on p. 201 in vol. II must be a misprint for 1835, since W. Fraser (see cat. no. 18) was killed in that year and not in 1834, as Bacon's text here suggests.
5. Sleeman 1844, vol. II, pp. 276–278.
6. Eden 1937, p. 97. It seems Miss Eden, like Mr. Bacon, partly confused the Divan-i Am with the Divan-i Khas as the birds she mentions are located only in the former.
7. Parks 1975, vol. II, p. 217.
8. *The Oriental Annual*, 1840, pp. 25–26.
9. Pfeiffer n.d., p. 185. For further descriptions from the 1840s cf. Orlich 1845, pp. 170–171; Kutzner 1857, pp. 242–243; T. Metcalfe in Kaye 1980, pp. 44–45.
10. For descriptions in guide-books, archaeological reports, etc. cf. Cooper 1863, pp. 41–43; Harcourt 1873, pp. 76–78; Fanshawe 1902, pp. 33–36; Hearn 1906, pp. 150–151; Sanderson 1915, pp. 14–16; Newell n.d., pp. 57–60; Sharp 1928, pp. 89–90; Reuther 1925, pls. 64–65; Sanderson 1945, pp. 13–17; Sharma 1974, pp. 153–154, to mention but a few.
11. Sleeman 1844, vol. II, illus. facing p. 262.
12. *The Illustrated London News*, No. 869, vol. XXXI, Saturday, July 18, 1857, p. 49. For the text see ibid., p. 58, where it is said that the illus. are based on photographs taken by Mr. Beresford, the author of one of the first English guidebooks on Delhi.
13. Butler 1872, woodcut-illus. facing p. 116.
14. It was published in Montgomery Martin: *The Indian Empire: history, topography, geology, finance and commerce; with a full account of the mutiny of the Bengal Army; of the insurrection in Western India; and an exposition of the alleged causes.* 3 vols. London: London Printing and Publishing Co., 1858–1861. The engraving is reproduced in *The India Collection* 1982, pp. 184–185, illus. in the center.
15. Medley 1858, p. 119.
16. Butler 1872, p. 115.
17. Butler 1872, pp. 113–114.
18. Sanderson/Zafar Hasan 1911, p. 108.
19. Russel 1877, p. 412.
20. Prinsep 1879, p. 24.
21. Wheeler 1904, pp. 170–176.
22. For a description of the daily life in the fort during the reigns of Akbar Shah II and Bahadur Shah II cf. Spear 1951, pp. 60–83.
23. Sotheby Parke Bernet N.Y., June 30, 1980, lot 18B; Christie's, July 12, 1979, lot 47, pl. 2, middle. A third version appears to be similar, but is not reproduced; for comparison, cf. Archer 1992, p. 139, no. 112.
24. Archer 1972, p. 186, no. 143v., titled as the dated version by Ghulam Ali Khan; reproduced: Welch 1978, p. 114, cat. no. 50; Skelton et al. 1982, p. 56, cat. no. 126.
25. Sanderson/Zafar Hasan 1911, pl. XLVI, cat. no. C.385, with a much reduced number of persons. Sanderson 1915, pl. IX, fig. 12, facing p. 16; preparatory drawing without any persons at all. Christie's, April 19, 1979, lot 154, pl. 27, bottom; without any figures. A painting in the Metcalfe album of 1840–1844, reproduced in Kaye 1980, p. 44, top, col., with but few persons.

69 Tom Raw Hiring a Palanquin on the Esplanade

∾

by Sir Charles D'Oyly, Bt. (1781–1845). Calcutta, 1812–1818, or Patna, 1821–1828.

Media: Pen and black ink on watercolor over pencil

Size: 7 x 9½ in. (17.8 x 24.1 cm.)

Published: Christie's, May 25, 1996, p. 135, lot 212.

Provenance: Spink and Son Ltd., London

The artist who painted this watercolor himself explained what a "palkee" or palanquin, is:

A wooden box, fitting the human figure, with two poles, one before and the other behind, in which people are carried about on the shoulders of four men, entitled bearers. Answering to a sedan, — the horizontal instead of perpendicular.[1]

Tom Raw, a fictive figure invented by the artist, arrives in Calcutta and is asked by the respective "bearers":

"Massa have palkee?—What the devil's a palkee?"
Off to the Ghaut Ram—Johnny's seen to skip,
And, bringing one, says, "Massa he not walkee."
"Faith that I can't," sighed Tom, "and therefore, will not baulk ye."

X.
Now new dilemmas rise; he knew not how
To place himself in this strange, long machine;

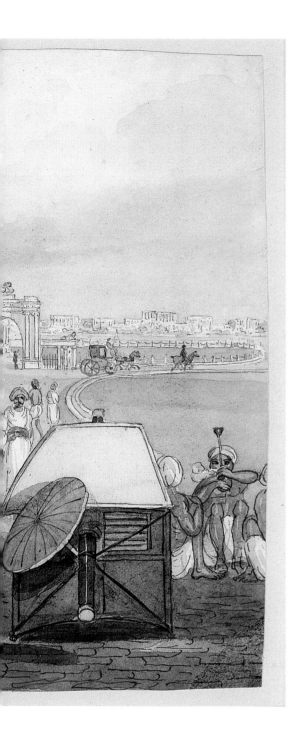

One leg he lifts, and runs it through and through,
Spraining most grievously his bended chine:
The bearers, who, to get their fare were keen,
Proceeded on, which made our hero hop,
Side-ways or crab-ways in a lateral line;
Till, roaring lustily, he made them stop,
Got in, hard knocking, with his hatless head, the top.[2]

The palki at Calcutta is a topic in itself. It was the front-cover illustration to one of Stuart Cary Welch's exhibition catalogues[3]; it appears at a prominent place in a Daniell's aquatint of Calcutta from 1786[4]; it figures as prominently in several of Fraser's *Views of Calcutta*[5]; and attracted the attention of several other artists at Calcutta.[6]

D'Oyly was not the only one to write satirically about this mode of transport. Of several others who did as well, one is quoted below:

A palanquin, vulgariter palki, and its modus operandi, should be familiar to the imagination of every one who condescends to peruse the wanderings of a traveller in India; since it must frequently occur that the whole point and seasoning of an anecdote may hinge upon a faithful conception of the conveyance. A bumpkin in some vulgar farce, asks the buffoon the way to the magistrate's house; the buffoon gives directions after his own fashion. "Do you know the bridge?" "Yes." "Well it ain't nowhere near there." — "Do you know the Church?" "Yes." "Well it ain't nowhere near there." Now let me beg the reader to take a peep into the miniature edition of Sam Johnson's Dictionary for the word Palanquin; it is thus defined, "A Indian Sedan or Chair." Now Sam. Johnson has left the reader just as far from any idea of a palanquin as the bumpkin was from the magistrate's after listening to the directions of the fool. A palki is no more like a sedan, no more like a chair than Sam. Johnson was like the Thames Tunnel: it might just as well have been described as a seaman's chest, or a flour-bin; nay, this would have been much nearer the mark; I will take either of them to work upon. Nail down the lid; cut a square hole in each of the longer sides of sufficient dimensions to admit the person, and put sliding doors thereto; to each of the other sides, a little above the centre of the panel, affix a pole about five feet in length; cover the whole with leather, or paint and varnish it, and you will have a very tolerable representation of a palki: It is borne upon the shoulders of four black men, who are bred to the office, and who perform their hard duty with astonishing activity and long-suffering. A d'ak stage is usually from 12 to 16 miles, and to perform this eight men only are requisite, and these relieve each other alternately about every quarter of a mile; but for the purpose of running about Calcutta, it is not necessary to employ more than four men. The posture adopted by Europeans, when riding in a palki, is almost recumbent; but a native is most frequently to be seen sitting cross-legged, like a tailor; which latter is undoubtedly the more comfortable, or rather the less disagreeable of the two; for it is an execrable mode of travelling take it which way you will, and would be avoided by any person having the option of riding in a wheeled vehicle, both on account of the abominable shaking and the slow rate of progression: the jog-trot averages about four miles an hour.[7]

The present watercolor was originally to be included as an illustration to part X, Canto the Second, of D'Oyly's "Tom Raw the Griffin: A Burlesque Poem," but for some reason was omitted from the printed version, as were several other illustrations.[8] A "griffin" was a man newly arrived in India. "Griffinage" lasted for a year. Charles D'Oyly explained: "The various adventures of a 'Griffin' or Johnny Newcome in the East, afforded ample scope for the display of what talents we might possess in broad caricature."[9] The closest English equivalent is probably "greenhorn." D'Oyly might have done the watercolors for his poem while at Calcutta, but he might have done them also later at Patna, where he was known for his drawings: "I found great amusement and interest in looking over Sir Charles's drawing-books; he is the best gentleman artist I ever met with. He says India is full of beautiful and picturesque country, if people would but stir a little way from the Ganges, and his own drawings and paintings certainly make good his assertion." (Reginald Heber, August 20, 1824)[10]

D'Oyly's drawings at Bankipore were also noticed by G. C. Mundy: "The greater portion of our party dined with Sir Charles D'Oyly. Here we met with a hospitable welcome and good cheer, and in the evening we heard some beautiful music, and saw some splendid drawings of the talented baronet."(G. C. Mundy, February 25, 1829)[11]

NOTES

1. D'Oyly 1828, p. 48. For a mid-nineteenth century photograph of a "palkee," see Worswick/Embree 1976, p. 87.
2. D'Oyly 1828, Canto the Second, p. 28, lines 591–603.
3. Bearce/Welch 1963.
4. "The Old Court House and Writer's Buildings" as plate 2 of *Views of Calcutta*, frequently republished, cf. e.g. Archer 1980, pp. 20–21, no. 5; Corfield 1910, p. 38, no. 48; Losty 1990, p. 51, fig. 23; Head 1991, p. 210, no. 090.006/2.
5. E.g. pl. 3 from James Baillie Fraser's *Views of Calcutta and its Environs*, cf. Archer/Falk 1989, p. 75, no. 38, col. pl. = (Guy/Swallow 1990, p. 198, plate 174, col. = Losty 1990, p. 72, col. pl. 15). This aquatint shows the Government House with one of its gates surmounted by a lion. Another gate belonging to the same compound is visible in the background of the present watercolor.
6. E.g. P. C. French, cf. Pal/Dehejia 1986, p. 49, no. 38.
7. Bacon 1837, vol. I, pp. 125–127.
8. There are two watercolors in the India Office Library, Oriental and India Office collections, London, cf. Kattenhorn 1994, p. 117, nos. 3771 and 3772. For an illus. of the former see Kattenhorn 1994, pl. 58. There are three published watercolors in the collection of the Victoria and Albert Museum, London, for which see Bayly et al. 1990, p. 187, no. 220, col. and Guy/Swallow 1990, p. 204, no. 182, col. (= Nevile 1996, p. 163, col. pl. 111) and Pal/Dehejia 1986, p. 35, no. 22. For some of the republished aquatints of the 1828 edition, see e.g. Archer 1989, p. 9, fig. 7 (*Tom Raw at a Hindoo Entertainment*) and fig. 8 (*Tom Raw Sits for His Portrait*), col.; Losty 1990, p. 74, fig. 39 (*Tom Raw's Misfortune at the Ball*); Moorhouse 1983, p. 116 (*Taylor's Emporium*); Woodford 1978, p. 118 (*Tom Raw Rejects the Embraces of the Nabob of Bengal*), p. 129 (*Tom Raw Between Smoke and Fire*), p. 141 (*Tom Raw Face to Face with the Enemy*) = Desmond 1989, p. 175, no. 13, col.), to mention just a few.
9. D'Oyly 1828, preface.
10. Heber 1828, vol. I, p. 238.
11. Mundy 1858, p. 267.

70 Henry Elliot, Aide-de-Camp
to Sir Thomas Hislop
(1764–1843), Carried in a
Palanquin beneath the Walls
of the Fort of Bharatpur
෴

by Thomas van Buerle
(fl. 1809–1835), Rajasthan,
ca. 1817.

Media: Watercolor over pencil
heightened with white

Size: 18⁷/₈ x 13⁵/₈ in.
(48 x 34 cm.)

Provenance: The Earls of Minto;
Spink and Son Ltd.

Published: Losty et al. 1996,
p. 54, no. 55.

This celebrated and maiden fortress of Bhurtpoor, which is distant about thirty miles W.N.W. from Agra, stands upon a plain amidst jungles and water. The place is of great extent, and at this time had a most numerous garrison. (William Thorn, January 1805)[1]

In January, 1805, Lake [cf. cat. no. 15] *invested the fort of Bhurtpore, in which, according to native report, were 8000 men. A breaching-battery of six eighteen pounders, and one of four eight-inch and four five-and-a-half-inch mortars were the means of offence with which operations were commenced against defences of vast size, massive proportions, and singular tenacity. Four successive attempts at storming were with little difficulty repelled by the well-prepared Jauts; and the British army, after a loss of 388 killed, 1,894 wounded, and fifty-two missing,—a total of 2,334, was compelled to retire. Though victorious, the rajah was obviously alarmed by the pertinacity of the besiegers, and his success was followed by overtures for peace. A treaty was accordingly concluded on April 17, 1805.* (Edward Thornton, as published in 1854)[2]

The defence of Bhurtpoor was a subject of admiration throughout India for many successive years; and it was a taunt that the British had not been able to prevail there as in other places." (John Clunes, as published in 1833)[3]

Lord Combermere has determined to proceed immediately to the Upper Provinces, and to have a fling at Bhurtpore. There is no doubt as to the event being successful, but the natives have a great conceit about it; it is another Pucelle, as it has never yet been taken. In Lord Lake's time, our troops were three times repulsed; but that is a tale of the times of old, when these matters were conducted on too small a scale. Now there is to be a fine park of artillery, fully capable of making an impression on the heart of this obdurate maiden. It will do much service in taking the conceit out of these people. They have songs, and even caricatures, in which Europeans are drawn as craving for mercy under their victorious swords, to the number of three or four to one Maratha horseman. It is an old grudge, and our sipahis fancy the affair hugely. We took Bhurtpore last night over the whist-table, by a coup de main; I trust we shall be able to play our cards as well when before it.
(Fanny Parks, September 18, 1825)[4]

Fanny Parks's entry in her diary needs some correction here, as to the date of the final storming of Bharatpur:

Lord Combermere, commander-in-chief, invested the town with an army computed to exceed 20,000 men, with 112 pieces of ordnance, besides fifty belonging to the horse-artillery. The fire of the besieging batteries, though maintained with great vigour, being found not to make a satisfactory impression on the defences, which were constructed of mud, supported and bound by beams and logs, recourse was had to mining; and on the 18th January, 1826, a mine of great dimensions having been sprung with good effect, the place was stormed and taken, after a desperate resistance made for an hour by the garrison, of whom 6,000 are reported to have been killed.... The fortifications of the city of Bhurtpore were completely dismantled.[5]

The identification of the subject of this picture was made by Karen Taylor, presumably based on information supplied by the descendants of the Earl of Minto, from whom this picture was acquired by Spink in London.[6] Sir Thomas Hislop as Commander-in-Chief in Madras, a post he held from 1814–1820, took part in the wars against the Pindaris (cf. cat. no. 14) and on November 10, 1817, reached as far north as Hurda, when he assumed command of the first division of the Deccan army.[7] It is possible that this brought Thomas van Buerle,[8] one of the aides-de-camp of Sir Thomas Hislop, as far north as Bharatpur, when van Buerle might have done the present watercolor. How the painting came into the possession of the Earls of Minto is explained by the following facts:

The painting "shows another member of Hislop's staff, Lieutenant-Colonel Henry Elliot, being carried in a palanquin after receiving a wound. Elliot was the eldest son of The Right Hon. Hugh Elliot, Governor of Madras from 1814 to 1820[9] and nephew of Gilbert Elliot, 1st Earl of Minto, who was Governor-General of India from 1807 to 1813. In 1823 Hislop married Henry Elliot's younger sister, Emma."[10]

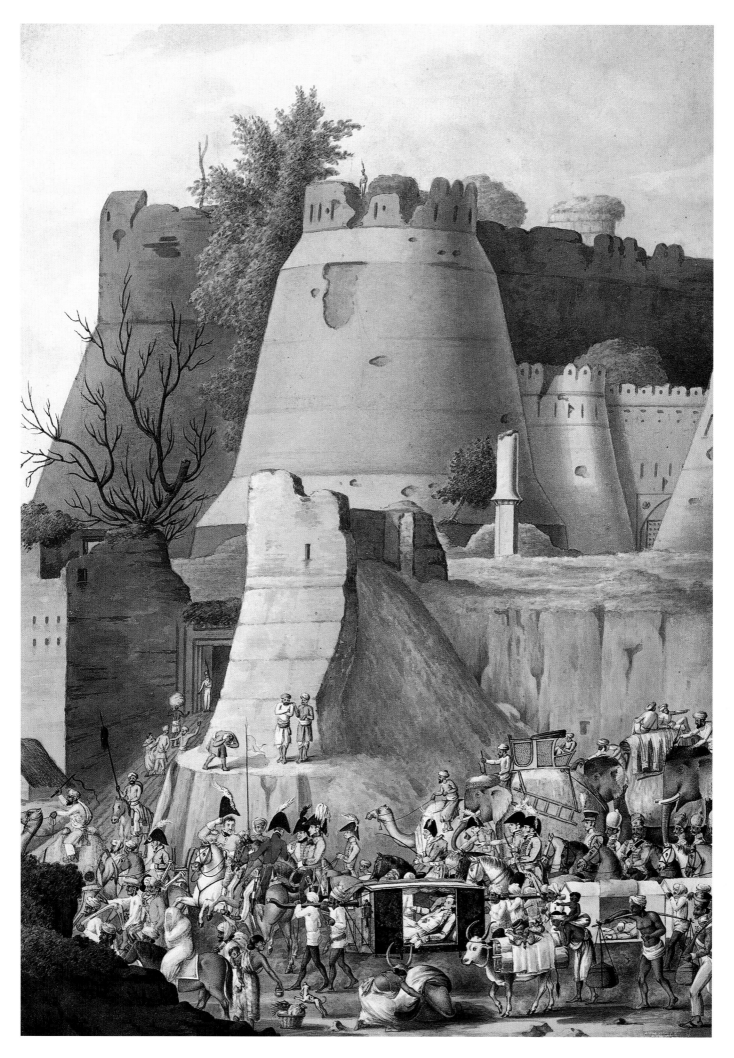

Fortresses, Cities, and Their Roads and Palaces

The animated procession below the walls of Bharatpur reminds strongly of a frequently published Kangra painting of about 1780–1785, showing Krishna's and Balarama's migration from the village of Gokul to Brindaban.[11] It is probably due to the watercolor technique that this painting resembles an Indian miniature more than any other painting by a Western artist in this catalogue. It is self-evident that the painting was done prior to the dismantling of the fort's walls and ramparts after the successful storming in 1826 as reported above. Today, the fort of Bharatpur houses one of the most interesting museums of ancient Indian sculptures, coins, and weapons, especially cannons.[12]

NOTES

1. Thorn 1818, p. 415.
2. Thornton 1854, vol. I, pp. 428–429. For a detailed description of the four attempts of storming the fortress of Bharatpur, a detailed plan showing the military operations during the siege, the appearance of Mir Khan Pindari on the scene, etc. see Thorn 1818, col. plan facing p. 415 and pp. 415–432; 447–464. For a near contemporary description and history of Bharatpur, cf. also Ritter 1836, pp. 938–941; Clunes 1833, pp. 157–160.
3. Clunes 1833, p. 159.
4. Parks 1975, vol. I., pp. 55–56.
5. Thornton 1854, vol. I, pp. 429–430.
6. The present view alone does not suffice to identify the fortress properly. In 1826, sixteen sketches illustrative of the siege and capture of Bharatpur designed on stone by Hutchisson were printed and published by the Asiatic Lithographic Press in Calcutta, but, as M. Archer remarked, "it is unlikely that Hutchisson himself was present at the siege and the illustrations were probably worked up by him from sketches made by army officers on the spot," Archer 1969, vol. II, p. 616. The first published view of "Baratpor" is a folded copper-engraving published in Tiefenthaler 1786, vol. I, planche V, facing p. 210, also published in Noti 1906, p. 38. It shows the large bastions still intact. The extent of British demolition of the fort following the successful storming in 1826 can best be judged from a photograph, for which see Noti 1906, p. 33.[7] For details of this campaign cf. Grant Duff 1863, vol. III, p. 325 and var. loc. Hurda is in the territory of Gwalior.
8. In a letter to Dr. William K. Ehrenfeld, dated July 19, 1996, Karen Taylor supplied the following information on Thomas van Buerle: "Commissioned 26th July 1909, 75th Foot; Lieut. 11th March 1812; Transferred to 56th Foot 23rd December 1812; Transferred to 89th Foot 11th March 1817; to half pay 1825; Changed name to Van Baerle or Van Baerd; Half pay until 1835; then disappears."
9. Hugh Elliot (1752–1830) was governor there from September 16, 1814, to June 10, 1820, to be precise. His brilliant career included ministerships in Prussia, Munich, and Dresden. He is buried in Westminster Abbey.
10 Losty et al. 1996, p. 54.
11 This well-known painting is in the collection of the National Museum, New Delhi, 49.19/239. Colored reproductions of this painting include Randhawa 1960, pl. V, facing p. 50 and Khandalavala 1974, pl. II.
12. Cf. Shiva Saran Lal n.d. and Shiva Saran Lal 1961.

**71 North View of the City
of Lahore**

*by a local artist,
ca. 1840–1845.*

Media: Gouache on paper

Size: 9 ¾ x 91 ½ in.
(24.8 x 232.4 cm.)

The fortified city of Lahore as seen from south to north was drawn by various European artists, but there is apparently no contemporary description by an artist from Lahore. It was also sketched by Frances ("Fanny") Eden (1801–1841), sister of the more famous Emily Eden (for her portrait of Hira Singh see cat. no. 22), at about the time when this monumental painting was made. She wrote:

I have been sketching Lahore from the plain, as you will see from the other side. If you could only see me at it. A very large quantity of Sikhs besides our own sepoys is quite nice company. And an aide-de-camp and the tonjaun I am carried in and my elephant following, in case I should want it, and servants with silver sticks running on before. And so having set off to sketch in this sweetly simple manner, an immense crowd of Sikhs gather in two minutes, upon which the Sikh guards ride about with their long spears and make them all sit down. They draw round in two half circles, and everything is quiet and comfortable, much quieter than a set of little children in a village—unless a faquir comes whose trade is to abuse us at the full extent of his voice, and his abuse is sacred so nobody interferes. Before I finished this sketch there were some hundred Sikhs assembled, but they said nothing and did not laugh much. (December 24, 1838)[1]

A slightly earlier description was given by Alexander Burnes:

On the morning of the June 18 we made our public entrance into the Imperial city of Lahore, which once rivalled Delhi. We moved among its ruins. . . . In our evening at Lahore, we had many opportunities of viewing this city. The ancient capital extended from east to west for a distance of five miles, and an average breadth of three, as may yet be traced by the ruins. The mosques and tombs, which have been more stably built than the houses, remain in the midst of fields and cultivation as caravan serais for the travellers. The modern city occupies the western angle of the ancient capital, and is encircled by a strong wall. The houses are very lofty, and the streets, which are narrow, offensively filthy, from a gutter that passes through the centre. The Bazars of Lahore do not exhibit much appearance of wealth, but the commercial influence of the Panjab is to be found at Amritsar, the modern capital. (June 1831)[2]

The topographical accuracy of this panoramic view is attested to by the "Plan of the City and Environs of Lahore shewing the Civil Station of Anarkullee and the Cantonment of Meean Meer." Edited by the Surveyor General's Office in Calcutta in August 1867, this zincographed and hand-colored map probably constitutes the first large published map of Lahore. The artist of the present painting must have stood at what in 1867 was called the Jemadar Khooshal Singh's temple. Looking south, he had nothing to disturb his view of the city walls, except the wells and gardens which the artist included in this panorama. Looking from left to right —or from east to west— the observer first notices the angular north-eastern bastion that hides Lahore's north-eastern gate, the Yakki Darwazah or Yakki gate.[3] The first gate that opens towards the north is the Khizri gate, named after a Muslim saint.[4] At the time of the present painting it was known by the name Sheranwala gate (lion's gate), due to two domesticated lions which were kept in a cage at this gate during Ranjit Singh's reign.[5] The four minarets in the distance, here to the west of the Sherenawala gate, belong to the mosque of Wazir Khan, "the chief ornament of the city of Lahore," founded in 1634.[6] It became known in the West through Rudyard Kipling's "The City of Dreadful Night." Since 1882, Rudyard Kipling worked for the *Civil & Military Gazette* in Lahore while his father, John Lockwood Kipling, published the

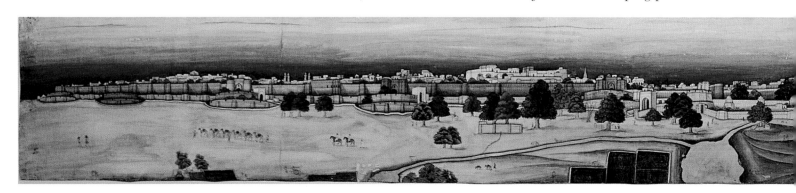

then most important article on that monument.[7] The next gate is the Kashmiri gate, "so named because it faces the direction of Kashmir."[8] The walled enclosure around two trees, beyond the canal in front of the city walls between the Kashmiri gate and the next gate to the west is a "privy," still marked as such in the map of 1867. The fields in the foreground —in the lowermost part of the painting— belong to "Allee Reza Khan's garden and tank," according to the map of 1867. The gate behind these fields is the Mustee Gate or Masti Gate, so called after the mosque of Mariam Zamani. Built in 1614, it is the oldest mosque of the city and stands in the vicinity of the Masti Gate, which is a corruption of Masjidi Darwaze or "gate of the mosque."[10] The Lahore map of 1867 marks it as the "Old Mosque." At the Masti Gate the moat along the city walls is interrupted. The moat is seen again immediately below the city walls a little further to the west. Within the city walls and to the west of the outer Masti Gate stands another Masti or Masjidi Gate, which belongs to the older part of the famous Lahore fort. It was built under the Mughal emperor Akbar in 1566 and consists of two octagonal towers flanking the doorway, forming the eastern entrance to the fort and hence seen here from the side.[11] The city is then dominated entirely by the Lahore fort and its various palaces, which were described by European travellers from the early seventeenth century onwards. Its northern facade stands out for its numerous and colorful tile mosaics from the reign of the emperor Jahangir (1605–1627) which the artist minutely indicated in this painting.[12] The representation of the fort starts with its north-eastern tower of the so called garden or quadrangle of Jahangir,[13] followed by the eastern *bangaldar* or pavilion with curvilinear roof of that quadrangle. This building still exists. In the center of the northern end of Jahangir's quadrangle stands the so-called Bari Khwabgah or large sleeping room,[14] which is flanked on its western side by the western *bangaldar*, which no longer exists. The western end of Jahangir's quadrangle is indicated by its western tower in its north-western corner,[15] to the west of which is the so called Diwan-i-Khas or Hall of Special Audience,[16] situated in the center of the northern end of "Shah Jahan's Quadrangle." Right below this building and partly hidden by trees stands the Arz Gah, a building in which the nobles of the court assembled in the morning to receive the emperor's commands. This is now in ruins.[17] Somewhat below and right behind the city wall is the tomb of Bhai Vustee Ram according to the Lahore map of 1867.

Further to the west the spacious octagonal Lal Burj (red tower) dominates the scene. It forms the northwest corner of Shah Jahan's Quadrangle. Its top story is a later addition from the Sikh period and the name of the building is said to be even of the post-Sikh period.[18] This Lal Burj flanks the central northern building known as Khilwat Khana or more correctly Khilat Khana in the Sikh period[19] or Ghusl Khana in earlier times.[20] The north-eastern corner of the courtyard of the Khilat Khana is marked by the Kala Burj (black tower) which externally corresponds to the Lal Burj in the north-eastern corner of the same courtyard. Used as a liquor bar during the Sikh period, it contains some of the most spectacular murals of the period of Jahangir (1605–1627).[21]

The northern facade of the fort is terminated by the large structure known as Musamman Burj, actually "octagonal tower." This old name was corrupted into Samman Burj, as it is known today. Earlier, it was probably known as the Shah Burj or royal tower.[22] This

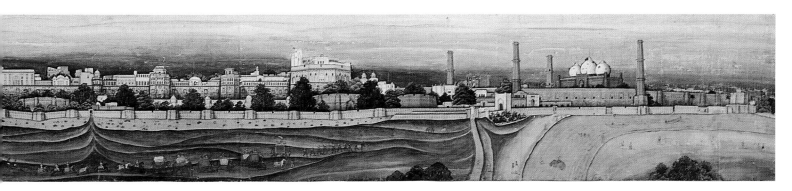

structure contains one of the most spectacular rooms of the fort, the so-called Shish Mahal or palace of mirrors, built basically in 1631–1632.[23] The two white towers topped by pavilions with here almost globular cupolas in the back belong to the Alamgiri Gate, the eastern entrance to the fort. It was built under the Mughal emperor Aurangzeb in 1673–1674.[24] The white gateway further to the west is the Roshnai or Roshani Darwaza (gate of splendour or gate of light). In former times it was brightly illuminated after dark, hence its name.[25] The spacious courtyard behind that gate is the Hazuri Bagh. The tower behind the Roshnai Gate is the south-eastern minaret of the Badshahi Masjid (emperor's mosque). Built under the Mughal emperor Aurangzeb in 1673–1674, it constitutes the largest mosque of the city. Noteworthy are the plants that grow on its three marble cupolas and the minars without their cupolas.[26] Hira Singh (cat. no. 22) mounted these minars with light guns to fight the enemy successfully.[27]

The gateway to the Badshahi Mosque can be seen between its two eastern minarets. The building in front of it, outside the courtyard of the Hazuri Bagh with a white square pavilion on top is in all probability the tomb or *samadh* of Maharaja Ranjit Singh in its unfinished state, as it was described by Leopold von Orlich in January, 1843.[28] Maharaja Ranjit Singh died on June 27, 1839 and the construction of the *samadh* started shortly afterwards. It was, however, not really completed by 1848 and it seems that the British helped in its completion. A part of the building was bequeathed by Rani Jindan, mother of the then Sikh ruler Dalip Singh (cat. no. 48).[29] The panoramic view of Lahore ends with the polygonal, north-western bastion of the city wall. A clue to the date of this large scroll is offered by the state of the monuments shown therein. The minarets of the Badshahi Masjid are devoid of their topmost stories. These had to be removed following an earthquake in 1840.[30]

The *samadh* of Maharaja Ranjit Singh was finished in 1849, as is shown by a photograph from that period.[31] The only other published comparable view of Lahore done by an Indian artist formerly belonged to General Ralph Young, Commissioner of Lahore some time between 1857–1877. It was identified as showing "A panoramic view of Delhi from the River Jumna showing the Red Fort and the Jami Masjid. . ."[32] A picture showing the Kashmiri Gate of Lahore is most probably a fragment of a similar long scroll painting.[33] An unpublished north view of the city of Lahore is kept in the collection of the Museum of Indian Art in Berlin, acc.no. I 3144. It measures 25.8 cm. in height and 242.5 cm. in width. It belongs to the collection of Prince Waldemar of Prussia who, in February 1846, met prince Dhulip Singh at Lahore and gave a vivid description of the city and its monuments while staying there until March. On that occasion Prince Waldemar must have acquired the view.[34]

The first ever published panoramic view of Lahore was released in 1852 as part of a book by Dr. Honigberger, a German[35] in the service of the Sikhs between 1829–1833 and 1839–1849. Though originally it might have been the work of a native artist, it was reworked heavily to suit European taste for its inclusion in the aforementioned publication.[36]

In March 1842, Honigberger sold "a panorama of Lahore done by a native artist to a visiting guest, the Russian artist Prince Alexis Soltykoff."[37] That drawing was also reproduced, with certain changes, as a double-paged woodcut illustration in the French *L'Illustration, Journal Universel* on October 24, 1857.[38] With regard to its minute documentation of buildings which no longer exist, the present scroll painting must be considered as being the most important nineteenth-century document on the architecture of the city of Lahore.

NOTES

1. Eden 1988, pp. 190–191. For the sketch of Lahore, see p. 191.
2. Alexander Burnes, *Travels into Bokhara,* 3 vols., London 1834, vol. III, pp. 158–159, quoted after Baqir 1952, p. 326.
3. This gate was already mentioned by the Venetian Niccolao Manucci, cf. Manucci 1981, vol. II, p. 173; For a description cf. Latif 1892, p. 86.
4. For a col. illus. of this saint dating from the first half of the seventeenth-century cf. Ehnbom/Topsfield 1987, pl. p. 16, cat. no. 4.
5. By the end of the nineteenth century it was known under both names, cf. Latif 1892, p. 86.
6. Latif 1892, p. 214.
7. Kipling 1887. For a monograph on that monument in English, see Chaghatai 1975. The best monograph in Urdu, illustrated by more than fifty-eight col. illus., is by Mian Abdul Wahid. See also Latif 1892, pp. 214–221; Baqir 1952, pp. 335–339; Khan 1964, pp. 45–46.
8. Manucci 1981, vol. II, p. 173; Latif 1892, p. 173.
9. Nawab Ali Raza Khan, a Kazalbash of Kabul, "rendered valuable services to the British Government in the first Afghan War of 1839." He died in 1866, cf. Latif 1892, p. 327; for the term "Kazalbash," see Yule/Burnell 1984, pp. 497–498.
10. Latif 1892, p. 85 and p. 131; Baqir 1952, pp. 342–343.
11. For a photograph and account of this gate, see Khan 1964 pp. 9–11 or Khan n.d., pp. 22–23.
12. See Vogel n.d., especially the folded pl. I, showing the north wall, Vogel 1904 and Vogel 1911; Khan n.d., col. photograph p. 33.
13. Khan 1964, p. 22. For a photograph of its north-eastern corner see Khan 1964, p. 21 or Khan n.d., p. 25. It is also called Daulat Khana-i-Jahangiri. The tower is marked "C" in the groundplan by LaRoche in LaRoche 1921–1922, vol. V, p. 199.
14. For groundplans of the fort see Fergusson/Spiers 1910, vol. II, p. 303; Vogel n.d., pl. II; Smith 1894, double-page pl. 67; Nur Bakhsh 1970, pl. XXXIII; La Roche 1921, vol. 5, p. 199; Reuther 1925, p. 74; Baqir 1952, p. 362; Khan 1964, p. 8; Koch 1991, p. 84. For the building as such see Reuther 1925, p. 59.
15. Marked "B" in the groundplan in La Roche 1921, vol. 5, p. 199.
16. Khan 1964, p. 26. This building is called Choti Khwabgah or "lesser Sleeping Room" by Baqir 1952, p. 367f., which, according to Khan 1964, p. 25, should be at the southern end of Shah Jahan's Quadrangle; see also Khan n.d., p. 27f. It seems Baqir confused the directions, but it is also called Chhoti Khwabgah by Vogel n. d., pl. I and Vogel 1911, April, p. 10 and LaRoche 1921, p. 199. It is called Khwabgah in the plan given by Nur Bakhsh 1970, pl. XXXIII and Diwan-i-Khas in the groundplan reproduced in Koch 1983, fig. 2.
17. Baqir 1952, p. 364; Vogel 1911, April, p. 10.
18. Khan 1964, p. 28; Khan n.d., p. 29.
19. Vogel 1911, April, p. 10.
20. For a description see Khan 1964, p. 30.
21. Koch 1983; Khan 1964, p. 32.
22. Baqir 1952, p. 355; Asher 1992, pp. 179–181; Koch 1991, pp. 114–115; Khan 1964, pp. 35–36.
23. For a woodcut see Latif 1892, illus. facing p. 126. For photographs cf. Reuther 1925, pls. 75–77; Koch 1991, p. 115, illus. 137; Asher 1992, p. 180, pl. 107. For the most detailed published groundplan see LaRoche 1921–1922, vol. V, p. 202.
24. For photographs see Baqir 1952, illus. facing p. 365; Khan 1964, p. 39.
25. Latif 1892, p. 119; Khan 1964, p. 84.
26. For descriptions and photographs cf. Latif 1892, pp. 113–116; Khan 1964, illus. p. 3 and pp. 70–80; Baqir 1952, pp. 331–335; Asher 1992, p. 258, pl. 162. For the plants on the cupolas see Aijazuddin 1991, p. 56.
27. Cf. Latif 1892, p. 114.
28. Orlich 1845, p. 135.
29. For an account and reproductions of this monument, see Latif 1892, p. 129 and accompanying woodcut-illus. Khan 1964, pp. 84–85; Aijazuddin 1991, pp. 82–83, no. 38, pp. 87–91.
30. Latif 1892, p. 114; Baqir 1952, p. 332.
31. Aijazuddin 1991, no. 41, reproduced p. 88.
32. Sotheby's, October 10, 1988, lot 8, and pl. XII for a detail (= Kyburg Limited 1989, no. 17, pp. 10–11).
33. *Maggs Bull.,* no. 17, August, 1970, p. 123, no. 102.
34. Cf. Kutzner 1857, pp. 373–382.
35. Cf. Orlich 1845, p. 134.
36. For a reproduction and discussion of this view see Aijazuddin 1991, pp. 48–50.
37. Aijazuddin 1991, p. 48.
38. Reproduced: *Les Grands Dossier* 1987, pp. 44–45.

**72 The "Burning Ghat,"
 Benares, as Seen from
 the City**

 ∾

 by George Landseer, Benares,
 1861.

 Media: Oil on canvas

 Size: 23¼ x 16⅝ in.
 (59 x 42.3 cm.)

 Inscribed: On verso, on canvas,
 in ink: "SKETCH of the
 Burning Ghaut / Benares."

 Signed below: "George Landseer /
 1861." An inscription on an old
 paper label attached to the top
 part of the back of the frame
 reads: "The Burning Ghat -
 Benares."

A *ghat* is a flight of steps or terraces leading down to a river or tank, a kind of quay, as shown in this painting. Probably the most contemporary published description of the scene is by William Howard Russel, who was later to accompany the Prince of Wales during his visit to India in 1876–1877:

Before us there is a long line of roofs, temples, cupolas, pillars, minaret-like spires rising up on a high ridge, between which and the road as it melts away among the trees is a deep ravine. As we drive always amid dust, and trampling feet, and multitudes of people, the ridge seems to rise and the ravine to deepen. At last in the far side under the ridge, the eye catches a streak of water which becomes broader as we get nearer, and then we see that underneath the sacred city of Benares, washing the steps of its temples which stretch for miles along its bank, flows the Holy Ganges, spanned by a large bridge of boats.... The city, seen from the right bank of the river, looks right glorious. If the Rhine flowed under the walls of the old city of Edinburgh, and swept along from the castle to Holyrood over the railway ravine, the scene would be something like that presented by Benares. But there are no lofty hills; no Calton; no Arthur's Seat in the distance.... (February 8, 1858)[1]

The bridge of boats mentioned by Russel can be seen in the present painting as a horizontal black line in the distance. Its position is shown in great detail in a near contemporary map (scale: 6 inches to 1 mile) entitled "Cantonments of Sikrol and Pandypoor, also The Civil Station & City of Benares. Season 1867, 68." [2]

Benares, probably more than any other Indian city, attracted the attention of European artists, to whom it combined both "picturesqueness" and "horror."

The scene was particularly picturesque; below the ghat ... were some native boats; and near them was a man dipping a piece of cloth embroidered in crimson and gold into the water; while with a brilliant light and shade the whole was reflected in the Ganges.... In the midst of hundreds and hundreds of temples and ghats, piled one above another on the high cliff, or rising out of the Ganges, the mind is perfectly bewildered; it turns from beauty to beauty, anxious to preserve the memory of each, and the amateur throws down the pencil in despair. Each ghat is a study; the intricate architecture, the elaborate workmanship, the elegance and lightness of form,—an artist could not select a finer subject for a picture than one of these ghats. (Fanny Parks, December 7, 1844)[3]

The "horror" part is mentioned, though comparatively discreetly, by another woman, the Austrian Ida Pfeiffer, who visited Benares only three years after Mrs. Parks. Pfeiffer gives the local name of the ghat, viz. Mankarnika, the designation "Burning Ghat" being entirely European:

Near the temple are the most holy places in the town, namely—the so-called holy well and the Mankarnika, a large basin of water.... The Mankarnika is a deep basin, paved with stone, about sixty feet long, and of equal breadth; broad steps lead from the four sides into the water.... Every pilgrim who visits Benares must, on his arrival, bathe in this holy pool, and, at the same time, make a small offering.... Fifty paces from this pool, on the banks of the Ganges, stands a remarkably handsome Hindoo temple, with three towers. Unfortunately, the ground sunk a few years ago, and the towers were thrown out of their proper position: one inclines to the right and the other to the left; the third is almost sunk into the Ganges. Among the thousands of other temples, there is here and there one which is worth the trouble of a cursory inspection, but I would not advise any one to go much out of their way on their account. The place for burning the dead is very near the holy pool. When we went there, they were just roasting a corpse — the mode of burning cannot be described by any other name, the fire was so small, and the corpse projected over on all sides. (December 27, 1847)[4]

The inclined towers of the temple at the Manikarnika Ghat were for some time the landmark of Benares, as they appear in a number of engraved plates.[5]

Probably no other guide on India has attained more fame than the "Murray." We quote here from the description of the *ghats* of Benares, as it appears in the edition of 1882:

The traveller will come to the Manikaranika, which is one of the 5 celebrated places of Hindu pilgrimage in Banaras, and is considered to be the most sacred of all the Ghats. It is also at the central point of the city, so that if a line was drawn from it to the W., it would divide Banaras into 2 portions N. and S. Close to it are 3 temples erected by the Raja of Amethi. Just above the flight of steps is the Manikaranika Well, and between it and the steps is the temple of Tarkeshwara, "god of salvation," as Tarak signifies "he who ferries over." Below this temple the bodies of Hindus are burned. The well has its name from Mani, "a jewel," and Karna, "the ear," Devi or Mahadeo having dropped an earring into it. During the eclipse of the sun it is visited by 100,000 pilgrims.[6]

The well, or, more properly, tank, is 35 ft. sq., and stone steps lead down to the water. Offerings of the Bel tree, flowers, milk, sandal-wood, sweet-meats, and water are thrown into it; and from the putrefaction of these a stench arises equal to that which ascends from the Well of Knowledge. According to a ridiculous Hindu legend, it was dug by Vishnu, and filled with his perspiration, and when he went away Mahadeo peeped in and saw innumerable suns, which so pleased him that he promised Vishnu anything he pleased ask for. Vishnu asked that Mahadeo should be with him for ever, and so gratified Mahadeo, that he shook with joy, until one of his earrings fell into the tank. According to others it was from Devi's ear, as she was sitting with Mahadeo, that the earring fell into the water. It may be mentioned that at the Cremation Ground below, the fire must be

Fig. 20

brought from the house of a Domra, a man of very low caste. The Domra who has the monopoly of giving fire for cremation, is very wealthy, as fees are demanded and given up to 1000 rs [rupees]...." [7]

A detail of Landseer's painting that requires attention is the slim tower in the back. This tower is a minaret belonging to the mosque of Aurangzeb which actually overlooks the city as shown in cat. no. 29. It remains hidden behind the temples when the *ghat* is seen from the lowermost steps, as in the case of the accompanying fig. 20 of a late nineteenth-century photograph from the Ehrenfeld collection. The location of this mosque is marked as "The Minarets" in the Benares map of 1869 mentioned above. Two accounts on these minarets are worth mentioning:

Among the other buildings, the Mosque Aurang Zeb is most worthy of the notice of travellers. It is famous on account of its two minarets, which are 150 feet high, and are said to be the slenderest in the world. They look like two needles, and certainly are more deserving of the name than that of Cleopatra at Alexandria. Narrow winding staircases in the interior lead to the top, upon which a small platform, with a balustrade a foot high, is erected. It is fortunate for those who are not subject to dizziness. They can venture out, and take a bird's-eye view of the endless sea of houses, and the innumerable Hindoo temples; the Ganges also, with its step quays, miles long, lies exposed below. I was told that on very clear, fine days, a distant chain of mountains was perceivable — the day was fine and clear, but I could not see the mountains (Ida Pfeiffer, December 1847) [8]

In this holy Head-quarters of Hindooism the most remarkable and prominent edifice is the great musjed of Aurangzebe, whose lofty minars seem to look down with contempt upon the Lilliputian crowds of Hindoo muts within view of its proud dome. How galling must the Muezzin's call be to the ears of the 500,000 followers of Brahmah who form the chief population of Benares! (G. C. Mundy, February 8, 1829) [9]

Ever since William Hodges' views of Benares from about 1780, Benares attracted a number of European artists like the Daniells (cf. cat. nos. 13, 53, 78, and 79), Forrest (cf. cat. no. 57.), Prinsep, Smith, Simpson (cf. cat. nos. 25, 59, and 87), Lear (cf. cat. nos. 84 and 85), Goodwin, and others. [10] Landseer's view of the Manikarnika, alias Burning Ghat, certainly ranks among the most reliable and artistic views, as can be shown by comparison with the accompanying fig. of a late nineteenth-century photograph of the same *ghat*. [11] The smoke in Landseer's painting, indicating the fires on which the bodies are cremated, appears also in earlier views but adds here to a more dramatic rendering of the subject since the actual bodies are concealed by the architecture of the *ghats*. Landseer's leading position as one of the great landscape artists in India is yet to be properly evaluated. [12]

NOTES

1. Russel 1860, vol. I, p. 147.
2. For a more complete quotation of this map see cat. no. 29
3. Parks 1975, vol. II, p. 438.
4. Pfeiffer n.d., p. 167–168.
5. Cf. e.g. Forrest 1824, pl. XIV (= Mahajan 1984, p. 81, col. pl. XII = Pal/Dehejia 1986, p. 40, fig. 27); Roberts/Elliot 1835, engraving facing p. 8: *Hindoo Temple -Benares* (= Mahajan 1984, front end paper). Parks exclaimed: "How soon Benares, or rather the glory of Benares — its picturesque beauty — will be no more! Since I passed down the river in 1836 many temples and ghats have sunk, undermined by the rapid stream."(Parks 1975, vol. II, p. 438).
6. James Prinsep drew the Manikarnika Ghat on the occasion of the eclipse of the moon on November 25, 1825, with crowds of pilgrims, see Mahajan 1984, double-page pl. pp. 124–125.
7. *Murray's Hand-Book* 1882, pp. 214–215. For a more informative description and account of this *ghat*, see Havell 1905, pp. 134–138.
8. Pfeiffer n.d., p. 168.
9. Mundy 1858, p. 260. For the estimated number of inhabitants of Benares, statistics, history etc. see Thornton 1854, vol. I, pp. 340–354.
10. For a comprehensive account on non-Indian artists in Benares cf. Mahajan 1984; W. G. Archer 1971; Pasricha 1995.
11. For a similar published photograph, see Havell 1905, frontispiece.
12. For recent accounts see Kattenhorn 1994, pp. 187–188; Godrej 1995, pp. 132–133.

73 A Street Scene in North-
West India, Probably
Udaipur

by Edwin Lord Weeks
(1849–1903), North-West
India or U.S.A., 1893–1900.

Media: Oil on canvas

Size: 18¾ x 12½ in.
(47.6 x 31.8 cm.)

Inscribed: Signed in lower left
corner: "E. L. Weeks." A
printed label of recent date on
the back of the frame gives the
title of the painting as *Arrival at
the City Gate* without further
reference.

Provenance: Estate of Edwin
Lord Weeks; Colin Stodgell
Fine Art

Oudeypore is a white city. Not only the pavilions, kiosks, and arcades which rise from the shores of the lake, but the lower walls of the great palace, the island palaces, and the town itself, are positively dazzling with whitewash.

A fellow-countryman whom I met on the road, whose name is everywhere known as an authority on Indian art, said that he had been greatly disappointed in Oudeypore, mainly because the whitewasher's brush had given it the semblance of a whited sepulchre. With all deference to his taste and judgement, I found the prevailing color to be rather agreeable than otherwise, and to have an enhanced value from its setting of dark foliage, so often relieved by brilliant masses of flowering vines.

The whitewash is not used in order to hide baseness of material, for most of the architecture is solidly built of the dark red sandstone of the country, purely Hindoo in style, abounding in colonnades with dentilated arches, and with richly sculptured brackets upholding the horizontal eaves: white, with its luminous reflections and cool shadows, is far more restful to the eye than the dull brick color of the stone beneath. (E. L. Weeks in Udaipur, Rajasthan, 1893)[1]

When arrayed in his court dress, and mounted on his horse caparisoned with corresponding splendour, the Rajput noble is at his best, and in the full glare of sunlight he is decorative to a dazzling degree. (E. L. Weeks in Udaipur, 1893)[2]

Most of Weeks's oils are composed, with perhaps the exception of the elephant portrait, cat. no. 93. Weeks, like the majority of his fellow orientalists, not only looked for the "picturesque" but something like the "exotic picturesque," done in a "super-realistic style,"[3] which he achieved by a combination of the real, in this case the whitewashed architectural setting, with the intimate moment, as in his *Indian Cloth Merchant*.[4] Most important for Weeks's compositions was the distribution of light: The object of the horseman's attention is gently touched by the sun, whereas the mounted Rajput noble himself is "in the full glare of sunlight," to become "decorative to a dazzling degree." Weeks set similar accents in his *Indian Cloth Merchant*: Only part of the face and both hands of the young woman are heightened by sunlight, whereas almost everything else is drowned by shadows. This use of dramatic distribution of light and shade was probably due to Weeks's training in Paris with Jean Léon Gérôme (1824–1904) and Léon Bonnart.

A young woman balancing a pitcher on her head belonged to Weeks's Indian street scenes. Here we see her dressed in red, with her left hand supporting the round pot, right below the apex of the gateway. She appears more prominently in a further Indian street scene with a gateway as architectural setting, in which she is the focus of attention of another rider, this time mounted on a camel.[5] She also figures prominently in the picture *In the Bazar, Oudeypore.*[6] Both the young woman and the other, not less attractive but apparently older woman — possibly the mother of the younger — reappear separately in other paintings by Weeks.[7] It even seems that the white-dappled horse reappears in another oil-painting with a gateway by Weeks.[8]

The Rajput horseman wears a dress known as *chogha*, a kind of coat, apparently made here of richly embroidered blue velvet or silk. Such *choghas* were often made at either Banares or Lucknow to be tailored in Jaipur.[9] The moisture of the Indian climate causes the whitewashed walls to darken irregularly after the first annual rains, as Weeks so convincingly demonstrated in this painting. Several studies of stone brackets from different places, partly comparable to those in the present painting, were published by Weeks himself.[10]

NOTES
1. Weeks 1896, pp. 254–255. The "fellow countryman" was probably Lockwood de Forest, for whom see cat. no. 75.
2. Weeks 1896, p. 285.
3. Pal et al. 1989, p. 214.
4. Sweetman 1991, p. 224, fig. 137.
5. For the painting titled: *Bazaar in Amritsar, Northwest India*, see Sotheby's N.Y., December 14, 1979, lot 451.
6. Weeks 1896, p. 285.
7. Cf. Weeks 1896, p. 191, p. 245, p. 265, p. 331.
8. Christie's, May 25, 1995, p. 87, lot 137, full-page col. pl.
9. For this kind of male Indian dress cf. Watson 1866, pl. VIII, no. 64, preferably in the hand-col. edition. See also Singh 1979, pl. 17, cat. no. 1217 and the descriptions of cat. nos. 1216, 1218–1228, 1244–1248, 1250, 1252–1253; Singh et al. 1988, col. pls. 43–45; Goswamy/Krishna 1993, pp. 87–88 and the col. illus. on pp. 92–93.
10. Cf. Weeks 1895, p. 580 (= Weeks 1896, p. 333); p. 582 (= Weeks 1896, p. 335).

74 **A Procession beneath the Ancient Palace of Man Singh at Gwalior**

∾

by Edwin Lord Weeks (1849–1903), Gwalior or U.S.A., late 19th century.

Media: Charcoal drawing on paper

Size: 18 x 22 in. (45.7 x 55.9 cm.)

Inscribed and signed in lower left corner: "To my friend / Scinnary[?] Natchill[?] / E. L. Weeks."

Our impressions of the marvels of Rajpootana would be incomplete without at least a brief reference to Gwalior and the fortress of Scindhia. Shattered, ruinous, and rapidly falling into decay, it still remains a striking landmark, and a unique monument even in India — unique, for although there is something in the bizarre forms of its architecture akin to the early Persian palaces at Persepolis and elsewhere, as well as to the later edifices in Toorkistan, it bears the stamp of complete originality, as if its builders had been allowed to work out their own conception unhindered. I refer more specifically to the older portion, called the palace of Man Mandi [Man Mandir]. Its long line of round sloping towers, capped with broad-rimmed cupolas, overtops the rocky ridge which raises straight from the plain, and the whole facade, within and without, is decorated with bands and panels of brilliant enamelled bricks, blue and green and vivid yellow, varied with courses of sculptured stone work. When the Emperor Baba [Babar] saw it in 1537, the domes were covered with gilded copper, and the whole vast fabric must then have been a blaze of color.... Within the fortress walls ... are two exquisite little courts in the palace so original in design that it would puzzle an architect to classify them. This fortress has long been the stronghold of the Mahratta rulers of the line of Scindia, and at the time of the Mutiny was occupied by the English, who have recently restored it to its original owners. Each race has left traces of its occupancy, and during the English regime many modern improvements were effected; ruinous palaces were fitted up as mess-rooms and officers' quarters, and as Cunningham says, "a lot of antiquarian rubbish was cleared away to make a parade-ground."

Edwin Lord Weeks concludes his description of Gwalior, after having described the modern palace and its European carriages:

A royal household, in order to keep up to the times, must include every article of luxury appertaining to

European royalty, as well as the whole antique "kit" and picturesque lumber of, palanquins, howdahs, and state chariots, which have come down to it from ancient days.[1]

Two towers from the "long line of round sloping towers, capped with broad-rimmed cupolas" which "overtop the rocky ridge which raises straight from the plain" are visible in the top right corner of the painting. Some of these towers also figure in his view of the fortress, published as illustration to the text partly quoted above.[2] Weeks also did not overlook at least one of the "two exquisite little courts in the palace."[3] The "bands and panels of brilliant enamelled bricks, blue and green and vivid yellow" were illustrated in vivid colors in a contemporary publication, which Weeks might have seen prior to his journey to Gwalior.[4] The fortress as such, with the Man Mandir on top, was then known from a number of photographs,[5] woodcut-engravings in *The Graphic*,[6] not to mention Hodges's early view of the fort.[7]

To Weeks, it did not suffice to introduce the Man Mandir as part of the ancient palace of Gwalior. Weeks decided to revive the old glory by showing again his foible for elephants and processions.[8] The same study exists as fully colored oil on canvas.[9] A cover of bright red rests on the back of both elephants in the colored version, and some of the turbans, like that of the first man carrying a sabre, are also colored red.

NOTES

1. Weeks 1896, p. 246–248. Alexander Cunningham (1814–1893), who is quoted by Weeks, was the first Archaeological Surveyor to the Government of India, from 1861–1865. He was then the Director of the Archaeological Survey of India, from 1870 to 1885, the year of his retirement. He is also quoted by Simpson. For the history of Sindhia and Gwalior, to which Weeks also refers, see Roy 1888. For the history of the fortress, dating from about the time Weeks visited Gwalior, cf. Balwant Rao n.d. The "Man" mentioned by Weeks is Man Singh Tomar (1486–1518). At the beginning of his article "Notes on Indian Art," Weeks described the vandalism in British-India more pointedly than in the above quoted passage. He wrote: "Only within the last few decades has the government of India realized the importance of preserving the national monuments from decay, and of restoring those which have suffered from neglect and vandalism. It is useless to dwell now on the havoc wrought by the rude conquerors who came in the service of 'John Company.' In those early days of conquest and plunder, when horses were stabled in memorial tombs and in palaces, audience-halls converted into powder-magazines, barracks, or offices of district magnates, sculptured colonnades roughly boarded up and pierced by windows, panels and screens of exquisite fret-work in sandstone or marble plastered with thick layers of stucco and whitewashed, whatever could be altered over and adapted to the temporary use of the conquerors was spared, and whatever stood in the way of improvements was ruthlessly torn down. In many cases articles of intrinsic value, such as the linings of marble baths, were dug up and carried away, just as Nadir Shah carried off the peacock throne of the emperors to Teheran. The grand gateway of one of the most imposing monuments of Shah Jehan's reign, the Jumma Musjid at Agra, was pulled down during the mutiny, and a wide expanse of railway tracks, the approach to the station, now extends up to the walls." (Weeks 1895, p. 567).
2. Weeks 1896, p. 247: *Palace of the Maharajah of Gwalior, Scindia.* This view is taken from south to north. The present view is taken from the north towards the south.
3. Sotheby Parke Bernet, N.Y., June 15, 1979, lot 397A. This painting shows the north-western corner of "court A," Cf. Reuther 1925, pls. 13–15 and the groundplan, pl. 9; Chakravarty 1984, illus. facing p. 92, center.
4. Le Bon 1887, full-page col. illus. facing p. 168.
5. For Bourne's photograph cf. Desmond 1982, pl. 12 (= Ollman 1983, pl. 4). For further nineteenth-century photographs see Worswick/Embree 1976, illus. p. 24 or Glasenapp 1925, pl. 9.
6. *The Graphic*, December 12, 1885, p. 648, three illus.
7. Hodges 1793, engraving facing p. 142. Reproduced from the earlier edition: Godrej/Rohatgi 1989, p. 75, fig. 35.
8. Cf. Pal et al. 1989, p. 209, no. 222, col.
9. Reproduced: Sotheby's N.Y., February 22, 1989, lot 69, col., size: 18$^{1}/_{4}$ x 22 in. (46.3 x 56 cm.).

75 One of the Twenty-four Ghats at Mathura

∾

by Lockwood de Forest
(1850–1932), New York, 1894.

Media: Oil on canvas

Size: 20 x 24¹/₂ in.
(51.8 x 62.2 cm.)

Inscribed: Signed and dated in lower left corner: "L. de Forest / 1894."

Reproduced: Christie's, June 5, 1996, p. 121, lot 156, col.

Muttra is one of the principal towns of Hindostan; and, though it has greatly declined from its ancient splendour, it has still a noble appearance, viewed from the banks of the Jumna, along which it extends in the shape of a crescent, displaying its lofty terraced houses and innumerable temples against the side of the steep banks, the base of which seems to be covered with stone kiosks and broad flights of stairs descending to the water's edge. From the remotest antiquity, certainly from twenty centuries before Christ, Muttra has been a large and important city. It was here that in the fifteenth or sixteenth century before our era the hero Krishna, the most popular divinity in the Hindoo Pantheon at the present day, was born; and, under the name of Mathurah, all the great Sanscrit poems describe his beauties and glories to us.

At the present day Muttra is one of the principal cities of the English province of Agra, and an important cantonment for troops; yet, notwithstanding all its misfortunes, it has continued to retain in the eyes of the Hindoos the first rank, after Benares, among the holy cities of India; and during the whole year pilgrims flock to it by thousands from the most distant countries of the peninsula. It is a spectacle to see the crowds, morning and evening, when the sun begins to gild the facades of the temples and palaces, thronging the ghâts[1] on their way to immerse themselves in the sacred waters of the Jumna, the Yamouna of the Sanscrit poets. Men and women up to their waists therein, their faces ecstatically raised towards heaven, then accomplish the mystic rites of purification by which both body and soul become cleansed from all their stains. (Louis Rousselet, January 15, 1868)[2]

The city [i.e. Mathura] stretches for about a mile-and-a-half along the right bank of the Jamunā, and from the opposite side has a very striking and picturesque appearance, which is owing not a little to the broken character of the ground on which it is built. A number of minor ghats stretch up and down the river, those to the north being called the uttar kot and those to the south the dakshin kot. They are invariably represented as twenty-four in all,

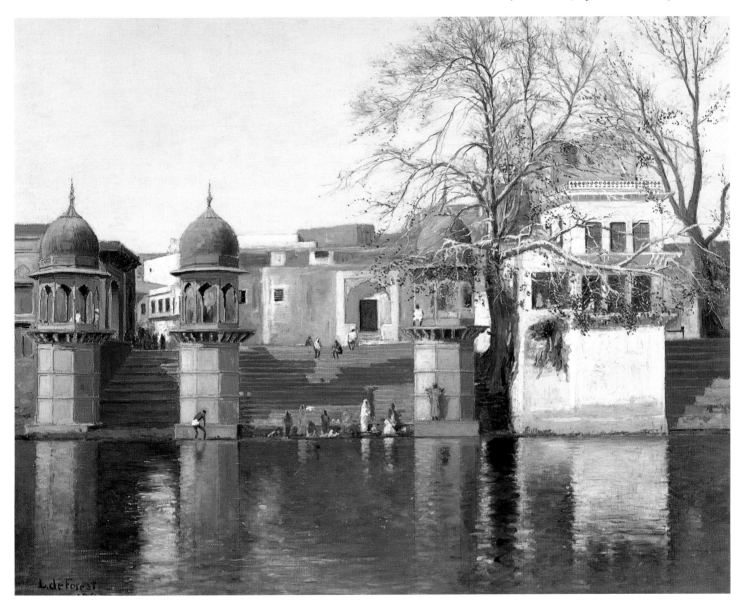

L. de Forest

twelve in either set, but there is a considerable discrepancy as to the particular names. Most of the ghats refer in their
names to well-known legends and are of no special historical or architectural interest. (Frederic Salmon Growse, 1880)[3]

In the beginning of May the Jamna is here 300 yds. broad. There is a paved street the whole way along it, with
bathing Ghats or flights of steps descending to the water, and ornamental chabutarahs or platforms, and small
but neat pavilions. (Murray's Handbook 1882)[4]

In the fall of 1892, Lockwood de Forest left New York for India. He was accompanied by his
wife. In early 1893 they went to Mathura, where Forest "hoped to visit a collector named
Growse."[5] Born in 1837, Frederic Salmon Growse went to India in 1866, where he served in
Mathura and Bulandshahr. He wrote and edited several books, e.g. *Mathura: A District Memoir*, of
which the second edition, published in 1880, is illustrated with actual photographs. In early
1876 his activities were described by a visitor to Mathura, the Belgian Comte Goblet d'Alviella,
who reports that he kept the monuments there in good repair.[6] Growse, who built a Catholic
church in Mathura, retired in 1890 and died on May 18, 1893, which explains why de Forest did
not meet him. The reason for de Forest's wish to meet Growse at Mathura will be given below.

In an unpublished typescript entitled "Indian Domestic Architecture," Lockwood de Forest
wrote: "In 1878 I became interested with Mr. Louis C. Tiffany and Mrs. Wheeler in
Architecture and Interior Decoration, doing some important work. In 1880 I made up my mind
that more could be learned from the East than anywhere else, so I started to make a study of
the Architecture and all the arts and crafts of India."[7] William Henry Shelton recollected:

In [1879] Mr. Tiffany was so strongly impressed by the Indian carvings in the British Museum that he returned to
say to his associates that one of them must go to India. Mr. Deforest was already something of an oriental traveler
and had observed the eastern workman in Egypt and Palestine. In November of 1880 de Forest and Meta Kemble
were married in New York. Soon thereafter they departed for India and arrived in Bombay on January 1, 1881.…
It was during this trip that de Forest's relationship with "oriental art" underwent a strong transformation. The trip
was initially conceived as a business venture, but de Forest's attitude toward the Indian art that he found
developed beyond that of a mere buyer and amateur connoisseur to that of an active sponsor and patron.[8]

In Bombay, de Forest hoped to find genuine Indian wood carvings which could be sold in the
United States only to realize what his compatriot, the artist Edwin Lord Weeks described :
It is amusing to find that to-day the native is competing successfully with the Englishman in the manufacture
of artistic furniture of the Chippendale order, but made from indigenous woods, and even underselling him, as
one may realize by walking through the show-rooms of the Parsee and Mussulman furniture dealers of
Bombay inhabiting the crowded streets near the Crawford market; he will also find that this competition
extends to boots and shoes and other articles of wearing apparel.…[9]

In Ahmedabad, however, de Forest found the Indian craftsmen that he was looking for. He
opened a workshop which employed Indian craftsmen working in traditional techniques of
wood carving and other such techniques for producing panels and furniture for sale in the
U.S. De Forest thus financed the revival of Indian decorative art, which in some places as
Bombay gave way to the mere imitation of English taste. Via Delhi and Amritsar, de Forest
proceeded to Lahore, where he met John Lockwood Kipling, father of the more famous
Rudyard Kipling. John Lockwood then was the curator of the Lahore Museum who
organized an exhibition on Indian art, to which de Forest sent quite a few objects from
Ahmedabad. These objects included copies of the stone window traceries of the mosque
from Ahmedabad, which de Forest estimated as "even finer than the stone originals."[10]
De Forest's workshop at Ahmedabad was also described by Edwin Lord Weeks:

While driving about in the town [of Ahmedabad] with the vague hope of finding some fragments of this
seductive wood-work, we came suddenly upon a signboard in front of an old house bearing the name in plain
English of a New York association of decorative artists. Here we found many of the most skilful workers of the

province engaged on American orders, such as chimney-pieces, sideboards, sculptured beams, and panels. This establishment had been recently inaugurated by Mr. Lockwood de Forrest [sic], who has since accomplished so much in popularizing Indian art, and at that time Anglo-Indian art had scarcely awakened to the fact that these things were even worthy of consideration even from an artistic or a commercial point of view.[11]

All this explains why de Forest went to Mathura in order to meet Growse, "who was also having certain types of craft done, similar to that produced at de Forest's Ahmedabad workshops."[12] Apart from Growse's presence in the city, Mathura offered a number of architectural features which always attracted Western travellers: "Some of the marble pavilions and carved balconies along the smaller streets are well worth the noxious job of seeking them out." (Thomas Bacon, December 1835)[13] Different statements are given with regard to the appearance of the city: "All Hindu cities are filthy: Bindrabund and Muttra are the filthiest of the filthy."[14] and: "The city of Mattra, which comprises some 60.000 souls, is one of the cleanest cities I've seen in India . . ."[15] De Forest's painting follows the tradition of showing the city either with or across the river, and since he was most interested in architectural details, he naturally saw it from a closer distance than most of his artistic predecessors.[16]

NOTES

1. For *ghat* see cat. no. 72.
2. Rousselet 1878, pp. 470–471. For the original French text, see Rousselet 1877, pp. 597–598.
3. Growse 1880, pp. 129–130; pp. 134–137, where all the names of the *ghats* are given with their variants and partly described.
4. *Murray's Handbook* 1882, p. 269.
5. Gatling/Lewis 1976, p. 24.
6. Goblet d'Alviella 1880, p. 218.
7. Gatling/Lewis 1976, p. 12.
8. Ibid.
9. Weeks 1895, p. 568; Weeks 1896, p. 310.
10. De Forest after Gatling/Lewis 1976, p. 15. Prior to his departure to India, de Forest might have as well seen a copy of Biggs/Hope/Fergusson 1866 and it seems that Edwin Lord Weeks met "Premchund Raichund" in Ahmedabad, under whose patronage the (text-) vol. was made, cf. Weeks 1895, p. 579; Weeks 1896, pp. 331–332.
11. Weeks 1895, p. 582; Weeks 1896, pp. 329–330.
12. Gatling/Lewis 1976, p. 24.
13. Bacon 1837, vol. II, p. 345.
14. Ibid.
15. Goblet d'Alviella 1880, p. 219.
16. Cf. e.g. an early nineteenth-century lithograph by James Moffat based on the drawing by an unknown artist in Godrej/Rohatgi 1989, p. 76, fig. 36; Bacon's lithograph in Bacon 1837, vol. II, facing p. 345; a watercolor by William Simpson from 1865 as published in Glynn 1995, p. 149, fig. 10; a full-page woodcut engraving after a photograph as published in Rousselet 1877, p. 599 or Rousselet 1878, full-page woodcut engraving facing p. 470; or the actual photograph of the "Visr'ant Ghat, Mathura" as published in Growse 1880, facing p. 132.

76 Rich Men Getting Haircuts

~

by an anonymous Indian(?) artist, Western India, late 19th century.

Media: Gouache on paper

Size: 13^{1}/$_{4}$ x 17^{5}/$_{8}$ in. (33.7 x 44.8 cm.)

Inscribed: In the top part, in *Nagari: amiram ki hajamat* (The cutting of hair of rich men [*Amirs*])

This watercolor represents a street scene in a small place in either Rajasthan or Gujerat.[1] The title probably has a double meaning as the two persons whose hair is being cut in the road do not give the impression of being wealthy men. Rather, the painting is an assembly of different incidents, different scenes one might encounter in a similar village even to this day.

Lacing of the kind that secures Western trousers is tied to the tail of a donkey. This lacing belongs to the elderly gentleman with a religious mark in the shape of a tuning-fork on his forehead, whose hair is being shaved by a barber kneeling at his side in the main road of this picture. A *tanpura,* or stringed musical instrument, suspended from a hook in the entrance above, seems to hover above his head. Another similar lace is tied to the tail of the same donkey; it is held in the right hand of a man seated cross-legged behind the animal. The end of the man's green turban rests in the mouth of a dog, which is tied to the same white lace. A squatting man with a white beard and turban seems to apply something to the turban of his client. The splashing sound in the air can be surmised to derive from the water carrier who offers fresh water in his mutton skin, as well as from the man blowing his nose in the entrance to the house nearby. A Muslim is engaged in his prayers while a bullock cart rumbles round the corner, followed by a camel led by a man in the vicinity of the draught animals. Two cocks witness the scene as a man in front of them carries firewood.

Two Jaina monks, recognizable by their mouth-protecting white cloths, intended to prevent the inhalation of flying insects, and the broom with which the monks brush away small animals in their path so as to spare their lives, stand inactive in the middle of the road, and pay but little attention to the woman passing by, who gracefully balances two pitchers on her head. Three donkeys trot toward the end of the road, followed by four of their kind, the last of which is occupied by a herder. Next to them sits another dog, witnessing a group of musicians performing in front of a snake-charmer, whose cobra emerges from the basket while the charmer plays his wailing wind-instrument. A woman behind him holds a scale while selling vegetables to a mother with her child. Two squatting bearkeepers, one of which smokes a *huqqa,* listen to the musicians, while their black bear waits patiently in the company of two monkeys, undisturbed by the coughing dog behind them.

This whole scene is supervised by a devout Hindu dressed in a pink garment, and his colleague on the roof above him. Another religious man with a yellow shawl and a red cap stands behind a resting, warrior-like man with a sword and peculiar turban, who seems to be oblivious to everything. A heard of sheep approaches, crowding a smaller lane that opens to the left. They pass the shop of a shoemaker, who exhibits his products. A black goat walks behind the herdsman with his stick; a watchdog barks at the buffalo which carries some building material, and is being driven by a woman from behind. In the entrance of the small house at the corner where both roads meet, stands a woman conversing with a seated man in front of her. Three young girls and a boy on the roof of the central building, watch a cat on the opposite side of the road, which has just caught one of the several cocks of the village. Other birds fill the cloudy sky while the sun's rays splash down like drops of milk.

The elevated viewpoint suggests that the work was most probably painted by an Indian artist. The shadows are arranged as if there were more than one light source. Several scenes seem to be native equivalents to Atkinson's well- known sequence of forty lithographs illustrating various events of Anglo-Indian daily life at a British "station."[2]

NOTES

1. This is suggested by the hill fort visible in the left part of the watercolor as well as the two Jaina monks and the headdress of the religious Hindus in the right-hand part of the picture.
2. Cf. Atkinson 1859, in particular pl. 1, *Our Station,* pl. 31, *Our Bazar,* and other outdoor scenes.

77 Landscape

∼

by Amrita Sher-Gil
(1913–1941), Simla, 1934.

Media: Oil on canvas

Size: 8¹/₂ x 12 in.
(21.6 x 30.5 cm.)

Inscribed: Signed and dated in lower left corner: "A. Sher-Gill / 1934." A contemporary paper label, filled in most probably by the artist herself, gives the following information (passages filled in are in italics):
SIMLA FINE ARTS SOCIETY / (See Instruction No. VII) / Exhibitor's Name *Miss Amrita Sher-Gill* / and Address *The Holme Summer Hill Simla* / Artist's Name *do.* / and Address / / Amateur, Professional or Student *Amateur* / If ordinary resident in India or Burma *Yes* / Title of Exhibit *Landscape* / Whether or not painted within 3 years of the opening of this Exhibition *Yes* / The price (in words) at which the Committee are authorised to sell the Exhibit *one / hundred rupees.*

LANDSCAPES, SEASCAPES, AND OTHER SITES

Marie Antoinette Gottesman, from a cultured, professional Hungarian family, went to India with Bamba Sofia Jindan Dalip Singh (1869–1957), granddaughter of Rani Jindan (cat. no. 48), where she met her husband Sardar Umrao Singh Sher-Gil, member of an aristocratic Sikh family and himself a Persian and Sanskrit scholar in Simla. After their marriage they went to Budapest[1] and, due to the outbreak of World War I and its aftermath, could only return to India in 1921. From 1921 to 1929, Amrita Sher-Gil lived in Simla and from 1929 to 1934 she studied painting in Paris, first under Pierre Vaillant at La Grande Chaumière and later under Lucien Simon at the Ecole des Beaux-Arts. At the end of 1934 she returned to India, where she declared: "Europe belongs to Picasso, Matisse and many others, India belongs only to me."[2] She made a similar remarkable statement when she was interviewed and photographed by Paul Coze, who visited her in her atelier in Simla in 1938: "She confessed to me that she only found her real way [i.e. style] after having returned to India by digging in the national heritage."[3]

The present painting was exhibited at the Simla Fine Arts Society, for which see cat. no. 27. It probably shows a view from her father's house and is certainly one of her first, if not the first, painting that she did in India. Most of her later paintings show people belonging to different social levels, but always in an aesthetically pleasing manner. The architecture, which is rarely a subject in her later, better known paintings, is reduced here as in a traditional Indian painting.

Amrita Sher-Gil only returned to Europe once, for about a year in 1938–39, when she married her cousin, Dr. Victor Egan. Exhibiting nationwide from 1936 onwards, she became the most celebrated Indian artist of her time, if not of the twentieth century. Like so many artists of the "Bengali school" (cf. cat. no. 88), Amrita Sher-Gil also received stylistic inspiration from the fifth century murals of Ajanta (cf. cat. no. 59) as a painting from 1936 in the Bradford Art Galleries and Museums shows.[4] The great majority of her paintings, however, are scattered over various public and private collections in India.

NOTES
1. For a photograph showing Amrita Sher-Gil at the age of two together with her parents in Budapest, see *India Magazine*, vol. 10, Dec. 1989, illus. p. 60. Amrita Sher-Gil's father was a gifted photographer.
2. Osborne (ed.) 1981, p. 495.
3. For this article published in *L'Illustration* of June 18, 1938, see *Les Grands Dossier* 1987, pp. 183–190.
4. Cf. Poovaya-Smith et al. 1991, p. 57, cat. no. 57, col.

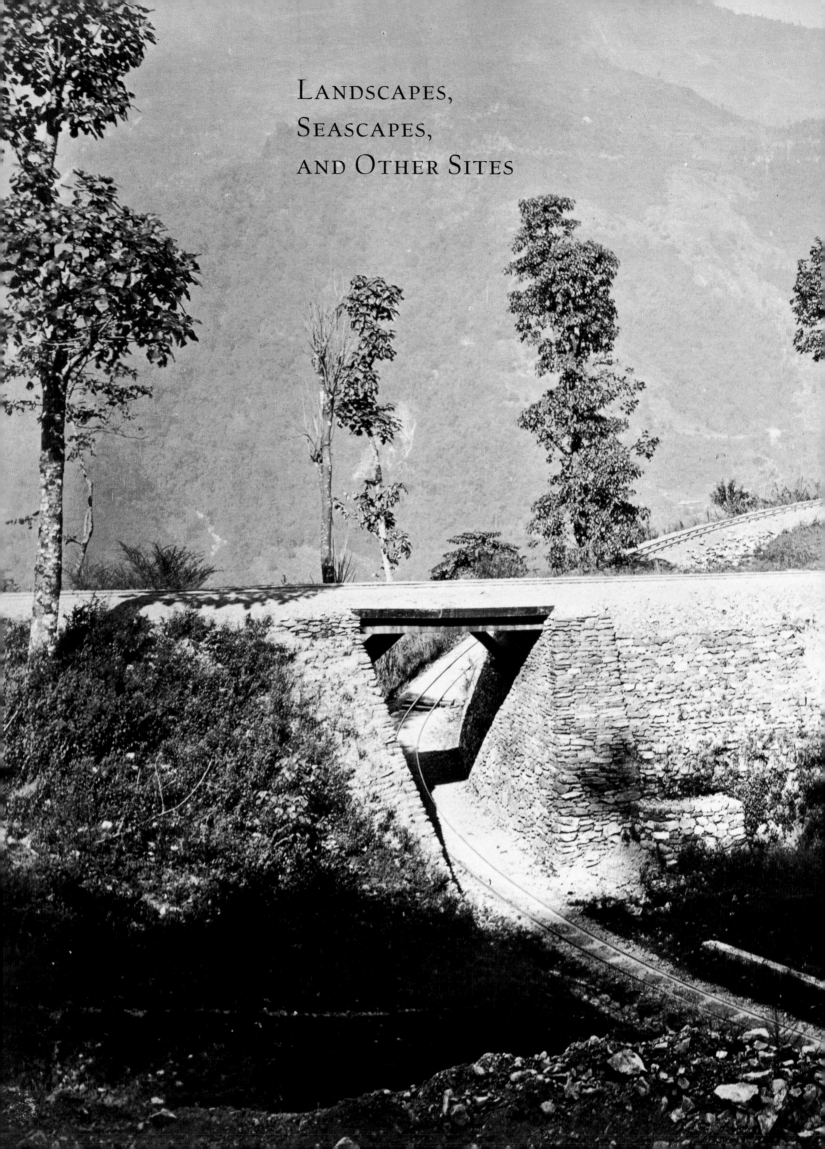

LANDSCAPES,
SEASCAPES,
AND OTHER SITES

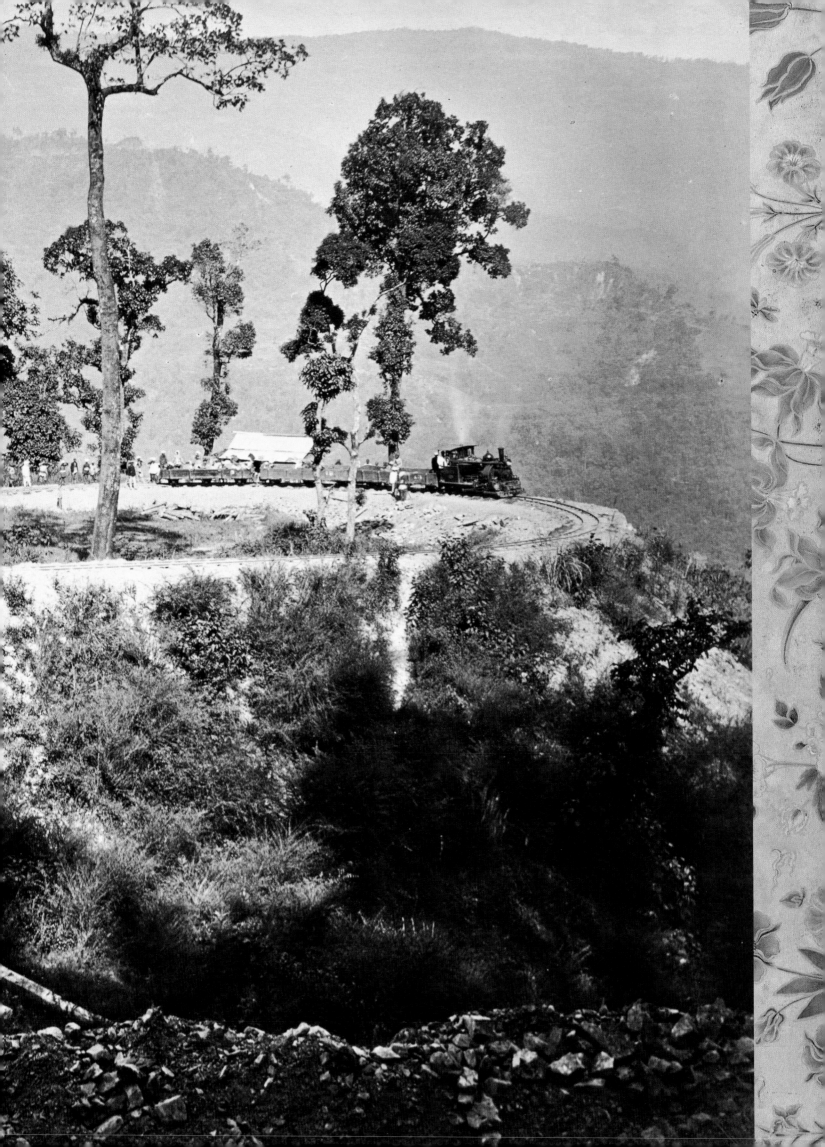

78 **East Indiamen on the Madras Roads, Bay of Bengal**

∾

by William Daniell, R.A.
(1769–1837), England, ca. 1833.

Media: Oil on canvas

Size: 27¼ by 35¼ in.
(69 x 89.5 cm.)

Publication and Provenance:
Sotheby's, April 13, 1994, p. 21,
lot 11.

Pages 296–297. The Darjeeling-Himalayan
railway—the loop below Tindharia.
Photographed ca. 1885.

William Daniell's notes in the *Oriental Annual* of 1834, through the pen of Hobart Caunter, seem to describe the present painting:

The roadstead at Madras is liable at all times to be visited by sudden and severe storms, and even in the calmest weather there is continually a heavy swell; nay, it has been noticed that all along the Coromandel coast the surf is frequently heaviest in calm weather, a circumstance for which no satisfactory reason has been yet assigned. Although from the beginning of October to the middle of December is considered the most dangerous season to remain in Madras roads, nevertheless ships frequently do anchor there at all seasons, in defiance of the cautions, nay even of the most peremptory orders, from the shore; being ready to cut or slip their cables and run out to sea on the first intimation of a hurricane. The only intercourse from the town with ships in stormy weather is by the Massoolah boats, and when the surf is too high for them to go off, a flag is hoisted at the beach-house, called the foul-weather flag. While this continues flying, all communication with the shore is interrupted; yet the catamaran men will at all times venture off upon their apparently insecure rafts with letters or any small packets. These they continue to keep perfectly dry by placing them in their skull-caps, a pointed cap made of matting, over which the folds of their turbans are so tightly twisted, as to prevent the access of the water. Medals are awarded to such among them as distinguish themselves by saving persons when the Massoolah boats are upset, or by conveying letters of importance through the surf during the violence of the monsoons. They are frequently washed off their catamarans by the prodigious impetus of the waters; but, unless a shark happens to seize them, they immediately regain their raft by swimming, at which they are extremely expert.[1]

The catamaran can clearly be seen in the right-hand foreground; the "Massoolah boat" approaches the coast from a distance, behind the five low-flying seagulls. This painting in oils is presumably based on a drawing which the Daniells made during their visit to Madras, in early 1793, when the Daniells noted: "The only vessels in use for passing through the surge to communicate with the shipping, are called Massoola boats. They are flat bottomed, and built without iron, the planks being sewed together with line made from the outer coat of the cocoa nut."[2]

A description of these boats accompanies an engraving after a picture by William Daniell, which shows these boats in action:

I got into a Massoolah boat, which immediately made for the shore. These boats are most singularly constructed; they have the appearance of a rude barge, are flat-bottomed and without timbers, the planks being sewed together with line made from the outer coat of the cocoa-nut, and caulked with the same material. They are rowed with broad elliptical paddles, and are so extremely lithe, that the planks yield readily to the percussion of the waters, and thus, by diminishing the resistance, so break the force of the concussion, that they sustain little injury from the lashing of the surf, which is so terrific in its might and violence that a European boat has scarcely ever known to pass through it without being dashed into pieces. It is really astonishing to see with what dexterity the boatmen manage these awkward-looking machines, steering them through the most boisterous sea, skilfully avoiding the stroke of the billows, and bringing them safely on shore through a surf that would appeal to the stoutest heart which had never before witnessed nature under any similar aspect of her power and of her sublimity. The Massoolah boats are almost invariably attended by catamarans; so that should any of the former chance to upset, which is sometimes the case when, from mismanagement, they are suddenly thrown forward upon the crest of the breaker, these latter pick up the luckless passengers and bear them safely to the shore. The catamaran is merely three large logs tied together in the form of a raft, the middle log being longer than the other two, and projecting a little above them: upon this the man who guides it is seated, and seems to be perched like a gull on the water, as the heavy raft upon which he sits is seldom seen above the surface. This simple contrivance is generally about ten feet long by eighteen inches broad.[3]

The surf at Madras and the use of the native boats for landing—Madras had no harbor until the 1880s—was noted already prior to the arrival of the Daniells:

Nothing is more terrible at Madras than the surf which…is not alarming but dangerous. They have here two kinds of boats to guard against this great evil, but yet, notwithstanding every care, many lives are lost. One

of these conveyances called the Massulah boat, is large, but remarkably light, and the planks of which it is constructed are actually sewed together by the fibres of the Cocoa-nut. It is well calculated to stem the violence of the surf but for greater safety it requires to be attended by the other, called a Catamaran, which is merely composed of bamboos fastened together and paddled by one man. Two or three of these attend the Massulah boat, and in case of its being overset usually pick up the drowning passengers. The dexterity with which they manage these things is inconceivable;—but no dexterity can entirely ward off the danger. (Eliza Fay, April 13, 1780)[4]

The same author also noted:

There seems to be a strange inconsistency in the character of the natives; they appear the most pusillanimous creatures in existence, except those employed on the water, whose activity and exertions are inconceivable. They will encounter every danger for the sake of reward, with all the eagerness of avarice, and all the heroism of courage; so that if you have occasion to send off a note to a ship, no matter how high the surf may run, you will always find some one ready to convey it for you, and generally without being damaged, as their turbans are curiously folded with waxed cloth for that purpose; so off they skip to their Catamarans,—for the prospect of gain renders them as brisk as the most lively Europeans. (April 17, 1780)[5]

The boats used by the natives on the Madras coast also captured the attention of Bishop Heber:

The masuli boats (which first word is merely a corruption of "muchli," fish,) have been often described, and, except that they are sewed together with coco-nut twine, instead of being fastened with nails, they very much resemble the high deep charcoal-boats which are frequently seen on the Ganges. The catamarans, however, I found I had no idea of till I saw them. They are each composed of three coco-tree logs, lashed together, and big enough to carry one, or, at most, two persons. In one of these a small sail is fixed, like those used in Ceylon, and the navigator steers with a little paddle; the float itself is almost entirely sunk in the water, so that the effect is very singular, of a sail sweeping along the surface with a man behind it, and apparently nothing to support them. Those which have no sails are, consequently, invisible, and the men have the appearance of treading water, and performing evolutions with a racket. In very rough weather the men lash themselves to their little rafts, but in ordinary seas they seem, though frequently washed off, to regard such accidents as mere trifles, being naked all but a wax-cloth cap, in which they keep any letters they may have to convey to the ships in the roads, and all swimming like fish. Their only danger is from sharks, which are said to abound. These cannot hurt them while on their floats, but woe be to them if they catch them while separated from that defence. Yet, even then, the case is not quite hopeless, since the shark can only attack them from below; and a rapid dive, if not in very deep water, will sometimes save them. (February 5, 1826)[6]

More contemporary information on the two different kinds of water-vehicles as painted here by William Daniell, was supplied by Thomas Bacon:

Soon after daylight in the morning of the 20th of July [1831], we made the coast of Coromandel, and about noon four of the natives came out to us on catamarans, a species of raft used along this coast for riding through the surf: it is constructed of two large pieces of timber, lashed together at some little distance from each other, so as to admit the action of the water between them ... The locality of Madras is certainly not a happy one: there is a continual current running from N.E. to S.W.; and the surf which prevails all along the Coromandel coast is so violent as to be scarcely ever practicable to anything but the native katamarans or massulah-boats. The latter are very capacious clumsy-looking craft, built of slender planks, sewn together with cords made of the rind of cocoa-nut, called kaiya, and caulked with dried grass. It is evidently the elasticity of these boats as much as their form in which their safety consists; they yield to the force of the sea in a manner by no means pleasurable to a nervous imagination. The crew usually musters from sixteen to twenty grotesque-looking figures almost naked, who accompany their labour with a wild song and heathenish antics infinitely picturesque. As soon as the boat arrives at the first line of surf, the boatmen back their oars until it is lifted and carried forward by the rolling wave; they then, with shouts and the most impassioned gestures, ply with redoubled energy their long unwieldly paddles, on order to prevent the boat from being carried back by the receding waters; which, should it take place, would inevitably subject all hands to a ducking, for the next surf meeting the returning boat would break clean over it at the risk of swamping it altogether.[7]

A similar experience while landing at Madras was also described by Leopold von Orlich in 1843.[8]

The "Masulah-boats" as well as the catamarans on the coast of Madras also attracted the attention of several artists and photographers. There is a pen-and-ink and wash drawing by George Chinnery,[9] which was published as an etching in 1807.[10] Loose sheets of colored aquatints were issued by Ackermann in 1837, based on drawings by J. B. East. They show the "Madras landing"[11] as well as the "Madras embarking."[12] The "Masulah-boats" were photographed in the nineteenth century[13] as were the catamarans.[14]

The most dramatic and most classical representations, however, are by the Daniells themselves. Thomas Daniell painted one version in oils in about 1792;[15] another one, by both Thomas and William, was published as an aquatint in September 1797, as part of *Oriental Scenery*.[16] William Daniell did one signed version in oils dated 1833,[17] and another, apparently unsigned and undated version, in about the same year.[18] A drawing by William Daniell, which borrows from both his versions in oils, was published in the *Oriental Annual* of 1834, along with the descriptive text quoted above.[19] From the beginning of the nineteenth century onwards, William Daniell favored subjects such as naval battles, with almost any number of sailing-vessels or a single sailing-vessel in a turbulent sea.[20] A less crowded, more peaceful painting, which is nonetheless packed with action, resulted here because of William Daniell's predilection for naval scenes.

NOTES

1. *Oriental Annual 1834*, pp. 11–12.
2. Archer 1980, p. 184.
3. *Oriental Annual 1834*, pp. 3–4.
4. Fay 1986, pp. 163–164.
5. Fay 1986, p. 167.
6. Heber 1828, vol. II, pp. 270–271.
7. Bacon 1837, vol. I, p. 95, pp. 97–98.
8. Orlich 1845, p. 267.
9. Archer 1969, vol. II, p. 572 and pl. 68 (= Pal/Dehejia 1986, p. 31, no. 18)
10. Conner 1995, p. 69, fig. 1
11. Woodford 1978, illus. on pp. 42–43 (= Bruhn 1987, p. 25, fig. 17, cat. no. 73 =Godrej/Rohatgi 1989, p. 101, fig. 50).
12. Woodford 1978, illus. on pp. 44–45 (= Bruhn 1987, p. 25, fig. 18, cat. no. 74 = Pal/Dehejia 1986, p. 62, no. 49, dated here 1856).
13. Desmond 1982, pl. 19
14. Desmond 1982, pl. 20; Glasenapp 1926, full-page pl. 217.
15. Shellim 1979, p. 47, TD26.
16. *Oriental Scenery II*, pl. 7, reproduced: Archer 1980, p. 184, no. 129 (= Muthiah/Rohatgi 1989, p. 211, fig. 1, col.)
17. Shellim 1979, p. 117, WD25, full-page col. pl. VIII, p. 29.
18. Shellim 1979, p. 117, WD26.
19. *Oriental Annual 1834*, engraving facing p. 7, pl. 3.
20. Cf. Shellim 1988, p. 17, WD4B; p. 18, WD4C; p. 29, WD9A; p. 31, WD10A.

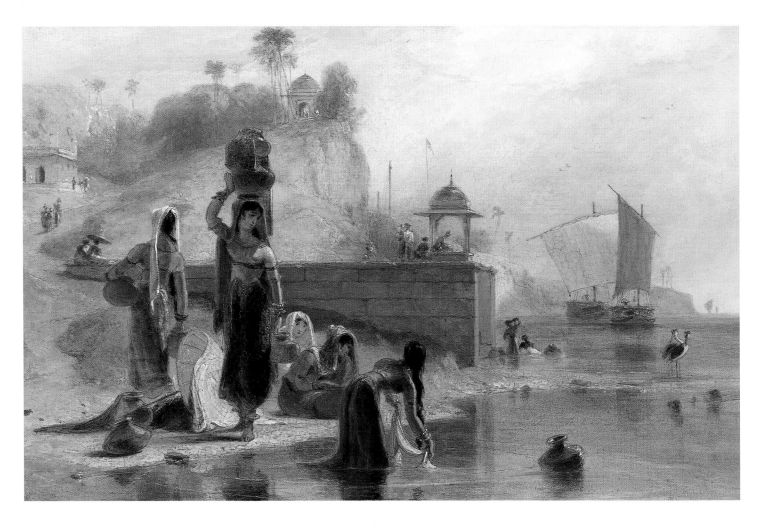

79 Women Fetching Water from the River Ganges near Kara (Currah)

~

by William Daniell, R.A.
(1769–1837), England,
ca. 1827.

Media: Oil on board

Size: 11½ x 17½ in.
(29.2 x 44.5 cm.)

Inscribed: Titled and signed
by the artist(?) on the back
of the board: "Near Currah
Manickpore on / the Ganges -
with native females / carrying
away the Water from the sacred
/ stream - W. Daniell. R.A.

From Shawpour to Currah the Banks are exceedingly picturesque, spotted with a great Variety of Building.… The buildings on the water side are appropriated to the religious purposes of the Hindoos. (Thomas and William Daniell, December 20, 1788)[1]

We … went on to Camaulpoor, near Currah. Here we encamped amid a vast field of tombs and ruins … and the whole scene, with its jungle, and deserted appearance, was singularly picturesque and romantic. The inhabited part of Currah is still, however, considerable, and we soon found that there were people in the neighbourhood, by the number of little shops at once set up under the trees around us, with an eye to our custom. Currah owes its fame, it seems, and stately buildings to a celebrated saint named Camaul Shek, who, with his son and several of his disciples, lies buried here. The tomb is still in tolerable repair, which is more than can be said of any of the others, which have been splendid but are now mere ruins, in a grave and solemn style of architecture, being a square tower pierced on each front with elegantly formed and carved Gothic door-ways, and surmounted with a dome of a very judicious form, and harmonizing with the general character of the building, not being semi-circular but conical, and in the same form of a Gothic arch, as is displayed in the other arches of the building. Besides this large chapel are many raised tombs, of different sizes, from small terraces, with kiblas for prayers, down to stone coffins as they are sometimes called in England, and as they are found in similar forms and with nearly the same ornaments, in our old Cathedrals. These ruins and sepulchres reminded me of Caffa; but there was no other similarity; instead of the bare rocks which surround that ancient city, we had a grove of noble trees, under which our horses, camels, and bullocks were disposed in different clusters, and the tents, the fires, the baskets of fruits, rice, ghee, &c. exposed for sale, and the varied and picturesque costume of the crowd assembled under it, the red uniforms of the Sepoys, the white garments of our servants, the long veils and silver ornaments of the female villagers, … gave the whole scene the animated and interesting effect of an eastern fair, an effect which the east, perhaps, can alone supply, and which I greatly regretted my want of skill to convey effectually to my friends in Europe. (Reginald Heber, October 2, 1824)[2]

I know no more elegant object in nature than the Hindoo girl returning from the well; her light graceful raiments veiling, yet not concealing or impeding the movements of her upright and supple figure, and slender,

LANDSCAPES, SEASCAPES, AND OTHER SITES

though well-rounded limbs; with the classic-shaped vase artfully poised on her head, and seldom requiring the support of the naked bangled arm, which is, perhaps, as often raised from coquetry as from necessity. (G. C. Mundy, November 13, 1828)[3]

Thomas and William Daniell passed through Kara twice, the first time in December 1788 and the second time in October 1789. These visits resulted in a number of drawings[4] and watercolors[5] showing various scenes and monuments at the site. The known watercolors were made into aquatints for the Daniells' opus magnum, *Oriental Scenery*.[6]

Many of the Daniells' sketches taken on the spot in India were later turned into oils, as e.g. cat. no. 78. The present painting appears to be another version of William Daniell's *Hindoo Females on the Banks of the Ganges*, which was exhibited at the Royal Academy in 1827 and which is now in the collection of the Victoria Memorial, Calcutta.[7] It was also shown at the Indian court in the Indian Section of the Festival of Empire and Imperial Exhibition, 1911 in London.[8] The Calcutta version was reportedly engraved by J. Lee for *The Oriental Annual* of 1834[9] which is, however, not correct. But something similar to the woman balancing two pitchers on her head, which she gracefully turns in the present painting, appears as the frontispiece in said volume of *The Oriental Annual*, titled *A Hindoo Female*, based on a watercolor by William Daniell and engraved by W. D. Taylor. The actual watercolor for that engraving recently appeared on the art-market.[10] Another comparable painting is a watercolor by William Daniell, with the river Ganges and a rustic boat in the right-hand half, and the slope of a hill, topped with a monument in the left-hand half; in addition, on the left there is a woman carrying a water-pot on her head and another woman sitting at the riverside, engaging in worship.[11]

The present painting is distinguished from its Calcutta version by the landscape, which in the present version seems to be a combination of two of the watercolors blended on the spot.[12] The Muslim tomb on top of the ridge in the present painting almost corresponds to the type of monument described by Bishop Heber, although the Daniells claimed it to be a Hindu monument.[13]Although in a strict sense the painting does not present a village scene well, its theme follows a very old Indian tradition of painting, of which a good number of examples survives. The nobleman, who in most Indian versions is being offered water by a woman, is replaced here by the (male) observer: William Daniell (or Charles Mundy) himself.[14] William Daniell thus followed the Indian tradition more closely than he himself possibly imagined.

NOTES

1. Archer 1980, p. 65.
2. Heber 1828, vol. I, pp. 344–345.
3. Mundy 1858, p. 171. Mundy does not describe a scene near a river but at a well, which makes but little difference for the purpose of the present picture, especially since William Daniell emphasized the presence of the attractive women more than the landscape with its monuments.
4. Cf. Christie's, June 5, 1996, p. 93, lot 123.
5. 1. *Ruins of the Fort Gate at Currah*, Archer 1962, no. 11 (= Archer 1974, no. 26 = Christie's, September 24, 1996, p. 73, lot 43, col.); 2. *Hindoo Temple at Nobusta, below Currah, on the Banks of the Ganges*, Archer 1974, no. 26 (= Christie's, September 24, 1996, p. 74, lot 44, col.); 3. *Currah, on the Ganges*, Archer 1974, no. 27 (Christie's, September 24, 1996, p. 75, lot 45, col.).
6. The first watercolor mentioned in the preceding annotation corresponds to *Oriental Scenery*, vol. III, no. 21, published April 1, 1803, cf. Archer 1980, no. 63; the second to *Oriental Scenery*, vol. I, no. 21, November 1796, cf. Archer 1980, p. 65, no. 26 and col. pl. III (= Mahajan 1984, p. 44, no. 22) and the third to *Oriental Scenery*, vol. III, no. 1, August 1801, cf. Archer 1980, pp. 64–65, no. 25.
7. Reproduced: Mahajan 1984, col. pl. IV; Shellim 1979, p. 111, WD14.
8. *The Journal of Indian Art and Industry*, vol. XV, New Series, no. 117, January 1912, p. 13.
9. Cf. Shellim 1979, p. 136, no.(5).
10. Christie's, June 5, 1996, p. 94, lot 125, col. pl.
11. Christie's, June 5, 1996, p. 83, lot 106, col. pl.; Losty et al. 1996, p. 18, no. 13, col. pl.
12. For these see note 5 supra, nos. 2 and 3.
13. Cf. Christie's, September 24, 1996, p. 74.
14. Cf. e.g. the following col. pls.: Welch/Beach 1965, p. 31, no. 33; Khandalavala/ Moti Chandra 1965, pl. J, facing p. 36; Anand/Goetz 1967, cat. no. 17; Hickmann 1979, no. 53.

80 A "Kose," a Particular Kind
of Boat Used at Chittagong,
Bengal
༄

by François (Frans) Balthazar
Solvyns (1760–1824), Bengal,
ca. 1795–1798.

Media: Gouache on paper

Size: 9⅝ x 14⅛ in.
(24.5 x 36.5 cm.)

Inscribed: "A KOSE," in pencil,
below painted surface;
"Section 9," in pencil, top left
corner, between black rules
and painted surface; "NN77,"
top right corner, between
black rules and painted
surface.

Published: Engraved, as in the
text below.

As in the preceding cat. no., the artist himself described this painting after introducing it as
follows:

*What I have said of the text, may also in some degree be applied to the prints themselves, in which the objects
such as they appeared to my view, and as such as they would appear at this hour to the reader, if he could be
suddenly transported into the midst of them.*[1]

The colored engraving which follows the present watercolor, except for the squatting man
in the left foreground, is then explained:

*This species of boat, much in use in the province of Chittagong, carries sail very well, and can navigate without
danger in all the rivers of Hindoostan. The wind has but little power over it, on account of the lowness of its
covering. The kose can even stand the sea. Its crew is generally composed of Mugs, a dirty and disgusting
people. The Mugs are perfectly acquainted with all the passes of Indian coasts, where the navigation is impeded
by a number of small islands. They are frequently obliged to wait for the tides, and can not approach the land
without the greatest danger from the tigers, the wild buffaloes, the crocodiles, and other ferocious animals,
with which the coasts are infested. The tigir [sic] especially are bred on account of their audacity: they
sometimes even swim to the boats, dart into them with incredible velocity, choose out the plumpest man of the
crew, and carry him off to their den. To avoid being surprised by night, the boats are surrounded with netting.*[2]

The Bengali boatmen's fear of tigers is corroborated by Bishop Heber who wrote in early
October 1823, while describing the "Saugor island" on the way to Calcutta:

*[T]he land was again abandoned to its wild deer and its tygers; for these last it has always been infamous, and
the natives, I understand, regard it with such dread, that it is almost impossible to induce them to approach the
wilder parts of its shore, or even boats, as instances are said to be by no means infrequent of tygers swimming
off from the coast to a considerable distance.*[3]

LANDSCAPES, SEASCAPES, AND OTHER SITES

For many reasons, the Ganges and Yamuna are the most important North Indian rivers. One of them is the fact that they were for quite some time the only (water-)way by which people coming from Europe and arriving at Calcutta could go "up country." European descriptions of native boats are hence abundant. Lieutenant-Colonel Charles Ramus Forrest, in his *Picturesque Tour along the Rivers Ganges and Jumna in India* described the *pinnace* as well as the *budjerow*,[4] the most common boats on these rivers. The *budgerow* was sketched as well as described in detail by Mundy in early February 1828.[5] Other native boats were also drawn by Bishop Heber, who offered interesting descriptions of its crew-members.[6]

Quite detailed descriptions were given by Fanny Parks, who mentioned the *pataila*, the *pateli* and other such boats, in addition to the more usual *budgerow* and *pinnace*.[7] When describing the beauty of the Indian river-scenery, Parks declared: "But the most picturesque of all are the different sorts of native vessels; I am quite charmed with the boats. Oh that I were a painter, who could do justice to the scenery! My pinnace, a beautiful vessel, so unlike anything else here, must add beauty to the river, especially when under sail."[8]

Parks probably did not know that Solvyns had painted and published practically all native vessels then still in use in Bengal and on the Bengal coast. Solvyns's project of drawing and publishing all the Indian vehicles and boats that were within his reach was very advanced for its time. His publications still offer the most important and comprehensive survey of its kind. It is unfortunate that Solvyns's engravings were apparently unknown to the majority of modern authors working on Indian boats and ships,[9] particularly because they show the great versatility of the Indian ship-builder. Only quite recently, a few of Solvyns's original watercolors showing native Indian ships and boats were published.[10] They are probably all that remains of the great variety of Bengal boats. As to the once so common boat, the *budgerow*, we know that by the beginning of this century, "[b]udgerows [were] . . . extinct. Steamers nearly drove them off the river, and the railroad ha[d] extinguished them."[11]

NOTES
1. Solvyns 1808–12, vol. I, p. 21. For the French text see ibid., p. 5.
2. Solvyns 1808–12, vol. III, 5e livraison (5th issue), planche IV , labeled *Kose*. In the published engraving also, the landscape at the extreme left was transformed into a larger *bangaldar*.
3. Heber 1828, vol. I, p. 1f.
4. Forrest 1824, pp. 123–124 and var. loc. The *budjerow* is also written *budgerow*.
5. Mundy 1858, illus. p. 254 and text pp. 254–256 and var. loc.
6. Heber 1828, vol. I, woodcut p. 2 and text pp. 2–9.
7. Parks 1975, vol. I, pp. 196–197, pp. 321–323 and var. loc.
8. Parks 1975, vol. I, p. 333f.
9. Solvyns's name is not even mentioned in the bibliography of Wiebeck 1987, just to give an example.
10. *A Poad*: Maggs Bros. Ltd. London: Catalogue 1123, *Voyages and Travels*, 1991, p. 26, no. 337; *A Sloop*: Kattenhorn 1994, pl. 48; Sotheby's N.Y., September 19, 1996, lot 194, col.
11. Carey 1907, vol. II, p. 13. For the development of Indian river navigation from the mid-seventeenth century onwards, cf. also Carey 1907, vol. II, pp. 13–27. For a survey of comparable boats still in use in Bangladesh, see Greenhill 1966.

81 Village Scene in Bengal

by Sir Charles D'Oyly, 7th
Baronet (1781–1845), Bengal,
ca. 1812–1820.

Media: Oil on canvas

Size: 8⅝ x 11 in. (22 x 28 cm.)

Published: Losty 1993, col. pl.
(p. 7); Losty 1995, col. pl. p. 90,
no. 11.

Provenance: Indar Pasricha Fine Arts

In my account of the architecture of the natives, I shall give some further detail concerning their houses. In the meantime I may state, that it is not the usual custom of Bengal to build one house with a number of different appartments sufficient for the purposes of the family; but, except the great, the natives in general build a separate house or hut for each purpose. The huts collectively sufficient for the accommodation of a family are usually surrounded by a common fence, and are called Vati or Vari. According to their structure they are called Banggola, Chauyari, or Dalan, as will be afterwards explained. Their comfort depends much on the nature of their materials. Except in the few brick houses, built after the Muhammedan or European fashion, thatched roofs are the only ones known in this district, and no doubt, in respect of excluding both heat and cold, are more comfortable than those covered with tiles; but they harbour vermin, especially snakes, and are more liable to fire. The general use of tiled roofs cannot however be proposed in the present state of capital; although such roofs, even under existing circumstances, might with great advantage be more numerous than they are at present.... In many parts of the country, the meanest huts have walls of clay, which are very much superior in comfort to those made of hurdles, especially in cold weather; but such are not attainable in the parts of the country, where the soil is loose; and in a climate of the most excessive moisture, even the huts that have mud walls, are very damp and unhealthy from their earthen floors. (Montgomery Martin quoting Francis Buchanan of about 1810, describing the village houses of the District Dinajpur, Bengal)[1]

The cows that are kept about farms and villages, are turned out to feed on the pasture about seven in the morning, return home in the evening, and remain all night in a hut, where they are allowed a little rice straw to eat, and in the rainy season some grass, which is cut from the little banks that divide the rice-fields. If the proprietor is rich, they receive also a little oil-cake or bran, which alone renders their condition tolerable, as the quantity of straw is very small, and at some seasons the food that can be procured on the pasture is next to nothing. The oxen are treated much in the same manner, only their time for procuring food is abridged by the five or six hours, during which they are employed in labour; and it is very seldom that the mere plough cattle receive either bran or oil-cake. These are reserved for the cows of the wealthy, and the oxen employed to carry loads. (Montgomery Martin quoting Francis Buchanan of about 1810, describing the cattle in the villages of Dinajpur, Bengal)[2]

Bengal is not included within the bounds of Hindostan, and the term of Bengalee is used to express any thing which is roguish and cowardly; such as they are, however, I am far from disliking them;... and I still am inclined to think some parts of the country the most beautiful, I am sure it is the most fertile, and to an European the most novel and exotic district which I have seen in India.... As we approach the frontiers of Bahar, these beauties disappear, and are replaced by two or three days' sail of hideously ugly, bare, treeless level country,... (Reginald Heber, October 19, 1824)[3]

Placed in the middle of the villages, (whose bamboo huts seem far cooler and cleaner dwellings) they are overhung with a dark and tangled shade of fruit-trees, and surrounded by stables, cow-houses, threshing floor, circular granaries raised on posts, and the usual litter of dirty and ill-managed farms; but the persons who reside in them are often really very wealthy.... Round the villages there are large orchards of mangoes, cocoa-nuts, and plaintains, together with many small crofts enclosed with fences of aloes, prickly pear and sometimes pine-apples, and cultivated with hemp, cotton, sugar-canes, mustard, gram, and of late years with potatoes and some other kinds of European vegetables. All beyond this is rice, cultivated in large open fields annually overflowed by the Ganges or the many canals which are drawn from it, and divided into little portions, or quillets, not laid out like our corn-fields in ridge and furrow, but on a flat surface, the soil being returned to its place after the crop is dibbled in, and intersected by small ledges of earth, both to mark property and to retain the water a sufficient time on the surface. There is no pasture ground. The cattle, sheep, and goats are allowed, during the day, to pick up what they can find in the orchards, stubbles and fallows, and along the road sides, but at night are always fetched up and fed with gram. No manure is employed, the dung being carefully collected for fuel, (except what little is used by the devout to rub their faces and bodies with,) nor, with an occasional fallow (and this is, I understand but seldom) is any other manure required than what the bountiful river affords. I have not yet seen them at plough, but am told that their instruments are the rudest that can be conceived, and, indeed, their cattle are generally too small and weak to drag any tackle which is not extremely light and simple; yet their crops are magnificent, and the soil, though much of it has been in constant cultivation beyond the reach of history, continues of matchless fertility. No where, perhaps, in the world, is food attained in so much abundance, and with, apparently, so little labour. Few peasants work more than five or six hours in the day, and half their days are Hindoo festivals, when they will not work at all. (Reginald Heber describing the countryside of Bengal, January 27, 1824)[4]

The present painting is one of the few oils that can be ascribed to Sir Charles D'Oyly, which is shown by a later D'Oyly lithograph of about 1828 treating the same subject. D'Oyly added the following information beneath his lithograph: "C. D'Oyly delt. from a composition from Chinnery's outline sketches. Bihar Lithographic Press."[5] It is evident that D'Oyly's painting follows Chinnery's composition (for which see cat. no. 83a.), especially since Chinnery exercised a decisive influence on D'Oyly's art when both were in Dacca between 1808 and 1811.

The painting shows the countryside of Bengal, as described by two contemporaries, Francis Buchanan and Reginald Heber, and must therefore have been painted originally prior to D'Oyly's stay in Patna from 1820 to 1832, the country in Bihar (of which Patna is the capital), being a "hideously ugly, bare, treeless level country." The painting was in all probability done during an excursion from Calcutta, when Charles D'Oyly was posted there, first as deputy collector and then as Collector of Government Customs and Town Duties, from 1812 until his move to Patna in 1820. Similarly framed small paintings, probably oils, decorated the walls of D'Oyly's "Drawing Room" of the "Behar School of Athens" in Patna, as a watercolor by D'Oyly from about 1820–1824 shows.[6]

Stylistically, D'Oyly's painting is very Western, as Partha Mitter in his essay rightly stated. This is probably not accidental. When Reginald Heber travelled through Bengal while going from Calcutta to Dacca in June 1824, he remarked at one place: "The scenery is still like that near the Thames, and the likeness is increased by the circumstance that there are no coco-trees."[7]

NOTES
1. Martin 1838, vol. II, pp. 696–697.
2. Martin 1838, vol. II, p. 887. For a more complete and contemporary account on bulls in India , cf. Perrin 1811, vol. I, pp. 69–72.
3. Heber 1828, vol. II, pp. 353–354.
4. Heber 1828, vol. II, pp. 324–325.
5. For a reproduction of this lithograph and a fuller treatment of the scene, see Losty 1993, pp. 8–9.
6. *Maggs Bull.* 1984, pp. 76–79, especially the col. frontispiece, reproduced in smaller size and without the title beneath the painting; also in Losty 1995, p. 91, no. 12.
7. Heber 1828, vol. I, pp. 90–91.

82 West View of a Mosque and a Gateway in Upper Bengal

~

by Sita Ram (fl. 1810–1822), Bengal, ca. 1820–1821.

Media: Watercolor on paper watermarked "1814"

Size: 13 x 19¹/₄ in. (33 x 48.8 cm.)

Suja Shah who governed Bengal in the year 1727, although he added some buildings to Gaur, usually resided at Rajmahal, and Gaur never afterwards was the seat of government. Immediately on being deserted the proprietors of the land began, naturally enough to sell the materials, and not only the towns on the Mahanonda; but even a great part of Moorshedabad and of the adjacent places have ever since been supplied with bricks from that source. Had this been merely confined to the dwelling houses, or even to the palace and city walls, there might have been little room for regret; although the two latter had they been left entire would have been great objects of curiosity, for they are of very astonishing magnitude. Materials however, having gradually become scarce, an attack has been made even on the places of worship, the endowments of which seem to be seized by the Zemindars. Even the very tombs of the kings have not been permitted to escape. The Moslems remaining about the few places that are endowed, and which are still in tolerable repair, complain most justly of this wanton rapacity, and are naturally alarmed for their own security, as even Europeans have most disgracefully been concerned in the spoil. Although the government was no doubt totally ignorant of these spoliations, committed on places deemed sacred by all civilized nations, yet its character has not failed to suffer in the eyes of the people about the place, most of whom are Fakirs and others, who view the actions of infidels with no favourable eye. It perhaps might be an act of justice, and would tend very much to conciliate their minds, were orders publicly issued to prevent any attack on their existing places of worship, and to compel the Zemindars [landholders] to make a remuneration for their rapacity, by adding some waste lands to the present endowments; for it is impossible to restore the works that have been destroyed. (Montgomery Martin as published in 1838, but based on the reports of Francis Buchanan, who travelled in the area in about 1810)[1]

elaborate messages and aides-mèmoire of various different kinds."[11] At times, Chinnery would comment on the size of the figures as in a drawing dated August 21, 1821 ("the figure rather too small"),[12] or the present case. Some of the present drawings are marked with an upright cross (+) meaning something like "correct," whereas a sketch with a diagonal cross (x) was regarded as unsatisfactory.[13] During his longer stay at Serampore, Chinnery produced a number of drawings of village scenes as well as scenes at the Hooghly. The mud huts with thatched roofs and a kind of regular grid on the wall, created by bamboo sticks which served to keep the mud in shape, appear in several of Chinnery's drawings done during that period,[14] as does a small bridge[15] or the river Hooghly, sometimes with its boats.[16] Huts with thatched roofs seem to have attracted Chinnery more than any other objects in the landscape.[17] The shrine that Chinnery sketched on the verso of the present drawing, standing correct when turning the sheet clockwise by 90°, was typical for the banks of the Hooghly river.[18] Chinnery's oils and watercolors which are related to these drawings are not considered here.[19] George Chinnery was one of the most important British artists in India, who particularly influenced Charles D'Oyly (cf. cat. nos. 69 and 81).[20]

NOTES

1. Heber 1828, vol. I, pp. 50–51.
2. Thornton 1854, vol. IV, p. 423.
3. Conner 1993, pp. 160–161.
4. July 8, 1824, Heber 1828, vol. I, p. 149.
5. For the best account on Chinnery's activities in India, see Conner 1993, pp. 50–161.
6. Conner 1993, p. 129.
7. April 8, 1828, Mundy 1858, p. 76.
8. Forrest 1824, p. 125
9. Heber 1828, p. 29.
10. Cf. Conner 1993, p. 158, plate 93.
11. Conner 1993, p. 138; on the shorthand used by Chinnery, see ibid, p. 275. Conner 1995, p. 72, fig. 5, dated May 2, 1813.
12. Conner 1995, p. 72, fig. 6.
13. Cf. Conner 1993, p. 144, pl. 85 for a drawing marked with several x's.
14. Cf. Conner 1993, p. 140, pl. 81; Losty et al. 1996, p. 29, no. 24 (dated July 27 and August 7, 1822) and no. 25 (dated July 21, 1822). Cf. also Godrej/Rohatgi 1989, illus. p. 63.
15. Losty et al. 1996, p. 29, no. 23 (dated July 21, 1822).
16. Losty et al. 1996, p. 29, no. 25 (dated July 21, 1822); Conner 1993, p. 146, pl. 89. (dated August 30, 1821) and pl. 94 (dated September 1821).
17. Cf. Pal/Dehejia 1986, p. 113, no. 106; Bayly et al. 1990, p. 205, no. 252; Losty et al. 1986, p. 29, no. 22, to mention just a few.
18. For a larger, similar shrine, cf. Forrest 1824, col. pl. III.
19. Cf. Conner 1993, p. 135, col. pl. 38, p. 138, col. pl. 39; p. 139, col. pl. 40, p. 142, col. pl. 42; Conner 1995, p. 74, col. pl. 8. Cf. also cat. no. 81
20. Cf. Conner 1993 p. 280ff.

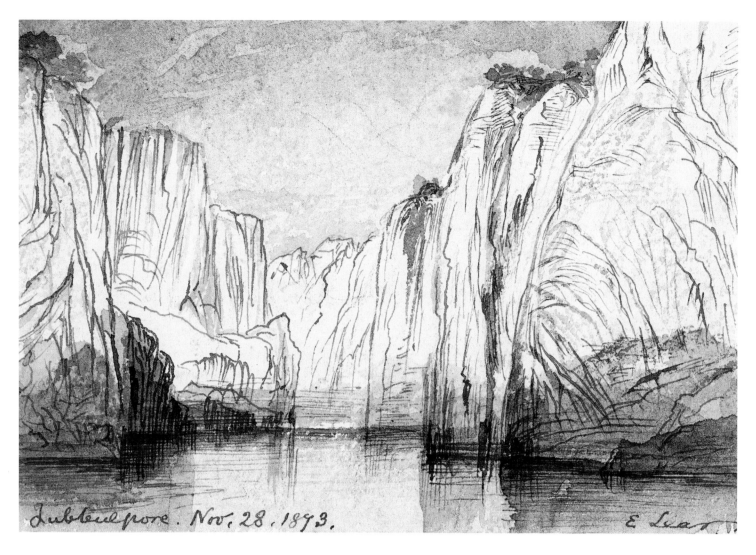

Jubbulpore. Nov. 28, 1873. *E. Lear*

84 **The Rocks of the Narbada River at Bheraghat, "Jubbulpore"**

~

by Edward Lear (1812–1888), Jabalpur, November 1873.

Media: Watercolor on paper

Size: 4¼ x 5⅞ in. (10.9 x 13.9 cm.)

Inscribed: In lower left corner: "Jubbulpore. Nov. 28, 1873," and signed in lower right: "E. Lear."

For November 28, 1873, Lear noted in his diary:

Off at 6.30 in a two horse garry [chariot], with wine and provisions. Great extent of flat ground, roads, cantonments. Endless good-looking houses and gardens and bright looking dwellings with thatched roofs, the scene often resembling England and Switzerland for trees. White tombs and temples everywhere; distant rocky low hills. Go through a wood of trees just like oaks; ground gray-yellow, scene like Marlboro forest. A lake, or marshy piece of water exquisitely reflects rocky hills and border of trees. All this formerly jungle. Did wrong in not putting on extra coat; chilly feeling, fear of fever. Decided to get in a boat and did so. Anything so powerfully and wonderfully beautiful in rock scenery I never saw; sublimely beautiful both as to colour and form and brilliancy … Such a loveliness of marbleism one never dreamed of. Falls of the Nerbudda, like first cataract of Nile, but valley very close and narrow. Fine bit of waterfall, rocks, foa. Sketch; very hot, tigers said to be about. Couldn't get to the proper place for drawing without a good deal of help from Giorgio.[1]

Lear was indeed so fascinated by the scenery that he returned to it the next morning:

At 7.15, in the boat again; the river scenery is truly delightful. More monkeys, calmly sitting unconcernedly on high rocks. Got several drawings, which may or may not be of some use some day. Boatmen very careful and good. Infinite loveliness of the spot. At 11 a capital breakfast, and later, payment, 13 Rs. 8 annas—awful lots of money go here! Much pleased with my stay at Bheraghat.[2]

Lear made several sketches of the scenery at different times of day. The published sketches mostly relate to the second visit,[3] whereas the present drawing reflects the real first impression of the artist; it also constitutes one of the first sketches Lear made in India, where he arrived on November 22, 1873, and remained until January 11, 1885, to make some 2,000 to 3,000 sketches.[4] Thomas George Baring, the Earl of Northbrook, became Viceroy

Fig. 21

of India in 1872 and soon afterwards invited Lear to go to India for a year as part of the viceregal suite. Lear, however, after having considered his weak health as well as his advanced age, was indecisive. Finally, in summer 1872, he and Giorgio set out for India, but only got as far as Suez: all further passages to India were booked. A second attempt, carried out in autumn 1873, was more successful. The voyage from Naples to Bombay lasted twenty-seven days.[5] When he finally arrived in India, Lear had his "ups and downs," as in probably no other place that he had visited, and he had visited quite a few. Only two days earlier, on November 26, 1873, Lear had noted in his diary:

"Rose at sunrise, very cold. Find nothing to draw. Angry and disgusted. Walk about place; odious idleness. Breakfast very badly served. Order garry to go to Jubbulpore town, but it don't come, so I and Giorgio set off to walk." Lear's mood then changed suddenly: "Broad road, fine trees, gradually increasing interest; houses, pagodas, people. Town of Jubbulpore wonderfully Indian and queer. Endlessly beautiful, but hot!"[6] It is also worth quoting from Lear's very first impressions of India, on the day of his arrival in Bombay: "O new palms! O flowers! O creatures! O beasts! Anything more overpoweringly amazing cannot be conceived. Colours and costumes and myriadism of impossible picturesqueness. These hours are worth what you will."[7]

The so-called Marble Rocks, actually of magnesian limestone, rising to a height of 90 to 120 ft.,[8] are situated at Bheraghat, 11 miles from Jabalpur in Central India. In his most famous work, Sleeman devoted one chapter to the Nerbuda River;[9] William Simpson published a view of them in 1867;[10] and Samuel Bourne took more than seven photographs of the scene, one of which is reproduced here (accompanying fig. 21).[11]

Lear was a most productive "landscape draughtsman," and would have included a larger version of the present drawing in a publication he would have probably called either "Illustrated Excursions in India" or "Journal of a Landscape Painter in India," in analogy to his earlier publications.[12] Unfortunately, Lear did not live long enough to accomplish such a project.

NOTES

1. Lear 1953, pp. 38–39. Giorgio Kokali, an Albanian born on Corfu, was Lear's personal servant, friend and travel companion since 1858.
2. Lear 1953, p. 39.
3. Cf. Pal/Dehejia 1986, p. 125, no. 100, inscribed in lower left: "15) / Marble Rocks / Nerbudda / 29. Nov. 1873 / 7.30 A.M. / 8.30." Dehejia 1989, p. 9, col. pl. 2, inscribed in lower left: "17) / Marblerocks / Nerbudda. / 8 AM. / Novem. 1873."
4. Cf. Pal/Dehejia 1986, p. 124 for an estimate of 3,000 drawings and Losty et al. 1996, p. 51 as well as Murphy in Lear 1953, text on front flap of dust-cover, for an estimate of 2,000 drawings.
5. Lear 1953, p. 34.
6. Lear 1953, p. 38.
7. Lear 1953, p. 37.
8. Murray 1907, p. 30.
9. Sleeman 1844, vol. I, pp. 18–40.
10. Simpson 1867, vol. II, pl. 45. For a monochrome illustration of this lithograph, see *The India Collection*, 1982, p. 138, top.
11. Bourne/Shepherd n.d., p. 30, nos. 1685–1691. The present photograph was also published in Glasenapp 1925, full-page pl. 2. An engraving after another Bourne/Shepherd photograph is reproduced in Reclus 1883, full-page illus. p. 441.
12. Cf. Hofer 1967, pp. 72–75.

Arrah

85 **Fan Palms at Arrah, Shahabad District, Bihar**

~

by Edward Lear (1812–1888), Arrah, February 1874.

Media: Watercolor on paper

Size: 4¼ x 5⅞ in. (10.8 x 15.1 cm.)

Inscribed: In lower left corner: "Arrah," and signed in lower right: "EL."

The entry in Edward Lear's Indian diary for February 8, 1874, reads:

Off in train for Arrah; very bright and beautiful morning. These fan palms towering above all things, infinitely spotting the plain, and seeming like specks against the pale hills, and over the dark masses of mango. But in general the landscape grows flat and bare, myriads of dry squares, rice beds, being the prevailing characteristic. . . . I went out and asked for Boyle Sahib's bungalow, and everybody knew it, an old creature showing me the way, which is for 1/4 of a mile along the high road, where there is a magnificent border of palmyra palms, and then through a park or compound to the house I wanted to see.[1]

The place-name "Arrah" possibly derives from Sanskrit, *aranya*, a forest,[2] but Lear's intention was not to sketch the "palmyra palms" but "the house of Arrah," called "Boyle Sahib's bungalow" by Lear, because "Boyle's defence of the 'House in Arrah' was one of the most striking features of that mutiny period," as Lear himself remarked.[3] Lear recorded the story of that house:

Sent in a card to Mr. Elliot who lives in the larger compound or sort of flat park, both houses being close together. Mr. Elliot was particularly amiable and polite, and told me the billiard room opposite was the building held out by Boyle, the three rebel regiments each 1,000 strong, being in and about the principal house, which Boyle had vacated on their approach, in order to have a better chance of holding out a smaller building. How it was that these 3,000 rebels, with 5,000 other troops of some defective rajah and two thousand or thereabouts of the town's people, did not take and destroy Boyle, one can only account for by the theory that these natives were either cowards or fools or both. Although on Boyle's side there were but forty in all, they had up-be-blocked the billiard room so well, storing it with provisions, that they could fire on any straggler. . . . I made a drawing of this very curious historical spot, and now sit on a wall and write these here notes.[4]

Lear might have seen a depiction of that house before he set out for India; at least he knew

the story about it.[5] Arrah was surveyed by Francis Buchanan in November 1812,[6] who noted: "[S]everal of the natives seem fond of gardens, in which they have collected a great variety of trees and a good many flowers. The environs are very neatly cultivated and well watered."[7] Quite remarkable in Lear's account of Arrah is that besides the palmyra palms and the "House in Arrah," he did not at all mention the older monuments of the place, such as the Jamai Mosque, the Moula Bagh mosque, or the Jain temple.[8]

Edward Lear actually started his career as a zoological artist. A book with his paintings of birds was published in 1830, when Lear was only eighteen years of age.[9] Lear was particularly fond of elephants,[10] and most refreshing are the little caricatures of elephants which include Lear's self- portrait.[11] The present drawing combines both Lear's talents: In outlining the elephants with a few strokes of the brush, he shows his talent as a zoological artist; in the rendering of the scenery with its trees in the distance hidden in mist, he demonstrates his skills as a landscape artist.

NOTES

1. Lear 1953, pp. 73–74.
2. Martin 1838, vol. I, p. 413; Buchanan 1926, p. 7.
3. Lear 1953, p. 74.
4. Ibid.
5. For a depiction of that house, cf. Malleson 1889, vol. III, illus. facing p. 54, or Kuraishi 1931, p. 137. More depictions are mentioned in *List of Ancient Monuments in Bengal 1896*, p. 343. For a more historical narrative of the events, see Malleson 1889, vol. III, pp. 52–67. For the house alone, see Buchanan 1926, p. 175 and Kuraishi 1931, pp. 136–139. A complete list of its European defenders is given in *List of Ancient Monuments in Bengal 1896*, p. 342.
6. Buchanan 1926, p. 2, p. 5, pp. 7–8.
7. Buchanan 1926, p. 8; Martin 1838, vol. I, p. 413, with additional remarks.
8. All described and listed in *List of Ancient Monuments in Bengal 1896*, pp. 344–345. See also Patil 1963, pp. 6–7.
9. Desmond 1989, pp. 172–173.
10. Losty et al. 1996, p. 51.
11. Lear 1953, p. 127 (= Alexander 1987, p. 32, mirror-reverse); Dehejia 1989, p. 61, dated August 25, 1873.

86 Old Portuguese Fort (Bassein?) near Bombay

∿

by John Varley, the younger (1850–1933), Bombay, dated 1891.

Media: Watercolor on paper

Size: 13³/₄ x 20¹/₂ in. (34.9 x 52.1 cm.)

Inscribed: Signed and dated in lower left corner: "John. Varley. 91." Inscribed on the reverse, top part: "54 Old Portuguese fort/Bombay" and in the center, upside down, twice underlined: "No 2."

The country round about Bombay unfolds before him who wishes to learn a history, both old and full of interest. Salsette and the district of Bassein are all covered with the remains of antiquity, and one of these places of antiquity which merits our attention is the old Portuguese Fort of Bassein,—relic of the vast Empire which the little kingdom of Portugal built up on sea power; silent monument to the sloth and folly that undid the work of some of the greatest adventurers the world has ever produced. These relics cannot fail to bring to our recollection the mighty struggles and the doughty deeds of those daring men who ran the race of life, amidst stormy seas braving many a typhoon and tornado. (A. Fernandes, in the second edition of *A Guide to the Ruins of Bassein*)[1]

Although historically Bassein, situated about 28 miles north of Bombay, is important to both Portuguese-Indian[2] as well as Anglo-Indian[3] history, it was described but rarely. Reginald Heber visited it in April 1825, and left an account of its more important monuments.[4] Varley probably knew about the ties of British history with Bassein from one of the then current guidebooks and went to see it. Since the inscription on the reverse does not expressly mention that the watercolor shows the fort of Bassein, one cannot exclude the possibility that it shows another "old Portuguese fort" near Bombay, like that of Chaul (also written Chowul or Choul), situated some 23 miles south of Bombay. However, when Varley visited the "old Portuguese fort," Chaul was not that well known. Besides, by road it is much farther from Bombay than Bassein. The inscription as such is in accordance with similarly numbered labels found on the reverse of other watercolors Varley did in India in the same year.[5] The artist who painted this watercolor is known as Varley the younger, since he is the grandson of his namesake (John Varley, 1778–1842), the more famous artist who was born, lived, worked, and died in London. Varley the younger visited India at least in 1891–1892,[6] exhibited at the Royal Academy and various galleries between 1870 and 1875, and is better known through his views of Egypt, which he visited around 1882,[7] rather than through his paintings, which he made in India.

NOTES
1. Fernandes 1948, p. 1.
2. For the role of Bassein in the history of Portuguese-India, cf. Whiteway 1967. For the most comprehensive historical account which includes the Portuguese, Maratha as well as English history of the town, see Fernandes 1948, pp. 1–6.
3. Cf. Thornton 1854, vol. I, pp. 279–281.
4. Heber 1828, vol. II, pp. 188–189 and var. loc.
5. Cf. Christie's, June 5, 1996, lot 104, reproduced on p. 81, inscribed: "128 on the Godavery above Nassik."
6. A watercolor in the India Office Library, Oriental and India Office Collections, showing a scene near Benares, is signed and dated "John Varley '92," cf. Kattenhorn 1994, p. 310, no. 4226.
7. Cf. Sotheby's, April 14, 1976, p. 10, lot 11 (*A View of Cairo*, dated 1882), p. 24, lot 45 (*A Scene on the Nile, near Alexandria*, exhibited at the Royal Society for painters in 1883); Sotheby's, October 18, 1978, p. 105, lot 276 (scene on the Nile, Egypt).

87 The Lake of Kashmir
(actually called "Dal Lake")
at Shrinagar

∾

by William Simpson
(1823–99), England(?) 1893.

Media: Watercolor on paper

Size: 10 x 14¹/₂ in.
(25.4 x 36.8 cm.)

Inscribed: "Wm. Simpson / 1893"
in lower left corner. "The Lake
of Kashmir" in the lower part,
left half, near center. Inscribed
on verso, lower right corner:
"The Lake of Kashmir," and
above the last word also
"Kashmir" and below: "w.
SIMPSON. R.W.S."

Simpson might well have prepared the original sketch for this splendid watercolor while
on his second Himalayan tour in early August 1861, when he wrote:

*The visitor to Kashmir finds on his arrival that the first thing he must do is to hire a boat. Otherwise he gets
no rest, for all the boatmen will wait at the door till one is selected. So, to get quit of the crowd, and find peace
of body and mind, a boat with its crew has to be engaged. A boat is the cab or omnibus of Kashmir, because it
can take you anywhere, and a horse cannot, owing to the river, the lakes, and the canals. Srinuggar is a
mountain Venice, and you must have your gondola, which is here called a "kishti," the Hindostani for boat.
Early in the morning, as soon as you rise, the kishti wallah transfers your bed to his boat. You follow, and you
are rowed up the stream a bit, where a plunge into the river is the method of performing the morning tub. One
day I jumped out of my boat into the Lake of Kashmir — a rash thing to do unless one has confidence in the
water, for the lake is a perfect garden of all sorts of vegetation, part on the surface and part below....*

The General [van Cortlandt], *as an official, had a very large boat, supplied by the Rajah, with a
comfortable space in it, covered with a dome-shaped canopy of red and gold. On some days the whole family
went to parts of the lake where I wished to sketch. This was done in the cool of the morning; a kitchen boat
would follow, and we had breakfast in some pretty spot, such as the Shalimar or Nisbat hoghs, sitting under
chunar trees. There was always something to sketch in these places. In the afternoon again we would move to
some other spot, and come home in the evening, while the men in the boat — I think there were forty of them —
would sing "Taza-be-taza" as we glided through acres of the lake covered with the large leaves of the lotus.*[1]

In Kashmir, Simpson was the guest of the government agent, General van Cortlandt.

*He had been in Runjit Singh's service, and held in it the rank of General. As he had long been familiar with
the Punjab, the Indian Government on the annexation of the country took him into their service. Under our
Government he had the rank of Colonel, had been made a C. B., and was employed in the Civil Service. Two
of the General's grown-up daughters had just come from England, and were with him, as well as his wife and
a younger daughter, and as he was anxious that the two should keep up their drawing, he was desirous of
taking me to places to sketch, so that they should come too, and get hints and encouragement.*[2]

As a result, Simpson "went on many sketching tours, sometimes being rowed in the
General's shikara over the lotus-studded lake."[3] Simpson must have in fact drawn the
original sketch while on a boat, which most probably looked like the one with the canopy
type of construction in this watercolor. It may even be identified with the government
agent's boat mentioned in the description. Simpson was on the Dal Lake (Lake of Kashmir),
in a part called "Dal Kotwal," looking from east to west. The hill with the fortification on
top is the "Hari Parbat" (literally "hill of Vishnu or Hari"). Most striking in this painting are
the lotusses, so typical for this city lake, the depth of which

*is not more than seven to ten feet, and the water being very clear, the bottom, covered with weeds, is almost
constantly visible; ... The Lotus, with its noble pink and white flower, is very common, and in fact, the leaves are
so numerous that in some places they form a verdant carpet, over which the water-hens, and others of the same
genus, securely run, without risk of being immersed. In the hot weather, the children in the boats pick a large leaf
and place it on their heads, as a shelter from the rays of the sun, or by breaking off the stalk close to the leaf,
obtain a tube through which they drink of the water poured in from above. The stalks are very commonly eaten
by the poorer classes. The seeds when dry are strung together like beads.* (Vigne, late 1830s to early 1840s)[4]

Another, more preliminary watercolor by Simpson, dated August 2, 1861, is also titled *The
Lake of Kashmir.*[5] That Simpson also did the preliminary sketch for the present watercolor in
early August 1861 is indicated by the presence of the lotusses; these were described by an
artist in the early twentieth century:

*Lotus time comes in July, when the great flowers and leaves rise on their slender stalks three or four feet from
the surface of the lake. They may be taken as the Hindu sacred flower, much as the rose is the first flower in*

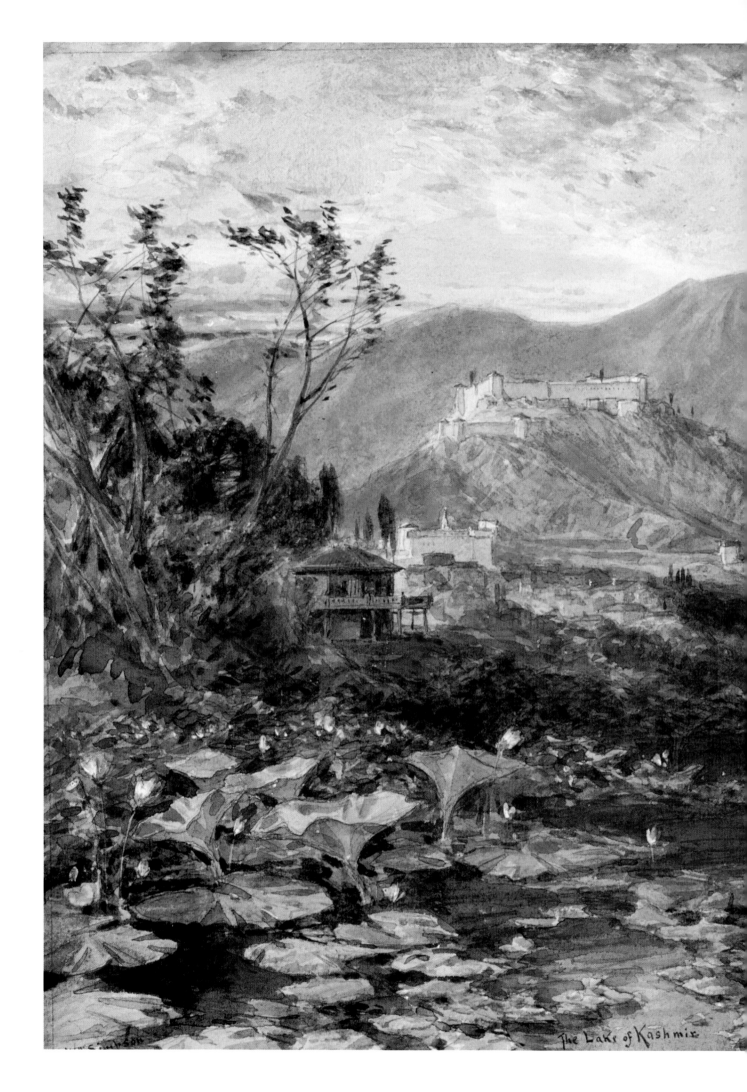

The Lake of Kashmir

LANDSCAPES, SEASCAPES, AND OTHER SITES

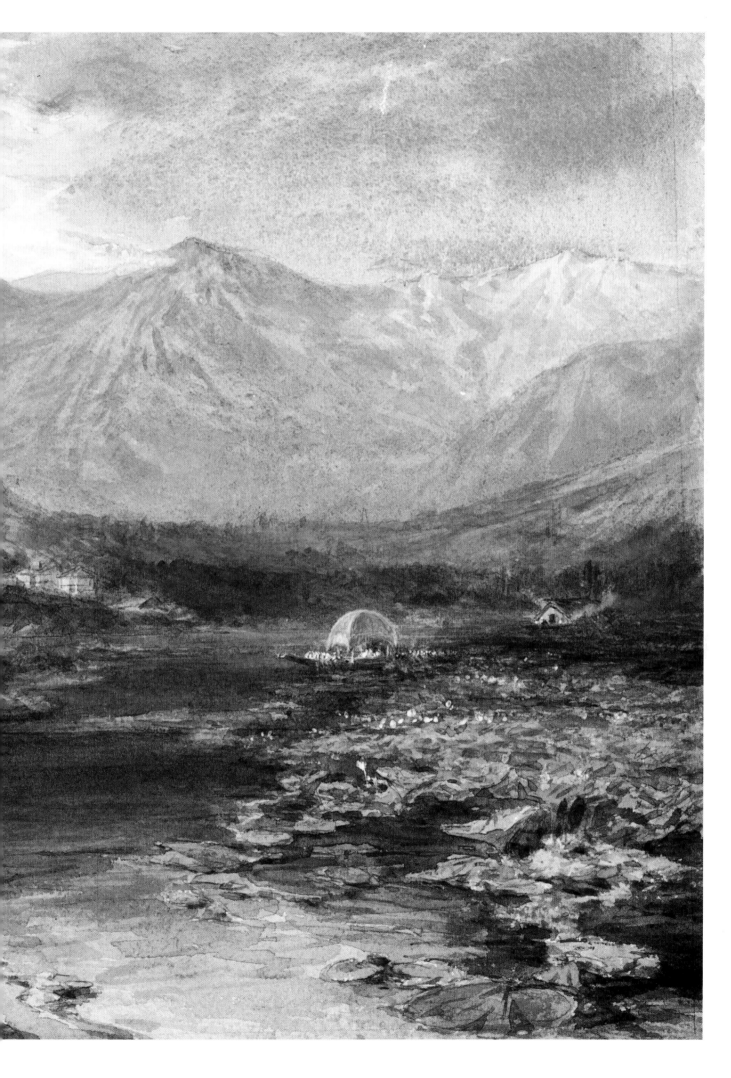

Fig. 22

the eyes of the secular Moslem poets; and all the world goes out to gaze on the bright pink lotus blooms. To see these flowers in perfection one must start at dawn, before the sun has climbed the mountain crags, and row out towards Nishat Bagh,[6] *where the lake-side gardens are lost in dim blue shadows and the surface of the water is pearly gray and mauve. Then forcing the light shikara [a type of boat, see above] through the sweeping freshness of the large leaves until the boat is almost among them, wait till the sun wakes the lotus buds of Brahma.*[7]

Simpson might have worked up his original sketch of early August 1861 into the present watercolor after having seen Valentine Prinsep's rather empty *View of the Dall Lake, from the Nishat Bagh*, published in 1879.[8] Simpson probably met Prinsep in India, especially since Simpson accompanied the Prince of Wales on his tour in India. Furthermore, on his first trip to India, Simpson might have run into George Landseer (cat. nos. 24 and 72), who, like Simpson, was entertained by Lord Canning.[9]

Simpson's blend of great accuracy and impressionistic effects is here demonstrated by a comparison with a published photograph, e.g. *Hari Parbat, Akbar's Fort, Seen across Lotus Leaves,*[10] or *Hari Parbat Hill, Fort, and Rampart.*[11] The Hari Parbat with its fort commands the valley of Shrinagar and is visible from any place within a certain distance, as shown in the accompanying fig. 22, a late nineteenth-century photograph by W. Baker. While looking at Simpson's picture, one is in fact inclined to believe that the lake of Kashmir or Dal Lake "is one of the most beautiful spots in the world."[13]

NOTES

1. Simpson 1903, pp. 152–154.
2. Simpson 1903, p. 152.6, p. 109.
3. Archer/Theroux 1986, p. 109. For photographs of a shikara, the *kishti* of Simpson, a kind of boat used particularly in Kashmir, see: Allen 1985, full- page illus. p. 124; Golish 1963, p. 130; Fabb 1986, no. 45.
4. Vigne 1987, vol. II, p. 99 and p. 114.
5. Archer/Theroux 1986, p. 115, no. 93.
6. A garden at the eastern border of the Dal or City Lake of Shrinagar, south of the more famous garden called Shalimar Bagh. Simpson probably did exactly what is here advised and described by Villiers Stuart.
7. Villiers Stuart 1913, p. 177: "Kashmir Lotus Fields."
8. Prinsep 1879, engraving p. 228.
9. For Prinsep's original watercolor entitled *Lord Canning's Return Visit to the MahaRajah of Cashmere at Sealkote, Punjab. 9th March, 1860*, see Archer 1969, vol. II, pl. 77. Simpson's watercolor of the Governor General's (i.e. Canning's) camp is illustrated in Allen 1985, col. pl. p. 33 (= Bayly et al. 1990, p. 311, no. 409, col.). For his watercolor showing H.R.H. The Prince of Wales in his private tent in Delhi in January 1876, see Bayly et al. 1990, p. 332, no. 473, col. For another watercolor, showing H.R.H. The Prince of Wales out hunting in February 1876, see Christie's, June 5, 1996, col. pl. p. 52, lot 63.
10. Crowe et al. 1972, p. 76.
11. Kak 1933, plate XI. For a description of the fort and its history, see Kak 1933, pp. 87–90.
12. Perhaps a relative of F. W. Baker who had a studio in Calcutta from the late 1850s onwards, cf. Thomas 1981, p. 7.
13. *Murray's Handbook* 1907, p. 254.

88 Hunting on the Wular (?) Lake

∾

by Abanindranath Tagore
(1871–1951), Calcutta, ca.
1897–1902.

Media: Wash and watercolor
on paper

Size: 8 x 11¹/₂ in.
(20.3 x 29.2 cm.)

Inscribed: Some signs in the
lower left corner seem to
imitate(?) an inscription in
Nashtaliq.[1] An inscription on
verso was partly pasted
and painted over. Still fairly
readable is: ". . . Hunting on
The Wular [?] Lake . . . / by / a.
n. Tagore."

This painting, as the previous cat. no. 9, does not depict an actual situation, but is the result of the artist's imagination, probably based on actual experience, paired with the visual impact of old Indian miniature paintings on the artist's mind. In contrast with the painting of the Goddess Lakshmi by Ravi Varma (cat. no. 9), it does not even depict a mythological figure, which every Indian would recognize immediately. The Indian painting which might have inspired the depiction of the present scene must have been akin to a picture showing "The emperor Aurangzeb seated in a royal barge on a lake during a hawking expedition. . . ."[2] Most probably, Abanindranath Tagore was shown by his then tutor, E. B. Havell, a Mughal painting now in the British Museum. It was entitled *A Royal Progress on Lake Wular, Kashmir,* and shows the emperor Jahangir crossing a lake.[3] The Wular Lake is situated in Kashmir, about twenty-five miles to the west of Shrinagar.[4] It was mentioned by Jahangir in his memoirs: "On 1 Shahriwar [about August 11(1620)] ducks (*murghabi*) appeared on the Wular lake, and on the 24th of that month they appeared on the Dal lake."[5]

Abanindranath Tagore's position in the development of Indian art should not be underrated. His eminence is best explained by an enthusiastic preface written in his quasi-contemporary biography:

To Indians Dr. Abanindranath Tagore needs no introduction. He is acknowledged all over the country as the Father of Modern Indian Art, even by those who criticise his work as hopelessly unrealistic. The number of such critics is quite large even in his part of the country and there is no reason why it should not be so. The glamour of western materialistic ideologies has such a strong hold on us that we are ever searching for scientific formula, even in art to make a comparative study. Hedged round by economic difficulties we have forgotten that the artists, the, musicians, the poets live in a world populated by eccentrics who conjure up peculiar forms for their enjoyment and talk in a language of their own. Therefore, the high significance of the work of such artists cannot be understood by realists who move on a lower plane. The situation has been

accentuated in this country by the continued slavery of its people extending over centuries. During this period we have always looked to the West for inspiration, first to Greece then to Persia and then to Europe and have been trying to forget our own art traditions. It is no wonder then that we still carry after our political independence a deep love for ideas occidental. Even in our ancient pieces of art we are ever trying to trace European influences to prove the ascendancy of the West over the East. Perhaps, slaves take a long time to realise their own worth.[6]

From about 1891 onwards, A. N. Tagore learned from an Italian artist, Signor Gilhardy, "all that this professor could teach him in [European] drawing and pastel work."[7] From 1894 onwards he took lessons in oil painting from Charles Palmer. A. N. Tagore soon mastered European painting techniques, but that did not make him happy, because "the soul of Nature behind the visible form alone could inspire him with the truths he was burning to express and that he must reject as worthless, the cold realistic representation he was labouring to imitate from European masters."[8] After a visit to Benares and Allahabad, A. N. Tagore produced paintings of Krishna in an "Indo European technique"; and Palmer told him: "Portraits and realistic landscapes will never give you what you want."[9] Tagore then learned the traditional method of Indian painting and mounting from a craftsman called Pawan. The final change came in about 1897, when he met E. B. Havell, the then principal of the Government School of Art at Calcutta. "Havell was the first European to grasp the true Indian line of thought and traditions and to do pioneer work in explaining the underlying principles of Indian paintings and sculpture, which according to him were based on a combination of ethics and aesthetics."[10] Havell was happy to find A. N. Tagore, and the latter said about the former: "He took me up and shaped me. He had my reverence all through as a Guru. Indeed he loved me as a younger brother."[11]

The latter statement is certainly true, as A. N. Tagore's "Some Notes on Indian Artistic Anatomy" is dedicated to E[arnest] B[infield] H[avell] (1864–1937).[12] Havell's position at the Government Art School from 1896–1905 greatly helped to review the status of Indian art and Indian artists.[13] His *Indian Sculpture and Painting*, published in 1908, "came as the dramatic breakthrough in the history of Western attitudes to Indian art, causing a sweeping reversal of hierarchies between West and East.[14] For the first time, high quality colored plates illustrating Indian miniatures[15] were published together with four paintings by Ananindranath Tagore,[16] in addition to two further plates illustrating works of artists belonging to the Bengali school.[17] Havell himself remarked:

New India has at last found an artist, Mr. Abanindro Nath Tagore, to show us something of its real mind, and it is significant that it is revealing itself in a continuity of the old artistic thought, a new expression of former convictions. . . . He devoted himself to a close study of the collection on Indian pictures which I was then beginning to make for the Calcutta Art Gallery, and this collection has been the guiding influence in his artistic development, although in matters of technique he adopted a compromise between Indian and European models.[18]

After explaining four reproduced paintings by A. N. Tagore on pp. 257–262 of his book, Havell concludes: "Mr. Tagore is no longer to be regarded as an isolated phenomenon in modern Indian art, for in the last two years, since he has been in temporary charge of the Calcutta School of Art, the latter has become the centre of a new school of Indian painting, founded on the traditions of the old, which already gives fair hopes that a real renaissance in Indian fine art is beginning."[19]

Only a few years later, the eminent Ceylonese art historian who was to become the keeper of Indian, Persian, and Muhammadan Art at the Boston Museum of Fine Arts, Ananda Kentish Coomaraswamy, remarked:

In the nineteenth century the tradition of Mogul and Rajput painting may be said to have finally disappeared,

largely as the result of the change of taste produced by "English Education," so called. A certain amount of work in oil-painting and water-colour was practised as the result of School of Art education. The late Raja Ravi Varma was the best known of the painters in a purely European style, but neither he nor any other workers of the pseudo-European school attained to excellence. His work at the best reached a very second-rate standard. Nevertheless, Ravi Varma's work is but too well known and widely distributed in India through the medium of cheap oleographs, which do not even give it a fair chance ... The work of the modern school of Indian painters at Calcutta is a phase of the national re-awakening. Whereas the ambition of the nineteenth century reformers had been to make India like England, that of the later workers has been to bring back or to create a state of society in which the ideals expressed and implied in Indian culture shall be more nearly realised.

The cooperation of two differently gifted men made possible a great change in the public attitude towards art. Mr. Abanindronath Tagore, an Indian painter already of great promise, encouraged by Mr. Havell, then Principal of the Calcutta School of Art, began to seek inspiration in the seventeenth-century Hindu and Mogul paintings, which had, till then, been so little appreciated. At the same time Mr. Havell was fortunate in being able to dispose of the collection of inferior European paintings which belonged to the School of Art, and to replace them with fine examples of seventeenth century Indian work. The collection thus begun is now one of the most important of its kind. It is remarkable evidence of the former state of feeling that this move was not effected without strenuous opposition on the part of students and the Nationalist Press, so strong was the belief that Europe must be the only source of artistic inspiration. Those days have long gone by. [20]

One of A.N. Tagore's comparable earlier works with a boat dates from about 1889. It is called *The Boat against the Wind*.[21] A similar wash showing a boat on a lake hidden in mist is in the Rabindra Bharati Society. It is signed in the "Japanese" way.[22]

NOTES

1. For similar "signatures(?)" in A. N. Tagore's paintings cf. Chandra 1951, illus. 26, lower right; Ray 1990, p. 169, col. pl. II, lower right.
2. Christie's, November 20, 1986, p. 24, lot 31. We were shown a col. transparency on the basis of which we would ascribe this painting to a Rajasthani artist of the eighteenth century copying a picture of an imperial atelier dating from the second third of the seventeenth century.
3. Crowe et al. 1972, p. 78. For reproductions of this painting see Binyon/Arnold 1921, pl. XIV, facing p. 32; Crowe et al. 1972, full-page pl. p. 79. Cf. also Titley 1977, p. 163, no. 395.7.
4. Crowe et al. 1972, p. 36.
5. Tuzuk 1978, vol. II, p. 168.
6. Chandra 1951, pp. i–ii.
7. Chandra 1951, p. 13.
8. Chandra 1951, p. 17.
9. Chandra 1951, p. 18. For a col. reproduction of a painting done in the "Indo-European technique," see Chandra 1951, illus. 20 (*Birth of Krishna*). Stylistically, this painting is in fact more than 85% Indian.
10. Chandra 1951, p. 19.
11. Chandra 1951, p. 20.
12. This article was first published in Bengali. An English translation by Sukumar Ray was published in 1914, cf. Tagore 1968.
13. For Havell's activities here, cf. Guha-Thakurta 1992, pp. 146–159.
14. Guha-Thakurta 1992, p. 158.
15. Among these is the crane, ascribed to Jahangir's master artist Ustad Mansur, which enchanted A. N. Tagore, who examined it with a magnifying glass, cf. Chandra 1951, p. 27 and Havell 1908, col. pl. LXI.
16. Pl. LXXIII, col. pl. LXXIV, pl. LXXV, col. pl. LXXVI.
17. Pl. LXXVII by Nanda Lal Bose; pl. LXXVIII, by Surendra Nath Ganguly.
18. Havell 1908, p. 256–257.
19. Havell 1908, p. 262.
20. Coomaraswamy 1912, p. 67. This was written in 1911.
21. Chandra 1951, illus. 11.
22. Ray 1990, p. 162, illus. 2.

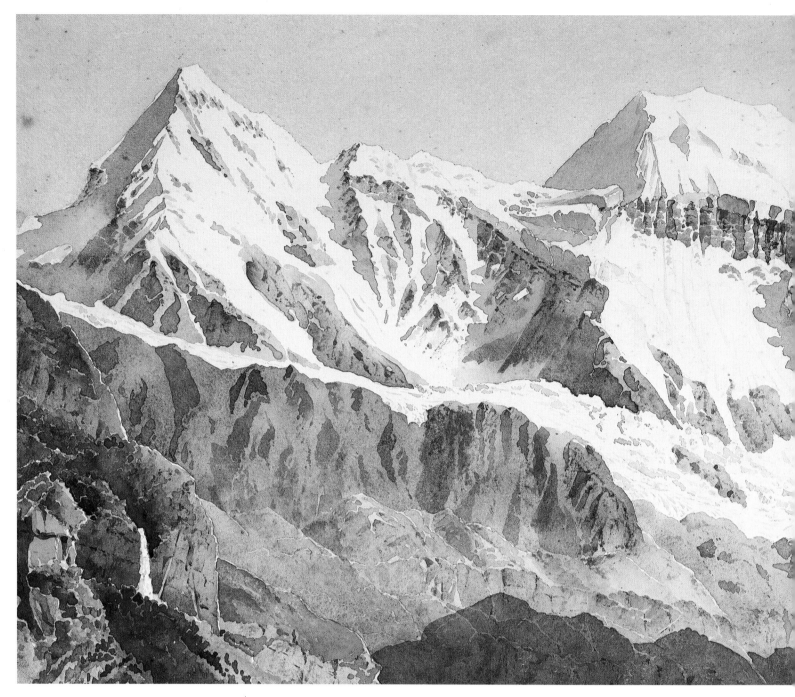

89 Mount Kailash(?)
in the Himalaya
∽
by Henry Richard Beadon
Donne (1860–1949), India,
ca. 1898.

Media: Watercolor on paper

Size: 11¹/₂ x 18¹/₂ in.
(29.2 x 47 cm.)

Inscribed: Signed in lower right
corner: "H R B Donne"; on verso:
"Shown from Pindari route /
H.R.B.D."

Seek then Kailasa's hospitable care,
With peaks by magic arms asunder riven,
To whom, as mirror, goddess repair
So lotus bright his summits cloud the heaven,
Like form and substance to god's daily laughter given.[1]

This verse describing Mount Kailasa or Kailash is from the poem "Meghaduta" (Cloud-Messenger), written by the most famous poet of classical Sanskrit, Kalidasa,[2] in about the fifth century. The Kailasa is one of the most important mountains of Hinduism, since it is the seat of Kubera, the king of the *yakshas* (often represented as dwarfish, pot-bellied goblins) who can either bestow or personify riches. It is also the home and seat of one of the most important deities of Hinduism, Lord Shiva, who resides on top of this mountain as "Kailasanatha" (Lord of the Kailas). Arjuna, the hero of the Indian epic *Mahabharata*, spent five years on that mountain as guest of the ancient Indian god Indra, while his brothers spent four years there, in the paradise of Kubera — four years which passed like one night. Others did the most severe penance on top of that mountain, in order to achieve the blessing of the gods. The mountain has become equally sacred to the Buddhists.

Mount Kailasa, situated in Western Tibet, where it is called Kangrinboqe Feng, is 6,714 m. (22,020 ft.) high, while its size in Indian mythology is given as one hundred *yojanas* (miles).[3] A mountain which looks very similar is the Kailas Baba ("smaller Kailas"), on the northern side of which is the Lebong Pass. It rises to a height of 5,300 m. (17,388 ft.).[4] As a comparison with photographs of both demonstrates, one of these two mountains may well have been the subject of this view by Donne, who also painted another Himalayan view, which is in the collection of W. K. Ehrenfeld. In the present watercolor, the Kailas may be identified by the peak on the right-hand side.

Henry Richard Beadon Donne spent several years in India where, from 1897–1898, he served on the North-West frontier, during which mission he might have done this watercolor. He also painted the Jama Masjid in Delhi (for which cf. cat. no. 61d.),[5] and two works by him are in the Oriental and India Office Collections, India Office Library, London.[6] Donne exhibited from 1906–1936.

NOTES
1. Gangoly 1963, p. 45, translation after Ryder.
2. *Purva Megha*, verse 11 of the common text editions.
3. For a photograph, cf. Raghubir Singh 1992, pl. 3. For a photographer's description, cf. Raghubir Singh 1992, pp. 11–14.
4. For a photograph cf. Hürlimann 1956, pl. 213. The present watercolor could also depict two mountains of the Chaukhamba-Punchchuli-Nandadevi range situated near Chaukori, a summer retreat in the hills of Kumaon.
5. Bonhams, April 23 and 24, 1996, col. illus. p. 67, lot 518.
6. Kattenhorn 1994, p. 116, nos. 3863 and 3864.

ELEPHANTS,
TIGERS,
AND OTHER
ANIMALS

90 A Painted Stork (Mycteria leucocephala [Pennant])

~

by Zayn-al-Din (fl. 1770–1790), Calcutta, 1782.

Media: Watercolor on European paper

Size: 32¼ x 22 in. (81.9 x 55.9 cm.)

Inscribed: Numbered "149"(?) in top left corner, faintly visible; in lower left corner, from top to bottom, in *Nashtaliq:* janghil (the Hindi name for this bird,[1] and below: *kibar*, probably another local name for this bird). Below: "In the Collection of Lady Impey at Calcutta." Below: "Painted by Zain-al-Din [the latter name written in *Nashtaliq*] native of Patna, 1782."

Inscribed on mount below the painting, in pencil: "White Headed Ibis."

Provenance: Sir Elijah Impey (1732–1809) and Lady Impey (1749–1818); his sale, Phillips, May 21, 1810. Archibald Elijah Impey (1766–1831); bequeathed by Mrs. Sarah Impey (a daughter-in-law of Lady Mary Impey) in 1855 to the Linnaean Society, London. Sotheby & Co., June 10, 1963, lot 26. Sotheby's, October 22 and 23, 1992, lot 493.

Published: Sotheby & Co., June 10, 1963, lot 26, as *A Painted Ibis.* Sotheby's, October 22 and 23, 1992, lot 493, full-page col. pl. p. 226. Galloway 1994, no. 8, full-page col. pl.

Pages 328–329. Fighting Elephants, North-West India, about 1900.

Field characters: A long-legged, long-necked, egret-like marsh bird with long, heavy, yellow bill slightly decurved at tip, and unfeathered, waxy yellow face. Plumage white, closely barred with metallic greenish black above, with a black band across breast. Delicate rose-pink near the tail (closed inner secondaries). Wing and tail-quills black. Sexes alike. Status, distribution and habitat: Resident, shifting locally with water conditions. Throughout the plains of the Indian Union, both Pakistans [i.e. Pakistan and Bangla Desh], *Nepal terai, Ceylon (low country dry zone). General habits: Normally met with in pairs or small parties. In the breeding season enormous congregations of up to several thousand strong may collect at favourite heronries, e.g. Keoladeo Ghana in Rajasthan,*[2] where the accompanying fig. 23 (see p. 332) was photographed in order to show the great reliability of the present painting.

The present painting is not the only example of a painted stork from the collection of Lady Impey. Another painting of the same bird, done by another artist in Lady Impey's employ, Bhawani Das, is also inscribed as representing a *kibar* and *janghil* respectively. It bears slightly less resemblance to an actual photograph of a painted stork than the present painting.[3]

The "Lady Impey at Calcutta" who is mentioned in the inscription, was Mary, wife of Sir Elijah Impey. While Sir Elijah Impey took up his post as Chief Justice of the Supreme Court at Fort William, Calcutta, in 1774,[4] Lady Impey commissioned natural history illustrations from 1777 onwards until early 1783. She is represented, together with her husband, in a painting by John Zoffany,[5] but more famous is a painting by an Indian artist, showing her at her Calcutta home surrounded by Indian servants.[6] This painting might have been done by one of those three artists whom she commissioned to paint the different animals and plants. The three artists were Shaykh Zayn-al-Din, Bhavani Das, and Ram Das. All three artists claimed that they came originally from Patna, in those days one of the most important places of northern India. Zayn-al-Din was a Muslim by name, whereas the other two, who had joined Zayn-al-Din by 1780, were Hindus. Zayn-al-Din was probably the leading figure in the project, since more than three-quarters of the known paintings done for Lady Impey were executed by him.

When Sir Elijah Impey was recalled from Calcutta, some 326 drawings, 197 of them birds, had been completed.[7] Most of the drawings show the animals in actual size. The sixty-four natural history drawings of Lady Impey that were bequeathed to the Linnean Society of London by Mrs. Sarah Impey in 1855 were all auctioned in June 1963.[8] Of these, almost every watercolor is a masterpiece, of which relatively few were reproduced.[9] Each detail is painted with the greatest care and precision. The colors were applied in different layers, which renders them more intense. Originally, this technique was employed by the Indian court painters and we may presume that Zayn-al-Din and his two colleagues stem from that great tradition. These paintings of the fauna and flora—most of the smaller birds are represented together with a branch of a particular tree—constitute the earliest dated natural history drawings painted for the British in India. When Zayn-al-Din painted this painted stork, the greatest of the American bird painters, Jean Jacques Fougère Audubon, was not even born.[10]

It is unscientific but tempting to speculate, whether the Zayn-al-Din of Patna is a descendant of Zayn al-Abidin, whose dated painting (1609/10 A.D.) of a young *mahawat* (elephant rider) taming an elephant once served as motif for a postal stamp in India.[11] After all, from the early seventeenth century onwards, Indian painters were known for their reliable portraits of birds and other animals. The Mauritius Dodo (Raphus cucullatus L.), a flightless pigeon-like bird known to Europeans only since 1598, became, "thanks to the active gastronomic interest taken in it by visiting European sailors to Mauritius," extinct by 1681. A portrait of this bird, ascribed to Jahangir's (r. 1605–1627) court painter Ustad Mansur Naqqash, "is considered by experts to be the most scientifically accurate one extant."[12] Whether or not the present Zayn-al-Din is related to Zayn-al-Abidin, he stems undoubtedly from the same line of great Indian animal painters.

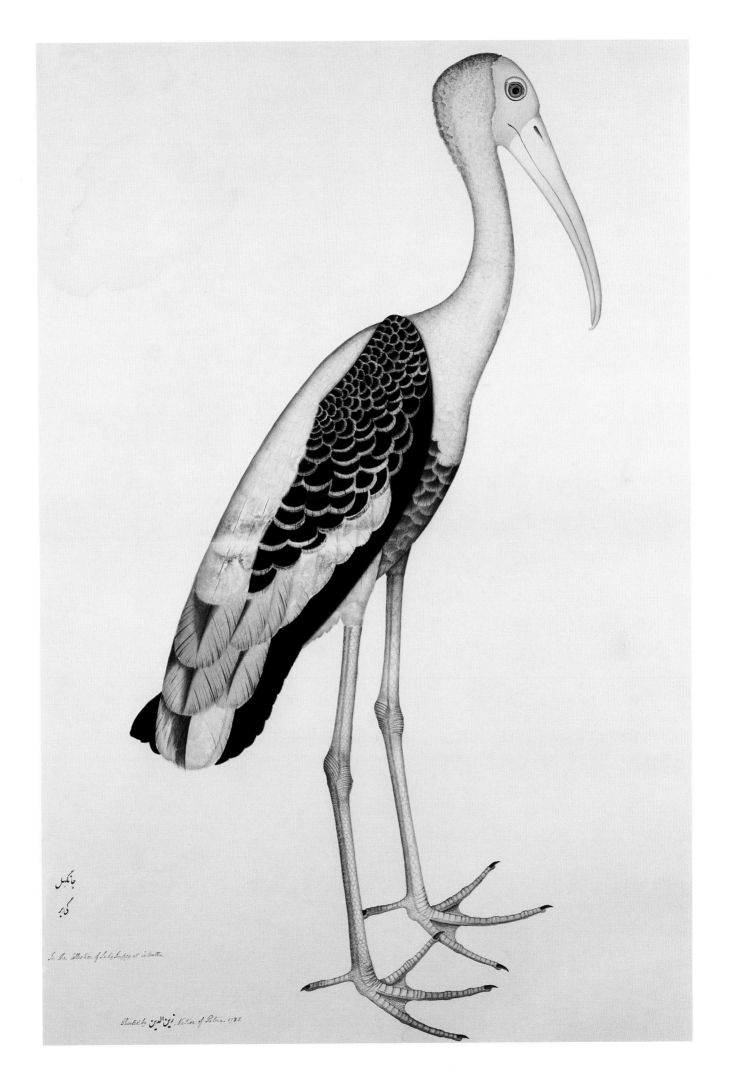

جانگل
گابر

In the Collection of Lady Impey at Calcutta

Painted by زین الدین Native of Patna 1782

Fig. 23

NOTES

1. Following Ali/Ripley 1983, p. 24 or vol. I, p. 93.

2. In the absence of a contemporary description by the artist we quote here from one of the most important and comprehensive publications on Indian birds, viz. Ali/Ripley 1983, p. 24 or vol. I, p. 93 of the original edition.

3. For a reproduction of this other painted stork, see Christie's, June 13 and 14, 1983, lot 24, p. 14 (= Colnaghi Oriental, Autumn 1983, *Painted Stork* = Christie's N.Y., October 3, 1990, lot 66, col. repro.).

4. For Sir Elijah Impey's portraits as Chief Justice see the platinotype after John Zoffany's portrait, reproduced in Archer 1979, p. 138, no. 86 (= Archer/Rowell/Skelton 1987, p. 13, fig. 4 = Bayly 1990, p. 112, no. 128) or the portraits by Tilly Kettle reproduced in Corfield 1910, p. 9, no. 15; Archer 1979, p. 89, nos. 45 and 46.

5. For which see Archer 1979, p. 136, no. 84.

6. For this often reproduced painting see Archer 1960, pl. 100 (= Irwin 1970, fig. 30 = Welch 1978, p. 23, fig. 3 = Woodford 1978, illus. p. 126 = Moorhouse 1983, col. pl. on pp. 58–59 = Losty 1990, p. 41, fig. 17 = Welch 1985, p. 424, no. 281c., col. pl.).

7. For this figure see Sotheby's, October 22, 1993, p. 120.

8. Sotheby & Co., June 10, 1963, lots 1–64.

9. Cf. the following paintings by Zayn-al-Din: undated: *Sarus Crane* (Harle/Topsfield 1987, col. pl. 20, no. 94 = Topsfield 1994, no. 38, col. pl. p. 78); *An Eastern Parrot on a Spray* (Archer/Archer 1955, fig. 47); *Strobilanthes, a Shrub of the Zingiberaceae Family* (Maggs Bull. 1964, no. 6, no. 135 = Mason 1986, no. 6, full-page col. pl.); *A Sulphur-crested Cockatoo* (Falk/Hayter 1984, col. front cover = Fischer/Goswamy 1987, no. 109, full-page col. pl. p. 217); *A Macaw Holding on to a Flowering Branch* (Binney 1973, p. 134, cat. no. 114); *A Spotted Munia or Spice Finch, A Purple Rumped Sunbird (Male), A Gloriosa Superba* and *A Double Rose of Sharon* (Welch 1978, no. 7, illus. p. 38); dated 1777: *A Red-vented Bulbul* (Falk/Hayter 1984, no. 9, col. pl. = Smart/Walker 1985, no. 20); *A Brahminy Myna,* numbered 3 (Sotheby's, October 22, 1993, lot 229, col. pl. p. 121 = Archer/Archer 1955, fig. 46, where labeled *Pagoda Trush on Bair Tree; A Fairy Bluebird,* numbered 6 (Falk/Hayter 1984, no. 2, col. pl. Welch 1985, p. 422, no. 281a, col. illus.); *The Caracal,* numbered 12 (Falk/Hayter 1984, no. 14, col. pl.); *A Crow-Pheasant or Coucal,* numbered 13 (Christie's, June 13 and 14, 1983, lot 21, not reproduced); *A Red-Whiskered Bulbul,* numbered 20 (Christie's, June 13 and 14, 1983, lot 22, not reproduced); *A Satyr Tragopan* or *Crimson Horned Pheasant,* numbered 23 (Falk/Hayter 1984, no. 15, col. pl.); *A Grand Eclectus Parrot on a Mango Branch,* numbered 29 (Falk/Hayter 1984, no. 4, col. pl.); dated 1778: *A Pied Bush Cat* (Maggs Bull. 1964, no. 6, no. 133); *A Mountain Rat on a Hindustani Almond Tree* (Archer/Archer 1955, fig. 45 = Welch 1978, no. 6, col. pl. p. 37); *An Indian Black-headed Oriole or "Mango Bird"* (Pal/Dehejia 1986, no. 171, p. 166 = Pal 1990, fig. 2, col. pl. p. 129 = Christie's, May 25, 1995, lot 20, col. pl. p. 25); *An Orange-Headed Ground Trush,* numbered 42 (Christie's, June 13 and 14, 1983, lot 19, not reproduced); *An Eastern Curlew about to Eat a Mudskipper,* numbered 50 (Falk/Hayter 1984, col. pl. p.[11] = Sotheby's, April 29, 1992, lot 1, col. pl. p. 10); *An Oriental Green Barbet,* numbered 58 (Falk/Hayter 1984, no. 10, col. pl.); *A Rainbow Lorikeet,* numbered 60 (Falk/Hayter 1984, no. 3); dated 1779: *A Young Sunbird* (Maggs Bull. 1964, no. 6, no. 134); *A Shawl Goat* (Archer 1992, no. 71(1), col. illus. p. 98); *A White's Trush* (Sotheby & Co., December 9, 1970, lot 133, not illus.); *An Indian Blue Jay or Roller* (Sotheby's, April 24, 1996, lot 67, col. pl. p. 72); *A Chinese Pangolin,* numbered 10 (Sotheby's, October 22 and 23, 1992, lot 494, col. pl. p. 227); *A Chestnut Mannikin,* numbered 71 (Falk/Hayter 1984, no. 16, col. pl.); *A Scarlett-backed Flowerpecker,* numbered 73 (Falk/Hayter 1984, no. 7, col. pl.); dated 1780: *A Blue-Throated Barbet* (Christie's, June 13 and 14, 1983, lot 20, not reproduced); *A Cheetah* (Welch 1973, no. 71a, p. 120 = Welch 1978, no. 9, p. 41); *A Dwarf Flying Squirrel* (Welch 1973, p. 121, no. 71b = Archer/Archer 1955, fig. 44 [as *Flying Fox*]); *An Ashy-crowned Finch-lark* (Falk/Hayter 1984, no. 8, col. pl.); *A Black-headed or Brahminy Myna,* numbered 97 (Christie's, June 11 and 12, 1984, lot 12A, col. pl. p. 7 = Falk 1987, no. 18, col. pl. p. 22); *A Pair of Lorikeets* (Pal 1990, p. 129, fig. 3); *A Chattering Lory,* numbered 100 (Falk/Hayter 1984, col. pl. inside front cover); *A Yellow-bibbed Lory,* numbered 101 (Falk/Hayter 1984, no. 13, col. pl.); *A Pied Myna,* numbered 103 (Christie's, June 13 and 14, 1983, lot 23, not reproduced); *The Spotted-billed or Grey Pelican,* numbered 105 (Falk/Hayter 1984, no. 18, col. pl. on back cover); dated 1781: *A Green Shank* (Christie's, June 13 and 14, 1983, lot 26, not reproduced); *A Golden Plover* (Christie's, June 13 and 14, 1983, lot 27, not reproduced); *A Female Pheasant-Tailed Jacana* (Sotheby & Co., December 9, 1970, lot 134, not illus.); *A Chestnut Bittern,* numbered 121 (Sotheby's, October 22 and 23, 1992, lot 492, full-page col. pl. p. 225); *A Milky Stork,* numbered 130 (Falk/Hayter 1984, no. 11, col. pl.); cf. also Welch 1985, p. 423, no. 281b, *A Sambar.* There are also two unpublished fish paintings by this artist dated 1777 and a painting of a horseshoe crab in the Wellcome Institute, London, cf. Robbins/Robbins 1991, p. 45. By Bhavani Das: undated: *A Branch of a Mango Tree* (Archer 1992, no. 71(2), col. illus. p. 98 = Skelton et al. 1979, no. 99, p. 50); the Eastern Goshawk (Falk/Hayter 1984, no. 12, col. pl.); *A Green Pigeon,* numbered 25 (Christie's, June 13 and 14, 1983, lot 25, not reproduced); *The Indian Darter or Snake-bird,* numbered 128 (Falk/Hayter 1984, no. 5, col. pl.); *A Giant Indian Fruit Bat or Flying Fox* (Welch 1978, no. 8, p. 40 = Pal 1990, p. 129, no. 4); dated 1783: *A Fish* (Christie's, July 4, 1985, lot 153, p. 102); In addition, there are thirty-nine fish paintings and eleven paintings of snakes, three depictions of insects, and two paintings of lizards by this artist in the Wellcome Institute, London. The paintings are dated between 1782 and 1783 (for the depiction of two snake pictures see Robbins & Robbins 1991, p. 45). By Ram Das: undated: *A Painted Stork,* numbered 46 (Christie's, June 13 and 14, 1983, lot 24 = Colnaghi Oriental, Autumn 1983, *Painted Stork* = Christie's N.Y., October 3, 1990, lot 66, col. repro.); dated 1781: *The Eastern Grey Heron,* numbered 156 (Falk/Hayter 1984, no. 17, col. pl.).

10. He was born in 1785.

11. For a facsimile of this painting, see Hickmann 1991, no. 14598, fol. 2, also published in Hickmann 1979, col. pl. 5 and p. 136 with further references to publications to which we would like to add the following: Kühnel 1937, col. pl. 10 and Kühnel 1946, col. pl. 5.

12. Ali 1968, p. 17.

**91 Hunting a Kuttauss
or Civet Cat**

∾

by Samuel Howitt
(1765–1822), after the original
design of Captain Thomas
Williamson (1758–1817),
Bengal before 1798 / London
ca. 1802–1807.

Media: Pencil and watercolor
on paper

Size: 11¼ x 16½ in.
(28.5 x 41. 9 cm.)

Published: Christie's, May 25,
1995, lot 67, p. 31.

Provenance: Paul F. Walter

This original watercolor was engraved for *Oriental Fieldsports*, probably the "most beautiful
publication ever created in the field [of books on sports]."[1] *Oriental Field Sports* was first
published by Edward Orme, 59 Bond Street London, in twenty parts between 1805 and
1807.[2] A second edition with all forty colored plates of the first, but in a reduced size, was
published in two volumes in London, 1819; the present aquatint being reproduced as plate
XXX in vol. II of that edition.[3] The best account on the animal is by Captain Williamson
himself, who describes it together with the tree which looks like a small forest at the right-
hand border of the picture on pages 109–120 in the second edition of his book. We quote
here only those passages which are relevant to the kuttauss and omit those on the tree in the
background, the trees shown in the left half of the painting, and an alligator hunt.

*The kuttauss is but little known to Europeans, although, under the designation of the civet, such profuse
encomiums are lavished on its alleged perfumes. The fact is, that, like many other scents which may be too
strong to please, the kuttauss is really offensive, and absolutely sickens both man and beast. It has a rank smell,
somewhat like musk, and so powerful as to occasion such dogs as mouth it, to vomit.[4] However, a faint
specimen of it is by no means disagreeable. This animal is perhaps the most obnoxious of all the wild tribes
known in India. It is seldom, if ever, seen on a plain, except at night, when it leaves its haunt in quest of prey.
The kuttauss is remarkably bold, sparing nothing which it can overcome, and frequently killing, as it were,
merely for sport. Its principal devastations are among sheep and swine, from which it purloins the young, and
commits dreadful havoc among poultry. To the rapacity of the wolf it joins the agility of the cat, and the
cunning of the fox. Its figure is a strange compound of the fox and pole-cat; its head being long and sharp with
pricked ears, its body low and long, and its tail rather long, but not very bushy. Its claws are concealed with
pleasure. The colour of its body is a dirty ash colour, somewhat striped with a darker shade, and its tail has
many rather indistinct circles, of the same tint.*

*This obnoxious animal is generally found in short underwood covers, mixed more or less with long grass, and
especially where palmyra, or cocoa trees are to be seen. Although it is sometimes met with in various detached*

jungles, yet, for the most part, its residence is confined to such as border old tanks, or jeels. These banks being formed by the excavation, are often very high and broad; with time they settle and become flatter, and are generally over-run with very strong brambles, through which even an elephant could not make his way without extreme difficulty. Of such covers the kuttauss is a regular inhabitant; seldom stirring in the day, during which time he appears to hide himself in the most opaque recesses. Such is the caution with which the kuttauss acts by night, that his depredations are ordinarily attributed to jackals, &c. Being from his size, which is equal to that of a full grown English fox, able to bear away a substantial booty, he is also capable of making a powerful resistance; and being familiar to trees, into which he can ascend with facility, it is not a very easy thing to overcome him. His bite is very sharp; and such is the strength of his jaw, that sometimes he is found to snap the legs of such dogs as incautiously subject their limbs to his powers. Like the camel, he has a very uncouth trick of keeping a fast hold, though worried by a dozen of sturdy dogs, all tugging at various parts. This we may presume operates much in his favour when seizing a prey. Jackals and foxes, and even wolves, when closely pursued, especially if hit with a stick or a stone, frequently drop what they have seized, and content themselves with an escape. The kuttauss is so very secret in his operations, that, were not the bones of his victims found in its haunts, one might almost doubt whether he were carnivorous.

Hounds are wondrously incited by the scent of a kuttauss; it seems to derange them; they defy all control, and often disregarding the voice of the hunter, as well as the sickness occasioned by the nauseous stench of the animal, remain in the cover, barking and baying, until a sharp bite sends them off howling; after which they shew great aversion from a fresh attack. If a jackal, or other hunted animal cross near the haunt of a kuttauss, he rarely fails to make his escape. The dogs all quit the chase and surround the stinking animal. Whether they be successful in killing, or not, it matters little; for their scent is completely overcome for that day, and the hunter may assure himself that unless a jackal may take to a plain, and be run in open view, no chance exists of killing him. Indeed, after having worried a kuttauss, dogs treat all other game with perfect indifference. Hence it is an object with those who hunt with hounds, which, however, are very scarce, there not being more than four or five packs in all Bengal, to avoid the banks of tanks, and rather to forego the abundance of game to be found there, than to risk the failure of their morning's diversion.

It is a curious fact that jackals, foxes, and kuttausses, are most numerous near to the villages inhabited by Mussulmans. This probably is to be attributed to their rearing poultry, which the Hindoos never do.... The Hindoo religion proscribes them as being unclean; whence a native of that persuasion will not even touch one! It is from the Mussulmans only that poultry can be obtained; though they are occasionally reared by the lower casts, or sects, who are considered as perfect outcasts, and are only tolerated on account of the convenience they afford by occupying the most menial offices, or by following the lowest occupations. The degenerate Portugueze, who abound in many parts of India, generally speaking, may be deemed as the most despicable of the human race, and who retain all the pride, without the valour of their illustrious ancestors, deal extensively in all kinds of poultry....[5]

Williamson had served in a Bengal European regiment for some twenty years but was compelled to leave India in 1798 for having had the courage to criticize the way in which the British dealt with Anglo-Indians.[6] Williamson's sketches, which were made on the spot, were worked up by Howitt for the publication. Although Howitt had never been to India he did a good job on Williamson's sketches. Howitt's (or Williamson's?) elephants, however, have little in common with Indian elephants, as the present example shows. The extent to which Howitt and then the engraver followed Williamson's original drawings is shown by published comparisons.[7]

ELEPHANTS, TIGERS, AND OTHER ANIMALS

NOTES

1. Thieme-Becker vol. 17, p. 588.
2. All forty aquatint-engravings of this edition were reproduced in Howitt/Williamson 1982; this cat. no. corresponds to no. 35. All pls. in the first edition are captioned in English as well as in French, the English title being printed below the left part and the French below the right part of each aquatint. For further examples of these etchings as reproduced in col., see India and Afghanistan 1986, no. 99; Christie's, June 5, 1996, p. 139, lot 203; Mahajan 1984, p. 109, pls. XV and XVI, both pls. taken from the second edition, for Mahajan 1984, pl. XVI as taken from the first edition, see Desmond 1989, p. 168, fig. 6.
3. Williamson/Howitt 1819, vol. II, pl. facing p. 109, etched by J. Clark. It was first published on July 1, 1807. For a hand-colored lithograph of a "viverra zibetta," published in London, 1834, see Desmond 1989, p. 173, fig. 10, col. There are about a half dozen different kinds of civets. The scientific names of those most common in India are *Viverra zibetha* and *Viverricula indiaca*.
4. In the late eighteenth century, James Forbes described a civet cat and closed his remarks on it: "I kept one for some time in a wooden cage, but the smell at length became so insufferable, that I gave him liberty."(Archer 1983, p. 2).
5. Williamson/Howitt 1819, vol. II, pp. 109–113.
6. For Williamson's career cf. Archer/Lightbown 1982, p. 67; Bruhn 1987, p. 61; Howitt/Williamson 1982, introduction.
7. Pal/Dehejia 1986, p. 74 and p. 116.

92 Two Tigers

∽

by Samuel Howitt
(1765–1822), London, ca.
1805–1807.

Media: Pencil and black ink
and watercolor heightened
with gum arabic

Size: 6¼ x 8⅞ in.
(15.9 x 22.6 cm.)

Inscribed: "Howitt," in lower left
corner

Published: Christie's, June 5,
1996, p. 68, lot 86, col.

It is difficult to find a suitable contemporary description of these two tigers since Samuel Howitt had not ever seen them in their natural habitat.[1] Howitt had never been to India and his watercolors of Indian wildlife are based primarily on Captain Williamson's sketches done on the spot (cf. the preceding cat. no. 91). It is assumed, however, that Howitt "was so fascinated by the great cats which he had seen in menageries that he used to go down to the East India Docks to sketch them as they were off-loaded from the Orient."[2] Howitt's tigers in fact resemble cats, or at least tamed tigers, more closely than the ferocious lord of the jungle, as the tiger was introduced in endless descriptions of tiger-hunts. Williamson alone devotes twelve aquatints to different situations of tiger-hunting, and they were all worked up by Howitt.[3] In these, the tiger is shown hunting, hunted, fighting, or dead.

The present watercolor reminds of the common Hindu saying: "If you want to know what a tiger is like, look at a cat,"[4] or Victor Hugo's "Dieu a fait le chat pour donner à l'homme le plaisir de caresser le tigre."[5] It is known that Howitt created more watercolors from

Williamson's sketches than were needed for the *Oriental Field Sports*, which contains forty aquatints in addition to two title-vignettes. Howitt prepared at least forty-four watercolors.[6] The present watercolor was either not selected by Williamson for the published work, or it is a study for a title-vignette, which we believe it was. There are two different title-vignettes with a tiger, both of which show the animal lying with the hind legs crossed. The hind part of the tiger in the 1807 edition, with its tail resting on the left hind leg, looks exactly like the corresponding part of the body of the right tiger in the present watercolor.[7] The tiger which precedes the title page of the first volume in the second edition closely resembles its counterpart in the first, but is mirror-reversed.[8] This is apparently the only watercolor of Indian animals actually signed by Howitt. Several other watercolors are known, but they all very closely relate to the aquatints in *Oriental Field Sports*.[9] The other major work of Howitt contains twenty large-sized colored illustrations, also published by Orme in 1807, titled *Collection of British Field Sports*. Rowlandson was another great painter of hunting-scenes of his day, and Howitt was married to his sister.

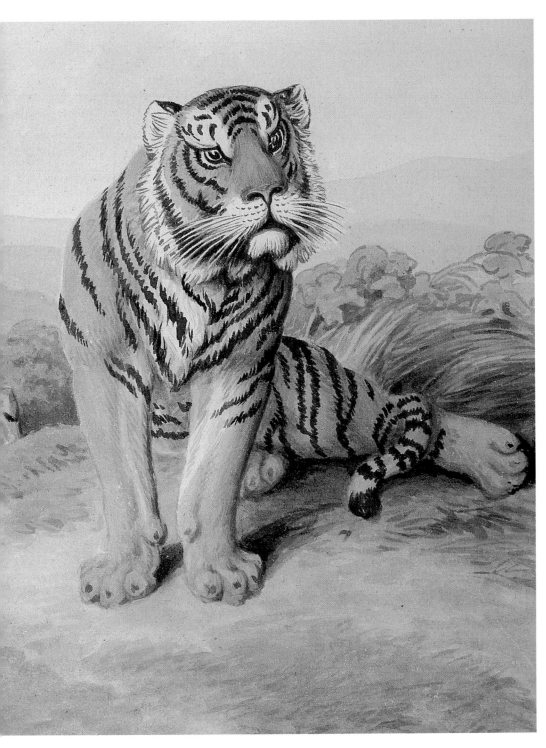

NOTES
1. For a contemporary account on tigers, with only casual references to tiger hunts, see Perrin 1811, vol. I, pp. 77–83. For a later survey which offers comprehensive information on tigers as described in previous literature, see the chapter "The Tiger (Felis Tigris)" in Sanderson 1879, pp. 266–292.
2. Howitt/Williamson 1982, p. 1.
3. Williamson/Howitt 1819, vol. I, pls. 12–20, vol. II, pls. 21–22, 24.
4. Kipling 1891, p. 315.
5. "God created the cat to give man the pleasure of caressing a tiger," after Kipling 1891, p. 315.
6. Howitt/Williamson 1982, p. 1.
7. Howitt/Williamson 1982, title-page.
8. This is in monochrome and it seems it was only published in that edition.
9. Cf. the preceding cat. no. and Christie's, May 25, 1995, lots 68–70 and 73–74.

93 A State Elephant at Bikaner, Rajasthan

∿

by Edwin Lord Weeks
(1849–1903), Bikaner, January
1893 (?).

Media: Oil on canvas

Size: 19³/₄ x 12¹/₂ in.
(50.2 x 31.8 cm.)

Inscribed: Signed in lower left
corner: "E. L. Weeks" and
below: "Bikanir." On the
canvas on verso, as ink-
impression in bold printed
letters: "Edwin Lord Weeks
Sale / March 15. 16. and 17.
1905."

"Three great elephants drawn up in line awaited us on our return to the bungalow, and the scarlet of their robes burned like a flame against the green foliage. They had been trained to raise their trunks and bellow forth a most effective salute," wrote the artist in Bikaner on January 16, 1893. Edwin Lord Weeks visited Bikaner in January 1893. The actual reason for his visit to Bikaner were

large photographs which looked as if they might have been taken in the days of Saladin. One of them represented a group of warriors in shirts of chain-mail and steel bascinets, mounted on camels, and armed with lances, drawn up in line in front of a vast palace standing alone in a plain of sand. They proved upon enquiry to have been taken at Bikanir, a place which no one seemed to know anything about, except that it was the capital of an ancient Rajpoot state, in the midst of a waterless desert, very far from anything else, and difficult to access. Just before my arrival in India last year [1892] the Jodhpore State Railway had been extended to Bikanir, and through trains had been put on, running from Marwar junction to Bikanir in twenty-seven hours, more or less.[2]

Weeks's description of the journey to Bikaner by railway is probably more entertaining than his description of the actual city and its palaces. When Weeks finally reached his destination, he did not see the "picturesque" in the shape of "warriors in shirts of chain-mail and steel bascinets, mounted on camels;" he was only shown "some superb photographs representing the whole regiment drawn up in the desert, but in place of the steel veiled and armored bandits [*sic*] were stalwart troopers uniformed and turbaned like her Majesty's Sikhs."[3] Weeks undoubtedly had a fondness for elephants, as illustrations of them appear throughout his book describing his adventures in India.[4] He painted a group of at least four elephants in front of the Bikaner palace, which he does not mention in the text, but of which he includes an illustration labeled *Palace of the Rajah of Bikanir.*[5] That illustration can well be compared to a photograph taken in 1937, showing ten elephants with similar trappings in front of the Bikaner palace.[6] That the present painting does not show any of the four or more elephants lined up at the Bikaner palace as shown by Weeks is also shown by the absence of the *howdah* as well as by Weeks's mentioning of the scarlet color of the elephant's "robe." The elephant in the present painting dominates the scene as in no other known picture involving one or more than one elephant by Weeks.[7]

Commenting on the domestic animals in Western Rajasthan, Lieutenant-Colonel Archibald Adams wrote at the end of the nineteenth century: "The elephant (Elephas indicus) is kept up for State processions and for shooting expeditions; he is an expensive luxury in these States, where suitable green food is rarely available, and where bread and unrefined sugar have to be provided for his support."[8] The elephant's tusks are shortened by one or two feet when entering the royal stable (cf. the elephants in cat. no. 41). The end of the tusks are then covered and protected by rings of gold or silver, as in the present case, in order to avoid further splinter or bursting at this part of the tusk.[9] As with many oil paintings showing Indian themes, it is not clear whether this one was actually done at the site or turned into oils in Europe on the basis of sketches and drawings done at Bikaner.

NOTES
1. Weeks 1896, p. 234.
2. Weeks 1896, p. 219. Weeks saw these photographs "at the Colonial Exhibition in London, some years ago."
3. Weeks 1896, p. 230.
4. Weeks 1896, p. 204, full-page illus., p. 230, ditto, p. 243: *Study of an Elephant's Head, Jeypore,* p. 256, p. 258 (as a wall painting), p. 275, full-page illus., p. 303: *Frieze of Elephants at Chitor.* For a fuller description of a royal elephant in Udaipur, which was also portrayed by Weeks, see Weeks 1896, pp. 295–298.
5. Weeks 1896, p. 230.
6. Patnaik 1990, illus. p. 114, top.
7. Cf. cat. no. 74 or Pal et al. 1989, p. 209, no. 222: *The Great Mogul and His Court Returning from the Great Mosque at Delhi, India.*
8. Adams 1900, p. 193. For an illus. see ibid., photograph facing p. 190, bottom.
9. Cf. Orlich 1845, p. 157.

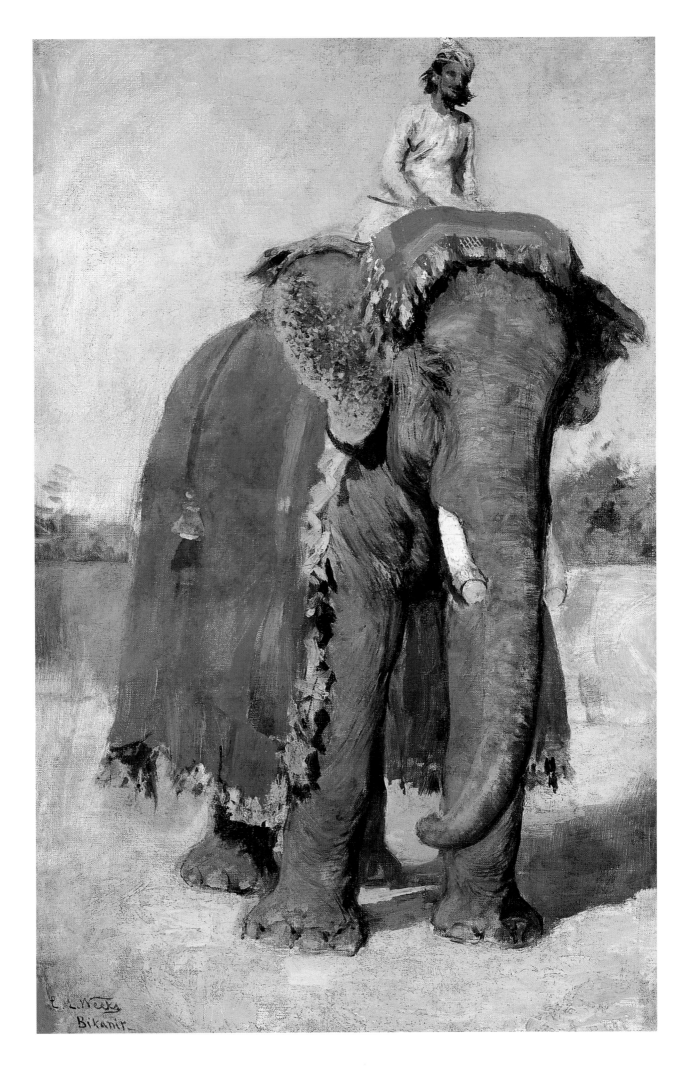

94 His Highness Sri Krisnaraja Wadiyar Bahadur, Maharaja of Mysore (b. 1884, r. 1895–1940), on his State Elephant

∾

by Hugo Vilfred Pedersen (1870–1959), Delhi or Mysore, ca. 1903–1908.

Media: Oil on canvas

Size: 22 x 15 in. (55.9 x 38.1 cm.)

Inscribed: Signed in lower left corner: "Hugo v.p."

From time immemorial Mysore has been ruled by a Hindu dynasty, the ancestors of the present Maharaja claiming to be descended from an offshoot of the Yadav Rajput line. In the middle of the eighteenth century it was usurped by the famous Hyder Ali, whose successor, the sill more notorious Tippu Sultan [cf. cat. no. 36], fell in arms against the British at the capture of Seringapatam in 1799. The old Hindu dynasty was restored in the person of a child whom a romantic fate had spared to survive as almost the sole representative of the ancient Rajas; but in 1831 the people of the State broke into open rebellion as a result of the misrule, and for the preservation of law and order the British Government then assumed the direct management of Mysore. In 1881, however, it was restored to native rule, and now ranks as one of the best administered feudatory States of the Empire. The present Maharaja, Krishnaraja Wadiyar Bahadur, is now in his twentieth year, and succeeded his father in 1895. He received his powers as a ruling Chief in August 1902, when the Viceroy, Lord Curzon, as a special mark of his interest in the young Chief and his State, made a journey from Simla to Mysore for the purpose of investing him. During the six preceding years he owed much to the friendly supervision of Lieutenant-Colonel Sir Donald Robertson, British Resident in the State, and received a careful general education and special training in his administrative duties at the hands of Mr. S. M. Fraser, of the Indian Civil Service, who was selected by the Government of India to act as the Maharaja's tutor and governor during his minority. (Stephen Wheeler, as published in 1904)[1]

Another painting by Pedersen of the same elephant was published in 1944, but without any identification that exceeds "Indien" (India).[2] Although the present painting is—like most of the works by Hugo Vilfred Pedersen—neither dated nor labeled, it can be properly identified with the help of datable photographs of the Mysore state elephant as well as photographs of Sri Krisnaraja Wadiyar Bahadur. The same caparisoned elephant was photographed in 1903. Most characteristic are the retainers carrying long sticks with apparently bundles of peacock feathers tied to the upper end.[3] In the famous elephant procession on the occasion of the Delhi Coronation Darbar, 1903, both the rulers of Mysore and Hyderabad immediately followed the elephant of Their Royal Highnesses the Duke and Duchess of Connaught. The elephant with His Highness Mysore is still the second elephant from the left in cat. no. 41.[4] The state of Mysore has always been known for its "kheddah operations, that is, the capture of wild elephants."[5] Around 1903, Krisnaraja Wadiyar Bahadur favored a particular kind of turban ornament (*sarpech*), which included a few white, fluffy feathers, which are clearly visible in the present oil, in photographs of the actual turban,[6] and in photographs of His Highness Sri Krisnaraja Wadiyar Bahadur, wearing the turban with this ornament.[7] This particular turban ornament does not appear in any of the later photographs showing the Maharaja of Mysore,[8] and it is also not apparent in earlier photographs of him.[9] It is not clear where Hugo Vilfred Pedersen painted his versions of the Maharaja of Mysore on his elephant. He might have done them in Delhi on the occasion of the Coronation Darbar, but he could also have done them at Mysore proper. One portrait of "H.H. the Maharaja of Mysore and Father," a painting of "4 Mysore Princes," and a painting of "H.H. The Maharaja of Mysore on State Elephant" were recorded in 1944.[10]

NOTES
1. Wheeler 1904, pp. 64–65.
2. Gautier 1944, illus. p. 65.
3. For the photograph of 1903, see Fabb 1986, illus. 72. For a painting of 1941 showing the Mysore state elephant on the occasion of the "Dusserah" celebrations at Mysore, see Allen/Dwivedi 1984, p. 278, top (= Ward/Joel 1984, pp. 90–91, col.). For a more recent photograph of a later Mysore state elephant surrounded by retainers with the same long sticks, see Golish 1963, p. 31.
4. The procession took place on December 29, 1902. For details cf. Wheeler 1904, pp. 32–33. A photograph of the procession, however, shows that at the height of the Jama Masjid, the elephant of H. H. Mysore fell back and trotted behind the two elephants of the Nizam of Hyderabad and the Gaekwar of Baroda. The elephant of H. H. Mysore is visible behind the elephant of the Gaekwar of Baroda, see Wiele/Klein 1903, pl. 15.
5. Walker 1923, p. 144. For a detailed, contemporary description of such an elephant-hunt in Mysore, see Abott 1906, pp. 253–259.
6. Golish 1963, p. 50, bottom.
7. Cf. e.g. Wiele/Klein 1903, twelfth illus. after p. 110; Wheeler 1904, photogravure facing p. 64; Ward/Joel 1984, col. illus. p. 123, no. 7; Okada/Isacco 1991, p. 34, right (the dress and insignia of the Grand Cross of the Star of India worn by the Maharaja in this photograph indicates that it was not taken before 1907, the year in which this decoration was conferred on him); Golish 1963, p. 50, top; Gabriel/Luard 1914, illus. facing p. 120 (= Sydenham of Combe 1915, illus. facing p. 48 = Vadivelu 1915, illus. facing p. 27).

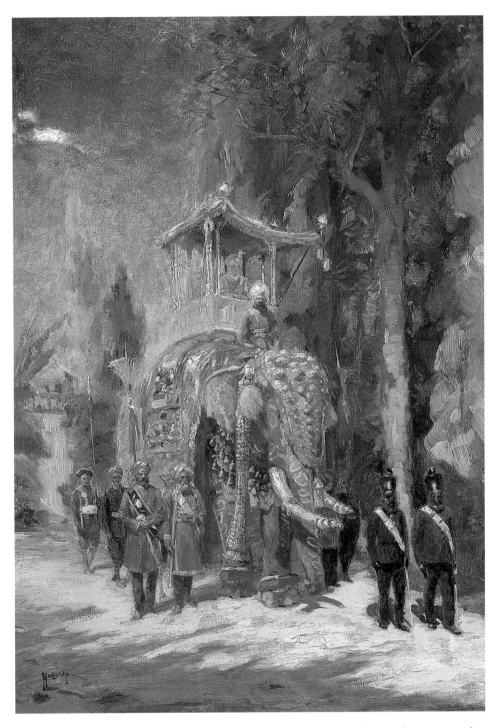

8. Cf. e.g. Walker 1923, full-page illus. facing p. 136; *The Illustrated London News*, Indian Number, no. 5039, vol. 187, November 16, 1935, p. 843, bottom left; Souvenir of the Coronation 1937, p. 32; Golish 1963, p. 51.

9. India Office Library Report 1978, frontispiece, showing a photograph of Sri Krisnaraja Wadiyar Bahadur at the time of his installation on February 1, 1895.

10. Gautier 1944, pp. 34–35; it is not clear whether the painting reproduced in Gautier 1944, p. 68 bottom, showing four princesses from Mysore (*Indiske Fyrstehorn, Mysore*) might be identical with *4 Mysore Princes* or whether *H. H. the Maharaja of Mysore on State Elephant* could be identified with Gautier 1944, illus. p. 65.

95 Two Hunting Scenes

~

by Colonel Edmund Arthur
Ponsonby Hobday
(fl. 1900–1910), India(?),
1907–1908.

a. A Tiger Having Slain a Domestic Cow

Media: Watercolor with
touches of white heightening

Size: 9⅝ x 13½ in.
(24.6 x 34.3 cm.)

Inscribed: Signed and dated on
recto in lower right corner:
"E Hobday. 1907." Inscribed:
On verso: "I The Kill."

Provenance: Christie's, May 25,
1995, p. 105, lot 159A.

b. Hunters on Elephants Looking Out for Game

Media: Watercolor with
touches of white heightening

Size: 9⅝ x 13½ in.
(24.6 x 34.3 cm.)

Inscribed: Signed and dated
on recto in lower left corner:
"E Hobday. 1908." Inscribed
on verso: "III The Beat."
And below, cancelled: "Beating
a swamp."

Provenance: Christie's, May 25,
1995, p. 105, lot 159A.

These two watercolors are part of a series of at least three paintings illustrative of the tiger hunt. The painting numbered "II," illustrated here as accompanying fig. 24, is labeled "Khubber," a term which is explained in the following description, which also contains an explanation of a. "The Kill": "Before describing the shooting, I must comment on the elaborate and extremely efficent methods adopted for giving prompt and exact news (khubber) of kills and the movements of game. This was accomplished by a precise system of signalling. . . . I would ring up for news and would be promptly informed as to the whereabouts of the last 'kill' or the location of a tiger, perhaps ten or fifteen miles away."[1]

A description relating to b.:

His Royal Highness mounted into his howdah, which, by the way, was the same as was used by his father when he last shot in Nepal. The rest of the party were the Earl of Cromer, Admiral Sir Lionel Halsey, Colonel Worgan, Lord Louis Mountbatten, Captain the Hon. Piers Legh, the Hon. Bruce Ogilvy and myself. Everybody was expectant, though nothing happened for some time. On the other side of the huge river bed, now reduced to a narrow stream, stretches the jungle for mile on mile. It is very hot, the elephants are impatient, and every now and then one of them gives utterance to restless trumpeting. Suddenly there is a movement on the left-hand side of the line. General Sir Kaiser, the Master of Ceremonies, who had organised all the shikar arrangements in connection with the shoots, rides in on a fast-trotting pad elephant with news of a tiger, and off we start. The elephants move forward with their weird lumbering gait. H.R.H. leads the procession, followed immediately by the party, and then an army of pad elephants, and still more pad elephants to be used in case of accidents. Ponderously the line proceeds through the dense jungle, crossing many a placid stream, and emerging at times from the cool shade of the giant trees into some glade where the sun beats hot and fierce, only to plunge again into the cool depths of the evergreen jungle. One cannot but be impressed with the calm and twilit grandeur of these gigantic forests. Within their depths all is stillness, and no movement is discernible. There is nothing to break the monotonous tread of the elephants save an occasional burst of drumming from cicadas whose shrill music subsides as quickly as it rises.

Suddenly there is a stir in the line. All the elephants begin to close up, shoulder to shoulder, and the great beasts stand to form the ring. All is expectancy: there is an outburst of shouting from the beaters: out rushes a deer and escapes terrified into the jungle, to be shortly followed by another and another. Then the real thing happens, and there is a cry "Bagh! Bagh!" [Tiger! Tiger!] *from the beaters. The tiger at last! A glimpse of yellowish form is seen in the long grass for the space of a few seconds, and is at once lost to view. Once again it is seen behind a tree trunk. Closer advance the beaters, the tiger charges out, but he is a weary beast, and seems to know intuitively where the guns are posted, and gives them a wide berth. Again and again he is driven out, only to seek cover in the long grass away from the guns. A shikari climbs a tree and pelts him with stones. The manoeuvre succeeds, and once again we get a half-length view of the tiger as he makes a spring at his tormentor in the tree top. The ring closes in upon him, but with a roar he dives into the long grass; another roar, and he shows himself quite near the Royal howdah. A moment's suspense, and H.R.H. fires, and a second afterwards two more shots ring out. The Prince has hit. The tiger, though mortally wounded, has plenty of go in him, and charges to the opposite side, and is buried once more in the heavy cover. The ring closes in: a shot rings out; and the tiger rolls over dead.* (Bernard C. Ellison, December 14, 1921)[2]

The above quoted description is so famous — and also so typical for all similar tiger shoots in India and Nepal — that it was quoted fully again in another official report on Prince Edward's sporting tour in India of 1921–1922, it was, after all, a report on "H.R.H.'s First Tiger in India."[3] And although the present watercolors were produced some fourteen years prior to the Prince of Wales's tiger hunt of 1921, they capture it so well that they could almost be illustrations of it, as the published photographs of this event show.[4] Similar hunts were organized for the Prince of Wales (Albert Edward) when he visited Nepal in February 1876.[5] They were pictorially recorded by William Simpson, who is mentioned in the official publication by William Howard Russel.[6] The photographs even resemble Simpson's paintings, when the Imperial Majesty, the King-Emperor (George V), went out tiger hunting in Nepal after attending the Darbar in Delhi, in December 1911.[7] Ellison alludes to this tiger shoot when mentioning the *howdah* "used by his father when he last shot in Nepal."

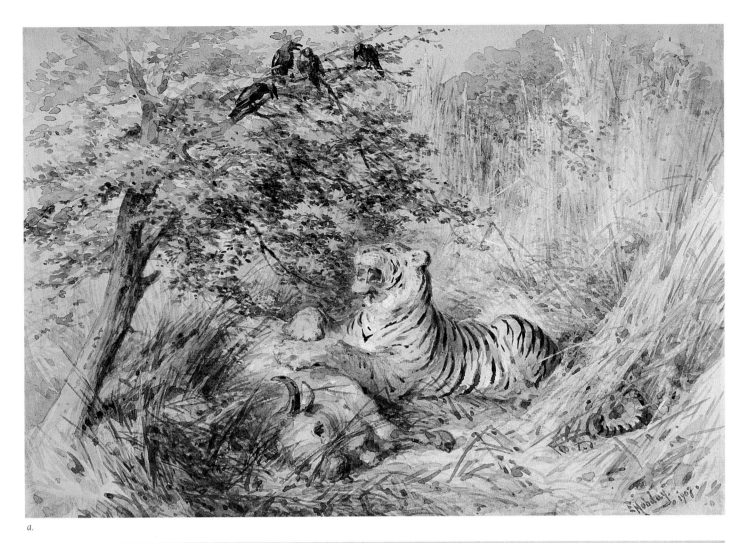

a.

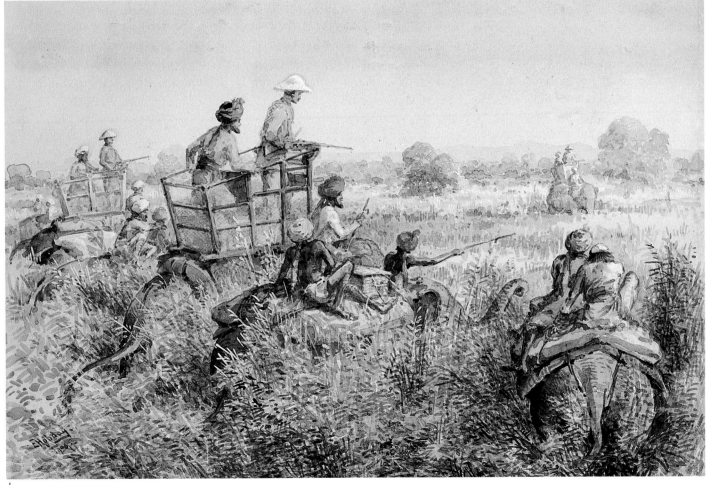

b.

Fig. 24

Fig. 25

Fig. 26

Perhaps nothing has been written about more often in India than tiger hunting, especially tiger hunting conducted from the back of an elephant. It is as customary as the description of the *nautch* or Indian dance entertainment. It was so common that it was even illustrated in Atkinson's *Curry and Rice*.[8] A visit to India without a tiger-hunt was considered almost as incomplete as a visit to Paris without a stop at the Eiffel Tower. As is well known, this led to the almost complete extinction of this animal in South Asia. One of the earlier photographers of *shikar* or hunting in India was Colonel Willoughby Wallace Hooper (1837–1912) from the Madras Light Infantry. His very accomplished photographs of *shikar*-scenes may date from the 1870s. One of his photographs, localized on the mount as "Ootacamund vicinity," illustrates the "Preparing for the tiger hunt," accompanying fig. 25. It may well be compared to Hobday's *Khubber*, fig. 24: The *sahibs* sit at the table in front of the tent, while the native *shikaris* either prepare for the march or report "news" (*kubber*) on the whereabouts of a tiger. Another scene, which is composed so masterly that it must be ascribed to the same photographer, shows the dead tiger on a rock, with the Western hunter a distance away on another rock, accompanied by numerous native *shikaris*, accompanying fig. 26. Another photograph belonging to the same series is labeled *Tiger Hunting–No. 3. Villagers Pointing Out Tiger*.[9] The very first photograph of this series was probably the one which illustrates the report on the whereabouts of a tiger (*Khubber*).[10] The date of Hooper's photographs illustrating various scenes and methods of hunting[11] is not entirely clear and might, according to one author, be much earlier than generally thought.[12] So far, Edmund Arthur Ponsonby Hobday is exclusively known for his depictions of Indian hunting and other outdoor scenes.[13]

NOTES
1. Ellison 1925, pp. 7–8.
2. Ellison 1925, pp. 9–10.
3. Ellison 1925, photograph facing p. 11, top, and text in Walker 1923, pp. 87–88.
4. Cf. Ellison 1925, photographs facing p. 9 and p. 10; Walker 1923, photographs facing p. 86 and p. 88.
5. Cf. Russel 1877, text and illus. pp. 463–492. For a photograph cf. Fabb 1986, no. 79. For a photograph of the Prince of Wales, Russel, and the "first tiger," see Christie's, June 5, 1996, p. 222, lot 359 (= Woodford 1978, p. 145).
6. Russel 1877, p. 482; Christie's, June 5, 1996, p. 52, lot 63.
7. Gabriel/Luard 1914, photographs facing p. 231, p. 232 and p. 233.
8. Atkinson 1859, pl. 26: *Our Tiger Shooting*.
9. Stapp 1994, p. 15, fig. 10.
10. Fabb 1986, illus. 84.
11. Cf. e.g. Okada/Isacco 1991, p. 51 (*Skinning of a Tiger*; Fabb 1986, illus. 86); Desmond 1982, p. 94, pl. 73 (= India Office Library Report 1978, p. 87, pl. 12); Fabb 1986, illus. 83.
12. Cf. Worswick/Embree 1976, p. 99, with an attribution to W. W. Hooper. The same photograph is reproduced in Gutman 1982, p. 98, but with the attribution to an "unnamed Bengali photographer" and the date "December 1853."
13. For two more scenes, reproduced in full color, cf. Allen 1975, p. 85, dated 1907 and Allen 1975, p. 104, also dated 1907.

Artists and Their Works Included in the Catalogue

347

GLOSSARY

Aftabgir or **Aftahadah:** Lit. "sun-seizer," a spade-shaped type of sunshade at the top of a pole; like the *chattri*, an emblem of royalty, carried behind the ruler.

Anderoon: A kind of litter, palanquin.

Andhra Pradesh: A state in Central-East India, the capital of which is Hyderabad.

Anna, plur. **annas:** One-sixteenth of a rupee in the Indian monetary system.

Anunderauze: For "Anandaraja" or "Raja Anand," name of the ruler who took part in the battle near Rajamandri (cat. no. 34).

Aranya: A forest, cf. cat. no. 85.

Arras: A particular kind of tapestry, after the town in northern France, where this textile was mostly produced during the Renaissance.

Baba, plur. **babas:** Here: a kind of holy man.

Bagh: Generally used here to mean garden; in a few cases, it denotes a tiger.

Bahuvrihi compositum: "Bahuvrihi" literally means "much rice," but denotes a particular compositum in Sanskrit which should be understood as "one who has much rice." An "eka bahu" (lit. "one arm") is hence "one, who has one arm."

Bairagi: Lit. "One who is devoid of passion"; a Hindu religious mendicant.

Baisakh: A month of the Indian calendar, corresponding to April-May.

Bakshish: Gift, reward, money.

Bangaldar: A curvilinear roof, or a building with such a roof, from Bengal, its presumed place of origin.

Bara Mahal: Lit. "great palace," a part of the Kotah palace.

Barat: A bridal procession at night.

Bari Chatur Chowk: A particular courtyard in the Udaipur palace.

Bari Chatur Shali: A particular room within the Udaipur palace.

Bari Chitrashala: Lit. "large picture hall," a particular room within the Udaipur palace.

Batta: An extra allowance made to officers, soldiers, and other public servants in India on special grounds. The right to obtain *batta* often created problems, and in 1828, Lord William Cavendish Bentinck, then Governor General of India, reduced the full *batta* to half *batta* within a certain distance from the Presidency of Bengal, which caused an enduring bitterness against him.

Begam or **Begum:** A lady of rank; a princess.

Bheel Agent: The Bhils are tribal members found in Mewar down to the Deccan. The Bheel Agent worked in the territory of the East India Company.

Bhisti or **Bhishti:** A water-bearer who often carries water in a goatskin.

Bhopa caste: Cf. cat. no. 5, the caste to which Ram Dani belongs. The nature of Ram Dani's caste is not explained in this short inscription.

Brahmin: A man of the first order in the Hindu caste system.

Budgerow: A lumbering, keel-less barge mostly used on Gangetic rivers.

Bungalo or **Bungalow:** Lit. "Bengali"; the most common class of home occupied by Europeans in India.

Burj: A tower of a fortress, a fortified tower.

Camera obscura: A device in the shape of a box which allowed the painter to draw a picture with a correct Western perspective.

Caste: The caste is the social status in Hindu society into which its members are born.

Ch'atr or **Chotro:** Lit. "umbrella," but also used to denote a particular kind of pavilion.

Chaitya: Here: A stūpa (q.v.).

Chaityagriha: Lit. a "stūpa house," the Buddhist church or cathedral.

Chandalah: A member of the lowest caste of the Hindu social system.

Chandni Chauk: The "silver street," the principal road in Shah Jahan's Delhi, today Old Delhi.

Charpoy: Lit. four feet; the common Indian bed.

Chatta or **Chattri:** An umbrella as sign of royalty. A cupola resting on pillars, from the word for "umbrella."

Chaube: Member of the Brahmin caste, who is well-versed in the religious texts (the four Vedas). In Rajasthan however, a *chaube* may also denote a member of this caste who no longer follows literary habits to the extent that he might be a wrestler.

Chaukidar: A watchman, a village watchman.

Chauri: A white tail of the yak on a handle, used as a symbol of sovereignty, waved behind the ruler.

Chini ki Chitrashala: Lit. "China(ware) picture gallery," a part of the Udaipur palace.

Chitara: A painter.

Choti Chitra Shali: Lit. "small picture gallery," a part of the Udaipur palace.

Chounree: Same as *chauri*.

Chubootra: A paved, plastered or inlaid platform.

Circars or **Sarkars:** Districts.

Company Style: See essays by J. P. Losty and Toby Falk in this catalogue.

Dagoba: A stūpa (q.v.) in Sri Lanka.

Dak: Actually "post," or "post-office," but also establishment for the conveyance of travellers.

Darbar: Court, royal reception, levée, king.

Dawat: Inkpot.

Deccani: Lit. "southern," from Sanskrit *dakshin*, used here for a style of painting which flourished in an area called the Dekhan (Deccan) from the sixteenth to the nineteenth centuries. The Deccani style is contemporary to the Mughal style of painting.

Devi: Lit. goddess; the consort of Shiva (q.v.).

Diwan: Chief minister; leader of a department.

Do Chasm: Full or frontal view, showing both eyes.

Ek b'al qalm: Very fine painting, as if with a brush of only one hair.

Faquier's choultries: A shed used by religious mendicants (*faquiers*).

Faquir or **Fakeer:** Initially a Muhammedan religious mendicant, in course of time also used to denote Hindu devotees and naked ascetics in general.

G.C.I.E.: Grand Commander of the most eminent order of the Indian Empire; an Anglo-Indian decoration.

G.C.S.I.: Grand Cross of the Star of India, an Anglo-Indian decoration.

Gaddi: The seat of royalty, or throne, mostly consisting of a square carpet and a large cushion or pillow, used as a backrest.

Gaekwar: Title of the ruler of the Baroda state.

Ghat: Steps leading down to a river, a landing place, quay, also a mountain pass.

Gopuram: Pyramidal tower over the entrance gate to a temple in South India.

Goswami: Lit. one who restrains his passions; title of a religious leader.

Guddee: See under *gaddi*.

Half-batta: See under *batta*.

Hammam: Bath.

Haram or **harem:** Same as *zenana* (q.v.).

Hathi: Elephant.

Haveli: Here: the temple Shri Nathji in Nathdwara.

Havildar: A *sepoy* (q.v.) non-commissioned officer, corresponding to a sergeant, and wearing the chevrons of a sergeant.

Hindu: A person of Indian religion and origin.

Hindusthan or **Hindustan:** The country of the Hindus, India in general, and Northern India without Bengal.

Hindusthani: A native of Hindustan; the language of Hindusthan.

Hircarrah or **Hurcarra:** A messenger, a courier.

Holkar: Like the Sindhias, a distinguished *Maratha* (q.v.) family, the rulers of Indore.

Hookah or **Houkha:** Indian water pipe for smoking.

Howdah: A kind of framed seat on an elephant, sometimes artistically covered and resembling a small pavilion.

Id: A Muhammedan holy festival.

Isvi samvat: Anno Domini.

Jagir: An assignment of land, an estate; sometimes hereditary, sometimes not.

Jagirdar: The holder of a jagir.

Janghil: An Indian name for the Painted Stork.

Jats: A numerous race of people in North-West India, "a brave and hardy race" (Wilson) to whom belongs the Raja of Bharatpur.

Jh'ul: Body clothing of an elephant or other domesticated animal.

Jilau Khana: A large courtyard in a palace; grand entry courtyard.

Jotdan: Here: the royal paintings inventory at Udaipur, Rajasthan.

K.C.I.E.: Knight Commander of the Indian Empire, an Anglo-Indian decoration.

K.C.S.I.: Knight Commander of the Star of India, an Anglo-Indian decoration.

Kankarava: Name of the place where the mother of Vallabha was born, in present-day Andhra Pradesh.

Kanphat yogin: A sect of *yogins* recognizable by their large earrings.

Karani (karnya): Like *aftabgir* (q.v.) a kind of sunshade.

Kartik: Here: a month of the Indian calendar, corresponding to October-November.

Katar or **Katarah:** Here: a cupola or arched building.

Kayasth: Here: a member of the caste of writers and accountants.

Keemcab: A kind of gold brocade.

Khansaman: A house-steward, chief table servant.

Khas or **Khass:** Special, particular, royal.

Kheddah or **Keddeh:** A system of hunting and capturing elephants; an enclosure constructed to entrap elephants.

Kinkob: Same as **keemcab** (q.v.).

Kishti: A kind of boat used in Kashmir.

Koran: The holy book of the Muslims.

Krishna: An incarnation of the Hindu god Vishnu.

Kubber: News, here about the whereabouts of a tiger.

Kuttra: A pavilion, related to *chattra* (q.v.).

Lac or **lakh:** 100,000 (rupees).

Lakshmi: Ancient Indian goddess of wealth and luck.

Madrasi: Bright, colored textiles formerly exported from Madras; of silk warf and cotton woof, exported mainly to the West Indies.

Mafamede: Muhammad.

Magh: A month of the Indian calendar, corresponding to January-February.

Mahadeo: Lit. "great god"; an epithet of Shiva (q.v.).

Mahal: A palace, a house.

Maharaja: Lit. "great king"; title of a Hindu ruler, also the title of a religious leader, a term of respect used for Brahmans; sire, majesty.

Maharana: Title of the Rajput kings of Udaipur.

Maharao: Title of certain Rajput kings, here of Kotah and Bundi.

Maharashtra ("large country").

Mahawat or **Mahout:** The driver and tender of an elephant.

Mahratta, or **Maratha:** A famous Hindu race, originally probably from the state Maharashtra ("large country").

Maidan: A large field; a large plain place.

Massoolah boat: The surf boat used on the Eastern coasts of India.

Meghaduta: Lit. "cloud messenger," a famous Sanskrit poem by the poet Kalidasa (ca. 5th century A.D.).

Mela: A festival.

Memsahib: From "Madam Sahib," the common respectful designation of a European married woman in India.

Mimber: A kind of pulpit in a mosque.

Moor: A Muhammedan, a Muhammedan inhabitant of India.

Mor Chowk: Lit. "peacock court," a particular court within the palace of Udaipur.

Morchal: An insignum of royalty, made of peacock feathers.

Moti: Lit. "pearl"; also a proper name.

Mughal: In India the name of a dynasty founded by Zahir ad-Din Muhammad Babur (1494–1530). It lasted officially until 1858. A member of the Mughals.

Mukhiya: Lit. "head"; a head of a department.

Mullah: A learned man, teacher, a doctor of the law.

Munshi: A native teacher of languages; an interpreter; a writer.

Muraqqa: In Mughal painting a magnificent album combining both paintings and calligraphies.

Musavir: A painter.

Mussulman: A Muhammedan, a Muslim.

Nagari: Here: a kind of Indian script in which languages such as Hindi are written to this day.

Najomie: An astrologer.

Nanda: Proper name; name of the foster-father of Krishna.

Nandgaon: Name of the village in which Krishna passed part of his youth.

Naqq'ash: An artist.

Nashtaliq: A ductus of the script in which in India the Urdu language is mainly written.

Nat: Lit. "to dance"; name of a particular mood illustrated in "Nat Ragini."

Nathdwara: A place in Rajasthan, north of Udaipur, in which the *haveli* of Shri Nathji stands.

Nawab or **Nabob:** Originally the designation of a viceroy or chief governor under Mughal rule, later a title of rank. During the Anglo-Indian period, wealthy Britons in India also were styled *Nawab*.

Nazar or **Nuzzer:** A votive offering; a ceremonial present, mostly from an inferior to a superior.

Nishki or **Naskhi:** The "round" ductus of the Islamic script.

Nizam: Hereditary title of the rulers of Hyderabad, after the name of the founder of the dynasty.

Pagoda: An idol temple; also an Indian currency.

Pahari painting: A mixture of painting styles which can be differentiated from Rajasthani or Mughal painting styles. After *pahari*, meaning hills, i.e. the lower Himalayan regions of North India.

Paiga: Royal stable.

Palankin or **Palanquin:** A kind of litter; for further details cf. cat. no. 69.

Palki: Another word for Palankin.

Pandit: A learned man.

Pani: Lit. "water"; for the meaning with regard to cock-fighting cf. cat. no. 35.

Pataila: A particular kind of boat mentioned, but not described, by Fanny Parks.

Pateli: See above.

Pettah: The extramural suburb of a fortress, or the town attached to a fortress, often separately fortified.

Picchvai: An embroidered, printed, or painted curtain hung behind the cult images of the Vallabhacharya Sampradaya.

Pietra dura: Actually, *commesso di pietre dure*, lit. "placing together of hard stone," a highly specialized form of stone intarsia.

Pinnace: A particular kind of boat.

Posh: A month of the Indian calendar, corresponding to December-January.

Pucca: Substantial, permanent, durable.

Puja: A Hindu religious service; idol worship; any kind of rite.

Pujari: A priest who conducts a *puja* (q.v.).

Punka (panka): A large fan.

Pushtimarg: Lit. "way of pleasure," a kind of religion for which cf. cat. no. 7.

Qalamdan: Lit. a "pen-case," a device by which in Islamic-Indian art the tomb of a male can be distinguished from the cenotaph of a female, cf. cat. no. 55.

Qanats: Tent-walls, mostly made of printed cotton.

Ragamala: In Indian painting a sequence of paintings illustrative of *ragas* or moods; colorings of moods.

Raja: Title of a ruler.

Rajasthani: Pertaining or belonging to Rajasthan, now a state in North-West India.

Rajput: A member of Kshatriya caste; a mixture of painting styles which can be distinguished from Mughal, Pahari, or Deccani paintings.

Ramachandra: An incarnation of Vishnu, hero of the epic *Ramayana.*

Ramayana: "Life of Rama," an Indian epic.

Rana Pratap: Famous Sisodiya ruler (1572–1596) of the royal house that founded Udaipur.

Rana: Title of the rulers of Udaipur, Rajasthan.

Rao: Title of certain Rajput rulers, like that of Bundi, Kotah, Sirohi, etc.

Resident: In the nineteenth century, an Englishman who resided at the capital of a native Indian state that had an alliance with the British. He watched over the movements of the local ruler.

Rupee: Indian currency.

Sahib: Respectful title by which European gentlemen are addressed in India.

Salaam: Oral salutation of Muhammedans to each other; a salutation.

Saluki: A sort of Persian greyhound, valued for the chase by people of distinction.

Samadh: A memorial.

Samvat: Year.

Sanad: A grant, patent, a document conveying individual titles.

Sanyasi: A Hindu religious mendicant.

Sarasvati: Goddess of learning.

Sarpech: An ornament tied to the turban.

Sarvai (?) erroneously for **Sawai** (?), in which case it is the title of the rulers of Jaipur in use since the granting of that state to Jai Singh (1688–1743), who founded the capital, Jaipur.

Savari: Cavalry; also, a kind of procession.

Sawbwa: A rank of chieftain in the Shan-states.

Sepoy: In Anglo-Indian use, a native Indian soldier, trained and dressed in European style.

Seraglio: The Western equivalent of *serail* (see below).

Serail: The women's quarters.

Shaikh: A chief; an elder; a Muhammedan saint.

Shaivaite: Belonging or pertaining to the cult of Shiva.

Shikar: A hunt, especially a big game hunt.

Shikari: A sportsman; a native expert who reports on the whereabouts of big game.

Shiva: One of the major Hindu gods, often recognizable by the third eye on the forehead.

Shravana: A month of the Indian calendar, corresponding to July-August.

Shri Nathji: Major cult image of the Vallabhacharya Sampradaya, housed in a temple in Nathdwara.

Shrimad Bhagavata: The tenth book of a text known as *Bhagavata Purana*, in which the childhood of Krishna is narrated.

Sicca rupees: Sicca rupees are newly coined rupees (q.v.) which were used as legal tender in Bengal, Bahar, and Orissa. A *Sicca rupee* contained more silver than the rupee issued by the East India Company. It was abolished in 1836.

Sikh: A member of the sect of that name, established in the sixteenth century.

Simhasana: Lit. "lion seat"; a throne.

Sindhia: A distinguished *maratha* (q.v.) family, the rulers of Gwalior.

Sindura: A red color, vermilion.

Sipahi: Same as *sepoy* (q.v.).

Sirdar: A leader, commander, officer.

Squadanee: A lineal descendant from Muhammad.

Star of India: An Anglo-Indian decoration.

Stūpa: The Buddhist monument in the shape of a solid dome, also called *chaitya.*

Subodhini: Vallabhacharya's commentary on part of the *Shrimad Bhagavat.*

Sultan: Title of an Islamic prince.

Sultanate: Pre-Mughal painting for Islamic patrons.

Surwarree: Same as *savari* (q.v.).

Swadeshi: Lit. "own country," an independence movement.

Taak: A kind of niche in a mosque.

Tailangi: A people and country in South-Eastern Deccan extending to the coast.

Tanjore or **Thanjavur:** A city in South India, in present-day Tamil Nadu.

Tapasya: A kind of penance.

Tazi: Like the Saluki (q.v.), a kind of greyhound used for hunting.

Thakur: A landlord; lord, master.

Tilak: A mark, mostly sectarian, on the forehead.

Tilakayat: Title of a chief priest in the *haveli* of Shri Nathji at Nathdwara.

Togre: A highly ornamental heading naming the title of the Sultan in an Islamic document.

Top khana: Artillery.

Tope: See under *stūpa*.

Torana: The ornamental gate at a *stūpa* (q.v.).

Tripundra: Three horizontal lines on the forehead of a Shaivaite.

Tusbeah khana: An oratory.

Urdhvabahu: An ascetic who holds an arm upright, cf. cat. no. 3.

Vaishnava tilak: Here: a mark on the forehead of worshippers of Vishnu in the shape of a diapason with a central vertical stroke.

Vakeel: An attorney; an authorized representative; a scribe.

Vallabhacharias: Followers of the religion founded by Vallabha.

Varada mudra: Wish-bestowing gesture.

Vazir: A minister, a principal minister.

Vishnu: One of the principal Hindu gods.

Vitthalnathji: The second son of Vallabha, founder of the religious movement, the Vallabhacharya Sampradaya.

Vizier: Same as *vazir* (q.v.).

Voiragee: Same as *bairagi* (q.v.).

Yek chasm: Profile view of the face, showing one eye only.

Yogin: A follower of one of the yoga philosophies, generally imagined in the West as a person who can stay in seemingly awkward positions of the body; more generally a Hindu mendicant.

Yojana: The Indian mile.

Zemindar: An often wealthy landholder.

Zenana: An Indian seraglio.

BIBLIOGRAPHY

Abbott, G.F.: *Through India with the Prince.* London: Edward Arnold, 1906.

Abu Talib: *History of Asafu'd Daulah, Nawab Wazir of Oudh. Being a Translation of "Tafzihu'l Ghafilin", A Contemporary Record of Events connected with his Administrations, Compiled by Abu Talib (An official of the day) and Translated from the original Persian by W. Hoey.* Lucknow: Pustak Kendra, 1971 [first published: Allahabad: North-Western Provinces and Oudh Government Press, 1885].

Adams, Archibald: *The Western Rajputana States. A Medico-Topographical and General Account of Marwar, Sirohi, Jaisalmir. Second edition.* London: Junior Army & Navy Stores, Limited, 1900.

Ahmed, Khalid Anis (ed.): *Intercultural Encounter in Mughal Miniatures (Mughal - Christian Miniatures).* Lahore: National College of Arts, 1995.

Ahmed, Nazimuddin: *An Album of Archaeological Relics in Bangladesh.* Dhaka: Published by the Director, Directorate of Archaeology & Museums, Govt. of the People's Republic of Bangladesh, 1984.

Ahsan, Syed Ali: Islamic Architecture: 5. Mughal Style. In: *Marg,* Volume XXVII, Number 2, March 1974, pp. 25–30.

Aijazuddin, F. S.: *Pahari Paintings and Sikh Portraits in the Lahore Museum.* London and New York: Sotheby Parke Bernet / Karachi and Delhi: Oxford University Press, 1977.

Aijazuddin, F. S.: *Lahore. Illustrated Views of the 19th Century.* Ahmedabad: Mapin Publishing Pvt. Ltd., 1991.

Akimushkin, Oleg F.: *The St. Petersburg Muraqqa'. Album of Indian and Persian Miniatures of the 16th–18th Centuries and Specimens of Persian Calligraphy of 'Imad al-Hasani.* Lugano: ARCH Foundation / Electa, 1994 (The St. Petersburg Branch of the Institute of Oriental Studies, Russian Academy of Sciences).

Alexander, Michael: *Delhi & Agra. A Traveller's Companion, Selected and Introduced.* London: Constable and Company, 1987.

Alexander, Michael / Anand, Sushila: *Queen Victoria's Maharajah Duleep Singh 1838–93.* London: Weidenfeld and Nicolson, 1980.

Ali, Salim: Dodo. In: Alvi, M.A. / Rahman, A: *Jahangir - the Naturalist.* New Delhi: National Institute of Sciences of India, 1968, pp. 15–17.

Ali, Salim / Ripley, S. Dillon: *Handbook of the Birds of India and Pakistan together with those of Bangladesh, Nepal, Bhutan and Sri Lanka. Compact Edition.* Delhi / Oxford / New York: Oxford University Press, 1983.

'Ali Khan, Khan Sahib M.: *Memoirs of Gaur and Pandua. Edited and revised by H.E. Stapleton.* Calcutta: Bengal Secretariat Book Depot, 1931.

Allen, Charles (editor): *Plain Tales from the Raj.* London: Century Publishing Co. Ltd. in association with André Deutsch Ltd. and the British Broadcasting Corporation, 1975.

Allen, Charles / Dwivedi, Sharada: *Lives of the Indian Princes.* London: Century Publishing in association with the Taj Hotel Group, 1984.

Ambalal, Amit: *Krishna as Shrinathji. Rajasthani Paintings from Nathdvara.* Ahmedabad: Mapin Publishing Pvt. Ltd., 1987.

Anand, Mulk Raj / Goetz, Hermann: *Indische Miniaturen.* Dresden: VEB Verlag der Kunst, 1967.

Annual Exhibition of Watercolours and Drawings. Wednesday 19 April to Friday 19 May 1995. London: Spink, 1995.

Annual Progress Report of the Archaeological Surveyor, Northern Circle, For the Year ending 31st March 1908. N.p.n.d.

Annual Progress Report of the Archaeological Surveyor, Northern Circle, For the Year ending 31st March 1909. N.p.n.d.

Annual Progress Report of the Superintendent, Muhammadan and British Monuments, Northern Circle, For the Year ending 31st March 1912. Allahabad: Printed by F. Luker, Supdt., Government Press, United Provinces, 1912.

Annual Progress Report of the Superintendent, Muhammadan and British Monuments, Northern Circle, For the Year ending 31st March 1914. Allahabad: Printed by W.C. Abel, Offg. Supdt., Government Press, United Provinces, 1914.

Archéologie. Arts d'Orient. Vente aux enchères publiques le vendredi 2 juillet 1993. Paris: François de Ricqlès, Drouot-Richelieu, 1993.

Archer, Major: *Tours in Upper India, and in Parts of the Himalaya Mountains; With Accounts of the Courts of the Native Princes, &c.* 2 Vols. London: Richard Bentley, 1833.

Archer, Mildred: *Patna Painting.* London: The Royal India Society, 1947.

Archer, Mildred: *Tippoo's Tiger*. London: Her Majesty's Stationery Office, 1959.

Archer, Mildred: *The Daniells in India*. Washington, D.C.: Smithsonian Institution, 1962.

Archer, Mildred: *Indian architecture and the British 1780–1830*. London: Country Life Books, 1968 (The R[oyal] I[nstitute of] B[ritish] A[rchitects] drawings series).

Archer, Mildred: *British Drawings in the India Office Library. Volume II: Official and Professional Artists*. London: Her Majesty's Stationery Office, 1969.

Archer, Mildred: Banaras and the British. In: *Chhavi Golden Jubilee Volume. Bharat Kala Bhavan 1920–1970*. Edited by Anand Krishna. Banaras: Bharat Kala Bhavan, 1971, pp. 70–74.

Archer, Mildred: *Company Drawings in the India Office Library*. London: Her Majesty's Stationery Office, 1972.

Archer, Mildred: *Artist Adventurers in Eighteenth Century India: Thomas and William Daniell*. London: Spink & Son Ltd., 1974

Archer, Mildred: *India and British Portraiture 1770–1825*. London and New York: Sotheby Parke Bernet / Karachi and Delhi: Oxford University Press, 1979.

Archer, Mildred: *Early Views of India. The picturesque Journeys of Thomas and William Daniell 1786–1794. The Complete Aquatints*. London: Thames and Hudson, 1980.

Archer, Mildred: *Between Battles. The Album of Colonel James Skinner*. London: Al-Falak and Scorpion Communications and Publications Ltd., 1982.

Archer, Mildred: *The Tranquil Eye. The Watercolours of Colonel Robert Smith. A Journey Down the Ganges, 1830*. London: Al-Falak and Scorpion Communications and Publications Ltd., 1982a.

Archer, Mildred: *The Marquis Wellesley Collection. Indian Artists under British Patronage*. London: ALFALAK and Scorpion Communications and Publications Ltd, 1983.

Archer, Mildred: *The India Office Collection of Paintings and Sculpture*. London: The British Library, 1986.

Archer, Mildred: Artists and Patrons in 'Residency' Delhi, 1803–1858. In: *Delhi Through the Ages. Essays in Urban History, Culture and Society*. Edited by R.E. Frykenberg. Delhi [etc.]: Oxford University Press, 1986a, pp. 270–277.

Archer, Mildred: The peoples of India. In: *India. A Pageant of Prints*. Edited by Pauline Rohatgi and Pheroza Godrej. Bombay: Marg Publications, 1989, pp. 1–20.

Archer, Mildred: Early Contributions to Indian Archaeology by British Amateur Artists. In: *Makaranda. Essays in honour of Dr. James C. Harle*. Edited by Claudine Bautze-Picron. Delhi: Sri Satguru Publications, 1990, pp. 239–243 (Sri Garib Dass Oriental Series No.105).

Archer, Mildred: *Company Paintings. Indian Paintings of the British Period*. London: Victoria and Albert Museum / Ahmedabad: Mapin Publishing Pvt. Ltd., 1992 (Victoria and Albert Museum. Indian Art Series).

Archer, Mildred / Archer, W[illiam] G[eorge]: *Indian Painting for the British 1770–1880*. Oxford: Oxford University Press, 1955.

Archer, Mildred / Falk, Toby: *India Revealed. The Art and Adventures of James and William Fraser 1801–35*. London / New York / Sidney: Cassell, 1989.

Archer, Mildred / Lightbown, Ronald: *India Observed. India as viewed by British Artists 1760–1860*. London: Victoria and Albert Museum, 1982.

Archer, Mildred / Rowell, Christopher / Skelton, Robert: *Treasures from India. The Clive Collection at Powis Castle*. London: The Herbert Press in association with The National Trust, 1987.

Archer, Mildred / Theroux, Paul: *Visions of India. The Sketchbooks of William Simpson 1859–62*. Oxford: Phaidon Press Limited, 1986.

Archer, W[illiam] G[eorge]: *Indian Miniatures*. London: Studio Books, 1960.

Archer, W[illiam] G[eorge]: *Paintings of the Sikhs*. London: Her Majesty's Stationery Office, 1966.

Archer, W[illiam] G[eorge]: Banaras and British Art. In: *Chhavi Golden Jubilee Volume. Bharat Kala Bhavan 1920–1970*. Edited by Anand Krishna. Banaras: Bharat Kala Bhavan, 1971, pp. 43–47.

Art d'Orient. Étude Daussy-Ricqlès. Vente aux enchères publiques. Paris: Hôtel Drouot, 13 décembre 1991.

Art Islamique. Vingt-deux Miniatures des Collections Louis Gonse. Objets d'Art, Textiles. Étude Daussy-Ricqlès. Vente aux enchères publiques. Paris: Drouot-Richelieu, 16 Décembre 1988.

Art Islamique. Meubles Syriens, Céramiques de Turquie, d'Iran et d'Inde, Boiseries, Mosaiques - Tableaux - Tapis. Vente aux enchères publiques. Paris: Drouot Richelieu, 24 Janvier 1996.

Arts d'Orient: Archéologie. Arts d'Orient. Francois de Ricqlès. Vente aux enchères publiques. Paris: Drouot-Richelieu, 2 juillet 1993.

Asad, Majda: *Indian Muslim Festivals and Customs*. New Delhi: Publications Division. Ministry of Information and Broadcasting, Government of India, 1988.

Asher, Catherine B.: *Architecture of Mughal India*. Cambridge: Cambridge University Press, 1992 (The New Cambridge History of India, I:4).

Atkinson, Geo[rge] F[rancklin]: *Curry & Rice (On Forty Plates) or The Ingredients of Social Life at "Our Station" in India*. London: John B. Day, Lithographer, Printer & Publisher, (1859).

Bacon, Thomas: *First Impressions and Studies from Nature in Hindostan; embracing an Outline of the Voyage to Calcutta, and Five Years' Residence in Bengal and the Do'ab, from MDCCCXXXI to MDCCCXXXVI*. 2 Vols. London: Wm.H. Allen and Co., 1837.

Balwant Rao Bhayasahab: *History of the Fortress of Gwalior*. Gwalior State: Printed under the Supervision of Pundit Oomachuran, Superintendent at Aleejab's Durbar Press, n.d. [ca.1892].

Banerjea, Jitendra Nath: *The Development of Hindu Iconography*. Calcutta: University of Calcutta, 1956.

Banerji, Brajendranath: *Begam Samru*. Calcutta: M.C. Sarkar & Sons, 1925.

Baqir, Muhammad: *Lahore Past and Present. (Being an account of Lahore compiled from original sources)*. Lahore: Panjab University Press, 1952 (Panjab University Oriental Publication No.34).

Barthorp, Michael: *The British Troops in the Indian Mutiny 1857–59*. London: Osprey Publishing Ltd., 1994 (Men-at-Arms Series 268).

Batra, H.C.: *The Relations of Jaipur State with East India Company (1803–1858)*. Delhi / Jullundur / Lucknow: S. Chand & Co., 1958.

Bautze, Joachim Karl: *Indian Miniature Paintings c.1590–c.1850*. Amsterdam: galerie Saundarya Lahari, 1987.

Bautze, Joachim Karl: *Drei "Bundi"-Ragamalas. Ein Beitrag zur Geschichte der rajputischen Wandmalerei*. Stuttgart: Franz Steiner Verlag Wiesbaden, 1987a (Monographien zur indischen Archäologie, Kunst und Philologie).

Bautze, Joachim Karl: Maharana Sangram Singh of Udaipur entertaining members of the Dutch East India Company led by Johan Josua Ketelaar. In: *Bulletin van het Rijksmuseum*, Jaargang 36, 1988, nummer 2, pp. 117–132.

Bautze, Joachim Karl: Zwei Entwurfsskizzen aus Kota im Linden-Museum. In: *Tribus, Jahrbuch des Linden-Museums Stuttgart*, Vol.37, 1988, pp. 83–117.

Bautze, Joachim Karl: Portraitmalerei unter Maharao Ram Singh von Kota. In: *Artibus Asiae*, Vol.XLIX, 3/4, 1988 / 1989, pp. 316–350.

Bautze, Joachim Karl: Did painters in Rajasthan follow a "shastric" tradition? A case study. In: *Shastric Traditions in Indian Arts*, ed. by Anna Libera Dallapiccola in collaboration with Christine Walter-Mendy [and] Stephanie Zingel-Avé Lallemant. 2 Vols. Stuttgart: Steiner Verlag Wiesbaden GmbH, 1989, Vol.I: pp. 27–33, Vol.II: Plates I–III (Beiträge zur Südasienforschung, Volume 125).

Bautze, Joachim Karl: The Ajmer Darbar of 1832 and Kota Painting. In: *South Asian Studies* Volume 6, 1990a, pp. 71–91.

Bautze, Joachim Karl: Painting at Khatoli - The Later Phase. In: *Makaranda. Essays in honour of Dr. James C. Harle*. Edited by Claudine Bautze-Picron. Delhi: Sri Satguru Publications, 1990b, pp. 227–233 (Sri Garib Dass Oriental Series No.105).

Bautze, Joachim Karl: German private collections of Indo-Islamic paintings. In: *Oriental Splendour. Islamic Art from German Private Collections*. Edited by Claus-Peter Haase, Jens Kröger and Ursula Lienert. Hamburg: Museum für Kunst und Gewerbe, 1993, pp. 247–283, 289–294.

Bautze, Joachim Karl: Die Welt der höfischen Malerei. Katalog der Malereien. In: *Rajasthan, Land der Könige*. Edited by Gerd Kreisel. Stuttgart: Linden -Museum Stuttgart / Gotha: Kunstverlag Gotha, 1995a, pp. 123–180, pp. 287–292, pp. 295–306.

Bautze, Joachim Karl: *Early Indian Terracottas*. Leiden / New York / Brill, 1995b (Iconography of Religions. Section XIII: Indian Religions. Fascicle Seventeen).

Bautze, Joachim Karl: A Second Set of Equestrian Portraits painted during the reign of Maharao Umed Singh of Kota. In: *Indian Painting. Essays in honour of Karl J[ahangir] Khandalavala*. Edited by B.N. Goswamy in association with Usha Bhatia. New Delhi: Lalit Kala Akademi, 1995c, pp. 35–51.

Bayly, C.A., et alii: *The Raj. India and the British 1600–1947*. London: National Portrait Gallery Publications, 1990.

Beach, Milo Cleveland: The Gulshan Album and Its European Sources. In: *Bulletin* [of the] *Museum of Fine Arts, Boston*, Volume LXIII, Number 332, 1965, pp. 62–90.

Beach, Milo Cleveland: *The Grand Mogul. Imperial Painting in India 1600–1660*. Williamstown, Massachusetts: Sterling and Francine Clark Art Institute, 1978.

Beach, Milo Cleveland: *The Imperial Image. Paintings for the Mughal Court*. Washington, D.C.: Freer Gallery of Art / Smithsonian Institution, 1981.

Beach, Milo Cleveland: Colonel Hanna's Indian Paintings. In: *APOLLO*, Vol.CXVIII, No.258, August 1983, pp. 154–159.

Beach, Milo Cleveland: Persian Culture and Mughal India. In: Soudavar, Abolala: *Art of the Persian Courts. Selections from the Art and History Trust Collection*. New York: Rizzoli International, 1992, pp. 302–363.

Beale, Thomas William: *An Oriental Biographical Dictionary, Founded on Materials collected by the late Thomas William Beale, a New Edition Revised and Enlarged by Henry George Keene*. London: W.H. Allen & Co., Limited, 1894.

Bearce, George D. / Welch, Stuart Cary: *Painting in British India 1757–1857*. Brunswick, Maine: Bowdoin College Museum of Art, 1963.

Begley, Wayne E.: The Symbolic Role of Calligraphy on Three Imperial Mosques of Shah Jahan. In: *Kaladarśana. American Studies in the Art of India*. Edited by Joanna G. Williams. New Delhi / Bombay / Calcutta: Oxford & I[ndian] B[ook] H[ouse] Publishing Co., 1981, pp. 7–18.

Begley, Wayne E. / Desai, Z.A.: *Taj Mahal. The Illumined Tomb. An Anthology of Seventeenth-Century Mughal and European Documentary Sources. Compiled and Translated*. Cambridge, Massachusetts: The Aga Khan Program for Islamic Architecture / Seattle and London: The University of Washington Press, 1989.

Benesch, Otto: *The Drawings of Rembrandt. Complete Edition in Six Volumes. Enlarged and edited by Eva Benesch*. Vol.V. London: Phaidon Press Limited, 1973.

Benn, R.A.E.: *Notes on Jaipur. Second Edition*. Jaipur [Printed by the Jaipur Central Jail], 1916.

Beny, Roloff / Matheson, Sylvia A.: *Rajasthan. Land of Kings*. London: Frederick Muller Limited, 1984.

Bernier, François: *Travels in the Mogul Empire A.D. 1656–1668. Translated, ... and annotated by Archibald Constable (1891). second edition revised by Vincent A. Smith*. Oxford [etc.]: Oxford University Press / Humphrey Milford, 1916.

Bernier, François: *Voyage dans les États du Grand Mogol. Introduction de France Bhattacharya*. Paris: Arthème Fayard, 1981 (La Bibliothèque des Voyageurs).

Biggs, T. / Hope, Theodore C. / Fergusson, James: *Architecture of Ahmedabad, The Capital of Goozerat. Photographed by Colonel Biggs, R.A. With an Historical and Descriptive Sketch by Theodore C. Hope, and Architectural Notes by James Fergusson. Published for the Committee of Architectural Antiquities of Western India under the Patronage of Premchund Raichund*. 2 Vols. London: John Murray, 1866.

Bignold, Robert: *The Taj-Mahal and other Historical Monuments erected during the Mogul Dynasty*. Norwich [privately published], 1950.

Binney, Edwin: *Indian Miniature Painting. From the Collection of Edwin Binney, 3rd. 1 The Mughal and Deccani Schools with some related Sultanate material*. Portland, Oregon: Portland Art Museum, 1973.

Binyon, Laurence / Arnold, T.W.: *The Court Painters of the Grand Moguls*. London [etc.]: Humphrey Milford / Oxford University Press, 1921.

Birdwood, George C[hristopher] M[olesworth]: *The Industrial Arts of India*. London: Chapman and Hall Limited, 1880.

Bonetti, Maria Francesca, et alii: *Federico Peliti (1844–1914) An italian [sic] photographer in India at the time of Queen Victoria*. Roma: Peliti Associati / Manchester: Cornerhouse Publications, 1994.

Bongard, Oscar: *Die Reise des Deutschen Kronprinzen durch Ceylon und Indien*. Berlin: Verlag C.U. Schwetschke und Sohn, [1911].

Bonhams Knightsbridge [sale catalogue of] *Oriental European Rugs & Carpets and Islamic Works of Art*. London, 23rd and 24th April 1996.

Bourne, Samuel / Shepherd, Charles: *Photographic Views in India, by Bourne & Shepherd*, Calcutta and Simla. [Reprint:] London: Howard Ricketts Limited, n.d. [reportedly first published in 1866].

Bowring, Lewin B.: *Haidar Ali and Tipu Sultan and the Struggle with the Musalman Powers of the South*. Oxford: At the Clarendon Press, 1893 (Rulers of India).

Boyé, Jérôme (ed. and comp.): *"L'Extraordinaire Aventure de Benoît de Boigne aux Indes"*. Chambéry: Musée Savoisien / Paris: Mona Bismarck Foundation, 1996.

Brentjes, Burchard: *Chane. Sultane. Emire. Der Islam vom Zusammenbruch des Timuridenreiches bis zur europäischen Okkupation*. Leipzig: Koehler & Amelang, 1974.

Bressan, L.: Mughal-Christian Miniatures. In: *Intercultural Encounter in Mughal Miniatures (Mughal -Christian Miniatures)*. Edited by Khalid Anis Ahmed. Lahore: National College of Arts, 1995, pp. 37–78.

Brief Historical Memoir: *A Brief Historical Memoir of Delhi and Guide to Points of Interest together with the Official Programme in Detail of the Imperial Coronation Durbar of 1911. With Sketch Maps, Plans, and Illustrations. Specially Compiled for the Guests of the Government of India*. Calcutta: Printed at the Office of the Superintendent, Government Printing, Bengal, (1911).

Briggs, George Weston: *Gorakhnath and the Kanphata Yogis*. [Reprint:] Delhi / Varanasi / Patna: Motilal Banarsidass, 1973 [first published Calcutta, 1938].

Brookes, J[ohn] C[heape]: *History of Meywar*. Calcutta: Printed by C.B. Lewis, Baptist Mission Press, 1859.

Brooke[s], J[ohn] C[heape]: *Political History of the State of Jeypore*. Calcutta: Office of the Superintendent of Government Printing, 1868 (Selections from the Records of the Government of India, Foreign Department. No.LXV).

Bruhn, Thomas P.: *A Journey to Hindoostan. Graphic Art of British India 1780–1860. Prints from the Max Allen & Peter Allen Collection*. Stoors, CT: The William Benton Museum of Art, 1987.

Brunel, Francis: *Delhi*. Boulogne: Editions Delroisse, n.d.

Buchanan, Francis: *Journal of Francis Buchanan kept during the Survey of the District of Shahabad in 1812–1813. Edited with Notes and Introduction by C.E.A. Oldham*. Patna: Superintendent, Govt. Printing, Bihar and Orissa, 1926.

Buchanan, Francis: *An Account of the Districts of Bihar and Patna in 1811–1812. Printed from the Buchanan Mss. in the India Office Library, with Permission of the Secretary of State for India in Council*. 2 Vols. Patna: Published by the Bihar and Orissa Research Society, (1936).

Buck, Edward J.: *Simla Past and Present. Second Edition*. Bombay: The Times Press, 1925.

Buddle, Anne: The Tipu Mania: Narrative Sketches of the Conquest of Mysore. In: *India. A Pageant of Prints*. Edited by Pauline Rohatgi and Pheroza Godrej. Bombay. Marg Publications, 1989, pp. 53–70.

Buddle, Anne: *Tigers round the Throne. The Court of Tipu Sultan (1750–1799)*. London: Zamana Gallery Ltd., 1990.

Butler, William: *The Land of the Veda: Being Personal Reminiscences of India; Its People, Castes, Thugs and Fakirs; Its Religions, Mythology, Principal Monuments, Palaces and Mausoleums; together with the Incidents of the Great Rebellion, and its results to Christianity and Civilization*. New York: Carlton & Lanahan / San Francisco: E. Thomas / Cincinnati: Hitchcock & Walden, 1872.

Carey, W.H.: *The Good Old Days of Honorable John Company, being Reminiscences illustrating Manners and Customs of the British in India during the Rule of the East India Company from 1600 to 1858. With brief Notices of Places and People of those Times &c., &c., &c. Compiled from newspapers and other publications*. 2 Vols. Calcutta: R. Cambray & Co., 1906, 1907.

Chaghatai, Abdullah M.: *The Wazir Khan Mosque, Lahore*. Lahore: Kitab Khana-i- Nauras, 1975.

Chakrabarti, Jadab Chandra: *The Native States of India*. Calcutta: S.K. Shaw, 1895.

Chakravarty, Kalyan Kumar: *Gwalior Fort. Art, Culture and History*. New Delhi: Arnold Heinemann, 1984.

Chakraverty, Anjan: *La Miniature Indienne*. Paris: Celiv / New Delhi: Lustre Press, 1996.

Chandra, Rai Govind: *Abanindranath Tagore*. Calcutta: Thacker, Spink & Co. (1933) Ltd., 1951.

Chatterjee's Picture Albums. Number 5. Calcutta: Modern Review Office, n.d.

Chaube Raghunath Das: *Report on the Administration of the Kotah State, for the Sambat Year 1964, (1st October 1907 to 30th September 1908)*. Ajmer: Scottish Mission Industries Co. Ltd., 1908.

Chiefs and Leading Families in Rajputana. Calcutta: Office of the Superintendent of Government Printing, 1894.

Chiefs and Leading Families in Rajputana.Second Edition. Calcutta: Office of the Superintendent of Government Printing, 1903.

Christie's [Catalogue of] Important Western and Oriental Manuscripts, Drawings and Autograph Letters and some Printed Books. London, June 19, 1968.

Christie's [Catalogue of] Fine Indian, Tibetan and Nepalese Works of Art. London, December 9, 1974.

Christie's [Catalogue of] Fine Islamic and Indian Miniatures, Manuscripts and Maps. London, July 7, 1976.

Christie's [Catalogue of] Islamic and Indian Manuscripts and Miniatures and European Paintings, Prints and Maps of Islamic Interest. London, November 17, 1976.

Christie's [Catalogue of] Fine Islamic and Indian Manuscripts and Miniatures. London, May 5, 1977.

Christie's [Catalogue of] Fine Indian Miniatures and Islamic Manuscripts. London, July 7, 1977.

Christie's [Catalogue of] Important Islamic Manuscripts and Indian Miniatures. London, November 9, 1977.

Christie's [Catalogue of] Important Indian Miniatures and Paintings. New York, May 25, 1978.

Christie's [Catalogue of] Important Indian Miniatures. London, July 6, 1978.

Christie's [Catalogue of] Important Islamic and Indian Manuscripts including property formerly in the collection of George P. Bickford. London, April 19, 1979.

Christie's [Catalogue of] Indian Miniatures. London, July 12, 1979.

Christie's [Catalogue of] Important Islamic and Indian Manuscripts and Miniatures. London, 16 October 1980.

Christie's [Catalogue of] Important Islamic and Indian Manuscripts and Miniatures. London, 23 April, 1981.

Christie's [Catalogue of] *Important Islamic and Indian Manuscripts and Miniatures*. London, 13 October 1982.

Christie's [Catalogue of] *Islamic, Indian, South-East Asian Manuscripts, Miniatures and Works of Art*. London, 13 June and 14 June 1983.

Christie's [Catalogue of] *Islamic, Indian, South-East Asian Manuscripts, Miniatures and Works of Art*. London, 11 June and 12 June 1984.

Christie's [Catalogue of] *Islamic, Indian, South-East Asian Manuscripts, Miniatures and Works of Art*. London, 22 November and 23 November, 1984.

Christie's [Catalogue of] *Islamic, Indian, South-East Asian Manuscripts, Miniatures and Works of Art*. London, 4 July 1985.

Christie's [Catalogue of] *Indian and Islamic Miniatures, Manuscripts and Works of Art, Oriental and Islamic Costume and Textiles*. London, South Kensington, July 23, 1985.

Christie's [Catalogue of] *Islamic, Indian, South-East Asian Manuscripts, Miniatures and Works of Art*. London, 25 November 1985.

Christie's [Catalogue of] *Islamic, Indian, South-East Asian Manuscripts, Miniatures and Works of Art*. London, 11 June 1986.

Christie's [Catalogue of] *Islamic, Indian, South-East Asian Manuscripts, Miniatures and Works of Art*. London, 16 June 1987.

Christie's [Catalogue of] *Islamic, Indian, and South-East Asian Manuscripts, Miniatures and Works of Art*. London, 24 November 1987.

Christie's [Catalogue of] *Oriental Ceramics, Works of Art, Indian Miniatures and Manuscripts*. London, South Kensington, October 20, 1988.

Christie's [Catalogue of] *Indian and Islamic Paaintings, Manuscripts and Works of Art, Oriental and Islamic Costume and Textiles*. London, South Kensington, September 23, 1986.

Christie's [Catalogue of] *Oriental Ceramics and Works of Art*. London, South Kensington, February 9, 1989.

Christie's [Catalogue of] *Indian, Himalayan and South-East Asian Miniatures and Works of Art*. London, 10 October 1989.

Christie's [Catalogue of] *Important Islamic, Indian, Himalayan and South-East Asian Art*. London, 24 April 1990.

Christie's [Catalogue of] *Indian, Himalayan and Southeast Asian Art*. New York, October 3, 1990.

Christie's [Catalogue of] *Oriental Ceramics and Works of Art*. London, South Kensington, 2 February 1995.

Christie's [Catalogue of] *Oriental Ceramics and Works of Art*. London, South Kensington, 27 April 1995.

Christie's [Catalogue of] *Visions of India including the Paul F. Walter Collection*. London, 25 May 1995.

Christie's [Catalogue of] *Visions of India including the Paul F. Walter Collection of Indian Photographs*. London, 5 June 1996.

Christie's [Catalogue of] *India Observed. The P&O Collection of Watercolours of India by Thomas Daniell, R.A. and William Daniell, R.A.* London, September 24th, 1996.

Christie's [Catalogue of] *Islamic Art and Indian Miniatures and Rugs and Carpets*. London, October 15th and 17th, 1996.

Chughtai, M[uhammad] A[bdur] Rahman / Chughtai, Arif Rahman: *Gaur Suhai*. Lahore, Pakistan: Jahangir Book Club, 1994.

Cimino, R[osa] M[aria] / Scialpi, F[abio]: *India and Italy. Exhibition organized in collaboration with the Archaeological Survey of India and the Indian Council for Cultural Relations*. Rome: Istituto Italiano Per Il Medio Ed Estremo Oriente, 1974.

Cimino, Rosa Maria: Life at Court in Rajasthan. Indian Miniatures from the Seventeenth to the Nineteenth Century. Firenze: Mario Luca Giusti, 1985 (Centro Piemontese di Studi sul Medio es Estremo Oriente).

Clunes, John: *An Historical Sketch of the Princes of India, Stipendiary, Subsidiary, Protected, Tributary, and Feudatory. With a Sketch of the Origin and Progress of British Power in India. By an Officer in the Service of the Honourable East India Company*. London: Smith, Elder & Co., 1833.

Cole, H.H.: *Catalogue of the Objects of Indian Art exhibited in the South Kensington Museum*. London: Chapman & Hall, 1874.

Colebrook[e], Robert H[enry]: *Twelve Views of Places in the Kingdom of Mysore, the Country of Tippoo Sultan*. London: Thomson, 1793–94.

Colnaghi Oriental. Recent Acquisitions. Autumn. London: Michael Goedhuis Ltd., 1983.

Compton, Herbert: *A Particular Account of the European Military Adventurers of Hindustan from 1784 to 1803*. London: T. Fisher Unwin, 1893.

Conner, Patrick: *George Chinnery 1774–1852. Artist of India and the China Coast*. Woodbridge, Suffolk: Antique Collectors' Club Ltd., 1993.

Conner, Patrick: The Poet's Eye. The Intimate Landscape of George Chinnery. In: *Under the Indian Sun. British Landscape Artists*. Edited by Pauline Rohatgi and Pheroza Godrej. Bombay: Marg Publications, 1995, pp. 67–80.

Coomaraswamy, Ananda K[entish]: The Modern School of Indian Painting. In: *The Journal of Indian Art and Industry*, Vol.XV, No.120, October, 1912, pp. 67–69.

Coomaraswamy, Ananda: *Rajput Painting. Being an Account of the Hindu Paintings of Rajasthan and the Panjab Himalayas from the Sixteenth to the Nineteenth Century Described in Their Relation to Contemporary Thought with Texts and Translations*. 2 Vols. [Reprint:] Delhi / Varanasi / Patna: Motilal Banarsidass, 1976 [First edition: London, 1916].

Cooper, Frederick: *The Handbook for Delhi. With Large Additional Matter, Illustrative Notes, Descriptions and Extracts from Scientific Travellers, Archaeologists and other Authors, on the Historic remains and Points of Modern Interest in Delhi... .* Delhi: Printed by R. Williams, At The Delhi Press, 1863.

Corfield, Wilmot: *Calcutta Faces and Places in Pre-Camera Days*. Calcutta: Thacker, Spink & Co., 1910.

Cotton, Evan: *The Sardhana Pictures*. Allahabad: Printed by the Superintendent, Printing and Stationery, United Provinces, Allahabad, 1934.

Cotton, Evan: Robert Home. In: *Bengal Past & Present*. Vol.XXXV, Part I, Serial No.69, January–March 1928, pp. 1–24.

Cousens, Henry: *Bijapur and its Architectural Remains with an Historical Outline of the 'Adil Shahi Dynasty*. Bombay: Printed at the Government Central Press, 1916 (Archaeological Survey of India, Imperial Series, Volume XXXVII).

Craufurd, Quentin: *Sketches Chiefly relating to the History, religion, Learning, and Manners of the Hindoos. With a concise Account of the Present State of the Native powers of Hindostan. The Second edition, Enlarged*. 2 Vols. London: Printed for T. Cadell, 1792.

Crewe, Quentin: *The Last Maharaja. A Biography of Sawai Man Singh II Maharaja of Jaipur*. Calcutta [etc.]: Rupa & Co., 1985.

Crooke, William: *Things Indian. Being Discursive Notes on Various Subjects Connected with India.* London: John Murray, 1906.

Crowe, Sylvia, et alii: *The Gardens of Mughul India. A history and guide.* London: Thames and Hudson, 1972.

Cundall, Frank (ed.): *Reminiscences of the Colonial and Indian Exhibition.* London: Published with the Sanction of the Royal Commission by William Clowes & Sons, Limited, 1886.

Cunningham, Alexander: *Report on a Tour in Bihar and Bengal in 1879–80 from Patna to Sunargaon.* [Reprint:] Delhi / Varanasi: Indological Book House, 1969 (Archaeological Survey of India. Volume XV).

Curzon, George Nathaniel, Marquess Curzon of Kedleston: *A Viceroy's India. Leaves from Lord Curzon's Note-book.* Edited by Peter King. London: Sidgwick & Jackson, 1984.

Daljeet: *Miniatures mogholes / Mogolminiaturen.* Brussels: Musées royaux d'Art et d'Histoire, 1994.

Dalrymple, William (introd.): *A Journey through India. Company School Pictures. Wednesday 9th October to Friday 1st November 1996.* London: Spink & Son Ltd., 1996.

Das, Asok Kumar: *Mughal Painting during Jahangir's Time.* Calcutta: The Asiatic Society, 1978.

Das, Asok Kumar: Painting. In: *Arts and Crafts of Rajasthan.* edited by Aman Nath and Francis Wacziarg. London: Thames and Hudson / New York: Mapin International, 1987, pp. 158–169.

Das, Asok Kumar: Maharaja Sawai Ram Singh II. The photographer prince. In: *the India magazine of her people and culture,* volume eight, October 1988, pp. 22–32.

Das, Asok Kumar / Sahai, Yaduendra: *The Photographer Prince Maharaja Sawai Ram Singh II. April 4 – April 30, 1985.* Jaipur: Maharaja Sawai Man Singh II Museum, City Palace Jaipur, 1985.

Davenport, Hugh: *The Trials and Triumphs of the Mewar Kingdom (Udaipur).* Udaipur: Maharana of Mewar Charitable Foundation, 1975.

David, Marie Christine / Soustiel, Jean: *Miniatures orientales de l'Inde 3. Exposition … du 19 Mai au 23 Juillet 1983.* Paris: Jean Soustiel, 1983.

David, Marie Christine / Soustiel, Jean: *Miniatures orientales de l'Inde 4. Exposition 28 fevri'er–9 Avril 1986 …* Paris: Jean Soustiel, 1986.

Davies, Philip: *The Penguin Guide to the Monuments of India. Volume Two: Islamic, Rajput, European.* London: Viking Penguin, 1989.

Deane, Alicia: *A Tour through the Upper Provinces of Hindostan; comprising a period between the Years 1804 and 1814.* London, 1823.

Dehejia, Vidya: *Impossible Picturesqueness. Edward Lear's Indian Watercolours, 1873–1875. With an essay by Allen Staley.* Ahmedabad: Mapin Publishing Pvt. Ltd., 1989.

Dehejia, Vidya (ed.): *Unseen Presence. The Buddha at Sanchi.* Bombay: Marg Publications, 1996.

Desai, Vishakha N[irubhai]: The Sidhu Collection[:] Paintings. In: *the India magazine of her people and culture,* volume nine, December 1988, pp. 26–35.

Desai, Vishakha N[irubhai] / Patry Leidy, Denise: *Faces of Asia. Portraits from the Permanent Collection.* Boston, Massachusetts: Museum of Fine Arts, 1989.

Desmond, Ray: *Victorian India in Focus, a selection of early photographs from the collection in the India Office Library and Records.* London: Her Majesty's Stationery Office, 1982.

Desmond, Ray: A Bountiful Ark. In: *India. A Pageant of Prints.* Edited by Pauline Rohatgi and Pheroza Godrej. Bombay: Marg Publications, 1989, pp. 161–176.

Dev Nath Purohit: *Mewar History. Guide to Udaipur.* Bombay: The Times of India Press, 1938.

Deville, Louis: *Excursions dans l'Inde.* Paris: Librairie de L. Hachette et Cie, 1860.

Dey, Mukul Chandra: *My Pilgrimages to Ajanta & Bagh.* New York: George H. Doran Company, 1952.

Diwakar, R.R. (General Editor): *Bihar Through The Ages.* Bombay [etc.]: Orient Longmans, 1959.

Dow, Alexander: *The History of Hindoostan,* translated from the Persian. The Third Edition in Three Voloumes. London: Printed by John Murray, 1792.

Downtown, Nicholas: *The Voyage of Nicholas Downtown to the East Indies 1614–15 as Recorded in Contemporary Narratives and Letters.* Edited by Sir William Foster. London: Printed for the Hakluyt Society, 1939 (Works issued by The Hakluyt Society. Second Series, No.LXXXII).

D'Oyly, Charles: *Antiquities of Dacca.* London: Published by John Landseer, Printed by John Tytler, 1814–27.

D'Oyly, Charles: *Tom Raw, the Griffin: a Burlesque Poem, in Twelve Cantos: Illustrated by Twenty-Five Engravings, Descriptive of The Adventures of a Cadet in the East India Company's Service, From the Period of His Quitting England to His Obtaining a Staff Situation in India. By a Civilian and an Officer on the Bengal Establishment.* London: Printed for R. Ackermann, 1828.

Eden, E[mily]: *Portraits of the Princes & People of India. Drawn on the Stone by L[owes] Dickinson.* London: J. Dickinson & Son, 1844.

Eden, Emily: *Up the Country. Letters written to her Sister from The Upper Provinces of India. With an Introduction and Notes by Edward Thompson.* Oxford: Oxford University Press / London: Humphrey Milford, 1937.

Eden, Fanny: *Tigers, Durbars and Kings. Fanny Eden's Indian Journals 1837–1838. Transcribed and edited by Janet Dunbar.* London: John Murray, 1988.

Edwin, Alfred J.: *A Living Witness.* Delhi: Published by the Pastorate Committee of St. James' Church, n.d. [about 1990].

Ehlers, E. / Krafft, Th. / Malik, J. (Editors): *Shahjahanabad. Delhi around 1850. Redrawn, by courtesy of the British Library, Oriental and India Office Collections, from a manuscript in the India Office Records. Archive reference: India Office Records X/1659.* Bonn: Geographische Institute der Universität Bonn, 1992.

Ehnbom, Daniel J[ames]: *Indian Miniatures. The Ehrenfeld Collection. With Essays by Robert Skelton and Pramod Chandra.* New York: Hudson Hills Press, 1985.

Ehnbom, Daniel J[ames] / Topsfield, Andrew: *Indian Miniature Painting. To be exhibited for sale….* London: Spink and Son Ltd., 1987.

Ellison, Bernard C.: *H.R.H. The Prince of Wales's Sport in India.* London: William Heinemann, Ltd., 1925.

Erskine, K.D.: *Rajputana Gazetteers Vol.II-A & Vol.II-B: The Mewar Residency.* [Reprint:] Gurgaon (Haryana): Vipin Jain for Vintage Books, 1992 [first published: 1908].

Ettinghausen, Richard: *Paintings of the Sultans and Emperors of India in American Collections.* New Delhi: Lalit Kala Akademi, 1961 (Lalit Kala Series of Indian Art).

Exhibition of Art: Catalogue of the Exhibition of Art chiefly from the Dominions of India and Pakistan 1947–48. London: Royal Academy of Arts, 1947.

Eyre & Hobhouse: *Landscape and Portraiture in India. An exhibition of oil paintings and watercolours by European artists, 1780–1900. Tuesday, 22nd September to Friday, 9th October.* London: Eyre & Hobhouse Ltd., 1981(?).

Eyre, Giles / Hobhouse, Niall: *Indian Painting 1760–1870. 12th – 29th April, 1983.* London: Eyre & Hobhouse, 1983.

Fabb, John: *The British Empire from Photographs: India.* London: B.T. Batsford Ltd., 1986.

Falk, Toby: *Elephants of Fame and other animals in Indian painting.* London: Indar Pasricha Fine Arts, 1988.

Falk, Toby / Archer, Mildred: *Indian Miniatures in the India Office Library.* London: Sotheby Parke Bernet / Delhi/Karachi: Oxford University Press, 1981.

Falk, Toby / Hayter, Gael: *Birds in an Indian Garden. Nineteen illustrations from the Impey Collection.* London: Michael Goedhuis Ltd, Colnaghi Oriental in association Mallet and Son (Antiquities) Ltd., 1984.

Falk, Toby: *The British Collector in India including important Works from the Collection of James and William Fraser.* London: Kyburg Limited, 1988.

Fanshawe, H.C.: *Delhi Past and Present.* London: John Murray, 1902.

Fatesinghrao Gaekwad / Fass, Virginia: *The Palaces of India.* London: William Collins and Co. Ltd., 1985 [first published: 1980].

Fay, Eliza: *Original Letters from India (1779–1815). With Introductory and terminal Notes by E.M. Foster. New introduction by M.M. Kaye.* London: The Hogarth Press, 1986.

Féderbe, Louis Laurent de: *Voyage en Inde du Comte de Modave 1773–1776 (Nouveaux Mémoires sur l'État Actuel du Bengale et de l'Indoustan). Texte établi et annoté par Jean Deloche.* Paris: École Française d'Extrême-Orient, 1971 (Publications de l'École Française d'Extrême-Orient, Volume LXXIX).

Fergusson, James: *Illustrations of the Rock-Cut Temples of India.* London: John Weale, 1845.

Fergusson, James / Burgess, James: *The Cave Temples of India.* London: W.H. Allen & Co.; E. Stanford and W. Griggs, 1880.

Fergusson, James / Spiers, R. Phené: *History of Indian and Eastern Architecture. Revised and edited, with Annotations [on] Indian Architecture by James Burgess.* 2 Vols. London: John Murray, 1910.

Fernandes, Braz A.: *A Guide to the Ruins of Bassein. Second edition, revised and enlarged.* Bombay: Bombay Historical Society, 1948 (B[ombay] H[istorical] S[ociety] Guides, No.1).

Findly, Ellison Banks: *Nur Jahan. Empress of Mughal India.* New York / Oxford: Oxford University Press, 1993.

Fischer, Eberhard / Goswamy, B[rijender] N[ath]: see: Goswamy, B[rijender] N[ath] / Fischer, Eberhard

Forrest, [Charles Ramus]: *A Picturesque Tour Along The Rivers Ganges And Jumna, In India: Consisting of Twenty-Four Highly Finished And Coloured Views, A Map, And Vignettes, From Original Drawings Made On The Spot; With Illustrations, Historical And Descriptive.* London: R. Ackermann, 1824.

Francklin, William: *The History of the Reign of Shah-Aulum, the Present Emperor of Hindustaun. Containing the Transactions of the Court of Delhi, and the Neighbouring States during a Period of Thirty-Six Years. Interspersed with Geographical and Topographical Observations on several of the Principal Cities of Hindustaun. With an Appendix, Containing the following Tracts, viz. I. An Account of Modern Delhi … .* [Reprint:] Allahabad: Panini Office, 1971 [first published 1798].

Francklin, William: *Military Memoirs of Mr. George Thomas; Who, By extraordinary Talents and Enterprize, Rose from an Obscure Situation to the Rank of a General, in the Service of the Native Powers in the North West of India […]. Compiled and arranged from Mr. Thomas's Original Documents.* London: Re-printed for John Stockdale, 1805 [First published: Calcutta, 1803].

Fraser, James: *The History of Nadir Shah, formerly called Thamas Kuli Khan, The present Emperor of Persia. To which is prefix'd A short History of the Moghol Emperors. At the End is inserted, A Catalogue of about Two Hundred Manuscripts in the Persic and other Oriental Languages, collected in the East. The Second Edition.* London: Printed for A. Millar, 1742.

Fraser, James Stuart: *Memoirs of the First Resident at Hyderabad.* N.p.n.d.

Gabriel, V. / Luard, C.E. [Compilers]: *The Historical Record of the Imperial Visit to India 1911. Compiled from the Official records under the Orders of the Viceroy and Governor-General of India.* London: Published for the Government of India by John Murray, 1914.

Gahlin, Sven: *The Courts of India. Indian Miniatures from the Collection of the Fondation Custodia, Paris.* Paris: Fondation Custodia / Zwolle: Waanders Publishers, 1991.

Gahlot, jagdīśsiṃh: *Būṃdī, koṭā tathā sirohi rājyoṃ kā itihās.* Jodhpur: Hindi sahitya mandir, 1960 (Rājpūtāne kā itihās. Paṃc bhāgoṃ meṃ. Dvitīya bhāg).

Gahlot, jagdīśsiṃh: *Jaypur va alvar kā itihās.* Jodhpur: Hindi sahitya mandir, 1966. (Rājpūtāne kā itihās. Paṃc bhāgoṃ meṃ. Tṛtīya bhāg).

Galerie Pierre-Yves Gabus: *Vente aux Enchères publiques. Dispersion de la collection d'Art islamique et de miniatures indiennes d'un amateur suisse. Hôtel Président, Genève, 10 décembre 1990.*

Galloway, Francesca: *Indian Miniatures. Textile Art.* London: Francesca Galloway, 1994.

Gascoigne, Bamber: *The Great Moghuls. Photographs by Christina Gascoigne.* London: Jonathan Cape, 1971.

Gatling, Eva Ingersoll / Lewis, Anne Suydam: *Lockwood de Forest. Painter, Importer, Decorator.* Huntington, New York: Heckscher Museum, 1976.

Gautier, C.: *Maleren Hugo V. Pedersen. Med Bidrag af Kunstneren selv og Antropologen, Friherre Dr. med. Hermann ten Kate.* Aarhus: W.T. Jr. Forlag, 1944.

Gayatri Devi of Jaipur / Rama Rau, Santha: *A Princess Remembers. The Memoirs of the Maharani of Jaipur.* London: Weidenfeld and Nicolson, 1976.

Gazetteer of Delhi: *Gazetteer of the Delhi District 1883–4. Compiled and published under the authority of the Punjab Government, 1884.* [Reprint:] Gurgaon, Haryana: Vintage Books, 1988.

Gentil, [Jean Baptiste Joseph]: *Mémoires sur l'Indoustan ou Empire Mogol.* Paris: Chez Petit, Librairie de S.A.R. Monsieur, et de S.A.S. Le Duc de Bourbon, 1822.

Ghosh, A. (editor): *Ajanta Murals. An album of eighty-five reproductions in colour.* New Delhi: Archaeological Survey of India, 1967.

Glasenapp, Helmuth von: *Indien.* München: Georg Müller Verlag, 1925 (Der Indische Kulturkreis in Einzeldarstellungen).

Glück, Heinrich: *Die Indischen Miniaturen des Haemzae-Romanes im Österreichischen Museum für Kunst und Industrie in Wien und anderen Sammlungen.* Zürich / Wien / Leipzig: Amalthea Verlag, 1925.

Glynn, Jenifer: Charged with the Spirit of the East - William Simpson. In: *Under the Indian Sun. British Landscape Artists*. Edited by Pauline Rohatgi and Pheroza Godrej. Bombay: Marg Publications, 1995, pp. 137–150.

Goblet d'Alviella, Eugène: *Inde et Himalaya. Souvenirs de Voyage. Deuxième édition*. Paris: E. Plon et Cie., 1880.

Godrej, Pheroza / Rohatgi, Pauline: *Scenic Splendours. India through the Printed Image*. London: The British Library / Bangalore [etc.]: Arnold Publishers, 1989.

Godrej, Pheroza: Nature's Tall Sentinels. Mountainscapes by British Artists in India. In: *Under the Indian Sun. British Landscape Artists*, edited by Pauline Rohatgi and Pheroza Godrrej. Bombay: Marg Publications, 1995, pp. 121–136.

Goetz, Hermann: *Bilderatlas zur Kulturgeschichte Indiens in der Grossmoghulzeit. Die materielle Kultur des Alltags, ihre Wurzeln, Schichten, Wandlungen und Beziehungen zu anderen Völkern. Auf Grund der indischen Miniatur-Malerei und anderen Quellen dargestellt*. Berlin: Dietrich Reimer / Ernst Vohsen, 1930.

Goetz, Hermann: The Early Oudh School of Mughal Painting: Two Albums in the Baroda Museum. In: *Bulletin of the Baroda Museum and Picture Gallery*, Vol.IX, pt.I–II (April, 1952 to March, 1953), Baroda, 1955, pp. 9–24.

Goldner, George R.: *European Drawings 1. Catalogue of the Collections. With the assistance of Lee Hendrix and Gloria Williams*. Malibu, California: The J. Paul Getty Museum, 1988.

Golish, Vitold de: *Splendeur et Crépuscule des Maharajahs*. Paris: Librairie Hachette, 1963.

Goswamy, B[rijender] N[ath] / Fischer, Eberhard: *Wunder einer Goldenen Zeit. Malerei am Hof der Moghul-Kaiser. Indische Kunst des 16. und 17. Jahrhunderts aus Schweizer Sammlungen*. Zürich: Museum Rietberg, 1987.

Gothein, Marie Luise: *Indische Gärten*. München / Wien / Berlin: Drei Masken Verlag A.G., 1926 (Die Baukunst. Herausgegeben von Dagobert Frey).

Gough, Charles / Innes, Arthur D.: *The Sikhs and the Sikh Wars: The Rise, Conquest, and Annexation of the Punjab State*. London: A.D. Innes, 1897.

Grant Duff, James: *History of the Mahrattas*. 3 Vols. Bombay: Printed at the "Exchange Press," 1863.

Gray, Basil: Painting. In: *The Art of India and Pakistan, a commemorative catalogue of the exhibition held at The Royal Academy of Arts London, 1947–8*. Edited by Sir Leigh Ashton. London: Faber and Faber Limited, 1950.

Greenhill, Basil: The Boats of East Pakistan. In: *The Mariner's Mirror (The Quarterly Journal of the Society for Nautical Research)*, Vol.34, Nos. 2 – 3, 1966, pp. 1 – 40.

Grek, T.V.: *Indiyskie Miniatyur y XVI – XVIII vv. Pod Redakciey: L.T. Gyuzal'yana*. Moskva: Nauka, 1971.

Griffith, M.: *India's Princes. Short Life Sketches of the Native Rulers of India*. London: W.H. Allen & Co., Publishers to the India Office, 1894.

Grindlay, Robert Melville: *Scenery, Costumes and Architecture, chiefly on The Western Side of India*. London: Smith, Elder & Co., 1830.

Growse, F[rederic] S[almon]: *Mathurá: A District Memoir. Second Edition. Illustrated, Revised and Enlarged*. N.p.: Printed at the North-Western Provinces and Oudh Government Press, 1880.

Guerreiro, Fernao: *Jahangir and the Jesuits. With an Account of The Travels of Benedict Goes and The Mission to Pegu. From the Relations of Father Fernao Guerreiro, S.J. Translated by C.H. Payne*. London: George Routledge & Sons, 1930 (The Broadway Travellers).

Guha-Thakurta, Tapati: *The Making of a New 'Indian' Art. Artists, aesthetics and nationalism in Bengal, c.1850–1920*. Cambridge: Cambridge University Press, 1992.

Gupta, R.P.: Some British and European Painters in India 1760–1850. In: *The Times of India Annual* 1979, pp. 49–60.

Gupta, S[amarendra] N[ath]: *Catalogue of Paintings in the Central Museum Lahore*. Calcutta: Printed at the Baptist Mission Press, 1922.

Gupte, Ramesh Shankar / Mahajan, B.D.: *Ajanta, Ellora and Aurangabad Caves*. Bombay: D.B. Taraporevala Sons & Co. Private Ltd., 1962.

Gutman, Judith Maria: *Through Indian Eyes. 19th and Early 20th Century Photography from India*. New York: Oxford University Press / International Center of Photography, 1982.

Guy, John / Swallow, Deborah (eds.): *Arts of India: 1550–1900*. London: Victoria and Albert Museum, 1990.

Härtel, Herbert / Lobo, Wibke: *Schätze indischer Kunst*. Berlin: Staatliche Museen Preussischer Kulturbesitz, Museum für Indische Kunst Berlin, 1984.

Härtel, Herbert / Lobo, Wibke: *Schätze indischer Kunst. Eine Ausstellung in der Josef-Haubrich-Kunsthalle Köln, 22. August bis 2. November 1986*. Berlin: Staatliche Museen Preussischer Kulturbesitz, Museum für Indische Kunst Berlin, 1986.

Harcourt, A.: *The New Guide to Delhi. Third edition, revised and enlarged*. Lahore: Printed at the Victoria Press, by Azizuddin, 1873.

Harle, J[ames] C[offin] / Topsfield, Andrew: *Indian Art in the Ashmolean Museum*. Oxford: Ashmolean Museum, 1987.

Harnath Singh: *Geneological Table of Kachawahas*. Jaipur: Shree Veer Press, 1965.

Hartsuiker, Dolf: *Sadhus. Holy Men of India*. London: Thames and Hudson, 1993.

Hasan, Syed Mahmudul: *Mosque Architecture of Pre-Mughal Bengal*. Dacca: University Press Limited Bangladesh, 1979.

Hatanaka, Kokyo: *Indian Court Miniature Painting*. Kyoto: Kyoto Shoin Co., Ltd., 1994.

Havell, E[arnest] B[infield]: *Benares. The Sacred City. Sketches of Hindu Life and Religion*. London: W. Thacker & Co. / Calcutta & Simla: Thacker, Spink & Co., 1905.

Havell, E[arnest] B[infield]: *Indian Sculpture and Painting Illustrated by Typical Masterpieces. With an Explanation of Their Motives and Ideals*. London: John Murray, 1908.

Hazlitt, Gooden & Fox: *Indian Painting for British Patrons 1770–1860. 27 February to 28 March 1991*. London: Hazlitt, Gooden & Fox, 1991.

Head, Raymond: *Catalogue of Paintings, Drawings, Engravings and Busts in the Collection of The Royal Asiatic Society*. London: Royal Asiatic Society, 1991.

Hearn, Gordon Risley: *The Seven Cities of Delhi*. London: W. Thacker & Co. / Calcutta and Simla: Thacker, Spink & Co., 1906.

Heber, Reginald: *Narrative of a Journey through the Upper Provinces of India, from Calcutta to Bombay, 1824–1825, (With Notes upon Ceylon,) An Account of a Journey to Madras and the Southern Provinces, 1826, and letters written in India*. 2 Vols. London: John Murray, 1828.

Heichen, Walter: *Unseres Kronprinzen Fahrt nach Indien. Ein Buch für Volk und Jugend.* Berlin [etc.]: Phönix-Verlag, n.d.

Hendley, Thomas Holbein: *The Rulers of India and the Chiefs of Rajputana, 1550 to 1897. ... With ... Illustrations ... from Miniatures in the Royal Collection...from Portraits in Government House, Calcutta...; and from portraits and miniatures lent by Indian Princes or copied by Native Artists.* London: W. Griggs, 1897.

Hendley, Thomas Holbein: Indian Jewellery. In: *The Journal of Indian Art and Industry*, Vol.XII, Nos. 95–107, July 1909 [concluding number].

Hesse-Wartegg: Ernst von: *Indien und seine Fürstenhöfe.* Stuttgart / Berlin / Leipzig: Union Deutsche Verlagsgesellschaft, ca.1906.

Hickmann, Regina: Geschichte der indischen Miniaturmalerei. In: *Miniaturen, Volks- und Gegenwartskunst Indiens,* by Regina Hickmann, Heinz Mode, Siegfried Mahn. Leipzig: VEB E.A. Seemann, 1975, pp. 7–120 (Der indische Kunstkreis in Gesamtschau und Einzeldarstellungen).

Hickmann, Regina: *Indische Albumblätter. Miniaturen und Kalligraphien aus der Zeit der Moghul-Kaiser.* Leipzig and Weimar: Gustav Kiepenheuer Verlag, 1979.

Hickmann, Regina: *Kunst der Moghul-Zeit. Indische Miniaturen des 16. bis 18. Jahrhunderts aus dem Islamischen Museum der Staatlichen Museen zu Berlin. Mit einem Beitrag von Volkmar Enderlein.* Lachen am Zürichsee: Coron Verlag Monika Schoeller & Co., 1991.

History of the Golden Temple. A Guidway [sic] *to the visitors to the Golden Temple Amritsar. And a full guide to other shrines around with full description & history. .* Amritsar: B. Buta Singh, Partap Singh, n.d.

History of the Military Transactions: *A History of the Military transactions of the British Nation in Indostan from the Year MDCCXLV. To which is prefixed a Dissertation on the Establishments made by Mahomedan Conquerors in Indostan.* Vol.II. [Reprint:] New Delhi: Today & tomorrow's Printers & publishers, 1985 [First published: London: John Nourse, 1778].

History of the Siege of Delhi by an Officer who served there. Edinburgh: Adam and Charles Black, 1861.

Hobhouse Limited: *Indian Painting during the British Period. 9th September – 27th September.* London: Hobhouse Limited, 1986.

Hodges, William: *Travels in India during the Years 1780, 1781, 1782, & 1783.* London: Printed for the Author, 1793.

Hofer, Philip: *Edward Lear as a Landscape Draughtsman.* Cambridge, Massachusetts: The Belknap Press of Harvard University Press, 1967.

Holman, Dennis: *Sikander Sahib. The Life of Colonel James Skinner 1778–1841.* London / Melbourne / Toronto: William Heinemann, 1961.

Home, Robert: *Description of Seringapatam, The Capital of Tippoo Sultaun.* London: Robert Bowyer, 1796.

Howitt, Samuel / Williamson, Thomas: *Aquatints from* Oriental Field Sports *by Samuel Howitt and Captain Thomas Williamson.* London: Eyre & Hobhouse, August 1982.

Hügel, Carl Freiherr von: *Kaschmir und das Reich der Siek.* Vol.3 [of 4, in 5 parts]. Stuttgart: Hallberger'sche Verlagsbuchhandlung, 1841.

Hürlimann, Martin: *India. The Landscape, the Monuments and the People.* Berlin: Ernst Wasmuth A.G., 1928.

Hürlimann, Martin (ed.): *Asien. Bilder seiner Landschaften, Völker und Kulturen.* Zürich: Atlantis Verlag, 1956.

Husain, Muhammad Ashraf: *A Record of all the Quranic and non-historical Epigraphs on The Protected Monuments in the Delhi Province.* Calcutta: Government of India, Central Publication Branch, 1936 (Memoirs of the Archaeological Survey of India, No.47).

Hutchison, J. / Vogel, J[ean] Ph[ilippe]: *History of the Panjab Hill States.* 2 Vols. [Reprint:] Simla: Department of Languages and Culture, Himachal Pradesh, 1982 [first published by the Superintendent of Government Printing, Punjab, Lahore, 1933].

India and Afghanistan. Prints from Stock. Autumn, 1986. London: Hobhouse Limited, 1986.

India Office Library Report: *India Office Library and Records.* Report for the year 1976. London: Foreign and Commonwealth Office, 1978.

Irwin, John C.: *Art & the East India Trade.* London: Victoria and Albert Museum, 1970.

Irwin, John: The Sanchi Torso. In: *Indologentagung 1971. Verhandlungen der Indologischen Arbeitstagung im Museum für Indische Kunst Berlin, 7.–9. Oktober 1971.* Edited by Herbert Härtel and Volker Moeller. Wiesbaden: Franz Steiner Verlag GmbH, 1973, pp. 210–223 (Glasenapp-Stiftung Band 8).

Islamic Arms and Armour from private Danish Collections / Islamiske vaben i dansk privateje. Kobenhavn: Davids Samling, 1982.

Ivanov, A.A. / Grek, T.V. / Akimuskin, O[leg] F.: *Albom Indiyskih i Persidskih Miniatyur XVI – XVIII vv. Pod Redakciey: L.T. Gyuzal'yana.* Moskva: Iezdatel'stvo Vostocnoy Literaturi, 1962.

Jacob, S[amuel] S[winton]: *Jeypore Portfolio of Architectural details. Part I* [of the 6 published in folio-size]. *Copings and Plinths. Issued under the patronage of His Highness Maharaja Sawai Madhu Singh, G.C.S.I. of Jeypore.* London: Bernard Quaritch, 1890.

Jacob, S[amuel S[winton] / Hendley, T[homas] H[olbein]: *Jeypore Enamels.* London: W. Griggs, 1886.

Jacquemont, V[ictor]: *Correspondance de V. Jacquemont avec sa famille et plusieurs de ses amis pendant son voyage dans l'Inde (1828–1832). Nouvelle édition augmentée de lettres inédites ...* 2 Vols. Paris: Garnier Frères / H. Fournier Ainé, 1841.

Jacquemont, Victor: *État Politique et Social de l'Inde du Nord en 1830. Extraits de son Journal de Voyage avec une Introduction d' Alfred Martineau.* Paris: Librairie Ernest Leroux / Masson et Cie, Éditeurs, 1933 (Bibliothèque d'Histoire Coloniale).

Jacquemont, Victor: *État Politique et Social de l'Inde du Sud en 1832. Extraits de son Journal de Voyage avec une Introduction d' Alfred Martineau.* Paris: Société de l'Histoire des Colonies Françaises et Librairie Ernest Leroux, 1934 (Bibliothèque d'Histoire Coloniale).

Jagat nārāyaṇ: *Koṭā ke mahārāv ummedsiṃh dvitíy evaṃ unkā samay.* Koṭā: Nehā vikās prakāśan, 1983.

Jain, Kesharlal Ajmera / Jain, Jawaharlal: *The Jaipur Album or All about Jaipur.* Jaipur: The Rajasthan Directories Publishing House, 1935 (The Indian Album series Vol. No.1).

Jancigny, Dubois de / Raymond, Xavier: *Inde.* Paris: Firmin Didot Frères, 1845 (L'Univers. Histoire et Description de tous les Peuples).

Jindel, Rajendra: *Culture of a Sacred Town. A Sociological Study of Nathdwara.* Bombay: Popular Prakashan, 1976.

Johnson, Robert Flynn / Breuer, Karin / Goldyne, Joseph R.: *Treasures of the Achenbach Foundation for Graphic Arts*. San Francisco: Fine Arts Museum of San Francisco, 1995.

Joshi, O.P.: *Gods of Heaven. Home of Gods. A Study of Popular Prints*. Jaipur: Illustrated Book Publishers, 1994.

Kak, Ram Chandra: *Ancient Monuments of Kashmir*. London: The India Society, 1933.

Kapur, Geeta: Ravi Varma: Historicizing Representation. In: *Indian Painting. Essays in honour of Karl J[ahangir] Khandalavala*. Edited by B[rijender] N[ath] Goswamy in association with Usha Bhatia. New Delhi: Lalit Kala Akademi, 1995, pp. 223–243.

Karsandas Mulji: *History of the Sect of MahÁrÁjas, or VallabhÁchÁryas in Western India*. London: Trübner & Co., 1865.

Kattenhorn, Patricia: *British Drawings in the India Office Library. Volume III*. London: The British Library, 1984 (Oriental and India Office Collections).

Kaye, M.M. (editor): *The Golden Calm. An English Lady's Life in Moghul Delhi. Reminiscences by Emily, Lady Clive Barley, and by her father, Sir Thomas Metcalfe*. New York: Viking Press, 1980.

Ketelaar, Joan Josua: *Journal von J.J. Ketelaar's Hofreis naar den Groot Mogol te Lahore 1711–1713. Uitgegeven door J.Ph. Vogel*. 'S-Gravenhage: Martinus Nijhoff, 1937 (Werken uitgegeven door de Linschoten-Vereeniging, XLI).

Khan, Muhammad Ishtiaq: *Lahore Fort*. Karachi: Department of Archaeology & Museums, n.d.

Khan, Muhammad Wali Ullah: *Lahore and its Important Monuments*. Karachi: Department of Archaeology and Museums, Ministry of Education, Government of Pakistan, 1964.

Khandalavala, Karl: *The Bhagavata Purana in Kangra Painting*. New Delhi: Lalit Kala Akademi, 1974 (Lalit Kala Series Portfolio No.14).

Khandalavala, Karl / Moti Chandra: *Miniatures and Sculptures from the Collection of the Late Sir Cowasji Jehangir, Bart.*. Bombay: The Board of Trustees of The Prince of wales Museum, 1965.

Kipling, J[ohn] L[ockwood]: The Mosque of Wazir Khan, Lahore. In: *The Journal of Indian Art*, No.19, July 1887, pp. 17–18 + plates.

Kipling, John Lockwood: *Beast and Man in India. A Popular Sketch of Indian Animals in Their Relation with the People*. London and New York: Macmillan and Co., 1891.

Kishore Singh: *Bikaner. A Fifth Centenary Commemorative Volume*. New Delhi: Cross Section Publications Pvt. Ltd., n.d.

Knight, Ian: *Queen Victoria's Enemies (3): India*. London: Osprey Publishing, 1990 (Men-at-Arms Series).

Knighton, William (Compiler): *The Private Life of an Eastern King Together with Elihu Jan's Story or The Private Life of an Eastern Queen.Edited, with Introduction and Notes, by S.B. Smith*. London [etc.]: Humphrey Milford / Oxford University Press, 1921.

Koch, Ebba: Jahangir and the Angels: Recently Discovered Wall Paintings under European Influence in the Fort of Lahore. In: *India and the West. Proceedings of a Seminar Dedicated to the Memory of Hermann Goetz*. Edited by Joachim Deppert. New Delhi: Manohar, 1983, pp. 173–195.

Koch, Ebba: Notes on the painted and sculptured decoration of Nur Jahan's pavilions in the Ram Bagh (Bagh-i Nur Afshan) at Agra. In: *Facets of Indian Art. A symposium held at the Victoria and Albert Museum on 26, 27, 28 April and 1 May 1982*. Edited by Robert Skelton, Andrew Topsfield, Susan Stronge and Rosemary Crill. London: Victoria and Albert Museum, 1986, pp. 51–65.

Koch, Ebba: *Mughal Architecture. An Outline of Its History and Development (1526–1858)*. Munich: Prestel, 1991.

Koenigsmarck, Hans von: *A German Staff Officer in India: Being the Impressions of an Officer of the German General Staff of his Travels through the Peninsula; with an Epilogue specially written for the English Edition. Authorised Translation by P.H. Pakley Williams*. London: Kegan Paul Trench, Trübner & Co., 1910.

Kramrisch, Stella: *Painted Delight. Indian Paintings from Philadelphia Collections*. Philadelphia: Philadelphia Museum of Art, 1986.

Krishna, Kalyan: Painted Pichhavais. In: *Parokṣa. Coomaraswamy Centenary Seminar Papers. Edited by Gulam Mohammed Sheikh, K.G. Subramanyan, Kapila Vatsyayan*. New Delhi: Lalit Kala Akademi, 1984, pp. 134–141.

Krishna, Naval: Les Insignes de Royauté. In: *"L'Extraordinaire Aventure de Benoît de Boigne aux Indes"*, comp. and ed. by Jérôme Boyé, Chambéry: Musée Savoisien / Paris: Mona Bismarck Foundation, 1996, pp. 112–116.

Kühnel, Ernst: *Indische Miniaturen*. Berlin: Staatliche Museen zu Berlin, Islamische Abteilung, 1937 (Bilderhefte der Islamischen Abteilung, Heft 1).

Kühnel, Ernst: *Indische Miniaturen*. Berlin: Verlag Gebr. Mann, 1946.

Kühnel, Ernst / Goetz, Hermann: *Indische Buchmalereien aus dem Jahangir-Album der Staatsbibliothek zu Berlin*. Berlin: Scarabaeus Verlag, 1924 (Buchkunst des Orients, Vol.2).

Kühnel, Ernst / Ettinghausen, Richard: *Indische Miniaturen*. Berlin: Staatliche Museen zu Berlin, Islamische Kunstabteilung, 1933 (Bilderhefte der Islamischen Kunstabteilung. Heft 1).

Kuraishi, Maulvi Muhammad Hamid: *List of Ancient Monuments Protected under Act VII of 1904 in the Province of Bihar and Orissa*. Calcutta: Government of India, Central Publication Branch, 1931 (Archaeological Survey of India. New Imperial Series, Vol. LI).

Kutzner, J.C.: *Die Reise Seiner Königlichen Hoheit des Prinzen Waldemar von Preußen nach Indien in den Jahren 1844 bis 1846*. Berlin: Verlag der Königlichen Geheimen Ober-Hofbuchdruckerei, 1857.

Kyburg Limited: *From Bournabat to Madurai. Early Views of Turkey, India and other Eastern Countries. 28 June – 28th July, 1989*. London: Kyburg Limited, 1989.

Lafont, Jean-Marie: *La Présence Française dans le Royaume Sikh du Penjab 1822–1849*. Paris: École Française d'Extrême-Orient, 1992 (Publications de l'École Française d'Extrême-Orient, Volume CLXVIII).

Larneuil, Michel: *Roman de la Bégum Sombre*. Paris: Albin Michel, 1981.

LaRoche, Emanuel: *Indische Baukunst*. 6 Vols. Basel: Bei Frobenius A.-G., 1921–1922.

Latif, Syad Muhammad: *Lahore: Its History, Architectural Remains and Antiquities, with an Account of its modern Institutions, Inhabitants, their Trade, Customs, &c.*. Lahore: Printed at the "New Imperial Press", 1892.

Latif, Syad Muhammad: *Agra. Historical & Descriptive, with an Account of Akbar and his Court and of the modern City of Agra. Illustrated with Portraits of the Moghul Emperors and Drawings of the Principal Architectural Monuments of that City and its Suburbs, and a Map of Agra*. Calcutta: Printed at the Calcutta Central Press Company, Limited, 1896.

Lawrence, Lord John: Murder of Commissioner Fraser - Delhi, 1835. A Tale of Circumstantial Evidence. In: *Blackwood's Edinburgh Magazine*, No.DCCXLVII, Vol. CXXIII, January 1878, pp. 32–38.

Leach, Linda York: Introduction to Indian Painting. In: *In the Image of Man. The Indian Perception of the Universe through 2000 Years of Painting and Sculpture*. London: Arts Council if Britain, 1982, pp. 25–32 et var. loc.

Leach, Linda York: *Indian Miniature Paintings and Drawings*. Cleveland: The Cleveland Museum of Art in cooperation with Indiana University Press, 1986 (The Cleveland Museum of Art. Catalogue of Oriental Art. Part One).

Leach, Linda York: *Mughal and Other Indian Paintings from the Chester Beatty Library*. 2 Vols. London: Scorpion Cavendish, 1995.

Lear, Edward: *Edward Lear's Indian Journal. Watercolours and extracts from the diary of Edward Lear (1873–1875). Edited by Ray Murphy*. London [etc.]: Jarrolds Publishers (London) Ltd., 1953.

Le Bon, Gustave: *Les Civilisations de L'Inde. Ouvrage illustré de 7 Chromolithographies, 2 Cartes et 350 Gravures et Héliogravures, d'après les Photographies, Aquarelles et Documents de l'Auteur.* Paris: Librairie de Firmin-Didot et Cie, 1887.

Le Bon, Gustave: *Les Monuments de l'Inde.* 2 Vols. Paris: Librairie de Firmin-Didot et Cie., 1893.

Lentz, Thomas W.: Edwin Binney, 3rd (1925–1986). In: *American Collectors of Asian Art*. Edited by Pratapaditya Pal. Bombay: Marg Publications, 1986, pp. 93–116.

Lewis, R.E.: *Indian and Persian Miniatures. Catalogue August 1986*. San Rafael, CA: R.E. Lewis, Inc, 1986.

Les Grands Dossiers de l'Illustration. L'Inde. Histoire d'un Siècle. Paris: Le Livre de Paris, 1987.

Lister, Raymond: *George Richmond. A Critical Biography*. London: Robin Garton Ltd., 1981.

List of Ancient Monuments in Bengal. Revised and corrected up to 31st August 1895. Published by Authority. Calcutta: Printed at the Bengal Secretariat Press, 1896 (Government of Bengal. Public Works Department).

Löwenstein, Felix zu: *Christliche Bilder in altindischer Malerei*. Münster, Westfalen: Aschendorfsche Verlagsbuchhandlung, 1958 (Veröffentlichungen des Instituts für Missionswissenschaft der Westfälischen Wilhelms-Universität Münster Westfalen, Heft 8).

Login, Lena: *Sir John Login and Duleep Singh. With an Introduction by Colonell G.B. Malleson*. London: W.H. Allen, 1890.

Losty, Jeremiah P[atrick]: *The Art of the Book in India*. London: The British Library, 1982.

Losty, J[eremiah] P[atrick]: *Indian Book Painting*. London: The British Library, 1986.

Losty, Jeremiah P[atrick]: Sir Charles d'Oyly's Lithographic Press and his Indian Assistants. In: *India. A Pageant of Prints*. Edited by Pauline Rohatgi and Pheroza Godrej. Bombay: Marg Publications, 1989.

Losty, J[eremiah] P[atrick]: The Great Gun at Agra. In: *The British Library Journal*, Volume 15, Number 1, spring 1989a, pp. 35–58.

Losty, J[eremiah] P[atrick]: *Calcutta. City of palaces. A Survey of the City in the Days of the East India Company 1690–1858*. London: The British Library / Arnold Publishers, 1990.

Losty, J[eremiah] P[atrick]: *Of Far Lands and People. Paintings from India 1783 – 1881*. London: Indar Pasricha Fine Arts, 1993.

Losty, J[eremiah] P[atrick]: The Governor-General's Draughtsman : Sita Ram and the Marquess of Hastings' Albums. In : *Marg*, Volume 47, No.2, 1995, pp. 80–84.

Losty, J[eremiah] P[atrick]: Early Views of Gaur and Pandua by the Indian Artist Sita Ram. In: *Journal of Bengal Art*, Volume 1, 1996, pp. 189–203.

Losty, J[eremiah] P[atrick], et alii: *A Journey through India. Pictures of India by British Artists*. London: Spink & Son Ltd., 1996.

Maclagan, Edward: *The Jesuits and the Great Mogul*. London: Burns Oates & Washbourne Ltd., Publishers to the Holy See, 1932.

Macmillan, Margaret: *Women of the Raj*. London: Thames and Hudson, 1996.

Maggs Bros. Ltd.: Oriental Miniatures & Illumination. Bulletin No.6. London: Maggs Bros. Ltd., February, 1964.

Maggs Bros. Ltd.: Oriental Miniatures & Illumination. Bulletin No.13. Vol.IV, part 1. London: Maggs Bros. Ltd., May 1968.

Maggs Bros. Ltd.: Oriental Miniatures & Illumination. Bulletin No.14. Vol.IV, part 2. London: Maggs Bros. Ltd., December 1968.

Maggs Bros. Ltd.: Oriental Miniatures & Illumination. Bulletin No.17. Vol.V, part 2. London: Maggs Bros. Ltd., August 1970.

Maggs Bros. Ltd.: Oriental Miniatures & Illumination. Bulletin No.18. Vol.V, part 3. London: Maggs Bros. Ltd., January 1971.

Maggs Bros. Ltd.: Oriental Miniatures & Illumination. Bulletin No.22. Vol.VII, part 1. London: Maggs Bros. Ltd., March 1974.

Maggs Bros. Ltd.: Oriental Miniatures & Illumination. Bulletin No.23. Vol.VII, part 2. London: Maggs Bros. Ltd., March 1975.

Maggs Bros. Ltd.: Oriental Miniatures & Illumination. Bulletin No.24. Vol.VII, part 3. London: Maggs Bros. Ltd., December 1975.

Maggs Bros. Ltd.: Oriental Miniatures & Illumination. Bulletin No.25 Vol.VIII (Islam). London: Maggs Bros. Ltd., May 1976.

Maggs Bros. Ltd.: Oriental Miniatures & Illumination. Bulletin No.27. London: Maggs Bros. Ltd., June 1977.

Maggs Bros. Ltd.: Oriental Miniatures & Illumination. Bulletin No.30. London: Maggs Bros. Ltd., January 1979.

Maggs Bros. Ltd.: Oriental Miniatures & Illumination. Bulletin No.31 Painting for the British. London: Maggs Bros. Ltd., December 1979.

Maggs Bros. Ltd.: Oriental Miniatures & Illumination. Bulletin No.34. London: Maggs Bros. Ltd., January 1981.

Maggs Bros. Ltd.: Oriental Miniatures & Illumination. Bulletin No.37. London: Maggs Bros. Ltd., Spring 1984.

Maggs Bros. Ltd.: Catalogue 1050: Septuaginta: 70 Rare Books and Manuscripts.... London: Maggs Bros. Ltd., September 1984.

Maggs Bros. Ltd.: Oriental Miniatures & Illumination. Bulletin No.39. London: Maggs Bros. Ltd., December 1985.

Mahajan, Jagmohan: *The Ganga Trail. Foreign Accounts and Sketches of the River Scene*. New Delhi: Clarion Books, 1984.

Mahajan, Jagmohan: *The Raj Landscape. British Views on Indian Cities*. Surrey / New Delhi: Spantech Publishers Pvt. Ltd., 1988.

Malcolm, John: *A Memoir of Central India, including Malwa, and adjoining Provinces. With the History, and copious Illustrations, of the Past and Present Condition of that Country. Second Edition*. 2 Vols. London: Kingsbury, Parbury, & Allen, 1824.

Malcolm, John: *The Political History of India, from 1784 to 1823*. 2 Vols. London: John Murray, 1826.

Malleson, G[eorge] B[ruce]: *An Historical Sketch of The Native States of India in Subsidiary Alliance with the British Government. With a Naotice on the Mediatized and Minor States*. London: Longmans, Green, and Co., 1875.

Malleson, G[eorge] B[ruce]: *Kaye's and Malleson's History of the Indian Mutiny of 1857-8. Edited by Colonel Malleson*. Vol.3 [of 6]. London: W.H. Allen, 1889.

Malleson, G[eorge] B[ruce]: *Kaye's and Malleson's History of the Indian Mutiny of 1857-8. Edited by Colonel Malleson*. Vol.6 [of 6]. London: W.H. Allen, 1889.

Mallmann, Marie-Thérèse de: *Les Enseignements iconographiques de l'Agni-Purana*. Paris: Presses Universitaires de France, 1963 (Annales du Musée Guimet, Bibliothèque d'Études, Tome soixante-septième).

Mani, Vettam: *Puranic Encyclopaedia. A Comprehensive Dictionary with Special Reference to the Epic and Puranic Literature*. Delhi / Patna / Varanasi: Motilal Banarsidass, 1975.

Manucci, Niccolao: *Storia do Mogor or Mogul India 1653-1708. Translated with Introduction and Notes by William Irvine*. 4 Vols. [Reprint]: New Delhi: Oriental Books Reprint Corporation, 1981 [first published 1907-08].

Marshall, John: *A Guide to Sanchi*. Delhi: Manager of Publications, 1936.

Marshall, John / Foucher, Alfred: *The Monuments of Sanchi, with translations and notes on the inscriptions by N.G. Majumdar*. 3 Vols. Calcutta: Superintendent of Government Printing, India, 1940.

Martin, Montgomery: *The History, Antiquities, Topography, and Statistics of Eastern India; comprising the Districts of Behar ... collated from the Original Documents at the E[ast] I[ndia] House ...*. 3 Vols. London: Wm. Allen and Co., 1838.

Martineau, Alfred: L'Inde de 1720 à nos jours. In: *Histoire des Colonies Françaises et de l'Expansion de la France dans le Monde*. Tome V. Paris: Société de l'Histoire Nationale / Librairie Plon, 1932, pp. 91-309.

Mason, Pippa: *Indian Painting during the British Period. 9th September - 27th September 1986*. London: Hobhouse Limited, 1986.

Masters, Brian: *Maharana. The Story of the Rulers of Udaipur*. Ahmedabad: Mapin Publishing Pvt. Ltd., 1990.

Maya Ram: *Rajasthan District Gazetteers: Tonk*. Jaipur: Publication Branch, Government Centrall Press, Jaipur (India), 1970.

Mayer, Otto: *Zwanzig Jahre an Indischen Fürstenhöfen. Indisches und Allzu- Indisches*. Dresden: Verlag Deutsche Buchwerkstätten, 1922.

McInerney, Terence: Manohar. In: *Master Artists of the Imperial Mughal Court*. Edited by Pratapaditya Pal. Bombay: Marg Publications, 1991, pp. 53-68.

Medley, Julius George: *A Year's campaigning in India, from March, 1857, to March, 1858. With Plans of the Military Operations*. London: W. Thacker and Co., 1858.

Mersey, (Viscount): *The Viceroys and Governors-General of India 1757-1947*. London: John Murray, 1949.

Michaud, J.: *Histoire des Progrès et de la Chute de l'Empire de Mysore, sous les Règnes d'Hyder-Aly et Tippoo-Saib;...* 2 Vols. Paris: Chez Giguet et Cie., 1801.

Michell, George / Martinelli, Antonio: *The Royal Palaces of India*. London: Thames and Hudson, 1994.

Mirza, H. A.: *Album of Agra. Containing 36 Views by H. A. Mirza & Sons*. Delhi: H.A. Mirza & sons, n.d. [ca.1890].

Mitra, Debala: *Sanchi*. New Delhi: Published by the Director General of Archaeology in India, 1957.

Mitter, Partha: *Much Maligned Monsters. History of European Reactions to Indian Art*. Oxford: Clarendon Press, 1977.

Mitter, Partha: *Art and Nationalism in Colonial India 1850-1922. Occidental orientations*. Cambridge: Cambridge University Press, 1994.

Modave, Comte de: see: Féderbe, Louis Laurent.

Molitor, Juliane Anna Lia Molitor: *Portraits in sechs Fürstenstaaten Rajasthans vom 17. bis zum 20. Jahrhundert. Voraussetzungen - Entwicklungen - Veränderungen. Mit besonderer Berücksichtigung kulturhistorischer Faktoren*. Wiesbaden: Franz Steiner Verlag GmbH, 1985 (Beiträge zur Südasienforschung. Südasien-Institut Universität Heidelberg. Band 92).

Moore, Thomas: *Lalla Rookh. An Oriental Romance. New Edition*. London: Longmans, Green, Reader & Dyer, 1868.

Moorhouse, Geoffrey: *India Britannica*. London: Harvill Press, 1983.

Moser-Charlottenfels, Henri: *Sammlung Henri Moser-Charlottenfels. Orientalische Waffen und Rüstungen*. Leipzig: Verlag von Karl W. Hiersemann, 1912.

Mundy, Godfrey Charles: *Pen and Pencil Sketches in India. Journal of a Tour in India. Third Edition. With many Illustrations*. London: John Murray, 1858 [first published in 2 Vols., 1832].

Mundy, Peter: *The Travels of Peter Mundy, in Europe and Asia, 1608-1667. Edited by Sir Richard Carnac Temple*. Vol.II: *Travels in Asia, 1628-1634*. London: Printed for the Hakluyt Society, 1914 (Works issued by The Hakluyt Society. Second Series, No.XXXV).

Murphy, Veronica: *Origins of the Mughal Flowering Plant Motif*. London: Indar Pasricha Fine Arts, [1987].

Murray's Hand-Book: *Handbook of the Bengal Presidency. With an Account of Calcutta City*. London: John Murray, 1882.

Murray's Hand-Book: *A Handbook for Travellers in India, Burma and Ceylon. Including the Provinces of Bengal, Bombay, Madras, the United Provinces of Agra and Lucknow, the Panjab, the North-West Frontier Province, Beluchistan, Assam, and the Central Provinces, and the Native States of Rajputana, Central India, Kashmir, Hyderabad, Mysore, etc.* London: John Murray / Calcutta: Thacker, Spink, & Co., 1907.

Muthiah, S. / Rohatgi, Pauline: Some Monuments of Old Madras. In: *India. A Pageant of Prints*. Edited by Pauline Rohatgi and Pheroza Godrej. Bombay: Marg Publications, 1989, pp. 209-224.

N., J. T.: *Hand-Book of the Taj at Agra; Fort of Agra; Akbar's Tomb at Secundra and Ruins of Futtehpore Sikri. Translated from a Persian Manuscript with an English Version of the Poetry inscribed on the Walls, Tombs, etc.; Description of the Taj, and Extracts from several Authors on the Subject*. Lahore: Dependent Press: Henry Gregory, 1862.

Nārāyan, rām: *Rājasthān ratnākar. rājpūtāne ke guhilvaṃśī rājyoṃ kā itihās. hindī bhāsā meṃ*. Ajmer: Vaidik-yantrālay, saṃvat 1970 vikramī, san 1913 īsvī (bhāg pratham, taraṅga 2). [History of the Guhil race of Rajputana, part I, second delivery. In Hindi].

Nath, R.: *Monuments of Delhi. Historical Study.* New Delhi: Ambika Publications / Indian Institute of Islamic Studies, 1979.

Nazim, N.: *Bijapur Inscriptions.* Delhi: Manager of Publications, 1936 (Memoirs of the Archaeological Survey of India, No.49).

Nevile, Pran: *Nautch Girls of India. Dancers, Singers, Playmates.* Paris / New York / New Delhi: Ravi Kumar Publisher / New Delhi: Prakriti India, 1996.

Newell, H.A.: *Three Days at Delhi (The Capital of India). A Guide to Places of Interest, with History and Map.* London: Harrison and Sons, n.d.

Newell, H.A.: *Madras. The Birth Place of British India. An Illustrated Guide with Map.* Madras: Printed at the Madras Times Printing & Publishing Co., Ld., 1919.

Nicholls, W.H.: Some old photographs of Delhi Fort. In: *Annual Report* [of the] *Archaeological Survey of India 1905–06,* Calcutta: Superintendent of Government Printing, India, 1909, pp. 29–31.

Nicholson, Louise: *The Red Fort, Delhi. Photographs by Francesco Venturi.* London: Tauris Parke Books, 1989 (Travel to Landmarks).

Noti, Severin: *Das Fürstentum Sardhana. Geschichte eines deutschen Abenteurers und einer indischen Herrscherin.* Freiburg im Breisgau: Herdersche Verlagsbuchhandlung, 1906.

Nou, Jean-Louis / Okada, Amina: *Taj Mahal.* München: Hirmer Verlag, 1993.

Nou, Jean-Louis / Okada, Amina: *Ajanta. Frühbuddhistische Höhlentempel.* München: Metamorphosis Verlag, 1993a.

Nou, Jean-Louis / Pouchepadass, Jacques: *Die Paläste der indischen Maharadschas.* Zürich / Freiburg im Breisgau: Atlantis Verlag, 1980.

Nur Bakhsh: Historical Notes on the Lahore Fort and its Buildings. In: *Annual Report* [of the] *Archaeological Survey of India 1902–03.* [Reprint:] Varanasi: Indological Book House, 1970, pp. 218–224.

Nusrat Ali: Bengal School of Paintings with Special Reference to the Specimens in the Lahore Museum. In: *Lahore Museum Heritage.* Edited by Anjum Rehmani. Lahore (Pakistan): Lahore Museum, 1994, pp. 235–259.

Octagon. Spink & Son Ltd. London. Volume XX, Number 2, October 1983.

Octagon. Spink & Son Ltd. London. Volume XXII, Number 2, June 1985.

Octagon. Spink & Son Ltd. London. Volume XXIV, Number 3, October 1987.

Okada, Amina: *Miniatures de l'Inde impériale. Les Peintres de la Cour d'Akbar.* Paris: Editions de la Réunion des Musées Nationaux, 1989.

Okada, Amina: *Imperial Mughal Painters. Indian Miniatures from the Sixteenth and Seventeenth Centuries.* Paris: Flammarion, 1992.

Okada, Amina / Isacco, Enrico: *L'Inde du XIXe Siècle. Voyage aux Sources de l'Imaginaire.* Marseille: AGEP, 1991 (Collection: Les Grands Voyages du XIXe Siècle).

Ollman, Arthur: *Samuel Bourne: Images of India.* Carmel, California: The Friends of Photography, 1983.

Oppé, A.P.: *Raphael. Edited with an introduction by Charles Mitchell.* London: Elek Books, 1970 [first published by Methuen and Co, London, 1909].

Oriental Annual: *The Oriental Annual, or Scenes in India; comprising Twenty-Five Engravings from original Drawings by William Daniell, R.A. and a Descriptive Account by the Rev. Hobart Caunter, B.D.* London: Published by Edward Bull, 1834 [title vignette dated October i. 1833].

Oriental Annual: *The Oriental Annual, or Secenes in India; comprising Twenty-Two Engravings from original Drawings by William. Daniell, R.A. and a Descriptive Account by the Rev. Hobart Caunter, B.D.* London: Published by Edward Churton, 1836 [title vignette dated Oct. i. 1835].

Oriental Annual: *The Oriental Annual. Lives of The Moghul Emperors. By the Rev. Hobart Caunter, B.D. with Twenty-two Engravings from Drawings by William Daniell, R.A.* London: Charles Tilt, 1837. [title vignette dated October 1, 1836].

Oriental Annual: *The Oriental Annual; containing a Series of Tales, Legends, & Historical Romances; by Thomas Bacon, With Engravings by W. and E. Finden, from Sketches by the Author and Captain Meadows Taylor.* London: Charles Tilt, 1840.

Orlich, Leopold von: *Reise in Ostindien in Briefen an Alexander von Humboldt und Carl Ritter.* Leipzig: Verlag von Mayer und Wigand, 1845.

Osborne, Harold (ed.): *The Oxford Companion to Twentieth-Century Art.* Oxford [etc.]: Oxford University Press, 1981.

Osborne, W[illiam] G[odolphin]: *The Court and Camp of Runjeet Sing. With an Introductory Sketch of the Origin and Rise of the Sihk* [sic] *State. Illustrated with Sixteen Engravings.* London: Henry Colburn, 1840.

Page, J.A.: *Guide to the Qutb, Delhi.* Calcutta: Government of India, Central Publication Branch, 1927.

Pal, Pratapaditya: *Court Paintings of India, 16th – 19th Centuries.* New York: Navin Kumar, 1983.

Pal, Pratapaditya, et alii: *Romance of the Taj Mahal.* London: Thames and Hudson / Los Angeles: Los Angeles County Museum of Art, 1989.

Pal, Pratapaditya: Indian Artists and British Patrons in Calcutta. In: *Changing Visions, Lasting Images. Calcutta through 300 years.* Edited by Pratapaditya Pal. Bombay: Marg Publications, 1990, pp. 125–142.

Pal, Pratapaditya / Dehejia, Vidya: *From Merchants to Emperors. British Artists in India 1757–1930.* Ithaca and London: Cornell University Press, 1986.

Palais Galliéra: Collection Jean Pozzi. Miniatures Indiennes et Orientales. Paris: Palais Galliéra, 5 Décembre 1970.

Panikkar, K. M.: *His Highness the Maharaja of Bikaner. A Biography.* London: Oxford University Press / Humphrey Milford, 1937.

Parks, Fanny: *Wanderings of a Pilgrim in Search of the Picturesque. With an introduction and notes by Esther Chawner.* 2 Vols. Karachi [etc.]: Oxford University Press, 1975 (Oxford in Asia Historical Reprints; [first published by Pelham Richardson, London, 1850]).

Pasricha, Indar: Apparell'd in Celestial Light. Indian Paintings of Albert Goodwin. In: *Under the Indian Sun. British Landscape Artists.* Edited by Pauline Rohatgi and Pheroza Godrej. Bombay: Marg Publications, 1995, pp. 151–166.

Patil, D.R.: *The Antiquarian Remains in Bihar.* Patna: Kashi Prasad Jayaswal Research Institute, 1963 (Historical Research Series Vol. IV).

Patnaik, Naveen: *A Desert Kingdom. The Rajputs of Bikaner.* London: Weidenfeld and Nicolson, 1990.

Patnaik, Naveen / Welch, Stuart Cary: *A Second Paradise. Indian Courtly Life 1590–1947.* London: Sidgwick & Jackson Limited, 1985.

Patrick, [Father]: *Sardhana: Its Begum, Its Shrine, Its Basilica*. Meerut: (Printed at Presidant [sic] Press), 1987.

Pavière, S.H.: Biographical Notes on the Devis Family of Painters. In: *The Twenty-Fifth Volume of the Walpole Society 1936–1937*, Oxford: At the University Press, 1937, pp. 138–166.

Pelsaert, Francisco: *Jahangir's India. The Remonstrantie of Francisco Pelsaert*. Translated from the Dutch by W.H. Moreland and P. Geyl. [Reprint:] Delhi: Idarah-i Adabiyat-i Delli, 1972. (IAD Oriental Series No.8).

Pemble, John: *The Raj, the Indian Mutiny and the Kingdom of Oudh 1801–1859*. Delhi [etc.]: Oxford University Press, 1977.

Perrin, M.: *M. Perrin's Reise durch Hindostan und Schilderung der Sitten, Einwohner, Natur-Producte und Gebräuche dieses Landes nach einem sechzehnjährigen Aufenthalte daselbst. Nach dem Französischen bearbeitet von Theodor Hell*. 2 Vols. Wien: In Commission bey B. Ph. Bauer, 1811.

Pfeiffer, Ida: *A Woman's Journey round the World, from Vienna to Brazil, Chili, Tahiti, China, Hindostan, Persia, and Asia Minor. An unabridged Translation from the German* London: Office of the National illustrated Library, n.d. [ca.1850].

Pinder-Wilson, R[alph] H. / Smart, Ellen / Barrett, Douglas: *Paintings from the Muslim Courts of India. An exhibition held in the Prints and Drawings Gallery, British Museum, 13 April to 11 July 1976*. London: World of Islam Festival Publishing Company Ltd., 1976.

Poovaya-Smith, Nima [and contributions by Khushwant Singh and Kaveri Ponnapa]: *Warm and Rich and Fearless. A brief Survey of Sikh Culture*. Bradford: Bradford Art Galleries and Museums, 1991.

Poster, Amy G., et alii: *Realms of Heroism. Indian Paintings at the Brooklyn Museum*. New York: The Brooklyn Museum in association with Hudson Hills Press, 1994.

Prinsep, Val[entine] C.: *Imperial India. An Artist's Journals. Illustrated by numerous Sketches taken at the Courts of the Principal Chiefs in India*. London: Chapman and Hall, 1879.

Priya Lall: *Pictorial Agra: Illustrated by a Series of Photographs of its Principal Buildings, Ancient and Modern, with Descriptive Letterpress of each*. Agra: Priya Lall and Co., 1911.

Purdon Clarke, C.: *Arms and Armour at Sandringham. The Indian Collection presented by the Princes, Chiefs and Nobles of India to His Majesty King Edward VII, when Prince of Wales, on the occasion of His visit to India in 1875–1876; also some Asiatic, African and European Weapons and War-Relics*. London: W. Griggs & Sons, Ltd., 1910.

Raghubir Singh: *The Ganges*. London: Thames and Hudson, 1992.

Randhawa, M[ohinder] S[ingh]: *Kangra Paintings of the Bhagavata Purana*. New Delhi: National Museum of India, 1960.

Rawson, Philip S.: *Indian Painting*. Paris: Pierre Tisné / New York: Universe Books, Inc., 1961.

Ray, Amita: Calcutta and the Early Growth of the Bengal School of Painting. In: *Changing Visions, Lasting Images. Calcutta through 300 years*. Edited by Pratapaditya Pal. Bombay: Marg Publications, 1990, pp. 159–172.

Reclus, Élisée: *L'Inde et l'Indo-Chine*. Paris: Librairie Hachette et Cie., 1885 (Nouvelle Géographie Universelle. La Terre et les Hommes).

Reinhardt, K[urt]: *Wegweiser zu den Quellen der Geschichte des deutschen Nabobs von Sardhana in Indien Walter Reinhardt genannt, Sombre*. Völklingen: Selbstverlag, 1993.

Reinhardt, Kurt: *Ein Justizverbrechen. Begangen im zweiten Viertel des 19. Jahrhunderts in England an David Ochterlony Dyce Sombre, dem Urenkel des deutschen Nabobs Walter Reinhardt*. Völklingen: Selbstverlag, 1995.

Reuther, Oscar: *Indische Paläste und Wohnhäuser. Mit Beiträgen von Conrad Preusser und Friedrich Wetzel*. Berlin: Leonhard Preiss Verlag, 1925.

Ricalton, James: *(100) Views of India*. New York [etc.]: Underwood & Underwood, Publishers, 1903.

Ricketts, M. Howard / Missillier, M. Philippe: *Splendeur des Armes Orientales / Splendour of Oriental Arms*. Paris: ACTE-EXPO, 1988.

Ritter, Carl: *Die Erdkunde von Asien. Band IV. Zweite Abtheilung. Die Indische Welt*. Berlin: G. Reimer, 1836 (Die Erdkunde im Verhältnis zur Natur und zur Geschichte der Menschen, oder allgemeine vergleichende Geographie als sichere Grundlage des Studiums und Unterrichts in physicalischen und historischen Wissenschaften. Sechster Teil. Zweites Buch. Ost-Asien. Band IV. Zweite Abtheilung).

Robbins, Kenneth X. / Robbins, Joyce: The Calcutta Collection of the Wellcome Institute for the History of Medicine. In: *From Thames to Hooghly. Calcutta Heritage 1690–1990*. Edited by Raj Krishna. Bethesda, Maryland: India School Inc., 1991, pp. 41–50 (Highlights: Notes, News and Views on Arts, History and Letters of India, Vol.V, Nos. 1 and 2).

Roberts, Emma / Elliot, Robert: *Views in India, China and on the Shores of the Red Sea*. London: Fisher, Son and Co., 1835.

Roe, Thomas: *The Embassy of Sir Thomas Roe to India 1615–19 as narrated in his Journal and Correspondence*. Edited by William Foster. Oxford: Oxford University Press / London: Humphrey Milford, 1926.

Rohatgi, Pauline: *Portraits in the India Office Library and Records*. London: The British Library, 1983.

Rohatgi, Pauline: William Hodges and the Daniells at Agra. In: *India. A Pageant of Prints*. Edited by Pauline Rohatgi and Pheroza Godrej. Bombay: Marg Publications, 1989, pp. 37–52.

Rohrer, E.: Orientalische Sammlung Henri Moser-Charlottenfels. Die kaukasischen Waffen. In: *Jahrbuch des Bernischen Historischen Museums in Bern*, XXIV. Jahrgang, 1945, pp. 131–160.

Rohrer, E.: Orientalische Sammlung Henri Moser-Charlottenfels. Die kaukasischen Waffen. In: *Jahrbuch des Bernischen Historischen Museums in Bern*, XXV. Jahrgang, 1946, pp. 155–168.

Rousselet, Louis: *L'Inde des Rajahs. Voyage dans l'Inde Centrale dans les Présidences de Bombay et du Bengale*. Paris: Librairie Hachette et Cie, 1877.

Rousselet, Louis: *India and its Native Princes. Travels in Central India and in the Presidencies of Bombay and Bengal. Carefully Revised and edited by Lieut.-Col. Buckle*. London: Bickers and Son, 1878.

Rousselet, Louis: *India of Rajahs. Text on Indian Court Costumes by Philippa Scott. Introduction by Stephen Jamail. Foreword by Diana Vreeland*. Milan: Franco Maria Ricci, 1985.

Roy, Surendra Nath: *A History of the Native States of India: Gwalior*. Calcutta: Thacker Spink & Co., 1888.

Russel, R.V. / Hira Lal, Rai Bahadur: *The Tribes and Castes of the Central Provinces of India*. Volume 3 [of four]. [Reprint:] Oosterhout N.B.: Anthropological Publications, 1969 [first published 1916].

366

Russel, William Howard: *My Diary in India, in the Year 1858–9. With Illustrations.* 2 Vols. London: Routledge, Warne and Routledge, 1860.

Russel, William Howard: *The Prince of Wales' Tour: A Diary in India; With some Account of the Visits of His Royal Highness to the Courts of Greece, Egypt, Spain and Portugal. Second Edition.* London: Sampson Low, Marston, Searle & Rivington, 1877.

Sahai, Bhagwant: *Iconography of Minor Hindu and Buddhist Deities.* New Delhi: Abhinav Publications, 1975.

Salmon, Th.: *Behelzende den Tegenwoordigen Staat van de Koninkryken PEGU, AVA, ARRAKAN, ACHAM. Als mede van het Eigentlyke INDIA, of het Ryk van den Groten MOGOL, en van MALABAR, KORMANDEL, en het Eiland CEILON. Nu vertaald en merkelyk vermeerderd door M. van Goch.* Amsterdam: Isaak Tirion, 1731 (Hedendaagsche Historie, of Tegenwoordige Staat van Alle Volkeren ...).

Sanderson, George P.: *Thirteen Years among the Wild Beasts of India: Their Haunts and Habits from Professional Observation; with an Account of the Modes of Capturing and Taming Elephants. Second Edition.* London: Wm. H. Allen & Co., Publishers to the Indian Office, 1879.

Sanderson, Gordon: The Shah Burj, Delhi Fort. In: *Annual Report* [of the] *Archaeological Survey of India 1909–10,* Calcutta: Superintendent of Government Printing, India, 1914, pp. 25–32.

Sanderson, Gordon: Shah Jahan's Fort, Delhi. In: *Annual Report* [of the] *Archaeological Survey of India 1911–12,* Calcutta: Superintendent of Government Printing, India, 1915, pp. 1–28.

Sanderson, Gordon: *A Guide to the Buildings and Gardens, Delhi Fort. Fifth Edition.* Delhi: Published by the Manager of Publications, 1945.

Sanderson, Gordon / Zafar Hasan: *Loan Exhibition of Antiquities. Coronation Durbar 1911. An illustrated Selection of the principal Exhibits.* Delhi: Archaeological Survey of India, 1911.

Sarkar, Jadunath. *A History of Jaipur c.1503–1938. Revised and edited by Raghubir Sinh.* Hyderabad: Orient Longman, 1984.

Sarre, Friedrich: Rembrandts Zeichnungen nach indisch-islamischen Miniaturen. In: *Jahrbuch der Königlich Preuszischen Kunstsammlungen.* Vol.25. Berlin: G. Grote'sche Verlagsbuchhandlung, 1904, pp. 143–158.

Sarre, F[riedrich] / Martin, F.R. (Editors): *Die Ausstellung von Meisterwerken Muhammedanischer Kunst in München 1910.* 3 Vols. München: F. Bruckmann, 1912.

Schatborn, Peter: *Tekeningen van / Drawings by Rembrandt, zijn onbekende leerlingen en navolgers / his anonymous pupils and followers.* Amsterdam: Rijksmuseum, 1985 (Catalogus van de Nederlandse Tekeningen in het Rijksprentenkabinet, Rijksmuseum, Amsterdam, Deel IV / Catalogue of the Dutch and Flemish Drawings in the Rijksprentenkabinet, Rijksmuseum, Amsterdam, Volume IV).

Scheurleer, Pauline Lunsingh: De Maharana van Udaipur ontvangt de V.O.C.-gezant J.J. Ketelaar in het voorjaar van 1711, India, Udaipur, ca 1711. In: *Bulletin van het Rijksmuseum,* Jaargang 37, 1989, nummer 3, pp. 242–245.

Schimmel, Annemarie: The Calligraphy and Poetry of the Kevorkian Album. In: Welch, Stuart Cary, et alii: *The Emperors' Album. Images of Mughal India.* New York: The Metropolitan Museum of Art, 1987, pp. 31–44.

Scindia: See under Balwant Rao Bhayasahab.

Scott, J. George: *Burma: A Handbook of Practical Information. With Special Articles by Recognised Authorities on Burma.* London: Alexander Moring Ltd., 1911.

Seely, John B.: *The Wonders of Ellora; or, the Narrative of a Journey to the Temples and Dwellings Excavated out of a Mountain of Granite, and Extended upwards of a Mile and a Quarter, at Elora, in the Esat Indies, by the Route of Poona, Ahmed-Nuggur, and Toka, Returning by Dowlutabad and Aurungabad; with some General Observations on the People and Country.* London: Printed for G. and W.B. Whitaker, 1824.

Sen, Sansar Chander: *A Short Account of His Highness the Maharajah of Jaipur and his Country.* Ajmer: Printed at the Rajputana Mission Press, 1902.

Shah, Priyabala: *Tilaka. Hindu Marks On The Forehead.* Ahmedabad: The New Order Book Co., 1985.

Sharar, Abdul Halim. *Lucknow: The Last Phase of an Oriental Culture. Translated and edited by E.S. Harcourt and Fakhir Hussain.* London: Paul Elek, 1975.

Sharma [śarmā], mathurālāl: *Koṭā rājya kā itihās.* 2 Vols. Koṭā: Dī koṭā priṃṭiṃg pres, 1939.

Sharma, R.C. (ed.): *Raja Ravi Varma. New Perspectives. An Exhibition of Paintings, Drawings, Water Colours, Oleographs from Shri Chitra Art Gallery, Thiruananthapuram, Kerala, The National Gallery of Modern Art, New Delhi and Private Collections.* New Delhi: National Museum, Department of Culture, Govt. of India, 1993.

Sharma, Y.D.: *Delhi and its Neighbourhood.* New Delhi: The Director General [of the] Archaeological Survey of India, 1974.

Sharp, Henry: *Delhi, its Story and Buildings.* London [etc.]: Humphrey Milford / Oxford University Press, 1928.

Shastri, R.P.: *Jhala Zalim Singh (1730–1823). The de-facto ruler of Kota, who also dominated Bundi and Udaipur, shrewd politician, administrator and reformer.* Jaipur: Raj Printing Works, 1971.

Shellim, Maurice: *Oil paintings of India and the East by Thomas Daniell RA, 1749–1840 and William Daniell RA, 1769–1837.* London: Inchcape & Co. Limited in conjunction with Spink & Son Ltd., 1979.

Shellim, Maurice: *Additional Oil paintings of India and the East by Thomas Daniell RA, 1749–1840 and William Daniell RA, 1769–1837.* London: Spink & Son Ltd., 1988.

Shellim, Maurice: *Oil Paintings by Sir Charles D'Oyly, 7th Baronet 1781–1845.* London: Spink & Son Ltd., 1989.

Sheppard, E.W.: *Coote Bahadur. A Life of Lieutenant-General Sir Eyre Coote, K.B.* London: Werner Laurie, 1956.

Shifting Focus: *A Shifting Focus: Photography in India 1850 – 1900.* (London:) The British Library, (1995).

Shiv Saran Lal: *Sculptures from The Bharatpur Museum, Bharatpur.* Jaipur: The Department of Archaeology & Museums, Govt. of Rajasthan, n.d.

Shiv Saran Lal: *Catalogue & Guide to State Museum, Bharatpur (Rajasthan).* Jaipur: Department of Archaeology & Museums, Government of Rajasthan, 1961.

Shyamaldas [śyāmaladās], [kavirāj]: *Vīrvinod.* 2 Vols. Udaypur: Rājayantrālay, 1886.

Simpson, W[illiam]: *India ancient and modern: a series of illustrations of the country and people of India and adjacent territories. Executed in chromo-lithography from drawings by William Simpson and descriptive literature by John William Kaye.* 2 Vols. London: Day & Son, 1867.

Simpson, William: *The Buddhist Praying-Wheel. A Collection of Material bearing upon the Symbolism of the Wheel and Circular Movements in Custom and Religious Ritual.* London: Macmillan and Co., Ltd. / New York: The Macmillan Co., 1896.

Simpson, William: *The Autobiography of William Simpson, R.I. (Crimean Simpson). Edited by George Eyre-Todd. Illustrated with many Reproductions of Simpson's Pictures...* London: T. Fisher Unwin, 1903.

Singh, Chandramani: *Textiles and Costumes from the Maharaja Sawai Man Singh II Museum.* Jaipur: Maharaja Sawai Man Singh II Museum Trust, 1979.

Singh, Chandramani, et alii: *The Costumes of Royal India.* Tokyo: Yurakucho Art Forum / Sapporo: Hokkaido Museum of Modern Art, 1988.

Singh, Khushwant: *A History of the Sikhs. Volume 2: 1839–1964.* Princeton, New Jersey: Princeton University Press, 1966.

Siraj-ud-Din, Razia: *Chughtai's Paintings. Thirty-Nine Plates in all.* Lahore (India): Jahangir Book Club, n.d. [pre 1947].

Skelton, Robert: Indian Painting of the Mughal Period. In: *Islamic Painting and the Arts of the Book. The Keir Collection.* Edited by B.W. Robinson. London: Faber and Faber Limited, 1976, pp. 231–274, Plates 107–138.

Skelton, Robert, et alii: *Arts of Bengal. The Heritage of Bangladesh and Eastern India.* London: Whitechapel Art Gallery, 1979.

Skelton, Robert, et alii: *The Indian Heritage. Court Life & Arts under Mughal Rule. Victoria & Albert Museum 21 April – 22 August 1982.* London: Victoria and Albert Museum, 1982.

Sleeman, W[illiam] H[enry]: *Rambles and Recollections of an Indian Official.* 2 Vols. London: J. Hatchard and Son, 1844.

Smart, Ellen S. / Walker, Daniel S.: *Pride of the Princes: Indian Art of the Mughal Era in the Cincinnati Art Museum.* Cincinnati: Cincinnati Art Museum, 1985.

Smith, Edmund W.: Decorative Paintings from the Tomb of Itmad-ud-Daulah at Agra. In: *The Journal of Indian Art and Industry,* Volume VI, no.51, July, 1895, pp. 91–96 + plates.

Smyth, Carmichael G.: *A History of the Reigning Family of Lahore, with some Accounts of the Jummoo Rajahs, their Seik Soldiers and their Sirdars.* [Reprint:] Lahore: Printed under the Authority of the Government of West Pakistan, 1961 [first published in 1847].

Solvyns, F[rançois] Balthazar: *A Collection of Two-Hundred and Fifty Coloured Etchings descriptive of the Manners, Customs and Dresses of the Hindoos. Including the Trades and Professions, Servants, Hindu Men and Women, Beasts of Burden, Palanquins, Boats, Ways of Smoking the Hooka, Musical Instruments, Festivals and Funerals, in twelve sections.* Calcutta: Mirror Press, 1799.

Solvyns, F[rançois] Baltazard: *Les Hindous.* 4 Vols. Paris: Chez l'Auteur, de l'Imprimerie de Mame Frères, 1808–1812.

Somani, Ram Vallabh: *Later Mewar.* Jaipur: Current Law House, 1985.

Sotheby & Co. *Catalogue of Western and Oriental Manuscripts and Miniatures comprising a Series of sixty-four Water-colour Drawings on Indian Animals, Birds and Plants executed for Lady Impey by three Muslim Artists between 1774 and 1782...* London, 10th June, 1963.

Sotheby & Co. *Catalogue of Western and Oriental Manuscripts and Miniatures.* London, 12th December, 1966.

Sotheby & Co. *Catalogue of Highly Important Oriental Manuscripts and Miniatures.* London, 6th December, 1967.

Sotheby & Co. *Catalogue of Western, Oriental and Hebrew Manuscript and Miniatures.* London, 10th July, 1968.

Sotheby & Co. *Catalogue of Highly Important Oriental Manuscripts and Miniatures.* London, 1st December, 1969.

Sotheby & Co. *Catalogue of Oriental Manuscripts and Miniatures.* London, 15th July, 1970.

Sotheby & Co. *Catalogue of Oriental Manuscripts and Miniatures.* London, 9th December, 1970.

Sotheby & Co. *Catalogue of Oriental Manuscripts and Miniatures and Printed Books.* London, 14th July, 1971.

Sotheby & Co. *Catalogue of Oriental Manuscripts and Miniatures.* London, 13th December, 1972.

Sotheby & Co. *Catalogue of Important Oriental Miniatures and a Mughal Manuscript.* London, 10th July, 1973

Sotheby & Co. *Catalogue of Oriental Miniatures and Manuscripts and a small Collection of Reference Books.* London, 23rd April, 1974.

Sotheby & Co. *Catalogue of Oriental Manuscripts and Miniatures.* London, 9th July, 1974.

Sotheby & Co. *Catalogue of Oriental Manuscripts, Indian and Persian Miniatures (Bibliotheca Phillippica. New Series: Medieval and Oriental Manuscripts, Part IX).* London, 27th November 1974.

Sotheby & Co. *Catalogue of Oriental Manuscripts and Miniatures.* London, 7th April, 1975.

Sotheby's *Catalogue of Fine Oriental Miniatures, Manuscripts and Qajar Paintings.* London, 9th December, 1975.

Sotheby's *Catalogue of Important Oriental Manuscripts and Miniatures.* London, 12th April, 1976.

Sotheby's *Catalogue of Eighteenth, Nineteenth and Twentieth Century Paintings, Watercolours, Prints and Photographs of Islamic interest by European Artists.* London, 14th April, 1976.

Sotheby's *Catalogue of Important Oriental Manuscripts and Miniatures.* London, 2nd May, 1977.

Sotheby's *Catalogue of Fine Indian Miniatures, Manuscripts and Qajar Paintings.* London, 4th April, 1978.

Sotheby's *Catalogue of Fine Eighteenth, Nineteenth and Twentieth Century European Paintings and Works of Islamic Interest.* London, 18th October, 1978.

Sotheby's *Catalogue of Fine Oriental Miniatures, Manuscripts, Qajar Paintings and Lacquer.* London, 24th April, 1979.

Sotheby Parke Bernet [Catalogue of] *Fine Oriental Miniatures, Manuscripts, Islamic Works of Art and 19th Century Paintings.* New York, June 15, 1979.

Sotheby Parke Bernet [Catalogue of] *Fine Oriental Miniatures, Manuscripts, Islamic Works of Art and 19th Century Paintings.* New York, December 14, 1979.

Sotheby Parke Bernet [Catalogue of] *Fine Oriental Miniatures, Manuscripts and Islamic Works of Art.* New York, June 30, 1980.

Sotheby's *Catalogue of Fine Oriental Manuscripts, Miniatures and Qajar Lacquer.* London, 7th / 8th July, 1980.

Sotheby's *Catalogue of Fine Oriental Manuscripts, Miniatures and Qajar Lacquer.* London, 13th / 14th October, 1980.

Sotheby Parke Bernet [Catalogue of] *Fine Oriental Miniatures and Islamic Works of Art including the Fraser Album.* New York, December 9, 1980.

Sotheby's *Catalogue of Fine Oriental Miniatures, Manuscripts and Printed Books.* London, 28th / 29th April, 1981.

Sotheby Parke Bernet [Catalogue of] *Fine Oriental Miniatures, Manuscripts and Islamic Works of Art.* New York, May 21, 1981.

Sotheby Parke Bernet [Catalogue of] *Fine Oriental Miniatures, Manuscripts and Islamic Works of Art.* New York, December 10, 1981.

Sotheby's *Catalogue of Fine Indian Miniatures, Indian and other Asian Works of Art, With related material by European Artists.* London, 29th March and 30th March, 1982.

Sotheby's *Catalogue of Fine Oriental Manuscripts and Miniatures.* London, 11th October, 1982.

Sotheby's [Catalogue of] *Fine Oriental Manuscripts and Miniatures.* London, 16th April, 1984.

Sotheby's [Catalogue of] *Oriental Miniatures and Manuscripts.* London, 2nd July, 1984.

Sotheby's [Catalogue of] *Fine Oriental Manuscripts and Miniatures.* London, 15th and 16th April 1985.

Sotheby's [Catalogue of] *Indian, Tibetan, Nepalese, Thai, Khmer and Javanese Art including Indian Miniatures.* New York, September 20th and 21st, 1985.

Sotheby's [Catalogue of] *Fine Oriental Manuscripts and Miniatures.* London, 22nd and 23rd May 1986

Sotheby's [Catalogue of] *Fine Oriental Manuscripts and Miniatures.* London, 20th November 1986.

Sotheby's [Catalogue of] *Khmer, Thai, Indian and Himalayan Works of Art.* London, 15th June 1987.

Sotheby's [Catalogue of] *Fine Oriental Manuscripts and Miniatures.* London, 14th December, 1987.

Sotheby's [Catalogue of] *Oriental Manuscripts and Miniatures.* London, 10th October, 1988.

Sotheby's [Catalogue of] *Nineteenth Century European Paintings, Drawings and Sculpture.* New York, February 22nd, 1989.

Sotheby's [Catalogue of] *Indian, Himalayan and Southeast Asian Art.* New York, March 22, 1989.

Sotheby's [Catalogue of] *Oriental Manuscripts and Miniatures.* London, 26th April, 1990.

Sotheby's [Catalogue of] *Indian, Himalayan and Southeast Asian Art.* New York, October 6, 1990.

Sotheby's [Catalogue of] *Oriental Manuscripts and Miniatures.* London, 12th October, 1990.

Sotheby's [Catalogue of] *Oriental Manuscripts and Miniatures.* London, 26th April, 1991.

Sotheby's [Catalogue of] *Islamic and Indian Art, Oriental Manuscripts and Miniatures.* London, 10th and 11th October, 1991.

Sotheby's [Catalogue of] *The Bachofen von Echt Collection - Indian Miniatures.* London, 29th April, 1992.

Sotheby's [Catalogue of] *Islamic and Indian Art. Oriental Manuscripts and Miniatures.* London, 29th and 30th April, 1992.

Sotheby's Colonnade. [Sale Catalogue of] *Oriental Works of Art from Neolithic to the 20th Century.* London, 13th and 14th October, 1992.

Sotheby's [Catalogue of] *Islamic and Indian Art, Oriental Manuscripts and Miniatures.* London, 22nd and 23rd October, 1992.

Sotheby's [Catalogue of] *Himalayan, Indian & South-East Asian Works of Art.* London, 21st October 1993.

Sotheby's [Catalogue of] *Oriental Manuscripts and Miniatures.* London, 22nd October, 1993.

Sotheby's [Catalogue of] *British Paintings 1500–1850.* London, 13th April, 1994.

Sotheby's [Catalogue of] *Indian Miniatures. The Property of the British Rail Pension Fund.* London, 26th April, 1994.

Sotheby's [Catalogue of] *Oriental Manuscripts and Miniatures.* London, 27th April, 1994.

Sotheby's [Catalogue of] *Indian and Southeast Asian Art.* New York, June 4, 1994.

Sotheby's [Catalogue of] *Indian and Southeast Asian Art.* New York, March 23, 1995.

Sotheby's [Catalogue of] *Indian and Southeast Asian Art.* New York, September 21, 1995.

Sotheby's [Catalogue of] *Oriental Manuscripts and Miniatures.* London, 18th October, 1995.

Sotheby's [Catalogue of] *Persian and Indian Manuscripts and Miniatures from the collection formed by the British Rail Pension Fund.* London, 23rd April, 1996.

Sotheby's [Catalogue of] *Oriental Manuscripts and Miniatures.* London, 24th April, 1996.

Sotheby's [Catalogue of] *Islamic Works of Art and Indian, Himalayan and South-East Asian Art.* London, 25th April, 1996.

Sotheby's [Catalogue of] *Indian and Southeast Asian Art.* New York, September 19, 1996.

Sotheby's [Catalogue of] *Modern and Contemporary Indian Paintings. One Hundred Years.* London, 8 October 1996.

Soustiel, Jean / David, Marie-Christine: *Miniatures Orientales de l'Inde: Les Écoles et leurs Styles.* Paris: Librairie Legueltel, 1973.

Souvenir of the Coronation: A Souvenir of the Coronation of His Majesty King George VI Emperor of India. Calcutta: The Publishing Co. of India, 1937.

Spear, Percival: *Twilight of the Mughuls. Studies in Late Mughul Delhi.* Cambridge: At the University Press, 1951.

Spink: Painting for the Royal Courts of India. To be exhibited for sale by Spink & Son Ltd ... April 7 – April 23. London: Spink & Son Ltd., 1976.

Spink: Indian Miniatures. This folder coincides with an exhibition which will be on view from: 1st – 31st October 1991. London: Spink & Son, 1991.

Stchoukine, Ivan: *La Peinture Indienne à l'époque des Grand Moghols.* Paris: Librairie Ernest Leroux, 1929a (Études d'art et d'archéologie publiées sous la direction d'Henri Focillon).

Stchoukine, Ivan: *Les Miniatures Indiennes de l'Époque des Grands Moghols au Musée du Louvre.* Paris: Librairie Ernest Leroux, 1929b (Études d'art et d'archéologie publiées sous la direction d'Henri Focillon).

Stchoukine, Ivan: Portraits Moghols: Deux Darbar de Jahangir. In: *Revue des Arts Asiatiques,* Tome VI, No.IV, Décembre 1929–1930, pp. 212–241.

Stapp, William F.: Souvenirs of Asia: Photography in the Far East, 1840–1920. In: *Image, Journal of Photography and Motion Pictures of George Eastman House,* Volume 37, Nos.3–4, Fall/Winter 1994, pp. 1–53.

Sugich, Michael: *Palaces of India. A Traveller's Companion Featuring The Palace Hotels.* London: Pavilion Books Limited, 1992.

Survey of India: Cantonments, City & Environs of Delhi 1867–68. Calcutta: Published under the direction of Colonel H.L. Thullier, Surveyor General of India, Surveyor General's Office, April 1869.

Sweetman, John: *The Oriental Obsession. Islamic Inspiration in British and American Art and Architecture 1500–1920.* Cambridge [etc.]: Cambridge University Press, 1988.

Sydenham of Combe, (Lord): *India and the War. With an Introduction by Lord Sydenham of Combe.* New York and London: Hodder and Stoughton, 1915.

Tagore, Abanindranath: *Some Notes on Indian Artistic Anatomy and Sadanga or the six Limbs of Painting.* [Reprint:] Calcutta: Indian Society of Oriental Art, 1968.

Takata, Osamu / Taeda, Mikihiro: *Ajanta.* Tokyo: Heibonsha Ltd., 1971.

Talwar, Kay / Krishna, Kalyan: *Indian Pigment Paintings on Cloth.* Ahmedabad: Calico Museum, 1979 (Historic Textiles of India at the Calico Museum, Ahmedabad, Volume III).

Tara Chand / Kashmira Singh, S.: *Chughtai's Indian Paintings. Thirty Five Plates in All.* New Delhi: Dhoomi Mal Dharam Das, 1951.

Tavernier, Jean Baptiste: *Travels in India. Translated from the original French Edition of 1676 with a biographical sketch of the Author, Notes, Appendices, &c. by V. Ball. Second Edition edited by William Crooke.* 2 Vols. London: Humphrey Milford / Oxford: Oxford University Press, 1925.

The India Collection. Catalogue of a collection of over 2,200 books covering the British period. New Delhi: The British Council, 1982.

The India magazine of her people and culture: Images in Time - 150 years. Volume ten [New Delhi], December 1989.

Thomas, G.: *History of Photography* [in] *India, 1840–1980.* [Hyderabad:] Andhra Pradesh State Akademi of Photography, 1981.

Thornton, Edward: *A Gazetteer of the Territories under the Government of The East-India Company, and of the Native States on the Continent of India. Compiled by the Authority of the Hon. Court of Directors, and Chiefly from Documents in their Possession.* 4 Vols. London: Wm. H. Allen & Co., 1854.

Tieffenthaler, Joseph: *Description Historique et Géographique de l'Inde, qui présente en trois Volumes, enrichis de 67 Cartes et autres Planches: I La Géographie de l'Indoustan, écrite en Latin, dans le pays même, par le Père Joseph Tieffenthaler, jésuite & Missionaire apostolique dans l'Inde...* Vol.1 [of 3]. Berlin: Jean Bernoulli / Paris: V. Tilliard & Fils / Londres: W. Faden, 1786.

Tillotson, Giles Henry Rupert: *Aa to Zywiec. Summer 1985.* London: Hobhouse Limited, 1985.

Tillotson, Giles Henry Rupert: *The Rajput Palaces. The Development of an Architectural Style, 1450–1750.* New Haven and London: Yale University Press, 1987.

Titley, Norah M.: *Miniatures from Persian Manuscripts. A Catalogue and Subject Index of Paintings from Persia, India and Turkey in the British Library and the British Museum.* London: Published for the British Library by British Museum Publications Limited, 1977.

Tod, James: *Annals and Antiquities of Rajasthan or the Central and Western Rajput States of India. Edited with an Introduction and Notes by William Crooke.* 3 Vols. London [etc.]: Humphrey Milford / Oxford University Press, 1920.

Topsfield, Andrew: *Paintings from Rajasthan in the National Gallery of Victoria. A Collection acquired through the Felton Bequests' Committee.* Melbourne: National Gallery of Victoria, 1980.

Topsfield, Andrew: *Ketelaar's Embassy and the Farangi Theme in the Art of Udaipur.* In: *Oriental Art,* New Series, Vol.XXX, No.4, Winter 1984/85, pp. 350–367.

Topsfield, Andrew: *The City Palace Museum Udaipur. Paintings from Mewar Court Life.* Ahmedabad: Mapin Publishing Pvt. Ltd., 1990.

Topsfield, Andrew: *A Portrait from the Court of Oudh.* In: *The Ashmolean.* Number Twenty five. Christmas 1993, pp. 10–12.

Topsfield, Andrew: *Indian paintings from Oxford collections.* Oxford: Ashmolean Museum in association with the Bodleian Library, 1994 (Ashmolean handbooks).

Topsfield, Andrew: The royal paintings inventory at Udaipur. In: *Indian Art & Connoisseurship. Essays in Honour of Douglas Barrett,* edited by John Guy. Middleton, NJ: Grantha Corporation / Ahmedabad: Mapin Publishing Pvt. Ltd., 1995, pp. 188–199 and col. plates, pp. 174–175.

Topsfield, Andrew: Rajputs in an interior. In: *The Ashmolean.* Number Twenty nine. Christmas 1995a, pp. 11–12.

Tucker, R. Froude: The Rang Mahall in Delhi Palace. In: *Annual Report* [of the] *Archaeological Survey of India 1907–08,* Calcutta: Superintendent Government Printing, India, 1911, pp. 23–30.

Tuzuk: The Tuzuk-i-Jahangiri or Memoirs of Jahangir. Translated by Alexander Rogers. Edited by Henry Beveridge. 2 Vols. [Reprint in one Volume:] New Delhi: Munshiram Manoharlal Publishers Pvt. Ltd., 1978 [first published 1909–1914].

Tytler, Harriet: *An Englishwoman in India. The Memoirs of Harriet Tytler 1828–1858. Edited by Anthony Sattin. With an Introduction by Philip Mason.* Oxford / New York: Oxford University Press, 1986.

Ubbas Ali, [Darogha]: *The Lucknow Album. Containing a Series of Fifty Photographic Views of Lucknow and its Environs, Together with a Large Sized Plan of the City... To the above is added a Full Description of each Scene depicted, the Whole forming a complete Illustrated Guide to the City of Lucknow, the Capital of Oude.* Calcutta: Baptist Mission Press, 1874.

Ujfalvy, Karl Eugen von: *Aus dem Westlichen Himalaya. Erlebnisse und Forschungen.* Leipzig: F.A. Brockhaus, 1884.

Vadivelu, A.: *The Ruling Chiefs, Nobles & Zamindars of India.* Vol.I. Madras: G.C. Loganadham Bros., 1915.

Vashistha, R[adha] K[rishna]: *Arts and Artists of Rajasthan (A Study on the Art & Artists of Mewar with reference to Western Indian School of Painting).* New Delhi: abhinav publications, 1995.

Vashishtha, [vaśisth], Radhakrishna [rādhākṛṣṇa]: *Mevāḍ kī citraṃkan paramparā. (rājasthānī chitrakalā kī prārambhik pṛṣṭhabhūmi).* Jaypur: Yūnik ṭreḍars, 1984.

Vatsyayan, Kapila: *Dance in Indian Painting.* New Delhi: abhinav publications, 1982.

Verma, Som Prakash: *Mughal Painters and their Work. A Biographical Survey and Comprehensive Catalogue.* Aligarh: Centre of Advanced Study in History / Delhi [etc.]: Oxford University Press, 1994.

Vignau, Sabine du / Renié, Pierre-Lin: *L'Inde. Photographies de Louis Rousselet 1865 - 1868.* Bordeaux: Musée Goupil, 1992.

Vigne, G[odfrey] T[homas]: *Travels in Kashmir, Ladak, Iskardo, the Countries adjoining the Mountain-Course of the Indus, and the Himalaya, North of the Panjab. With Map ... and other Illustrations. Second edition.* 2 Vols. [Reprint:] Karachi: Indus Publications, 1987 [first published 1844].

Villiers Stuart, C[onstance] M.: *Gardens of the Great Mughals.* London: Adam and Charles Black, 1913.

Vitsaxis, Vassilis G.: *Hindu Epics, Myths and Legends in Popular Illustrations*. Delhi [etc.]: Oxford University Press, 1977.

Vogel, J[ean] Ph[ilippe]: Tile mosaics on the Lahore Palace. In: *Annual Progress Report of the Superintendent of the Archaeological Survey, Panjab and United Provinces Circle*. For the Year ending 31st March 1904, pp. 71–74.

Vogel, J[ean] Ph[ilippe]: Tile-Mosaics of the Lahore Fort. In: *The Journal of Indian Art and Industry*. Vol.XIV, no.113, January, 1911.

Vogel, J[ean] Ph[ilippe]: Tile-Mosaics of the Lahore Fort. In: *The Journal of Indian Art and Industry*. Vol.XIV, no.114, April, 1911.

Vogel, J[ean] Ph[ilippe]: Tile-Mosaics of the Lahore Fort. In: *The Journal of Indian Art and Industry*. Vol.XIV, no.115, July, 1911.

Vogel, J[ean] Ph[ilippe]: Tile-Mosaics of the Lahore Fort. In: *The Journal of Indian Art and Industry*. Vol.XIV, no.116, October, 1911.

Vogel, J[ean] Ph[ilippe]: Tile-Mosaics of the Lahore Fort. In: *The Journal of Indian Art and Industry*. Vol.XV, no.118, April, 1912.

Vogel, J[ean] Ph[ilippe]: *Tile-Mosaics of the Lahore Fort*. Karachi: Pakistan Publications, n.d. [first published in 1920 as No.41 of the Archaeological Survey of India, New Imperial Series].

Walker, David: *The Prince in India. A Record of the Indian Tour of His Royal Highness The Prince of Wales - Nov. 1921 to March 1922*. Bombay / Calcutta / London: Bennett, Coleman & Co., Ltd., 1923.

Ward, Geoffrey C. / Joel, Seth: *Die Maharadschas*. München: Christian Verlag, 1984 (Schatzkammern und Herrscherhäuser der Welt).

Waris Shah: *Hir und Ranjha. Eine klassische indische Liebesgeschichte. Deutsch von Esmy Berlt*. Berlin: Verlag Neues Leben, 1989.

Watson, J[ohn] Forbes: *The Textile Manufactures and the Costumes of the People of India*. London: Printed for the India Office, by George Edward Eyre and William Spottiswoode, 1866.

Weber, Rolf: *Porträts und historische Darstellungen in der Miniaturensammlung des Museums für Indische Kunst Berlin*. Berlin: Museum für Indische Kunst, 1982 (Veröffentlichungen des Museums für Indische Kunst, Band 6).

Webster, Mary: *Johan Zoffany 1733–1810*. London: National Portrait Gallery, 1976.

Weeks, Edwin Lord: Notes on Indian Art. In: *Harper's New Monthly Magazine*, Vol.91, 1895, pp. 567–585.

Weeks, Edwin Lord: *From the Black Sea through Persia and India. Illustrated by the Author*. London: Osgood, McIlvaine & Co., 1896.

Welch, Stuart Cary: *The Art of Mughal India. Painting & Precious Objects*. New York: The Asia Society Inc., 1963.

Welch, Stuart Cary: *A Flower from Every Meadow. Indian Paintings from American Collections*. New York: The Asia Society, 1973.

Welch, Stuart Cary: *Indian Drawings and Painted Sketches. 16th through 19th Centuries*. New York: The Asia Society in Association of John Weatherhill, Inc., 1976.

Welch, Stuart Cary: *Room for Wonder. Indian Painting during the British Period 1760–1880*. New York: The American Federation of Arts, 1978.

Welch, Stuart Cary: *Indische Buchmalerei unter den Großmoghuln 16.–19. Jahrhundert*. München: Prestel Verlag, 1978a.

Welch, Stuart Cary: *India. Art and Culture 1300–1900*. New York: The Metropolitan Museum of Art / Holt Rinehart and Winston, 1985.

Welch, Stuart Cary / Beach, Milo Cleveland: *Gods, Thrones, and Peacocks. Northern Indian Painting from two Traditions: Fifteenth to Nineteenth Century*. New York: The Asia Society, Inc., 1965.

Wellesz, Emmy: *Akbar's Religious Thought Reflected in Mogul Painting*. London: George Allen and Unwin Ltd., 1952 (Ethical and Religious Classics of East and West, No.7).

Wheeler, Stephen: *History of the Delhi Coronation Durbar. Held on the First of January 1903 to celebrate the Coronation of His Majesty King Edward VII, Emperor of India. Compiled from Official Papers by Order of the Viceroy and Governor-General of India. With Portraits and Illustrations*. London: John Murray, 1904.

Wheeler, J. Talboys: *The History of the Imperial Assemblage at Delhi, Held on 1st January, 1877*. London: Longmans, Green, Reader, and Dyer, 1877.

White, George Francis: *Views in India, chiefly among the Himalaya Mountains. Edited by Emma Roberts*. London and Paris: Fisher, Son, and Co., 1838.

Whiteway, R.S.: *The Rise of Portuguese Power in India 1497–1550. Second edition*. London: Susil Gupta, 1967 [first edition: 1899].

Wiebeck, Erno: *Indische Boote und Schiffe*. Rostock: VEB Hinstorff Verlag, 1987.

Wiele / Klein: *Coronation Durbar Delhi. Illustrated*. Madras: Wiele & Klein, 1903.

Wilkinson, J.V.S.: *Mughal Painting*. London: Faber and Faber Limited, 1948 (The Faber Gallery of Oriental Art).

Wilkinson-Latham, Christopher: *The Indian Mutiny*. London: Osprey Publishing, 1977 (Men-at-Arms Series).

Williamson, Thomas / Howitt, Samuel: *Oriental Field Sports; being a complete, detailed, and accurate Description of the Wild Sports of the East;... *. London: by William Bulmer and Co. for Edward Orme, 1807.

Williamson, Thomas / Howitt, Samuel: *Oriental Field Sports; being a complete, detailed, and accurate Description of the Wild Sports of the East; and exhibiting, in a novel and interesting Manner, the Natural History of the Elephant, the Rhinoceros, the Tiger, the Leopard, the Bear, the Deer, the Buffalo, the Wolf, the Wild Hog, the Jackall, the Wild Dog, the Civet, and other domesticated Animals: As likewise the different Species of feathered Game, Fishes, and Serpents. The Whole interspersed with a Variety of Original, authentic, and Curious Anecdotes, taken from the Manuscript of Captain Thomas Williamson, Who served upwards of Twenty Years in Bengal; The Drawings by Samuel Howitt, made uniform in Size, and engraved by the first artists. Second Edition. 2 Vols*. London: Printed for H.R. Young, by J. M'Creery, 1819.

Wilson, Francesca H.: *Rambles in Northern India. With Incidents and Descriptions of many Scenes of the Mutiny, including Agra, Delhi, Lucknow, Cawnpore, Allahabad, etc.* London: Sampson Low, Marston, Low, and Searle, 1876.

Wilson, H.H.: *A Glossary of Judicial and Revenue Terms, and of useful Words occuring in official Documents relating to the Administration of the Government of British India, from the Arabic, Persian, Hindustani, Sanskrit, Hindi, Bengali, Uriya, Marathi, Guzarathi, Telugu, Karnata, Tamil, Malayalam, and other Languages. Compiled and published under the Authority of the Honorable The Court of Directors of the East-India Company*. [Reprint:] Delhi: Munshiram Manoharlal, 1968 [First Published: London: Wm. H. Allen & Co., 1855].

Wimalagnana, Beratuduwe: *Sanchi. Citadel of the Sculptures of Indian Buddhism*. (Colombo:) Maha Bodhi Society of Ceylon, 1972.

Woerkens, Martine van: *Le Voyageur étranglé. L'Inde des Thugs, le colonialisme et l'imaginaire.* Paris: Albin Michel, 1995.

Woodford, Peggy: *Rise of the Raj.* Turnbridge Wells, Kent: Midas Books / Atlantic Highlands, New Jersey: Humanities Press, Inc., 1978.

Woodruff, Philip: *The Men who ruled India. The Founders.* London: Jonathan Cape, 1953.

Worswick, Clark: *Princely India. Photographs by Raja Deen Dayal 1884–1910.* London: Hamish Hamilton, 1980.

Worswick, Clark / Embree, Ainslie: *The Last Empire. Photography in British India, 1855–1911.* London: Gordon Fraser, 1976.

Yate, C.E.: Gazetteer of Meywar. In: *The Rajputana Gazetteer.* Volume III. Simla: Government Central Branch Press, 1880, pp. 1–73.

Yazdani, Ghulam: *Ajanta. The Colour & Monochrome Reproductions of the Ajanta Frescoes based on Photography. ... Part IV [of 4] Comprising 17 Colour and 65 Monochrome Plates of Caves XVII–XXVII.* London / New York / Bombay: Oxford University Press, 1955.

Young, Desmond: *Fountain of the Elephants.* London: Collins, 1959.

Yule, Henry / Burnell, A. C.: *Hobson-Jobson. A Glossary of colloquial Anglo-Indian Words and Phrases, and of Kindred Terms, Etymological, Historical, Geographical and Discursive. New edition edited by William Crooke.* [Reprint:] New Delhi: Munshiram Manoharlal Publishers Pvt. Ltd., 1984 [originally published by John Murray, London, 1903].

Zebrowski, Mark: *Deccani Painting.* London: Sotheby Publications / Berkeley and Los Angeles: University of California Press, 1983.

Zebrowski, Mark: Painting. In: *Islamic Heritage of the Deccan.* Bombay: Marg Publications, 1986, pp. 92–109.

INDEX